1989

Understanding Art

ABOUT THE COVER

In 1956, a young photographer found himself in Nice, on the French Riviera. He was photographing a still life of perfume bottles in a sea of flowers for Holiday Magazine, when he decided to telephone Pablo Picasso. Two years earlier, this giant of modern art had posed for him in what has become one of the most familiar portraits in the history of photography. The young man was the now internationally acclaimed portrait photographer, Arnold Newman, who has captured on film some of the most famous faces in the worlds of art and music. Picasso had been asking Newman for some time to provide him with copies of his portrait. The photographer saw this request as an opportunity to visit once more the artist's studio at his ornate villa, La Californie, in Cannes. Newman asked if he might bring along a few rolls of film. Permission was granted and Newman shot every inch of film he had.

On that day Picasso's studio was, as usual, visited by members of the cultural elite—poets, writers, artists, critics—and was alive with the antics of Picasso's children, Claude and Paloma. The artist's mistress, Jacqueline Roque, was also there. Newman photographed Picasso and every corner of his studio. One striking view appears on the cover of this book.

Understanding Art

SECOND EDITION

LOIS FICHNER-RATHUS
Trenton State College

PRENTICE HALL, Englewood Cliffs, New Jersey 07632

Library of Congress Cataloging-in-Publication Data

FICHNER-RATHUS, LOIS (date)
 Understanding art.

 Includes index.
 1. Art appreciation—Study and teaching (Higher)
I. Title.
N345.F45 1989 701'.1 88–25492
 ISBN 0–13–936253–3 (pbk.)

For Allyn, Jordan, and Spence

Editorial and production supervision: Hilda Tauber
Cover photograph by Arnold Newman
Manufacturing buyer: Ray Keating
Page layout: Meryl Poweski
Photo research: Joelle Burrows, Kay Dellosa
Photo editor: Lori Morris-Nantz

Printed in the United States of America
10 9 8 7 6 5 4 3 2 1

ISBN 0-13-936253-3 01

Prentice-Hall International (UK) Limited, *London*
Prentice-Hall of Australia Pty. Limited, *Sydney*
Prentice-Hall Canada Inc., *Toronto*
Prentice-Hall Hispanoamericana, S.A., *Mexico*
Prentice-Hall of India Private Limited, *New Delhi*
Prentice-Hall of Japan, Inc., *Tokyo*
Simon & Schuster Asia Pte. Ltd., *Singapore*
Editora Prentice-Hall do Brasil, Ltda., *Rio de Janeiro*

Brief Contents

Contents

9

THE ART OF EVERYDAY LIVING: CRAFTS AND DESIGN 202

10

THE ART OF THE ANCIENTS 234

13
THE RENAISSANCE 320

14
THE AGE OF BAROQUE 351

Preface

I was gratified when Prentice-Hall asked me to revise *Understanding Art*. The acceptance of the first edition confirmed the value of our unique approach to the teaching of art appreciation and I was exhilarated to have the opportunity to "fine tune" the text for a second go-around.

The first edition had been an enormous task—the creation from scratch of a book that would work both for students and for professors. I needed to compose a tool that would help organize and enlighten this demanding, often whirlwind-like course. In a sense I wanted to write a book that would do it all—to edify and inform students and at the same time to keep them engaged, animated, inspired. It was not enough for me to satisfy my own needs through eloquent metaphor, or to meet the desire of instructors for comprehensive exposition—I wanted to make *Understanding Art* "user friendly" to its ultimate consumers—students.

I had envisioned writing the revision as a simpler task than the original, but I was mistaken. Once I commenced it became very clear to me that I was going about the risky business of tampering with the successful. Broadly speaking, my task was to develop the text but also to retain the features, topics, and coverage that worked well the first time around. More specifically, it was decided that I would expand the discussions of media and methods but retain the comprehensive coverage of art history that set the first edition apart from other art appreciation textbooks. It was resolved that I would introduce more examples of contemporary art and women's art but maintain the celebrated monuments from the history of art. And it was determined that we would triple the number of color illustrations and enlarge their dimensions—yet somehow keep the text to a manageable size.

To my delight, and somewhat to my surprise, we have managed to meet out goals.

COVERAGE

Understanding Art is comprehensive and balanced in coverage. It communicates the excitement, relevance, and beauty of art by combining stimulating discussions of the language and elements of art with a comprehensive treatment of the history of art. The elements of art—media, methods, con-

tent, composition, style—and its purposes constitute the first part of the book. Chapters 1–9 focus on what we respond to in a work of art and how artists go about their work. It was my intention to show that our lives are enriched not only by drawing, painting, sculpture and architecture, but also by photography, cinematography, video art, crafts, even advertising design.

We are affected not only by the art we view in the world's famous museums. The carpeting we tread upon, the furniture on which we sit, even the logos on our business stationery can all have an aesthetic influence on our daily lives. I felt that I must open students' eyes to all this; I must help them to understand and appreciate the beauty all about them.

But to understand where we are, we must also understand where we have been. To provide such insight, the history of art is covered chronologically in the second part of the book. It was my goal to demonstrate that artists from all periods and all cultures have used the same elements and language of art in order to commemorate their experiences, express religious values, protest the social order, decorate their communities, or persuade their audiences. Their works, of course, have taken very different forms. Yet each, when understood, may be seen to have a certain integrity—indeed, a certain necessity—that expresses the artist's time, place, and personality.

PEDAGOGY AND STYLE

It is not sufficient, however, for textbooks to be comprehensive in coverage. They must also meet the students' needs by presenting the subject in an accessible form.

Most students who take art appreciation or introduction to art history courses are nonmajors. Some are fulfilling a distributional requirement in the humanities. As such, many of them begin their studies with little or no idea of what art is about. This textbook uses a number of pedagogical and stylistic features to stimulate and enlighten the contemporary broad-based college population:

- INTRODUCTION: An introductory chapter called "What Is Art?" discusses the meanings, purposes, and styles of art.
- "A CLOSER LOOK" AND "THE ARTIST SPEAKS" BOXES: Boxed highlights in each chapter contain discussions of the methodology of art history, insights into artists' personalities, art-related news items, and meaningful quotations from artists and other sources.
- LINE DRAWINGS: Pertinent and clearly labeled diagrams, maps, architectural plans, and explanatory drawings for complex artistic processes are interspersed throughout the chapters on media and methods.
- GLOSSARY: Key terms are boldfaced in the text and defined in an end-of-book glossary.
- STYLE: The style of writing and the explanations of concepts are tailored to communicate to the students without compromising the complexity of the subject matter. As I wrote *Understanding Art*, I tried to remain keenly aware of what had come before and what would come ahead, so that I could build concepts logically and gradually. I avoided using difficult technical terms arbitrarily; and, when I did use them, I attempted to explain them clearly.

Whatever else good writing does, it must also communicate, and I did not subordinate communication to the subject matter; instead, I made every effort to integrate style and subject.

ACKNOWLEDGMENTS

I consider myself fortunate to have studied with a fine group of artists and art historians who helped shape my thinking throughout my career. Without the broad knowledge, skills, and dedication of these individuals, *Understanding Art* would never have come into being. They include: James S. Ackerman, Wayne V. Andersen, Stanford Anderson, Whitney Chadwick, Charles C. Cunningham, Mojmir Frinta, Michael Graves, George Heard Hamilton, Ann Sutherland Harris, Diane U. Headley, Julius S. Held, Henry A. Millon, Sam Hunter, Konrad Oberhuber, John C. Overbeck, Michael Rine-

hart, Andrew C. Ritchie, Mark W. Roskill, Theodore Roszak, Joan Snyder, and Jack Tworkov.

A number of colleagues provided valuable suggestions and insights at various stages in the development of *Understanding Art*, second edition. My sincere gratitude to the following instructors who reviewed the text in manuscript: Nathan Goldstein, Art Institute of Boston; Diane Kirkpatrick, History of Art, University of Michigan, Ann Arbor; Tuck Langland, Fine Arts, Indiana University, South Bend; George M. Craven, Photography, DeAnza College, Cupertino; and Frederick J. Zimmerman, Art, S.U.N.Y. College at Cortland, New York. For her helpful suggestions regarding the glossary, I am grateful to Susan G. Jackson, Marshall University, Huntington, West Virginia.

I acknowledge with pleasure the fine group of publishing professionals at Prentice Hall. Bud Therien, Executive Editor, is to be credited with bringing the manuscript to Prentice Hall. His enthusiasm and support inspired me throughout the developmental process of both editions. Hilda Tauber ably guided the project through the multiple demanding stages of production. Lori Morris and Joelle Burrows obtained the hundreds of new photographs. Meryl Poweski is responsible for the superb page layouts, and Christine Wolf for the handsome appearance of the text.

Finally, I would like to thank my husband, Spence, for his patience and help in certain aspects of preparing the manuscript. Writing a textbook can be an engulfing experience, and during the past several years he learned what it means to be an author's "widower."

1

What Is Art? Meanings, Purposes, Styles

Everyone wants to understand art. Why not try to understand the song of a bird? Why does one love the night, flowers, everything around one without trying to understand them? But in the case of a painting, people have to understand. —Pablo Picasso

Cold exactitude is not art; ingenious artifice, when it pleases or when it expresses, is art itself. —Eugène Delacroix

What is a work of art? A word made flesh. —Eric Gill

Art is nothing but humanized science. —Gino Severini

Beauty, truth, immortality, order, harmony—these concepts and ideals have occupied us since the dawn of history. They enrich our lives and encourage us to extend ourselves beyond the limits of flesh and blood. Without them, life would be but a mean struggle for survival, and the value of survival itself would be unclear.

It is in the sciences and the arts that we strive to weave our experiences into coherent bodies of knowledge and to express them aesthetically. Many of us are more comfortable with the sciences than with the arts. Science teaches us that the universe is not ruled purely by chance. The sciences provide ways of observing the world and experimenting so that we can learn what forces determine the courses of atoms and the galaxies. Even those of us who do not consider ourselves scientific recognize that the scientific method permits us to predict and control many important events on a grand scale.

The arts are more elusive to define than the sciences, more difficult to gather into a conceptual net. We believe that the arts are essential to daily experience; we link them to the very quality of life. Artistic undertakings in the form of crayon drawings, paper cutouts, and block towers are parts of the daily lives of our children. Art has touched the lives of primitive peoples, and art is all around us today. We do not want to be without the arts, yet we are hard pressed to define them and sometimes even to understand them. In fact, the very word *art* encompasses many meanings, including ability, process, and product. As ability, art is the human capacity to make things of beauty, things that stir us; it is creativity. As process, art encompasses acts such as drawing, painting, sculpting, designing buildings, and composing photographs. As product, art is the completed work, such as the print, statue, structure, or tapestry. If as individuals we do not understand science, we are at least comforted by the thought that others do. With art, however, we suspect that there is something about its very nature that transcends understanding.

This book is about the **visual arts.** Despite the enigmatic nature of the visual arts, we shall try to share something of what is known about them so that understanding may begin. We shall attempt to heighten awareness of what we respond to in a work of art. In so doing, at times we shall explore some of the principles of human perception.

We shall explore the basic language of art and see how the elements of art, such as line, color, and shape, are composed into artworks. We shall explore several **media** of the visual arts: drawing, painting, and printmaking; sculpture and architecture; photography and cinematography; and the functional arts of design and craft. A traditional distinction has been made between **fine arts** such as painting and sculpture and **applied arts** such as advertising design, ceramics, and fiber arts. We shall see that applied work can also be fine, and that the creative urges that stir the painter can also stir the weaver.

When asked why we should study history, historians often answer that we must know about the past in order to have a sense of where we are and where we may be going. This argument also holds true for the visual arts; therefore, we shall explore the journey of art from the wall paintings of the Stone Age through the steel-and-glass structures and the **wordworks** of the present day. The media, the forms, and the subject matter of art may evolve and change from day to day, but uniting threads lie in the persistent quest for beauty, truth, and other ideals.

In the remainder of this chapter we explore the purposes and styles of art to see how art meets many needs of the artist and of the viewing public.

PURPOSES OF ART

L'art pour l'art.
 Art for art's sake.

—Victor Cousin

Art never expresses anything but itself.

—Oscar Wilde

"*L'art pour l'art*"—art for art's sake. . . . Many philosophers have argued that art serves no function, that it exists for its own sake. Some have believed that there is something about the essence of art that transcends the human occupation with usefulness. Others have felt that in trying to analyze art too closely, we lose sight of its beauty and wonderment.

These may be valid concerns. Nevertheless, our understanding of art often can be enhanced by asking the questions: "Why was this created?" "What is its purpose?" In this section we shall see that works of art come into existence for a host of reasons that are as varied as the human condition.

To Create Beauty

The beautiful is in nature, and it is encountered in the most diverse forms of reality. Once it is found, it belongs to art, or, rather, to the artist who discovers it.

—Gustave Courbet

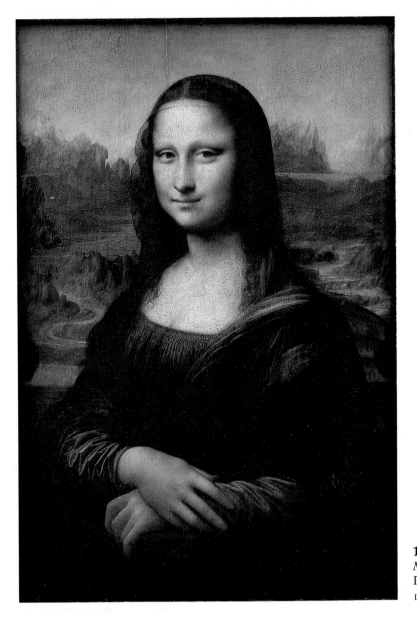

1–1 LEONARDO DA VINCI
Mona Lisa (c. 1503)
Panel. 30¼ x 21″.
Louvre Museum, Paris.

[Art] has as its foundation the beautiful, which is eternal and natural.

—Jean-Auguste-Dominique Ingres

The artist . . . makes life more interesting or beautiful.

—George Bellows

Art has always added beauty to our lives. Art may portray what is beautiful, but art can also elevate the commonplace to the beautiful. The Classical Greeks were obsessed with beauty, and fashioned mathematical formulas for rendering the human body in sculpture so that it would achieve a majesty and perfection unknown in nature.

The *Mona Lisa* (Fig. 1–1) by Renaissance artist and inventor Leonardo da Vinci is perhaps the most famous painting in the history of art. The woman's hands are folded before her in stately repose—an extraordinarily poetic study. The subtle gradations of light are created by layer upon layer of delicate **glazing.** The mysteriousness of the smile has enchanted generations of viewers, each trying to discern the personality of the sitter. The gentleness of the smile and the softness of the skin seem to evoke the ideals of femininity and motherhood.

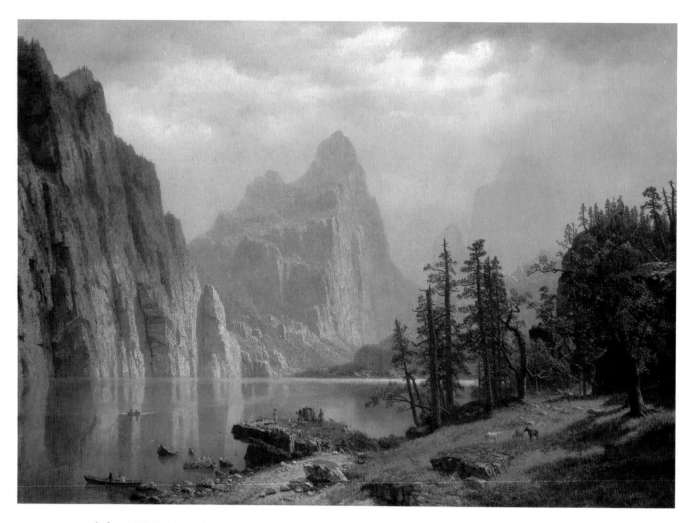

1–2 ALBERT BIERSTADT *Merced River, Yosemite Valley* (1866).
Oil on canvas. 36 x 50".

The Metropolitan Museum of Art. Gift of the sons of William Paton, 1909.

Nineteenth-century German-American artist Albert Bierstadt captured and expanded the beauty of the American wilderness in paintings such as *Merced River, Yosemite Valley* (Fig. 1–2). The wild horses and the encampment of Native Americans on the rock ledge may seem a touch trite, but when the painting was executed these were more than romantic touches; they depicted what was then a mysterious Western frontier. As pictorial devices, they lend a sense of scale to the awesome cliffs that rise from the water to pierce the heavens. The dramatic diffusion of natural light, the mirror of the water, the mountains lost in haze, and the churning clouds all make the painting as much a product of the imagination as it is a record of the geology and meteorology of the setting.

To Provide Decoration

Paintings are not only objects of beauty unto themselves; they also hang on walls or are painted directly on walls. Sculptures find their way into rooms, courts, and gardens; photographs are found in books; and fiber arts are seen on walls and floors. Whatever other functions they may serve, many works of art are also decorative.

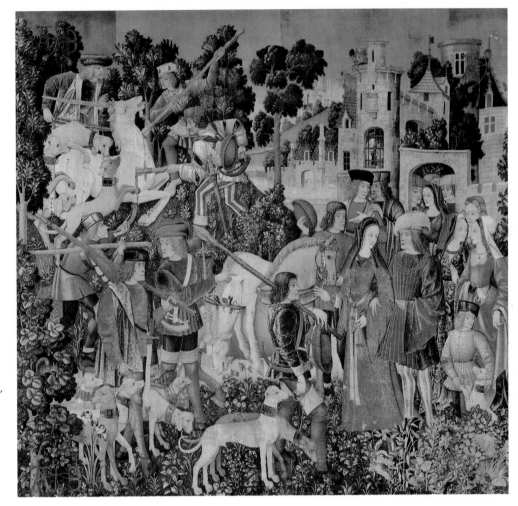

1–3 *The Hunt of the Unicorn, VI: The Unicorn Is Killed and Brought to the Castle* (Franco-Flemish, 15th century). Silk, wood, silver, and silver-gilt threads. 12′1″ x 12′9″.

The Metropolitan Museum of Art. Gift of John D. Rockefeller, Jr., The Cloisters Collection, 1937.

One of the most familiar and noble images in art is Michelangelo's *The Creation of Adam* (see Fig. 13–29), one of the many **fresco** panels that adorn the ceiling of the Sistine Chapel. Pope Julius II commissioned the painting of the ceiling to decorate what had been a big barn of a place. Michelangelo agreed to the project only in order to gain the pontiff's favor, so that he would eventually be allowed to complete the tomb that was to house his statue *Moses*. Raphael's well-known *The School of Athens* (see Fig. 13–26) was one of a number of ''wall decorations'' commissioned by Pope Julius II for his apartments, a commission that stirred the brooding Michelangelo to great jealousy.

The Unicorn Tapestries (Fig. 1–3) were commissioned at the end of the sixteenth century as a wedding present to Anne of Brittany and King Louis XII, and were meant to adorn the walls of one of the King's chateaus. The tapestries are tightly woven from wool and silk and are highlighted by threads of silver and silver-gold. Rich reds, oranges, yellows, and blues contrast with the whiteness of the unicorn and the true colors of the shrubbery. Eighty-five varieties of plants are accurately portrayed. The subject of the tapestries, the hunt of the unicorn, symbolizes courtly love and marriage and, possibly, the story of Jesus. The next-to-last scene shows the slaying of the unicorn, but in the final scene the unicorn is risen; it lives in captivity, its wounds visible.

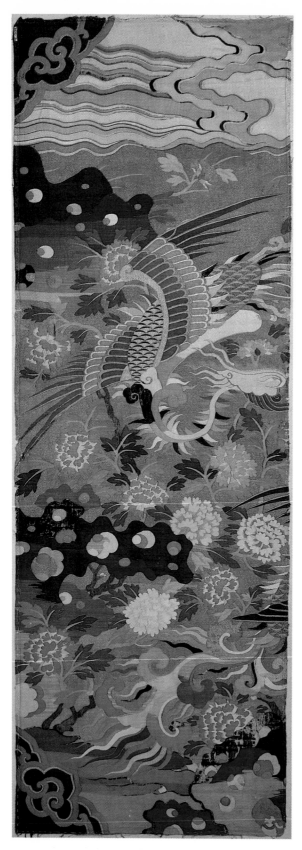

1–4 K'o-Ssu Tapestry. Fragment of a panel (Ming Dynasty, 1368–1644).
Silk and gold threads.

The Cleveland Museum of Art. Gift of Mr. and Mrs. J. H. Wade.

The silk and gold K'o-Ssu Tapestry (Fig. 1–4) is contemporaneous with the European Unicorn Tapestries. It is a handsome example of the weaving of the Ming Dynasty, which ruled China from the fourteenth century through much of the seventeenth. These tapestries were frequently inspired by well-known paintings, but never copied them exactly. Soft, flat color schemes like that of the tapestry were also used in woven robes that suggested the status or official rank of the wearer.

To Reveal Truth

It is the glory and good of Art,
That Art remains the one way possible
Of speaking truths, to mouths like mine at least.
—Robert Browning

My aim in painting has always been the most exact transcription possible of my most intimate impressions of nature.

—Edward Hopper

There is no such thing as symbolic art, social art, religious art, or monumental art; there is only the art of the representation of nature by an artist whose sole aim is to express its truth.

—Adolphe William Bouguereau

We must be able to see in order to appreciate the visual arts, but art can also make us see anew. It can highlight what is important and pierce façades to reveal what is beneath.

The truth, it is said, is not always pretty. Sometimes, in fact, it is ugly. Contemporary artist Chuck Close ruthlessly magnifies close-ups of photographed heads, projects them onto canvases and then paints them. His *Self-Portrait* (Fig. 1–5) measures almost 9 by 7 feet. Close's portraits, and those of many other **Photorealists,** carry the truth of photographic exactitude. All the imperfections of skin, the oiliness of unwashed hair, and the asymmetry of facial features assault the viewer. What a far cry from the *Mona Lisa*. Yet Close's self-portrait exemplifies another purpose of art.

The "ugly truth," like the beautiful truth,

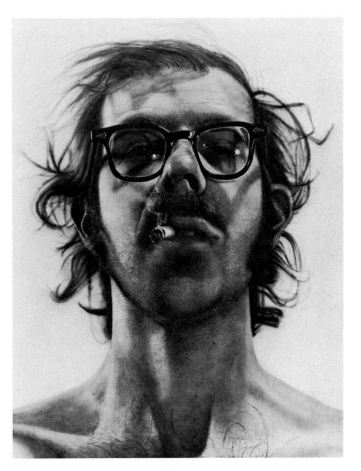

1–5 CHUCK CLOSE
Self-Portrait (1968)
Acrylic on canvas.
8'11½" x 6'11½".
Collection, Walker Art Center, Minneapolis.

provides a valid commentary on the human condition. Just as people have vastly discrepant personal qualities, such as humility and arrogance, the subjects and methods of artists reveal what is ugly as well as what is beautiful.

To Immortalize

Blest be the art that can immortalize.

—William Cowper

All passes. Art alone
Enduring stays to us;
The Bust outlasts the throne,—
The coin, Tiberius.

—Henry Austin Dobson

I believe in Michelangelo, Velasquez, and Rembrandt; in the might of design, the mystery of color, the redemption of all things by Beauty everlasting.

—George Bernard Shaw

The sculpted bust of the emperor outlasts the emperor, according to Dobson's verse, above. The coin that shows Tiberius passes on through the centuries long after Tiberius himself has returned to dust. For millennia, art has been used to overleap the limits of this life. The patrons of art, and the artists themselves, have sought immortality through works of art.

The Great Pyramids at Giza in Egypt (see Fig. 10–13) were designed as tombs. They were meant to endure for centuries in order to guarantee a permanent resting place for the spirits of the pharaohs.

Many tales have been told of the struggles between Michelangelo and Pope Julius II concerning the completion of the Pope's tomb. The original commission called for a two-story building with twenty-eight statues. Michelangelo saw it as the crowning achievement of his career. But funds were diverted from the tomb during the Pope's

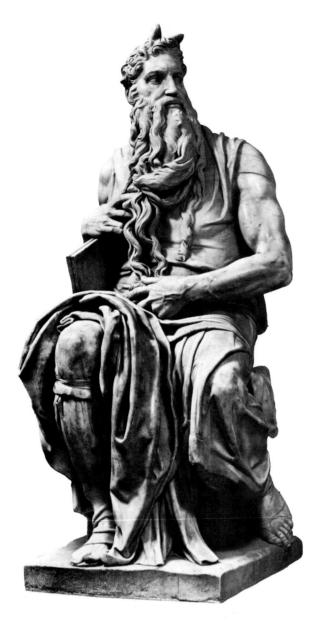

1–6 MICHELANGELO *Moses* (c. 1515–16)
Marble. Height: 91½"

San Pietro in Vincoli, Rome.

chelangelo. Artist and patron, dead for centuries, achieve places in our consciousness through the powerful realism of a statue.

In the twentieth century, American popular culture has seized upon a few figures whose fame has grown after their untimely deaths. Among these are James Dean, Elvis Presley, and Marilyn Monroe. In *Four Multicolored Marilyns* (Fig. 1–7), **Pop artist** Andy Warhol participated in the cultural immortalization of the film icon of the 1960s by reproducing a well-known photograph of Monroe on canvas. One of the original "sex symbols" of the silver screen, Monroe rapidly rose to fame and shocked her fans by taking her own life at an early age. In the decades since her death, images of her are still found on posters and calendars, books are still written about her, and the public's appetite for information about her early years and romances remains insatiable. In other renderings of Monroe, Warhol produced multiple images of the star as if lined up on supermarket shelves, commenting, perhaps, on the ways in which contemporary flesh peddlers have packaged and sold her—in death as well as life.

1–7 ANDY WARHOL *Four Multicolored Marilyns* (1963). Oil on canvas. 60 x 40".

Private collection

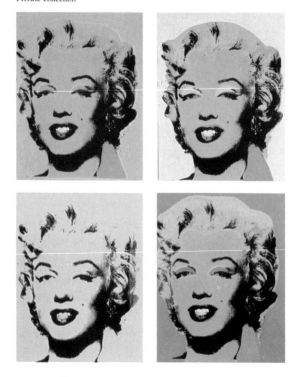

lifetime, and the project was curtailed to eight statues after the Pope's death.

The most majestic of the tomb's statues is Michelangelo's *Moses* (Fig. 1–6). In this sculpture the weary leader of Israel appears to have been resting after receiving the commandments, which are tucked beneath the right arm, but he is about to be called to his feet by his people's return to idolatry. We witness his terrible wrath that carves his face with lines, the righteous indignation that tightens his grip on his beard. The veins swell in his arms, the muscles contract. All fury is about to break loose, but it is frozen permanently in the marble shaped by Mi-

To Express Religious Values

The use of art to express religious values predates civilization. Art has been used to express hopes for fertility, to propitiate the gods, to symbolize great religious events and values, and to commend heavenward the souls of the departed. In postrevolutionary Russia, ironically, once religion was banned, art was used to express social values and raise social consciousness.

The statue of Tlazolteotl (Fig. 1–8), the Aztec "Mother of God" and goddess of childbirth, is a powerful image of childbirth only 8 inches high. Tlazolteotl squats in the manner of Aztec women, and bares her teeth in pain as the god of maize issues forth.

The sacrifice of Isaac has been represented by a number of artists, including the Renaissance artists Lorenzo Ghiberti and Filippo Brunelleschi (see Chapter 13). Their versions passionately depict the moment when Abraham thrusts the knife toward Isaac's throat. Contemporary sculptor George Segal's *Abraham's Sacrifice of Isaac* (Fig. 1–9)

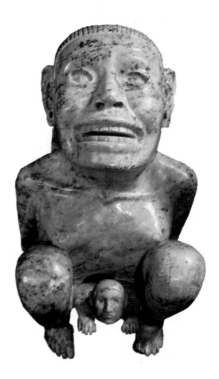

1–8 *The Goddess Tlazolteotl in the Act of Childbirth* (Aztec, 16th century) Aplite with garnets. 8 x 4¾ x 5⅞".

Dumbarton Oaks, Research Library and Collections, Washington, D.C.

1–9 GEORGE SEGAL
Abraham's Sacrifice of Isaac (1973) Plaster. 84 x 84 x 102".

Donated by the Tel Aviv Foundation for Literature and Art to the City of Tel Aviv-Yafo; Tel Aviv, Israel.

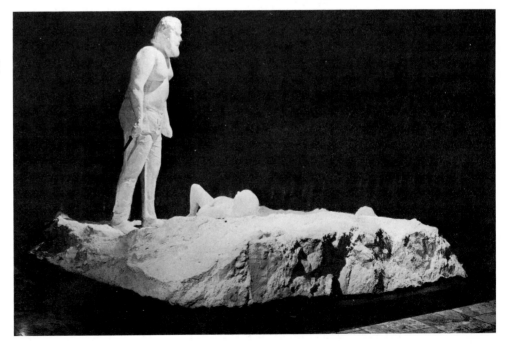

is very different. Set against what Segal refers to as "the rock-like desolate lunar landscape," the visual center of the composition is Isaac—the only growing, vibrant thing in Abraham's world, made more pitiable because he is, in Segal's words, so "soft, vulnerable, trusting." At the edge of the composition Abraham is "ground to a halt on the rock, the hand holding the knife drawn back."[*] Segal's Abraham, true to the 300-pound model after whom he was fashioned, seems rounded and androgynous— that is, possessing both maternal and paternal traits—as though he might have given birth to and nursed the boy as well as fathered him. The tension in the space between parent and child becomes unbearable because it must be breached by the knife thrust. But the act is less horrible than its contemplation—than Abraham's knowledge that it must take place. Abraham's consciousness is the subject of Segal's psychological portrait. Knowledge of the statue's Renaissance forebears heightens our appreciation of Segal's approach. (Segal's method of sculpture is described in Chapter 6; for a biographical sketch, see Chapter 17.)

To Express Fantasy

It's as if my mind sees shapes; it creates shapes that I don't know about. That's the only way I can explain it.

—Georgia O'Keeffe

Art also serves as a vehicle by which artists can express their inmost fantasies. Whereas some artists have labored to reconstruct reality and commemorate actual experiences, others have used art to give vent to their imaginary inner lives. Many twentieth-century artists, for example, from the **Surrealists** to the **Abstract Expressionists,** have been influenced by the psychoanalytic writings of Sigmund Freud and Carl Jung, who suggested that primeval forces are at work in the unconscious reaches of the mind. These artists have sought to use their art as an outlet for these unconscious forces, as we shall see in Chapters 16 and 17. There are also many other types of fantasies, such as those found in dreams and daydreams or simply in the objects and landscapes that are conceived in the imagination. As noted by the French artist Odilon Redon, there is "a kind of drawing which the imagination has liberated from any concern with the details of reality in order to allow it to serve freely for the representation of things conceived" in the mind.

The paintings of French artist Henri Rousseau contain exotic images within mysterious imaginary landscapes. In one of his best-known works, *The Sleeping Gypsy* (Fig. 1–10), a silent desert dreamscape is lit by the pale, cool moon. The lion is at once menacing and a child's stuffed toy, its mane brushed to perfection. The gypsy, who is perhaps the dreamer, lies vulnerably amid symbols of peace. Gravity seems to hold little sway here; the laws of this universe are stylized by the artist. The gypsy is very much alone among the strange assemblage of objects, as we, in our own dreams and fantasies, can be very distant from our human comforters and protectors.

Marc Chagall's self-portrait, *I and the Village* (Fig. 1–11), provides a fragmented image of the artist among fantasized objects that seem to float in and out of one another. Fleeting memories of life in his Russian village are pieced together like so many pieces of a dreamlike puzzle. Chagall's world is a private one; the strange juxtapositions of images are reconciled only in his own mind.

[*] Jan van der Marck, *George Segal* (New York: Harry N. Abrams, 1975), p. 67.

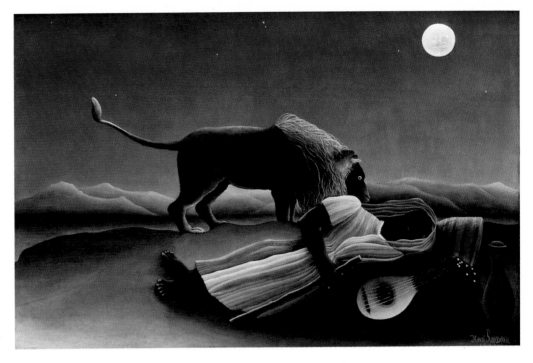

1–10 HENRI ROUSSEAU
The Sleeping Gypsy (1897)
Oil on canvas.
4′3″ x 6′7″.

Collection, The Museum of Modern Art,
N.Y. Gift of Mrs. Simon Guggenheim.

1–11 MARC CHAGALL
I and the Village (1911)
Oil on canvas. 6′3⅝″ x 4′11⅝″.

Collection, The Museum of Modern Art, N.Y. Mrs.
Simon Guggenheim Fund.

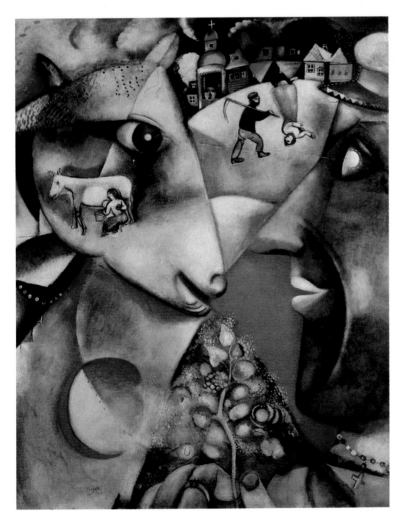

To Stimulate the Intellect

In addition to stirring the emotions and the aesthetic sense, art makes one think. Beautiful or controversial paintings, sculptures, structures, photographs, films, and crafts trigger series of associations. We think about what the subjects of art are doing, thinking, and feeling. We reflect on the purposes of the artist. We see some thing or person through the eyes of another individual. We seek to trace the sources of our own emotional response; we advance our self-knowledge and our knowledge of the outside world.

The intellectual role of art perhaps reaches a peak in works such as the gardens of the Japanese (Fig. 1–12) and in contemporary **Conceptual art.** In Conceptual art, rather than representing external objects, the work is fully conceived in the artist's mind. Such a view of art challenges the traditional conceptualization of the artist as both creative visionary and skilled craftsperson or master of one's media. For example, in *Art as Idea as Idea* (Fig. 1–13), Joseph Kosuth photocopied and enlarged the definition of an abstract term from the dictionary, thereby lending it a tangible quality. Presumably it requires no great artistic skill to use a photocopier; the "art" in the piece lies in the artist's conception of it. Conceptual art **wordworks** such as these also seem to comment on the impersonal information systems of the modern day. They pose a challenge to the formal premises of art, and they also stir an intellectual response in viewers.

A second motive of Conceptual art is to counter the commercialization of art. At its

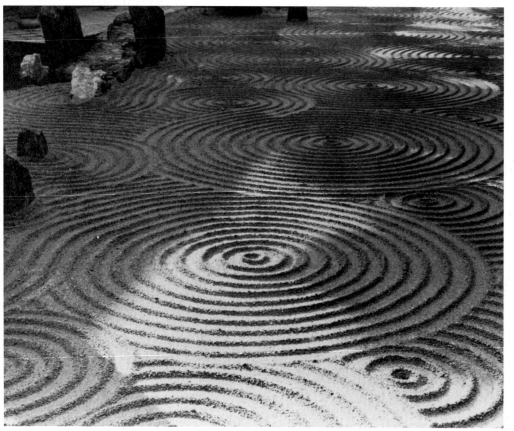

1–12 Tofuku-ji Garden, Kyoto, Japan

RED *adj.* [**RED·DER**, **RED·DEST**] **1** Of a bright color resembling blood; of the same hue as that color of the spectrum farthest from the violet; also, of a hue approximating red; as, *red* gold. **2** Revolutionary; anarchistic: a use derived from the red flag as an emblem of revolution or anarchy. **3** Pertaining to the pole of a magnet which points to the north. Compare BLUE.
— *noun* **1** One of the primary colors, occurring at the opposite end of the spectrum from violet; the color of fresh human blood. **2** Any pigment or dye having or giving this color. **3** An anarchist or ultra–radical in political views. **4** A red object considered with special reference to its color; as, the *red* (color) in roulette, the *red* (ball) in billiards. — **IN THE RED** [Pop.] Operating at a loss; owing money: from the practice of making entries in the debit column of an account book in red ink. — **TO SEE RED** To be very angry. [<OE. *read*] — **RED·LY** *adv.* — **RED·NESS** *noun.*

1–13 JOSEPH KOSUTH
Art as Idea as Idea (1967)
Photostat. 48 x 48".
Courtesy of Leo Castelli Gallery, N.Y.

most extreme, the Conceptual art product exists solely in the mind of the artist. Therefore, it is entirely subjective and incapable of being purchased. On the other hand, conceptual artist Lawrence Weiner did sell the following concept to a patron who installed it himself: "A two-inch wide, one-inch deep trench cut across a standard one-car driveway." Before leaving this section, let us share the verbal content of a Robert Barry wordwork:

ALL THE THINGS I KNOW
BUT OF WHICH I AM NOT
AT THE MOMENT THINKING—
1:36 PM; JUNE 15, 1969

We presume that there are a number of them.

To Express or Create Order and Harmony

Art is harmony.

—Georges Seurat

All nature is but art unknown to thee,
All chance, direction which thou canst not see;
All discord, harmony not understood.

—Alexander Pope

I try not to have things look as if chance had brought them together, but as if they had a necessary bond between them.

—Jean-François Millet

Artists and scientists have been intrigued by, and have ventured to discover and describe, the underlying order of nature. In many instances, they have tried to fine-polish the rough edges of nature. The Classical Greeks, as we noted earlier, applied mathematical formulas to the human figure in order to create statuary more perfect than the flesh. The Greek temples and the great cathedrals all employ harmonious processions of majestic stone columns, arches, or vaults. Much contemporary architecture is also characterized by the stately repetition of columns and girders, now usually fashioned from steel.

One of the most perfect expressions of order and harmony is found in the fragile Japanese sand garden. These medieval gardens frequently accompany pavilions and are placed at the service of Zen, a Buddhist sect that seeks inner harmony through introspection and meditation. The gentle raked pattern of the sand in Figure 1–12 precludes walking. The sand symbolizes water, and the rocks suggest mountains reaching heavenward. Such gardens are microcosms, universes unto themselves.

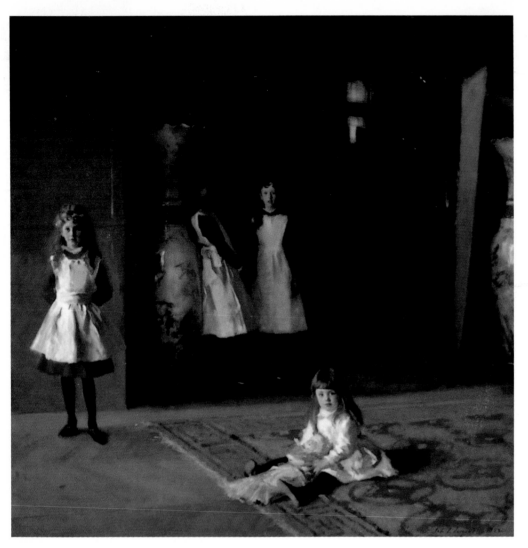

1–14 JOHN SINGER SARGENT
The Daughters of Edward D. Boit (1882)
Oil on canvas. 87 x 87".

Museum of Fine Arts, Boston. Marianne Brimmer Fund.

1–15 JOSEF ALBERS
Homage to the Square: Apparition (1959)
Oil on masonite. 48 x 48".

Solomon R. Guggenheim Museum, N.Y.

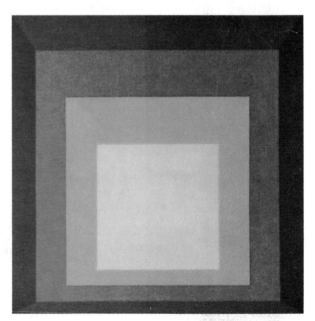

John Singer Sargent's *Daughters of Edward Darley Boit* (Fig. 1–14) is a study in textured elegance. Most children are charming—even disarmingly so—but they are also a disorderly lot. Not these children, however. Their doll-like placement is as precise as that of the great fluted vases set down among them. Despite their great beauty, they are not treated artistically as individuals. They are the creations and possessions of the father, recreated by the artist. All is harmony and balance. Imagine removing the screen to the right and placing a pin in the center of the composition. Would the painting not seem to rotate in a counterclockwise direction? But the screen is there, and so all the elements—living and inert—are in balance.

Josef Albers's *Homage to the Square: Apparition* (Fig. 1–15) is one of a series of nested squares whose subtle variations in color and size occupied the contemporary painter for twenty years. The shapes and colors in his paintings relate to one another according to exact principles of geometry and color vision. As we shall see in Chapter 2, the yellow and blue color fields would present a much harsher contrast if they were not separated by the field of gray, but the blue and green fields can be expected to get along quite well. (If you wish to try a brief experiment, stare at the painting for thirty seconds, allowing your eyes to relax or "glaze over." First note what colors seem to vibrate in the gray, at the edges of the yellow and blue. Then look at a piece of white or gray paper. What colors do you see? The visual results are explained in Chapter 2.)

To Record Experience

Art is not a handicraft, it is the transmission of feeling the artist has experienced.

—Leo Tolstoy

In addition to its aesthetic functions, art can serve to record and communicate experiences and events. Leonardo's *Mona Lisa* is a masterpiece of beauty and harmony, but it is also a visual record of the poser. Bierstadt's landscapes are romanticized, but they also to some degree show the American wilderness as it was and, in many instances, still is. Erwitt's photograph *Mother and Child* (Fig. 1–16) touches a universal theme, but it also functions as a snapshot of his wife

1–16 ELLIOT ERWITT *Mother and Child* (1953). Photograph.
Magnum Photos.

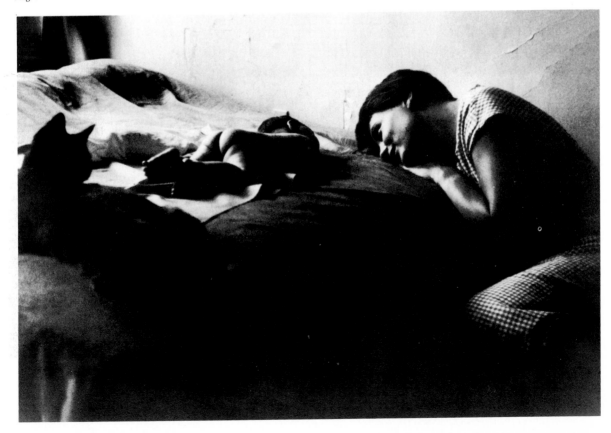

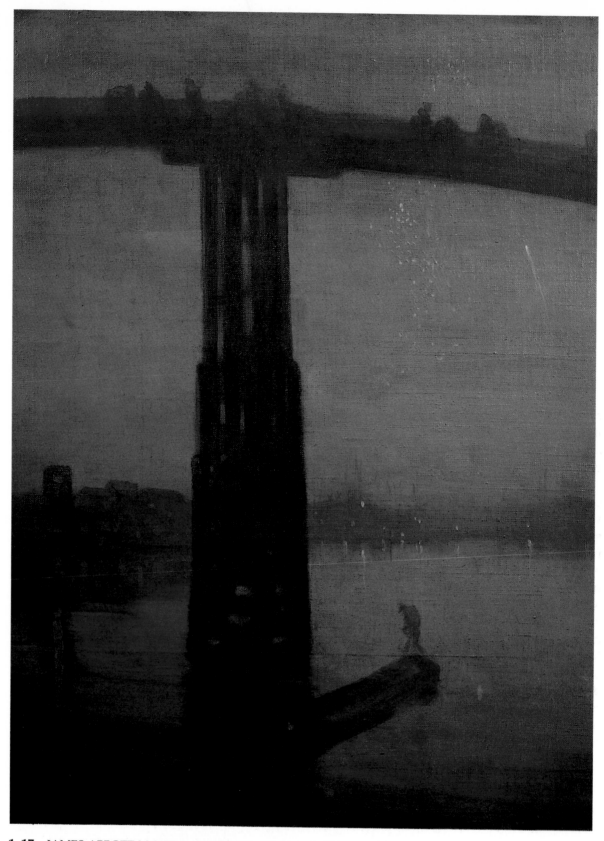

1–17 JAMES ABBOTT McNEILL WHISTLER *Nocturne in Blue and Gold*
(*Old Battersea Bridge*). (1872–75). Oil on canvas. 26¾ x 20″.
Tate Gallery, London.

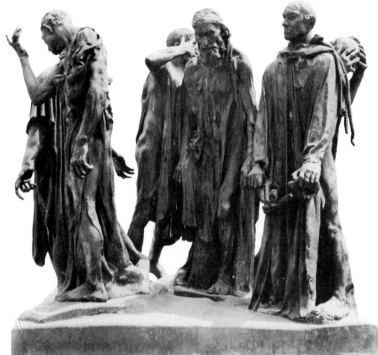

1–18 AUGUSTE RODIN
The Burghers of Calais (1884–95)
Bronze. 82½ x 94 x 75".
Rodin Museum, gift of Jules E. Mastbaum.

and child that will find its way into the family album. Triumphal arches and funerary art also record and commemorate major events and passings of the day.

Art also serves to record and communicate personal experiences in ways that words cannot. A nocturne is a romantic musical piece composed to accompany the hazy images of the night that find their ways into our consciousness as we undertake the journey from wakefulness to sleep. James McNeill Whistler's haunting *Nocturne in Blue and Gold—Old Battersea Bridge* (Fig. 1–17) captures the misty distances of the Thames River at twilight. The sky is an interplay of dusk, factory smoke, and fireworks. The drawing is sketchy, but the mood is precise and delicate. There is a fleeting coalescence of industrialization, celebration, water, atmosphere, and artist's eye that surpasses words. The moment is lost in time, but the record of the moment is complete.

Auguste Rodin's *The Burghers of Calais* (Fig. 1–18) commemorates the surrender of a French fortress to the English in 1347. It portrays a group of civic leaders who heroically offered their lives to save their fellow citizens. Their physical and psychological

anguish is marked by dramatic gesture, by taut lips and hands, by toes eloquently gripping earth. The burghers do not face one another; their emotions—resignation, hopelessness, tacit defiance—are experienced and registered individually. The bronze work was initially modeled in clay, and much emotion was invested in the figures by the artist's repeated kneading with finger and thumb.

Alfred Stieglitz fought for recognition of photography as a creative art as well as a recorder of events. He happened upon the striking composition of *The Steerage* (Fig. 1–19) on an Atlantic crossing aboard the Kaiser Wilhelm II. He rushed to his cabin for his camera, hoping that the upper and lower masses of humanity would maintain their balanced relationships to one another, to the drawbridge that divides the composition, to the stairway, the funnel, and the horizontal beam of the mast. The "steerage" of a ship was the least expensive accommodation. Here the "huddled masses" seem suspended in limbo by machinery and by symbolic as well as actual bridges. Yet the tenacious human spirit may best be symbolized by the jaunty patch of light that strikes

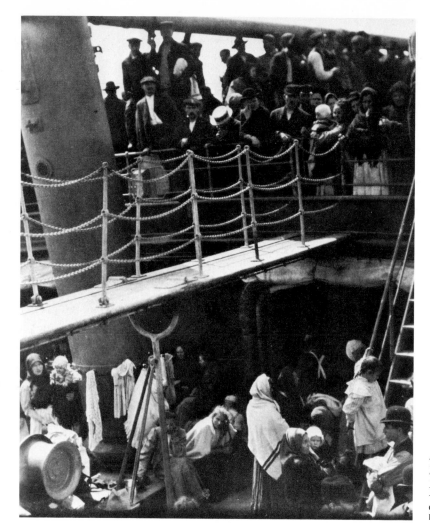

1–19 ALFRED STIEGLITZ
The Steerage (1907)
Photograph.

Courtesy The Library of Congress, Washington, D.C.

the straw hat of one passenger on the upper deck.

About *The Steerage*, Stieglitz wrote:

A round straw hat, the funnel leaning left, the stairway leaning right, the white draw-bridge with its railings made of circular chains—white suspenders crossing the back of a man in the steerage below, round shapes of iron machinery, a mast cutting into the sky, making a triangular shape. I stood spell-bound for a while, looking and looking. Could I photograph what I felt, looking and looking and still looking? I saw shapes related to each other. I saw a picture of shapes and underlying that the feeling I had about life. . . . Rembrandt came into my mind and I wondered would he have felt as I was feeling.*

*Nathan Lyons, ed., *Foundations of Modern Photography* (Englewood Cliffs: Prentice-Hall, 1966), p. 129.

To Reflect the Social and Cultural Context

Works of art all through the ages show us in the clearest fashion how mankind has changed, how a stage that has once appeared never reappears.

—Philipp Otto Runge

Art must be parochial in the beginning to become cosmopolitan in the end.

—George Moore

In recording experience, artists also frequently record the activities and objects of their times and places. The subject matter of a work of art usually does not exist in a vacuum. People and objects reflect the fashions and beliefs of the times, as well as the states of the crafts and sciences. Artists may intend to use their subjects to imply univer-

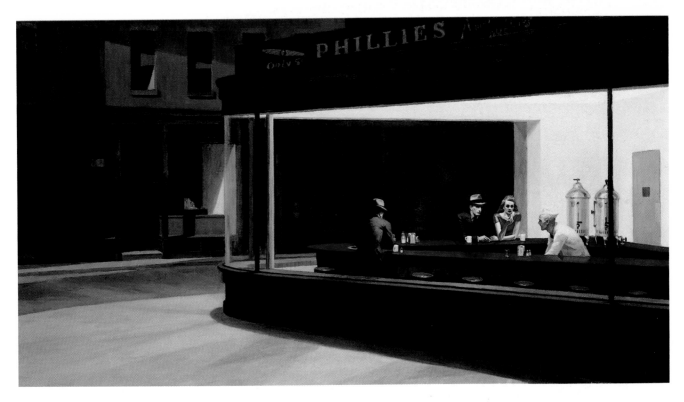

1–20 EDWARD HOPPER *Nighthawks* (1942). Oil on canvas. 30 x 60".
Courtesy of The Art Institute of Chicago.

sal themes or truths, but they must first come to aesthetic terms with their subjects as they are.

The architecture, the wide-brimmed hats, the shoulder pads, the coffee urns, even the price of the cigars (five cents) advertised above the plate-glass windows all set Edward Hopper's painting *Nighthawks* (Fig. 1–20) unmistakably in an American city during the late 1930s or 1940s. The subject is commonplace, even boring, but there is a tension in the depiction of large empty areas outside and within the corner restaurant. Familiar objects become distant. The warm patch of light seems precious, even precarious, as if night and all its troubled symbols are threatening to break in on disordered lives. Hopper uses a specific sociocultural context to communicate an unsettling, introspective mood of aloneness, of being outside the mainstream of experience.

Robert Riger's *Touchdown Over the Top* (Fig. 1–21) is on one level a standard football photograph of the sort one may see on the cover of *Sports Illustrated*. Like the Hopper painting, it is singularly American. Football is a twentieth-century phenomenon and,

1–21 ROBERT RIGER *Touchdown Over the Top* (1960) Photograph.
© Robert Riger, 1960.

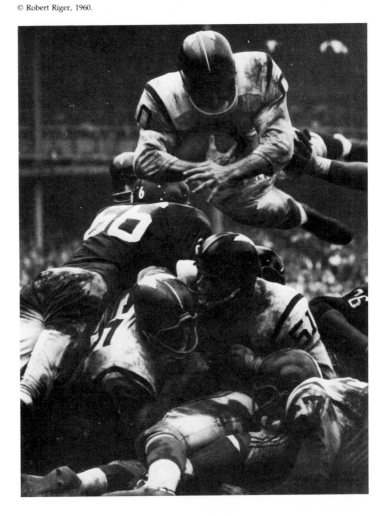

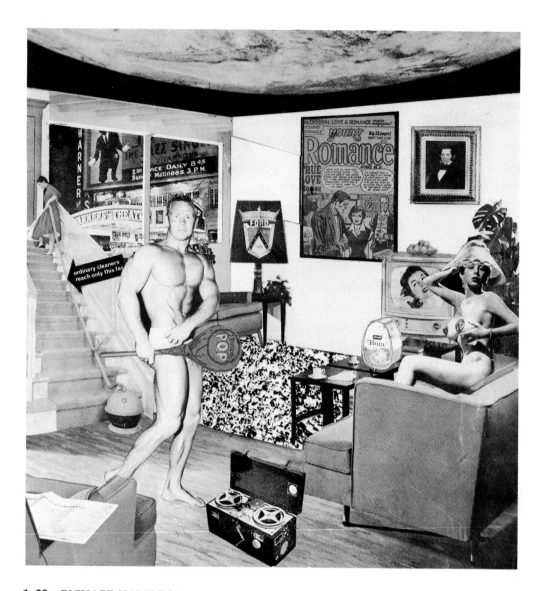

1–22 RICHARD HAMILTON *Just What Is It That Makes Today's Homes So Different,
So Appealing?* (1956). Collage. 10¼ x 9¾".
Kunsthalle Tübingen, Germany.

more than most other sports, one that most
non-Americans, including Western Europe-
ans, have difficulty understanding. But
there is nothing to misunderstand about this
photograph. Men are transformed by their
helmets and the intensity of their strife into
warrior gods that challenge the nobility of
Greek statues. The composition has a pyra-
mid shape that is a hallmark of Classical
art. Note the sensitive portrayal of tension
in the forearm. Note the emotion expressed
by hands. Note the eloquent portrayal of
universal brute force and counterforce that
transcends the "game" of football.

Pop artist Richard Hamilton's *Just What
Is It That Makes Today's Homes So Different,
So Appealing?* (Fig. 1–22) features a weight-
lifter and a stripper each of whom comment
on the 1950s' preoccupation with develop-
ment of the upper torso. In this little **collage,**
a comic book cover serves as wall painting,
a Ford emblem decorates a lamp, and state-
of-the-art household equipment—a televi-
sion set, tape recorder, and vacuum
cleaner—serve as mementos of the time and
place to future generations. One wonders
what objects Hamilton would place in such
a "time capsule" today.

To Protest Injustice

Art has always been employed by the different social classes who hold the balance of power as one instrument of domination—hence, as a political instrument. One can analyze epoch after epoch—from the Stone Age to our own day—and see that there is no form of art which does not also play an essential political role.

—Diego Rivera

The spectacle of the intolerance and the crimes of humanity is as powerful a force in the exercise of my art as the funds of serene contemplation that I have been able to gather together since childhood.

—Theodore Rousseau

Artists, like other people, have taken on bitter struggles against the injustices of their times. Like other people, they have tried to persuade others to join them in their causes, and it has been natural for them to use their creative skills in doing so.

As is noted in Chapter 15, the great nineteenth-century Spanish painter Francisco Goya used his art to satirize the political foibles of his day and to condemn the horrors of war (see Fig. 15–5). In the twentieth century another great Spanish painter, Pablo Picasso, would condemn war in his masterpiece *Guernica* (Fig. 16–9).

Goya's French contemporary, Eugène Delacroix, painted the familiar image of *Liberty Leading the People* (Fig. 1–23) in order to keep the spirit of the French Revolution alive in 1830. In this painting, people of all classes are united in rising up against injustice, led onward by an **allegorical** figure. Rifles, swords, a flag—even pistols—join in an upward rhythm, underscoring the classical pyramid shape of the composition.

1–23 EUGÈNE DELACROIX *Liberty Leading the People* (1830). Oil on canvas. 8'6" x 10'10".

Louvre Museum, Paris.

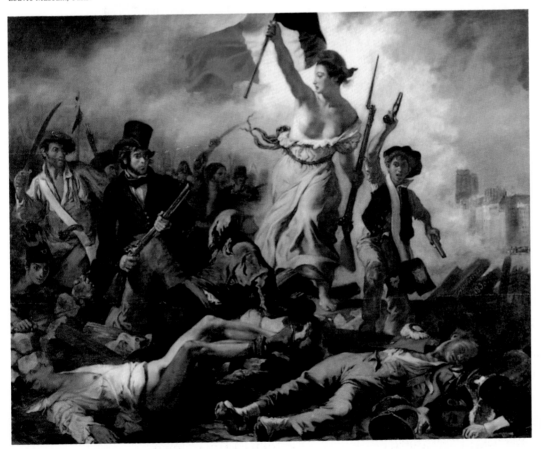

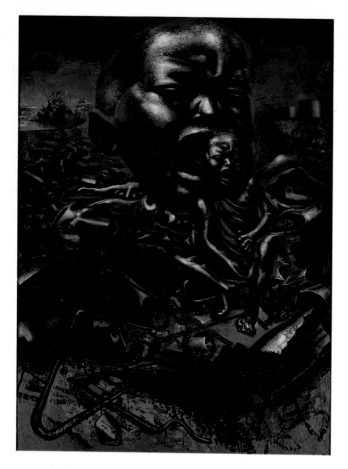

1–24 DAVID ALFARO SIQUEIROS
Echo of a Scream (1937). Duco on wood. 48 x 36".

Collection, The Museum of Modern Art, N.Y. Gift of Edward M. W. Warburg.

Twentieth-century Mexican artists have frequently portrayed the misery of the masses and the exploitation of peasants by landowners. In *Echo of a Scream* (Fig. 1–24), David Alfaro Siquieros expresses the pain of children abandoned to poverty in an industrial wasteland. Flesh takes on the values and texture of discarded machine parts. The hallucinatory imagery has an astonishing emotional impact that challenges the viewer to confront a social reality. Walking away from this painting, you feel that you are also figuratively walking away from a problem that you should have faced.

Russian film maker Sergei Eisenstein's *Potemkin* (Fig. 1–25) is a silent film classic whose almost surrealistic imagery inflamed idealistic revolutionary audiences against the defeated czar. There is an especially haunting scene of brutal repression. Men, women, and children attempt to escape the czar's riflemen by running up a vast series of steps that suggest the inescapable quagmire of a dream. There are close-ups of violence, and in a master stroke, a baby carriage careens down the steps after the child's mother has been shot.

Contemporary artist Hans Haacke's *Continuity* (Fig. 1–26) is a protest against Ger-

1–25 SERGEI EISENSTEIN
Film still from *Potemkin* (1925)

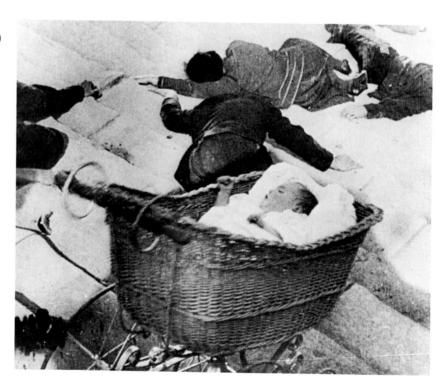

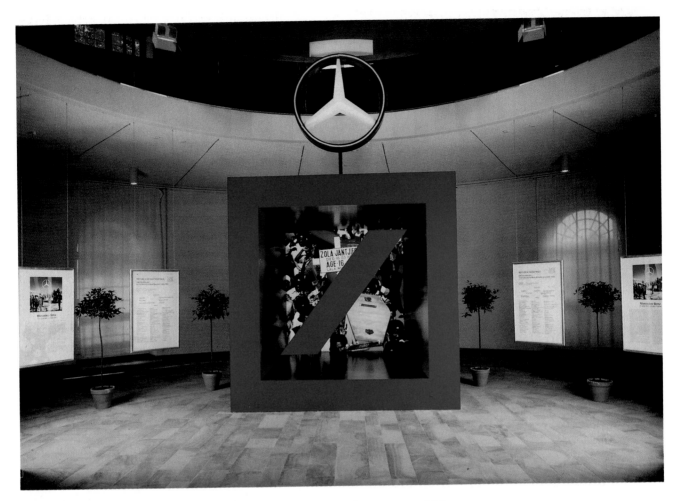

1–26 HANS HAACKE *Continuity* (1987). Mixed media. Installation size variable.
Courtesy John Weber Gallery, New York.

man corporations that he accuses of lending support to the apartheid policy of South Africa. *Continuity* is a specific-site **installation,** which means that the artist constructed it for its setting—in this case, the circular lobby of a German office building. The style mimics slick corporate advertising. Its centerpiece is a three-dimensional version of the bold square logo of Germany's Deutsche Bank, topped by a rotating, neon-lit facsimile of the Mercedes-Benz symbol. The centerpiece frames a huge lightbox, which contains a news photo of a funeral procession for fallen demonstrators. The photo is obfuscated by an assertive "Do Not Enter" diagonal, and the entire structure is flanked by corporate-inspired informational panels. Haacke's point of protest is the connection between the Daimler-Benz corporation, in which the Deutsche Bank is heavily invested, and the South African government. He asserts that the South African police and military have regularly purchased armored vehicles from Daimler-Benz, which they have put into use against the nation's black demonstrators.

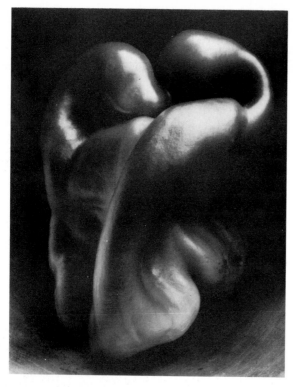

1–27 EDWARD WESTON *Pepper No. 30* (1930)
Photograph.

1–28 MARCEL DUCHAMP *Fountain* (1917)
(1951 version after lost original) Porcelain urinal.
24″ high.

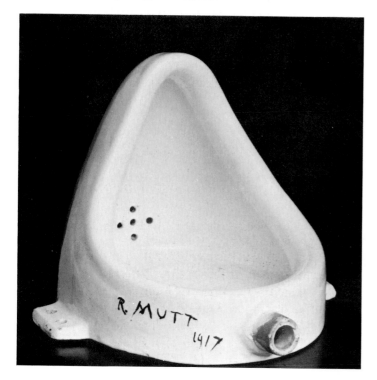

To Elevate the Commonplace

The matter-of-factness of the title of Edward Weston's photograph *Pepper No. 30* (Fig. 1–27) communicates that the subject of the photograph is, in fact, a pepper—nothing more. But the title does little to explain how art can elevate the commonplace. Weston's photographs of everyday objects are revelations of geometry and dynamic movement. The rhythms and straining sinews of the vegetable lead many viewers to perceive an **abstraction** of passionate yearning and intertwining of flesh. But it is more remarkable that the sensuousness lies in the twisting surfaces and smooth texture of the pepper itself.

Some of the more interesting elevations of the commonplace to the realm of art are found in the **ready-mades** and **assemblages** of twentieth-century artists. Marcel Duchamp's *Fountain* (Fig. 1–28) is a urinal, turned upside down and labeled. Pablo Picasso's *Bull's Head* (Fig. 6–17) is fashioned from the seat and handlebars of an old bicycle. In **Pop art,** the dependence on commonplace objects and visual clichés reaches a peak. Prepared foods, soup and beer cans, media images of beautiful women and automobile accidents—these became the subject matter of Pop art. As we saw in Figures 1–7 and 1–22, works of Pop art impel us to cast a more critical eye on the symbols and objects with which we surround ourselves.

To Express the Universal

There is no such thing as English art. You might as well talk of English Mathematics. Art is Art, and Mathematics is Mathematics.

—James A. McNeill Whistler

Drawings, paintings, sculptures, and other art forms frequently portray universal themes, hopes, and fears. Art can reveal what is specific to a certain time and place, but it can also reveal what is common in the human experience. Human languages, customs, socioeconomic levels, skills, and

values vary widely, but all of us are mortal, all of us are of woman born.

Most of us have taken photographs of members of our families. Elliott Erwitt's *Mother and Child* (see Fig. 1–16) is a sensitive portrayal of one mother and one child that captures the feelings of attachment and dreams for the future that millions of mothers have experienced. The soft textures of skin, bedding, and fur bathe the picture in actual and symbolic warmth. The child is encompassed and protected by mother, cat, and wall. The cat serves as a counterpoint and balance for the mother. The subject matter of the photograph lifts gradually from darkness into light, suggestive of the role of light as a universal symbol of goodness and hope. The baby's face remains in darkness. This pictorial feature allows viewers to project their own children into the photograph and also suggests that the child's personal experiences are yet to be written.

To Sell Products

Art among a religious race produces relics; among a military one, trophies; among a commercial one, articles of trade.

—Henry Fuseli

Art is also used to sell products. To some degree it could be argued that Madison Avenue has replaced the patrons of olden days. Although many artists shun any brand of commercialization, including the selling of their own works, a number of interesting works have been created whose purpose is admittedly commercial.

Gary Perweiler's photograph of the *Woman's Red Shoe* (Fig. 1–29) was commissioned by Gucci. Setting aside the reasons for which the picture was taken, we can admire its stunning composition. The rhythm of the gray blinds evolves into a fascinating neutral metal abstraction that serves as counterpoint to the vibrant color and textures of the shoe and fingernails. The shoe balances and joins the hand as a decidedly human element in a disorientingly impersonal high-tech universe. In such a setting, the human

1–29 GARY PERWEILER *Woman's Red Shoe* (1979) Photograph.
Courtesy of Gary Perweiler, N.Y.

element should look somewhat helpless and out of place. And so there is an irony in the boldness and precision of shoe, fingers, and nails. The picture makes one yearn for texture—to touch, to have the shoe. Such qualities of composition would seem to justify calling this advertising photo a work of art.

To Meet the Needs of the Artist

Artists may have special talents and perceptive qualities, but they are also people. As people, they have a number of needs and are motivated to meet these needs.

The psychologist Abraham Maslow spoke of a hierarchy, or ordered arrangement, of needs, including (1) physiological needs such as needs for food and water; (2) safety needs, such as protection from the elements through housing and clothing, and security from financial hardship; (3) needs for accep-

Is There an Artistic Personality?

No two artists are quite alike, just in the same way that no two people from any walk of life are quite alike—with the possible exception of identical twins. Still, many philosophers and psychologists have labored to divine the possible common elements of the so-called artistic personality. One such psychologist is Raymond B. Cattell, who has administered his personality test, the Sixteen Personality Factors scale, to many vocational groups, including artists, creative writers, and airline pilots.

A personality factor, or trait, is an enduring characteristic that lends consistency to an individual's behavior in different situations. As you can see in Figure 1–30, the factors assessed by Cattell's test are quite varied, ranging from imagination and sensitivity to emotional stability and self-control.

In a study that compared artists and creative writers with airline pilots, the first two groups appeared to be more sensitive, imaginative, and intelligent than the pilots. The airline pilots appeared to be more stable, self-controlled, conscientious, practical, tough-minded, and relaxed. The pilots—at least those tested by Cattell— seemed to have the stable and controlled sort of personality that is desirable in the cockpit of the airliner. On the other hand, the artists and writers seemed to possess traits that—combined with artistic talent—can give rise to aesthetic self-expression.

The study has its limitations. First, it sampled only a relatively small number of artists in modern-day America. Second, there were individual variations among the artists, as within the other groups. Third, we must still wonder which came first, the chicken or the egg—that is, does an artistic "temperament" urge the individual to enter art, or, once an artist, does the individual tend to assume the traits of the peer group? These limitations aside, it is of interest that some effort has been made to quantify the unquantifiable—the artistic personality.

tance and love; (4) needs for achievement, recognition, approval, and prestige; and (5) the need for "self-actualization"—that is, the need to fulfill one's unique genetic potential. Self-actualizing people have cognitive needs for novelty, exploration, and understanding, and they have aesthetic needs for art, beauty, and order.

Maslow argued that when we encounter two incompatible needs, we will strive to meet the lower or more basic need first. And so, art and social approval become less important when we are parched or starving. Other psychologists, such as Carl Rogers,

have noted that we often seek higher levels of fulfillment even when lower needs have not been met. Many artists have devoted themselves fully to their creative work, even at the expense of a persistent struggle with poverty.

In many cases, of course, art permits the individual both to earn a living and to meet physiological and safety needs. In a few instances artists become wealthy and find social acceptance and recognition. In some quarters the very term "artist" elicits admiration and respect, although elsewhere it may arouse suspicion.

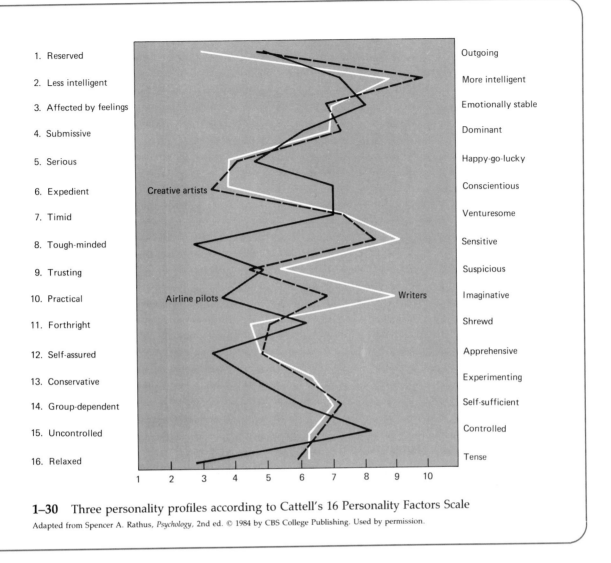

1. Reserved	Outgoing
2. Less intelligent	More intelligent
3. Affected by feelings	Emotionally stable
4. Submissive	Dominant
5. Serious	Happy-go-lucky
6. Expedient	Conscientious
7. Timid	Venturesome
8. Tough-minded	Sensitive
9. Trusting	Suspicious
10. Practical	Imaginative
11. Forthright	Shrewd
12. Self-assured	Apprehensive
13. Conservative	Experimenting
14. Group-dependent	Self-sufficient
15. Uncontrolled	Controlled
16. Relaxed	Tense

1–30 Three personality profiles according to Cattell's 16 Personality Factors Scale

Adapted from Spencer A. Rathus, *Psychology*, 2nd ed. © 1984 by CBS College Publishing. Used by permission.

Psychological research does suggest that needs for sensory stimulation, activity, and exploration are inborn. Art gives an individual a stimulating mandate to explore the underlying order in the external world and the limits of the internal cognitive world.

Do artists differ genetically from those of us who are not artistic? Do they experience an inner urge to find self-actualization through art? It is not easy to say. The question of the relative influences of heredity and experience is a hotly debated issue in psychology, but research suggests that each plays an indispensable role in artistically related traits such as introversion (the tendency to focus on one's inner experiences and feelings) and intelligence—even in the ability to visualize spatial relationships. If there is a need for self-actualization, and if artistic capacities are to some degree inherited, we could argue that there is something akin to an inborn need to express oneself through art. Art would then, indeed, be as Ralph Waldo Emerson wrote: "a jealous mistress."

In the visual arts, **style** refers to the characteristic ways in which artists express themselves. Artists throughout history have portrayed familiar themes, but their works have differed not only in their social and cultural contexts, but also in their style.

Compare Jan van Eyck's *Giovanni Arnolfini and His Bride* (Fig. 13–4), with Roy Lichtenstein's *Forget It! Forget Me!* (Fig. 1–31), Oskar Kokoschka's *The Tempest* (Fig. 1–32), and Constantin Brancusi's *The Kiss* (Fig. 1–33). They are similar in that they all show couples. One way in which they differ is in their sociocultural context. The context of the van Eyck painting is clearly Renaissance Europe, while that of the Lichtenstein is modern-day America. The Kokoschka painting and the Brancusi sculpture could be said to be without context. Another way they differ is in the attitudes

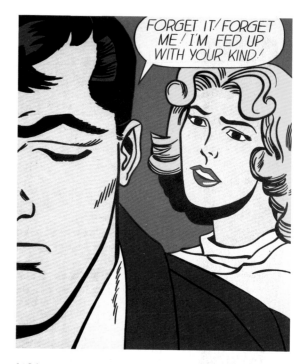

1–31 ROY LICHTENSTEIN *Forget It! Forget Me!* (1962) Magna and oil on canvas. 79⅞ x 68".

Rose Art Museum, Brandeis University, Waltham, Mass. Gevirtz-Mnuchin Purchase Fund.

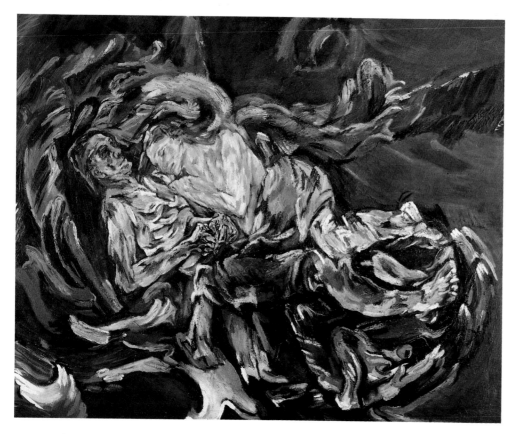

1–32 OSKAR KOKOSCHKA
The Tempest (1914)
Oil on canvas. 71½ x 86½.

Kunstmuseum Basel, Switzerland.

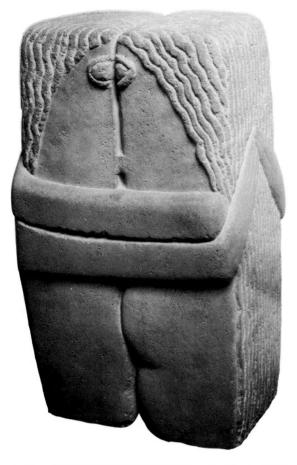

1–33 CONSTANTIN BRANCUSI *The Kiss* (c. 1912) Limestone. Height: 23″: width: 13″; depth: 10″.

Philadelphia Museum of Art, Louise and Walter Arensberg Collection.

and behavior of the couples. The van Eyck couple are taking their marriage vows, whereas the Lichtenstein couple are arguing. The Kokoschka couple seem in danger of being swept away by the elements, and the Brancusi couple are making love. But a third way in which the works differ is in *style*.

Realistic Art

"Imitate nature" is the invariable rule.
—Sir Joshua Reynolds

The style of the van Eyck couple (Fig. 13–4) is **realistic.** The term *realism* has had many meanings in art; it is, for instance, the name of a specific school of art that flowered during the nineteenth century. But more broadly, realism refers to the portrayal of people and things as they are really thought to be, without idealization, without distortion. Northern Renaissance painters represented their subjects as exactly as possible. Moreover, the van Eyck painting was intended in part to serve as a record of the marriage contract. Therefore, the features of the couple had to be unmistakably precise.

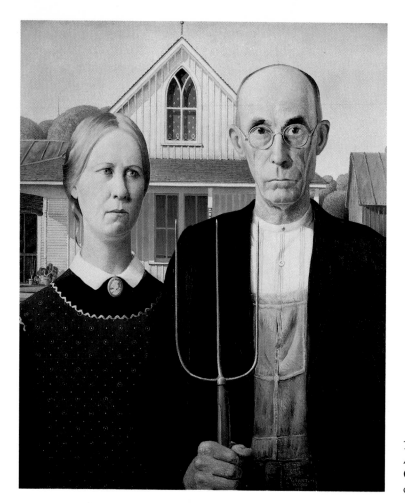

1–34 GRANT WOOD
American Gothic (1930)
Oil on beaver board. 29⅞ x 24⅞".
Courtesy of The Art Institute of Chicago.

Grant Wood's familiar *American Gothic* (Fig. 1–34) is a painstakingly realistic portrait of the staid virtues of the rural life in America. It is also one of our more commercialized works of art; images derived from it have adorned boxes of breakfast cereal and other products. Note the repetition of the pitchfork pattern in the man's bib, in the upperstory window of the house, and in the plant on the porch. He is very much tied to the soil. The pattern of the woman's apron is also repeated in the window, tying her to the house. These people are unliberated in the contemporary sense. They are solid, stolid, and boring as the composition of the painting is masterful.

Realistic versus Representational Art

The Lichtenstein couple are portrayed in the pop art style. Pop art can be highly realistic, as in the Andy Warhol rendering of Marilyn Monroe. But this particular Lichtenstein is not realistic, rather, it is **representational.**

It adopts the visual clichés of the comic strip, emphasizing the sort of chiseled features that were idealized during the 1950s and early 1960s and omitting the blemishes.

The term *representational art*, like realism, has also had various meanings. Some use it synonymously with realistic art, defining it as representing people and objects as closely as possible. But representational art more commonly refers to art that represents people or objects in *recognizable form*. The people in the Lichtenstein may not be realistic, but they are clearly recognizable.

A number of aspects of the Brancusi sculpture are recognizable. One can determine an upper torso, arms, eyes, and hair. Yet the artist seems to have been more interested in expressing his own perceptions of the act of kissing than in being true to the human form. For this reason most people would not characterize *The Kiss* as representational. As we shall see below, *The Kiss* is an example of abstract art.

Expressionistic Art

Be guided by feeling alone.
— Jean-Baptiste-Camille Corot

In **expressionistic** art, form and color are freely distorted by the artist in order to achieve a heightened emotional impact. **Expressionism** as a school of art refers to a movement in modern art, but many earlier works of art are expressionistic in the broader sense of the term.

In *The Burial of Count Orgaz* (Fig. 14–4), **Baroque** artist El Greco's expressionistic elongation of the heavenly figures seems to emphasize their ethereal spirituality. **Postimpressionist** Vincent van Gogh relied on expressionistic brushstrokes to transfer emotion to his canvases. Emil Nolde, the great colorist of early twentieth-century German Expressionism, emotionally applied clashing hues to create a fever pitch in his recounting of the biblical tale in *Dance Around the Golden Calf* (Fig. 16–3).

Kokoschka's expressionistic *The Tempest* (Fig. 1–32) is marked by frenzied brushstrokes that mirror the torment of his inner life. Reclining figures occupy the center of a dark, imaginary landscape. Fleeting images of earth, water, flesh, and bedding are distinguished in color and by continuous rounded forms. All seem caught up in a churning sky, very much in danger of being swept away.

Abstract Art

Abstract art does not refer to a specific movement in art. Instead, the term applies to art that departs significantly from the actual appearance of things. Brancusi created *The Kiss* (Fig. 1–33) in order to capture what, to him, was the essential nature of the act of kissing—the merging of the participants—not to capture the shapes of the human subjects.

ABSTRACTED VERSUS NONOBJECTIVE ART

Brancusi's sculpture, though abstract, refers to figurative subject matter, that is, to people. But abstract art, at its most extreme,

1–35 JACKSON POLLOCK *Male and Female*
Oil on canvas. 73¼ x 49".
Philadelphia Museum of Art, partial gift of Mrs. H. Gates Lloyd.

may refer to nothing in the real world. We may make a distinction between abstract art that refers to things, which is called **abstracted art,** and abstract art that does not, called **nonobjective art.**

The Kiss is an example of abstracted art. We perceive the human torso as abstracted, or reduced, into a simple block form. The twentieth-century movement of **Cubism** also involves abstracted art. Proponents such as Pablo Picasso and Georges Braque (see Figs. 16–5 to 16–9) reduced, or abstracted, natural forms into largely angular geometrical equivalents. To some degree, despite their reduction to geometrical forms, the figures of Picasso and Braque remain recognizable. We can pick them out if we work at it.

Contemporary painter Jackson Pollock's *Male and Female* (Fig. 1–35) is yet another

depiction of a couple. Like the Brancusi, it is abstracted, but the "figures" are a great deal more difficult to locate than Brancusi's. At the time of the painting, Pollock was undergoing psychoanalysis, and he was quite convinced that the unconscious played a major role in art. Using the method of **psychic automatism,** Pollock attempted to clear his mind of purpose and the concerns of the day so that inner conflicts and ideas could find automatic expression through his work. Pollock's method reminds one of Edgar Degas's remark that "The artist does not draw what he sees, but what he must make others see. Only when he no longer knows what he is doing does the painter do good things." In *Male and Female* we find recognizable numbers and geometric forms. In future chapters we shall see that Pollock's later works are more fluid and dynamic and show even less reference to recognizable forms.

Nonobjective art makes no reference to nature. Many of the paintings of twentieth-century artists Kasimir Malevich and Piet Mondrian (see Chapter 16) and Helen Frankenthaler (see Chapter 2) are nonobjective. In *Magic Carpet* (Fig. 2–9), Frankenthaler poured rather than brushed her paint onto the canvas. Viewers may find much that is familiar in her composition—perhaps perceiving it as a landscape with accumulating cloud masses, but the artist's technique and her intent appear to be fully nonobjective.

Theo van Doesburg's renditions of *The Cow* (Fig. 1–36) provide a fascinating record of the process of abstraction. Figure 1–36a is a fully recognizable drawing of a cow. Figures 1–36b and 1–36c show phases of abstraction that progressively reduce the

cow to geometric blocks. The contrast of the values also increases: the lights become lighter and the darks become darker.

You are quite likely to perceive Figure 1–36d as a cow as well, particularly since you are aware of the process of abstraction. But if you were to stand back from this work, you might also perceive it as the gabled roofs, chimneys, or pilasters of a cityscape. Finally in Figure 1–36e, all elements are reduced to nonoverlapping rectangular solids. Although you can still follow the process of abstraction, the cow is no longer recognizable. If you had seen only Figure 1–36e, you would have labeled the work nonobjective and considered its title arbitrary.

As we said at the outset of this chapter, the question "What is art?" has no single answer and raises many other questions. The meanings, purposes, and styles of art we have discussed are meant to facilitate the individual endeavor to understand art, but they are not intended to be exhaustive. Some people will feel that we have omitted several important meanings and purposes of art; others will disagree with our definitions of some of the styles of art. But these considerations merely hint at the richness and elusiveness of the concept of art.

In Chapter 2 we shall expand our discussion of the meanings and purposes of art to include the "language" of art. That chapter will not provide us with a precise definition of art either, but it will afford us insight into the ways in which artists use elements of art such as line, shape, color, and texture to create works of art. Even though art has always been with us, the understanding of art is in its infancy.

(a) Pencil. 4⅝ × 6¼".

(b) Pencil. 4⅝ × 6¼".

(c) Pencil. 4⅝ × 6¼".

(d) Gouache. 15⅝ × 22¾".

1–36 THEO VAN DOESBURG
(a)(b)(c) *Studies for Composition (The Cow)* (no date)
(d) *Composition (The Cow)* (1916)
(e) *Composition (The Cow)* (1916–17)

Collection, The Museum of Modern Art. Purchase.

(e) Oil on canvas. 14¾ × 25".

2

The Language of Art: Elements, Composition, and Content

Hermann Rorschach, the originator of the Rorschach inkblot test, might very well have been a frustrated artist. His father, Ulrich, was an undistinguished painter who supported his family by teaching drawing. Hermann spent his childhood in a picturesque village on the Rhine as the nineteenth century drew to a close. Hills verdant at times and snow-topped at others surrounded him. There was an old fort, an assortment of relics and monuments—even a museum. During his last two years in the German equivalent of high school, he was nicknamed "Klex" by his fraternity brothers. The proper spelling of the word is *klecks*, and it means "inkblot." Even then Hermann might have been preoccupied with the children's game of dropping ink on paper, folding it in two, and opening it to see what interesting shape results.

As an adult in the early years of the twentieth century, the psychiatrist Hermann Rorschach discovered that he could use inkblots to investigate

the psychological functioning of normal people and of residents at a sanitarium. Inkblots such as that in Figure 2–13 are presented one by one, and people are asked what the blots look like, what the blots could be.

Some answers are given frequently, because the lines, shapes, texture, shading, and, in some cases, the color of the blots may suggest familiar objects. But many responses are idiosyncratic. The responses reflect not only the features of the blot, but also what the observer *projects* of his or her personality into the blot. For when we look at an inkblot, or a work of art, or any other feature of our environment, our responses reflect not only what is actually there, but also our interests, our cultural and ethnic backgrounds, even our preoccupations and conflicts. Psychoanalysts argue that our responses also reflect ideas and urges of which we are not consciously aware.

Just as viewers project their own experiences and feelings into an inkblot or a work of art when they are responding to it, so do artists project their experiences and their feelings, as well as their craft, into a work of art when they create it. First artists select their medium—drawing, painting, sculpture, architecture, photography, a craft, or something else. Then they use the **plastic elements** of art—line, shape, texture, shading, color, and so on—to express themselves in this medium. In their self-expression, they use the plastic elements to create **compositions** of a certain **content.**

ART AS LANGUAGE

Plastic elements, composition, and content—these three comprise what we refer to as the language of art. A **language** is a means of communicating thoughts and feelings. In spoken and written languages we communicate by means of sounds and symbols. The language of music communicates by sound, and the visual arts through media such as drawing, painting, sculpture, and photography.

Languages like English and French have symbols such as letters or words that are combined according to rules of grammar so they can create a message. The visual arts have plastic elements that are composed or organized according to principles of unity, balance, and rhythm, among others. The composition of the elements creates the content of the work—even if this content is an abstract image and not a common **subject,** such as a human figure or a landscape.

In this chapter we explore the language of art and examine the ways in which artists organize the elements of art in their creations.

ELEMENTS OF ART

The elements in the language of art include line, shape, light, color, texture, mass, and space. In this section we shall also include time and motion, because artists use actual and implied time and motion as compositional elements.

Line

A **line** is the mark left by a moving point. Lines can be straight or curved. In geometry the line has no width, but in art lines may be light and slender or dark and thick. Lines imply action because they are created by action. In sculpture and other three-dimensional media, lines are perceived edges that may shift as we move about rounded forms. Lines may be perceived as delicate, tentative, elegant, assertive, forceful, or even brutal.

The line, as an element of art, is alive with possibilities. Artists use line to outline shapes, to evoke forms and movement, to imply solid mass, and for its own sake. In groupings, lines can create shadows and even visual illusions.

Renaissance artist Sandro Botticelli's *The Birth of Venus* (see Fig. 13–22) shows how line can be used to outline forms and evoke movement. In this painting, firm lines carve out the figures from the rigid horizontal of the horizon and the verticals of the trees.

2–1 RICHARD DIEBENKORN
Ocean Park #22 (1969)
Oil on canvas. 93 x 81".

Virginia Museum of Fine Arts, Richmond; Sydney and Frances Lewis Collection.

Straight lines carry the breath of the Zephyr from the left, and the curved lines of the drapery imply the movement of the Zephyrs and of the nymph to the right.

In *Ocean Park No. 22* (Fig. 2–1), American artist Richard Diebenkorn separates color fields of blue and green with thick white lines that overlap and intersect to form the predominant pattern in the painting. The effect is akin to slats of wood nailed across an open window or supporting an architectural structure. In *Loulou in a Flowered Hat* (see Fig. 5–9), French artist Henri Matisse etched a few delicate curved lines not only to imply the shape of a head, but also to create a cheerful mood through the jaunty tilt of the hat and the perkiness of the flowers.

In Jackson Pollock's abstractions (see Fig. 17–4), it is the process of painting lines itself that becomes the focus of the artist. The loose, **gestural** lines seem not only to be the means to an end, but also the end—or content—as well. Billy Apple's light sculpture (Fig. 2–2) also uses the line for its own sake. In this case a neon path is traced like a signature in space. From various angles

2–2 BILLY APPLE
Untitled (1967)
Neon. Multiple edition of 10.

Photo: Courtesy of the artist.

one could perceive profiles, curved letters, and mysterious symbols, but such subject matter would lie more in the projections of the viewer than in the tracery of the line.

In his *Venus*, Botticelli implied movement by a combination of straight and curved lines that show action. In the **Op painting** *Current* (Fig. 2–3), Bridget Riley uses line to create the illusion of movement. Fixate your gaze on any point in the picture and note how the surrounding areas seem to be in motion. In *Current*, movement is evoked by use of a **moiré pattern,** in which nearly identical patterns—in this case patterns of wavy lines—are placed next to one another. The eye bounces from line to adjacent line, creating the illusion of movement.

Shape

What do you see in Figure 2–4, a vase or two profiles? What do you see in Figure 2–5, meaningless splotches of ink or a horse and rider?

During the early part of this century, Gestalt psychologists studied human perception and developed a number of principles of perceptual organization. For example, we organize lines and shapes into figure–ground relationships. That is, we perceive figures against backgrounds. We also tend to integrate parts into meaningful wholes, even when there are gaps in sensory information. In Figure 2–4, which psychologists term the Rubin Vase, perception of both

2–3 BRIDGET RILEY *Current* (1964). Synthetic polymer paint on composition board. 58⅜ x 58⅞".
Collection, The Museum of Modern Art, N.Y. Philip Johnson Fund.

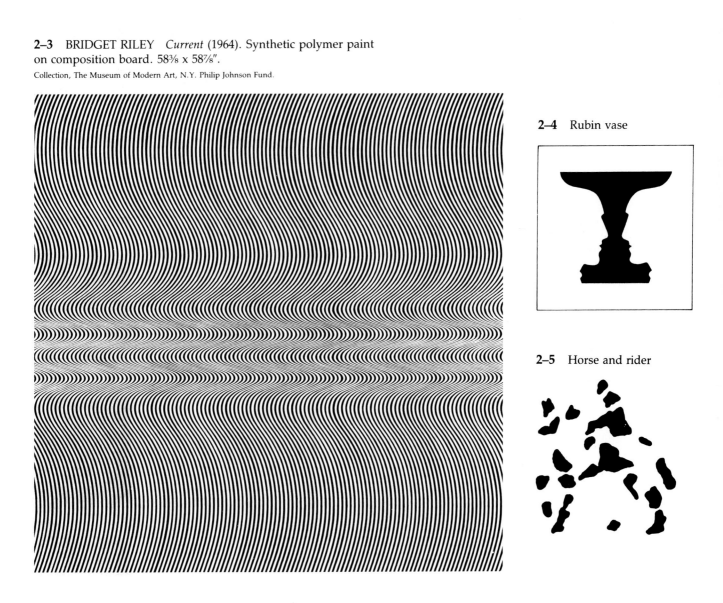

2–4 Rubin vase

2–5 Horse and rider

2–6 Black Hummingbird Pattern Quilt, c. 1925 unknown artist. (Amish, Shipshewana, Indiana). Cotton. 88 x 66".

Collection, Museum of American Folk Art, gift of David Pottinger.

the vase and profiles is justified, and so we may undergo perceptual shifts, now perceiving the vase and now the profiles. The splotches of ink in Figure 2–5 contain enough information to evoke an image of a horse and rider for most of us.

Shape can be communicated in a number of ways. In Botticelli's *Venus*, shape is clearly communicated by dominant lines that enclose specific areas of the painting. Shape can also be communicated through patches of color (Figs. 2–18 and 2–19) or texture (Fig. 2–9). In three-dimensional works such as sculpture and architecture, shape is created when the work is perceived against its environment. The edges, colors, and textures of the work give it shape against the background. If it were not for this tendency to perceive meaningful forms, how would we interpret Matisse's *Loulou*? Would not the etching consist of a few disjointed lines?

The *Black Hummingbird Pattern Quilt* (Fig. 2–6) by an unknown Amish artist is a playful demonstration of figure–ground relationships. The quilt is constructed of octagonal and diamond-shaped pieces of cloth in black

and primary colors. The viewer alternately focuses on the octagons and the diamond shapes, bringing each in turn to the foreground, because neither pattern is by its nature secondary to, or supportive of, the other.

Figure–ground relationships take on major importance in works such as the African mask shown in Figure 6–8 and Le Corbusier's chapel, *Notre-Dame-du-Haut* (Fig. 7–21). British sculptor Henry Moore noted that negative spaces, or "holes," can have as much "shape-meaning" as positive spaces, or masses. In the African mask, the dark wood is clearly the "figure"—or is it? With a little visual persistence the geometric shapes of the voids take on equal significance; perceptual shifts are required to fully appreciate the beauty of the mask. In Le Corbusier's church, the shapes implied by the window apertures are perhaps more interesting than the expanse of the interior concrete wall itself. Our selection of "figure" and "ground" will determine which shapes we perceive and our appreciation of the entirety of the work.

In addition to creating positive or negative shapes, artists can create shapes that are organic or geometric, and well-defined or amorphous. **Organic** shapes reflect those found in nature. Most of the organic shapes found in art are soft, curvilinear, and irregular, although some natural shapes, such as those found in the structure of crystals, are harsh and angular. **Geometric** shapes are regular and precise, such as polygons (triangles, rectangles, and so on) and circles. Geometric shapes are frequently used in art to portray objects and environments made by humans.

Jean Arp's statue, aptly titled *Growth* (Fig. 2–7), has the semblance of skin wrapping bone, although it is cast in bronze. While it is natural in the sense of having an organic form, it is clearly not of nature, but of Arp's fantasy. Similar organic forms are found in the **Surrealistic** works of Salvador Dalí (Fig. 16–25) and Joan Miró (Fig. 16–26). The color and movement of the organic shapes in Calder's mobiles (Fig. 6–20) create a bright, playful mood, whereas the junk sculpture of Richard Stankiewicz ironically assembles the hardness of metallic debris into organic forms (see Fig. 6–16). The architecture of recent years also abounds in organic forms, such as the winged creature defined by Eero Saarinen's TWA Terminal (Figs. 7–23 and 7–24).

The paintings of Kenneth Noland (Fig. 17–10) and Ellsworth Kelly (Fig. 17–11) show a hard geometry rarely found in nature. The sculpture of David Smith (see Fig. 17–27) assembles machined cylinders, cubes, and other shapes into aesthetic geometric puzzles. The regimented structures of Mies van der Rohe (Figs. 7–17 and 7–20) and the trussed fantasy of Louis Kahn's skyscraper project (Fig. 2–8) are but two examples of a geometric architecture very remote from the flesh and blood that inhabits it.

The pylons that support the boxy factory space in Pier Luigi Nervi's paper mill (Fig. 7–28) refer to neither human nor machine. Given their flat industrialized surface and their "legs" and steel-cable "arms," they could be said to occupy an innovative middle ground between the organic and the geometric.

2–7 JEAN ARP
Growth (1938)
Bronze. 31¼ x 12½ x 8".
Philadelphia Museum of Art, Curt Valentin.

2–8 LOUIS KAHN Model for skyscraper (1956)

2–9 HELEN FRANKENTHALER
Magic Carpet (1964)
Acrylic on canvas. 96 x 68″.
André Emmerich Gallery.

Throughout most of the history of art, shapes have been clearly defined. Although artists have added their personal touches, as Botticelli did in his *Venus,* they have by and large chosen their shapes from the environment and expressed them with **Realism.** In modern abstract art, too, as in that of Noland and Kelly, shapes can be well defined.

But many artists, such as the contemporary painters Mark Rothko (Fig. 2–14) and Helen Frankenthaler, create amorphous shapes. In *Magic Carpet* (Fig. 2–9), Frankenthaler literally poured paint onto her canvas, creating an amorphous work dense in form and rich in texture. The picture may evoke mountains against a sky of billowing cumulus clouds—indeed, it feels as though some-

thing is about to break loose—but the painting does not in fact represent objects.

Light

According to the Bible, in the beginning light was set apart from darkness. Light was good and the potential for evil lay in darkness. We speak of the "light" of reason. In almost all cultures light symbolizes goodness and knowledge. What is this stuff called light? **Light** is electromagnetic energy of various wavelengths, that part of the spectrum that stimulates the eyes and produces visual sensations.

The **value** of a color of a surface is its lightness or darkness. The value is deter-

2–10 The effect of context

gray squares in Figure 2–10 are equal in value. But, as Gestalt psychologists have learned, we perceive sensations in relation to their backgrounds. For this reason the gray square is perceived as being lighter when it lies against the black background. A difference in value creates a contrast in lightness and darkness.

Pictures that strongly contrast light and dark often make forceful differentiations between figure and ground, as does the silhouette of a figure against bright sunlight. Emil Nolde's woodcut *The Prophet* (Fig. 5–3) highlights the expressiveness of high contrasts of black and white.

The seventeenth-century painting by Georges de La Tour (Fig. 2–11) uses a single source of artificial light to highlight the front of the figure and the forehead of the skull

mined by the amount of light reflected by the surface: the greater the amount of light reflected, the lighter the surface. More light is reflected by a white surface than by a gray surface, and gray reflects more than black. White, therefore, is lighter than gray, and gray is lighter than black. The inner

2–11 GEORGES DE LA TOUR *Saint Mary Magdalen with a Candle* (c. 1640) Oil on canvas. 50½ x 37".

Louvre Museum, Paris.

in her lap. Parts of the figure of Saint Mary Magdalen (the orifices and the lower part of the skull), the books, and the area below the table rapidly recede into shadow and darkness. The strong contrast between the light and dark form a counterpoint to the distinction between life and death and the choice of good over evil. The flesh, the drapery, and the background all seem washed out—as if only the source of light had reality.

There is minimal contrast between light and dark in Malevich's *White on White* (Fig. 16–15), forcing the viewer to work harder to perceive the form in the painting. Malevich wished to evoke a pure emotional response from the viewer by removing the content of his work from the world of natural forms. Both squares are off-white, differentiated only by size, position, and slight variations in texture and hue.

By use of many gradations of value, objects portrayed on a flat surface can be given a rounded, three-dimensional appearance. The method of gradually shifting from light to dark to create the illusion of a curved surface is called **chiaroscuro.**

In *La Source* (Fig. 2–12), Pierre-Paul Prud'hon creates the illusion of rounded surfaces on blue-gray paper by using black and white chalk to portray light gradually dissolving into shade. His subtle **modeling** of the nude is facilitated by the middle value of the paper. In contrast to La Tour's point of artificial light, Prud'hon's light source is diffuse and apparently natural. As in the Malevich composition, the forms are not sharply outlined; we must work to find outlining anywhere but in the drapery and in the hair. But in contrast to Malevich, the values within the forms are widely varied.

It is an irony and a credit to the expertise of the artist that the stone blocks to the right of and below the nude are rendered as having the same texture as her flesh, even though their shapes, of course, are flat. Why, then, do we perceive the flesh to be soft and the stone hard? Perhaps because we *know* flesh to be soft and stone to be hard. The artist was apparently well aware that he could rely on the observer to make this distinction.

2–12 PIERRE-PAUL PRUD'HON
La Source (c. 1801)
Black and white chalk on blue-gray paper.
21³⁄₁₆ x 15⁵⁄₁₆".

Sterling and Francine Clark Art Institute, Williamstown, Mass.

On Abstract Art, Hamlet, Leonardo da Vinci, and Inkblots

Have you ever stood before an abstract work of art and asked yourself: What could this be? What does it look like? Different people interpret abstract artworks in different ways. Have you ever wondered what their responses to ambiguous shapes might tell us about them?

The notion that ambiguous shapes might be used to tell us something about the psychology of the individual lies at the heart of the Rorschach inkblot test, but the concept did not originate with Hermann Rorschach. In the early 1500s, Renaissance inventor and artist Leonardo da Vinci suggested that individual differences could be studied through interpretations of cloud formations. About 100 years later, Hamlet, Prince of Denmark, was portrayed in the Shakespearean play as toying with Polonius by suggesting alternately that a cloud looked like a camel, a hunched weasel, or a whale. Polonius, by agreeing with each suggestion, showed more political sense than personal integrity. His concern was to ingratiate himself with the prince, not to determine the "truth" about the cloud. The prince saw through him, of course.

Rorschach may not have been first, but he devised a system for interpreting responses to inkblots that a number of psychologists have found useful. Consider the inkblot in Figure 2–13. What do you see? What is there about the blot that inspired your responses?

2–13 HERMANN RORSCHACH
Inkblot #1

Rorschach suggested some interesting hypotheses. For example, were you annoyed at being asked to respond to a meaningless blot? If so, what does your annoyance suggest about your willingness to take time out for creative meanderings? Was your response based on the blackish-gray shapes or on the white spaces in between. Responses to the white space are "figure–ground reversals," and persons who engage in such reversals tend to see things very much in their own way. Did you see the blot as threatening or foreboding? Could the rough texture of the blot have contributed to this emotional response?

If pressed to it, can you see why other people might see a winged flying creature, or an animal's face, or perhaps a jack-o'-lantern? If not, is it possible that you're not willing to admit to sharing common ways of looking at things or common values?

2–14 (*right*) MARK ROTHKO
Earth and Green (1955)
Oil on canvas. 90¼ x 73½".
Collection, Galerie Beyeler, Basel.

2–15 (*below*) Prism
Courtesy of Bausch & Lomb.

Color

Color is a central element in our spoken language as well as in the language of art. We speak of being blue with sorrow, red with anger, green with envy. The poets paint a thoughtful mood as a brown study.

A person's response to the colors of Rorschach inkblots is interpreted as reflective of his or her emotional life. Some people, in fact, become so preoccupied by the color of inkblots that they lose sight of the outlines or shapes. The color in works of art can also trigger strong emotional responses in the observer, working hand in hand with line and shape to enrich the viewing experience. In some amorphous abstract works, such as Mark Rothko's *Earth and Green* (Fig. 2–14), it seems that the color itself is very much the "message" being communicated by the artist. The boundaries and back-

grounds of the rectangular forms in the painting are left hazy, creating an even purer emotional intensity. Subtle changes in the tonality of Rothko's radiating color fields lend them a mysterious light that envelops the viewer. In Chapter 15 you will see that the Postimpressionists Paul Gauguin and Vincent van Gogh chose color more for its emotive qualities rather than for its fidelity to nature.

And so, it is time for us to ask, What is color?

You have no doubt seen a rainbow or observed how light sometimes separates into several colors when it is filtered through a window. Sir Isaac Newton discovered that sunlight, or white light, can be broken down into different colors by a triangular glass solid called a **prism** (Fig. 2–15).

The wavelength of light determines its color, or **hue.** The visible spectrum consists of the colors red, orange, yellow, green, blue, indigo, and violet. The wavelength for red is longer than that for orange, and so on through violet.

The **value** of a color, like the value of any light, is its degree of lightness or darkness. If we wrap the colors of the spectrum around into a circle, we create a color wheel such as that shown in Figure 2–16. (Note that we must add some purples not found in the spectrum in order to complete the circle.) Yellow is the lightest of the colors on the wheel, and violet is the darkest. As we work our way around from yellow to violet, we encounter progressively darker

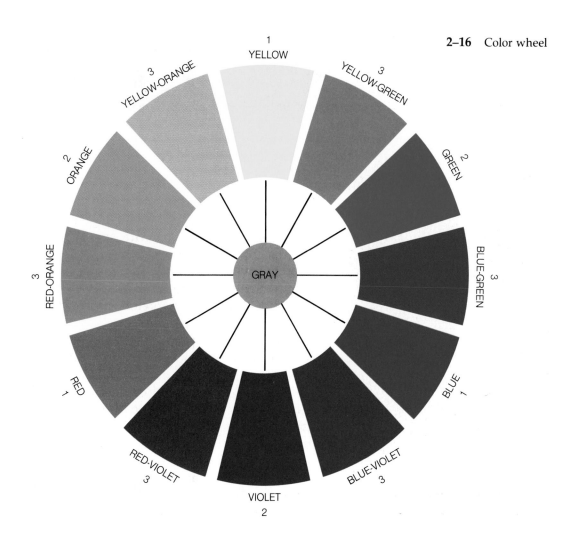

2–16 Color wheel

colors. Blue-green is about equal in value to red-orange, but green is lighter than red.

The colors on the green-blue side of the color wheel are considered **cool** in "temperature," whereas the colors on the yellow-orange-red side are considered **warm.** Perhaps greens and blues suggest the coolness of the ocean or the sky, and hot things tend to burn red or orange. A room decorated in green or blue may appear more appealing on a hot day in July than a room decorated in red or orange. On a canvas, warm colors seem to advance toward the picture plane, a phenomenon that partly explains why the oranges and yellows of *Summer's Sunlight* (see Fig. 2–20) appear to pulsate toward the viewer. Cool colors, on the other hand, seem to recede.

The **saturation** of a color is its pureness. Pure hues have the greatest intensity, or brightness. The saturation, and hence the intensity, decrease when another hue or black, gray, or white are added. Artists produce **shades** of a given hue by adding black, and **tints** by adding white.

The colors opposite each other on the color wheel are said to be **complementary.** Red-green and blue-yellow are the major complementary pairs. If we mix complementary colors together, they dissolve into neutral gray.

Wait! you may say: Blue and yellow cannot be "complementary" because by mixing **pigments** of blue and yellow we create green, not gray. That is true, but we are talking about mixing *lights*, not pigments. Light is the source of all color; pigments reflect and absorb different wavelengths of light selectively. The mixture of lights is an *additive* process, whereas the mixture of pigments is *subtractive* (see Fig. 2–17).

Pigments attain their colors by absorbing light from certain segments of the spectrum and reflecting the rest. For example, we see most plant life as green because the pigment in chlorophyll absorbs most of the red, blue, and violet wavelengths of light. The remaining green is reflected. A red pigment absorbs most of the spectrum but reflects red. White

2–17 Additive color mixtures (*left*) and subtractive color mixtures (*right*).

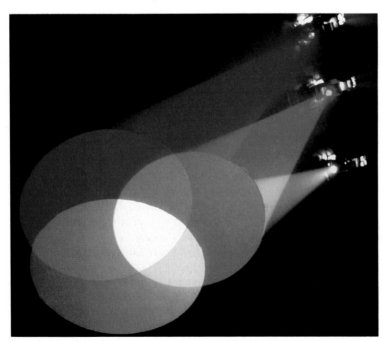

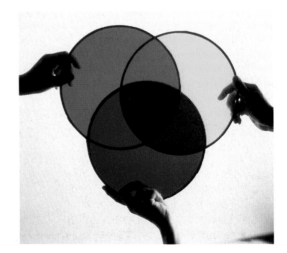

2–18 JASPER JOHNS *Flags* (1965)
Oil on canvas with raised canvas.
72 x 48".

Photo courtesy of Leo Castelli Gallery, N.Y.

pigment reflects all colors equally. Black pigment reflects very little light; it absorbs all wavelengths without prejudice. Black and white may be considered colors, but not hues. Black, white, and their mixture of gray are **achromatic,** or neutral, "colors," also referred to simply as **neutrals.**

The pigments of red, blue, and yellow are the **primary colors,** those that we cannot produce by mixing other hues. **Secondary colors** are created by mixing pigments of the primary colors. The three secondary colors are orange (derived from mixing red and yellow), green (blue and yellow), and violet (red and blue), denoted by the number 2 on the color wheel. **Tertiary colors** are created by mixing pigments of primary and adjoining secondary colors and are denoted by a 3 on the color wheel.

An interesting phenomenon occurs when we stare at colors for a while and then look away. Try this experiment: Look at the light-colored dot in the center of the green, black, and yellow flag painted by Jasper Johns (Fig. 2–18) for about thirty seconds. Then gaze at the dot in the center of the rectangle below. If you have followed directions and are not color-blind, you should see the familiar red, white, and blue. The red, white, and blue flag is an **afterimage** of the green, black, and yellow. Why do afterimages occur? The eye is constructed so that prolonged sensations of color become opposed by perception of the complementary color. The same holds true for black and white; staring at one will create an afterimage of the other.

2–19 JACK TWORKOV *Red & Green with Yellow Stripe* (1964). Oil on canvas. 91 x 79".
Nancy Hoffman Gallery, N.Y.

Hues that lie next to one another on the color wheel are **analogous**. They form families of color such as yellow and orange, orange and red, and green and blue. As we work our way around the wheel, the families intermarry, such as blue with violet and violet with red. Works that use closely related families of color seem harmonious, like *Earth and Green* (Fig. 2–14). The title of a Barnett Newman painting, *Who's Afraid of Red, Yellow, and Blue*, suggests the jarring effect that can be achieved by juxtaposing hues so far apart on the color wheel.

On a number of occasions, American painter Jack Tworkov set himself the task of creating compositions from potentially harsh color combinations. *Red & Green with Yellow Stripe* (Fig. 2–19) is an interplay of analogous, complementary, and primary colors. Fields of primary blue abut contrasting red. Fields of red conflict with complementary green. Like a nourishing river, the vertical yellow stripe creates a harmony. The color of the stripe is analogous to the red field in the upper part of the picture, and to the green field beneath. At once the harsh elements on each side of the canvas are made to balance one another along a bold, dynamic vertical. Additional experiments in contrast are found along the lower left edge of the painting, where fields of white abut a field of dark blue, and red and light blue swaths leap out from the dark blue patch to balance fields of red and light blue on the right side of the canvas.

Beatrice Whitney Van Ness's *Summer Sunlight* (Fig. 2–20) uses many of the colors in the Tworkov painting, but here the artist's highly saturated vibrant colors evoke the sense of a hot summer day. Everything is bathed in a hot orange-yellow light that filters through the beach umbrella and the woman's hat to impart an intense orange glow to her face and body. Patches of cool blue offer the viewer's eye respite from the overall heat of reds and yellows, much as a swim is the only escape from the intense heat of the summer afternoon.

Many pictures show a balance of hues, although artists do not necessarily think in terms of complementary and analogous colors. Artists may simply experiment with their compositions until they find them pleasing, but our analyzing their use of color and other elements of art helps us to appreciate their work.

2–20 BEATRICE WHITNEY VAN NESS *Summer Sunlight* (c. 1936)
Oil on canvas. 39 x 49".

National Museum of Women in the Arts, Washington, D.C. Gift of Wallace and Whilhelmina Holladay.

2–21 CLAUDE MONET *Haystack at Sunset Near Giverny* (1891).
Oil on canvas. 29½ x 37".

Courtesy, Museum of Fine Arts, Boston. Juliana Cheney Edwards Collection. Bequest of Robert J. Edwards in memory of his mother.

LOCAL VERSUS OPTICAL COLOR

Have you ever driven at night and wondered whether vague wavy lines in the distance outlined the peaks of hills or the bases of clouds? Objects may take on different hues as a function of distance or lighting conditions. The greenness of the trees on a mountain may make a strong impression from the base of the mountain, but from a distant vantage point the atmospheric scattering of light rays may dissolve the hue into a blue haze. Light-colored objects take on a dark appearance when lit strongly from behind. Hues fade as late afternoon wends its way to dusk and dusk to night. **Local color** is defined as the hue of an object as created by the colors its surface reflects under normal lighting conditions. **Optical color** is defined as our perceptions of color, which can vary markedly with lighting conditions.

Consider the *Haystack at Sunset Near Giverny* (Fig. 2–21) by the French **Impressionist** Claude Monet. Hay is light brown or straw-colored, but Monet's haystack takes on fiery hues, reflecting the angle of the light from the departing sun. The upper reach of the

2–22 GEORGES SEURAT *The Models* (small version, 1888).
Oil on canvas. 15½ x 19¼".

Private Collection, Switzerland

stack, especially, is given a forceful silhouette through flowing swaths of dark color. Surely the pigments of the surface of the haystack are no darker than the roofs of the houses that cling tenuously to an implied horizontal line across the center left of the picture. But the sun washes out their pigmentation. Nor can we with certainty interpret the horizontal above the roofs. Is it the top of a distant hill or the base of a cloud? Only in the visual sanctuary to the front of the haystack do a few possibly accurate greens and browns assert themselves. The amorphous shapes and pulsating color fields of *Haystack* lend the painting a powerful emotional impact.

In *The Models* (Fig. 2–22), French Postimpressionist Georges Seurat paints elegant figures, frozen motionless in time, posing in the artist's studio before his famous painting *Sunday Afternoon on the Island of La Grande Jatte* (Fig. 15–17). *The Models* shows how Seurat molded his forms from dabs of pure and complementary (local) colors. Rather than mixing his pigments, he juxtaposed points of pure color, yielding the impression (optical) of color mixtures.

In Chapter 15 we shall learn more about Seurat and his color theory. Now let us turn our attention to texture, another element of art that can evoke a strong emotional response.

Texture

The softness of skin and silk, the coarseness of rawhide and homespun cloth, the coolness of stone and tile, the warmth of wood—these are but a few of the **textures** that artists capture in their works. The word *texture* derives from the Latin for "weaving," and it is used to describe the surface character of woven fabrics and other materials as experienced primarily through the sense of touch.

Artists use line, color, and other elements of art to create the illusion of various textures in flat drawings and paintings. When the appearance of depicted objects differs from that of the paper, canvas, or other support, they are said to have **implied texture.** Sculptors and architects deal with the **actual textures** of their media of stone, wood, and other materials. In doing so, they may create works that yield visual impressions quite different from the surface character of the material. Note, for example, how Baroque sculptor Gianlorenzo Bernini (see Fig. 6–5) carved marble to simulate the soft textures of flesh and drapery.

The portraits by Rembrandt van Rijn (see Chapter 14) achieve a strong tactile quality through the artist's use of actual and implied texture. Rembrandt frequently used dabs

2–23 MAX ERNST *The Eye of Silence* (1943–44). Oil on canvas. 42½ x 55½".
Washington University Gallery of Art, St. Louis.

2–24 MERET OPPENHEIM
Object (1936) Fur-covered cup, saucer, and spoon. Overall height: 2⅞″.

Collection, The Museum of Modern Art, N.Y. Purchase.

of **impasto** to express the ways in which light can alternately construct and dissolve objects. The character of his brushstrokes lends reality to the visual impressions of skin, delicate lace, and here and there the impetuous emergence of a brilliant gem. He advised viewers not to stand too close to his canvases. When we do so, the art of his masterly illusion-making becomes apparent, and his subjects dissolve into the texture of his brush strokes.

Twentieth-century artist Max Ernst believed that irrational impulses and chance arrangements should play an important role in art. In his *The Eye of Silence* (Fig. 2–23), Ernst used innovative methods of applying paint to generate forms that have the implied texture of geological formations that never were. His fantastic "landscapes"—or perhaps we should say, his intended vistas of the unconscious—achieve much of their emotional impact through texture. Soft, rounded, even voluptuously vulnerable organic forms grow out of, or are consumed by, harsh, rocklike entities.

Similar or identical materials can be worked to show quite different textures. David Smith's steel sculptures (see Fig. 17–27) frequently possess a smooth, even satiny though hard surface, whereas from a distance Richard Stankiewicz's metal **assemblages** (see Fig. 6–16) often have a mottled, softer, organic look. Wood can be rough hewn, as in the African mask *Kagle* (Fig. 6–8), or as smooth as ivory, as in Fumio Yoshimura's *Dog Snapper* (Fig. 6–10). Contrast the smoothness of the Etruscan terracotta **sarcophagus** (Fig. 11–18) with the coarseness of Reuben Nakian's terra-cotta sculpture (Fig. 6–2).

Textures can attract and repel us. Consider the appealing–gruesome quality of Luca Samaras's *Untitled Box No. 3* (Fig. 6–18). Meret Oppenheim's *Object* (Fig. 2–24) is a cup lined with fur. The shape and function of the usually smooth teacup may trigger associations to utterly civilized and refined social settings and occasions. The coarse primal fur, on the other hand, stimulates rather different ideas, and the thought—even fleeting—of drinking from this cup is repugnant.

Mass

In the science of physics, the **mass** of a body is a reflection of its weight. The larger its mass, the more difficult a body is to move. In art, the mass of a depicted object—or of a sculpture or work of architecture—is its implied or actual bulk, size, or magnitude. In a two-dimensional drawing or painting, the term *mass* usually refers to a large area or form of one color. For example, in the paintings by Rothko and Tworkov, we can speak of masses of green and other colors as well as of *fields* of these colors. The large color fields of these paintings affords them an **implied mass** that is not generally found in paintings that are characterized by smaller forms of more varied colors.

Henri Gaudier-Brzeska's *Crouching Figure* (Fig. 2–25) is a small marble sculpture of both actual and implied mass. Marble is a dense material, and the figure is not easy to lift, even though it is only 8¾ inches tall. The form of the sculpture augments the

2–25 HENRI GAUDIER-BRZESKA
Crouching Figure (c. 1914)
Marble. 8¾ x 12 x 4".

Walker Art Center, Minneapolis. Gift of the T. B. Walker Foundation

2–26 HENRY MOORE *Reclining Mother and Child* (1960–61)
Cast bronze. 86½ x 33¼ x 54".

Walker Art Center, Minneapolis. Gift of the T. B. Walker Foundation.

denseness of the material to heighten the sense of massiveness. The limbs are compact. Nothing protrudes. When a wrestler flails his arms, he is easy to bring to the mat, but a wrestler who assumes a compact position is hard to budge, difficult to topple.

The **actual mass** of Henry Moore's *Reclining Mother and Child* (Fig. 2–26) vastly outscales that of the Gaudier-Brzeska figure. Moore's bronze sculpture is more than 7 feet long and nearly 3 feet high. But Moore's lyrical wrapping of large spaces imparts a lightness to his figures that denies their massiveness. The easy flow of air and light integrates the work into its surroundings, whereas the Gaudier-Brzeska maintains a stubborn aloofness.

The actual mass or massiveness of the Stonehenge **megaliths** (see Fig. 10–4) is an integral element of their artistic quality. These stone blocks must be larger than we are—visually, they must resist great forces—if they are to have impact. Similarly, the massiveness of the Egyptian Pyramids, of the great cathedrals, and of skyscrapers lends them their impact. Small models of these structures can accurately depict their shapes and colors, can suggest something of their textures, and can readily portray the harmony of the relationships among their parts. But without massiveness the structures remain toys; an essential element of their aesthetic character is lost.

On the other hand, the open interiors and skeletal support systems of Gothic cathedrals and contemporary skyscrapers imply a lightness and airiness that is not found in the Pyramids. How is it, the viewer may wonder, that these churches and urban structures of metal, stone, and glass can be supported by their "skeletons"? Their paradoxical lightness contributes to our appreciation of their massiveness.

Space

"No man is an island, entire of it self," wrote the poet John Donne. If Donne had been speaking of art, he might have written, "No subject exists in and of itself." A building has a site, a sculpture is surrounded by space, and even artists who work in two-dimensional media such as drawing and painting create figures that bear relationships to one another and to their grounds. Objects exist in three-dimensional space. Artists either carve out or model their works within three-dimensional space, or else somehow come to terms with three-dimensional space through two-dimensional artforms.

In Chapters 6 and 7, which discuss the three-dimensional artforms of sculpture and architecture, we explore ways in which artists situate their objects in space and envelop space. In Chapter 7 we chronicle the age-old attempt to enclose vast reaches of space that began with massive support systems and currently focuses on lightweight steel-cage and shell-like structures. In this section we will examine ways in which artists who work in two dimensions create the illusion of depth—that is, the third dimension.

OVERLAPPING

We all know that when nearby objects are placed in front of more distant objects, they obscure part or all of the distant objects. Figure 2–27 shows two circles and two arcs, but our perceptual experiences encourage us to interpret the drawing as showing four circles, two in the foreground and two in back. That is, our perceptual experiences allow an artist to create the illusion of depth by overlapping objects, or apparently placing one in front of another.

2–27 Overlapping circles and arcs.

2–28 EDWARD HOPPER
Methodist Church, Provincetown
(1930). Watercolor on paper.
25 x 19¾".

Wadsworth Atheneum, Hartford. Ella Gallup Sumner
and Mary Catlin Sumner Collection.

2–29 Luke Sullivan after
WILLIAM HOGARTH
Illustration for *"Dr. Brook Taylor's
Method of Perspective Made Easy…"*
(*False Perspective*) (1754).
Engraving. 10⅛ x 7⅞".

Yale Center for British Art, Paul Mellon Collection.

Frontispiece.

Whoever makes a DESIGN*, without the Knowledge of* PERSPECTIVE
will be liable to such Absurdities as are shewn in this Frontispiece.

In *Methodist Church, Provincetown* (Fig. 2–28), Edward Hopper overlaps rooftops to dramatize the visual communality of the buildings in this Cape Cod town. In the engraving *False Perspective* (Fig. 2–29), English artist William Hogarth uses overlapping and a number of other cues for depth to play with the viewer. Note, for example, that the building in the upper right part of the picture is in front of the hills to the left and therefore closer to the **picture plane.** However, the flag that hangs from this building drops "behind" the distant trees, thereby appearing farther from the viewer. In what other whimsical ways does Hogarth use overlapping?

RELATIVE SIZE AND LINEAR PERSPECTIVE

Objects become smaller as they recede into the distance, creating the phenomenon of **linear perspective.** In *Sunday Afternoon on the Island of La Grande Jatte* (Fig. 15–17), Seurat leads us to perceive the two figures toward the right side of the composition as closest to the picture plane because of their height. Figures recede dramatically in size along steep diagonals that run from the lower left and center right of the composition toward a point in the upper right center. The smaller figures in the upper center part of the painting seem frozen deep in space.

Artists over the centuries have tended to place nearby objects toward the bottom of their compositions. In the Hopper painting (Fig. 2–28), the buildings anchored to the bottom of the canvas appear larger than those in the middleground or background. Also the building façade that bleeds off the right border of the canvas is much larger than its neighbor to the left, placing it nearer to the viewer, although the perspective of

2–30 A visual illusion

the painting suggests that the neighbors would probably be quite close in size.

Note how the cylinders in Figure 2–30 appear to grow larger toward the top of the composition. Why? For at least two reasons: (1) As has been noted already, objects at the bottom of a composition are usually perceived as being closer to the picture plane, and (2) the converging lines are perceived as being parallel, even when they are not. However, if they were parallel, then space would have to recede toward the center right of the composition, and the cylinder in that region would have to be farthest from the viewer. According to rules of perspective, a distant object that appears to be equal in size to a nearby object would have to be larger, and so we perceive the cylinder to the right as the largest, although it is equal in size to the others.

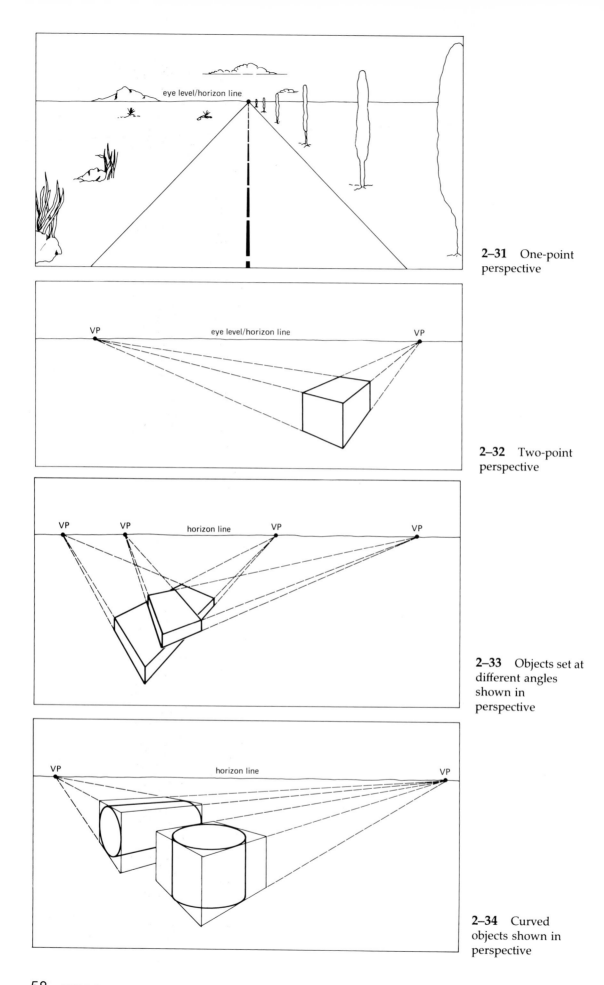

2–31 One-point perspective

2–32 Two-point perspective

2–33 Objects set at different angles shown in perspective

2–34 Curved objects shown in perspective

Figures 2–31 through 2–34 show that the illusion of depth can be created in art by making parallel lines come together, or converge, at one or more **vanishing points** on an actual or implied horizon. The height of the **horizon** in the composition corresponds to the apparent location of the viewer's eyes, that is, the **vantage point** of the viewer. As we shall see in later chapters, the Greeks and Romans had some notion of linear perspective, but perspective was refined by Renaissance artists such as Leonardo da Vinci.

In **one-point perspective** (Fig. 2–31), parallel lines converge at a single vanishing point on the horizon. In *Sunday Afternoon on the Island of La Grande Jatte* (Fig. 15–17) the vanishing point is near the top of the composition, so that the viewer looks down upon the scene. Renaissance artist Albrecht Dürer's woodcut *The Adoration of the Magi* (Fig. 2–35) functions very much like an exercise in one-point perspective. One can locate the vanishing point by following converging parallel lines (Fig. 2–36) to where they intersect near the center of the composition. By placing the vanishing point near the eye level of the figures, Dürer gives the viewer a psychological sense of communicating with them.

In **two-point perspective** (Fig. 2–32), two sets of parallel lines converge at separate vanishing points on the horizon. Two-point perspective is appropriate for representing the recession of objects that are seen from an angle, or obliquely. In *Methodist Church, Provincetown* (Fig. 2–28), the vanishing points are actually outside the painting and can be found by tracing the horizontal lines of cornices, eaves, and rooftops to the left and right.

We can use additional sets of parallel lines to depict objects that are set at different angles, as shown in Figure 2–33. Figure 2–34 shows how curved objects may be "carved out" of rectangular solids.

2–35 ALBRECHT DÜRER *The Adoration of the Magi* (1511). Woodcut. 11½ x 8⅝".
The Metropolitan Museum of Art, Gift of Junius S. Morgan, 1919.

2–36 Converging parallel lines intersect at the vanishing point.

In **atmospheric perspective** (also called *aerial perspective*), the illusion of depth is created by techniques such as texture gradients, brightness gradients, color saturation, and the manipulation of warm and cool colors.

A gradient is a progressive change. The effect of a **texture gradient** relies on the fact that closer objects are perceived as having rougher or more detailed surfaces. In the Dürer woodcut (Fig. 2–35), the grain of the wooden posts and beams in the foreground is more detailed than that of the posts and beams behind the figures, heightening the perception of depth. In *Sunday Afternoon on the Island of La Grande Jatte* (Fig. 15–17), the distant figures are barely outlined, whereas we can sense the weave of the fabrics that adorn the nearby figures. In the Hogarth engraving (Fig. 2–29), the building just behind the large fisherman's head has a rougher texture and thus seems closer than the building with the window from which the woman is leaning. And so we are surprised by the moon sign's depiction as hanging from both buildings.

The effect of a **brightness gradient** is due to the lesser intensity of distant objects. In

Thomas Eakins's *The Gross Clinic* (Fig. 15–28), the audience is made to recede by a gradual loss of intensity and color saturation as well as by loss of detail.

Allan D'Arcangelo's *Highway 1, No. 2* (Fig. 2–37) provides graphic evidence of the tendency of warm red and orange-yellow to leap out toward the viewer while cool blue recedes. The intense white of the road striping and the highway sign float against the backdrop of the blackened road and countryside. The dramatic one-point perspective underscores the way in which civilization's brute geometry furrows through the random elements of nature. There may be some worthy detail beyond the flat black wall of countryside, but it is not to be seen. How many of us fail to attend to natural beauty as we rush headlong from one thing to another and note only the objects made meaningful by cultural conditioning?

Time and Motion

Objects and figures exist and move not only in space, but also in the dimension of time. In its inexorable forward flow, time provides us with the chance to develop and grasp

2–37 ALLAN D'ARCANGELO
Highway 1, No. 2 (1963)
Acrylic on canvas. 70 x 81".
© Allan D'Arcangelo, 1963.

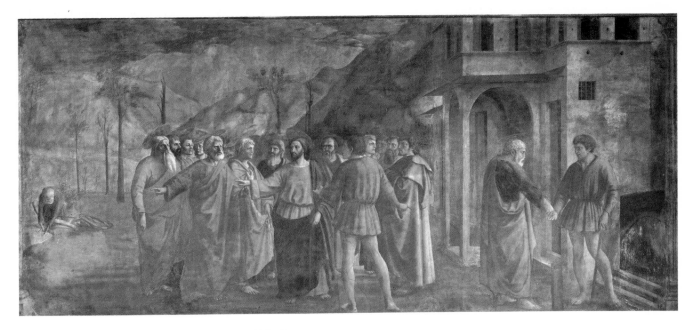

2–38 MASACCIO *The Tribute Money* (c. 1427). Fresco.
Brancacci Chapel, Santa Maria del Carmine, Florence.

the visions of our dreams. Time also creates the stark limits beyond which none of us may extend.

Artists have sought not only to represent three-dimensional space in two-dimensional art forms, but also to represent the passage of time. Only recently have art forms been developed that involve *actual* time and *actual* movement. In the following chapters we shall discuss a number of them, including kinetic sculpture and motion pictures. In this chapter we confine our discussion to ways in which artists have represented time and motion in more traditional media such as painting, sculpture, architecture, and photography. Through these modes of expression, artists create **implied time** and **implied motion**.

The Italian Renaissance artist Masaccio told a three-part story in his fresco *The Tribute Money* (Fig. 2–38). In the center grouping, Jesus is advising St. Peter that he will find a coin to pay the tax collector in the mouth of a fish. At the left of the composition, St. Peter is extracting the coin from the fish's mouth. To the right, he is shown disdainfully handing the coin to the tax collector. The viewer must know the story to interpret the painting, because the background is continuous, implying that the depicted events happen concurrently. Note, too, how dramatically the single-point perspective is defined by the horizontals of the building to the right.

Masaccio's fresco tells a story by showing three related events in a single frame. The photographer Eadward Muybridge told "stories" about the nature of motion

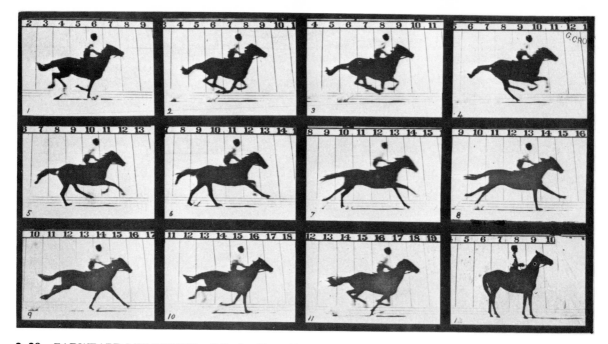

2–39 EADWEARD MUYBRIDGE *Galloping Horse* (1878). Photograph.
International Museum of Photography at George Eastman House, Rochester, N.Y.

2–40 GIACOMO BALLA
Dynamism of a Dog on a Leash (1912)
Oil on canvas. 35⅜ x 43¼".

Albright-Knox Gallery, Buffalo, N.Y. Bequest of A. Conger Goodyear and gift of George F. Goodyear, 1964.

through series of frames, each of which stopped rapid action. In *Galloping Horse* (Fig. 2–39), the motion of a running horse is implied in eleven frames, with the twelfth showing animal and rider at rest. In two dramatic frames, all hooves are in the air at once.

Muybridge's story of motion is told in eleven frames, each representing a single exposure of film to light. What if he had exposed the same frame to light several times and created a multiple-exposure photograph? Ignoring technical problems of photography, the results might have resembled the paintings by Giacomo Balla (Fig. 2–40) and Marcel Duchamp (Fig. 16–23).

Balla's *Dynamism of a Dog on a Leash* expresses the fact that moving images are

never static on the retina. Balla creates a jaunty abstraction of movement through simultaneous portrayal of multiple positions of the animal's limbs and tail. Duchamp's **cubist** *Nude Descending a Staircase #2* fractures space as well as time. The figure is abstracted into planes and portrayed from several vantage points at once. The abstracted figure is then portrayed descending the staircase as in a series of multiple exposures.

Working in the media of painting and architecture, Henri de Toulouse-Lautrec and Eero Saarinen fashioned similar portrayals of movement. In Toulouse-Lautrec's *Loïe Fuller in the Dance of Veils* (Fig. 2–41), billowing organic drapery is filled with air, implying a sweep of arms. The sweeping shell structures of Saarinen's TWA Terminal (Figs. 7–23 and 7–24) seem also buoyed by air like the wings of a prehistoric bird or flying reptile, although they are constructed from reinforced concrete. In each case, a fleeting moment seems to have been arrested. Each work grants permanence to a dynamic relationship between air and vessel that otherwise can last but an instant.

COMPOSITION

Composition is a process—the act of composing or organizing the plastic elements of art. Composition can occur at random, exemplified by the old concept that if an infinite number of monkeys type away at an infinite number of typewriters, eventually one might create *Hamlet*. But artistic composition takes place according to aesthetic principles such as proportion and scale, unity, balance, and rhythm. When we use principles of organization such as these, beautiful works are created by a finite number of artists.

2–41 HENRI DE TOULOUSE-LAUTREC
Loïe Fuller in the Dance of Veils (1893)
Oil on cardboard. 24 x 17⅜".
Toulouse-Lautrec Museum, Albi, France.

This is not to say that all artists try to apply these principles. Some artists create fine works by purposefully violating them. Still others—"primitive" artists, for example—work without being aware of their names or their historical application. Nevertheless, most primitive artists' sense of order suggests that their creative processes were guided by similar, even if unlabeled, principles.

2–42 HENRI MATISSE *Large Reclining Nude* (1935) Oil on canvas. 26 x 36½".
Baltimore Museum of Art. The Cone Collection, formed by Dr. Claribel Cone and Miss Etta Cone of Baltimore, Maryland.

Proportion and Scale

Proportion is the comparative relationship of the parts of a composition to each other and to the whole. The historic attempt of philosophers and artists to discover or establish mathematical rules of proportion that will lead to aesthetic compositions is older than the ancient Greeks.

The Classical Greek sculptor Polykleitos created noble athletic figures (see Fig. 11–10) in which the height of the body was precisely eight times the length of the head. This rule was not intended so much to reflect reality as to perfect it. Much of the Classical Greek Parthenon (Fig. 11–8) was con-

structed according to the principle of the **Golden Section,** which states that a small part must relate to a larger part as the larger part relates to the whole.

The beauty of Titian's *Venus of Urbino* (Fig. 14–1) is inseparable from its classical proportions. Henri Matisse's voluptuous *Large Reclining Nude* (Fig. 2–42), by contrast, reclines majestically in a traditional pose, but the proportions of the body appear disorderly. Each part taken separately is appealing, even sensuous, but in combination the proportions are unrealistic: the head is too small, the torso too long, the shoulders and arms too massive. But Matisse's violation of realistic proportions is intentional. In two-

2–43 RENÉ MAGRITTE *Personal Values* (1952). Oil on canvas. 31½ x 39″.
Collection Harry Torczyner, New York.

dimensional art and in sculpture, he sought to create the essential lines of a woman but then to infuse the forms with emotion and personal meaning by distorting them.

Whereas proportion is the relationship of parts to each other and a whole work, **scale** is the relative size of an object compared with others of its kind, its setting, or people. The Pyramids of Giza and the skyscrapers of New York are massive because of their scale, that is, their size compared with the size of other buildings, their sites, and people. Their massiveness is essential to their impact.

It is in part the play on the viewer's sense of scale that creates the mystery and amusement of René Magritte's *Personal Values* (Fig. 2–43). The objects themselves are banal—a comb, a shaving brush, a wine glass, a matchstick, and a bar of soap. But their scale in relation to rugs, wardrobe, floor, and ceiling, and their setting against the clouds lends them a monumentality that forces the viewer to study their forms and their importance anew. Scale also elevates Claes Oldenburg's *Clothespin* (Fig. 2–44) to a work of art.

Claes Oldenburg: On Clothespins, Baseball Bats, and Other Monuments

When one drives around Philadelphia's Center Square, one is impressed by the broadness of the avenues, the Classical columns and arches of City Hall, the steel and glass curtain walls of the new office buildings, and . . . by a 45-foot-tall clothespin (Fig. 2–44).

Why a clothespin? "I like everything about clothespins," reported Pop artist Claes Oldenburg, "even the name." The clothespin sculpture, aptly called *Clothespin* by its creator, was erected as a tribute to the 1976 Bicentennial. The line down the center of the pin suggests an updating of the cracked Liberty Bell, and the spring could be viewed as spelling out '76. Moreover, the clothespin consists of two structures clasped together, by a spring, in an embrace—an appropriate symbol for Philadelphia, the City of Brotherly Love. One might think that this symbolism was incidental, but in 1972 Oldenburg made a silk screen comparing his clothespin to Brancusi's *The Kiss* (Fig. 1–33), which also depicts an embrace.

Clothespin is just one of the ordinary objects to which Oldenburg has lent monumentality by upgrading their scale. A 24-foot-high *Lipstick* rises serenely on a Yale University quadrangle, and the Houston Public Library sports an 18-foot-high mouse. The plaza of the Social Security Administration building in Chicago, a city that supports two major league baseball franchises, is punctuated by a 100-foot-tall baseball bat. Oldenburg has drawings of typewriter erasers and upside-down ice cream cones whose scales rival those of the Egyptian Pyramids.

It could be argued that the subjects of Oldenburg's monuments are trivial, but we must also admit that they have a certain symbolic meaning and depth for Americans. In centuries to come, they may say more about twentieth-century America than would a few more bronze riders on horseback.

Unity

Unity is oneness or wholeness. A work of art achieves unity when its parts seem necessary to the composition. One way in which the Classical Greeks afforded their artistic works unity was through their exacting proportions.

Artists frequently stir the viewer's interest by creating variety within unity, as found in Louise Bourgeois' *Eyes* (see Fig. 6–6) and in Robert Indiana's *The Demuth American Dream No. 5* (Fig. 2–45). The work is a tribute to Charles Demuth and his painting *I Saw the Figure 5 in Gold*. Indiana multiplies the older artist's work into five panels unified by the number 5 and the overall shape of the cross. The inscriptions and colors of the panels vary, extending the symbolic import of the imagery.

Balance

A work of art possesses **balance** when its visual or actual weights or masses (including color masses) are distributed in such a way that they achieve harmony. In Calder's **mobile** (Fig. 6–20), the actual weights are balanced and account for both physical and visual harmony.

2–44 CLAES OLDENBURG
Clothespin (1976)
Corten steel with stainless steel
base. 45' high.

Courtesy Leo Castelli Gallery, N.Y.

2–45 ROBERT INDIANA
The Demuth American Dream No. 5 (1963)
Oil on canvas. 5 panels, each 48 x 48",
assembled 144 x 144".

Art Gallery of Ontario, Toronto. Gift from the Women's
Committee Fund, 1964.

2–46 JOAN MIRÓ *The Birth of the World*
(Montroig, summer, 1925)
Oil on canvas, 8′2¾″ x 6′6⅘″.

2–47 GERTRUDE KÄSEBIER *Blessed Art Thou Among Women* (c. 1898). Photograph.

Note how there is a balance or equilibrium between tensed and relaxed limbs in Polykleitos's *Doryphoros*, or Spear Bearer (Fig. 11–10). The human body, the Parthenon (Fig. 11–8), and many cathedrals and contemporary office buildings achieve balance through **bilateral symmetry,** in which the left side of the work is largely mirrored by the right. The balance of Oldenburg's *Clothespin* (Fig. 2–44) also stems from bilateral symmetry.

Asymmetrical balance is achieved when nonequivalent forms, masses, or other elements balance one another. For example, the massive dark rooflines of Le Corbusier's *Notre-Dame-du-Haut* (Fig. 7–21) are balanced by the whiteness of the walls and the vertical thrust of adjoining towers.

In *The Birth of the World* (Fig. 2–46), Joan Miró first allowed paint to run freely across his canvas. Then he placed emergent forms in black, white, and red against this background, suggesting a sort of primordial soup. Note how the red and white circular shapes balance one another. If you cover the white shape, the composition seems lopsided to the right; if you cover the red shape, it seems lopsided to the left. Although Miró claims to have placed his shapes at random, a strong sense of composition is evident.

What an exquisite sense of composition we find in Gertrude Käsebier's delicately textured photograph *Blessed Art Thou Among Women* (Fig. 2–47). Notice how the dark value of the girl's dress is balanced both by the dark wall to the left and by the woman's hair. Similarly, the stark light value of the vertical shaft of the doorway to the left and the light values of the right side of the composition are in equilibrium. The floor and painting in the background provide unifying middle values. If the composition of works such as these is instinctive, some artists' instincts are well schooled indeed.

Rhythm

The world would be a meaningless jumble of sights and sounds were it not for the regular repetition of sensory impressions. Natural **rhythms,** or orderly progressions,

regulate events ranging from the orbits of the planets to the unfolding of the genetic code into flesh and blood. Such a rhythm unfolds in the spines of Edward Weston's *Cabbage Leaf* (Fig. 2–48). The photographer's sensitive composition transforms a vegetable into an eternal statement of mathematical truth.

The rhythm of Muybridge's *Galloping Horse* (Fig. 2–39) similarly elevates the series of photographs from a study of mechanical principles to the realm of art. Repetition grants Duchamp's *Nude Descending a Staircase #2* (Fig. 16–23) its dynamic impact. Among contemporary artists, Andy Warhol has duplicated the homely artificial rhythm of groceries assembled on supermarket shelves through his multiple images of soup cans, Brillo boxes, and Coca-Cola bottles (Fig. 17–15). Wayne Thiebaud's stately procession in *Pie Counter* (Fig. 2–49) seems to be a comment on the homogeneity of con-

2–48 EDWARD WESTON *Cabbage Leaf* (1931). Photograph.
© Arizona Board of Regents, Center for Creative Photography, Tucson.

2–49 WAYNE THIEBAUD
Pie Counter (1963).
Oil. 30 x 36".

Collection of Whitney Museum of American Art, N.Y. Larry Aldrich Foundation Fund.

temporary American society as fostered by the advertising designs of Madison Avenue.

The architects of the Middle Ages (see Chapters 7 and 12) imbued the great cathedrals with a sense of rhythm by repeating their open spaces, or **bays,** very much as Robert Indiana did in *The Demuth American Dream No. 5* (Fig. 2–45). The structure of the Roman Pont du Gard at Nîmes, France (Fig. 11–22) is elevated to art by the regular procession of its three rows of arches. Many modern buildings are given a rhythmic composition by the repetition of the elements of their steel skeletons. This structural rhythm is made evident in the Wainwright Building (Fig. 7–15) and Seagram House (Fig. 7–17) by the equidistant vertical lines between the windows.

In contrast to the Wainwright and Seagram buildings, the U.S. Air Force Academy Chapel at Colorado Springs (Fig. 2–50) wears its skeleton on the outside. Light and shade strongly affirm its advancing series of thrusting aluminum pylons. From the front the building appears to be a simple triangle, and from the side it is a ribbed rectangle. Only from an oblique angle do

we receive the dramatic impact of its triangles within triangles, abstractions that echo the spikes of the chapel's Rocky Mountain setting.

CONTENT

The *content* of a composition is everything that is contained in it. The content of a work refers not only to its lines or forms, but also to its subject matter and its underlying meanings or themes.

The Levels of Content

Recall the Rorschach inkblot shown in Figure 2–13. On the surface, the content of the figure is an inkblot; it was formed by pouring ink on paper, then folding the paper to create bilateral symmetry. Asked what it is, someone might respond, ''A person being pulled apart by winged creatures.'' A psychoanalyst might then suggest additional underlying, or **latent,** content to this response: fear of being torn apart by inner conflict. The psychoanalyst would be suggesting that the response ''A person being pulled apart'' is symbolic of inner processes, underlying themes and meanings, of which the person is unaware.

In terms of its (1) *elements and composition*, the content of the inkblot consists of balanced, highly textured forms created by ink spilled on paper. However, the content of the viewer's response operates on two additional levels: (2) the *subject matter* suggested by the forms, and (3) their underlying or *symbolic meanings or themes*. Altogether, then, there are three levels of content—as in many works of art.

Jan van Eyck's fifteenth-century masterpiece *Giovanni Arnolfini and His Bride* (Fig. 13–4) will help clarify these ideas. In terms of the first level of content—elements and composition—we may make a number of observations that are elaborated on in Chapter 13. For example, the two vertical figures balance one another as the window frame balances the canopy of the bed. Light values define the faces, hands, and veil, whereas

2–50 SKIDMORE, OWINGS AND MERRILL
U.S. Air Force Academy Chapel, Colorado Springs
(1956–62)

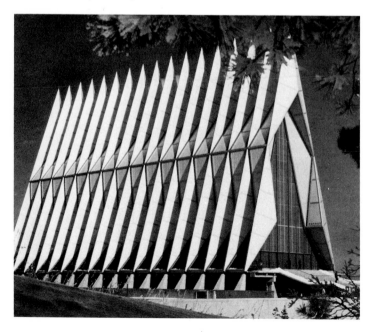

On the Language of Art

NICHOLAS HILLIARD on Line: Forget not . . . that the principal part of painting or drawing from life consists in the truth of the line.

TINTORETTO on Color: Black and white [are the most beautiful colors], because black gives force to the figures by making the shadows deeper; and white by making the highlights stand out.

NICOLAS POUSSIN on Color: One may speak of the friendships and enmities of colors and their rules.

GIUSEPPE BOSSI on Light and Color: For fierce and forceful subjects, violent shadows and lights with an exuberance of shadow and a predominance of primary colors are best suited. For gentle, sad . . . subjects, a great moderateness and balance of light and shade are suitable, with a sacrifice of the primary colors and a predominance of the derived. For gay subjects, bright lights, soft shadows, and a mingling of many primary and derived colors.

LEONARDO DA VINCI on Proportion: From the chin to the starting of the hair is a tenth part of the figure. From the chin to the top of the head is an eighth part. And from the chin to the nostrils is a third part of the face.

THOMAS EAKINS on the Elements of Art: The first things to attend to in painting the model are the movement and the general color. The figure must balance, appear solid and of the right weight.

HENRI MATISSE on Composition and Color: Composition is the art of arranging in a decorative manner the various elements at the painter's disposal for the expression of his feelings. . . . Both harmonies and dissonances of color can produce very pleasurable effects.

JEAN-BAPTISTE-CAMILLE COROT on Composition: Begin by determining your composition. Then the values—the relation of the form to the values. . . . Then the color.

middle and dark values predominate elsewhere. As for color, we may be impressed by the complementary green of the wedding dress and red of the bed.

In terms of subject matter, we are witnessing a marriage ceremony. We may also compile a list of figures and objects in the room: woman, man, dog, bed, shoes, chandelier, window, and so on. It is on the underlying, symbolic level that the content of the picture grows rich with meaning. For example, the dog symbolizes loyalty, and the shoelessness of the groom symbolizes the holiness of the ground.

Iconography

You may argue that there is a major difference between the content of the Rorschach inkblot and the content of the van Eyck painting: Rorschach created nothing but an inkblot, whereas the observer both creates the subject matter and suggests the underlying meaning. In the painting, van Eyck created the composition, the subject matter, and the **iconography**, that is, the representation of the underlying themes and meanings by symbols.

Your argument would be partly correct. In many cases, artists do supply the viewer with clear, familiar images, and frequently they intend to communicate certain underlying themes. But in some cases, the underlying themes may be purely the invention of the viewer. In Helen Frankenthaler's *Magic Carpet* (Fig. 2–9), for example, we may interpret the billowing yellow-orange masses as symbolic of the emotions that build within us and threaten our composure, but did the artist intend this symbolism, or is it our own invention? Many of us love a puzzle and are willing to spend a great deal of time attempting to decipher the possible iconography of a work of art.

We might also wonder whether one could fully appreciate van Eyck's marriage ceremony without being aware of its iconography. No simple answer is possible. Certainly one could appreciate the composition and the subject matter for their own sake, but awareness of the symbolism enriches the viewing experience. In other words, it pays for viewers to do their homework.

Content in Nonobjective Art

In other cases, any definition of the subject matter of a work is an invention of the viewer. What is the subject matter and underlying meaning of Piet Mondrian's **nonobjective** paintings, such as that shown in Figure 16–17? In nonobjective art it may be that the elements and composition are the entirety of the content. Any other content may originate with the viewer, not the artist. Still, perhaps much of the beauty of nonobjective art, as in so many instances of objective art, derives from its appearance as a rich, fertile ground for the viewer's imagination.

The language of art sometimes opens a direct line of communication with the symbolic systems of the observer. Since the ideas and symbols we use to make meaning of the world cannot overlap perfectly, art may trigger different associations in each of us.

3

Drawing

The first sketch was probably an accident. Perhaps some Stone Age human idly ran a twig through soft clay and was astounded to find an impression of this gesture in the ground. Perhaps this individual then made such impressions as signs for family members (as in an arrow pointing "that-a-way") and to record experiences, such as the hunt for a beast or a gathering around a fire. Similarly, a child may learn to trace a shell fragment through damp sand at the shore's edge. Soon the child is drawing sketches of geometric shapes, animals, toys, and people. Michelangelo was engaging in an essentially similar act when he sketched his models from life—albeit with a bit more skill and flair.

In this chapter we discuss drawing, the most basic of the two-dimensional artforms. In the next two chapters we will discuss two other forms of two-dimensional art—painting and printmaking. We shall see how people over the centuries have used a variety of materials, frequently

from surprising sources, to express themselves through two-dimensional artforms.

In its broadest definition, **drawing** is the result of an implement running over a surface and leaving some trace of the gesture. But as we shall discover, the art of drawing goes far beyond this simple description.

The surface, or **support,** onto which an image is sketched is usually, although not always, two-dimensional. Most often the support is **monochromatic** paper or parchment, although drawings can be found on a variety of surfaces. The implements can range from charcoal (which is burnt wood) to bristle brushes dipped in ink. Most drawings, by virtue of the implements, consist of black and tones of gray. But many full-color drawings have also been created with colored chalks, pastels, and wax crayons.

Some drawings are predominantly **linear,** others are constructed solely by tonal contrasts. The quality of line and the nature of shading are affected by the texture of the support. We shall see how the artist capitalizes on the idiosyncratic characteristics of the implements and support to capture a desired expression in the drawing.

CATEGORIES OF DRAWING

Drawing is basic to the visual arts. For centuries, painters and sculptors have made countless preparatory sketches for their major projects, working out difficulties on paper before approaching the more permanent medium of paint or bronze. Architects proceed in the same fashion, outlining buildings in detail before breaking ground. Drawing has also served artists as a kind of shorthand method for recording ideas.

But drawing does not serve only a utilitarian purpose. In most cases, drawing is the most direct route from mind to support. Many artists enjoy the sheer spontaneity of drawing, tracing a pencil or piece of chalk across a sheet of paper to capture directly their thoughts or to record the slightest movement of their hand.

Many drawings, by contrast, stand as complete works of art. Thus, drawings may be said to fall into at least three categories:

1. Sketches that record an idea or provide information about something the artist has seen.

2. Plans or preparatory studies for other projects such as buildings, sculptures, crafts, paintings, plays, and films.

3. Fully developed and self-sufficient works of art.

MATERIALS

Over the millennia methods of drawing have become increasingly sophisticated and materials more varied and standardized. It would seem that we have come a long way from our prehistoric ancestors' use of twigs, hollow reeds, and lumps of clay. Drawing materials can be divided into two major groups: *dry media* and *fluid media*.

Dry Media

The *dry media* used in drawing include silverpoint, pencil, charcoal, chalk, pastel, and wax crayon.

SILVERPOINT

Silverpoint is one of the oldest drawing media. It was used widely from the late Middle Ages to the early 1500s. Silverpoint drawings are created by dragging a silver-tipped implement over a surface that has been coated with a **ground** of bone dust or chalk mixed with **gum,** water, and **pigment.** This ground is sufficiently coarse to allow small flecks of silver from the instrument to adhere to the prepared surface as it is drawn across. These bits of metal form the lines of the drawing; they are barely visible at the start but eventually oxidize, becoming tarnished or darkened and making the image visible. Each silverpoint line darkens to the same unvarying tone. If the artist desires to make one area of the drawing appear darker than others, it is necessary to build up a series of close, parallel, **cross-**

hatched lines in that area to give the impression of deepened tone. Because they lack sharp tonal contrasts, the resultant drawings are extremely delicate in appearance.

The technique of working in silverpoint is itself delicate. The medium allows for little or no correction. Thus, the artist is not in a position to experiment or think while proceeding. There must be a fairly concrete notion of what the final product will look like, and the lines must be accurate and confidently drawn. The fifteenth-century portrait, *Cardinal Niccolo Albergati* created by the Flemish artist Jan van Eyck (Fig. 3–1), illustrates both the characteristic delicacy and necessary precision of the silverpoint medium. The portrait is a cool, somewhat detached record of the cardinal's facial features rendered with the utmost clarity and control. Yet although the drawing appears to be flawless in execution, upon close inspection you will notice that what seems to be a single, firmly drawn line defining the contour of the face (particularly around the chin) is actually composed of a number of lines that are "ghosts" of one another. These lines betray van Eyck's efforts to find the most accurately descriptive line.

In light of all the complications and limitations inherent in the silverpoint medium, you might wonder, "Why bother?" And, in fact, few artists do today.

Pencil

Silverpoint was largely replaced by the lead **pencil,** which came into use during the 1500s. Medieval monks, like the ancient Egyptians, ruled lines with metallic lead. Pencils as we know them began to be mass produced in the late eighteenth century.

A pencil is composed of a thin rod of **graphite** encased within wood or paper. The graphite is ground to dust and mixed with clay, and the mixture is baked to harden the clay. The relative hardness or softness of the implement depends on the quantity of clay present in the mixture. The more clay, the harder the pencil.

Pencil is capable of producing a wide

3–1 JAN VAN EYCK *Cardinal Niccolo Albergati* (c. 1431). Silverpoint, 8⅜ x 7".
Staatliche Kunstsammlungen, Dresden.

range of effects. Lines drawn with hard pencil can be thin and light in tone; those rendered in soft lead can be thick and dark. The sharp point of the pencil will create a firm, fine line suitable for meticulous detail. Softer areas of tone can be achieved through a buildup of parallel lines, smudging, or stroking the support with the side of the lead tip.

3–2 GIORGIO DE CHIRICO *Il Condottiero* (1917)
Pencil. 12⅜ x 8½".

Staatliche Graphische Sammlung, Munich.

3–3 UMBERTO BOCCIONI *Male Figure in Motion Towards the Left* (1913). Pencil. 6 x 4⅛".

Lydia Winston Malbin Collection, N.Y.

As seen in the contemporaneous, though contrasting, works of Giorgio de Chirico and Umberto Boccioni, pencil can be manipulated to create dramatically different effects that complement the subject. Chirico's mannequin (Fig. 3–2) is a controlled construction of wood pieces that have been fitted together to the likenesses of muscles, ligaments, and tendons. The precision of the construction is communicated through the fine lines of a hard pencil point.

Boccioni's drawing (Fig. 3–3), on the other hand, is a free expression of dynamic movement. The highly abstracted male figure seems to whirl as it strides forcefully to the left. The contours of the figure are not sure and clear, but rather are composed of smaller, darker, and more agitated lines that underscore the energy of motion. A restlessness in the image is communicated through the irregularity of the line. Boccioni was not interested in creating a photographic likeness of his figure. Rather, he used his medium to render the distorted impression of a figure moving rapidly through space. Chirico, by contrast, used pencil in a more static and controlled manner to present us with a factual duplication of his bizarre inanimate object. (The works of Chirico and Boccioni are discussed at greater length in Chapter 16.)

CHARCOAL

Like pencil, **charcoal** has a long history as a drawing implement. Used by our primitive ancestors to create images on cave walls, these initially crumbly pieces of burnt wood or bone now take the form of prepared sticks that are formed by the controlled charring of special hard woods. Charcoal sticks are available in a number of textures that vary from hard to soft. The sticks may be sharpened with sandpaper to form fine and clear lines, or may be dragged flat across the surface to form diffuse areas of varied tone. Like pencil, charcoal may also be smudged or rubbed to create a hazy effect.

When charcoal is dragged across a surface, bits of the material adhere to that surface, just as in the case of silverpoint and pencil. But charcoal particles rub off more

3–4 KÄTHE KOLLWITZ
Self-Portrait (1933)
Charcoal. 18¾ x 25".

National Gallery of Art, Washington, D.C.
Rosenwald Collection.

easily, and thus the completed drawing must be sprayed with a solution of thinned varnish to keep them affixed. Also, because of the way in which the charcoal is dispersed over a surface, the nature of the support is evident in each stroke. Coarsely textured paper will yield a grainy image, whereas smooth paper will provide a clear, almost pencil-like line.

A self-portrait of the German Expressionist Käthe Kollwitz (Fig. 3–4) reveals the character of the charcoal medium. Delicate lines of sharpened charcoal drawn over broader areas of subtle shading enunciate the two main points of interest: the artist's face and her hand. Between these two points—that of intellect and that of skill—runs a surge of energy described by aggressive, jagged strokes overlaying the lightly sketched contour of her forearm. Charcoal can be descriptive or expressive, depending on its method of application.

Values in the drawing range from hints of white at her knuckles, cheekbone, and hair to the deepest blacks of the palm of her hand, eyes, and lip area. The finer lines override the texture of the paper, whereas the shaded areas, particularly around the neck and chest area, reveal the faint white

lines and tiny flecks of pulp that are visual remnants of the paper-making process.

CHALK AND PASTEL

The effects of charcoal, **chalk,** and **pastel** as they are drawn against the paper surface are very similar, though the compositions of the media differ. Chalk and pastel consist of pigment and a **binder,** such as **gum arabic,** shaped into workable sticks.

Chalks are available in a number of colors, some of which occur in nature. **Ocher,** for example, derives its dark yellow tint from iron oxide in some clays. **Umber** acquires its characteristic yellowish or reddish brown color from earth containing oxides of manganese and iron. Other popular "organic," or "earth," colors include white, black, and a red called **sanguine.**

Michelangelo used red chalk in a sketch for the Sistine Chapel, discussed in Chapter 13, in which he attempted to work out certain aspects of the figure of the Libyan Sibyl (Fig. 3–5). Quick, sketchy notations of the model's profile, feet, and toes lead to a detailed torso rendered with confident lines and precisely defined tonal areas built up from hatching. The exactness of muscular

3-5 MICHELANGELO
Studies for the Libyan Sibyl
(1510–11)
Red chalk. 11⅜ x 8⅜".

The Metropolitan Museum of Art, Purchase, 1924, Joseph Pulitzer Bequest.

detail and emphasis on the edges of the body provide insight into the concerns of an artist whose forte was sculpture.

In contrast to Michelangelo's essentially linear approach to his medium, the *Portrait of a Woman* (Fig. 3–6) by the nineteenth-century French painter Jean-Baptiste Carpeaux appears to materialize from the background through subtle tonal contrasts. Whereas Michelangelo emphasized the edges of his model, Carpeaux was more interested in the subtle roundness of his model's form. Carpeaux capitalized on the effect of soft chalk drawn across a coarsely textured paper to create a hazy atmosphere that envelops the sitter.

Pastels consist of ground chalk mixed with powdered pigments and a binder. Whereas chalk drawings can be traced to prehistoric times, pastels did not come into wide use until the 1400s. They were introduced to France only in the 1700s, but within

3-6 JEAN-BAPTISTE CARPEAUX
Portrait of a Woman (1874). Black chalk heightened
with white, on buff paper. 7⅞ x 5⅞".

a century pastels captured the imagination of many important painters. Their wide range of brilliant colors offered a painter's palette for use in the more spontaneous medium of drawing.

One of the masters of pastel drawing was the nineteenth-century French painter and sculptor, Edgar Degas. The directness and spontaneity of the medium was well suited to some of his favorite subjects: ballet dancers in motion, horses racing toward a finish line, and women caught unaware in the midst of commonplace activities. Degas's *Woman at Her Toilette* (Fig. 3–7) is a veritable explosion of glowing color. The pastels are manipulated in countless ways to create a host of different effects. The contours of the figure are boldly sketched, whereas the flesh is composed of more erratic lines that create a sense of roundness through a spectrum of color. Degas scratched the pastels over the surface to form sharp lines or dragged them flatly to create more free-flowing strokes. At times the colors were left pure and intense, and at other times subtle harmonies were rendered through blending or smudging.

3-7 EDGAR DEGAS
Woman at Her Toilette (1903)
Pastel on paper. 30 x 30½".

Strictly defined, the term **crayon** includes any drawing material in stick form. Thus, charcoal, chalk, and pastels are crayons, as are the wax implements you used on walls, floors, and occasionally coloring books when you were a child. One of the most popular commercially manufactured crayons for artists is the **conté crayon.** Its effects on paper are similar to those of chalk and pastel, although its harder texture makes possible a greater clarity.

Conté crayon was one of the favorite media of the nineteenth-century French painter, Georges Seurat. By working the crayon over a highly textured surface, he was able to emulate the fine points of paint he used to describe forms in his canvas works (see Chapter 15). Seurat's *Café Concert* (Fig. 3–8) is built up almost solely through contrasts of tone. Deep, velvety blacks absorb the almost invisible heads of the musicians in the orchestra pit, while a glaring

3–8 GEORGES SEURAT *Café Concert* (c. 1887–88) Conté crayon with white heightening on Ingres paper. 12 x 9¼".

Museum of Art, Rhode Island School of Design, Providence. Gift of Mrs. Murray S. Danforth.

strip of untouched white paper seems to illuminate the stage. The even application of crayon to coarse paper creates a diffuse light that accurately conveys the atmosphere of a small café.

Wax crayons, like pastels, combine ground pigment with a binder—in this case, wax. Wax crayon moves easily over a support to form lines that have a characteristic sheen. These lines are less apt to smudge than charcoal, chalk, and pastels.

Fluid Media

The primary **fluid medium** used in drawing is ink, and the instruments used to carry the medium are pen and brush. Appearing in Egyptian **papyrus** drawings and ancient Chinese scrolls, ink has a history that stretches back thousands of years. Some ancient peoples made ink from the dyes of plants, squid, and octopus. By the second century A.D., blue-black inks were being derived from galls found on oak trees. The oldest known type of ink is India or China ink, which is used in oriental **calligraphy** to this day. It is a solution of carbon black and water, and it is permanent and rich black in color.

As with the dry media, dramatically different effects can be achieved with fluid media through a variety of techniques. For example, the artist may alter the composition of the medium by diluting it with water to achieve lighter tones, or may vary the widths of brushes and pen points to achieve lines of different character.

PEN AND INK

Pens also have been used since ancient times. The earliest ones were hollow reeds that were slit at the ends to allow a controlled flow of ink. **Quills** plucked from live birds became popular writing instruments during the Middle Ages. These were replaced in the nineteenth century by the mass-produced metal **nib,** which is slipped into a wooden **stylus.** These are the pens that many artists use today.

Pen and ink are used to create drawings that are essentially linear, although the na-

ture of the line can vary considerably according to the type of instrument employed. A fine, rigid nib will provide a clear, precise line that is uniform in thickness. Lines created by a more flexible quill tip, in contrast, will vary in width according to the amount of pressure the artist's hand exerts.

The narrative versus expressive properties of the pen-and-ink technique are well illustrated by contrasting the drawings of the German Renaissance artist Albrecht Dürer (Fig. 3–9) and the nineteenth-century French painter Eugène Delacroix (Fig. 3–10). The purpose of Dürer's drawing was to describe accurately for his fellow artists and other curious parties the exotic animals he had seen during a visit to a Brussels zoo in 1521. Fine, even lines define a number of the animals' essential characteristics, from attitude to overall shape to distinguish-

On Drawing

TITIAN: It is not bright colors but good drawing that makes figures beautiful.

JEAN-AUGUSTE-DOMINIQUE INGRES: To draw does not simply mean to reproduce contours; drawing does not consist merely of line; drawing is also expression, the inner form, the plane, modeling. . . . Drawing includes three and a half quarters of the content of painting. . . . Drawing contains everything, except the hue.

ing markings. In the absence of photography, Dürer's task was to provide as honest a record of these creatures as his skill would allow.

Dürer's comrades would have learned little about the likeness of lions had they been looking at Eugène Delacroix's drawing (Fig. 3–10), but they would have come away with a better understanding of the power and personality of these felines. The styles of the artists differ markedly: Dürer's is painstakingly descriptive, whereas Delacroix's is free and expressive. In the Delacroix rendition, vigorous lines describe the animal's ferocity as she readies to spring and pounce. Curving, calligraphic strokes envelop her nonthreatening form in sleep. The lines themselves exude a certain emotion in their varying thicknesses, densities, and values.

PEN AND WASH

Fine, clear lines of pure ink are often combined in drawings with **wash**—diluted ink that is applied with a brush. Wash provides a tonal emphasis absent in pen-and-ink drawings. In Giovanni Battista Tiepolo's eighteenth-century drawing (Fig. 3–11), the contours of the biblical figures are described in pen and ink, but their volume derives from a clever use of wash. An illusion of three-dimensionality is created by pulling the white of the untouched paper forward to function as form and enchancing it with contrasting areas of light and dark wash. The gestural vitality of the pen lines and the generous swaths of watery ink accentuate the composition's dynamic movement.

BRUSH AND INK

Brushes are extremely versatile drawing implements. They are available in a wide variety of materials, textures, and shapes that afford many different effects. The nature of a line in brush and ink will depend on whether the brush is bristle or nylon, thin or thick, pointed or flat-tipped. Likewise, characteristics of the support—texture, absorbency, and the like—will influence the character of the completed drawing. Brush and ink touched to silk leaves an impression quite different from that produced by brush and ink touched to paper.

Japanese artists are masters of the brush-and-ink medium. They have used it for centuries for every type of calligraphy, ranging from works of art to everyday writing. Their facility with the technique is most evident in seemingly casual sketches such as those done in the late eighteenth and early nineteenth centuries by Japanese artist Katsushika Hokusai (Fig. 3–12). Longer, flowing lines range from thick and dark to thin and faint, capturing, respectively, the heavy folds of the boy's clothing and the pale flesh of his youthful limbs. Short, brisk strokes humorously describe the similarity between the hemp of the woven basket and the youngster's disheveled hair. There is an extraordinary simplicity to the drawing attributable to the surety and ease with which Hokusai handles his medium.

3–11 GIOVANNI
BATTISTA TIEPOLO
*Hagar and Ishmael in the
Wilderness* (c. 1725–35) Pen,
brush and brown ink, and
wash, over sketch in black
chalk. 16½ x 11⅛".

Sterling and Francine Clark Art Institute,
Williamstown, Mass.

3–12 KATSUSHIKA HOKUSAI (1760–1849)
Boy Playing Flute
Ink and brush on paper. 4½ x 6¼".

Courtesy of Freer Gallery of Art, Smithsonian Institution,
Washington, D.C.

3–13 LEONARDO DA VINCI
Study of Drapery (c. 1473)
Brush, gray wash, heightened with white,
on linen. 7⅜ x 9¼".

3–14 CLAUDE LORRAIN *Tiber Above Rome* (c. 1640). Brush and wash.

The medium of brush and wash is even more versatile than that of brush and ink. While it can duplicate the linearity of brush-and-ink drawings, it can also be used to create images solely through tonal contrasts. The ink can be diluted to varying degrees to provide a wide tonal range. Different effects can be achieved either by adding water directly to the ink, or by moistening the support before drawing.

It is again surprising to note how adaptable the drawing media can be to different artistic styles or subjects. Consider the drawings by the Italian Renaissance master Leonardo da Vinci (Fig. 3–13) and the seventeenth-century French painter Claude Lorrain (Fig. 3–14). Even upon close inspection, one would not guess that both works were created in the same medium, despite their tonal emphasis. Leonardo captured the intricacies of drapery as it falls over the human form, dramatically lit to provide harsh contrasts between surfaces and crevices. The voluminous folds are realized through a meticulous study of tonal contrasts.

The shape of Lorrain's landscape also relies on tonal variations rather than line, but here the similarity ends. Leonardo's drawing is descriptive, and almost photographic in its realism. Lorrain's work is suggestive—a quick rendition of the artist's visual impression of the landscape. Whereas Leonardo worked his wash over linen, Lorrain worked on damp paper. By touching a brush dipped in ink to the wet surface, Lorrain made his forms dissolve into the surrounding field and lose their distinct contours. Broadly brushed liquid formations constructed of varying tones yield the impression of groves of trees on the bank of a body of water that leads to distant mountains. These nondescript areas of diffuse wash were here and there given more definition through bolder lines and brush strokes applied after the paper was dry. Lorrain used brush and wash to define space; Leonardo used it to reveal form.

CARTOONS

The word **cartoon** derives from the Italian *cartone,* meaning paper. Originally cartoons were full-scale preliminary drawings done on paper for projects such as fresco paintings, stained glass, or tapestries. The meaning of cartoon was expanded to include humorous and satirical drawings when a parody of fresco cartoons submitted for decoration of the Houses of Parliament appeared in an English magazine in 1843. Regardless of their targets, all modern cartoons rely on **caricature,** the gross exaggeration and distortion of natural features to ridicule a social or political target.

Honoré Daumier is perhaps the only famous painter to devote so great a part of his production—some 4,000 works—to cartoons. Known for his riveting images of social and moral injustices in nineteenth-century France, he also created caricatures in which he displayed a sharp, sardonic wit. Daumier's *Three Lawyers* (Fig. 3–15) is a

3–15 HONORÉ DAUMIER *Three Lawyers* (c. 1855) Pen and black ink, black chalk, brush and black and blue-black ink, gray and beige wash, and white gouache. 12¹⁵⁄₁₆ x 9¾".
Sterling and Francine Clark Art Institute, Williamstown, Mass.

3–16

Drawing by Modell; © 1983 The New Yorker Magazine, Inc.

taunting illustration of what he perceived to be the grossly overstated importance of this professional group. Each lawyer strains to raise his nose and eyebrows higher than those of his comrades, effectively communicating his self-adulation. The absurd superficiality of the trio's conversation is communicated by their attempts to strike a meaningful pose in their clownlike embodiments.

Of course, all cartoons need not have deep-rooted messages. Cartoons can also just be fun, as is the Modell cartoon (Fig. 3–16) published in a 1983 issue of *The New Yorker* magazine. One could seek to find in the drawing a "message" about the way in which the general public tends to categorize works of art, but to do so might be "reaching."

NEW APPROACHES TO DRAWING

Thus far we have examined traditional drawing media used by artists over many centuries. Keeping in mind, however, our all-encompassing definition of a drawing, it is not surprising that today "anything goes."

It is not unusual to find drawings that are not "drawn" at all. In Figure 3–17, for example, Jackson Pollock, an American artist working in the years surrounding World War II, dripped and whipped an enamel-like paint onto paper surfaces to record his spontaneous gestures. Other artists have used airbrushes to spray a fine mist of ink onto their supports.

The surfaces on which drawings are made are also no longer sacred. They may be punctured or slashed; they may be littered with foreign matter such as string, sand, or pieces of paper. If the paper is handmade by the artist, its texture can be radically manipulated while the pulp is wet.

Contemporary artist Chris Craig does not limit herself to traditional flat pieces of paper as the supports for her drawings. In #239 (Figs. 3–18 and 3–19), Craig folds her paper support and draws geometric shapes across the folds in pencil, crayons, charcoal, and pastels or acrylic paint. Acrylic paint, when

3–17 JACKSON POLLOCK *Untitled* (1950). Pencil, duco on paper. 22 x 59⅜".
Graphische Sammlung Staatsgalerie, Stuttgart.

3–18 CHRIS CRAIG *#239* (1987). Mixed media on paper. 26 x 100".

3–19 CHRIS CRAIG
Detail of *#239*

used, might be spattered or dripped. The paper is then flattened so that the shapes she has drawn become fragments. She continues a number of the fragmented lines, in this way completing new shapes, while others are left as they are. The paper is folded again, but sometimes along new lines. In these ways Craig's work takes on an element of accident or chance. On the wall, such drawings have the effect of three-dimensional reliefs. Given their monumental scale, the viewer who walks in front of them has the sense of shifting topography.

Art has always hinged on exploration. Although the new materials and techniques in use today might have shocked him, the inventive Leonardo da Vinci would have delighted in their unorthodoxy and their limitless possibilities.

And so drawings show surprising versatility in terms of their intended purposes, their media, and their techniques of execution. In the next chapter we shall see that paintings show similar versatility.

4

Painting

The line between drawing and painting is sometimes blurred. The art historian will speak of linear aspects in painting or painterly qualities in drawing. At times the materials used in the two media will overlap. Jackson Pollock, for example, used enamel paint in his gestural paper drawings, as was noted in Chapter 3 (see Fig. 3–17). **Painting** is generally defined as the application of pigment to a surface. Yet we have already seen the use of pigment in pastel drawings.

Paint can be applied to a number of surfaces. It has been used throughout history to decorate pottery, enhance sculpture, and embellish architecture. In this section we shall explain the composition of paint and explore painting in works created on two-dimensional supports.

PAINT

To most of us, paint is synonymous with color. The color in a paint derives from its pigment. The pigment in powdered form is mixed with a binding agent, or **vehicle,** and a solvent, or **medium,** to form **paint**—the liquid material that imparts color to a surface.

Pigments are available in a wide chromatic range. Their color is derived from chemicals and minerals found in plant and animal life, clay, soil, and sand.

Different vehicles are employed in different painting media. The main criterion for a successful vehicle is that it hold the pigments together. Lime plaster, wax, egg, oil, acrylic plastic, water, and gum arabic are commonly used vehicles. Unfortunately, most vehicles are subject to long-term problems such as cracking, yellowing, or discoloration.

The task of a medium is to provide fluency to the paint, so that the color may be readily dispersed over the surface. Water or turpentine are frequently used as thinning agents for this purpose.

TYPES OF PAINTING

A variety of supports and tools have been used throughout the history of art to create paintings. We shall discuss the characteristics of several types of painting.

Fresco

Fresco is the art of painting on plaster. **Buon fresco,** or true fresco, is executed on damp, lime plaster; **fresco secco** is painting on dry plaster. In buon fresco, the pigments are mixed only with water, and the lime of the plaster wall acts as a binder. As the wall dries, the painted image on it becomes permanent. In fresco secco—a less popular and less permanent method—pigments are combined with a vehicle of glue that affixes the color to the dry wall.

Fresco painters encounter a number of problems. Since in true fresco the paint must be applied to fresh, damp plaster, the artist cannot bite off more than it is possible to chew—or paint—in one day. For this reason, large fresco paintings are composed of small sections, each of which has been painted in a day. The artist tries to arrange the sections so that the joints will not be obvious, but sometimes it is not possible to do so. In a fourteenth-century fresco painting by the Italian master Giotto (Fig. 4–1), these joints are clearly evident, particularly in the sky, where the artist was not able to complete the vast expanse of blue all at once. It is not surprising that sixteenth-century art historian Giorgio Vasari wrote that of all the methods painters employ, fresco painting "is the most masterly and beautiful, because it consists in doing in a single day that which, in other methods, may be retouched day after day, over the work already done."

Another problem: although fresco paintings can be brilliant in color, some pigments will not form chemical bonds with lime. And so these pigments are not suitable for the medium. Artists in Giotto's era, for example, encountered a great deal of difficulty with the color blue. Such lime resistance limits the artist's palette and can make tonal transitions difficult.

Leonardo da Vinci, in his famous *The Last Supper* (Fig. 13–24), attempted to meet these nuisances head on, only to suffer disastrous consequences. The experimental materials and methods he employed to achieve superior results were unsuccessful. He lived to see his masterpiece disintegrate beyond repair.

Despite these problems, fresco painting enjoyed immerse popularity from prehistoric times until its full flowering in the Renaissance. Although it fell out of favor for several centuries thereafter, the art of fresco was revived by Mexican muralists after World War I.

4–1 GIOTTO *Lamentation* (c. 1305). Fresco. 7'7" x 7'9".

Arena Chapel, Padua, Italy.

4–2 *Mummy Portrait of a Man* (Egypto-Roman)
(Faiyum, c. 160–179 A.D.). Encaustic on wood.
14 x 8".

Albright-Knox Art Gallery, Buffalo, N.Y. Charles Clifton Fund, 1938.

Encaustic

One of the earliest methods of applying
color to a surface was **encaustic.** It consists
of pigment in a wax vehicle that has been
heated to a liquid state. The ancient Egyp-
tians and Greeks tinted their sculptures with
encaustic to grant them a lifelike appear-
ance. The Romans applied encaustic to
walls, using hot irons. Often, as in the Egyp-
tian *Mummy Portrait of a Man* (Fig. 4–2) dat-
ing back to the second century A.D., the
medium was applied to small, portable
wooden panels covered with cloth. As evi-
denced by the startling realism and fresh-
ness of the portrait, encaustic is an ex-
tremely durable medium whose colors
remain vibrant and whose surface maintains
a hard luster.

But encaustic is a difficult medium to ma-
nipulate: one must keep the molten wax
at a constant temperature. For this reason,
it has been used only by a handful of con-
temporary artists.

Egg Tempera

Egg tempera, like encaustic, was popular
for centuries but is rarely used today. In
egg tempera, ground pigments are mixed
with a vehicle of egg yolk and thinned with
water. The use of tempera dates back to
the Greeks and Romans. Tempera was the
exclusive painting medium of artists during
the Middle Ages. Not until the invention
of oil paint in Northern Europe in the 1300s
did tempera fall out of favor.

Tempera offered many advantages. It was
an extremely durable medium if applied to
a properly prepared surface. Pure and bril-
liant colors were attainable. Colors did not
become compromised by gradual oxidation.
Also the consistency and fluidity of the mix-
ture allowed for a great deal of precision.
Tempera, unlike oil paint, however, dries
quickly and is difficult to rework. Also, un-
like oils, it cannot provide subtle gradations
of tone.

Tempera can be applied to wood or can-
vas panels, although the latter did not come
into wide use until the 1500s. Both types
of supports were prepared by covering the
surface with a **ground.** The ground was gen-
erally a combination of powdered chalk or
plaster and animal glue called **gesso.** The
gesso ground provided a smooth, glistening
white surface on which to apply color.

All that is desirable in the tempera me-
dium can be found in Figure 4–3, the panel
painting by the fifteenth-century Italian art-
ist Gentile da Fabriano. Combined with the
technique of **gilding**—the application of
thinly hammered sheets of gold to the panel
surface—the luminous reds and blues and
pearly grays of the tempera paint provide
a sumptuous display. The fine details of
the ornate costumes testify to the precision
made possible by egg tempera.

Several contemporary artists, such as the
American Andrew Wyeth, have also been
enticed by the exactness and intricacies
made possible by tempera. Suited to a me-
thodical and painstaking approach to paint-
ing, this medium of the old masters yields
unparalleled displays of contrasting textures
and sharp-focused realism, as shown in Fig-
ure 4–4.

4–3 GENTILE DA
FABRIANO
Adoration of the Magi (1423)
Tempera on wood panel.
9′10⅛″ x 9′3″.

Uffizi Gallery, Florence.

4–4 ANDREW WYETH
Braids (1979)
Tempera. 16½ x 20½″.

© 1986 Leonard E. B. Andrews.

Oil

The transition from egg tempera to **oil paint** was gradual. For many years following the introduction of the oil medium, artists used it only to apply a finishing coat of glazes to an underpainting of tempera. **Glazing,** or the application of multiple layers of transparent films of paint to a surface, afforded subtle tonal variations and imparted a warm atmosphere not possible with tempera alone. Oil paints have been in wide use since the fifteenth century.

Oil paint consists of ground pigments combined with a linseed oil vehicle and turpentine medium or thinner. Oil paint is naturally slow in drying, but drying can be facilitated with various agents added to the basic mixture.

Oil painting's broad range of capabilities makes it a favorite among artists. It can be applied with any number of brushes or painting knives. Colors can be blended easily, offering a palette of almost limitless range. Slow drying facilitates the reworking of problem areas. When it is finely applied, oil paint can capture the most intricate detail. When it is broadly brushed, it can render diaphanous fields of pulsating color. Oil paint can be diluted to barely tinted film to achieve subtle flesh tones, or it can be applied in thick **impastos** that physically construct an image, as in Rembrandt's *Head of St. Matthew* (Fig. 4–5).

4–5 REMBRANDT VAN RIJN
Head of Saint Matthew (c. 1661)
Oil on wood. 9⅞ x 7¾".

National Gallery of Art, Washington, D.C. Widener Collection, 1942.

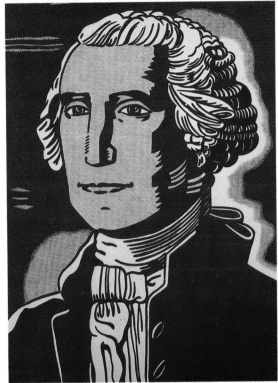

4–6 GILBERT STUART
George Washington (detail) (1796)
Oil on canvas. 39⅝ x 34½″ (entire work).

Museum of Fine Arts, Boston, and The National Portrait Gallery,
Smithsonian Institution, Washington, D.C.

4–7 ROY LICHTENSTEIN
George Washington (1962)
Oil on canvas. 51 x 38″.

Private Collection. Courtesy Leo Castelli Gallery, N.Y.

The first oil paintings were executed on wood panels, and then a gradual shift was made to canvas supports. Like wood panels, the canvas surface is covered with a gesso ground prior to painting. The pliability of fabric stretched over a wooden framework renders the working surface more receptive to the pressure of the artist's implement. The light weight of canvas also allows for larger compositions than were possible on wooden panels.

The versatility of oil paint is seen in portraits of George Washington by two American artists who worked centuries apart. Gilbert Stuart's familiar eighteenth-century portrait (Fig. 4–6) provides us with our stereotypical image of Washington. The work was left unfinished; much of the composition still reveals the reflective gesso ground. Stuart created the realistic likeness through clearly defined brush strokes and a subtle **modeling** of the paint. The illusion of three-dimensionality is provided by the graceful play of light across the surfaces of Washington's face. Some features are sharply defined, others cast into shadow. Although this image is second nature to us, we can still notice the sensitivity with which Stuart portrayed his famous sitter. The delicate treatment of the pensive eyes and the firm outline of the determined jaw describe central personality traits of the wise and aging leader.

Roy Lichtenstein's contemporary portrait (Fig. 4–7), by contrast, is an image of glamour and success. A younger, debonair Washington is presented as if on a campaign poster, or as a comic-strip hero with a chiseled profile akin to that of Dick Tracy. The eyes are alert and enthralling; the chin is jaunty and confident. Lichtenstein capitalized on oil paint's clarity and precision. Sharp contrasts, crisp lines, and dot patterning such as that found in comic strips deprive the painting of any subtlety or atmosphere. The rich modeling that imparted a

4–8 ED PASCHKE
Anesthesio (1987)
Oil on linen. 68 x 80".

Phyllis Kind Gallery, Chicago and New York

sense of roundness to Stuart's figure is replaced by stylized shadows that sit flatly on the canvas. Lichtenstein forsakes the psychological portrait in favor of billboard advertising. This is a Washington who has suffered visual saturation by the contemporary media; the physical characteristics tell us nothing of the human being to whom they refer.

Contemporary artist Ed Paschke's oil painting of Abraham Lincoln (*Anesthesio*, Figure 4–8) brings new life to a hackneyed image by traversing it with abstract patches of neon-like color. The effect is not unlike that attained by a teenager who defaces a poster of a presidential candidate with spray paint, or it could almost be a face on a video screen with electronic color bleeding through irrelevantly on the image. In either case, environmental "noise" obscures the target. Ironically, the need to work to see through the obfuscating patches of color renders the image of the president more tantalizing.

On Painting

LEON BATTISTA ALBERTI: Painting is possessed of a divine power, for not only, as is said of friendship, does it make the absent present, but it also, after many centuries, makes the dead almost alive, so that they are recognized with great admiration for the artist, and with great delight.

LEONARDO DA VINCI: If the painter wishes to see enchanting beauties, he has the power to produce them. If he wishes to see monstrosities, whether terrifying, or ludicrous and laughable, or pitiful, he has the power and authority to create them. If he wishes to produce towns or deserts, if in the hot season he wants cool and shady places, or in the cold season warm places, he can make them. If he wants valleys, if from high mountaintops he wants to survey vast stretches of country, if beyond he wants to see the horizon on the sea, he has the power to create all this; and likewise, if from deep valleys he wants to see high mountains or from high mountains deep valleys and beaches. Indeed, whatever exists in the universe, whether in essence, in act, or in the imagination, the painter has first in his mind and then in his hands.

TINTORETTO: The study of painting is toilsome, and the further one advances into it, the more difficulties appear, and the sea grows larger and larger.

CARLO RIDOLFI: There is no profession . . . in which you may expect less happiness and contentment than in painting. For a painter, before he can attain even a moderate degree of perfection, has to submit to so many drudgeries and toils, that they exceed human credibility. . . . But what causes us even greater astonishment is that, when the artist who was so unlucky during his lifetime has passed away and can no longer enjoy the fruit of his labors, then his works begin to be praised and coveted.

JOHN SLOAN: Painting is drawing, with the additional means of color. Painting without drawing is just "coloriness," color excitement. To think of color for color's sake is like thinking of a sound for sound's sake. Who ever heard of a musician who was passionately fond of B flat? Color is like music. The palette is an instrument that can be orchestrated to build forms.

Acrylic

Acrylic paint offers many of the advantages of oil paint, but "without the mess." Acrylic paint is a mixture of pigment and a plastic vehicle that can be thinned (and washed off brushes and hands) with water. Unlike linseed oil, the synthetic resin of the binder dries colorless and does not gradually compromise the brilliance of the colors. Also, unlike oil paint, acrylic can be used on a variety of surfaces that need no special preparation. Acrylic paint is flexible and fast drying, and, as it is water soluble, it requires no flammable substances for use or cleanup.

One of the few effects of oil paint that cannot be duplicated in acrylic is delicate nuance of colors. Like oil, however, acrylic paint can be used thinly or thickly; it can be applied in transparent films or opaque impastos. Because it dries so quickly, many contemporary artists, such as Richard Anuszkiewicz, have been able to create crisp—

4–9 RICHARD ANUSZKIEWICZ *Entrance to Green* (1970) Acrylic on canvas. 108 x 72″.

4–10 MORRIS LOUIS *Saraband* (1959). Acrylic resin on canvas. 101⅛ x 149″.
Solomon R. Guggenheim Museum, N.Y.

or **hard-edge**—geometric images (as in Fig. 4–9) with acrylic paint by sectioning off areas with masking tape before applying it. When the tape is removed, both lines and blocks of color are sharply articulated. Anuszkiewicz's painting *Entrance to Green* is of the **Op art** movement of the 1960s and 1970s, in which various techniques were employed to provide the illusion of movement or of vibrations. In *Entrance to Green*, complementary red and greens are sharply juxtaposed, and the contrasts lead viewers to perceive vibrations in the lines where the colors meet.

Acrylic paint can also be used to create gauzelike washes of luminous color, as in Morris Louis's *Saraband* (Fig. 4–10). The free-flowing imagery is derived from the controlled pouring of diluted acrylic paint onto unprepared, unstretched canvas. As they are absorbed into the weave of the canvas itself, the colors bleed together yet maintain their brilliant individuality.

Why Modern Art May Never Become Old Masterpieces

With the prices for modern art rising ever higher, many art collectors are discovering an alarming secret: Some of the contemporary treasures are falling apart.

The problem results from one of the same qualities that makes modern art interesting and exciting: It tends to be experimental. "The cliché is that artists since the mid-nineteenth century have violated the traditional rules of painting," says Clarke Bedford, paintings conservator for the Hirshhorn Museum in Washington, D.C. Thirty years ago, Jackson Pollock stunned the art world by pouring paint onto canvases from cans, and Willem de Kooning took to mixing mayonnaise into his colors. Today, German artist Anselm Kiefer glues wads of straw onto his paintings.

As the shock value of these revolutionary modes has faded, art conservators have been left to pick up the pieces—sometimes quite literally. Zora Pinney, a Los Angeles conservator, says a couple recently tried to enlist her refurbishing services for a large, disintegrating sculpture made out of bread and blood-soaked rags. She declined the job.

CONTRASTING ERAS

But many valuable modern works also are crumbling in far shorter times than older ones created with traditional techniques. Louis Pomerantz, a Chicago conservator, says the transient nature of modern art hit him starkly when he was working simultaneously on a painting by old master Hans Holbein, done in 1517, and one by Pop artist Andy Warhol, done in 1964. "The Warhol was flaking all over," he says, "while the Holbein was in beautiful condition."

It seems the Warhol was painted on plywood, and paint doesn't adhere properly to plywood. What's more, nails in the wood had rusted, staining the paint.

So far, though, the conservation concerns don't seem to have hurt the market for modern art. "It doesn't deter people from spending a huge lot of money for a painting," says Lucy Havelock-Allan, a specialist in twentieth-century art at Sotheby's of London. In 1983, a painting by Mark Rothko, who combined oil and acrylic paints with substances like raw eggs, fetched $1.8 million despite false rumors it had been damaged.

At the Rothko Foundation, conservator Dana Cranmer says she won't take certain steps to protect Mark Rothko's canvases, such as varnishing them, because these treatments would violate the artist's aesthetics. Some of Rothko's unusual mixtures result in delicate surfaces that are likely to crack or become smudged. "His spontaneous technique was at odds with the notion of permanence," Ms. Cranmer says.

The foundation keeps Rothko canvases in a temperature-controlled studio in New York and will transfer them to museums only on the promise that these conservation techniques will be continued.

RE-BUTTING A CANVAS

Sometimes, the solutions to conserving modern paintings aren't complex. Denise Domergue, president of Los Angeles-based Conservation of Paintings Ltd., recalls that in the process of cleaning a Jackson Pollock picture, a cigarette butt the artist had embedded in the paint plopped out onto the floor, badly disintegrated. Her solution: "Somebody had to smoke a Camel down, bend it into the right shape, and stick it back."

Generally conservators go to unusual lengths to hold fast to the artist's original vision. Mr. Pomerantz once had to replace a pickle jar that artist Robert Rauschenberg had dangled from one of his paintings. "I went to the supermarket and bought dozens of jars of kosher pickles and finally found exactly the right size," based on earlier photographs of the work, he says.

Even experimental works that aren't so prone to fall apart can cause big headaches if they become dirty or stained. Many postwar American artists applied paint by soaking it into raw, unprimed canvas. When such paintings are cleaned by traditional methods, the colors sometimes run.

Margaret Watherston, a New York conservator, recalls that a collector recently encountered a problem with a Morris Louis painting "when a dog disapproved of the painting and left a yellow stain on the corner." A relatively straightforward cleansing would have worked on an old masterwork that had undergone such an indignity. But because the paint was soaked into unprimed canvas, Ms. Watherston had to use a complicated process that she concocted specifically to deal with this school of paintings.

Some artists today are more concerned with creating drama than making art objects. Joseph Beuys, a German artist, once lived in a tableau for three days with a live coyote in the Rene Block Gallery in New York with copies of *The Wall Street Journal* delivered throughout. This show was commemorated in a 1985 show at the Hirshhorn; the piece included a yellowing stack of *Wall Street Journals* and the artist's overcoat. The coyote wasn't preserved.

4–11 ALBRECHT DÜRER
The Great Piece of Turf (1503)
Watercolor. 16¼ x 12⅜".
Albertina Collection, Vienna.

Watercolor

The term **watercolor** originally defined any painting medium that employed water as a solvent. Thus, fresco and egg tempera have been called watercolor processes. But today watercolor refers to a specific technique called **aquarelle,** in which transparent films of paint are applied to a white, absorbent surface. Contemporary watercolors are composed of pigments and a gum arabic vehicle, thinned, of course, with a medium of water.

Variations of the watercolor medium have been employed for centuries. Ancient Egyptian artists used a form of watercolor in their paintings. **Gouache,** or watercolor mixed with a high concentration of vehicle and an opaque ingredient such as chalk, was the principal painting medium during the Byzantine and Romanesque eras of Christian art. Watercolor was also used extensively for **manuscript illumination** during the Middle Ages, as we shall see in Chapter 12.

Transparent watercolor, however, did

not appear until the fifteenth century with Albrecht Dürer. It is a difficult medium to manipulate, despite its simple components. Tints are achieved by diluting the colors with various quantities of water. White, then, does not exist; white must be derived by allowing the white of the paper to "shine" through the color of the composition, or by leaving areas of the paper exposed. To achieve the latter effect, all areas of whiteness must be mapped out with precision before the first stroke of color is applied.

With oil paint and acrylic, the artist sometimes overpaints areas of the canvas in order to make corrections or to blend colors. With transparent watercolors, overpainting obscures the underlying layers of color. For this reason, corrections are virtually impossible, and so the artist must have the ability to plan ahead, as well as a sure hand and a stout heart. When used skillfully, watercolor has an unparalleled freshness and delicacy. The colors are pure and brilliant, and the range of effects surprisingly broad.

Dürer used transparent watercolor only briefly, although ingeniously. His virtuoso handling of the medium can be seen in small nature studies such as *The Great Piece of Turf* (Fig. 4–11), which belie the difficulties of the medium. Confident strokes of color precisely define leaves, flowers, and individual blades of grass. Washes are kept to a minimum; the painting emphasizes form over color, line over tonal patterns.

The broader appeal of watercolor, however, is not to be found in its capability of rendering meticulous detail. When the medium came into wide use during the sixteenth century, it was seen as having other, very different advantages. The fluidity of watercolor was conducive to rapid sketches and preparatory studies. Simple materials allowed for portability. Artists were able to cart their materials to any location, indoors or outdoors, and to register spontaneously their impressions of a host of subjects.

Of course, watercolor is also used for paintings that stand as completed statements. Artists such as the German Expres-

4–12 EMIL NOLDE
Still Life, Tulips (c. 1930)
Watercolor on paper. 18½ x 13½".
Collection of the North Carolina Museum of Art, Raleigh. Bequest of W. R. Valentiner.

sionist Emil Nolde (see Fig. 4–12) were enticed by the transparency of tinted washes. Such washes permitted a delicate fusion of colors. As with the drawing medium of brush and wash, the effect is atmospheric. The edges of the forms are softened; they seem to diffuse into one another or the surrounding field. Unlike Dürer, who used watercolor in a descriptive, linear manner, Nolde creates his explosions of blossoms through delicately balanced patches of bold color and diaphanous washes. The composition is brightened by the white of the paper, which is brought forward to create forms as assertive as those in color. (We shall see more of Nolde's work in Chapter 16.)

4–13 MIRIAM SCHAPIRO
Maid of Honour (1984). Acrylic
and fabric on canvas. 60 x 50".
Courtesy Bernice Steinbaum Gallery, N.Y.

COMBINING PAINTING WITH OTHER MATERIALS

Contemporary painters have in many cases combined traditional painting techniques with other materials, or they have painted on nontraditional supports, stretching the definition of what has usually been considered painting. For example, in *The Bed* (Fig. 17–14), **Pop artist** Robert Rauschenberg splashed and brushed paint on a quilt and pillow, which he then hung on a wall like a canvas work and labeled a "combine painting." The **Synthetic Cubists** of the early twentieth century, Picasso and Braque, were the first to incorporate pieces of newsprint, wallpaper, labels from wine bottles, and oilcloth into their paintings. These works, as we shall see in Chapter 16, were called *papiers collés*, and have come to be-called **collages.**

Contemporary artist Miriam Schapiro is best known for her paint and fabric con-

structions which she has labeled "femmage," to express what she sees as their unification of feminine imagery and materials with the medium of collage. In *Maid of Honour* (Fig. 4–13), Schapiro combines bits of intricately patterned fabric with acrylic pigments on a traditional canvas support to construct a highly decorative garment that is presented as a work of art. The painting is a celebration of women's experiences with sewing, quilting, needlework, and decoration.

The two-dimensional media we have discussed in Chapters 3 and 4, drawing and painting, create unique works whose availability to the general public is usually limited to photographic renditions in books such as this. Even the intrepid museum goer usually visits only a small number of collections. So let us now turn our attention to the two-dimensional medium that has allowed millions of people to own original works by masters—printmaking.

5

Printmaking

The value of drawings and paintings lies, in part, in their uniqueness. Hours, weeks, sometimes years are expended in the creation of these one-of-a-kind works. Printmaking permits the reproduction of these coveted works, and also the production of many copies of original prints. Printmaking is an important artistic medium for at least two reasons. First, it allows persons to study great works of art from a distance. Second, since prints are less expensive than unique works by the same artist, they make it possible for the general public, and not just the wealthy few, to own original works. With prints, that is, art has become accessible. Like some drawings, however, prints not only serve a functional purpose, they also may be great works of art in themselves.

The printmaking process begins with a design or image made in or on a surface by hitting or pressing with a tool. The image is then transferred to paper or a similar material. The transferred image is called the **print.** The working surface, or **matrix,** varies according to the printmaking technique. Matrices include wood blocks, metal plates, stone slabs, and silk screens. There are special tools for working with each kind of matrix, but the images in printmaking are usually rendered in ink.

Printmaking processes are divided into four major categories: relief, intaglio, lithography, and serigraphy (Fig. 5–1). We shall examine a variety of techniques within each of them. Finally we will consider the monotype and the combining of printmaking media with other media.

5–1 **Printmaking techniques**

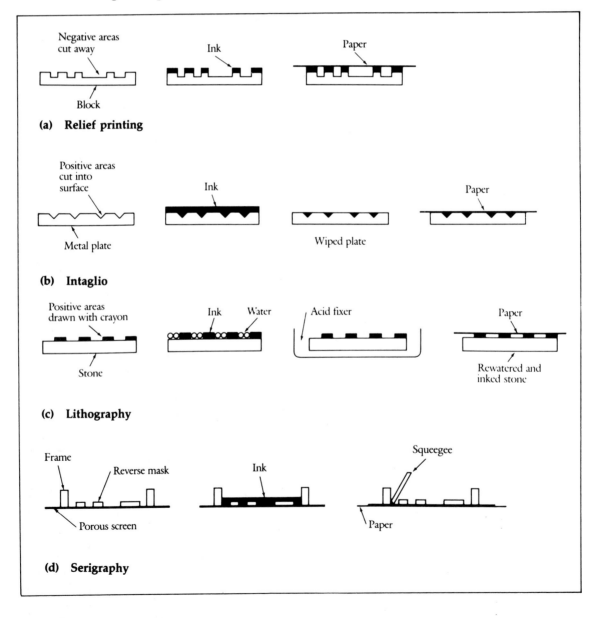

(a) **Relief printing**

(b) **Intaglio**

(c) **Lithography**

(d) **Serigraphy**

In **relief printing,** the matrix is carved with knives or gouges. Areas that are not meant to be printed are cut below the surface of the matrix (see Fig. 5–1a), and areas that form the image and are meant to be printed are left raised. Ink is then applied to the raised surfaces, often from a roller. The matrix is pressed against a sheet of paper, and the image is transferred. The transferred image is the print. Relief printing includes wood cut and wood engraving.

Woodcut

Woodcut is the oldest form of printmaking. The ancient Chinese stamped patterns onto textiles and paper using carved wood blocks. The Romans used woodcuts to stamp symbols or letters on surfaces for purposes of identification. During the 1400s in Europe, woodcuts provided multiple copies of religious images for worshippers. After the invention of the printing press, woodcut assumed an important role in book illustration.

Woodcuts are made by cutting along the grain of the flat surface of a wooden board with a knife. Different types of wood and different gouging tools yield various effects. As is seen in a print by the nineteenth-century Japanese artist Ando Hiroshige (Fig. 5–2), the finest details can be achieved with a close-grained wood and a tightly controlled manipulation of carving tools. Clean-cut, uniform lines define the steady rain and the individuals who tread huddled against the downpour across a wooden footbridge.

The slow, meticulous process by which Hiroshige achieved his sharply defined images could not seem farther removed from Emil Nolde's energetic, almost violent, approach in *The Prophet* (Fig. 5–3). Nolde created his primitive image by using a broadly grained, splintering block of wood, yielding sharply contrasting areas of black and white. The downward pull of the imagery, suggested by vertical gouges parallel to the

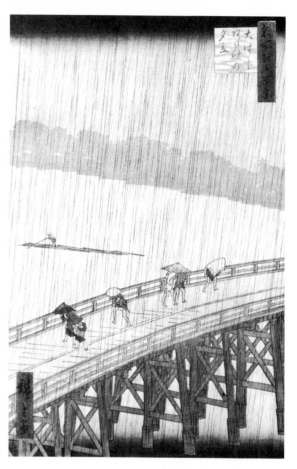

5–2 ANDO HIROSHIGE
Rain Shower on Ohashi Bridge (1857)
Color wood block on paper. 13⅞ x 9⅛".
The Cleveland Museum of Art. Gift of J. J. Wade.

5–3 EMIL NOLDE
The Prophet (1912) Woodcut. 12¾ x 9".
National Gallery of Art, Washington, D.C. Rosenwald Collection.

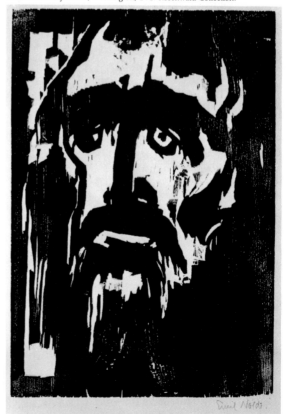

wood grain, contributes to the drama of the print.

This oldest of the printmaking techniques has been revived by a number of contemporary artists, such as the Japanese-American Hiroshi Murata. For *Momigi No Niwa* (Fig. 5–4), which means "Maple in the Garden," Murata drew the imagery on rice paper and commissioned a Japanese master woodcarver to transfer the work onto a wood block. It took the woodcarver approximately three months to carve the matrix, which was then inked in several colors and printed. The meticulous, mazelike design is a stable counterpoint to the diffuse colors that spread across the paper. Despite the mechanical nature of the grid, the overall atmospheric effect produced by the broad color fields emerging and dissolving into haze is not unlike that found in some Far Eastern landscapes, such as those shown in Chapter 18.

5–4 HIROSHI MURATA
Momigi No Niwa (1981)
Wood block print printed in traditional *Ukiyoe* technique. 18¼ x 26½".

Wood Engraving

The technique of **wood engraving** and its effects differ significantly from those of woodcuts. Whereas in woodcuts the flat surface of boards is used, in wood engraving many thin layers of wood are **laminated.** Then the ends of these sections are planed flat, yielding a hard, nondirectional surface. In contrast to the softer matrix used for the woodcut, the matrix for the wood engraving makes it relatively easy to work lines in varying directions. These lines are **incised** or engraved with tools such as a **burin** or **graver** (Fig. 5–5) instead of being cut with knives and gouges. The lines can be extremely fine and are often used in close alignment to give the illusion of tonal gradations. This process was used to illustrate newspapers, such as *Harper's Weekly*, during the nineteenth century.

The razor-sharp tips of engraving implements and the hardness of the end-grain blocks make possible the exacting precision found in wood engravings such as that by Paul Landacre (Fig. 5–6), a famous twentieth-century American printmaker. Tight, threadlike parallel and crosshatched lines comprise the tonal areas that define the form. The rhythmic, flowing lines of the seedling's unfurling leaves contrast dramatically with the fine, prickly lines that emanate like rays from the young corn plant. The print is a display of technical prowess in a most demanding and painstaking medium.

5–5 Burin

5–6 PAUL LANDACRE
Growing Corn (1940)
Wood engraving. 8½ x 4¼".
Library of Congress, Washington, D.C.

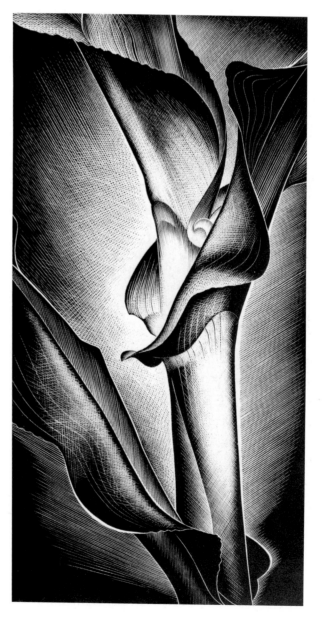

The popularity of relief printing declined with the introduction of the **intaglio** process. Intaglio prints are created by using metal plates into which lines have been incised. The plates are covered with ink, which is forced into the linear depressions, and then the surface is carefully wiped. The cut depressions retain the ink, while the flat surfaces are clean. Paper is laid atop the plate, and then paper and plate are passed through a printing press, forcing the paper into the incised lines to pick up the ink and thereby accept the image. In a reversal of the relief process, then, intaglio prints are derived from designs or images that lie *below* the surface of the matrix (see Fig. 5–1b).

Intaglio printing encompasses many different media, the most common of which are engraving, drypoint, etching, and mezzotint and aquatint. Some artists have used these techniques recently in interesting variations or combinations and have pioneered approaches using modern equipment such as the camera and computer.

Engraving

Although **engraving** has been used to decorate metal surfaces such as bronze mirrors or gold and silver drinking vessels since ancient times, the earliest engravings printed on paper did not appear until the fifteenth century. In engraving, the artist creates clean-cut lines on a plate of copper, zinc, or steel, forcing the sharpened point of a burin across the surface with the heel of the hand. Because the lines are transferred to paper under very high pressure, they not only reveal the ink from the grooves, but themselves have a ridgelike texture that can be felt by running a finger across the print.

An early and famous engraving came from the hand of the fifteenth-century Italian painter Antonio Pollaiuolo (Fig. 5–7). Deep lines that hold a greater amount of ink define the contours of the ten fighting figures. As did Landacre, Pollaiuolo used parallel groupings of thinner and thus lighter lines to render the tonal gradations that define the exaggerated musculature. The detail of the print is described with the utmost precision, revealing the artist's painstaking mastery of the burin.

5–7 ANTONIO POLLAIUOLO
Battle of Ten Naked Men (c. 1465–70). Engraving. 15½ x 23³⁄₁₆".

The Metropolitan Museum of Art, N.Y. Purchase, 1917. Joseph Pulitzer Bequest.

5–8 REMBRANDT
VAN RIJN
Christ Crucified Between the Two Thieves (1653). Drypoint, 4th state. 15 x 17½".

Courtesy Museum of Fine Arts, Boston. Katherine E. Bullard Fund in memory of Frances Bullard.

Drypoint

Drypoint is engraving with a simple twist. In drypoint a needle is dragged across the surface, and a metal burr, or rough edge, is left in its wake to one side of the furrow. The burr retains particles of ink, creating a softened rather than crisp line when printed. The burr sits above the surface of the matrix and therefore is fragile. After many printings, it will break down, resulting in a line that simply looks engraved.

The characteristic velvety appearance of drypoint lines is seen in Rembrandt's *Christ Crucified Between the Two Thieves* (Fig. 5–8). The more distinct lines were rendered with a burin, whereas the softer lines were created with a drypoint needle. Rembrandt used the blurriness of the drypoint line to enhance the sense of chaos attending the Crucifixion and the darkness of the encroaching storm. Lines fall like black curtains enshrouding the crowd, while rays of bright light illuminate the figure of Jesus and splash down onto the spectators.

Etching

Although they are both intaglio processes, **etching** differs from engraving in the way the lines are cut into the matrix. With engraving, the depth of the line corresponds to the amount of force used to push or drag an implement over the surface. With etching, minimal pressure is exerted to determine the depth of line. A chemical process does the work.

In etching, the metal plate is covered with a liquid, acid-resistant ground consisting of wax or resin. When the ground has hardened, the image is drawn upon it with a fine needle. Little pressure is exerted to expose the ground; the plate itself is not scratched. When the drawing is completed, the matrix is slipped into an acid bath which immediately begins to eat away, or etch, the exposed areas of the plate. This etching process yields the sunken line that holds the ink. The artist leaves the plate in the acid solution just long enough to achieve the desired depth of line. If a variety of

5–9 HENRI MATISSE
Loulou in a Flowered Hat (1914)
Etching, printed in black. 7¹/₁₆ x 5″.
Collection, The Museum of Modern Art, N.Y. Purchase.

5–10 GIOVANNI DOMENICO TIEPOLO
A Negro (1770). Etching, 2nd state.
Courtesy, Museum of Fine Arts, Boston. George R. Nutter Fund.

tones is desired, the artist may pull the plate out of the acid solution after a while, cover lines of sufficient depth with the acid-resistant ground, and replace the plate in the bath for further etching of the remaining exposed lines. The longer the plate remains in the acid solution, the deeper the etching. Deeper crevices hold more ink, and for this reason they print darker lines.

Etching is a versatile medium, capable of many types of lines and effects. The modern French painter Henri Matisse used but a few dozen uniformly etched lines to describe the essential features of a woman, *Loulou in a Flowered Hat* (Fig. 5–9). The extraordinarily simple yet complete image at-

tests to the delicacy that can be achieved with etching.

Whereas Matisse's figure takes shape through the careful placement of line, the subject of the etching (Fig. 5–10) by Giovanni Domenico Tiepolo (who was the son of Giovanni Battista Tiepolo) exists by virtue of textural and tonal contrasts. This eighteenth-century Italian artist used a variety of wavy and curving lines to differentiate skin from cloth, fur from hair, figure from ground. Lines are spaced to provide a range of tones from the sharp white of the paper to the rich black of the man's clothing. The overall texture creates a hazy atmosphere that caresses the pensive figure.

Mezzotint and Aquatint

Engraving, drypoint, and etching are essentially linear media. With these techniques, designs or images are created by cutting lines into a plate. The illusion of tonal gradations is achieved by altering the number and concentration of lines. Sometime in the mid-seventeenth century the Dutchman Ludwig von Siegen developed a technique whereby broad tonal areas could be achieved by nonlinear engraving, that is, engraving that does *not* depend on line. The medium was called **mezzotint,** from the Italian word meaning ''halftint.''

With mezzotint engraving, the entire metal plate is worked over with a curved, multitoothed implement called a **hatcher.** The hatcher is ''rocked'' back and forth over the surface, producing thousands of tiny pits that will hold ink. If printed at this point, the plate would yield an allover consistent, velvety black print. But the mezzotint engraver uses this evenly pitted surface as a point of departure. The artist creates an image by gradually scraping and burnishing the areas of the plate that are meant to be lighter. These areas will hold less ink and therefore will produce lighter tones. The more persistent the scraping, the shallower the pits and the lighter the tone. A broad range of tones is achieved as the artist works from the rich black of the rocked surface to the highly polished pitless areas that will yield bright whites. Mezzotint is a rarely used, painstaking and time-consuming procedure.

The subtle tonal gradations achieved by the mezzotint process can be duplicated with a much easier and quicker etching technique called **aquatint.** In aquatint a metal plate is evenly covered with a fine powder of acid-resistant resin. The plate is then heated, causing the resin to melt and adhere to the surface. As in line etching, the matrix is placed in an acid bath, where its uncovered surfaces are eaten away by the solution. The depth of tone is controlled by removing the plate from the acid and covering the pits that have been sufficiently etched.

Aquatint is often used in conjunction with line etching and is frequently manipulated to resemble tones produced by wash drawings. In *The Painter and His Model* (Fig. 5–11), Pablo Picasso brought the forms out of void space by defining their limits with dynamic patches of aquatint. These tonal areas resemble swaths of ink typical of wash drawings. Descriptive details of the figures are rendered in fine or ragged lines, etched to varying depths.

5–11 PABLO PICASSO
The Painter and His Model (1964)
Etching and aquatint. 12⅝ x 18½".

Courtesy, Museum of Fine Arts, Boston, Lee M. Friedman Fund.

5–12 JOSEF ALBERS
Solo V (1958)
Inkless intaglio. 6⅝ x 8⅝".
The Brooklyn Museum, Brooklyn, N.Y.

Some Other Etching Techniques

Different effects may also be achieved in etching by using grounds of different substances. **Soft-ground etching,** for example, employs a ground of softened wax and can be used to render the effects of crayon or pencil drawings. In a technique called **lift-ground,** the artist creates the illusion of a brush-and-ink drawing by actually brushing a solution of sugar and water onto a resin-coated plate. When the plate is slipped into the acid bath, the sugar dissolves, lifting the brushed image off the plate to expose the metal beneath. As in all etching media, these exposed areas accept the ink.

Given that the printing process implies the use of ink to produce an image, can we have prints without ink? The answer is yes—with the medium called **gauffrage,** or inkless intaglio. Joseph Albers, a twentieth-century American abstract artist, created *Solo V,* the geometric image shown in Figure 5–12, by etching the lines of his design to two different depths. Furrows in the plate appear as raised surfaces when printed. We seem to feel the image with our eyes, as light plays across the surface of the paper to enhance its legibility. Perceptual shifts occur as the viewer focuses now on the thick, now on the thin lines. In trying to puzzle out the logic of the form, the viewer soon discovers that Albers has offered a frustrating illustration of "impossible perspective."

LITHOGRAPHY

Lithography was invented at the dawn of the nineteenth century by the German playwright Aloys Senefelder. Unlike relief and intaglio printing, which rely on cuts in a matrix surface to produce an image, the lithography matrix is flat. Lithography is a surface or **planographic** printing process (Fig. 5–1c).

In lithography, the artist draws an image with a greasy crayon directly on a flat stone slab. Bavarian limestone is considered the best material for the slab. Sometimes a specially sensitized metal plate is used, but a metal surface will not produce the often-desired grainy appearance in the print. Small particles of crayon adhere to the granular texture of the stone matrix. After the design is complete, a solution of nitric acid is applied as a fixative. The entire surface of the matrix is then dampened with water. The untouched areas of the surface accept the water, but the waxy crayon marks repel it.

A roller is then used to cover the stone

with an oily ink. This ink adheres to the crayon drawing but repels the water. When paper is pressed to the stone surface, the ink on the crayon is transferred to the paper, revealing the image.

Different lithographic methods yield different results. Black crayon on grainy stone can look quite like the crayon drawing it is. Color lithographs employing brush techniques can be mistaken for paintings. Henri de Toulouse-Lautrec, a nineteenth-century French painter and lithographer, was well versed in the medium's flexibility, as is evident in his portrait of a clowness (Fig. 5–13). The outlines of the figures were drawn with a crayon, and the broad areas of her tights and ruffled collar were brushed in with liquid crayon. The overall spray effect that dapples the surface of the print was probably achieved by his scraping a finger-

5–13 HENRI DE TOULOUSE-LAUTREC
The Seated Clowness (1896)
Color lithograph. 28 x 22".

The Metropolitan Museum of Art, N.Y. The Alfred Stieglitz Collection, 1949.

5–14 KÄTHE KOLLWITZ *The Mothers* (1919). Lithograph. 17¾ x 23".
Philadelphia Museum of Art. Anonymous donor.

nail along a stiff brush loaded with the liquid substance.

The impact of Käthe Kollwitz's lithograph *The Mothers* (Fig. 5–14), which highlights the plight of lower-class German mothers left alone to fend for their children after World War I, could not be further removed from that of *The Seated Clowness*. The high contrast of the black and white and the coarse quality of the wax crayon yield a sense of desperation suggestive of a newspaper documentary photograph. All the imagery is thrust toward the picture plane, as in high relief. The harsh contours of protective shoulders, arms, and hands contrast with the more delicately rendered faces and heads of the children—all contributing to the poignancy of the work.

Some artists have experimented with commercial lithography techniques similar to those used in the production of books and magazines. Hiroshi Murata's *Hinode* (Fig. 5–15), which means "Sunrise," employs what is known as *offset lithography*. The image is hand-drawn by the artist on mylar (a kind of polyester made in thin, silver-colored sheets and used for videotapes), but the principle of the technique—that water repels grease—is identical to the lithography method in which stones are used. The imagery in *Hinode* is a three-dimensional grid reminiscent of a steel-cage structure. The imagery seems to be ascending and revolving in space, like a human-made celestial body. The sturdiness of the metallic projections provides an ironic contemporary structure for the intangible diffusion of light into space.

5–15 HIROSHI MURATA *Hinode* (*Sunrise*) (1986). Offset lithograph/silkscreen diptych. 29⅜ x 42¾".

Brandywine Graphic Workshop.

In **serigraphy** or silk-screen printing, stencils are used to create the design or image. Unlike the case with other graphic processes, these images can be rendered in paint as well as ink.

One serigraphic process begins with a screen constructed of a piece of silk, nylon, or fine metal mesh stretched on a frame. A stencil with a cutout design is then affixed to the screen, and paper or canvas is placed beneath (Fig. 5–1d). The artist forces paint or ink through the open areas of the stencil with a flat, rubber-bladed implement called a **squeegee,** similar to those used in washing windows. The image on the support corresponds to the shape cut out of the stencil. Several stencils may be used to apply different colors to the same print.

Images can also be "painted" on a screen with use of a varnishlike substance that prevents paint or ink from passing through the mesh. This technique allows for more gestural images than cutout stencils would provide. Recently a serigraphic process called *photo silkscreen* has been developed; it allows the artist to create photographic images on a screen covered with a light-sensitive gel.

Serigraphy was first developed as a commercial medium and is still used as such to create anything from posters to labels on cans of food. The American Pop artist Andy Warhol raised the commercial aspects of serigraphy to the level of fine art in many of his silk-screen prints of the 1960s, such as *Campbell's Soup Can* (Fig. 5–16). These faithful renditions of everyday items satirize the mass media's bombardment of the consumer with advertising. They also happen to be amusing.

5–16 ANDY WARHOL
Campbell's Soup Can (1964)
Silkscreen on canvas. 35¾ x 24".
Courtesy of Leo Castelli Gallery, N.Y.

MONOTYPE

Monotype is a printmaking process, but it overlaps the other two-dimensional media of drawing and painting. Like drawing and printmaking, monotype yields but a single image, and like them, therefore, it is a unique work of art.

In monotype, drawing or painting is created with oil paint or watercolor on a nonab-sorbent surface of any material. Brushes are used, but sometimes fine detail is rendered by scratching paint off the plate with sharp implements. A piece of paper is then laid on the surface and the image is transferred by hand rubbing the back of the paper or passing the matrix and paper through a press. The result, as can be seen in a monotype by Edgar Degas (Fig. 5–17), has all the spontaneity of a drawing and the lushness of a painting.

5–17 EDGAR DEGAS
The Ballet Master (c. 1874)
Monotype in black ink. 22 x 27½".

National Gallery of Art, Washington, D.C. Rosenwald Collection.

Sometimes printmaking techniques can be combined, and other media can be employed collaterally, to achieve dramatic effects. An example is found in the contemporary Frank Stella print, *The Butcher Came and Slew the Ox* (Fig. 5–18), in which the artist combines lithography, linoleum-block printing, serigraphy, and other printmaking techniques. Stella also used collage and hand-colored segments of the print. In pure printmaking the artist tends to be removed from the completed work; the print is frequently made by a technician in a graphics studio, rather than by the artist. Hand coloring allowed Stella to add his personal, gestural signature to the work. *The Butcher Came and Slew the Ox* is one of a series of twelve prints based on illustrations for a children's Passover song executed by an early twentieth-century Russian artist.

In Chapters 6 and 7 we turn our attention to sculpture and architecture. In drawing, painting, and printmaking, artists have frequently attempted to create the illusion of three-dimensionality. We shall see some of the opportunities and problems that attend actual artistic expression in three dimensions.

5–18 FRANK STELLA *The Butcher Came and Slew the Ox* (1984)
No. 8 from a series of 12 "Illustrations after El Lissitzky's *Had Gadya*"
Hand colored and collaged with lithographic, linoleum block, and silkscreen printings.
56⅞ x 53⅜" overall sheet.
Waddington Graphics, London. Collection of Jane and Howard Ehrenkranz.

6

Sculpture

What is a stone? To a farmer it is an obstacle to be dug and carted from the field. To a Roman warrior it was a powerful missile. To an architect it is a block, among many, to be assembled into a home or a bridge. But to a sculptor it is the repository of playful inner forms yearning for release. What is a steel girder? To an architect it is part of the skeleton of a skyscraper. To a sculptor it is the backbone of a fantastic animal or machine that never was, except in the imagination.

Stone, metal, wood, clay, plastics, light, and earth—these are some of the materials and elements that we have carved, modeled, assembled, and toyed with to create images of ourselves and to express our inmost fears and fantasies. Each of them affords the artist certain opportunities and limitations for self-expression. In this chapter we will see how they have been used in sculpture to grant three-dimensional reality to ideas. In the next chapter we will see how architects have used them to create aesthetic structures that protect us from the elements and provide settings for communal and intimate activities.

According to the Greek myth, Pygmalion, the king of Cyprus, fell in love with the idealized statue of a woman. Aphrodite, goddess of love, heard his prayers and brought the statue to life. In one version of the myth, the statue becomes the goddess herself. In still another, Pygmalion was the sculptor who created the statue. In this myth we find the elements of the human longing for perfection. We glimpse the emotionality that sculptors can pour into their works.

Sculpture is the art of carving, casting, modeling, or assembling materials into three-dimensional figures or forms. Within this broad definition, architecture could be seen as a type of sculpture. But architecture serves the utilitarian purpose of providing housing and other structures for work and play, whereas sculptures need serve no practical purpose at all.

It could be argued that sculpture is more capable of grasping the senses than do the two-dimensional art forms of drawing, painting, and printmaking. We view two-dimensional works from vantage points to the front of the support. We might move closer or farther away, or squat or stand on tiptoe to gain new perspective, but the work itself, even if thickly laden with impasto, is essentially flat. **Relief sculptures** are similar to two-dimensional works in that their three-dimensional forms are raised from a flat background. In low-relief, or **bas-relief,** especially, the forms project only slightly from the background; in **high-relief,** figures project by at least half their natural depth.

But **free-standing sculptures** have fronts, sides, backs, and tops; they invite the viewer to walk around them. In some cases viewers may climb on them, walk through them, or, as in the case of a Calder **mobile,** look up at them from beneath. As we move about a sculpture, we are impressed by new revelations. The spaces or voids in and around the work may take on as much meaning as the sculpted forms themselves.

Two-dimensional art forms are not meant to be touched, but much of the pleasure of appreciating a sculpture derives from imagining what it would be like to run one's hands over sensuous curving surfaces of cool marble or hand-rubbed walnut. In many cases we may be prevented by ropes and guards—or by self-control—from touching sculptures, but many are made purposefully to be caressed. Some fool the eye, such as the "leather" jacket modeled from clay (see Fig. 9–2), or the fish skeleton carved from wood (Fig. 6–10).

Recently developed forms of sculpture may interact with the viewer in other ways. The viewer may become involved in watching a kinetic sculpture run full cycle, or in trying to decipher just what the cycle is. Some kinetic sculptures and light sculptures may also be literally turned on and off, sometimes by the viewer.

Sculpture is a highly familiar medium. For thousands of years we have used sculpture to portray our visions of the gods, saints, and devils. Religious people in earlier times and even now believe that their gods actually dwell within the stone they chisel or the wood they carve. We have carved and modeled the animals and plants of field and forest. We have exalted our heroes and leaders, and commemorated our achievements and catastrophes, in stone and other materials. The size of a sculpture has often been commensurate with the power ascribed to the hero or with the magnitude of the event. In addition to serving community and religious functions, sculptures are decorative. They adorn public buildings and parks. They sit on pedestals in walkways and stand in fountains, impervious to the spray, or perhaps contributing to the pool from the mouth or nether parts. Sculptures, of course, also serve as vehicles to express an artist's ideas and feelings.

In our discussion of sculpture we will first distinguish between subtractive and additive sculpture and describe the techniques of each. Then we will examine the characteristics of a number of works that have been rendered in the traditional materials such as stone, wood, clay, and metal. Finally we

will explore several modern materials and methods, ranging from new metals and found objects to kinetic sculpture, light sculpture, and earthworks.

TYPES OF SUBTRACTIVE AND ADDITIVE SCULPTURE

Sculptural processes are either subtractive or additive. In a **subtractive process,** such as carving, unwanted material is removed. In the **additive processes** of modeling, casting, and constructing, material is added, assembled, or built up to reach its final form.

Carving

In **carving** the sculptor starts with a block of stone or a log of wood and cuts material away until the desired form is created. Carving could be considered the most demanding type of sculpture because the sculptor, like the fresco painter, must have a clear conception of the final product at the outset. The material chosen—stone, wood, ivory—strongly influences the mechanics of the carving process and determines the type of creation that will emerge, as we shall see.

Michelangelo believed that the sculptor liberated forms that already existed within blocks of stone. *The Cross-Legged Captive* (Fig. 6–1) is one of a series of unfinished Michelangelo statues in which the figures remain partly embedded in marble. In its unfinished state, the tension and twisting in the torso almost cause us to experience the struggle of the slave to free himself fully from the marble and, symbolically, from his masters. Despite the massiveness of the musculature, the roughness of the finish imparts a curious softness and humanity to the figure, which further increase our empathy. Perhaps a chord in us is struck: Do we not all struggle to break free from confining forces of one kind or another?

6–1 MICHELANGELO
The Crossed-Legged Captive (c. 1530–34)
Marble. Height: 7′6½″.
Academy, Florence.

Modeling

In **modeling** a pliable material such as clay or wax is shaped into a three-dimensional form. The artist may manipulate the material by hand and use a variety of tools. Unlike carving, in which the artist must begin with a clear concept of the result, in modeling the artist may work and rework the material until pleasing forms begin to emerge.

Twentieth-century sculptor Reuben Nakian created realistic **figurative** forms until the early 1940s. His **terra-cotta** *Europa and the Bull with Cupid* (Fig. 6–2) is an example of a later work in which he portrayed mythical subjects, frequently of seduction, in twisting diagonals. Here the emotional pressing, kneading, and gouging of clay lends the fleeing female form its loose, abstract quality.

6–2 REUBEN NAKIAN
Europa and the Bull with Cupid (1947–48).
Terra cotta, painted. 26½ x 24¾ x 21".

Hirshhorn Museum and Sculpture Garden, Smithsonian Institution, Washington, D.C.

Casting

In the **casting** process, a liquid material is poured into a **mold.** The liquid hardens into the shape of the mold and is then removed. In casting, an original model, made of a material such as wax, clay, or even styroform, can be translated into a more durable material such as bronze. The mold is like a photographic negative, but one of form and not of color; the interior surfaces of the mold carry the reversed impressions of the model's exterior.

Any material that hardens can be used for casting. Bronze has been used most frequently because of its appealing surface and color characteristics, but concrete, plaster, liquid plastics, clay diluted with water, and other materials are also appropriate. Once the mold has been made, the casting may be duplicated a number of times.

THE LOST-WAX TECHNIQUE

Bronze casting is usually accomplished by means of the **lost-wax technique,** which has changed little over the centuries. In this technique, an original model is usually sculpted from clay, and a mold of it is made, usually from sectioned plaster or flexible gelatin. Molten wax is then brushed or poured into the mold to make a hollow wax model. If the wax has been brushed onto the inner surface of the mold, it will form a hollow shell. If the wax is to be poured, a solid core can first be placed into the mold and the liquid wax poured around the core. After the wax hardens, the mold is removed, and the wax model stands as a hollow replica of the clay. The hollow wax model is placed upside down in a container, and wax rods called **gates** are connected to it. Then a sandy mixture of silica, clay, and plaster is poured into and around the wax model, filling the shell and the container. The mixture hardens into a fire-resistant mold, or **investiture.** Thus the process uses two models and two molds: models of clay and wax, and molds of plaster or gelatin and of the silica mixture.

The silica mold, or investiture, is turned over and placed in a **kiln.** As the investiture becomes heated, the wax turns molten once

more and runs out. Hence the term *lost-wax technique*. The investiture is turned over again while it is still hot, and molten bronze is poured in. As the metal flows into the mold, air escapes through the gates so that no air pockets are left within. The bronze is given time to harden. Then the investiture and core are removed, leaving the bronze sculpture with strange projections where the molten metal had flowed up through the gates as it filled the mold. The projections are removed, and the surface of the bronze is **burnished** or treated chemically to take on the texture and color desired by the sculptor, as we shall see below.

A statue by the French Impressionist Edgar Degas has an interesting history and metamorphosis from wax to bronze. As Degas grew blind, he turned to sculpture so that he could work out anatomical problems through the sense of touch. With one exception, his wax or clay experiments were left crumbling in his studio or discarded, although the intact figures were cast as a limited edition of bronze sculptures after his death. The exception was *The Little Dancer* (Fig. 6–3), which he showed as a wax model at the 1881 Impressionist exhibition and later cast in bronze. This diminutive painted wax figure startled the public and critics alike with its innovative sculptural realism: it sported real hair, a satin hair ribbon, a canvas bodice, and a tulle skirt. The styles of hair and clothing make the fourteen-year-old ballerina very much a product of her time and place.

The realism of *The Little Dancer* seems to have inspired a number of contemporary sculptors, such as Duane Hanson, who models and colors the new plastic media to create the illusion of actual flesh. Just as Degas clothed *The Little Dancer*, Hanson clothes his statues in trappings such as Hawaiian shirts to make them the products of their time and place. So that no mistake is possible—and no possibility for sardonic commentary overlooked—Hanson also bestows omnipresent twentieth-century props upon them such as shopping bags, cameras, and sunglasses (see Fig. 17–26).

6–3 EDGAR DEGAS
The Little Dancer, 14 Years Old (1880–81)
Bronze. Height: 39".
Sterling and Francine Clark Art Institute

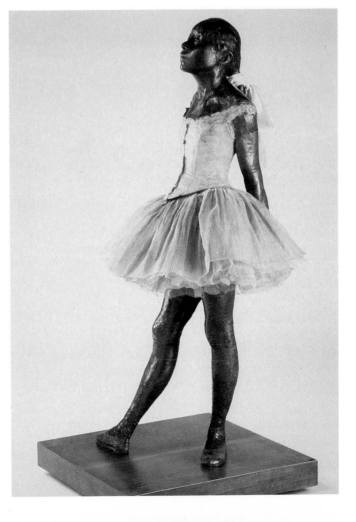

6–4 GEORGE SEGAL
The Bus Riders (1964)
Plaster, metal and vinyl.
69 x 40 x 76″.

Hirshhorn Museum and Sculpture Gallery,
Smithsonian Institution, Washington, D.C.

PLASTER CASTING OF HUMAN MODELS

The Bus Riders (Fig. 6–4) by contemporary sculptor George Segal is an intriguing variation of the casting process. Segal produces ghostlike replicas of dehumanized people by means of plaster casts. "Plaster," notes Segal, "is an incredible recorder of what is there, more effective to me than the movie camera." Segal's methodology combines casting and modeling. Friends and colleagues leave impressions of parts of their bodies in quick-drying plaster casts, whose surfaces are molded and kneaded by the artist's hand as they sit. These sections are then assembled and adjusted into whole figures. Segal's figures are literally and figuratively shells. In unimaginable aloneness, his apparitions occupy an urban landscape of buses, gas stations, and other machinelike settings that take no heed of personal needs, aspirations, or—indeed—creativity. The amorphousness of the surface textures is not unlike that of the Nakian sculpture, placing the figures further into what Segal apparently sees as the limbo of contemporary life.

Construction

In construction, or **constructed sculpture,** forms are built from materials such as wood, paper and string, sheet metal, and wire. As we shall see in works by Picasso, Louise Nevelson, and other artists later in the chapter, traditional carving, modeling, and casting are abandoned in favor of techniques such as pasting and welding.

Sculptors have probably employed every material known to humankind in their works. Different materials tend to be worked in different ways, and they can also create very different effects. In this section we will explore the varieties of ways in which sculptors have worked with the traditional materials of stone, wood, clay, and metal. In the section on modern and contemporary materials and methods, we shall see how sculptors have worked with nontraditional materials, such as plastic and light.

Stone Sculpture

Stone is an extremely hard, durable material that may be carved, scraped, drilled, and polished. The durability that makes stone so appropriate for monuments and statues that are meant to communicate with future generations also makes working with stone a tedious process. The granite used by ancient Egyptians was extremely resistant to detailed carving. This is one reason that Egyptian stone figures are simplified and resemble the shape of the quarried blocks. The Greeks used their abundant white marble to embody the idealized human form in action and in respose. However, they painted their marble statues, suggesting that they valued the material more for its durability than for its color or texture.

The hand tools used with stone—such as the chisel, mallet, and **rasp**—have not changed much over the centuries. But contemporary sculptors do not find working with stone to be quite so laborious since they can use power tools for chipping away large areas of unwanted material and for polishing the finished piece.

The Stone Age *Venus of Willendorf* (see Fig. 10–2) has endured for perhaps 25,000 years. The same stone that lent such durability to this rotund fertility figure apparently pressed the technological limits of the sculptor. There are clues that the artist found the stone medium arduous. As with ancient Egyptian sculpture, the shape of the figurine probably adheres closely to that of the block or large pebble from which it was carved. The rough finish further suggests the primitive nature of the artist's flint tools.

It is a leap from the stone art of the Stone Age to the sculpture of, say, Michelangelo in *The Cross-Legged Captive* (Fig. 6–1) or the *David* (Fig. 13–30). The *Captive*, interestingly, like the *Venus*, does not stray far from the shape of the block or precariously extend its limbs. But except for the eternal nature of the *David*, the statue belies the nature of the material. The furrowed brow, the taut muscles, the veins in the hand all breathe life into the work.

The *Apollo and Daphne* (Fig. 6–5) of the Italian Baroque sculptor and architect Gianlorenzo Bernini shows us more of the potential of marble. Note how marble can capture the softness and sensuousness of flesh and the textures of hair, leaves, and bark. Ob-

6–5 GIANLORENZO BERNINI
Apollo and Daphne (1622–24). Marble. 7'6".
Galleria Borghese, Rome.

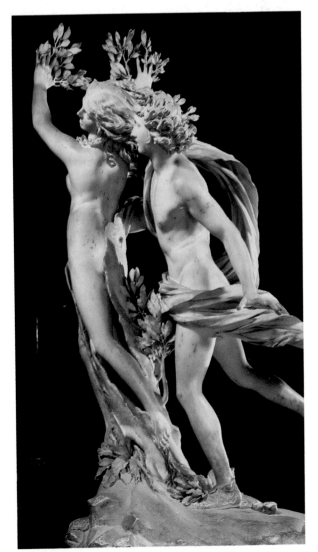

serve the hundreds of slender projections and imagine the intricacy of cutting away the obstinate stone to reveal them. Bernini's work portrays the fleeting moment of myth when Daphne, fleeing the lithe god Apollo, futilely calls to her father for rescue but instead is transformed into a laurel tree. The sculpture is suffused with sweeping motion and conveys the antagonistic emotions of passion and terror.

In his *David* (see Fig. 14–10), Bernini portrays the moment in which the youth is twisting in preparation to fire the sling. David bites his marble lips; the muscles and veins of the left arm reflect the tightening of the hand; even his marble toes grip the rock beneath. When we view this sculpture, perhaps our own muscles tighten in empathy.

In *Eyes* (Fig. 6–6), contemporary sculptor Louise Bourgeois explores the relationships among a group of abstracted individuals by clustering carved marble units of varying sizes. The shapes are neither male nor female; the projections and rounded forms exude an androgynous life force. The marble medium lends these abstracted lifeforms an essential endurance that seems to underlie the conflicting motives for affiliation and individuation. Although Bourgeois could be thought of as remaining close to the shapes of the marble blocks that compose her work, the polish of the surfaces and the precise variations on a theme show that the blockiness of the units stems completely from aesthetic choice and not from the difficulties of working the medium.

6–6 LOUISE BOURGEOIS
Eyes (1982). Marble.
74¾ x 54 x 45¾".

The Metropolitan Museum of Art. Anonymous gift, 1986.

The Vietnam Memorial

When we view the expanses of the Washington Mall, we are awed by the grand obelisk that is the Washington Monument. We are comforted by the stately columns and familiar shapes of the Lincoln and Jefferson Memorials. But many of us do not know how to respond to the two 200-foot-long black granite walls that form a V as they recede into the ground. There is no label—only the names of 58,000 men chiseled into its silent walls. This is the Vietnam Memorial (Fig. 6–7), completed in 1982 on a two-acre site on the Mall. In order to read the names, we must descend gradually into earth, then just as gradually work our way back up. This progress is perhaps symbolic of the nation's involvement in Vietnam. As did the war it commemorates, the eloquently simple design of the memorial also stirs controversy.

This dignified understatement in stone has offended many who would have preferred a more traditional memorial. One conservative magazine branded the design a conspiracy to dishonor the dead. Architecture critic Paul Gapp of *The Chicago Tribune* argued that "The so-called memorial is bizarre . . . neither a building nor sculpture." One Vietnam veteran had called for a statue of an officer offering a fallen soldier to heaven.

How did the Vietnam Memorial come to be so uniquely designed? It was picked from 1,421 entries in a national competition. The designer, Maya Ying Lin, is a Chinese-American woman who was all of twenty-two years old at the time she submitted her entry. A native of Ohio, Lin had just been graduated from Yale University, where she had majored in architecture. Lin recognized that a monumental sculpture or another grand building would have been intrusive in the heart of Washington. Her design meets the competition criteria of being "neither too commanding nor too deferential," and is yet another expression of the versatility of stone.

6–7 MAYA YING LIN *Vietnam Memorial, Washington, D.C* (1982)
Polished black granite. Length: 492'.

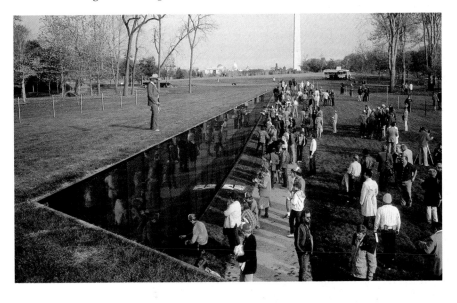

Wood Sculpture

Wood, like stone, may be carved, scraped, drilled, and polished. But unlike stone, wood may also be permanently molded and bent. Under heat, in fact, plywood can be bent to take on any shape. Wood, like stone, varies in hardness and grain, but it is more readily carved than stone.

Although wooden objects may last for many hundreds of years, wood does not possess the durability of stone and tends to warp and crack. But wood appeals to sculptors because of its grain, color, and workability. Wood is warm to the touch, whereas stone is cold. When polished, wood is sensuous. Wood's **tensile strength** exceeds that of stone, so that projecting wooden parts are less likely than their stone counterparts to break off. In recent years, wood has also become commonly used in assemblages.

The capacity of wood to yield beautiful, rough-hewn beauty is shown in the mask called *Kagle* (Fig. 6–8), by a sculptor of the African Dan people. The Dan of Sierra Leone, the Ivory Coast, and Liberia have carved masks for use in rituals and celebrations. Some Dan masks are polished and refined; others are intentionally crude. *Kagle* is a powerful work of thrusting and receding planes. The abstracted, geometric voids are as commanding as the wooden form itself. Such a mask is believed to endow its wearer with the powers of the bush spirits and is an essential element in the garb of tribal law-enforcement officers.

British sculptor Barbara Hepworth's abstract *Two Figures* (Fig. 6–9) is carved from elmwood. Like Henry Moore (see Fig. 17–21), Hepworth was fascinated with piercing solid masses in order to reveal negative shapes. The concavities, which are painted white, and the voids in her carved figures

6–8 *Poro Secret Society Mask (Kagle)* (Liberian, Dan Tribe). Wood. 9" high.

Yale University Art Gallery, Gift of Mr. and Mrs. James M. Osborn.

have as much "shape-meaning"—to use Moore's term—as the solids. The viewer feels the urge to identity each form as male or female, but the sculptural "evidence" is too scant to allow such classification. At first glance it might seem that a similar artistic effect could have been achieved by carving these figures from marble, but the wood grain imparts a warmth to the surface that would not have been attained in marble, and the painting of the concavities lends them a "durability" and hardness not found in the outer surface. Ironically, the voids attain more visual solidity than the outer surfaces.

Kagle and *Two Figures* each has an implied massiveness. Wood can also be used to create figures and forms of great delicacy and intricacy. *Dog Snapper* (Fig. 6–10), by Japanese-born Fumio Yoshimura, is a **trompe l'oeil** sculpture whose multiple projections seem to be of natural bone, not wood. The lightness of the work would not have been attainable in stone, although the piece could have been carved from ivory. The sculptor's knowledge of the material is part and parcel of the creative process: a stone sculptor would not be likely to consider a fish skeleton as a suitable subject.

6–9 BARBARA HEPWORTH
Two Figures (1947–48)
Elmwood and white paint.
38 x 17".

University Gallery, University of Minnesota, Minneapolis.
John Rood Sculpture Collection.

6–10 FUMIO YOSHIMURA
Dog Snapper (1981)
Linden wood. 21 x 40 x 12".

Courtesy of Nancy Hoffman Gallery, N.Y.

On Sculpture

LEORNADO DA VINCI: The sculptor's work entails greater physical effort and the painter's greater mental effort. . . . The sculptor, in carving his statue out of marble or other stone wherein it is potentially contained, has to take off the superfluous and excessive parts with the strength of his arms and the strokes of the hammer—a very mechanical exercise causing much perspiration, which, mingling with the grit, turns into mud. His face is pasted and smeared all over with marble powder, making him look like a baker; he is covered with minute chips as if emerging from a snowstorm, and his dwelling is dirty and filled with dust and chips of stone. . . .

The painter sits in front of his work at perfect ease. He is well dressed and handles a light brush dipped in delightful color. . . . His home is clean . . . and he often enjoys the accompaniment of music . . . to which he can listen . . . without the interference of hammering and other noises.

BENVENUTO CELLINI: I say that the art of sculpture is eight times as great as any other art . . . because a statue has eight views and they must all be equally good.

AUGUSTE RODIN: Sculpture is the art of the depression and the protuberance.

HENRY MOORE: Every material has its own individual qualities. . . . Stone, for example, is hard and should not be falsified to look like soft flesh. . . . A hole can itself have as much shape-meaning as a solid mass.

Clay Sculpture

Clay is more pliable than stone or wood. The modeling of clay is personal and direct; the fingerprints of the sculptor may be found in the material. Children, like sculptors, enjoy the feel of clay and the smell of clay.

Unfortunately, clay has little strength, and it is not usually considered a permanent material, even though an *armature* may be used to prevent clay figures from sagging. Because of its weakness, clay is frequently used to make three-dimensional sketches, or models, for sculptures that are to be executed in more durable materials. As was noted earlier, clay models may be translated into bronze figures. In *ceramics*, clay is fired in a kiln at high temperatures so that it becomes hardened and nonporous. Before firing, clay can also be coated, or *glazed*, with substances that provide the ceramic object with a glassy monochromatic or polychromatic surface.

A comparison of Figures 6–2 and 11–18 affords an impression of the versatility of clay—in these cases, terra-cotta. In Nakian's sculpture one senses the pressure from the thumbs and fingers of the artist as he left his very personal imprint on his material. But the Sarcophagus from Cerveteri could have been carved from stone. As is noted in Chapter 11, the stylized facial features and hair are reminiscent of the Greek marble statuary of the period from about 660 to 480 B.C. Nakian's gestural kneading of his material lends it a soaring lightness, whereas one is impressed by the horizontal massiveness of the sarcophagus.

Metal Sculpture

Metal has been used by sculptors for thousands of years. Metals have been cast, **extruded, forged, stamped,** drilled, filed, and burnished. The familiar process of producing cast bronze sculptures has changed little over the centuries. But in recent years artists have also assembled **direct-metal sculptures** by welding, riveting, and soldering. Modern adhesives have also made it possible to glue sections of metal together into three-dimensional constructions.

Different metals have different properties. Bronze has been the most popular casting material because of its pleasing surface and color characteristics. Bronze surfaces can be made dull or glossy. Chemical treatments can produce colors ranging from greenish-blacks to golden or deep browns. Because of oxidation, bronze and copper surfaces age to form rich green or greenish-blue **patinas.**

The French artist Auguste Rodin is considered by many to be the greatest sculptor of the nineteenth century. Nevertheless, Rodin's *The Walking Man* (Fig. 6–11) and similar sculptural fragments were not well received in his day, since they have an unfinished look. They were not incomplete, of course. Instead, they reflected Rodin's obsession with the correct rendition of anatomical parts. Rodin's *The Walking Man* is hollow, yet it retains the solid, massive appearance of the clay from which it was modeled—as well as the imprints of Rodin's fingers and tools. It speaks of the personal, gestural touches with which the sculptor can caress the most pliable materials, yet it has the strength, durability, and patina of bronze.

Rodin's figurative sculptures could not be farther removed from the blunt power and brutality of twentieth-century sculptor David Smith's stainless-steel constructions (see Fig. 17–27). The roles of subject and material seem reversed or at least merged. Rodin used metal to create the human figure. With Smith, abstract buoyant masses of machined steel are themselves the subject. Yet despite their apparent antagonism, the sculptures of Rodin and Smith are both expressions of the versatility of metal.

6–11 AUGUSTE RODIN
The Walking Man (1905) (cast 1962)
Bronze. 83 x 61 x 28".
Hirshhorn Museum and Sculpture Garden,
Smithsonian Institution, Washington, D.C.

Throughout history sculptors have searched for new forms of expression. They have been quick to experiment with the new materials and approaches that have been made possible by advancing technology. During the twentieth century, technological changes have overleaped themselves, giving rise to new materials, such as plastics and fluorescent lights, and to new ways of working traditional materials.

6–12 PABLO PICASSO *Guitar*
(Paris, early 1912) Sheet metal and wire.
30½ x 13⅛ x 7⅝".

Collection, The Museum of Modern Art, N.Y. Gift of the artist.

In this section we will explore a number of new materials and approaches, including constructed sculpture, mixed media, light sculpture, and earthworks. Though the search for novelty has been exhausting, this list is by no means exhaustive.

Constructed Sculpture

In constructed sculpture the artist builds or constructs the sculpture from materials such as cardboard, celluloid, translucent plastic, sheet metal, or wire, frequently creating forms that are lighter than those made from carving stone, modeling clay, or casting metal. Picasso apparently inspired a movement in this direction in 1912 with his three-dimensional construction of a guitar from paper and string. Later constructions by Picasso consisted of wood, sheet metal, and wire (Fig. 6–12). Picasso's early constructions, however, were reliefs. In spirit they were very much extensions of his two-dimensional works.

A Russian visitor to Picasso's Paris studio, Vladimir Tatlin, is credited with having realized the three-dimensional potential of constructed sculpture, which was then further developed in Russia by the brothers Antoine Pevsner and Naum Gabo. Naum Gabo's *Column* (Fig. 16–16) epitomizes the ascendance of form and space over mass that is characteristic of many constructed sculptures. Gabo's translucent elements transform masses into planes that frame geometric voids. "Mass" is created in the mind of the viewer by the empty volumes.

Charles Kumnick's *Bi-plane* (Fig. 6–13) is constructed from sheets of plastic and pieces of metal—brass, copper, steel, and sterling silver. The plastic planes contain space which is very much, as in the Gabo *Column*, a part of the work. *Bi-plane* is rigidly architectural, although the plastic affords a lightness that conflicts with the sense of massiveness. The jaunty red tube is sort of umbilical or intravenous, providing a shocking warm, organic counterpoint to the coldness of the rest of the piece—a coldness, by the way, that somehow manages to be lyrical.

6–13 CHARLES KUMNICK
Bi-Plane (1985). Acrylic, brass, copper, steel and sterling silver. 15 x 15 x 18″.

Courtesy of the author.

Pop artist Claes Oldenburg's *Soft Toilet* (Fig. 6–14) is constructed from vinyl, kapok, cloth, and Plexiglas. In Chapter 17 we shall explore some of the ways that this **soft sculpture** might be expressive—or, shall we say, expulsive?—of the trappings of contemporary life. Here let us note that the notion of sculpture as soft is a complete reversal of the driving forces that have given rise to marble sculptures. With the Oldenburg, sculpture gives in to the weight of the viewer who would press a finger against the work. The Oldenburg is not intended to endure through the ages—which, perhaps, is not so bad an idea. *Soft Toilet* had to be constructed, of course; one does not carve or model soft vinyl.

6–14 CLAES OLDENBURG
Soft Toilet (1966). Vinyl filled with kapok painted with liquitex, and wood. 52 x 32 x 30″.

Collection Whitney Museum of American Art, N.Y. 50th anniversary gift of Mr. and Mrs. Victor W. Ganz.

Assemblage

Assemblage is a form of constructed sculpture in which preexisting, or found, objects, recognizable in form, are integrated by the sculptor into novel combinations that take on a life and meaning of their own. American artist Louise Nevelson's *Black Secret Wall* (Fig. 6–15), like many other of her wooden sculptures, is a compartmentalized assemblage of rough-cut geometric shapes painted black. Similar assemblages include banal objects such as bowling pins, chair slats, and barrel staves and may be painted white or gold as well as black.

Why walls? Here is Nevelson's own explanation: "I attribute the walls to this: I had loads . . . and loads of creative energy. . . . So I began to stack my sculptures into an environment. . . . I think there is something in the consciousness of the creative person that adds up, and the multiple image that I give, say, in an enormous wall gives me so much satisfaction."[*] The overall effect of Nevelson's collections is one of nostalgia and mystery. They suggest the pieces of the personal and collective past, of lonely introspective journeys among the cobwebs of Victorian attics—of childhoods that never were. Perhaps they are the very symbol of consciousness, for what is the function of intellect if not to impose order on the bits and pieces of experience?

Assemblages by fellow-American Richard Stankiewicz, such as *Figure* (Fig. 6–16), weld battered scraps of metal and rusted machine parts into oddly graceful structures of iron and steel. The artist's hand breathes a new vitality into discarded mechanical equipment. The work could not have been created by traditional means, nor would it have been conceived by a sculptor who used them:

[*] Louise Nevelson, *Louise Nevelson: Atmospheres and Environments* (New York: C. N. Potter in association with the Whitney Museum of American Art, 1980), p. 77.

6–15 LOUISE NEVELSON *Black Secret Wall* (1970). Black wood. 100 x 139 x 7".
Courtesy of Pace Gallery, N.Y.

the thousands of projections would have been unthinkable in stone, and one cannot imagine what would have inspired a wooden carving in this form. In *Figure* Stankiewicz seems neither worshipful of nor horrified by the machine age and its dehumanizing aspects. His objects seem silently to assert that things as we know them disintegrate with time and that their elements take on new form. Other assemblers of junk use found objects ranging from coffee cans to auto bumpers.

Perhaps the best-known assemblage is Picasso's *Bull's Head* (Fig. 6–17). Consisting of the seat and handlebars of an old bicycle, the work possesses a rakish vitality. It is immediately and whimsically recognizable as animal—so much so that on first impression, its mundane origins are obscured.

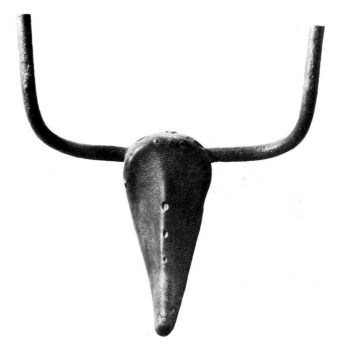

6–17 PABLO PICASSO
Bull's Head (1943). Bronze cast of parts of a bicycle. Height: 16⅛″.

Réunion des Musées Nationaux, France.

6–16 RICHARD STANKIEWICZ
Figure (1955). Steel. 80 x 20½ x 19¼″.

Hirshhorn Museum and Sculpture Garden, Smithsonian Institution, Washington, D.C.

Ready-Mades

The assemblages of Nevelson, Stankiewicz, and Picasso are constructed from found objects. Early in this century Marcel Duchamp (discussed in Chapter 16) declared that found objects, or **ready-mades,** such as bottle racks and urinals, could be literally elevated as works of art by being placed on pedestals—literally or figuratively. No assembly required. The urinal in Figure 1–28 could be turned on its back, to put the object in a new context, and given the title *Fountain*. These adjustments were said by the artist to provide the object with a new *idea*. Duchamp argued that the dimension of taste, good or bad, was irrelevant. The function of the ready-made—not that it needed one—was to prompt the spectator to think, and to think again.

Duchamp recognized that artists could take advantage of the concept of the ready-made object and substitute cleverness for solid work should the "making" of ready-mades become a habit. For this reason Du-champ advised that artists elevate common objects to the realm of art only a few times each year.

Mixed Media

In **mixed media** constructions and assemblages, sculptors use materials and ready-made or found objects that are not normally the elements of a work of art. Contemporary painters also sometimes "mix" their media by attaching objects to their canvases. Robert Rauschenberg, discussed in Chapter 17, has attached ladders, chairs, and electric fans to his paintings and run paint over them as if they were continuations of the canvas. What do we call the result—painting or sculpture?

Greek-born contemporary artist Lucas Samaras has constructed boxes with knives, razor blades, and other menacing objects that are frequently accompanied by delicate shells, pieces of colored glass, and mysterious and sensuous items of personal import. *Untitled Box No. 3* (Fig. 6–18) is constructed

6–18 LUCAS SAMARAS
Untitled Box Number 3 (1963)
Pins, rope, stuffed bird
and wood. 24½ x 11½ x 10¼".

Collection of Whitney Museum
of American Art. Gift of the Howard and
Jean Lipman Foundation, Inc.

from wood, pins, rope, and a stuffed bird. The viewer is drawn masochistically to touch such frightening sculptures, to test their eroticism and their danger.

The sculptural environment known as the *Simon Rodia Towers in Watts* (Fig. 6–19) were constructed by an Italian-born tile setter who immigrated to Watts, a poor neighborhood in Los Angeles. Rodia's whimsical towers are built sturdily enough—of cement on steel frames, the tallest one rising nearly 100 feet. As a mixed-media assemblage, the towers are coated with debris such as mirror fragments, broken dishes, shards of glass and ceramic tile, and shells. The result is a lacy forest of spires that glisten with magical patterns of contrasting and harmonious colors. The towers took 33 years to erect and were built by Rodia's own hands. Rodia, by the way, knew nearly nothing of the world of art.

6–19 SIMON RODIA
Simon Rodia Towers in Watts (1921–54)
Cement with various objects. 98' high.
Cultural Affairs Department, Los Angeles.

6–20 ALEXANDER CALDER *Zarabanda* (1955). Painted sheet metal, metal rods and wire. 33 x 89½ x 21½".

Hirshhorn Museum and Sculpture Garden, Smithsonian Institution, Washington, D.C.

Kinetic Sculpture

Sculptors have always been concerned with the portrayal of movement, but **kinetic sculptures** actually do move. Movement may be caused by the wind, magnetic fields, jets of water, electric motors, variations in the intensity of light, or the active manipulation of the observer. During the 1930s the American sculptor Alexander Calder was one of the early pioneers of the first form of art that made motion as basic an element as shape or color—the mobile. As in *Zarabanda* (Fig. 6–20), carefully balanced weights are suspended on wires such that the gentlest current of air sets them moving in prescribed orbits. The weights themselves are colorfully reminiscent of animals, fish, leaves, and petals.

In George Rickey's *Four Lines Oblique Gyratory II* (Fig. 6–21), sensitively balanced blades of stainless steel are driven by the breeze. A sense of weightlessness belies the actual mass of the blades that gently but persistently explore new relationships to one another. The air through which the blades revolve, the changing backdrop of sky and cloud—these, too, become an integral part of the work as the observer tries to divine the kinetic possibilities.

Among the kinetic sculptures are the intendedly absurd machines of Swiss-French sculptor Jean Tinguely. As we shall see in Chapter 17, some of Tinguely's machines, such as the scorpion-like *Meta-matic No. 9* (Fig. 6–22), were constructed to "create" "art." In this case, ballpoint pens—one of our less aesthetic contemporary expressive media—were affixed to agitated arms that moved about at random within certain limits. There are, of course, multiple layers of satire. The age of the machine, the conveyor belt, the automatized contraption, even the works of the artist's contemporaries fall prey to Tinguely's commentary.

6–21 GEORGE RICKEY
Four Lines Oblique Gyratory II (1972)
4 stainless steel blades, each 15′
(40′ maximum)
Collection of the artist.

6–22 JEAN TINGUELY
Meta-matic No.9 (1954)
Motorized kinetic sculpture. 35½″ high.
Museum of Fine Arts, Houston. Gift of D. and J. de Menil.

Light Sculpture

Light has always been an important element in the visual arts, but only in the twentieth century have artists used sources of light as materials. Inspired by the fluorescent commercial lettering of the urban scene, the Greek-born Chryssa was the first American artist to use electric light and neon in sculp-ture. In *Fragments for the Gates to Times Square* (Fig. 6–23), she assembles neon signs to produce a rhythmic arrangement that seems to idealize, rather than satirize, contemporary technology and the city environment. The repetition of the lines of light can produce a pulsating illusion that imbues the work with animation.

6–23 CHRYSSA
Fragment for the Gates to Times Square (1966) Neon and plexiglass. 81 x 34½ x 27½" (with base).

Collection of Whitney Museum of American Art, N.Y. Gift of Howard and Jean Lipman.

Earthworks

In **earthworks** or Land Art, large amounts of earth or land are shaped into a sculpture. In a sense, earthworks are nothing new. Native American sand paintings, Zen rock gardens, Stonehenge, and contour farming provide ample precedent. But in their contemporary form earthworks originated in the 1960s as something of a literal return to nature. As expressed by land artist Robert Smithson, "Instead of putting a work of art on some land, some land is put into the work of art." Perhaps earthworks were a reaction against some of the highly industrialized, unnatural materials that had found their way into sculpture throughout the earlier years of the century. Earthworks are also likely to appeal to the human desire to give shape to rude matter on a grand scale.

Contemporary earthworks include great trenches and drawings in the desert, collections of rocks, shoveled rings in ice and snow, and installations of masses of earth on the urban gallery floor. Smithson's *Spiral Jetty* (Fig. 6–24) in Utah's Great Salt Lake is composed of earth and related natural materials. Observers may try to find microscopic and macroscopic symbolism in the jetty: its shape might suggest the spiraling strands of the DNA that composes our basic genetic material, as well as the shape of galaxies. The mass of the jetty stands somewhere between these extremes and also forms a relationship between earth and water.

In the next chapter we will turn our attention to the shaping of materials into structures that house our work, our play, our family life, our worship, and our sleep—architecture.

6–24 ROBERT SMITHSON
Spiral Jetty (1970) Great Salt Lake, Utah.
Black rocks, salt, earth, water, algae. Length: 1,500'.
Width: 15'.

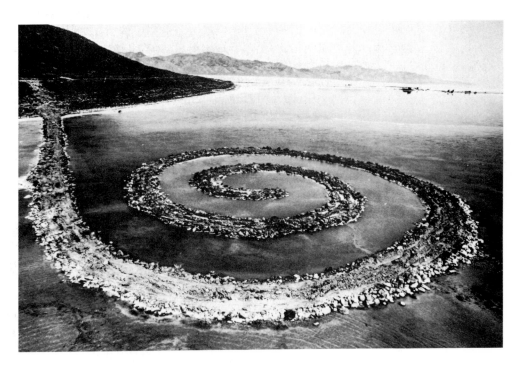

Christo: Of Running Fences and Skirted Islands

In 1968 Bulgarian-born artist Christo Javacheff, known professionally simply as Christo, told a reporter that in the future artworks would have the scale of the Great Wall of China. In September 1976 the *Running Fence* (Fig. 6–25), the best known of Christo's works, was completed in northern California. While the fence did not have the scale of the Great Wall, its 24½ miles of shimmering white nylon slung between steel posts did run from the sea at Bodega Bay across the hills and dales of Marin and Sonoma counties.

Running Fence was a spectacular work and, to many, a spectacle. At dawn and at dusk the nylon took on a purple cast. In the brilliant sun, black clung to the inner shadows. Blues and browns reflected sky and earth. All this required 165,000 yards of nylon, 2,050 posts, 300 students, countless hooks, and miles and miles of wire. The Herculean effort was dismantled in two weeks. It had run its course.

Christo raises the vast sums of capital needed to finance his environmental sculptures by selling sketches and studies. *Running Fence* cost more than $2 million, much of it for legal fees to combat suits brought by concerned environmentalists. In more recent times, Christo has failed to convince the city of New York to grant permission to construct thousands of 15-foot-high steel gates draped with gold-colored cloth across Central Park—a chain that would have linked disparate ethnic and socioeconomic segments of the metropolis.

Other cities have been more open to Christo's concepts. In 1983 he skirted ten small islands off Miami in floating pink fabric. From the air the islands were transformed into colorful lily pads. After two weeks the islands, like the California landscape before them, lost their finery. "Art must disappear," noted Christo. "Art doesn't exist forever." But perhaps the photographic record of his works will last as long as sculptures carved from marble.

6–25 CHRISTO *Running Fence* (1972–76). Installed in Sonoma and Marin counties, California, for two weeks, fall, 1976. Nylon fabric and steel poles. Height: 18';
length: 24½ miles.

7

Architecture

Early humans looked for and found their shelters—the mouth of a yawning cave, the underside of a ledge, the boughs of an overspreading tree. But for thousands of years we having been building shelters and fashioning them to our needs. Before we became capable of transporting bulky materials over vast distances, we had to rely on local possibilities. Native Americans have constructed huts from sticks and bark and conical tepees from animal skins and wooden poles. They have also carved their way into the sides of cliffs, as we shall see. African villagers have woven sticks and grass into walls and plastered them with mud; their geometrically pure cone roofs sit atop cylindrical bases. Desert peoples have learned to dry clay in the sun in the form of bricks. From ice the Eskimo has fashioned the dome-shaped igloo.

Architecture is the art and science of designing buildings, bridges, and other structures to help us meet our personal and communal needs.

Of all the arts, architecture probably has the greatest impact on our daily lives. For most of us, architecture determines the quality of the environments in which we work, play, meditate, and rest.

Architecture is also a vehicle for artistic expression in three dimensions. More than any other art form, architecture is experienced from within as well as without, and at great length. If sculptures have fronts, backs, sides, tops, and bottoms, buildings have **façades,** foundations, roofs, and a variety of interior spaces that must be planned. If some sculptures are kinetic and some are composed of light sources, buildings may contain complex systems for heating, cooling, lighting, and inner transportation.

Architects, like sculptors, must work within the limits of their materials and the technology of the day. In addition to understanding enough of engineering to determine how materials may be used efficiently to span and enclose sometimes vast spaces, architects must work with other professionals and with contractors who design and install elements of the **service systems** of their buildings.

In a sense the architect is not only an artist but a mediator—a compromiser. The architect mediates between the needs of the client and the properties and aesthetic possibilities of the site. (Today's technology permits the erection of twenty-story high, twenty-feet wide "sliver skyscrapers" on expensive, narrow urban sites, but at what aesthetic cost to a neighborhood of row houses?) The architect balances aesthetics and the building codes of the community. (Since the 1930s architects in New York City have had to comply with the so-called set-back law and step back or contour their highrises back from the street in order to let the sun shine in on an environment which seemed in danger of devolving into a maze of blackened canyons.) Climate, site, materials, building codes, clients, contractors, service systems, and the amount of money available—these are just some of the variables that the architect must employ or

contend with, to create an aesthetically pleasing, functional structure.

In this section we will explore traditional and modern ways in which architects have come to terms with these variables. We will survey the traditional materials and methods associated with building in stone and wood. Then we will examine a number of modern and contemporary architectural materials and methods, including those associated with cast iron and steel cage construction, use of reinforced concrete, and steel cable. Finally we will have a look at some innovative approaches that reflect the recent rise in energy costs: solar and underground or earth-sheltered structures.

STONE ARCHITECTURE

As a building material, stone is massive and virtually indestructible. Contemporary woodframe homes frequently sport stone fireplaces, perhaps as a symbol of permanence and strength as well as of warmth. The Native American cliff dwellings at Mesa Verde, Colorado (Fig. 7–1) could be considered something of an "earthwork high relief." The cliff itself becomes the back wall or "support" of more than one hundred rectangular apartments. Circular, underground **kivas** served as community centers. Construction with stone, **adobe,** and timber creates a mixed media functional fantasy. Early man also assembled stone temples and memorials.

Post and Lintel Construction

The prehistoric Stonehenge (see Fig. 10–4) probably served religious or astronomical purposes. Its orientation toward the sun and its layout in concentric circles is suggestive of the amphitheaters and temples to follow. Stonehenge is an early example of **post and lintel** construction (Fig. 7–2a). Two stones were set upright as supports and a third

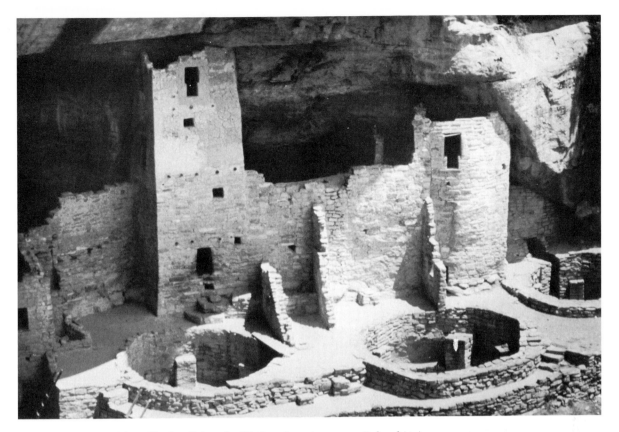

7–3 Cliff Palace, Mesa Verde, Colorado (Native American, pre-Columbian).
U.S. Department of the Interior.

was placed across them, creating an opening beneath. How the massive blocks of Stonehenge were transported and erected remains a mystery.

Early stone structures were erected without benefit of mortar. Their **dry masonry** relied on masterly carving of blocks, strategic placement, and sheer weight for durability. Consider the imposing ruin of the fortress of Machu Picchu, perched high above the Urubamba River in the Peruvian Andes. Its beautiful granite walls (Fig. 7–3), constructed by the Incas, are pieced together so perfectly that not even a knife blade can pass between the blocks. The faces of the great Pyramids of Egypt (Fig. 10–13) are assembled as miraculously, perhaps even more so considering the greater mass of the blocks.

Stone became the favored material for the public buildings of the Egyptians and the Greeks. The Egyptian Temple of Amen-Re at Karnak (Fig. 7–4) and the Parthenon (Fig. 11–8) of the Classical period of Greece begin to speak of the elegance as well as the massiveness that can be fashioned from stone. The Temple of Amen-Re is of post and lintel construction, but the paintings, relief sculptures, and overall smoothness of the columns belie their function as bearers of stress. The virtual forest of columns was a structural necessity because of the weight of the massive stone lintels. The Parthenon is also of post and lintel construction. Consistent with the Greeks' emphasis on the functional purpose of columns, the surfaces of the marble shafts are free from ornamentation. The Parthenon, which may be the most studied and surveyed building in the world, is discussed at length in Chapter 11.

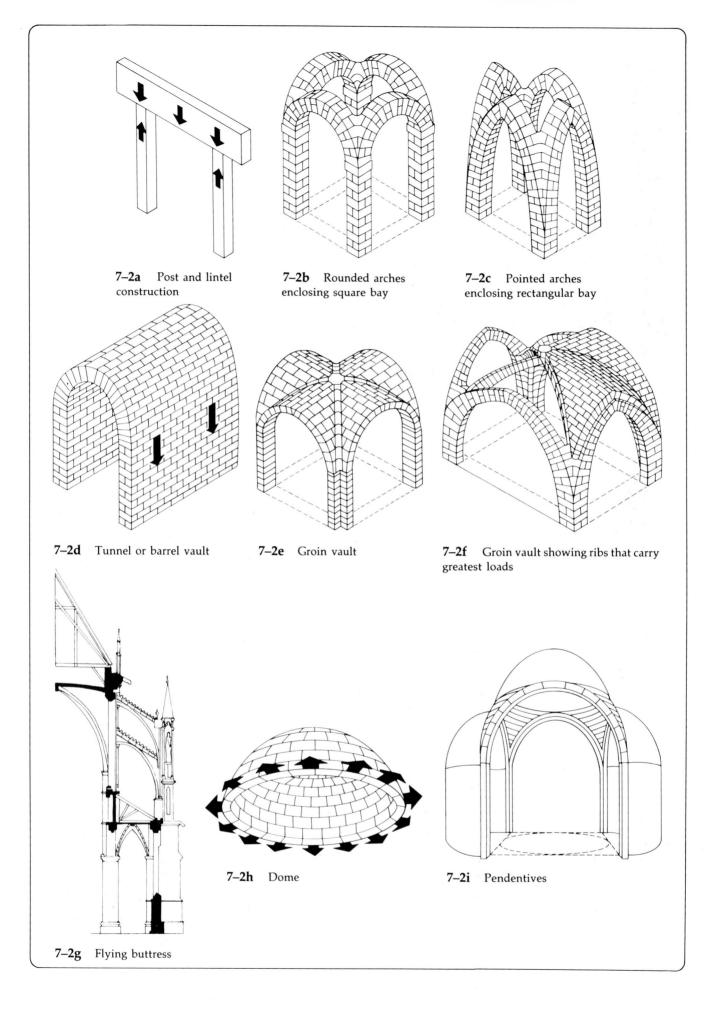

7–2a Post and lintel construction

7–2b Rounded arches enclosing square bay

7–2c Pointed arches enclosing rectangular bay

7–2d Tunnel or barrel vault

7–2e Groin vault

7–2f Groin vault showing ribs that carry greatest loads

7–2g Flying buttress

7–2h Dome

7–2i Pendentives

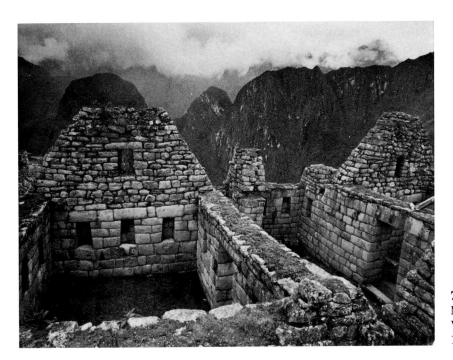

7–3 Walls of Fortress of Machu Picchu, Urubamba Valley, Peru (Incan, 1490–1530).

7–4 Temple of Amen-Re, Karnak (Egyptian, XVIII Dynasty, 1570–1342 B.C.)

7–5 EERO SAARINEN Jefferson National Expansion Memorial, Gateway Arch, St. Louis, Mo. (1966)

Arches

Architects of stone also use **arches** to span distances (see Figs. 7–2b and c). Arches have many functions, including supporting other structures, such as roofs, and serving as actual and symbolic gateways. An Arch of Triumph, as in the city of Paris, provides a visual focus for the return of the conquering hero. Eero Saarinen's Gateway Arch (Fig. 7–5), completed in St. Louis in 1965, stands 630 feet tall at the center and commemorates the westward push of the United States after the Louisiana Purchase of 1803. The Pont du Gard (Fig. 11–22) near Nîmes, France, employs the arch in a bridge that is part of an **aqueduct** system discussed in Chapter 11. It is a marvel of Roman engineering. Early masonry arches were fashioned from **bricks;** each limestone block of the Pont du Gard weighs up to two tons, and they were assembled without benefit of mortar. The bridge stands and functions today, two millennia after its creation.

In most arches wedge-shaped blocks of stone, called **voussoirs,** are gradually placed in position ascending a wooden scaffold called a **centering.** When the center or **keystone** is set in place, the weight of the blocks is all at once transmitted in an arc laterally and downward, and the centering can be removed. The pull of gravity on each block serves as "cement"; that is, the blocks fall into one another so that the very weight that had made their erection a marvel now prevents them from budging. The **compressive strength** of stone allows the builder to place additional weight above the arch. The Pont du Gard consists of three **tiers** of arches, 161 feet high.

Vaults

An extended arch is called a **vault.** A tunnel or **barrel vault** (see Fig. 7–2d) simply places arches behind one another until a desired depth is reached. In this way impressive spaces may be roofed and tunnels may be constructed. Unfortunately, the spaces enclosed by barrel vaults are dark, since piercing them to let in natural light would compromise their strength. The communication of stresses from one arch to another also requires that the centering for each arch be kept in place until the entire vault is completed.

Roman engineers are credited with the creation of the **groin vault,** which overcame limitations of the barrel vault, as early as the third century A.D. Groin vaults are constructed by placing barrel vaults at right angles to cover a square space (see Fig. 7–2e). In this way the load of the intersecting vaults is transmitted to the corners, necessitating **buttressing** at these points but allowing the sides of the square to be open. The square space enclosed by the groin vault is called a **bay.** Architects could now construct huge buildings by assembling any number of bays. Since the stresses from one groin vault are not transmitted to a large degree to its neighbors, the centering used for one vault can be removed and reused while the building is under construction.

The greatest loads in the groin vault are thrust onto the four arches that comprise the sides and the two arches that run diagonally across them. If the capacity of these diagonals is increased to carry a load, by means of **ribs** added to the vault (see Fig. 7–2f), the remainder of the roof can be fashioned from stone **webbing** or other materials much lighter in weight. A true stone skeleton is created.

Note from Figure 7–2b that rounded arches can enclose only square bays. One could not use rounded arches in rectangular bays because the longer walls would have higher arches. Architects over the centuries solved the rectangular bay problem in a number of ingenious ways. The most important of these is found in **Gothic** architecture, discussed in Chapter 12, which uses ribbed vaults and **pointed arches.** Pointed arches can be constructed to uniform heights even when the sides of the enclosed space are unequal (see Fig. 7–2c). Gothic architecture also employed the so-called **flying buttress** (Fig. 7–2g), a masonry strut which transmits part of the load of a vault to a buttress positioned outside a building.

Most of the great cathedrals of Europe achieve their vast open interiors through the use of vaults. Massive stone rests benignly above the heads of worshippers and tourists alike, transmitting its brute load laterally and downward. The **Ottonian** St. Michael's (Fig. 12–15), built in Germany between 1001 and 1031 A.D., uses barrel vaulting. Its bays are square, and its walls are blank and massive. The **Romanesque** St. Sernin (Fig. 12–17), built in France between about 1080 and 1120, uses round arches and square bays. The walls are heavy and blunt, with the main masses subdivided by buttresses. St. Étienne (Fig. 12–19), completed between 1115 and 1120, has high rising vaults—some of the earliest to show true ribs—that permit light to enter through a **clerestory.** Stone became a fully elegant structural skeleton in the great Gothic cathedrals such as those at Laon (Figs. 12–23 and 12–24) and Chartres (Fig. 12–27) and in the Notre Dame of Paris (Fig. 12–25). Lacy buttressing and ample **fenestration** lend these massive buildings an airy lightness that seems consonant with their mission of directing upward the focus of human awareness.

7–6 BUCKMINSTER FULLER United States Pavilion, Expo 67, Montreal (1967)

Domes

Domes are hemispherical forms that are rounded when viewed from beneath (see Fig. 7–2h). Like vaults, domes are extensions of the principle of the arch and are capable of enclosing vast reaches of space. (Buckminster Fuller, who designed the American Pavilion [Fig. 7–6] for the 1967 World's Fair in Montreal, proposed that the center of Manhattan should be enclosed in a weather-controlled transparent dome two miles in diameter.) Stresses from the top of the dome are transmitted in all directions to the points at which the circular base meets the foundation, walls, or other structures beneath.

The dome of the Buddhist temple or Stupa of Sanchi, India, completed in the first century A.D., rises 50 feet above the ground and causes the worshipper to contemplate the dwelling place of the gods. It was constructed from stones placed in gradually diminishing concentric circles. Visitors find the domed interior of the Pantheon of Rome (Fig. 11–25), completed during the second century A.D., breathtaking. Like the dome of the Stupa, the rounded inner sur-

face of the Pantheon, 144 feet in diameter, symbolizes the heavens.

The dome of the vast Hagia Sophia (Fig. 12–8) in Constantinople is 108 feet in diameter. Its architects, building during the sixth century A.D., used four triangular surfaces called **pendentives** (see Fig. 7–2i) to support the dome on a square base. Pendentives transfer the load from the base of the dome to the **piers** at the corners of the square beneath.

Stone today is rarely used as a structural material. It is expensive to quarry and transport, and it is too massive to handle readily at the site. Metals are lighter and have greater tensile strength, and so they are suitable as the skeletons or reinforcers for most of today's larger structures. Still, buildings with steel skeletons are frequently dressed with thin façades or **veneers** of costly marble, limestone, and other types of stone. Residents of New York State were scandalized during the 1960s to learn that the public coffers had funded the purchase of marble worth several years' production of the entire state of Vermont in order to cloak the steel monoliths of the capital's office mall with dignity. On a smaller scale, many tract homes are granted decorative patches of stone across the front façade and slabs of slate are frequently used to provide minimum-care surfaces for entry halls or patios in private homes.

WOOD ARCHITECTURE

Wood is as beautiful and versatile a material for building as it is for sculpture. It is abundant and, as many advertisements have proclaimed, a renewable resource. It is relatively light in weight and is capable of being worked on the site with readily portable hand tools. Its variety of colors and grains as well as its capacity to accept paint or to weather charmingly when left in its natural state make wood a ubiquitous material. Wood, like stone, can be used as a structural element or as a façade. In many structures it is used as both.

Wood also has its drawbacks. As was noted earlier, it warps and cracks. It rots. It is also highly flammable and stirs the appetite of termites and other devouring insects. However, modern technology has enhanced the stability and strength of wood as a building material. Chemical treatments decrease wood's vulnerability to rotting from moisture. **Plywood,** which is built up from sheets of wood glued together, is unlikely to warp and is frequently used as an underlayer in the exterior walls of small buildings and homes. Laminated wood beams possess great strength and are also unlikely to become distorted in shape from exposure to changing temperatures and levels of humidity.

Architect Paul Schweikher's contemporary northern Arizona home (Figs. 7–7 and 7–8) is a Japanese-inspired clean design of glass and wood in which sturdy but graceful fir timbers provide both a structural system and a primary source of decoration. The cedar **siding** exudes both warmth and crisp elegance. Timbers and siding are integrated into the surrounding red rock country by means of a crushed red sandstone driveway, a rock path bordered in red gravel, and a floor throughout of 4- by 8-inch **quarry tile.** There are times during the day when the light is such that the huge panels of glass seem to melt away and the house is very much one with the butte on top of which it sits.

7–7 PAUL SCHWEIKHER
Schweikher House, Sedona, Arizona (1972)

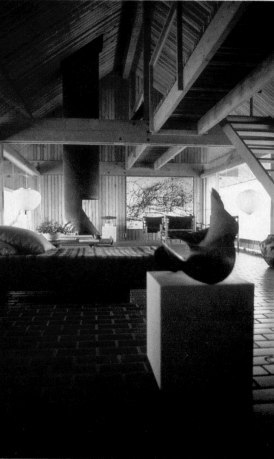

7–8 PAUL SCHWEIKHER
Interior of Schweikher House

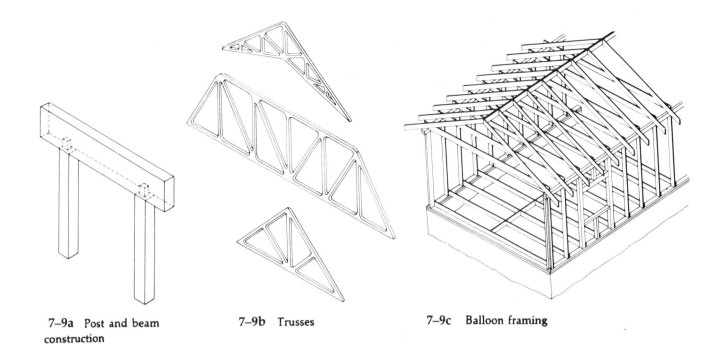

7–9a Post and beam construction

7–9b Trusses

7–9c Balloon framing

Post and Beam Construction

Schweikher's house is of **post and beam** construction (Fig. 7–9a), which is similar to post and lintel construction; vertical and horizontal timbers are cut and pieced together with wooden pegs. The beams span openings for windows, doors, and interior spaces, and they can also support posts for another story or roof trusses.

Trusses

Trusses are lengths of wood, iron, or steel pieced together in triangular shapes of the sort shown in Figure 7–9b in order to expand the abilities of these materials to span distances. Trusses acquire their strength from the fact that the sides of a triangle, once joined, cannot be forced out of shape. In many buildings, roof trusses are exposed and become elements of the design.

Balloon Framing

Balloon framing (Fig. 7–9c), a product of the industrial revolution, dates back to the turn of the century. In balloon framing factory-cut "studs," including the familiar two-by-four, are mass produced and assembled at the site by thousands of factory-produced metal nails. Several light, easily handled pieces of wood replace the heavy timber of post and beam construction. Entire walls are framed in place or on their sides and then raised into place by a crew of carpenters. The multiple pieces and geometric patterns of balloon framing give it a sturdiness that rivals that of the post and beam, permitting the support of slate or tile roofs, but the name "balloon" was originally a derisive term: Inveterate users of post and beam were skeptical that the frail-looking wooden pieces could provide a rugged building.

Balloon framing, of course, has now been used on millions of smaller buildings, not only homes. Sidings for balloon-framed homes have ranged from **clapboard** to asbestos shingle, brick and stone veneer, and aluminum. Roofs have ranged from asphalt or cedar shingle to tile and slate. These materials vary in cost, and each has certain aesthetic possibilities and practical advantages. Aluminum, for example, is lightweight, durable, and maintenance-free. However, when aluminum siding is shaped like clapboard and given a bogus grain, the intended *trompe l'oeil* effect usually fails and can create something of an aesthetic embarrassment.

Two other faces of wood are observable in American architect Richard Morris Hunt's Griswold House (Fig. 7–10), built at Newport, Rhode Island, in 1862–1863 in the *Stick style*, and in the Cape Cod style home in Levittown, Long Island, a suburb of New York City (Fig. 7–11). The Griswold House shows the fanciful possibilities in wood. The Stick style sported a skeletal treatment of exteriors that remind one of an assemblage of matchsticks, open interiors, and a curious interplay of voids and solids and horizontal and vertical lines. Shapes proliferate in this short-lived movement. Turrets and gables and dormers poke the roof in every direction. Trellised porches reinforce a certain wooden laciness. One cannot imagine the Griswold House constructed in any material but wood.

The house at Levittown is more than a home; it is a socio-aesthetic comment on the need for mass suburban housing that impacted so many metropolitan regions during the marriage and baby boom that followed World War II. This house and 17,000 others almost exactly like it were built, with few exceptions, on 60- by 100-foot lots that had been carved out from potato fields. In what was to become neighborhood after neighborhood, bulldozers smoothed already flat terrain and concrete slabs were poured. Balloon frames were erected, sided, and roofed. Trees were planted; grass was sown. The houses had an eat-in kitchen, living room, two tiny bedrooms, and one bath on the first floor, and an expansion attic. Despite the tedium of the repetition, the original Levittown house achieved a sort of architectural integrity, providing living space, the pride of ownership, and an inoffensive façade for a modest price. Driving through Levittown today, it seems that every occupant thrust random additions in random directions as the family grew, despite the limitations of the lots. The trees only partly obscure the results.

7–10 RICHARD M. HUNT
J. N. A. Griswold House, Newport, R.I. (1862–63)

7–11 Cape Cod style houses built by Levitt & Sons, N.Y. (c. 1947–51)

A Pyramid in Paris

The controversy hit long before the first bulldozers. In 1983, President François Mitterrand of France used his authority to engage the Chinese-born American I. M. Pei as architect for the much-needed renovation of the Louvre; and when Pei's sleekly contemporary design emerged, it generated public outrage on both political and cultural grounds [Fig. 7–12].

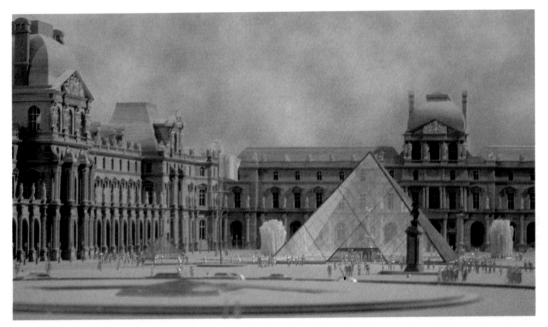

7–12 I. M. PEI Pyramid constructed at the Louvre, Paris (1988)

Pei designed a network of underground rooms and walkways beneath the Cour Napoléon, the courtyard between the museum's two wings. The added space will serve as a public entryway and reception area, and will house facilities—conference rooms, storage areas, restaurants, information booths and the like—that the museum has always been lacking. Digging began in 1985; the new space opened in the fall of 1988. The focus of longstanding complaint is a mammoth pyramid—61 feet high at the apex, 108 feet wide at the base, and comprised of 105 tons of glass. It shelters the underground addition and stands in modern juxtaposition to the Palais du Louvre, whose first wing was erected by François I in 1527.

Mitterand, who unveiled the pyramid in an official ceremony, was attacked by those who object to a foreigner's interfering with the design of a French cultural landmark. He has been accused of defacing the nation's cultural heritage in order to leave his own personal mark. And the pyramid itself has been criticized as inappropriate, out of sync with the French spirit in general, and the Louvre's architecture in particular. Of course, in 1889, when the Eiffel Tower was erected for the Paris exposition, no one was crazy about it either. As for the pyramid, opinion polls indicate that Parisians have come around.

Nineteenth-century industrialization also introduced **cast iron** as a building material. It was one of a number of structural materials that would change the face of architecture. Cast iron was a welcome alternative to stone and wood. Like stone, iron has great strength, is heavy, and has a certain brittleness, yet it was the first material to allow the erection of tall buildings with relatively slender walls. Slender iron beams and bolted trusses are also capable of spanning vast interior spaces, freeing them from the forests of columns that are required in stone.

At the mid-nineteenth–century Great Exhibition held in Hyde Park, London, Sir Joseph Paxton's Crystal Palace (Fig. 7–13) covered seventeen acres. Like subsequent iron buildings, the Crystal Palace was **prefabricated.** Iron parts were cast at the factory,

not the site. The new railroads facilitated their transportation, and it was a simple matter to bolt them together at the Exhibition. It was also a relatively simple matter to dismantle the structure and reconstruct it at another site. The iron skeleton, with its myriad arches and trusses, was an integral part of the design. The huge plate-glass paneled walls bore no weight. Paxton asserted that "nature" had been his "engineer," explaining that he merely copied the system of longitudinal and transverse supports that one finds in a leaf. Earlier architects were also familiar with the structure of the leaf, but they did not have structural materials at hand that would permit them to build, much less conceptualize, such an expression of natural design.

The Crystal Palace was moved after the Exhibition, and until heavily damaged by fire, it served as a museum and concert hall. It was demolished in 1941 during World

7–13 Engraving of Sir Joseph Paxton's Crystal Palace, London (1851)
Victoria and Albert Museum, London.

7–14 GUSTAVE EIFFEL
Eiffel Tower, Paris (1889)

War II, after it was discovered that it was being used as a landmark by German pilots on bombing runs.

The Eiffel Tower (Fig. 7–14) was built in Paris in 1889 for another industrial exhibition. At the time, Gustave Eiffel was castigated by critics for building an open structure lacking the standard masonry façade. Today the Parisian symbol is so familiar that one cannot visualize it without its magnificent exposed iron trusses. The pieces of the 1,000-foot-tall tower were prefabricated, and the tower was assembled at the site in 17 months by only 150 workers.

Structures such as these encouraged steel-cage construction and the development of the skyscraper.

STEEL-CAGE ARCHITECTURE

Steel is a strong metal of iron alloyed with small amounts carbon and a variety of other metals. Steel is harder than iron, and more rust- and fire-resistant. It is more expensive than other structural materials, but its great strength permits it to be used in relatively small quantities. Light, narrow, prefabricated "I" beams have great tensile strength. They resist bending in any direction and are riveted or welded together into skeletal forms called **steel cages** at the site. Façades and inner walls are hung from the skeleton and frequently contribute more mass to the building than does the skeleton itself.

7–15 LOUIS SULLIVAN
Wainwright Building, St. Louis, Missouri (1890)

The Wainwright Building (Fig. 7–15), erected in 1890, is an early example of steel-cage construction. Architect Louis Sullivan, one of the fathers of modern American architecture, emphasized the verticality of the structure by running **pilasters** between the windows through the upper stories. Many skyscrapers run pilasters up their entire façades. Sullivan also emphasized the horizontal features of the Wainwright Building. Ornamented horizontal bands separate most of the windows, and a severe decorated **cornice** crowns the structure. Sullivan's motto was "form follows function," and the rigid horizontal and vertical processions of the elements of the façade suggest the regularity of the rectangular spaces within. Sullivan's early "skyscraper"—in function, in structure, and in simplified form—was a precursor of the twentieth-century behemoths to follow.

Two of these behemoths are New York City's **Modernist** Lever House (Fig. 7–16) and the Seagram Building (Fig. 7–17), which are situated across the street from one another on Park Avenue. Lever House was designed by Gordon Bunshaft of Skidmore, Owings, and Merrill, a firm that quickly became known for its "minimalist" rectangular solids with their "curtain walls" of glass. The nation was excited about the clean, austere look of Lever House, and about its donation of open plaza space to the city. The plaza prevents the shaft from overwhelming its site. The evening light angles down across the plaza and illuminates the avenue beneath.

In form, the Seagram Building, like the Wainwright Building and Lever House, is also very much an expression of its steel-cage construction. Instead of allowing light to sweep onto Park Avenue by terracing the building, architects Mies van der Rohe and Philip Johnson have emphasized the sheer strength of steel in an elegant monolith clad in bronze whose height achieves their client's quest for floor space while occupying only half its site. The slender columns and unornamented façade speak of a purely twentieth-century aesthetic.

7–17 MIES VAN DER ROHE and PHILIP JOHNSON Seagram Building, New York (1958)

7–16 GORDON BUNSHAFT
Lever House, New York (1951–52)

The Seagram Building, like a number of other Manhattan buildings—Lever House, the World Trade Center, and the Chase Manhattan Bank Building—relates to human passers-by and visitors by way of a platform or plaza that provides a visual frame as well as recreational or exhibition space. Reflecting pools and fountains, a sweeping staircase from the avenue, a receded glass curtain at ground level, and an entry canopy further tie the Seagram Building to its site and give it a human scale.

By the mid-1970s, the clean Modernist look of buildings such as the Seagram were overwhelming the urban cityscape. A few buildings of the kind—even a few dozen buildings of the kind—would have been most welcome, but now architectural critics

7–18 BURGEE ARCHITECTS with PHILIP JOHNSON AT&T Corporate Headquarters, New York (1984)

were arguing that a national proliferation of steel-cage rectangular solids was threatening to bury the nation's cities in boredom. Said John Perrault in 1979, "We are sick to death of cold plazas and 'curtain wall' skyscrapers."

The critics were heard. By the end of the 1970s, a new steel-cage monster was being bred throughout the land—one that utilized contemporary technology but drew freely from past styles of ornamentation. These structures, which are **Postmodernist,** disdain the formal simplicity and immaculate finish of Modernist structures and make a more democratic appeal to the person in the street.

The same Philip Johnson who had collaborated with Mies van der Rohe to fashion the Seagram Building also designed New York's AT&T Building (Fig. 7–18). Like many other Postmodernist structures, it is

something of an architectural assemblage. Pop elements from the history of architecture are wedded to the familiar cage of steel. High atop the sweeping pink stone façade sits a Classical broken pediment, a fragment from the architectural past. How do we characterize the AT&T Building: bold? brilliant? bastardized? beautiful? ugly? nonconformist? provocative? ludicrous? It is all of that. In my opinion it is also fun to look at—a feeling quite at odds with my first impression.

If the AT&T Building is a steel-cage structure with a Chippendale hat, Michael Graves's steel-cage Humana Building (Fig. 7–19) is reminiscent of a Sphinx or of an Egyptian pharaoh seated on a throne. A high vaulted glass entryway dissolves the heavy "legs" which, left and right, look something like a pair of unwilling Wainwright Buildings. The alternation of ex-

panses of glass with small windows punched through stone suggests that the overriding rule is that rules are made to be broken.

A more surprising, and rather unique, example of steel-cage architecture is found in Mies van der Rohe's Farnsworth House (Fig. 7–20). The rhythmic procession of white steel columns suspend it above the Illinois countryside. In its perfect technological elegance, it is in many ways visually remote from its site. Why steel? Less expensive wood could have supported this house of one story and short spans, and wood might have appeared more natural on this sylvan site. The architect's choices, of course, may be read as a symbol of our contemporary remoteness from our feral past. If so, the architect seems to believe that the powerful technology that has freed us is to the good, for the house is as beautiful as it is austere in ornamentation. Like the Seagram Building, the Farnsworth House has platforms, steps, and a glass curtain wall (as on Seagram's ground level) that allows the environment to flow through. In both cases the steps and platforms provide access to a less well-ordered world below.

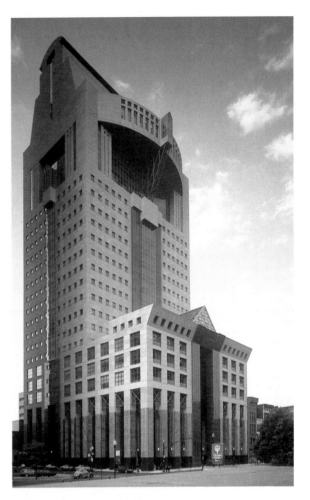

7–19 MICHAEL GRAVES
Humana Building, Louisville, Kentucky (1986)

7–20 MIES VAN DER ROHE Farnsworth House, Fox River, Plano, Illinois (1950)

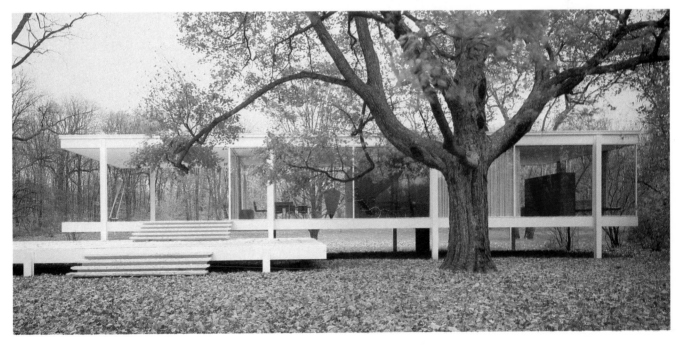

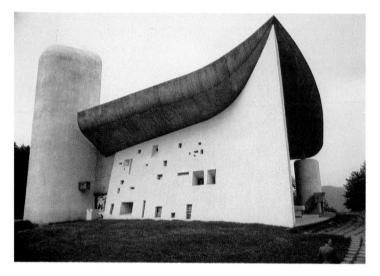

7–21 LE CORBUSIER
Chapel of Notre-Dame-du-Haut, Ronchamp, France
(1950–54)

7–22 LE CORBUSIER
Interior, South Wall, Notre-Dame-du-Haut

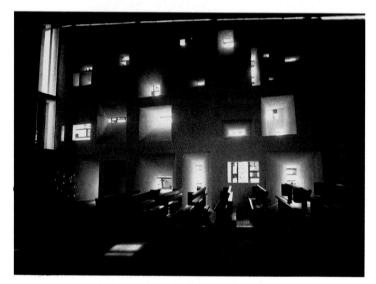

REINFORCED CONCRETE ARCHITECTURE

Although cement was first produced in the early 1800s, the use of **reinforced concrete** is said to have begun with a French gardener, Jacques Monier, who proposed strengthening concrete flower pots with a wire mesh in the 1860s. In reinforced or **ferroconcrete,** steel rods and/or steel mesh are inserted at the points of greatest stress into concrete slabs before they harden. In the resultant slab, stresses are shared by the materials.

Ferroconcrete has many of the advantages of stone and steel, without some of the disadvantages. The steel rods increase the tensile strength of concrete, making it less susceptible to tearing or pulling apart at stress points. The concrete in turn prevents the steel from rusting. Reinforced concrete can span greater distances than stone, and it supports more weight than steel. Perhaps the most dramatic advantage of reinforced concrete is its capacity to take on natural curved shapes that would be unthinkable in steel or concrete alone. Curved slabs take on the forms of eggshells, bubbles, seashells, and other organic shapes that are naturally engineered for the even spreading of stress throughout their surfaces, and are hence enduring.

Reinforced concrete, more than other materials, has freed the architect to think freely and sculpturally. There are limits to what ferroconcrete can do, however; initial spatial concepts are frequently somewhat refined by computer-aided calculations of marginally more efficient shapes for distributing stress. Still, it would not be far from the mark to say that buildings of almost any shape and reasonable size are possible today, if one is willing to pay for them. The architects of ferroconcrete have achieved a number of buildings that would have astounded the ancient stone builders—and perhaps Joseph Paxton.

Le Corbusier's chapel of Notre-Dame-du-Haut (Fig. 7–21 and 7–22) is an example of what has been referred to as the "new brutalism," deriving from the French *brut,*

meaning rough, uncut, or raw. The steel web is spun and the concrete is cast in place, leaving the marks of the wooden forms on its surface. The white walls, dark roof, and white towers are "decorated" only by the texture of the curving reinforced concrete slabs. In places the walls are incredibly thick. Windows of various shapes and sizes (Fig. 7–22) expand from small slits and rectangles to form mysterious light tunnels; they not so much light the interior as draw the observer outward. The massive voids of the window apertures recall the huge stone blocks of prehistoric religious structures.

Eero Saarinen's TWA Terminal (Figs. 7–23 and 7–24) at Kennedy Airport in New York is a more dramatic example of the capacity of reinforced concrete to span distances with curving organic forms. Saarinen sought a unique design that would symbolize flight and achieve an identity among the boring boxy designs of the other terminals. He succeeded. The wing-shaped ferro-concrete roof structure seems to belong to some fossilized prehistoric bird trapped in midflight. Free-form arches and vaults span **biomorphic** interior spaces, so that the sensitive traveler seems to be passing through the maw of the beast—a part of some ancient ritual that commemorates the passage from ground to air.

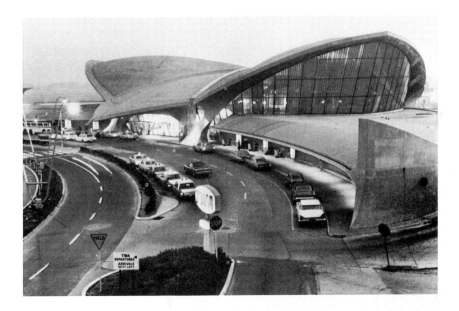

7–23 EERO SAARINEN
TWA Terminal, John F. Kennedy International Airport, N.Y. (1962)

7–24 EERO SAARINEN
Interior of TWA Terminal

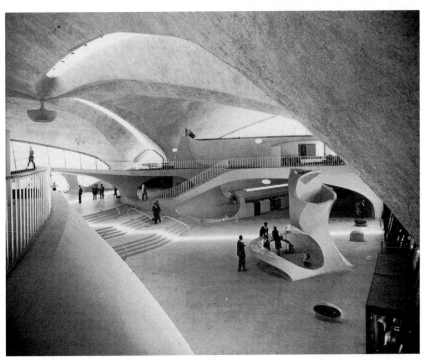

Frank Lloyd Wright's Kaufmann House (Fig. 7–25), which has also become known as "Falling-Water," shows a very different application of reinforced concrete. Here cantilevered decks of reinforced concrete rush outward into the surrounding landscape from the building's central core, intersecting in strata that lie parallel to the natural rock formations. Wright's **naturalistic style** integrates his building with its site. In the Kaufmann House, reinforced concrete and stone walls complement the sturdy rock of the Pennsylvania countryside.

For Wright, modern materials did not warrant austerity; geometry did not preclude organic integration with the site. A small waterfall seems mysteriously to originate beneath the broad white planes of a deck. The irregularity of the structural components—concrete, cut stone, natural stone, and machine-planed surfaces—complements the irregularity of the wooded site. The Kaufmann House, naturalistic, might have always been there. It is right. The Farnsworth House, while not "wrong," is a technological surprise on its landscape.

Israeli architect Moshe Safdie's Habitat (Fig. 7–26) is another expression of the versatility of concrete. Habitat was erected for EXPO 67 in Montreal as one solution to the housing problems of the future. Rugged, prefabricated units were stacked like blocks about a common utility core at the site, so that the roof of one unit would provide a private deck for another. Only a couple of Safdie-style "apartment houses" have been erected since, one in Israel and one in Puerto Rico, so today Safdie's beautiful sculptural assemblage evokes more nostalgia than

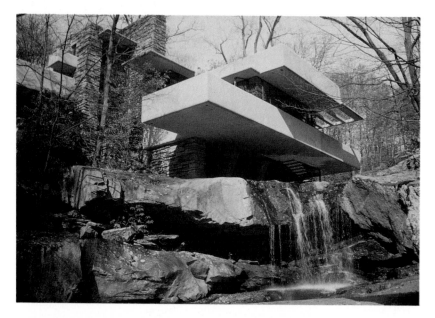

7–25 FRANK LLOYD WRIGHT
Kaufmann House, Bear Run, Pa. (1936)

7–26 MOSHE SAFDIE
Habitat, Expo 67, Montreal (1967)

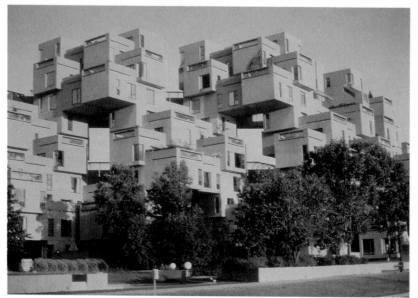

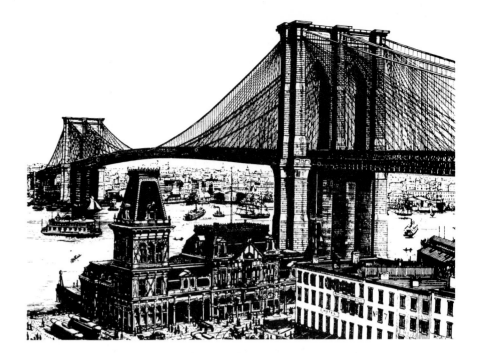

7–27 JOHN A. ROEBLING
Brooklyn Bridge, New York (1869–83)

hope for the future. Its unique brand of rugged, blocky excitement is rarely found in mass housing, and this is our loss.

OTHER ARCHITECTURAL METHODS

Steel-Cable Architecture

The notion of suspending bridges from cables is not new. Wood and rope suspension bridges have been built in Asia for thousands of years. Iron suspension bridges such as the Menai Straits Bridge in Wales and the Clifton Bidge near Bristol, England, were erected during the early part of the nineteenth-century. But in the Brooklyn Bridge (Fig. 7–27), completed in 1883, John Roebling exploited the great tensile strength of steel to span New York's East River with **steel cable.** In such a cable, many parallel wires share the stress. Steel cable is also flexible, allowing the roadway beneath to sway, within limits, in response to changing weather and traffic conditions.

Roebling used massive vaulted piers of stone masonry to support parabolic webs of steel, which are rendered lacy by the juxtaposition. In many more recent suspension bridges, steel cable spans more than a mile, and in bridges like the Golden Gate, the George Washington, and the Verrazano Narrows, the effect is aesthetically stirring.

7–28 PIER LUIGI NERVI
Paper Mill, Mantua, Italy (1964)

Steel cable has also been used to span great spaces and support the roof structures in buildings such as Eero Saarinen's Terminal for the Dulles Airport in Washington, D.C., Pier Luigi Nervi's paper mill at Mantua, Italy, and numerous exhibition halls that have had the appearance of circus tents. In Nervi's mill (Fig. 7–28), biomorphic **pylons** strut above and support the roof of an otherwise purposefully dull rectangular enclosure, freeing the interior from columns.

Shell Architecture

Modern materials and methods of engineering have made it possible to enclose spaces with relatively inexpensive shell structures. Masonry domes have been replaced by lightweight shells that are frequently flatter and certainly capable of spanning greater spaces. Shells have been constructed from reinforced concrete, wood, steel, aluminum, and even plastics and paper. The concept of shell architecture is as old as the canvas tent and as new as the Geodesic dome (Fig. 7–6) designed by Buckminster Fuller for the American Pavilion at EXPO 67 in Montreal. In a number of sports arenas, fabric roofs are held up by keeping the air pressure inside the building slightly greater than that outside. Like balloons, these roof structures are literally inflated.

Fuller's shell is an assemblage of lightweight metal trusses into a three-quarter sphere that is 250 feet in diameter. Looking more closely, one sees that the trusses compose six-sided units that give the organic impression of a honeycomb. Light floods the climate-controlled enclosure, creating an environment for any variety of human activity—and any form of additional construction—within. Such domes can be covered with many sorts of weatherproofing, from lightweight metals and fabric to translucent and transparent plastics and glass. Here the engineering requirements clearly create the architectural design.

Solar Architecture

Because of the rise in energy costs in recent years, many architects have begun to design buildings that are energy efficient. In a number of cases this has meant making minor adjustments to traditional designs, such as heavily insulating attic floors and balloon-framed walls, and using double glazing—that is, two layers of glass separated by a "dead space" of air—in windows. One can also decrease the amount of glass area in walls in cool climates and increase the overhang of shading roofs in hot climates.

The solar house shown in Figures 7–29 and 7–30 makes more dramatic adjustments to increase energy efficiency. Slanted glass walls along the south side of the house admit winter sun into a **sunspace** that functions as a greenhouse, additional living space, and collector of heat. Shades help keep out the heat of summer. Glass walls are angled according to the latitude of the building in order to maximize the entry of light in winter. Because of this dramatic angling, many solar homes have forceful triangular profiles. Sunspaces have thick brick or stone floors and are sometimes backed by brick or stone **trombe walls,** because masonry stores heat during the day and releases it gradually through the night. Water, like masonry, collects heat, which is why temperatures along the beach are usually more moderate than those inland. For this reason, pools or columns of water are also frequent features of sunspaces.

The house is also wrapped on the cold north and west sides by an earth **berm.** Underground temperatures are more moderate than those above ground, and berms conduct warmth to the house in winter and heat away from the house in summer. The berm also helps protect the structure from northwesterly winter winds. Strategic planting is an asset. Evergreens to the north and west help shield the house from cold winds, and deciduous trees to the south shade the house in summer but open it to the winter light.

Efficient venting systems for excessive heat further reduce energy requirements in warm weather. Most solar homes have traditional auxiliary heating systems to supplement the natural heating, but these systems typically cost less than half of what it costs to heat and cool nonsolar homes of the same size.

Berms made the house in Figure 7–29 **earth-sheltered.** Why, you may ask, do we not construct buildings completely underground to save energy? After all, one could argue that the surrounding and covering earth would be moderate in temperature, and the buildings would not be the victims of summer sun or winter winds.

7–29 RHYS CHRISTENSEN
Solar home, Iowa (1980)

7–30 RHYS CHRISTENSEN
Interior, solar home

7–31 DAVID BENNETT Williamson Hall, University of Minnesota (1977)

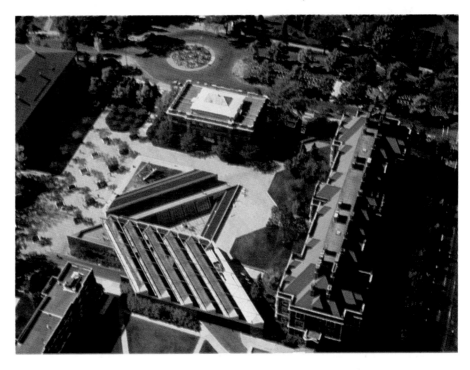

Few of us would be willing to live completely underground. However, many architects have designed innovative, energy-efficient structures that are mostly underground yet offer enough natural light to heat them in winter and, frequently, breathtaking views of the countryside. Williamson Hall, the student center at the University of Minnesota, is shown in **cross-section** in Figure 7–31. Architect David Bennett placed the building 95 percent below ground level, brought light into the bookstore

through a **clerestory** window, and angled the glass wall of an interior courtyard 45 degrees to collect the winter sun. The building has an aesthetic integrity and is estimated to run only 45 percent of the energy costs of a traditional structure of similar size and function.

Other campuses ranging from the University of Florida to Harvard University have placed major structures underground to escape extremes of temperature. Hundreds of appealing underground private homes have also been built, many with southern panoramas or dramatic interior courtyards that open to the sky.

In contrast to the cave dwellings of millennia gone by, our contemporary "caves" have garages, electric kitchens, and interior plumbing, and they poke television antennae through the earth, reaching for the sources of communal stimulation that orbit the planet. We presume that we are better off than our ancestors.

CONTEMPORARY MUSEUMS: FUNCTIONS AND FORMS

Some of the more fascinating expressions of contemporary architecture are found in our museums. Museums are rather special works. Not only do they house many of our most important artworks, but they also frequently occupy prominent sites in major cities. And so their architects, cognizant of their functions and sites, see them as special design challenges and opportunities.

It is of interest that museums as we know them have existed for only about two centuries. Prior to that time works of art and other valuables were collected into treasure chambers, essentially for purposes of hoarding. Treasure chambers belonged to the ruling families of Europe, such as the Medicis, the Hapsburgs, and a few others, and were open only to a select few. But as the numbers of the educated expanded, and as a revolutionary democratic spirit swept much of Europe and the American Colonies in the latter part of the eighteenth century, museums were constructed that could accommodate the general public.

Museums today serve several functions. They still "hoard" valuables, in the sense of collecting them and preserving them, but they also show their treasures to the general public, who visit in large numbers. Thus, they have large exhibition areas throughout which people must be able to circulate in comfort and relative freedom. Other public areas of the museum may include study rooms or a library, and meeting rooms or an auditorium. Most museums have shops or bookstores, and large museums also have dining facilities. In nonpublic areas of the museum, the director plans budgets and the **acquisitioning** and **deacquisitioning** of works of art. **Curators** catalog collections and plan exhibitions. **Conservators** preserve and restore older or damaged works. Educators, office workers, guards, and others carry out ther functions.

Frank Lloyd Wright's Solomon R. Guggenheim Museum (Figs. 7–32 and 7–33) sits across Fifth Avenue from Central Park, about ten blocks uptown from the Metropolitan Museum of Art. Its main exhibition hall is devoted to transient shows. Visitors are brought to the top of the **rotunda** by elevator and then walk down a continuous spiral gallery. Works of art are placed against the outside wall of the gallery. Visitors can peer out across the rotunda from any level, up at the glass dome, or down at exhibits that are out in the center court. The permanent collection and office and service areas are housed in rooms adjacent to the rotunda. From the outsde, space flows across Fifth Avenue from the park and freely around the sculptured forms of the museum. The park is mirrored in entry-level expanses of plate glass and hanging plants within. From the interior, the openness of the rotunda and the detailing of the glass dome are stunning. If they have a fault, it is that they vie for attention with the works they exhibit.

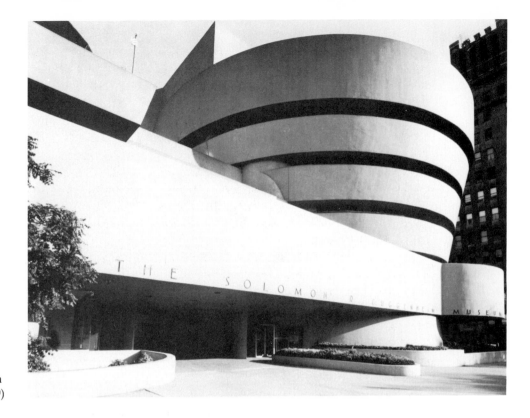

7–32 FRANK LLOYD WRIGHT
The Solomon R. Guggenheim Museum, New York (1957–59)

7–33 FRANK LLOYD WRIGHT
Interior view of the Guggenheim Museum

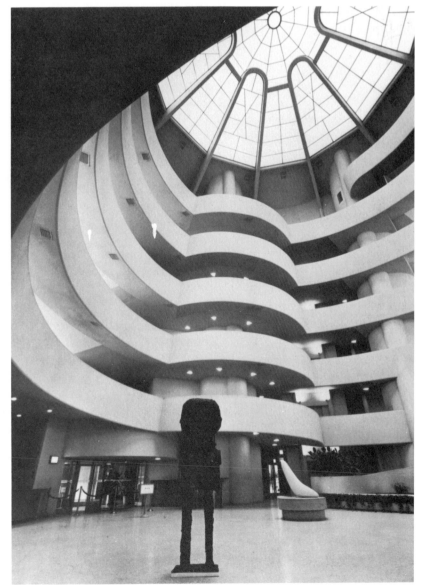

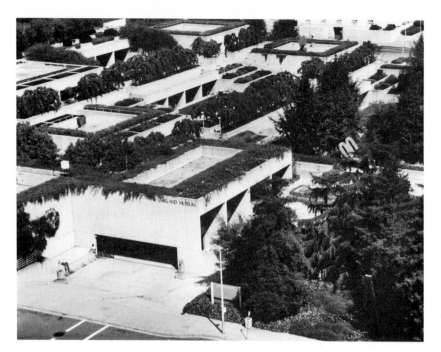

7–34 KEVIN ROCHE and
JOHN DINKERLOO
The Oakland Museum,
Oakland, California (1961)

7–35 RICHARD ROGERS
and RENZO PIANO
Georges Pompidou National
Center of Art and Culture,
Paris (1971–78)

Given the exhibition space of the Oakland Museum (Fig. 7–34), designed by Kevin Roche and John Dinkerloo, it could have been a monumental feature of the urban landscape. Instead, the architects decided to provide Oakland with an unexpected, terraced garden. The roofs of one level serve as green terraces for the next. Rather than another huge building, Oakland possesses formal clusters of greened environments. The overall effect is one of a hilly park, which is perfectly integrated with California's geology.

In Paris the Georges Pompidou National Center of Art and Culture (Fig. 7–35), designed by Richard Rogers and Renzo Piano, is very different from the Greek-inspired Classicism of a more familiar Parisian jewel—the Louvre. Given its trussed steel-cage structure, it could have been just another Minimalist cube, but the architects decided to form it much like an animal wearing

its organs outside rather than under the skin. Service ducts, a huge escalator, and stacks that remind one of an ocean liner serve as the building's external ornamentation. Contemporary service systems provide the subjects for a Pop reworking of a Modernist theme. As if their presence were not clear enough, the systems are boldly painted in primary colors and white. It could, of course, be remarked that by placing these services outside the skin, the architects further freed interior spaces for unobstructed circulation and visual continuity. Perhaps. But the Pompidou Center is also a humorous assemblage, in the best sense of the word.

The Musée d'Orsay (Fig. 7–36) is another Parisian innovation. Prior to its opening in 1986, it had been the old Gare d'Orsay, the grandest railway station in the city. Italian architect Gae Aulenti was given the task of resurrecting a live museum from the dead station. In its new incarnation, the familiar floriated clock still tells time and punctuates the imposing barrel vault that rises a hun-

7–36 (*right*) Gare d'Orsay, former railroad station, Paris. (*Below*) Musée d'Orsay, designed by GAE AULENTI. View of Sculpture Avenue (1986)

7–37 MARCEL BREUER
Whitney Museum of American Art, New York (1966)

dred feet from the floor and stretches 150 yards from end to end. Natural light still filters through this secular cathedral with its elliptical side vaults that, like the rose window of Notre Dame, look upon the Seine. Where steam locomotives once lumbered through, there is now a "sculpture avenue." Manets, Courbets, Rodins, and other works from the second half of the nineteenth century and the first decade of the twentieth populate byways where passengers once rushed. The Musée d'Orsay does many, many things. It preserves the architectural past while preserving the paintings and sculptures of the previous century. It also displays—both itself and its contents. If there is a fault, it is the same fault as that of the Guggenheim: the building competes for attention with the objects it houses. In the context of the achievement of the Musée d'Orsay, art critic Robert Hughes wrote: "A hundred years ago you had brilliant painters and dumb museums; today the reverse." Let us accept Hughes's enthusiasm for the museum but leave judgment of contemporary painters to future generations.

Marcel Breuer's Whitney Museum of American Art (Fig. 7–37) is a top-heavy work in reinforced concrete. The massiveness of the upper floors seems a cocky human thrust against the inevitability of gravity as well as a matter-of-fact statement of contemporary engineering. The few windows emphasize the fact that it is the exhibits of the inner space, rather than of the outer space, that are to be the focus of attention. The windows are similar to the light tunnels of Le Corbusier's Notre-Dame-du-Haut (Fig. 7–22) and seem to serve a similar purpose as focal points for meditation.

It seems appropriate to wrap up this chapter with Christo's wrapping of the Whitney (Fig. 7–38). As noted in Chapter 6, the public and critics alike have burned several years' worth of the world supply of midnight oil in attempting to decipher Christo's cryptic messages. An insecure acquaintance once insisted that by wrapping such massive elements of landscape and cityscape, Christo was fulfilling the unconscious urge to demonstrate that he could control them—which shows, perhaps, that we project our own needs into the intrigues of others very well.

Where do we go from here? The rest is wrapped—or rapt.

7–38 CHRISTO
Wrapped Whitney Museum of American Art, project for New York (1967). Scale model: 20 x 19½ x 22". Fabric, twine, rope, polyethelene, wood, and paint.
Collection of Jeanne-Claude Christo.

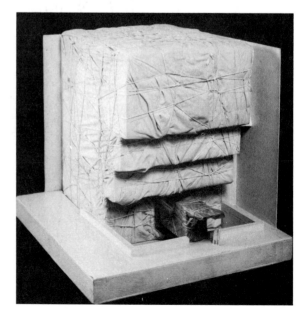

8

Camera Arts

Photography has or will eventually negate much of painting—for which the painter should be deeply grateful; relieving him, as it were, from certain public demands [such as] representation, objective seeing.

—Edward Weston

Modern technology has revolutionized the visual arts. For thousands of years one of the central goals of art has been to imitate nature as exactly as possible. Today, as the great photographer Edward Weston has suggested, any one of us can point a camera at a person or an object and capture a realistic image. Many cameras no longer even require that we try to place the subject in proper focus, or that we regulate the amount of light so as not to overexpose or underexpose the subject. The technology of today can do these things for us.

Also, the art of the stage was once unavailable to all but the few who lived in the great urban centers. Now and then a traveling troupe of actors might come by, or local groups might put on a show of sorts, but most people had little or no idea of the ways in which drama, opera, the dance, and other performing arts could have an impact on their lives. Then motion pictures or **cinematography** suddenly brought a flood

of new imagery into new local theaters, and a new form of communal activity was born. People from every station of life could flock to the cinema on the weekend. It is also in cinematography that sound or the sound track began to accompany the visual arts. Over time, cinematography evolved into an art form independent of its beginnings as a mirror of the stage.

More recently, television has brought this imagery into the home, where people can watch everything from the performing arts to sporting events in privacy and from the vantage points of several cameras. We have immediate access to the best seats in the "house" or the ballpark. If we have turned away for an instant when something important takes place, we need not be concerned; we are soon barraged by instant replays from several angles. "Live" coverage of events of the day enabled hundreds of millions to witness Neil Armstrong's first steps on the moon. And many millions watched in horror the "live" assassination of President Kennedy, the subsequent killing of Lee Harvey Oswald, and the shooting of President Reagan.

Recent uses of technology have also given rise to computer arts, or **computer graphics.** With the aid of artificial intelligence, we can instantly view models of objects from all sides. We can be led to feel as though we are sweeping in on our solar system from the black reaches of space, then flying down to the surface of our planet and landing where the programmer would set us down. Millions of children spend hours playing videogames that challenge them to shoot down computer-drawn images of extraterrestrial invaders or to gobble up the images of the ghosts before their computer-drawn heroes and heroines are gobbled up themselves. And here and there a number of artists are exploring the possibilities of computer graphics purely for their own sake. Computer graphics is a medium, not a subject. The term applies equally to illustrations of blue jeans that appear to fly like rockets through space and to sinuous abstract forms like moiré patterns.

In this chapter we discuss photography, cinematography, and television. Many years ago it might have been daring to assert that photography and cinematography are forms of art, but today most critics will agree that these media have given rise to unique possibilities for artistic expression. Many today argue that television is not a form of art in its own right—that it is merely technical equipment. They may have a point. Nevertheless, television is such a pervasive aspect of the contemporary experience that it would seem appropriate to discuss it.

PHOTOGRAPHY

Photography is a science and an art. The word *photography* is derived from Greek roots meaning "to write with light." The scientific aspects of photography concern the ways in which images of objects are made on a **photosensitive** surface, like film, by light that passes through a **lens.** Chemical changes occur in the film so that the images are recorded. This much—the creation of an objective image of the light that has passed through the lens—is mechanical.

We shall see that it would be grossly inaccurate to think of the *art* of photography as mechanical. As the French photographer Henri Cartier-Bresson has noted, photographers make artistic choices. First, they decide exactly what to point the camera at. Second, they decide which pictures they will retain and which they will discard. Any amateur photographer knows that it takes a certain courage to toss out one's weaker efforts, especially when they may number in the hundreds or thousands.

Photography is truly an art of the hand, head, and heart. The photographer must understand films and grasp skills related to using the camera and, in most cases, to developing **prints.** The photographers must also have the intellect and the passion to search for and to see what is important in things—what is beautiful, harmonious, universal, and worth recording.

8–1 ANSEL ADAMS
*Moon and Half Done, Yosemite
National Park, California, 1960*

The subject may be a vast landscape, as in American photographer Ansel Adams's *Moon and Half-Dome, Yosemite National Park* (Fig. 8–1), or quite small, as in du Hauron's sensitive photograph of leaves and flowers (Fig 8–2). In Adams's picture majestic cliffs leap into the sky, which is deep and cold. Ironically, the perfect order of the spherical moon contrasts with the roughness of the rock, but we know that the surface of the moon is just as rough and chaotic. Its geometric polish is an illusion wrought by dis-

tance. Through a variety of lenses and vantage points, photographers choose the distances and the scales of their subjects. Adams's cliffs are massive; their emergence from black shadow may lead us to reflect on the emergence of light from darkness and of life from inert material.

Leaves and Flower Petals (Fig. 8–2) was photographed by Louis Ducos du Hauron well over one hundred years ago. The yellow-orange background and the yellow-oranges and analogous pale greens of the leaves and

flowers create a warm, delicate composition that contrasts markedly with the sturdy formations of the black-and-white Adams photograph. The Adams photograph distances viewers, stimulating them to long for texture. The du Hauron photograph is richly textured, veined, and altogether comforting.

Let us now consider two of the technical aspects of photography: cameras and films.

Cameras and Films

CAMERAS

Cameras may look very different from each other and boast a variety of equipment, but they all possess certain basic features. As you can see in Figure 8–3, the camera is similar to the human eye. In both cases, light enters a narrow opening and is projected onto a photosensitive surface.

The amount of light that enters the eye is determined by the size of the *pupil*, which is an opening in the muscle called the *iris;* the size of the pupil responds automatically to the amount of light that strikes the eye. The amount of light that enters a camera

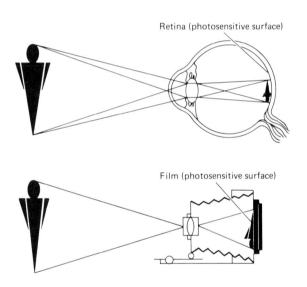

8–3 The camera and the human eye compared

is determined by the size of the opening, or **aperture,** in the **shutter.** The aperture opening can be adjusted manually or, in advanced cameras, automatically. The size of the aperture, or opening, is the so-called **stop.** The smaller the F-stop, the larger the opening. The shutter can also be made to remain open to light for various amounts of time, ranging from a few thousandths

of a second—in which case **candid** shots of fast action may be taken—to a second or more.

When the light enters the eye, the *lens* keeps it in focus by responding automatically to its distance from the object. The light is then projected onto the retina, which consists of cells that are sensitive to light and dark and to color. Nerves transmit visual sensations of objects from the retina to the brain.

In the same way, the camera lens focuses light onto **film,** which is photosensitive, like the retina. A camera lens can be focused manually or automatically. Many photographers purposely take pictures that are out of focus, for their soft, blurred effects. **Telephoto** lenses magnify faraway objects and tend to collapse the spaces between distant objects that recede from us. The Riger photo (see Fig. 1–21) was made possible by a telephoto lens that helped collapse the distances between the players. **Wide-angle** lenses allow a broad view of objects within a confined area.

In their early days, cameras tended to be large and were placed on mounts. Today's cameras are usually small and held by hand. *The Steerage* (see Fig. 1–19) was shot with an early hand-held camera. Many contemporary cameras contain angled mirrors that allow the photographer to see directly through the lens and thereby to be precisely aware of the image that is being projected onto the film.

Films

Contemporary black-and-white films are very thin, yet they contain several layers, most of which form a protective coat and backing for the photosensitive layer. The "active" layer contains an **emulsion** of small particles of a photosensitive silver salt (usually silver halide) that are suspended in gelatin.

After the film is exposed to light and treated chemically, it becomes a **negative,** in which metallic silver is formed from the crystals of silver halide. In this negative, areas of dark and light are reversed. Since the negatives are transparent, light passes through them to a print surface which becomes the final photograph, or print. Here the areas of light and dark are reversed again, now matching the shading of the original subject. Prints are also usually made significantly larger than the negative.

Black-and-white films differ in color sensitivity (the ability to show colors like red and green as different shades), in contrast (the tendency to show gradations of gray as well as black and white), in graininess (the textural quality, as reflective of the size of the silver-halide crystals), and in speed (the amount of exposure time necessary to record an image). Photographers select films that will heighten the effects they seek to portray.

Color film is more complex than black-and-white film, but similar in principle. Color film also contains several layers, some of which are protective and provide backing. There are two basic kinds of color film: **color reversal film** and **color negative film.** Both types of color film contain three light-sensitive layers.

Prints are made directly from *color reversal film.* Therefore, each of the photosensitive layers corresponds to one of the **primary colors** in additive color mixtures: blue, green, or red. When color reversal film is exposed to light and treated chemically, mixtures of the primary colors emerge, yielding a full-color image of the photographic subject.

Negatives are made from *color negative film.* Therefore, each photosensitive layer corresponds to the **complement** of the primary color it represents. (See Chapter 2 for an explanation of additive color mixtures and primary and complementary colors.)

Color films, like black-and-white films, differ in color sensitivity, contrast, graininess, and speed. But color films also differ in their appropriateness for natural (daylight) or artificial (indoor) lighting conditions.

A Brief History of Photography

The cameras and films described above are rather recent inventions, but photography has a long and fascinating history. Although true photography does not precede the du Hauron photograph by many years, some of its principles can be traced back another three hundred years, to the *camera obscura*.

THE CAMERA OBSCURA

The **camera obscura**—literally, the covered-over or darkened room—was used by Renaissance artists to help them accurately portray depth, or perspective, on two-dimensional surfaces. The camera obscura could be a box, as shown in Figure 8–4, or an actual room with a small hole that admits light through one wall. The beam of light projects the outside scene upside down on a surface within the box. The artist then simply traces the scene, as shown, to achieve a proper perspective—to truly imitate nature.

DEVELOPMENT OF PHOTOSENSITIVE SURFACES

The camera obscura could only temporarily focus an image on a surface while a person labored to copy it by tracing. The next developments in photography concerned the search for photosensitive surfaces that could permanently affix images. These developments came by bits and pieces.

In 1727 the German physicist Heinrich Schulze discovered that silver salts had light-sensitive qualities, but he never tried to record natural images. In 1802 Thomas Wedgwood, son of the well-known English potter, reported his discovery that paper soaked in silver nitrate did take on projected images as a chemical reaction to light. Unfortunately, the images were not permanent.

HELIOGRAPHY

In 1826 the Frenchman Joseph-Nicéphore Niepce invented **heliography. Bitumen,** or asphalt residue, was placed on a pewter plate to create a photosensitive surface. The bitumen was soluble in **lavender oil** if kept in the dark, but insoluble if struck by light. Niepce used a device based on the concept of the camera obscura to expose the plate to the view from his window for eight hours, and then he washed the plate in lavender oil. The pewter showed through where there had been little or no light, creating the image of the darker areas of the scene. The bitumen remained where the light had

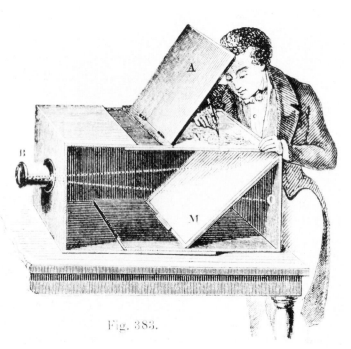

8–4 The camera obscura
International Museum of Photography at George Eastman House, Rochester, N.Y.

Fig. 383.

8–5 LOUIS-JACQUES-MANDÉ DAGUERRE
The Artist's Studio (1837)

struck, however, leaving lighter values. The resultant heliograph was quite blurred, but it was an unmistakable image of Niepce's view.

THE DAGUERREOTYPE

The **daguerreotype** resulted from a partnership formed in 1829 between Niepce and another Frenchman, Louis-Jacques-Mandé Daguerre. The daguerreotype used a thin sheet of silver-plated copper. The plate was chemically treated, placed in a camera obscura, and exposed to a narrow beam of light. After exposure, the plate was treated chemically again.

Figure 8–5 shows the first successful daguerreotype, taken in 1837. Remarkably clear images could be recorded by this process. In this picture, called *The Artist's Studio*, Daguerre, a landscape painter, sensitively assembled deeply textured objects and sculptures. The contrasting light and dark values help create an illusion of depth.

There were drawbacks to the daguerreotype. It had to be exposed for from 5 to 40 minutes, requiring long sittings and making it impossible to record motion. The recorded image was reversed, left to right. The image

was delicate and had to be sealed behind glass to remain fixed. Also, the plate that was exposed to light became the daguerreotype. There was no negative, and consequently, copies could not be made. However, some refinements of the process did come rapidly. Within ten years the exposure time had been reduced to about 30 to 60 seconds, and the process had become so inexpensive that families could purchase two portraits for a quarter. Daguerreotype studios opened all across Europe and the United States, and families began to collect the rigid, stylized pictures that now seem somehow to reflect the olden days.

THE NEGATIVE

The negative was invented in 1839 by British scientist William Henry Fox Talbot. Talbot found that light-sensitized paper could be substituted for the copper plate. After exposure to the image and subsequent chemical treatment, the image would appear with the light and dark values as well as left and right reversed.

Contact prints were then made by placing the negative in contact with a second sheet of sensitized paper and exposing them both

8–6 NADAR
Sarah Bernhardt (1859)
International Museum of Photography at George Eastman House, Rochester, N.Y.

to light. The resultant print was a "positive," with left and right, and light and dark, again as in the original subject. Many prints could be made from the negative. Unfortunately, the prints were not as sharp as daguerreotypes. Subsequent advances have led to methods in which pictures with the clarity of daguerreotypes can be printed from color negatives as well as black and white.

By the 1850s, glass plates were being used from which several sharp prints could be made. Figure 8–6 is an 1859 portrait of the famous actress Sarah Bernhardt, printed from a glass plate. The early portrait photographers not only imitated nature, they also imitated painting. Note the classic drapery. In this picture, the French photographer,

Gaspard Felix Tournachon, called "Nadar," apparently sought to capture the essential sensitivity and naturalness of his sitter, so he avoided using the recognizable fashions of the day. The picture is soft and smoothly textured, with a predominance of a middle range of values. We see the actress as pensive and brooding, but not as downcast. In other pictures of Bernhardt, Nadar did clothe her in contemporary styles.

Nadar's contemporary, Julia Margaret Cameron, took sensitive portraits of many famous people, including Charles Dickens, Lord Tennyson, and Henry Wadsworth Longfellow.

THE ADVENT OF PHOTOJOURNALISM

Prior to the nineteenth century there were few illustrations in newspapers and magazines. Those that did appear were usually in the form of engravings or drawings. Photography revolutionized the capacity of the news media to bring realistic representations of important events before the eyes of the public. Pioneers such as New York photographer Matthew Brady first used the camera to record major historical events such as the U.S. Civil War. Brady and his crew trudged along the roads alongside the soldiers, horses drawing their equipment behind them in wagons referred to by the soldiers as "Whatsits."

Brady's equipment did not allow him to capture candid scenes, and so there is no direct record of the bloody to and fro of the battle lines, no photographic record of each lunge and parry. Instead, Brady brought home photographs of officers and of life in the camps along the lines. Although battle scenes themselves would not hold still for his cameras, the litter of death and devastation caused by the war most certainly did. Despite their novelty and their accuracy, not many of Brady's graphic scenes of death and destruction were sold. There are at least three reasons for this tempered success. First, the state of the art of photography made the photographs high priced. Second, methods for reproducing photographs on newsprint were not invented until about 1900; therefore, the works of the photojour-

nalists were usually rendered as drawings, and the drawings translated into woodcuts, before they appeared in the papers. Third, the American public might not have been ready to face the brutal realities they portrayed. In a similar vein, social commentators have suggested that the will of many Americans to persist in the Vietnam War was sapped by the incessant barrage of televised war imagery.

PHOTOGRAPHY AS AN ART FORM IN THE TWENTIETH CENTURY

Toward the end of the nineteenth century and in the early part of this century, a number of photographers became aware of the full potential of photography as an art form. Edward Weston, Paul Strand, Edward Steichen, and others argued that photographers must not attempt to imitate painting but must find modes of expression that are truer to their medium. In 1902 American photographer Alfred Stieglitz founded the Photo-Secession, a group dedicated to advancing photography as a separate art form. Stieglitz himself enjoyed taking pictures under adverse weather conditions and in the evening to show the versatility of his art and of the hand-held camera.

Edward Steichen's *The Flatiron Building—Evening* (Fig. 8–7) is among the foremost examples of photography as art from this period. It is an exquisitely sensitive nocturne of haunting shapes looming in a rain-soaked atmosphere. The branch in the foreground provides the viewer with a psychological vantage point. The values are predominantly middle grays, although here and there, beaconlike, a light source sparkles in the distance. The infinite gradations of gray of the cast-iron skyscraper after which the picture is named, and of the surrounding structures, yield an immeasurable softness. Although much is present that we cannot readily see, there is nothing gloomy or frightening about the picture. Rather it seems pregnant with many wonderful things that will happen as the rain stops and the century progresses. In case one might think that the artist found rather than created this picture, consider the sense of

8–7 EDWARD STEICHEN
The Flatiron Building—Evening (1906)
The Library of Congress.

composition required to frame the black figure with the umbrella to the left, to include the hansom cabs, and to capture just this perspective of building and street. Consider also the technical knowledge required to find the proper exposure for this study in gray and black.

PHOTOJOURNALISM DURING THE DEPRESSION AND THE WAR YEARS

During the Great Depression, the conscience of the nation was stirred by the work of many photographers hired by the Farm Security Administration. Dorothea Lange and Walker Evans, among others, portrayed the lifestyles of migrant farm workers and sharecroppers.

Lange's *Migrant Mother* (Fig. 8–8) is a record of a 32-year-old woman who is out of work but who cannot move on because the tires have been sold from the family

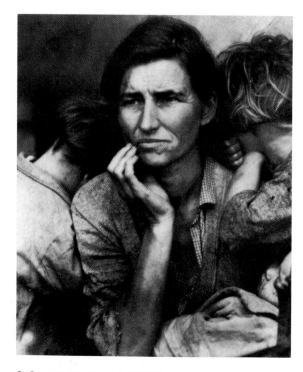

8–8 DOROTHEA LANGE
Migrant Mother (1936)

8–9 ALFRED EISENSTAEDT
V-J Day: Sailor Kissing Girl (1945)

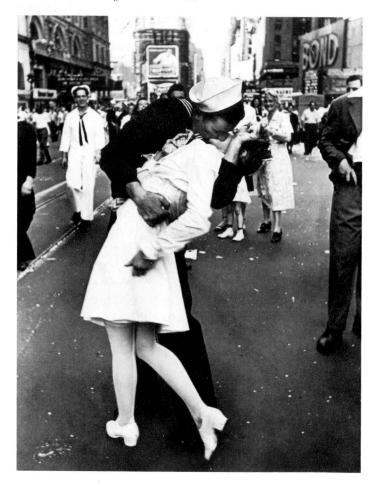

car to purchase food for her seven children. The etching in the forehead is an eloquent expression of the mother's thoughts, and the etching at the outer edges of the eyes serves as witness to the premature aging process. The ragged textures of the fabrics complement flesh and the out-of-focus background. The turning away of the children from the camera heightens the futility of their plight. Their facelessness lends them a universal quality with which the viewer can freely empathize.

During the early 1940s, photographers carried their hand-held cameras into combat and captured tragic images of the butchery in Europe and in the Pacific. *V-J Day: Sailor Kissing Girl* (Fig. 8–9), taken by Alfred Eisenstaedt, one of the original *Life* staff photographers, speaks of the sense of abandon and relief with which the end of World War II was met. It is a stunning composition of black and white central figures surrounded by a range of middle values with an occasional splash of light or dark. Despite the absolute value contrast of their costumes, the sailor and the woman are united in a simple C-curve. *V-J Day* is clearly a record of its time and place, but it also captures the essential quality of celebration.

Margaret Bourke-White's *The Living Dead of Buchenwald* (Fig. 8–10), published in *Life Magazine* in 1945, shows a very different aspect of the war experience. In 1929 Bourke-White became a staff photographer for *Fortune,* a new magazine published by Henry Luce. When Luce founded *Life* in 1936, Bourke-White became one of its original staff photographers. Bourke-White, like Dorothea Lange, recorded the poverty of the Great Depression. In the 1940s she became one of the first female war photojournalists. As World War II was drawing to an end in Europe, she arrived at the Nazi concentration camp of Buchenwald in time for its liberation by General Patton. One of her photographs has become a classic image of the Holocaust, the Nazi effort to exterminate the Jewish people. The expressionless faces of the survivors paradoxically give ample expression to what they have witnessed. In her book *Dear Fatherland, Rest Quietly,*

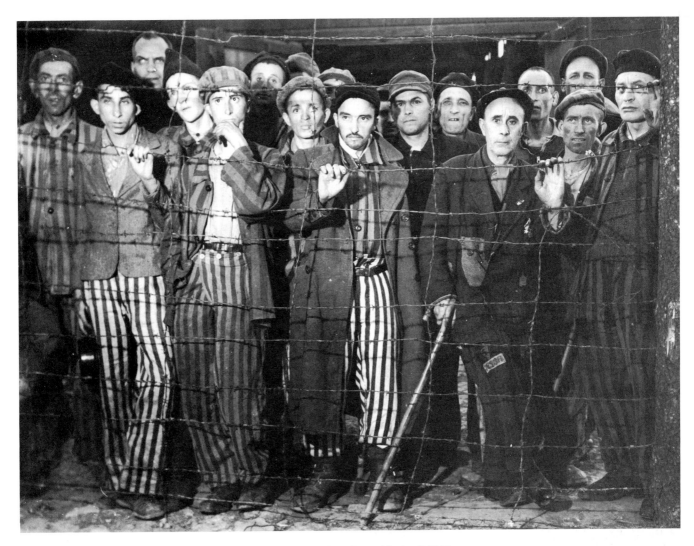

8–10 MARGARET BOURKE-WHITE *The Living Dead of Buchenwald, April 1945* (1945)

Life Magazine © 1945 Time Inc.

Bourke-White put into words her own reactions to Buchenwald. In doing so, she showed how artistic creation, an intensely emotional experience, can also have the effect of objectifying the subject of creation:

> I kept telling myself that I would believe the indescribably horrible sight in the courtyard before me only when I had a chance to look at my own photographs. Using the camera was almost a relief; it interposed a slight barrier between myself and the white horror in front of me . . . it made me ashamed to be a member of the human race.[*]

[*] Margaret Bourke-White, *Dear Fatherland, Rest Quietly* (New York: Simon and Schuster, 1946), p. 73.

POSTWAR YEARS

Photography has advanced in the postwar years as a medium both for recording events and for artistic expression. Powerful microscopes and fast films have permitted the photography of previously invisible molecular and crystal structures that have a hard geometrical abstract quality. As we have pushed back the frontiers of space, we have also taken the camera with us.

Earthrise (Fig. 8–11) is a NASA photograph taken during the first landing on the moon. The sharp lights and darks of the metal hull and protrusions of the lunar landing module contrast with the grays of the softly textured surface of the moon but are

8–11 NASA *Earthrise* (1969)
Photo courtesy of NASA.

8–12 AARON SISKIND
Martha's Vineyard III (1954)
Courtesy of Light Gallery, N.Y.

8–13 J. SEELEY
Trees and Fence (1969)

© J. Seeley, 1969.

balanced by the highly contrasting values of black space and the distant Earth above. The curve of the lunar surface is repeated in the truncated Earth. The distance of the home planet lends it an abstract geometric appearance. Out here, in space, the heavy landing module is very much closer and, despite its mechanical grotesqueness, it looks, frankly, much more like home.

Aaron Siskind's *Martha's Vineyard* (Fig. 8–12) has a strong sculptural quality, reminiscent of the reclining figures of Henry Moore (see Figs. 2–26 and 17–21). As in a Moore sculpture, the negative spaces speak as powerfully as the stone or other material from which the forms are composed. The dense rock texture, the abstract triangular and rounded shapes, are balanced perfectly by the stark light that plays between. In an abstract sculpture, we may wonder what, if anything, the artist sought to represent. In the Siskind photograph, we know that the actual subject is a natural stone formation. Nevertheless, we are as intrigued to know what Siskind saw in the rocks as we would have been if he had carved and

placed them himself. We wonder how many times he walked around the formation, kneeling or standing on tiptoe, watching as the atmospheric effects subtly charged, before he found his ideal subject.

In *Trees and Fence* (Fig. 8–13), J. Seeley used a high-contrast film to eliminate the middle ranges of gray. Thus, all grays are resolved to a brilliant light or deep shade. Light values usually leap out from dark, but since the perspective brings the black forms at the base of this picture nearer, black and white compete for the viewer's eye. There is confusion of figure and ground. The starkness of the season is heightened; the subject becomes a technological abstraction of itself. The timbers of the fence cross the lower part of the picture like broad swaths of black paint in an Abstract Expressionist painting. The black lines of trees rise from an empty white center as in an etching. Massive branches take on the character of myriad tossed sticks in a children's game. The photograph is literally a landscape, but the choice of vantage point and film create an overall air of experimental forms.

8–14 HAROLD EDGERTON
Fan and Flame Vortices (1973)
Dye transfer print. 13 x 20".

Spencer Museum of Art, Lawrence, Kansas. Gift of Gus and Arlette Kayafas.
Photo courtesy of Palm Press.

Harold Edgerton's *Fan and Flame Vortices* (Fig. 8–14) is an example of the types of images that have been made possible by evolving photographic technology. Edgerton is an electrical engineer and the inventor of the strobe light, which emits brief and brilliant flashes of light that seem to stop action in the theater and in cinematography. *Fan and Flame Vortices* is a high-speed photograph of a metal fan blade that is rotating at 3,600 revolutions per minute through the flame emitted by an alcohol burner.

Changes in the density of the air and other gases are responsible for their color. That is how the photograph was made, but Edgerton, like many other contemporary photographers, has used technological innovations to transform some of the mundane objects of the real world into vibrant abstract images.

Several contemporary artists have also experimented with the technique of **collage** in photography. Foremost among these is the painter and photographer David Hockney, whose photo-collages are constructed of individual photographs of detailed portions of a single scene. For example, Figure 8–15 is a collage of photographs of a California desert highway. In the process of photographing the scene, he fragments the total structure, only to rebuild it in his studio. It is almost as if he were reconstructing the scene as most of us do from fragmented memories.

More recently, artists and identical twins Mike and Doug Starn have collaborated on a number of collage-like photographs in which they incorporate foreign materials such as pieces of film and Scotch tape. They also violate their works with scratches, wrinkles, and tears. They often leave the product covered with fingerprints and other damages, as in *Boots* (Fig. 8–16). Thus they give their works a weathered look, as if they had been lying around in the attic or the basement for many years.

Technical advances are still being made in photography. For example, the **stereoscopy** of the nineteenth century, which provided the illusion of a three-dimensional image, has given way to the **holography** of today and a variety of other experimental techniques that may soon provide us with more realistic three-dimensional images. It remains to be seen whether further technical refinements will meaningfully increase the range of experiences that may be communicated by photography.

The capacity of photography to stir us is heightened in cinematography. A large screen, movement, and—since the 1930s—sound, capture the visual and auditory senses of the audience for hours at a time.

8–15 DAVID HOCKNEY *Pearblossom Highway 11–18th April 1986 #2* (1986)
Photographic collage. 78 x 111″.

© David Hockney 1986.

8–16 MIKE and DOUG STARN
Boots (1983–87). Silverprint, scotch tape
and metal. 6 x 5′.

Private collection; courtesy of Stax Gallery, N.Y.

On Photography

ANSEL ADAMS: The beauty of a photograph by Weston does not lie in the assortment of facts about negative, material, paper, developers—it lies in the realization of his vision.

A great photograph is a full expression of what one feels about what is being photographed in the deepest sense, and is, thereby, a true expression of what one feels about life in its entirety.

Simplicity is a prime requisite. The equipment of Alfred Stieglitz or Edward Weston represents less in cost and variety than many an amateur "can barely get along with."

To photograph truthfully and effectively is to see beneath the surface and record the qualities of nature and humanity which live or are latent in all things.

HENRI CARTIER-BRESSON: In photography, the smallest thing can be a great subject.

To me, photography is the simultaneous recognition, in a fraction of a second, of the significance of an event as well as of a precise organization of forms which give that event its proper expression.

DOROTHEA LANGE: Documentary photography records the social scene of our time. It mirrors the present and documents for the future. Its focus is man in his relation to mankind. It records his customs at work, at war, at play, . . . It portrays his institutions. . . . It shows not merely their façades, but seeks to reveal the manner in which they function, absorb the life, hold the loyalty, and influence the behavior of human beings.

EDWARD WESTON: Look at the things around you, the immediate world around you. If you are alive, it will mean something to you, and if you care enough about photography, and if you know how to use it, you will want to photograph that meaning.

Great painters . . . are keenly interested in, and have deep respect for photography when it is photography both in technique and viewpoint, when it does something they cannot do; they only have contempt, and rightly so, when it is an imitation of painting.

CINEMATOGRAPHY

Cinematography is the art of making motion pictures. As was suggested earlier, however, motion pictures do not really move. The illusion of movement is created by **stroboscopic motion,** which is the presentation of a rapid progression of images of stationary objects. The audience is shown 16 to 24 pictures or frames per second, like those shown in the series of Muybridge photographs (see Fig. 2–39). Each picture or frame differs slightly from that preceding it, and showing them in rapid succession creates the illusion of movement.

At a rate of 22 or 24 frames per second, the "motion" in a film seems smooth and natural. At fewer than 16 or so frames per second, movement is clearly choppy. For that reason, **slow motion** is achieved by

filming 100 or more frames per second. When they are played back at 22 or 24 frames per second, movement appears to be very slow yet smooth and natural.

A Brief History of Cinematography

Eadward Muybridge's *Galloping Horse* sequence was shot in 1878 by 24 cameras placed along a racetrack, and was made possible by new fast-acting photosensitive plates. (If these plates had been developed fifteen years earlier, Brady could have bequeathed us a photographic record of Civil War battle scenes.) Muybridge had been commissioned to settle a bet as to whether racehorses ever had all hooves off the ground at once. As is noted in Chapter 2, he found that they did, and also that they never assumed the so-called rocking-horse position in which the front legs and back legs are simultaneously extended as far as possible.

Muybridge is generally credited with performing the first successful experiments in cinematography. He fashioned a device that could photograph a rapid sequence of images, and he invented the **zoogyroscope,** which projected these images onto a screen.

The motion picture camera and projector were perfected by the inventor of the light bulb, Thomas Edison, toward the end of the nineteenth century. In 1893 the photographer Alexander Black made a motion picture of the President of the United States. In 1894 Thomas Edison's assistant Fred Ott was immortalized on film in the act of sneezing. Out of these inauspicious beginnings, a new medium for art was suddenly born.

Within a few short years, commercial movie houses sprang up across the nation and motion picture productions were distributed for public consumption. Sound was added to visual sensations by means of a **sound track,** and a number of silent film stars with noncompelling voices fell by the wayside. Color came into use in the 1930s.

During the 1930s Walt Disney's studios first produced the full-color stories and images that still possess parts of the topography of our minds. With every rerelease, *Snow White* (Fig. 8–17) brings in young audiences of yet another generation. Mickey

8–17 Film still from *Snow White and the Seven Dwarfs*
© 1937 Walt Disney Company.

Mouse, Donald Duck, Bambi, and Pinocchio are part of our folklore. The recent establishment of a Disneyland in Tokyo seems to suggest that these images and storylines strike cross-cultural chords.

The screen version of Margaret Mitchell's *Gone with the Wind* was one of the first color epics or "spectaculars." It remains one of the highest-grossing films of all film eras. In addition to the sweeping **panoramas** of the Civil War battlefield wounded and the burning of Atlanta, *Gone with the Wind* included close-ups of the emotional fire transmitted by Clark Gable as Rhett Butler and Vivian Leigh as Scarlett O'Hara (Fig. 8–18).

Additional innovations have had a checkered history. There have been expansions to wider and wider screens, including Cine-

8–18 Film still from *Gone with the Wind*
© 1939 Metro-Goldwyn-Mayer.

mascope, Cinerama, Panavision, and films that are projected completely around the audience on a 360-degree strip wall or on the inner surface of a hemispherical dome. Stereophonic sound has been introduced. A number of 3-D (three-dimensional) movies requiring special eyeglasses have been made. Today the stereophonic sound, color, and reasonably wide screens remain in common use. But what photographers have noted about the role of photographic equipment seems also to apply to cinematography: the vision or creativity of the cinematographer is more important than technical advances.

Cinematographic Techniques

Although motion pictures tell stories, cinematography is essentially a visual medium. Some critics argue that one test of a motion picture film is its capacity to communicate to the audience without sound or other explanation of the action. There are a number of techniques that originated with cinematography that help fashion interesting films and, today, television as well.

Fixed Cameras and Staged Productions

With a stage play, the audience is fixed and must observe from a single vantage point. Similarly, many early motion pictures used a single camera that was more or less fixed in place. Actors came on stage and exited before them.

Much of the Busby Berkeley musicals of the 1930s (Fig. 8–19) was shot on indoor stages that pretended to be nothing but stages. The motion picture had not yet broken free from the stage that had preceded it. Many directors used cinematography to bring the stages of the great urban centers to small cities and rural towns. We can note that the musicals of the 1930s were everything that the photographs of Dorothea Lange and the other Depression photographers were not: they were bubbly, frivolous, light, even saucy. Some musicals of the 1930s showed apple-cheeked "kids" getting

their big break on the Great White Way. Others portrayed the imaginary shenanigans of the wealthy few in an innocent era when Hollywood believed that they would offer amusement and inspiration to destitute audiences, rather than stir feelings of social conflict through depiction of conspicuous consumption and frivolity.

Lengthy, fixed-camera "motion pictures" of a sleeping man (Fig. 8–20) and the Empire State Building were made by Pop artist Andy Warhol during the 1960s. *Sleep* recorded the tosses, turns, and snores of one man during about eight hours of nocturnal activity. *Empire State Building* documented the changing play of light across the skyscraper over an entire day. Some critics hailed the return to the early days of the fixed camera. Warhol himself suggested that these motion pictures were intended as a new form of environmental art, to be played on a wall at a cocktail party while people toyed with drinks and conversation.

Occasionally, motion pictures of stage plays are still made in the **legitimate theater** and shown in the motion picture theater. Or motion pictures may use but a few sets to tell their stories.

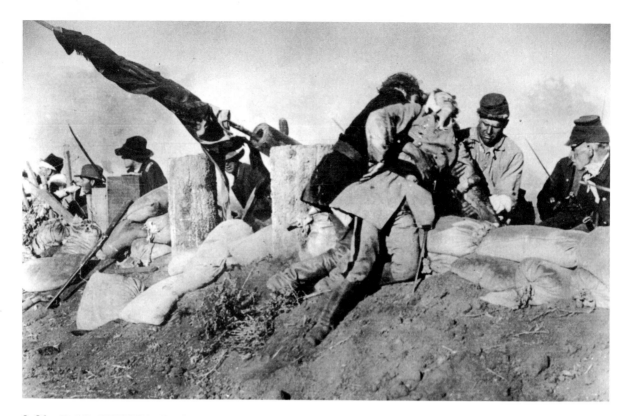

8–21 D. W. GRIFFITH Battle scene from *Birth of a Nation* (1915)

THE MOBILE CAMERA

Film critics usually argue that motion pictures should tell their stories in ways that are inimitable through any other medium. One way is through the mobile camera. Film pioneer D. W. Griffith is credited with making the camera mobile. He attached motion picture cameras to rapidly moving vehicles and used them to **pan** across expanses of scenery and action, as in the battle scenes in his *Birth of a Nation* (Fig. 8–21). Today it is not unusual for cameras to be placed aboard rapidly moving vehicles and also to **zoom** in on and away from their targets.

EDITING

Griffith is also credited with making many advances in film **editing.** Editing is the separating and assembling, sometimes called "patching and pasting," of sequences of film. Editing helps make stories coherent and heightens dramatic impact.

In **narrative editing** multiple cameras are used during the progress of the same scene or story location. Then shots are selected from various vantage points and projected in sequence. **Close-ups** may be interspersed with **longshots,** providing the audience with abundant perspectives on the action while advancing the story. Close-ups usually better communicate the emotional responses of the actors, while longshots describe the setting.

In **parallel editing,** the story shifts back and forth from one event or scene to another. Scenes of one segment of a battlefield may be interspersed with events taking place on another or back home, collapsing space. Time may also be collapsed through parallel editing, with the cinematographer shifting back and forth between past, present, and future.

In the **flashback,** one form of parallel editing, the storyline is interrupted by the portrayal or narration of an earlier episode, often through the implied fantasies of an actor or actress. The flashback usually gives current action more meaning. In the **flashforward,** editing permits the audience glimpses of the future. The flashforward is frequently used at the beginning of dramatic television shows to capture the interest of the viewer who may be switching channels.

On the Power of Cinematography

INGMAR BERGMAN: I can transport my audience from a given feeling to the feeling that is diametrically opposed to it, as if each spectator were on a pendulum. I can make an audience laugh, scream with terror, smile, believe in legends, become indignant, take offense, become enthusiastic, lower itself or yawn with boredom. I am, then, either a deceiver or—when the audience is aware of the fraud—an illusionist. I am able to mystify, and I have at my disposal the most precious and the most astounding device [the motion picture camera] that has ever, since history began, been put into the hands of the juggler.[*]

[*] Andrew Sariff, Ed., *Interviews with Film Directors*, trans. Alice Turner (New York: Avon Books, 1969), p. 35.

Motion pictures may proceed from one scene to another by means of **fading.** The current scene becomes gradually dimmer, or *fades out.* The subsequent scene then grows progressively brighter, or *fades in.* In the more rapid, current technique of the **dissolve,** the subsequent scene becomes brighter while the current scene fades out, so that the first scene seems to dissolve into the second.

In **montage,** a sequence of abruptly alternating images or scenes conveys associated ideas or the passage of time. Images can suddenly flash into focus or whirl about for impact, as in a series of newspaper headlines meant to show the progress of the actors over time.

A Portfolio of Recent Cinematography

In this section we will discuss the Swedish film director Ingmar Bergman (see "The Artist Speaks") and a number of other important film makers and films.

Since the 1950s, filmgoers have been struck by Bergman's mostly black-and-white films (Fig. 8–22). As in so much other art, nature serves as counterpoint to the vicissitudes of the human spirit in Bergman's films. The Swedish summers are short and precious. The bleak winters seem, to Bergman, to be the enduring fact of life. Against their backdrop, he portrays modern alienation from comforting religion and tradition.

8–22 INGMAR BERGMAN
Film still from *The Seventh Seal*
(1956)

Bergman's films have ranged from jocular comedies to unrelieved dark dramas, and his bewitching screen images have brought together Nordic mythology and themes of love, death, and ultimate aloneness.

Stanley Kubrick's *2001* explored the limits of time and space through high-tech special effects that became commonplace in the *Star Wars* and *Star Trek* series. We observe how tool making and weapon making evolve from the found bludgeon to the spaceship. We follow humans—once victims of the environment, now its masters—insulated from the perfect cold of space as they seek their origins. Their guardian and companion is a literal-minded computer whose ultimate flaw is the inability to continue to function when faced with conflicting demands—a capacity that most of us mere humans show each day. In a number of scenes, we view the humans through a forbidding lens—the "eye" of the computer. Close-ups seem to transport us into the frightening, unknowable heart of artificial intelligence. As human and mechanical fantasies and plots unwind, we experience the power, mystery, and perhaps the evil of intelligence divorced from flesh.

In *2001*'s innovative climax, a man makes a fantastic journey through eons of space-time which are the *surrealistic* spacescapes of the imagination of the director (Fig. 8–23). Perhaps only through media such as cinematography and television can we be so compellingly drawn through illusionary space. For many minutes we accompany actor Keir Dullea through a sequence of organically evolving or harsh geometric forms. These forms remind one alternately of the primordial soups of Yves Tanguy or Salvador Dali, or of the **nonobjective** geometries of Frank Stella or Piet Mondrian. Despite highly saturated hues, form predominates, making the journey more intellectual than emotional. If there is a flaw in all of this, it is that the evolving and dissolving scenes too much mirror their precedents in painting. They are too studiedly abstract. Nevertheless, the passage remains unique as a cinematographic experience.

Francis Ford Coppola's *The Godfather* is a richly textured masterpiece of pasta, power, and butchery. There are juxtapositions of loyalty and treachery, of eating and killing, of divine infallibility and fathomless evil. American gang wars take on cosmic proportions as what seems to be the natural order is restored through vengeance. The

8–23 STANLEY KUBRICK Film still from *2001: A Space Odyssey*
© 1968 Metro-Goldwyn-Mayer.

opposites in the human makeup are portrayed in scenes like that in which Marlon Brando, the Godfather of the title, is picking fruit from an apple cart as he is shot. The Godfather's son, Michael—and the audience—are exposed to sweeping extremes of experience. Close-ups in which Michael commits murder in a claustrophobic Bronx restaurant are contrasted with longshots of his stroll, in exile, through an impressionistic Sicilian landscape to the strains of a lyrical operatic musical score (Fig. 8–24).

In *Apocalypse Now*, Coppola's personalized epic of the Vietnam years, he explored yet new cinematographic territory. In one scene, the invulnerable helicopter gunships of the industrial age—kinetic sculptures fashioned from metal—descend in formation upon a nearly prehistoric enemy village (Fig. 8–25). The fiery romantic Western music of Richard Wagner blares from their loudspeakers—music that had ushered the clashing gods of German mythology across the operatic stages of nineteenth-century Europe. American troops waterski as their commander makes his well-known comment that he loves the "smell of napalm in the morning." Reaching for the ultimate simile, he remarks that "it smells like victory."

Another scene in *Apocalypse Now* is a bizarre reversal of Whistler's *Nocturne in Blue and Gold* (see Fig. 1–17). The central character of the film—he cannot be termed the "hero"—makes a symbolic and actual river journey into the film's heart of darkness. At night his boat approaches a bridge that is being held by a battered group of Americans who no longer know who commands them. The tracer bullets of the enemy replace the fireworks in Whistler's *Nocturne*. They highlight the sense of the unreality

8–24 FRANCIS FORD COPPOLA
Film still from *The Godfather*
© 1972 Paramount.

8–25 FRANCIS FORD COPPOLA
Film still from *Apocalypse Now*
© 1979 United Artists.

of war by creating an eerie distance between aesthetic visual experience and meaning.

No discussion of cinematography can hope to recount adequately the richness of the motion picture experience. With apologies, we have omitted reference to great social documents such as *The Grapes of Wrath* and to the Surrealistic experimental films of Salvador Dali and Fernand Léger. We have omitted the films of the Marx Brothers and Laurel and Hardy. We have not included the wonderful postwar films of the English, French, Germans, and Japanese, and others. We have omitted the black-and-white horror classics of the 1930s and the color disaster films of the 1970s. We have merely included a small number of recent films that have in their own way advanced the art of cinematography.

Now let us turn our attention to video, which has been responsible for a number of art forms, including television. This is one visual medium that is found in almost every American home.

VIDEO

Video is a rather new term on the art scene, referring not only to commercial television, public television, and cable programming, but also to experimental video and the use of the video screen in conjunction with the computer. Many of the techniques of television are a derivation and extension of those of cinematography. Television executives broadcast motion pictures into homes and produce their own dramas. Television, like cinematography, uses the camera, and all the techniques of cinematography—methods of editing, and so on—apply also to television.

The sights and sounds that are recorded by the television camera are transformed into electronic codes or messages. These messages are broadcast or transmitted through the air and received by antennae, or they are transmitted into the home by means of a cable; when the cable is underground, the picture is relatively free of the distortions that can be produced by inclement weather.

The television set reconstructs these electronic messages into visual images and sounds. The picture actually consists of hundreds of lines that run across the screen. The greater the number of lines, the higher the **resolution**, that is, the sharper the picture. The impression of a single picture is built up from light and dark areas along these lines. Color television is made possible by the exciting of various particles within the screen that glow either blue, green, or red. The wide range of hues we see is created by additive color mixtures.

Advantages of Television

Television has two techniques unavailable in cinematography: live transmission and **videotape.** As was noted earlier, television can achieve great impact through transmission of events as they are happening. Not only is a record of events made public immediately; this record is basically uncensored and unpredictable. Mistakes and unintended pictures can be transmitted, all heightening the suspense of the viewer. An image that is recorded on magnetic videotape is instantly replayable and cannot be distinguished from live transmission.

Another advantage of television is its intimacy. In contrast to the movie theater with its throngs, television is most often watched in the home, frequently by lone viewers. For many people, television is an indispensable companion.

Disadvantages of Television

If there are disadvantages to the medium of television, perhaps they include the relatively small size of the screen and the same-

ness that is achieved by repeated presentation or minor variations of images. Television generally thrives on the close-up rather then the longshot, although longshots and middle-range shots are certainly used to establish settings. Because of the smallness of the screen, many television shows, like early cinematography, tend to rely on a few staged sets. Most of the plots of *The Bill Cosby Show* unwound in a living room, and most of the story lines of *Cheers* unfolded in a tavern.

THE PROBLEM OF SAMENESS

It is not unusual for the same commercial message to be shown several times during the same show. It may be seen literally dozens of times a week by many viewers. Some people leave their television sets on literally all day long, even as they are occupied in other rooms. After a while story lines, commercials, and the faces of actors and actresses tend to merge so that figure and ground are obscured. As the afternoon wears on and soap opera blends into soap opera, shows lose their individuality.

In weekly television series, show after show is based on minor variations in character and plot. On the news, warfare, weather, the gyrations of the stock market, sports, and love stories are all presented with the same objective intensity. Because everything is presented as being important, sometimes nothing seems to be very important. Some critics have argued that genocide and tissue commercials may be presented with equal visual impact.

Because of the tendency toward sameness, directors and producers spend much effort in trying to give their shows individual stamps. Unfortunately for television as an artistic medium, these stamps frequently take the form of loud music, violence, and purposeless sexuality—all as raw as public standards will allow.

The Commercial in Commercial Television

A number of commercials have been patently offensive to art and the artistic taste. Two decades ago, for example, an underarm deodorant was hawked while the camera swam in space around a replica of the *Venus de Milo*. This was a clear degradation of a beloved image.

On the other hand, it is an irony that some of the most creative aspects of commercial television are found in the brief commercials themselves. Cartoon characters such as "Speedy Alka Seltzer" and "Poppin Fresh" are clever and uniquely American. The light beer commercials of the football season possess a humor lacking in the sportscasts themselves. Through creative use of montage, many commercials make visual innovations. Some, like the Chanel perfume commercials, are surrealistically erotic. Others, such as the perennial "Christmas card" of a brewing company, in which a horse-drawn wagon is pulled through the evening snow, seem to reach for a genuine warmth.

Public Television

Artistic values often find greater freedom of expression on public television than on commercial television. Public television shows are supported by viewers, grants from corporations and foundations, and, to an increasingly lesser degree, by government. For this reason, commercials are unnecessary, and shows may be targeted toward smaller audiences with more specialized interests. Ballets, operas, serious talk shows, shows on science, and even shows of experimental visual imagery find their place on public television.

8–26 Cast of "Sesame Street"

8–27 Cast of "Upstairs, Downstairs"

On commercial television, children's shows are characterized by conflict, violence, and frequent commercials for toys and breakfast cereals. On public television, there is room for educational productions such as *Sesame Street* (Fig. 8–26), *The Electric Company*, and *Upstairs, Downstairs* (Fig. 8–27). The antics of the familiar friendly "monsters" and other characters of *Sesame Street* are interrupted by mock "commercials" about letters and numbers. The methods of the commercial world take on satirical artistic expression in the rapidly changing, colorful background against which letters and numbers are shown. Rote associative learning of sounds and visual images of letters and numbers is stimulated by the repetition found in the commercial.

The Element of Time in Television

Motion pictures have different lengths. Although there may be limits to audience ability to sit without fidgeting and losing interest, the motion picture's length varies according to its narrative and aesthetic needs. For commercial reasons, American television shows are usually broken down into half-hour and hour-long segments. When we include commercial messages, the half-hour show has about 24 minutes in which to establish and resolve its conflicts. Given that commercial breaks are also phased in according to certain industry standards, the upper limits of the lengths of scenes are also predetermined.

Into these time periods authors must squeeze their drama. It is perhaps more difficult than funneling poetic concepts into the fourteen prescribed lines of the sonnet. Certainly there is much "junk" on television, but the ability of writers to adapt their story lines to these time restrictions is a sign of their merit. Consider just a few of the excellent shows that have told their stories within the confines of half-hour or hour-long formats: *I Love Lucy, The Mary Tyler Moore Show, All in the Family, Taxi, M*A*S*H, Hill Street Blues, L.A. Law, Cheers,* and *The Bill Cosby Show,* among many, many others.

Video Art

Nam June Paik and a number of others have experimented with the use of the television screen for representing nonobjective works such as *Rondo Electronique* (Fig. 8–28), whose fluctuating images are reminiscent of the light sculptures shown in Figure 6–23. Other works show moving moiré patterns that look now like nested sine curves, now like curved nets.

Paik refers to his work as **video art,** in order to distinguish it from the commercial efforts of the television establishment. In

8–28 NAM JUNE PAIK
Rondo Electronique (1966–68). Video.
Photo by Peter Moore.

other works Paik has used miniature television sets as parts of the cups of a female cellist's bra, and piled large numbers of full-sized television sets into sculptural assemblages. The *Bra for Living Sculpture* may be a comment on the "intellectual nourishment" that many of us seem to seek of television. The assemblage of sets could reflect the often-heard characterization of television as a wasteland.

Technical advances may prompt further variations in commercial and public television and in video art. Projected television, while still quite expensive, provides a significantly larger screen. High-resolution television, also expensive, provides a sharper picture. Experimentation is under way with three-dimensional television. The futures of television and video art remain an open book.

9

The Art of Everyday Living: Crafts and Design

Imagine archaeologists of the future digging into the records of our civilization. Not only would they find paintings and sculptures and evidence of our buildings, bridges, and writings, they would also find pottery, Tiffany glassware, Persian and Native American rugs, silverware, jewelry, Breuer chairs, Brillo boxes, Calvin Klein jeans, electric coffeemakers, microcomputers, Coke bottles, and Volkswagens.

These products of **craft** and **design** are indispensable aspects of our daily lives. Yet they do more than serve a purpose. A nondescript vessel of stoneware or glass will hold water as well as a graceful china cup. An economy car will transport us to our destinations as well as sportier models. But when they are finely crafted and designed, ceramics, products of industrial design, and other objects add immeasurably to the quality of life. These crafts and designs become what we refer to as the art of everyday living: They surround us with beauty and elegance.

In this chapter we will first discuss several forms of craft: ceramics, glass, fiber arts, metalwork and jewelry, and furniture making. Then we will turn to the disciplines of graphic design, clothing design, industrial design, interior design, and urban design.

Ceramics

Ceramics refers to the art or process of making objects of baked clay. Ceramics includes many objects ranging from the familiar pots and bowls that comprise **pottery** to building bricks and the extremely hard tiles that protect the surface of the space shuttles from the intense heat of atmospheric reentry.

Methods of Working with Clay

Ceramics is a venerable craft which was highly refined in the ancient lands of the Middle East and in China. For thousands of years people have modeled, pinched, and patted various types of wet clay into useful vessels and allowed them to dry or bake in the sun, creating hard, durable containers. They have rolled clay into rope shapes which they coiled around an open space. They have rolled out slabs of clay like dough, cut them into pieces, fastened them together, and smoothed them with simple tools, as Native Americans still do today.

They discovered that if they allowed clay vessels to dry, then fired them in a type of oven called a **kiln,** or over coals, they became waterproof and yet more durable.

Isamu Noguchi created his *Big Boy* (Fig. 9–1) by pinching and modeling the clay forms of the hands and feet. The clay slab that forms the poncho was rolled, cut, folded, and pressed onto the other pieces. The rough edges of the clay echo the artist's intentional crudeness of form, in which the spread-eagled limbs of the subject are contained by the simple T-shape of the garment.

Marilyn Levine's mostly clay *John's Jacket* (Fig. 9–2) shows the whimsical use of materials that sometimes defines the aesthetic of

9–1 ISAMU NOGUCHI
Big Boy (1952)
Karatsu ware. 7⅞ x 6⅞".
Collection, The Museum of Modern Art, N.Y. A. Conger Goodyear Fund.

9–2 MARILYN LEVINE
John's Jacket (1981)
Ceramic, zipper, and metal fasteners. 36 x 23½ x 7".
Courtesy of the artist.

the craftsperson. In galleries we circle suspiciously around works such as these. We are drawn to test out our visual sensations by touching them, and perhaps we are simultaneously amused by and annoyed at the craftsperson who would push our senses to the limit. Perhaps we are also on the lookout for gallery employees who might frown on our using our hands to test what we sense with our eyes, and for fellow patrons who might doubt our intelligence or criticize our quest for tactile sensation. Ultimately the combination of the phony and the real shock the sense of touch. Levine's jacket is, in reality, composed of rolled-out slabs of clay that have the look of leather, while the work also contains stitching and real metal snaps and a zipper. The shifting back and forth between illusion and reality functions as a metaphor for what arts and crafts are all about: in so many instances they transform the world that they represent.

THE POTTER'S WHEEL

The potter's wheel (Fig. 9–3) was first used in the Middle East about 4000 B.C. and seems to have come into common use by

9–3 Throwing a pot on a potter's wheel

about 3000 B.C. A pot can be **thrown** quite rapidly on a wheel. The walls of such vessels tend to be thinner and more uniform in thickness than walls made by **coiling,** and the surface is smoother. Greek potters threw wide-necked jugs for water and wine and narrow-necked vials for body oils and perfumes.

GLAZING

Variation in color and texture is secured by the choice of clay and by **glazing.** The earliest known glaze dates from about 3000 B.C. and is found on tile from the tomb of the Egyptian King Menes.

Glazes, which contain finely ground minerals, are used in liquid form. They are brushed, sprayed, or poured on ceramics after a preliminary **bisque firing** removes all water. During the second firing, the glaze becomes glasslike, or **vitifies,** fusing with the clay. It gives the clay a glassy, **nonporous** surface coating that can be shiny or dull, depending on its composition. Glazing can create intricate, glossy patterns across otherwise uniform and dull surfaces.

Contrast the simple, pure forms of the vases by Gertrud and Otto Natzler (Fig. 9–4) with the crude forms found in *Big Boy.* The deep but mellow glazes of the Natzler pieces are modulated by light to impart a glowing intensity, in contrast to the rough surface of the rolled, folded, and pressed Noguchi.

Robert Arneson's *Jackson Pollock* (Fig. 9–5) provides a very different example of a glazed ceramic work and illustrates how blurred the line between craft and fine art can be. Arneson's figures are purposefully unrefined, intentionally flawed, mirroring the ceramic artist's view of human nature as imperfect. As is noted in Chapter 17, the subject of the work, Jackson Pollock, was an Abstract Expressionist who became renowned for his drip paintings. Arneson's clay portrait unifies the artist and his works by providing the illusion of overall dripping and splattering on the bust.

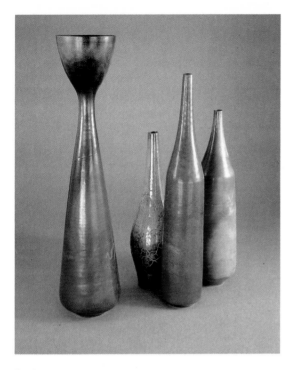

9–4 GERTRUD and OTTO NATZLER
Four tall reduction-glaze vases (1957–74)
Courtesy of Otto Natzler; photo, Gail Reynolds Natzler.

9–5 ROBERT ARNESON
Jackson Pollock (1983)
Glazed ceramic. 23 x 13 x 7".

Collection of Dr. Paul and Stacy Polydoran. Courtesy Frumkin/Adams Gallery, N.Y.

TYPES OF CERAMICS

Ceramic objects and **wares** are classified according to the type of clay and the temperature at which they are fired.

Earthenware derives its name from the fact that it is usually red or tan in color. It is made from coarse clay or shale clay and is usually fired at 1,000–2,000 degrees Fahrenheit. It is somewhat porous and is used for common bricks and coarse pottery. The Mangbetu bottle from Zaire (Fig. 9–6) is made from **terra-cotta,** a heavy clay earthenware product fired at a higher temperature of about 2,070–2,320 degrees F. The head is an effigy or portrait of a Mangbetu citizen. Note that the textural decoration is reminiscent of a basket weave. It was probably fired in the open, on a bed of straw and twigs.

9–6 Mangbetu portrait bottle (Zaire, 19–20th century). Terra cotta. Height: 11⅜".

The Metropolitan Museum of Art, N.Y. The Michael C. Rockefeller Memorial Collection, Gift of Nelson A. Rockefeller, 1960.

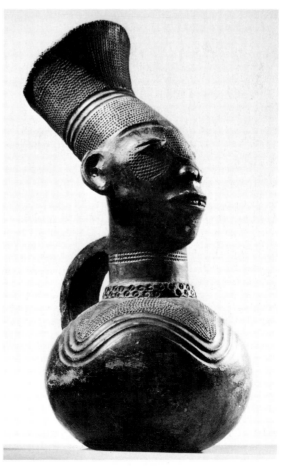

9–8 JUDY CHICAGO
Georgia O'Keeffe plate from *The Dinner Party* (1979)
China painting on porcelain. Diameter: 14″.

© Judy Chicago 1979.

Stoneware is usually gray but may be tan or reddish. It is fired at from about 2,300 to 2,700 degrees F. It is slightly porous or fully nonporous and is used for most dinnerware and much ceramic sculpture.

Porcelain is hard, nonporous, and usually white or gray in color. It is made from fine, white kaolin clay and contains other minerals such as feldspar, quartz, and flint in various proportions. It is usually fired at 2,400–2,500 degrees F., and it is used for fine dinnerware. Chinese porcelain, or **china,** is white and fired at low porcelain temperatures. It is glasslike or vitreous, nonporous, and may be translucent. It makes a characteristic ringing sound when struck with a fingernail.

Porcelain has been used by various cul-tures for vases and dinnerware for thousands of years. Like other kinds of wares, it has also provided a vehicle for artistic expression. Marianne Weinberg-Benson's *Spring Twilight Triptych* (Fig. 9–7) is a series of three porcelain vessels articulated with sand-blasted designs. In daily use, of course, the vessels would be separated and perhaps placed at random, but in Weinberg-Benson's conception, the precise grouping shown in the figure exists as a total work of art with a unified design image that continues from vessel to vessel.

The 39 porcelain plates from Judy Chicago's *The Dinner Party* have quite a different look. Chicago's feminist work consists of a table in the shape of an equilateral triangle with thirteen place settings along each 48-foot-long side. Each setting symbolizes the life and achievements of a great woman, such as Queen Elizabeth I, suffragette Susan B. Anthony, poet Emily Dickinson, and American artist Georgia O'Keeffe (Fig. 9–8). The equilateral triangle symbolizes equality and the patterns on the plates are frequently suggestive of female genitalia. O'Keeffe's plate exudes an organic power and permanence, inspired by botany and by O'Keeffe's own work. Many of Georgia O'Keeffe's gigantic paintings of flowers, such as the one shown in Figure 16–13, are also often reminiscent of female sex organs.

Jasper, or jasperware, is a type of porcelain developed by the Englishman Josiah Wedgwood in the second half of the eighteenth century. It is characterized by a dull surface, usually in green or blue, and white raised designs (Fig. 9–9). The raised patterns usually show Greek themes or draped figures in graceful robes.

9–9 JOSIAH WEDGWOOD Flowerpot, vase, and box with cover (c. 1780–1800).
The Metropolitan Museum of Art, N.Y., Rogers Fund, 1909.

Because of its expense, families are more likely to buy a few pieces of Wedgwood for decoration than they are to buy sets for table use. Most tableware is mass-produced, machine-made stoneware or porcelain. Much is relatively plain and unadorned or has simple lines that accent the shapes of the pieces. Other tableware in daily use has printed designs that range from users' first names to landscapes to animals and Pop art types of images. Tableware varies widely in price and aesthetic value.

As was noted in Chapter 6 in the discussion of clay as a material for sculpture, one of its fascinating features is its versatility. Clay can be used to form the refined vessels of the Natzlers and Weinberg-Benson and the crude, slablike structures of both primitive and contemporary workers. It is said that one test of the integrity of a work is its trueness to its material. In the case of ceramics, however, one would be hard pressed to point to any one of the products of clay as representative of its "true" face.

Glass

Glass products, like ceramics, serve both utilitarian and decorative functions. Unlike clay, glass is transparent or translucent. The color and hardness of glass depend on its components and vary greatly.

TECHNIQUES OF WORKING GLASS

Glass is generally made from molten sand, or **silica,** mixed with minerals such as lead, copper, cobalt, cadmium, lime, soda, or potash. Certain combinations of minerals afford the glass a rich quality as found in the stained-glass windows of the great cathedrals and in the more recent stained-glass works of Henri Matisse and Marc Chagall.

Like ceramics, glass is versatile. Molten glass can be modeled, pressed, rolled, blown, and even spun into threads. **Fiberglass** is glass that has been spun into fine filaments. It can be woven into yarn for textiles, used in woolly masses for insulation, and pressed and molded into a plastic material that is tough enough to be used for the body of an automobile. About 4,000 years ago the Egyptians modeled small bottles and jars from molten glass. Contemporary machine-made glassware is usually pressed. Molten glass is poured into molds and then forced into shape by a plunger. The plate glass that is used for windows and mirrors is made by passing rollers over molten glass as it cools.

Glass was first **free-blown** in the Middle East between 3,000 and 4,000 years ago. A hollow tube or blowpipe is dipped into molten glass and then removed. Air is blown through the tube, causing the hot glass to

form a spherical bubble whose contours are shaped through rolling and pulling with various tools. The process is usually quite rapid, but the glass can be reheated if it must be worked extensively.

Once the desired shape has been achieved, the surface of glass can be decorated by cutting or **engraving** planes that reflect light in certain patterns, by etching, or by printing.

EXAMPLES OF GLASSWARE

One of the earliest and best-known pieces of glassware is the Roman Portland Vase (Fig. 9–10), which survives from the third century A.D. The refinement of the piece testifies to the long tradition of glassmaking in Rome even before that time. The Portland Vase was created in three steps. The underlying form was blown from dark blue glass. Next a coating of semi-opaque white glass was added to the surface of the basic blue form. Finally, the white glass was carved away to provide the bas-relief of figures and vegetation that circumscribe the vase. The relief consists of many subtle gradations. Where it is thinnest, the blue from beneath

9–10 Portland vase (Roman, 3rd century A.D.) Cameo-cut glass.

British Museum, London.

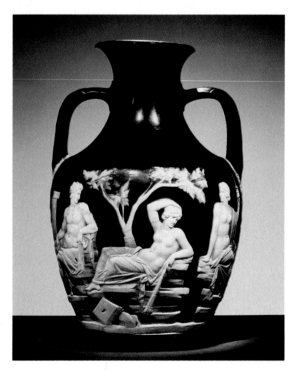

shows through to provide a shaded quality. Imagine the patience of the cameo cutter who meticulously chipped glass away from glass, leaving unscratched the brittle blue surface that serves as background for the figures.

In various eras, different world centers became renowned for glassmaking. For example, during the Middle Ages, Venetian glass became known for its lightness and delicacy. The assembling of pieces of colored or stained glass reached a height at about the same time that architects and builders used stained glass windows to bring light into their Gothic cathedrals and to represent religious figures and scenes. The *Tree of Jesse* (geneology of Christ) (Fig. 9–11) is one of a series of windows in the west façade wall of Chartres Cathedral. This majestic window, like the others, consists of hundreds of pieces of tinted glass that are bound together by strips of lead. The fine details, such as the hair, eyes, and folds of drapery, were painted or drawn on the glass surfaces. Matisse's contemporary stained-glass windows for the Chapel of the Rosary of the Dominican Nuns (Fig. 9–12) are assembled in much the same way as the Gothic windows, but lightness and gaiety are accomplished through juxtaposition of broad areas of pure tone. In this way, the colors achieve maximum intensity and create form rather than decorate form.

Eighteenth-century Stiegel glass, made in Pennsylvania, became known for its use of flint (lead oxide) to achieve hardness and brightness. So-called **flint glass** is used for lenses of optical instruments and for crystal. Nineteenth-century Sandwich glass—from the town of Sandwich, Massachusetts—was pressed into molds to take on the appearance of a cut pattern. Ornamental Sandwich glass pieces in the shapes of cats, dogs, hens and ducks became common home decorations.

During the second half of the nineteenth century, Louis Comfort Tiffany designed some of the most handsome **Art Nouveau** interiors. His glassware (Fig. 9–13) attains a similar marriage of simplicity and exotic refinement. Graceful botanical forms swell and become attenuated. The translucent or

9–11 *Tree of Jesse*. Stained-glass window, Chartres Cathedral, west façade (13th century A.D.)

9–12 HENRI MATISEE
Stained-glass windows, Chapel of the Rosary of the Dominican Nuns, Vence, France (c. 1951)

9–13 LOUIS COMFORT TIFFANY
Four pieces of glassware in Art Nouveau style made
by the Tiffany Studios. Glass, favrile. Left to right:
2⅞" high; 15½" high; 18¹¹⁄₁₆" high; 4¹⁄₁₆" high.
The Metropolitan Museum of Art, N.Y.

9–14 HARVEY K. LITTLETON
Implied Movement (1986) 41 x 18 x 12".
Heller Gallery, New York.

iridescent glass is decorated by spiral
shapes, swirling lines, and floating forms
that seem naturally to grow out of the glass-
blowing process. They keep faith with the
Art Nouveau creed that decoration should
be a natural expression of the manufacturing
process. Tiffany also fashioned many fine
candlesticks, lamps, and lighting fixtures
from bronze showing the same botanical
whimsy he expressed in his glassware.

Harvey K. Littleton's contemporary *Im-
plied Movement* (Fig. 9–14), like Tiffany's
glassware, shows bulbous organic forms
that become attenuated toward the tips. Lit-
tleton's work, moreover, could be either bo-
tanical or zoological, depending perhaps on
whether the viewer perceives the "implied
movement" to stem from fluctuations in air
or under water, or from the movement of
abstract limbs. Also, whereas Tiffany's
works, despite our reluctance to "use" them,
do function as vessels, Littleton's grace-
ful forms speak more of art for art's sake.

Fiber Arts

Fibers are slender, threadlike structures that
are derived from animals (for example, wool
or silk), vegetable (cotton or linen), or syn-
thetic (rayon, nylon, or fiber glass) sources.
The fiber arts refer to a number of disciplines
in which fibers are combined to make func-
tional or decorative objects or works of art.
They include, but are not limited to, weav-
ing, embroidery, crochet, and macramé.

WEAVING

Weaving was known to the Egyptians,
who placed patterned fabrics before the
thrones of the pharaohs 5,000 years ago.
Only royalty could tread on certain fabrics.
According to ancient Greek legend, King
Agamemnon showed excessive pride by

walking upon purple fabrics that were intended for the gods.

The **weaving** of fabric or cloth is accomplished by interfacing horizontal and vertical threads. The lengthwise fibers are called the **warp,** and the crosswise threads are called the **weft** or **woof.** The material and type of weave determine the weight and quality of the cloth. Wool, for example, makes soft, resilient cloth that is easy to dye. Nylon is strong, more durable than wool, moth-proof, resistant to mildew and mold, nonallergenic, and easy to dye.

There are a number of types of weaves. The **plain weave** found in burlap, muslin, and cotton broadcloth, is the strongest and simplest: the woof thread passes above one warp fiber and beneath the next. In the **satin weave,** woof threads pass above and beneath several warp threads. Warp and woof form broken diagonal patterns in the **twill weave.** In **pile weaving,** which is found in carpeting and in velvet, loops or knots are tied; when the knotting is done, the ends are cut or sheared to create an even surface. In sixteenth-century Persia, where carpet weaving reached an artistic peak, pile patterns often had as many as 1,000 knots to the square inch.

The Persian rug shown in Figure 9–15 was woven in the seventeenth century. Like others of its kind, it portrays the old Islamic concept of Paradise as a garden. Here a light-colored tree and an assortment of other plants grow on a claret red background. The date palm, the iris, a symbolic tree of life,

9–15 Persian rug (1600–50)
8'11" x 5'10". Wool.

9–16 Chilkat blanket, Alaska (collected in 1907). Woven of goat's wool on a shredded cedar-bark base. 64″ wide.

hyacinths, and tulips were frequently depicted on such rugs.

Weaving is typically carried out by the hand **loom** or a power loom, although some weavings, like the Alaskan Chilkat blanket (Fig. 9–16), was woven by Native American women without benefit of a loom. Chilkat women achieved a very fine texture with a thread made from a core of a strand of cedar bark covered with the wool from a mountain goat. Clan members used blankets such as these on important occasions to show off the family crest. Here a strikingly patterned animal occupies the center of a field of eyes, heads, and mysterious symbols.

A tightly woven tapestry of the quality of the Unicorn Tapestries (Fig. 1–3) could take years to complete on a hand loom. Medieval weavers worked from patterns called "cartoons," such as those used in fresco painting (see p. 85). Cartoons were as large as the final product and enabled the weaver to incorporate hundreds of colors into intricate scenes. The first power looms were adapted to carpet weaving in England and France in the late 1830s, and the textile industry experienced rapid growth through Europe and America soon afterward. It is the power loom that has placed wall-to-wall pile carpeting within the reach of the middle class.

APPLYING DESIGNS TO FABRICS

The surfaces of fabrics can be enhanced by printing, embroidery, tie-dyeing, or batik. Hand printing has been known since ancient times, and Oriental traders brought the practice to Europe. A design was stamped on a fabric with a carved wooden block that had been inked. Contemporary machine printing uses inked rollers in the place of blocks, and fabrics can be printed at astonishingly rapid rates. In **embroidery,** the design is made by needlework.

Tie-dyeing and batik both involve dyeing fabrics. In **tie-dyeing,** designs are created by sewing or tying folds in the cloth to prevent the dye from coloring certain sections of fabric. In **batik,** applications of wax prevent the dye from coloring sections of fabric that are to be kept light-colored or white. A series of dye baths and waxings can be used to create subtly deeper colors.

Tim Harding's textile works, such as *Coat* (Fig. 9–17), consist of many layers of hand-dyed cotton cloth that have been quilted or sewn together. He then slashes through one or more of the quilted sections with a knife, revealing the colors of dyed cloth beneath the surface. After the garment is washed, the edges of these slashed lines fray or curl back so that the underlayers are revealed. The result is a highly textured

9-17 TIM HARDING *Coat* (1987). Dyed, layered, quilted, slashed and frayed cottons. 54 x 70 x 3".

textile relief that is at once crisp and weathered in appearance. Harding's garments range from shimmery waves of color with subtle variations of tone to intricate landscape designs with a strong suggestion of topographical variations.

OTHER FIBER ARTS

There are a number of other fiber arts, including but not limited to basketry, stitchery or embroidery, and macramé.

In basketry, or basket weaving, fibers are also woven together in various patterns. The delightful Pomo gift basket (Fig. 9–18) was woven from grass and glass beads. Triangles of warm primary red leap out from a backdrop of cool primary blue and pale straw.

9-18 Ceremonial basket with overall beaded decoration, Pomo, California (American Indian, Pomo tribe, 1900). 3¾" high.

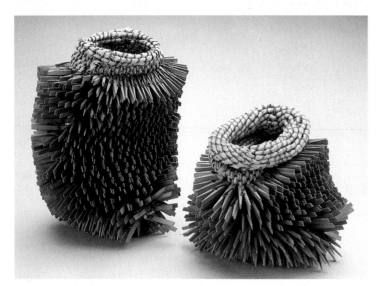

9–19 KARYL SISSON
The Sister Vessels (1986). Brass zippers and wood spring clothespins. 16 x 12 x 12″ and 10½ x 12 x 12″.

Courtesy of Swan Gallery, Philadelphia

These Native Americans from California made extremely fine basketry, with as many as sixty stitches to the inch. Barks, roots, and other fibers supplemented grass, and precious feathers and shells were sometimes employed in the design.

Karyl Sisson's *The Sister Vessels* (Fig. 9–19), like Levine's *John's Jacket* (Fig. 9–2), illustrates the artist's delight in selecting materials that stun the senses by toying with the orderly categories we have constructed for interpreting our worlds. The sister vessels are composed of brass zippers and wood spring clothespins, nontraditional materials which, when woven together, function as a basket.

Needlework is practiced here and there today, but during the nineteenth century American women embroidered many pillows, **samplers,** and furniture covers. A few women stitched ambitious artistic works.

Macramé is the knotting of coarse threads or fibers. Originally it was a purely functional craft, used for knotting fishing nets and sacs. Later it was used decoratively to make fringes for furniture and bedspreads. Today macramé is a focus of new creative activity. It is used to make wall hangings, which often serve the functions of the tapestries of the past, plant hangers, handbags, belts, and other articles of clothing.

Metalwork and Jewelry

The refining and working of metals has been known for thousands of years. Iron and its alloys have been used to fashion horseshoes and arrowheads and, more recently, as is noted in Chapter 7, the skeletons of skyscrapers. **Stainless steel** is used in kitchen utensils and furniture. Lightweight aluminum is used in cookware and in aircraft. Bronze is the favorite metal of sculptors. **Brass** is seen everywhere from andirons to candlesticks to beds.

Silver and gold have been prized for millennia for their rarity and their appealing colors and textures. They are used in jewelry, fine tableware, ritual vessels, and sacred objects. In jewelry these precious metals often serve as settings for equally precious gems or polished stones; or their surfaces can be **enameled** by melting powdered glass on them. These metals even find use as currency; in times of political chaos, gold and silver are sought even as the value of paper money drops off to nothing. Threads of gold and silver find their way onto precious china and into the garments and vestments of clergy and kings. Gold leaf adorns books, paintings, and picture frames.

Metals can be hammered into shape, **embossed** with raised designs, and cast according to procedures described for bronze in Chapter 6. Each form of working metal has its own tradition and its advantages and disadvantages.

Some of the finest gold jewelry was wrought by ancient Greek goldsmiths. The pectoral piece shown in Figure 9–20 was meant to be worn across the breast of some nomadic chieftain from southern Russia, and, probably, buried with him. Fortunately, it was not. People and animals are depicted with a realism that renders the fanciful **griffins** in the lower register as believable as the horses, dogs, and grasshoppers found elsewhere in the piece. The figures are balanced by the refined scrollwork in the central register, and all are contained by the magnificent coils.

The Renaissance sculptor and goldsmith Benvenuto Cellini created a gold and enamel

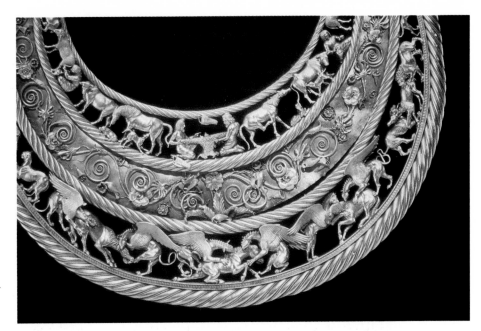

9–20 Pectoral piece from Ordzhonikidze, Russia (4th century B.C.). Gold. 12″ diameter.
Historical Museum, Kiev.

9–21 BENVENUTO CELLINI
Saltcellar of Francis I (1539–43). Gold and enamel. 10⅛″ high; 13¹⁄₁₆″ long.
Kunsthistorisches Museum, Vienna.

9–22 JOHN CONEY
Monteith bowl (c. 1700–10). Silver. 10¾″ high.
Yale University Art Gallery, New Haven, Mabel Brady Garvan Collection.

saltcellar (Fig. 9–21) for the French King Francis I that shows the refinement of his art. Its allegorical significance is merely an excuse for displaying the skill of Cellini's craft. Salt, drawn from the sea, is housed in a boat-shaped salt container and watched over by a figure of Neptune. The pepper, drawn from the earth, is contained in a miniature triumphal arch and guarded by a female personification of Earth. Figures on the base represent the seasons and the segments of the day—all on a piece 13 inches

long. Unfortunately, the saltcellar is Cellini's sole major work in gold that survives.

The large silver punch bowl shown in Figure 9–22, like the Cellini saltcellar, is an emblem of the conspicuous consumption of the very wealthy. It may represent the most embellished work of Boston silversmith John Coney. The **gadrooning** of the base balances the **fluting** of the swelling upper body. The elaborate **corbels** of the rim are decorated with intricate patterns of leaves and flowers and balanced by swivel-

9–23 RACHELLE THIEWES (a) Ear wrappings, silver (1981). (b) "Django" (bracelet), silver with patina (1984).

Courtesy of the artist.

ing handles that are attached to the bowl at lions' heads with open mouths. Wine glasses and ladles can be hung from the notched rim and chilled by the ice water inside.

Few Americans have owned elaborate punch bowls of precious metal, but American homes have been the settings for ornate and sometimes whimsical work wrought from more common metals. Doorknobs, handles, bolts and locks, key plates, andirons, stair rails, gates, and fences have all received embellishment. Weather vanes have been enhanced with fish and fowl, animals, and the initials of the owner.

Jewelry usually serves decorative functions, and finger rings can also offer information about the wearer's marital status or alma mater. Bracelets may carry "charms" that commemorate special occasions. Rachel Thiewes's contemporary jewelry (Fig. 9–23) is fabricated from wire or sheets of metal with traditional metalsmithing techniques like soldering, forming, and fitting. Her lyrical ear wrappings (Fig. 9–23a), made from silver and gold, have an organic quality, as of ribs arching away from a curved spinal cord. The "spines" follow the outer edges of the ears while the "ribs" embrace the upper lobe. Her silver bracelet (Fig. 9–23b), by contrast, has "charms" with strong, simple geometric forms. The blackness of the charms is a **patina** that results from chemical treatment.

Furniture

Over the centuries, furniture has reflected the technology, the politics, and the arts of the times. To understand this point, let us do a little bit of "antique-ing."

A HIGHLY SELECTIVE SURVEY OF ANTIQUES

Consider the wooden chairs in Figure 9–24. The French Louis XIV armchair (Fig. 9–24a) was designed during the period (1643–1700 A.D.) when the palace and gardens at Versailles were built. Similar to the contemporaneous **Baroque style** in painting and architecture (see Chapter 14), it is massive, splendid, and elaborate in its detail. Chairs were regal, thronelike, sometimes wrought from silver.

The Louis XV armchair (Fig. 9–24b) reflects the voluptuousness and frivolity of the **Rococo style** (1730–1760). Legs were curved and cabinets had bulging, flowing fronts.

In the Louis XVI armchair (Fig. 9–24c), we see how excavations at Pompeii and other ancient sites influenced home furnishings. Embellishment and the free curve were replaced with the simplicity and straight lines of the **Neoclassical style** (1760–1789).

Furniture in the **Empire style** of the Napoleonic era (1804–1815) again became massive and elaborate. Power and dignity replaced frivolity (see Fig. 9–24d). Empire style furniture was frequently embellished with de-

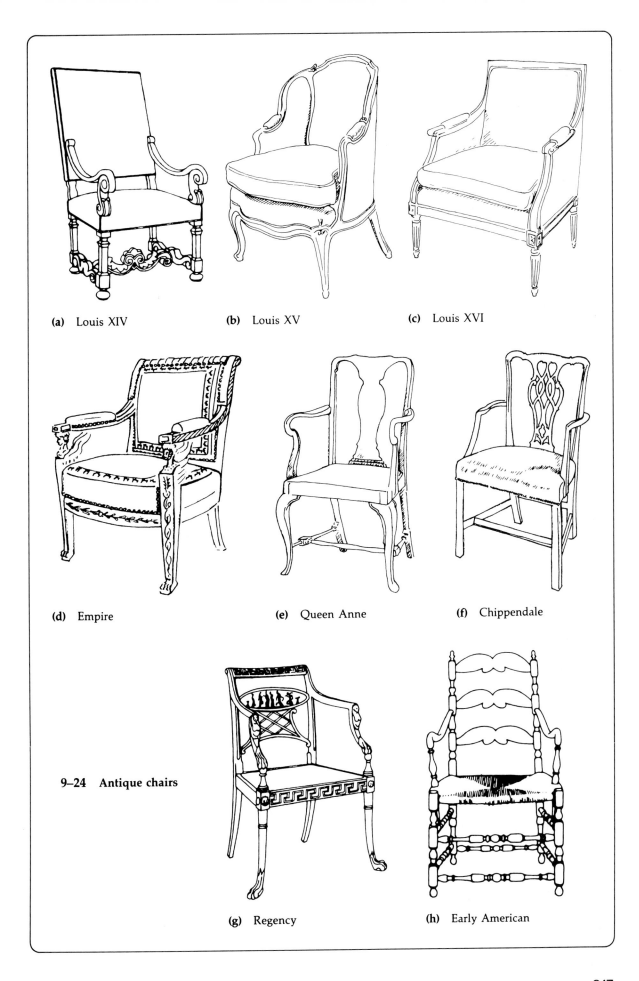

(a) Louis XIV

(b) Louis XV

(c) Louis XVI

(d) Empire

(e) Queen Anne

(f) Chippendale

9–24 Antique chairs

(g) Regency

(h) Early American

signs from military or ancient sources—lions, eagles, swords, spears.

The English Queen Anne style (1702–1714) was similar to the French Rococo style of the same period. The splat-back chair (Fig. 9–24e), with its curved lines, may be the most typical and elegant piece of this period.

The Chippendale chair (Fig. 9–24f) of the Middle Georgian period (1750–1770), with its refined tracery back, was a response to the fanciful quality of the French Rococo style. London cabinetmaker Thomas Chippendale usually chose mahogany because of its capacities to hold carving and to take on a rich luster when polished. Chippendale was also influenced by Chinese architecture and furniture, and many of his designs took on the ornate nature of **chinoiserie.**

The Regency style (1810–1830) reflects the new sense of opulence and power of the English people following the defeat of Napoleon at Waterloo. The painted armchair shown in Figure 9–24g is a strong, bold interpretation of classical Greek lines. Chairs and "Grecian" sofas sported lion's paw feet carved from rich mahogany.

The Early American style (1608–1720) is known for its heavy proportions and solidity. More so than its European counterparts, it was built by local carpenters and reflected functional necessity. Figure 9–24h shows the so-called ladder-back chair. Embellishment, such as it is, is derived from the lathework of wooden rods, making for a procession of cylindrical, globular, rectangular (not shown), and swelling shapes. In contrast to the rich fabrics of European furniture, the seat of this chair is made from rope. But many cushions of the period were made from imported silk and some showed elegant needlework.

CONTEMPORARY EXAMPLES

Contemporary furniture, like Early American furniture, tends to stress the relationship between form and function. But in contrast to the European and American styles that precede it, contemporary furniture is characterized by an almost forced simplicity and severity of shape. It is also constructed from a variety of contemporary materials, including but not limited to molded plywood, acrylic resins like Lucite and Plexiglas, and chrome-plated steel, whose visual qualities and strength suggest new possibilities in form.

The Breuer chair (Fig. 9–25), designed by twentieth-century architect Marcel Breuer, consists of chrome-plated steel tubing, wood, and cane. The steel frame is somewhat flexible—anchored by the planes of wood and cane—and achieves an artistic integrity from the flow of the single steel line through space. (From the side, the Breuer chair is an upside-down question mark.) However, most chairs in this style are actually pieced together from several tubes. The chrome plating provides a highly machined, no-maintenance finish to the steel, and the cane yields a just bearably soft seating surface. Perhaps the relative

9–25 (*far left*) MARCEL BREUER
Side chair (1928) Chrome-plated steel tube, wood, cane. 32″ high.

Collection, The Museum of Modern Art, N.Y. Purchase.

9–26 MIES VAN DER ROHE
Barcelona chair (1929) Chrome-plated steel bars, leather. 29½″ high.

Collection, The Museum of Modern Art, N.Y. Gift of the manufacturer, Knoll Associates, Inc., USA.

lack of comfort can be excused by the fact that this is a side chair, not intended for lounging.

The "Barcelona" chair of Mies van der Rohe (Fig. 9–26) was designed by the architect for the 1929 German Exposition in the Spanish city of that name. The frame of the chair is characterized by the intersection of two curved chrome-plated steel bars. More comfortable than the Breuer chair, it has relatively deep cushions covered in quilted leather. Copies today are more likely to be of a quilted **vinyl.** It is of interest that much contemporary furniture has been designed by architects, including Le Corbusier and Eero Saarinen as well as Breuer and Mies.

DESIGN

Successful designs . . . stand out because . . . they raise the human spirit and make life a little easier.
—Wolf Von Eckardt

In this section we will discuss the design disciplines that raise the quality of life. They touch us in every advertisement we see, everything we wear, every product we use, every interior in which we live, work, and play, and every town and city.

Graphic Design

Graphic design refers to visual arts in which designs or patterns are made for commercial purposes. Examples of graphic design include the postage stamp, greeting cards, book design, advertising brochures, newspaper and magazine ads, billboards, product packages, posters, signs, trademarks, and **logos.** Frequently, graphic products include written copy that is set in type. **Typography** refers to the related art or process of setting and arranging type for printing. Once graphic products, including type, have been designed, they are usually mass produced by one of the types of printing discussed in Chapter 5, through use of blocks, plates, or screens.

PACKAGE DESIGN

The packaging of products is a delicate affair. Not only must packages catch con-

sumers' eyes as they wander down the aisles of supermarkets, they must also communicate something about the nature and quality of the contents. Manufacturers must state their case quickly, for people may glance at their packages for only a fraction of a second. In order to achieve this end, some packages have simple contemporary designs. Others hark back to "the old days."

The familiarity of many product packages has provided a fertile inspiration for **Pop art.** Much of the work of Andy Warhol and other Pop artists depicts the designs of these packages. Warhol is perhaps best known for his series of silk screens of Campbell's Soup cans (Fig. 5–16), but he has also produced multiple images of Coca-Cola bottles (Fig. 17–15) and oversized assemblages of Brillo boxes made from acrylic silk screen on wood (Fig. 9–27). Manufacturers use the same silk-screen process for printing many of their packages.

9–27 ANDY WARHOL
Brillo (1964). Painted wood. 17 x 17 x 13".
Leo Castelli Gallery, N.Y.

9–28 JULES CHÉRET
Loïe Fuller at the Folies-Bergère (1893)
Lithograph poster. 4'¾" x 2'10"

POSTERS

Posters are relatively large printed sheets of paper, usually illustrated, that publicize or advertise products or events. Posters from art galleries frequently show a single work of art from a current exhibition and contain some explanatory copy. Since they are usually attractive and inexpensive, college students tend to use them for wall decorations.

Jules Chéret's poster art was intended to advertise the shows at the Parisian Folies Bergères and other establishments. As is suggested in his color lithograph poster of Loïe Fuller (Fig. 9–28), Chéret's poster art came to do more than gather audiences; it also contributed to the Art Nouveau movement and to the flat, serpentine rendering of line found in Postimpressionist art. Chéret's poster is a joyous and provocative depiction of the female form in motion. The dancer's flowing costume provides abstract lines suggestive of movement as well as the decency of drapery.

Perhaps with the exception of the shapely turn of calf, the color lithograph poster of cabaret dancer Jane Avril (Fig. 9–29) by the French Postimpressionist Henri de Toulouse-Lautrec is a more abstract and vibrant crowd puller. Toulouse-Lautrec dwelled in the nighttime Paris—its cafés, music halls, night clubs, and brothels. The oblique perspective and bold patterns of line in his poster were probably influenced by Japanese prints. The high contrast in values may reflect the glare of artificial lighting and suggests a potent juxtaposition of textures. The dramatic silhouetting and bold outlining provided by dancer and violin add an abstract quality that speaks of a direct titillation of the senses.

The Chéret and Toulouse-Lautrec posters, in a single image, capture the spirit and personality of the establishments they advertise. Contemporary artists who make posters for motion pictures, rock concerts, and museum exhibitions face the same challenge and opportunity.

9–29 HENRI DE TOULOUSE-LAUTREC
Jane Avril at the Jardin de Paris (1893).
Color lithograph, 4'1" x 2'11¼".

LOGOS

The logo of a company or an organization is extremely important. It communicates an instant impression of the company character, and it becomes part of the company identity. The next time you are watching television, note the CBS eye and the NBC peacock. Observe company logos in magazine ads and on buildings. Note the emblem of the company of your automobile. All of them are carefully planned to deliver a specific visual message.

The Minnesota Zoo logo (Fig. 9–30), designed by Lance Wyman, Ltd., is a refreshing, clean graphic design of white set against a backdrop of blue. With a few whimsical strokes, the "M" is transformed into a moose. The assertive yet gentle and charming sign telegraphs the fact that the zoo has the world's premier collection of this North-country mammal.

9–30 LANCE WYMAN
Minnesota Zoo logo

Courtesy of Minnesota Zoo, Apple Valley, Minn., and Lance Wyman, Ltd., N.Y.

Clothing Design

There is a saying that "Clothing makes the man"—or woman. It would be more accurate, perhaps, to say that clothing helps create a first impression of men and women. Psychologists have found, for example, that hitchhikers wearing neatly pressed suits are more likely to be offered rides than the same individuals in shabby dress.

By and large we tend to gravitate toward those who dress like us, and not to socialize with those whose dress is very different. We experience powerful social pressure to conform our clothing to that worn by the groups with which we identify. Rising businessmen and businesswomen wear suits, or comparably tailored clothing, while many students would not be caught in anything other than jeans. When people seem indifferent to what they wear, we tend to assume, correctly or incorrectly, that they are indifferent about the ways in which they behave.

FUNCTIONS OF CLOTHING

Clothing, like architecture, protects us from the elements, and like architecture, clothing also serves many other purposes. Clothing is a reflection of the modesty of an age: it indicates what may or may not be revealed at the office, at the beach, or in the bedroom. Clothing is an expression of personality, mood, taste, socioeconomic status, aesthetic preferences, and even, to some degree, political attitudes. Clothing can be a sign of one's occupation or activities. The military, the police, Boy and Girl Scouts, and nurses all wear uniforms that say something about what they do.

The uniforms of athletes help inspire a team and community spirit. The football helmets shown in the Riger photograph (Fig. 1–21) protect the heads of the players but also lend them an anonymous superhuman quality. The wigs worn by judges in England and by American men of high status in colonial times and the robes and vestments worn

by the high clergy help extend respect for tradition to the representative individual.

The apparel of *Giovanni Arnolfini and His Bride* (Fig. 13–4) contributes to the sanctity of the occasion. The shoes have been removed to show that the room is a sacred place. The heads of bride and groom are both covered, as the Bible proclaims that they must be before God. The extensive draping of bride and groom emphasizes the spiritual as opposed to the carnal meaning of the sacraments of marriage.

FASHION AND FAD IN CLOTHING DESIGN

The garments with which Arnolfini and his bride are draped are not the invention of the painter Jan van Eyck; they reflect the fashions of northern Europe in the fifteenth century. Arnolfini's overgarment is lavish in its use of fur, and his high-crowned hat is made from beaver fur, a costly, rare status symbol. His pointed shoes are conservative in style, as would befit a wealthy man. The bride's kerchief is edged with a wealth of ruffles. Her neckline is flat. Round, vertical pleats distribute the fashionable fullness of her hoop skirt. (She is not yet in a "family way.")

Styles come and go. Hemlines rise and fall, ties narrow and widen, and so do lapels. One year bell-bottom jeans are in style; the next year "everyone" is wearing straight legs. A new style can seem atrocious at first glance, and we may wonder how the trailblazers can wear it. But then, as time passes, we often see the new "look" as the normal state of affairs. There may be no limit to the diversity of styles that look right once we have become habituated to them.

Today women's dress tends to be somewhat more colorful and flamboyant than men's, but it was not always so. Note Hyacinthe Rigaud's painting of *Louis XIV* (Fig. 9–31), the "sun king." The fleur-de-lis design of the cape, the ermine lining, and the stockings might today be considered appro-

9–31 HYACINTHE RIGAUD
Louis XIV (1701). Oil on canvas. 9'1" x 6'3".
Louvre Museum, Paris.

priate for society women, but certainly not for men. Yet there was nothing effeminate about the king's dress; in his day such finery, along with elaborate wigs, was the norm for men of high station.

Since the reign of Louis XIV, the world has tended to look to Paris as the center of **haute couture,** or high fashion, to see, for example, what the French designers would do about hemlines or shoulder pads this year. What designers do in a given year is also to some degree expressed in concurrent developments in the visual arts and crafts. The Rococo period, as we mentioned in the discussion of furniture, was characterized by ornate frivolity, richness, and light. The reclining man and the woman in Jean-Honoré Fragonard's The Swing (Fig. 14–26), like Louis XIV in the Rigaud painting, are richly appareled in a manner that reflects the style of the Louis XV furniture, which had reached the height of its popularity just a few years earlier. The woman on the swing, like the bower of the setting, seems luxuriously feminine and perfumed. Her frills and petticoats simultaneously conceal and invite intrusion.

John Singer Sargent's portrait of *Madame X* (Fig. 9–32), painted toward the end of the nineteenth century, shows how simple lines can enhance the female form. The color of the dress contrasts sharply with the alabaster skin of the model, Madame Pierre Gautreau, and Madame Gautreau along with her family is said to have been outraged by the décolletage. While her dress is hardly shocking by today's standards, it highlights how clothing designers have been assigned the challenge of simultaneously draping and enticing.

Only the very few could afford to dress like the figures in the Fragonard painting, of course, or like Madame Gautreau. Today, as well, very few can afford "originals" by noted designers. But the changes in haute couture frequently trickle down to the masses. France has lost something of its unique position in the fashion world today. New York, London, Tokyo, and a few other cities are also considered fashion centers, and their designers make major contributions to the new looks.

9–32 JOHN SINGER SARGENT
Madame X (Mme. Pierre Gautreau) (1884). Oil on canvas. 82⅛ x 43¼".
Metropolitan Museum of Art, N.Y. Arthur H. Hearn Fund, 1916.

9–33 Blue jeans advertisement, *Jordache Basics because life . . . is not*

Since the nineteenth century, blue jeans have been mass produced and, because of their durability, comfort, and affordability, have been worn by many laborers. Figure 9–33 suggests the current chic and popularity of designer jeans. While standard jeans sell for from $12 to $20 or so, designer jeans sell for about $30 to $100 or more, increasing their acceptability as general leisure wear among today's relatively affluent members of the middle class. Of course, designer jeans usually have more tightly woven denim, better fits, higher-quality stitching, and a bit more flair in the detailing—but part of the price clearly goes for the right to identify one's backside with the logo of the designer.

A Little Something for the Birds

What could be more mundane than the lowly birdhouse? Aficionados of the flighty comings and goings of our feathered friends usually pick up simple wooden homes at the nursery or the supermarket. What are the designer's requirements for these hung-up harbingers of domestic delight? Usually little more than a floor, a roof, and an entryway (hole) just large enough for the welcome species, so that large intruders will have to do their house hunting elsewhere.

At least those were the requirements until some noted contemporary architects and designers were given the opportunity to pour their creative juices into these peripatetic pads. The results? Some of the most fascinating designs of the Post-modern era, as shown in Figure 9–34. The double-turreted design to the left was unwrapped for the wren by Michael Graves, architect of the Humana headquarters (Fig. 7–19). It's complete with classical pediment, columns, and tic-tac-toe fenestration. Occupants presumably will eye the oculi with glee. The other designs, respectively and respectably, were created by Ronald H. Schmidt for the great-crested flycatcher; Charles Moore with Arthur Andersson for the Bewick's wren; Theresa Angelini for the bluebird of happiness who chances to gaze upon this gazebo; and Alfredo de Vido for the black-capped chickadee who seeks a severe geometry to complement his coif.

9–34 Bird house designs by contemporary architects

Industrial Design

Industrial design refers to the planning and artistic enhancement of industrial products ranging from space shuttles and automobiles to coffeemakers, typewriters, and microcomputers. To a large degree, functional and mechanical problems have been the responsibility of engineers. Designers then embellish the mechanical necessities as best they can by creating attractive skins or housing for them.

FORM AND FUNCTION

Consider the forms of the lunar landing module shown in the photograph *Earthrise* (Fig. 8–11) and the space shuttle. The forms of each were determined largely by their functions. The lunar landing module needed only to travel from outer space down to the lunar surface and then back from the Moon to an orbiting spacecraft. It never navigated through an atmosphere, and so it did not need to be aerodynamic; it could afford its odd shape and many protrusions. The space shuttle, on the other hand, must glide from outer space down to the surface of the Earth. To a large degree, its shape is designed mathematically so that the atmosphere will provide a maximum of lift to the underside of its bulky body. The instrument panels in both spacecrafts were designed by experts in human psychology and engineering. They had to be placed in strategic locations and differentiated from one another. In order not to hamper the work of pilots and navigators, their forms had to suggest their functions.

In most cases, designers have a larger influence on the final appearance of a product than they did with the lunar landing module and the space shuttle. The factors that usually enter into an industrial design include utility (that is, in what form is the equipment easiest to use?), cost, and aesthetic considerations. The aesthetic appeal of an industrial product not only provides a sense of satisfaction for the designer and the manufacturer, it also affects sales.

New York's Museum of Modern Art has an extensive collection of superior industrial designs. It includes teapots (Fig. 9–35), Olivetti typewriters, the Breuer and Barcelona chairs discussed earlier in this chapter, electric coffeemakers, the Movado watch (Fig. 9–36), and the Volkswagen sports car the Kharmann Ghia (Fig. 9–37). The design of

9–35 MARIANNE BRANDT
Teapot (1924) Nickel silver, ebony. 7″ high.
Collection, The Museum of Modern Art, N.Y. Phyllis B. Lambert Fund.

9–36 NATHAN GEORGE HORWITT
Watch Face (1947) Diameter 1⅜″. Specially designed face without numerals, silver hands and single silver dot indicating position of number twelve.
Collection, The Museum of Modern Art. Gift of the designer.

9–37 1972 VW Karmann Ghia

Courtesy of Volkswagen of America, Inc., Englewood Cliffs, N.J.

the minimalist Movado watch is pure, elegant, and efficient. At the time of the Kharmann Ghia's appearance in the 1950s, it was one of a very few automobiles that could boast efficient use of space and gasoline as well as a unique and, to some degree, aerodynamic sculpted body. In more recent years, the Honda Accord and the Porsche bubble-shaped sports cars have been applauded by industrial designers both for their engineering and for their appearance.

Interior Design

Interior design is the organization and furnishing of interior spaces to serve human needs in the home, at places of business, and in other enclosed areas. The fine interior designer has spatial relations ability, knowledge of architecture, awareness of the elements of art, a sense of composition, knowledge of the history and periods of furniture and the fiber arts, the skill to use contemporary materials, and an understanding of the human needs of everyday living.

A fine interior design is expressive of the personalities of its inhabitants. The designer must use lighting, structural materials, fabrics, and colors that set certain moods and are consistent with the lifestyles of the clients. Good interior design is also true to the architecture of the building. This does not mean that a contemporary building must have contemporary furniture, but it does mean that the relationship between a building and its furnishings cannot look arbitrary.

The largely Neoclassic interior from the period of Louis XVI (Fig. 9–38) shows furnishings with light and delicate proportions. The straight line predominates over the free curve of the earlier Rococo period in the **dentil molding** that projects from the **cornice,** the rectangular paneling of the walls, the mantle of the fireplace, the backs of armchairs, and the shape of the desk. The intricately ornate console table beneath the mirror is a frivolous remnant from the reign of Louis XV, but good taste does not require that we discard our favorite pieces when styles change.

The room has a free flow of space around the central area, which is defined by the desk and elegant chandelier. The mirror between the windows balances the mirror over the mantle. Cornice and moldings, area rug, windows, wall panels, **wainscoting,** and door decorations all fortify the rhythmic Neoclassic repetition of the rectangle.

The Peacock Room (Fig. 9–39), decorated by American artist James McNeill Whistler, exudes an organic quality that contrasts with the Neoclassic geometry of the Grand Salon. The lamps, for example, are the blossoms on stems that grow down from the ceiling.

9–38 Grand Salon of the Hôtel de Tessé, Paris (1768–72). Painted and gilded oak, with 4 plaster overdoor reliefs. 16' high; 33'7½" long; 29' 6½" wide.

Intended as a showcase for the owner's collection of Japanese porcelain, the room shows Japanese and English Tudor influences. Whistler's painted blue and gold peacocks were intended to heighten the Japanese atmosphere of the design.

The contemporary interior of Philip Johnson's Glass House (Fig. 9–40), like the Grand Salon, shows a predominance of classical straight lines and is fully consistent with the severe horizontals and verticals of the house itself. The furniture was designed by fellow architect Mies van der Rohe and includes the latter's Barcelona chair. (Johnson and Mies would later collaborate on the Sea-gram Building, discussed in Chapter 7.) Space flows without obstruction from the bucolic Connecticut setting through the house. A formal island for conversation is defined by the area rug. A theme of machined flawlessness replaces the sense of hand-crafted perfection that pervaded the Louis XVI interior. Like the chandelier and Rococo table in the Neoclassic room, the organic sculpture and the plant serve as counterpoint to the unrelieved rectangularity of ceiling, walls, furnishings, and floor. Each room possesses an elegant unity that expresses a major aesthetic of its times.

9–39 JAMES A. McNEILL WHISTLER Peacock room, home of F. R. Leyland. (1876–77)

Courtesy of The Freer Gallery of Art, Washington, D.C.

9–40 PHILIP JOHNSON Interior of Glass House (Philip Johnson residence), New Canaan, Conn. (1949)

Urban Design

Perhaps it is in urban design that our desire for order and harmony achieves its most majestic expression. Throughout history most towns and cities have more or less sprung up. They have pushed back the countryside in all directions, as necessary, with little evidence of an overall guiding concept. As a result, the masses of great buildings sometimes press against other masses of great buildings, and transportation becomes a worrisome afterthought. The Rome of the early republic, for example, was an impoverished seat of empire, little more than a disordered assemblage of seven villages on seven hills. Later, the downtown area was a jumble of narrow streets winding through mud-brick buildings. Not until the first century B.C. were the major building programs undertaken by Sulla and then the Caesars.

THE RECTANGULAR PLAN

The new towns of the Roman empire were laid out largely on a rectangular grid. This pattern was common among centrist states, where bits of land were parceled out to the subjects of mighty rulers. The gridiron was also found to be a useful basis for design by the ancient Greeks and the colonial Americans.

The rectangular plan shown in Figure 9–41 was designed by Albrecht Dürer. It is a city-fortress with a central square intended for public gatherings and for the housing of the ruler and his court. It serves not to meet social needs, but to answer the military question of how a prince or duke can construct satellite towns to protect the heart of his domain.

THE CIRCULAR PLAN

Many cities of the Near and Middle East, like Baghdad, have a circular tradition in urban design, which may reflect the old belief that they were the hubs of the universe. The throne room of the palace in eighth-century Baghdad was at the center of the circle. The "palace"—including attendant buildings, a game preserve, and pavilions set in perfumed gardens—was more than a mile in diameter, and the remainder of the population occupied a relatively narrow ring around the palace. But the population eventually exploded in several outward directions. Members of the court began to construct other palaces in the suburbs, creating a sort of cluster of intersecting circles.

The late sixteenth-century plan for Palma Nuova (Fig. 9–42), a Venetian outpost village, is another example of the city-fortress. The city center is a hexagon in which troops can be gathered. Radiating streets permit rapid deployment to any part of the city wall.

9–41 ALBRECHT DÜRER
Plan for rectangular city-fortess (1527). Woodcut.
Stadelsches Kunstinstitut, Frankfurt, West Germany.

9–42 Plan for Palma Nuova
From *Paolo Soleri, Arcology: The City in the Image of Man.*

© 1969 by M.I.T., Cambridge, Mass. Reproduced by permission of M.I.T. Press.

PARIS

Much of Paris is centered around the Place de la Concorde, a square that was constructed along the Seine River during the eighteenth century. From the center of the Place de la Concorde, one can look in any direction and find major monuments. To the west, along the Champs-Élysées, is the Place de l'Étoile, in which is set the Arc de Triomphe, built by Napoleon to celebrate his victorious armies. And from the Place de l'Étoile again radiate many streets.

WASHINGTON, D.C.

Few urban designs are as simple and rich as Pierre-Charles L'Enfant's plan for Washington, D.C. (Fig. 9–43). The city is cradled between two branches of the Potomac River, yielding an uneven overall diamond shape. Within the diamond a rectangular grid of streets that run east-west and north-south is laid down. Near the center of the diamond, with its west edge at the river, an enormous mall or green space is set aside. At the east end of the mall is the Capitol Building. To the north, at its west end, is the President's house (which is now the White House). Broad boulevards radiate from the Capitol and from the White House, cutting across the gridiron. One radiating boulevard runs directly between the Capitol and the White House, and other boulevards parallel it.

The design is a worthy composition in which the masses of the Capitol Building and White House balance one another, and the rhythms of the gridiron pattern and radiating boulevards provide contrast and unity. The mall provides an open central gathering place reminiscent of the central polygons of the Renaissance city-fortresses.

9–43 PIERRE-CHARLES L'ENFANT Plan for Washington, D.C. (1792)

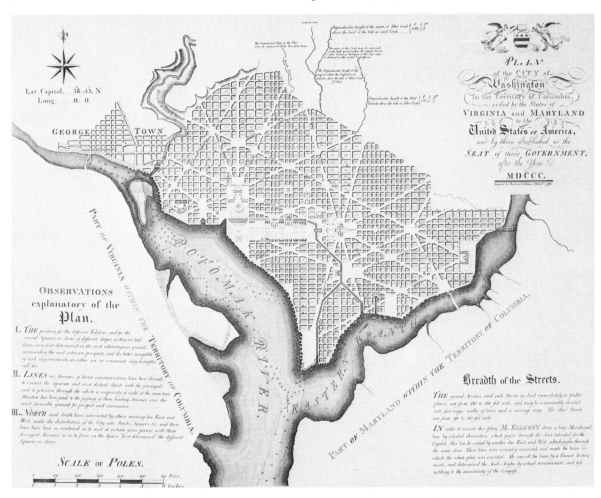

The Parks of Frederick Law Olmsted

In the center of the "asphalt jungle" of Manhattan lies Central Park—a rectangular strip of grass, trees, hills, and lakes some two and a half miles long and almost a mile wide (Fig. 9–44). A jewel of landscape architecture and urban design, it forms the geographical and spiritual heart of Manhattan. Joggers run around the reservoir, children sail boats in a pond, animals stretch and growl in the zoo, and lovers meander along its paths. New Yorkers pay premium rents to have a view of the park.

According to a book review that appeared in *The New York Times*, Frederick Law Olmsted was "an authentic American genius." His major contribution to the quality of American life lay in a series of urban parks that he designed to provide city dwellers with a "sense of enlarged freedom" and a "common, constant pleasure."

Olmsted's parks are verdant, living works of art. Each one achieves uniqueness and unity by being designed according to one theme or motif. Of their composition, Olmsted wrote that all are "framed upon a single noble motive, to which design of all its parts, in some more or less subtle way, shall be confluent and helpful."

A central theme and major innovation in Manhattan's Central Park is its transportation system. Multiple roadways meander above and below one another so that through-traffic, pedestrian walkways, and bridle paths can all function simultaneously. Forty-six bridges and arches contribute to the harmonious functioning of the transportation system. So that monotony could be avoided, each is different.

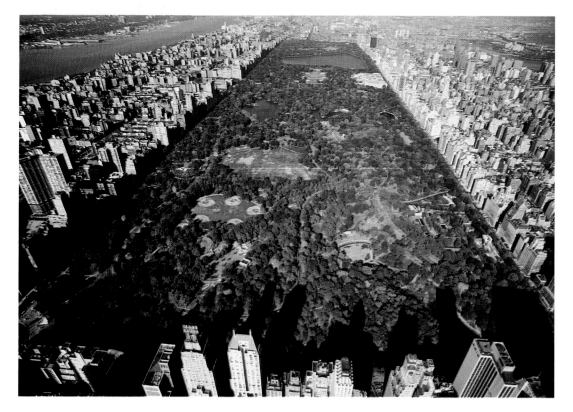

9–44 FREDERICK LAW OLMSTED Central Park, New York City (c. 1858)

Now and then fanciful plans are drawn for extending cities across the great bay of Tokyo, across the skies of Paris, or underneath the seas. These visionary ideas extend contemporary technology to solve potential future problems brought about by population growth and further urbanization.

Paolo Soleri's concepts attempt to solve these social problems through the so-called **arcology.** *Arcology* is a term combining the words *architecture* and *ecology*, and it describes Soleri's view that the city can evolve into a single structure. In order to appreciate Soleri's Drawing of Babeldiga (Fig. 9–45), consider a large, well-planned office building. Horizontal circulation is provided by hallways. There are vertical service cores that provide vertical circulation through elevators and stairways, that house heating, cooling, and ventilating systems, and that contain rest rooms and sewage ducts. Some of our larger contemporary office buildings could be said to function like efficient small cities with thousands of residents. Soleri would bring this efficiency in circulation and services to the larger city.

What would we lose in Babeldiga or other cities of that type? Perhaps something of our link to the land, or of our link to our traditional roots. On the other hand, we are thinking that it may someday be possible to send masses of humanity to dwell on planets in far-off solar systems. If so, their interstellar craft might not look totally unlike Babeldiga. Perhaps such spacecraft will become the ultimate design projects.

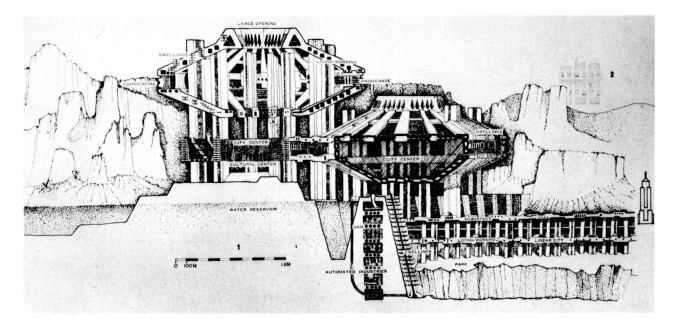

9–45 PAOLO SOLERI Drawing of Babeldiga (1965). From *Paolo Soleri, Arcology: The City in the Image of Man.*

10

The Art
of the Ancients

The phrase "Stone Age" often conjures up an image of men and women dressed in skins, huddling before a fire in a cave, while the world around them—the elements and the animals—threatens their survival. We do not generally envision prehistoric humankind as intelligent and reflective, as having needs beyond food, shelter, and reproduction. Somehow we never imagine these people as performing religious rituals or as creating works of art. Yet these aspects of life were perhaps as essential to their survival as warmth, nourishment, and offspring.

As the Stone Age progressed from the Paleolithic to the Neolithic periods, people began to lead more stable lives. They settled in villages and shifted from hunting wild animals to herding domesticated animals and farming. They also fashioned tools of stone and bone and created pottery and woven textiles. Most important for our purposes, they became image makers, capturing forms and figures on cave walls with the use of primitive artistic implements.

Stone Age humans were preoccupied with protecting themselves from intimidating or unknown forces. To this purpose they created shelters and tools and even images. It is possible, for example, that Stone Age artists tried to ensure the successful capture of prey by first "capturing" it in wall painting. They also tried to ensure their own continuation by carving small fertility goddesses.

Images, symbols, supernatural forces—these were but a few of the concerns of prehistoric and ancient artists. Stone Age people were the first to forge a link between religion and life, life and art, and art and religion.

PREHISTORIC ART

Prehistoric art is divided into three phases that correspond to the cultural periods of the Stone Age: **Upper Paleolithic** (the late years of the Old Stone Age), **Mesolithic** (Middle Stone Age), and **Neolithic** (New Stone Age). These periods span roughly the years 14,000 to 2000 B.C.

Works of art from the Stone Age include cave paintings, reliefs, and sculpture of stone, ivory, and bone. The subjects consist mainly of animals, although some highly abstracted human figures have been found. There is no surviving architecture as such. Many Stone Age dwellings consisted of caves and rock shelters. Some impressive "architectural" monuments such as Stonehenge exist, but their function remains a mystery.

Upper Paleolithic Art

Upper Paleolithic art is the art of the last ice age, during which time glaciers covered large areas of northern Europe and North America. As the climate got colder, people retreated into the protective warmth of caves, and it is here that we find their first attempts at artistic creation.

The great cave paintings of the Stone Age were discovered by accident in northern Spain and southwestern France. At Lascaux, France, two boys, whose dog chased a ball into a hole, followed the animal and discovered beautiful paintings of bison, horses, and cattle that are estimated to be over 15,000 years old. At first, because of the crispness and realistic detail of the paintings, they were thought to be forgeries. But in time, geological methods proved their authenticity.

One of the most splendid examples of Stone Age painting, the so-called Hall of Bulls (Fig. 10–1), is found in a cave at Lascaux. Here, superimposed upon one another, are realistic images of horses, bulls, and reindeer that appear to be stampeding in all directions. With one glance, we can understand the early skepticism concerning their authenticity. So fresh, lively, and purely sketched are the forms that they seem to have been rendered yesterday!

In their attempt at **naturalism,** the artists captured the images of the beasts by first confidently outlining the contours of their bodies. They then filled in these dark outlines with details and colored them with shades of **ocher** and red. The artists seem to have used a variety of techniques ranging from drawing with chunks of raw pigment to applying pigment with fingers and sticks. They also seem to have used an early "spray painting" technique in which dried, ground pigments were blown through a hollowed-out bone or reed. Although the tools were primitive, the techniques and results were not. They used **foreshortening** and contrasts of light and shadow to create the illusion of three-dimensional forms. They strove to achieve a most convincing likeness of the animal.

Why did prehistoric people sketch these forms? Did they create these murals out of a desire to delight the eye, or did they have other reasons? We cannot know for certain. However, it is unlikely that the paintings were merely ornamental, because they were confined to the deepest recesses of the cave, far from the areas that were inhabited, and were not easily reached. Also, the figures were painted atop one another with no apparent regard for composition. It is believed

10–1 Hall of Bulls, Lascaux (Dordogne), France (Upper Paleolithic, c. 15,000–10,000 B.C.)

10–2 Venus of Willendorf
(Upper Paleolithic, c. 15,000–10,000 B.C.)
Stone. Height: 4⅜"

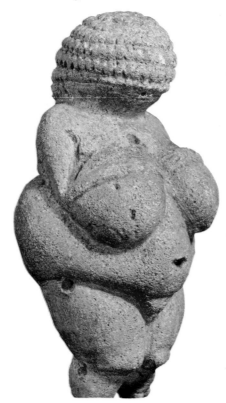

that successive artists added to the drawings, respecting the sacredness of the figures that already existed. It is further believed that the paintings covered the walls and ceilings of a kind of inner sanctuary where religious rituals concerning the capture of prey were performed. Some have suggested that by "capturing" these animals in art, Stone Age hunters believed that they would be guaranteed success in capturing them in life.

The prehistoric artist also attempted to "capture" fertility by creating small sculptures called **Venuses.** The most famous of these is the Venus of Willendorf (Fig. 10–2). The tiny figurine is carved of stone and is just over 4 inches high. As with all sculptures of this type, the female form is highly abstracted, and the emphasis is placed on the anatomical parts associated with fertility: the breasts, swollen abdomen, and en-

larged hips. Other parts of the body are subordinated to those related to reproduction.

Thus, the artistic endeavors of the Stone Age during the Upper Paleolithic period reflected a concern with survival. People created their images, and perhaps their religion, as a way of coping with these concerns.

Mesolithic Art

The Middle Stone Age began with the final retreat of the glaciers. The climate became milder and people began to adjust to the new ecological conditions by experimenting with different food-gathering techniques. They established fishing settlements along river banks and lived in rock shelters. In the realm of art, a dramatic change took place. Whereas Paleolithic artists emphasized animal forms, Mesolithic artists concentrated on the human figure.

The human figure was abstracted, and the subjects ranged from warriors to ceremonial dancers. Of the many wall paintings and stone carvings that survive, perhaps none is more appealing to the modern eye than the Ritual Dance (Fig. 10–3). Fluid yet concise outlines describe the frenzied movement of human figures dancing and diving in the presence of animals. These simple and expressive contours call to mind the languid nudes of twentieth-century artists such as Henri Matisse (Fig. 2–42). Whatever the function of a Mesolithic work such as this might have been, it is clear that human beings were beginning to assert their identities as a more self-sufficient species.

10–3 Ritual Dance (c. 10,000 B.C.) Rock engraving. Cave of Addaura, Monte Pellegrino (Palermo)

Soprintendenza Beni Culturali Ambrentali, Palermo

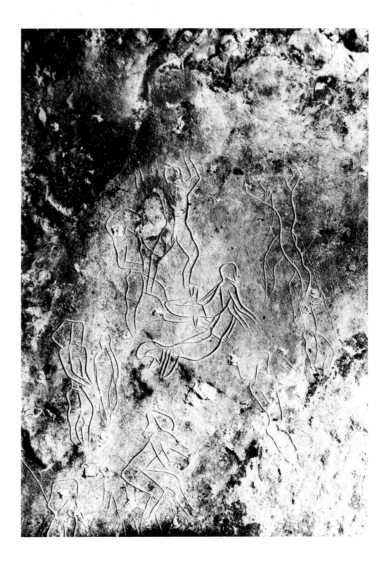

Neolithic Art

During the New Stone Age, life became more stable and predictable. People domesticated plants and animals, relinquishing hunting weapons for plows. Toward the end of the Neolithic period in some areas, crops such as maize, squash, and beans were cultivated, metal implements were fashioned, and writing appeared. About 4000 B.C., huge architectural monuments were erected.

The most famous of these monuments is Stonehenge (Fig. 10–4) in southern England. It consists of two concentric rings of stones surrounding others placed in a horseshoe shape. Some of these stones are quite large and weigh several tons. They are called **megaliths,** from the Greek meaning "large stones." The purpose of Stonehenge remains a mystery, although over the years many theories have been advanced to explain it. At one time it was widely believed to have been a druid temple. Lately, some astronomers have suggested that the monument served as a complex calendar that charted the movements of the sun and moon, as well as eclipses. This theory, too, has been contested, but archaeologists seem to agree that the structure had some type of religious function.

The Neolithic period probably began about 8000 B.C. and spread throughout the world's major river valleys between 6000 and 2000 B.C.—the Nile in Egypt, the Tigris and Euphrates in Mesopotamia, the Indus in India, and the Yellow in China. In the next section, we examine the birth of the great Mesopotamian civilizations.

10–4 Stonehenge, Salisbury Plain, Wiltshire, England (Neolithic, c. 1800–1400 B.C.) Diameter of circle: 97'; height of stones above ground: 13½'.

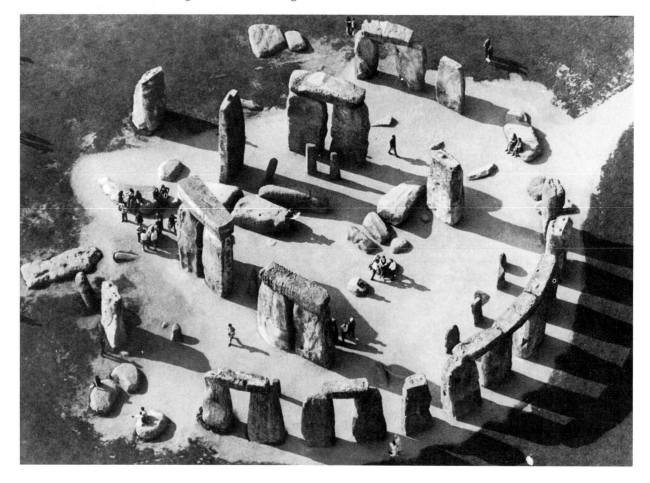

Historic (as opposed to prehistoric) societies are marked by a written language, advanced social organization, and developments in the areas of government, science, and art. They are also often linked with the development of agriculture. Historic civilizations began toward the end of the Neolithic period. In this section we will discuss the art of the Mesopotamian civilizations of Sumer, Akkad, Babylonia, Assyria, and Persia. We will begin with Sumer, which flourished in the river valley of the Tigris and Euphrates at about 3000 B.C.

Sumer

The Tigris and Euphrates rivers flow through what is now Syria and Iraq, join in their southernmost section, and empty into the Persian Gulf (Map 1). The major civilizations of ancient Mesopotamia lay along one or the other of these rivers, and the first to rise to prominence was Sumer.

Sumer was located in the Euphrates River valley in southern Mesopotamia. The origin of its people is unknown, although they may have come from Iran or India. The earliest Sumerian villages date back to prehistoric times. By about 3000 B.C., however, there was a thriving agricultural civilization in Sumer. The Sumerians constructed sophisticated irrigation systems, controlled river flooding, and worked with metals such as copper, silver, and gold. They had a government based on independently ruled city-states, and they developed a system of writing called **cuneiform,** from Latin *cuneus*, meaning "wedge"; the characters in cuneiform writing are wedge shaped.

Excavations at major Sumerian cities have revealed sculpture, craft art, and monumental architecture that seems to have been created for worship. Thus the Sumerian people may have been among the first to establish a formal religion.

One of the most impressive testimonies to the Sumerian's religion-oriented society is the **ziggurat,** a form of temple also found in the Babylonian and Assyrian civilizations

Map 1

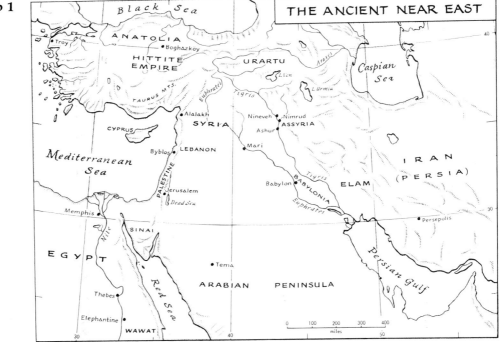

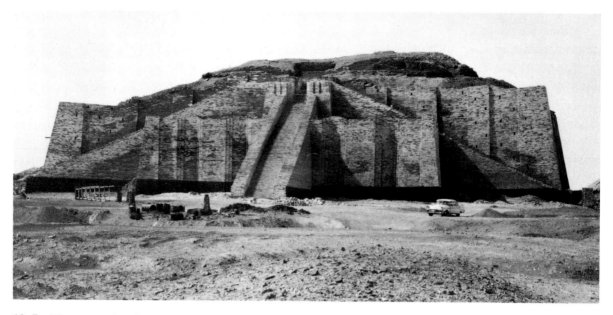

10–5 Ziggurat at Ur (Sumerian, Third Dynasty, c. 2100 B.C.). Sun-dried brick.

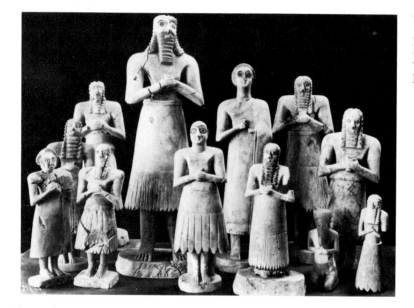

10–6 Statues from Abu Temple, Tel Asmar (Sumerian, Early Dynastic Period, c. 2900–2600 B.C.). Marble with shell and black limestone inlay. Height of tallest figure: 30″.

of later years. The ziggurat was the focal point of the Sumerian city, towering high above the fields and dwellings. It was a multilevel structure consisting of a core of sun-baked brick faced with fired brick, sometimes of bright colors. Access to the **shrine,** which sat atop the ziggurat, was gained by a series of ramps leading from one level to the next, or, in some instances, by a spiral ramp that rose continuously from ground to summit.

The Ziggurat at Ur (Fig. 10–5) is a splendid example of this type of architecture. The base alone is some 50 feet high. Some ziggu-

rats, such as the one erected in Babylon, reached a height of almost 300 feet. It was the ziggurat at Babylon that was named the "Tower of Babel" by the Hebrews, who scorned its construction on the basis that people should never be so proud as to try to reach their God.

The Sumerian gods were primarily deifications of nature. Anu was the god of the sky; Abu, the god of vegetation. Votive sculptures found in the sanctuary of Abu also indicate the Sumerians' preoccupation with religion. A group of these sculptures from Tel Asmar (Fig. 10–6) show interesting

characteristics. The cylindrical figures wear skirtlike garments, some of whose hems were adorned with feathers. They all stand erect with hands folded over their chests, as if in prayer. The men are distinguished by stylized beards and long, patterned hair. All the figures stare forward with wide eyes that have been inlaid with shell and black limestone, rendering the figures hauntingly realistic despite their strong stylization. The largest figure may represent a king, since it is common to find kings and queens of ancient Near Eastern civilizations towering over their accompanying figures.

These Sumerian statuettes are sculpted from marble, but clay was the most readily available material. It is believed that the Sumerians traded crops for metal, wood, and stone so that they could create works of art from these materials as well. Because of the abudance of clay, however, the Sumerians were expert ceramicists and their buildings were constructed of mud brick.

The Sumerian repertory of subjects included fantastic creatures such as music-making animals, bearded bulls, and composite man-beasts with bull heads or scorpion bodies. These were rendered in lavishly decorated objects of hammered gold inlaid with **lapis lazuli.** These art works were found in the Sumerian royal courts. Their function, too, is believed to have been religious. Perhaps they represented struggles between known and unknown forces.

For a long time the Sumerians were the principle force in Mesopotamia, but they were not alone. Semitic peoples to the north became increasingly strong, and eventually they established an empire that ruled all of Mesopotamia and assimilated the Sumerian culture.

Akkad

Akkad, located north of Sumer, centered around the valley of the Tigris River. Its government, too, was based on independent city-states which, along with those of Sumer, eventually came under the influence of the Akkadian ruler Sargon. It was under Sargon and his successors that the civilization of Akkad flourished.

Akkadian art exhibits distinct differences from that of Sumer. It commemorates rulers and warriors instead of offering homage to the gods. It is a art of violence instead of prayer. Also, although artistic conventions are present, they are coupled with a naturalism that was absent from Sumerian art.

Of the little extant Akkadian art, the **Stele** of Naram Sin (Fig. 10–7) shines as one of the most significant works. This relief sculpture commemorates the military exploits of Sargon's grandson and successor, Naram Sin. The king, represented somewhat larger

10–7 Victory Stele of Naram Sin (Akkadian, c. 2300–2200 B.C.). Stone. Height: 6'6".
Louvre Museum, Paris.

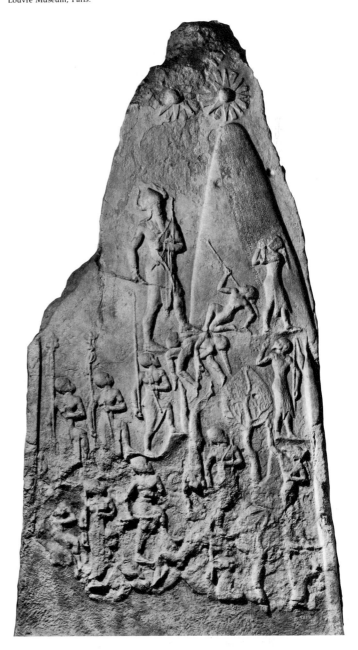

in scale than the other figures, ascends a mountain, trampling his enemies underfoot. He is accompanied by a group of marching soldiers, spears erect, whose positions contrast strongly with those of the fallen enemy. One wrestles to pull a spear out of his neck, another pleads for mercy, another falls head first off the mountain. The chaos on the right side of the composition is opposed by the rigid advancement on the left. All takes place under the watchful celestial bodies of Ishtar and Shamash, the gods of fertility and justice.

The king and his men are represented in a **conceptual** manner. That is, the artist rendered the human body in all of its parts as they are known to be, not as they appear at any given moment to the human eye. This method resulted in figures that are a combination of frontal and profile views. **Naturalism** was reserved for the enemy, whose figures fall in a variety of contorted positions. It may be that the convention of conceptual representation was maintained as a sign of respect. On the other hand, the conceptual manner complements the upright positions of the victorious, while the naturalism echoes the disintegration of the enemy camp.

The Akkadian Empire eventually declined, having been overrun by tribes of barbarians. The Sumerians regained power for a while but were eventually overtaken by fierce warring tribes. Mesopotamia remained in a state of chaos until the rise of Babylon under the great lawmaker and ruler, Hammurabi.

Babylonia

During the eighteenth century B.C. the Babylonian Empire, under Hammurabi, rose to power and dominated Mesopotamia. Hammurabi's major contribution to civilization was the codification of Mesopotamian laws. Laws had become cloudy and conflicting after the division of Mesopotamia into independent cities.

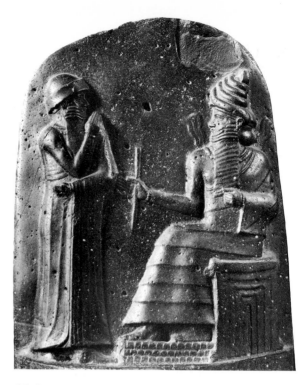

10–8 Stele (upper portion) inscribed with the Law Code of Hammurabi, at Susa (Babylonian, c. 1760 B.C.). Diorite. Height: 25½".
Louvre Museum, Paris.

This law code was inscribed on the Stele of Hammurabi (Fig. 10–8), a relief sculpture of **basalt** that also contains the figures of Hammurabi and Shamash, the god who was believed to have inspired him to the task. The representation of the figures is similar to that reserved for important personages— a combination of frontal and profile views. Shamash is seated on a stylized mountain. His legs and face are shown in profile, while his torso faces front. He gestures toward Hammurabi with a staff that symbolizes his divine power. Hammurabi is also depicted in combined profile and frontal views, although the artist has turned his figure toward us in an attempt at a more naturalistic stance. Draped from shoulder to feet, Hammurabi's figure is columnar, bearing similarity to the cylindrical votive figures of Sumeria's Tel Asmar. Note that at this time the artist conceptualizes the god in human form, not as the composite beast of Sumerian art or the abstracted celestial sphere of the Akkadian period.

How Old is Ancient? Some Notes on Carbon-14 Dating

Have you ever wondered how art historians can attach a date like 2000 B.C. to a building, sculpture, or piece of pottery? There is no long master list of every stone, chip of marble, or pot shard that has been created. Yet all of the artworks and objects in art history books are labeled with one date or another. How can the authors know that these dates are accurate?

The fact is that they cannot know for certain. But because of certain geological, archaeological, and chemistry-based dating techniques, their guesses probably come fairly close to the time at which the work was created. A margin of error is indicated by listing many early dates with the prefix "circa," abbreviated "c." Circa is the Latin word for "about."

The method most widely used by archaeologists is the radioactivity method of dating. It is based on the rate at which an isotope of a particular element present in a substance decays. The most common isotope used to date ancient works of art and architecture is carbon-14. It is a natural choice because all organic matter contains carbon and therefore some amount of carbon-14. Thus the age of an art object can be discerned by knowing the rate at which carbon-14 decays, and the relative amounts of radioactive material and decay products (carbon-14 decays into nitrogen-14) left in the substance.

But many art objects are not organic, you say. True. But archaeologists examine organic matter found alongside the art objects, such as human remains, or even garbage, and by deduction derive their dates for the art.

After the death of Hammurabi, Mesopotamia was torn apart by invasions. It eventually came under the influence of the Assyrians, a warring people to the north who had had their eyes on the region for hundreds of years.

Assyria

The ancient empire of Assyria developed along the upper Tigris River. For centuries the Assyrians fought with their neighbors, earning a deserved reputation as a fierce, bloodthirsty people. They eventually prevailed, and from about 900 to 600 B.C. they controlled all of Mesopotamia.

The Assyrians owed much to the Babylonians, having been influenced by their art, culture, and religion. Unlike Babylonia, Assyria was an empire built wholly on military endeavors. Because the Assyrians were obsessed with war and conquering, they began to be undermined by economic problems. They spent too much money on military campaigns and eventually depleted their resources. They ignored agriculture and wound up having to import most of their food. Their preoccupation with violence instead of production eventually led to their demise.

Assyrian art became distinct from Babylonian art in about 1500 B.C. The most common art form in Assyria was carved stone relief

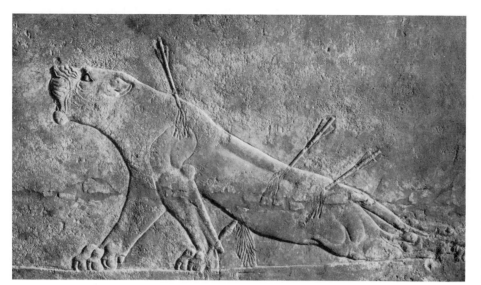

10–9 The Dying Lioness from Ninevah (Assyrian, c. 650 B.C.). Limestone. Height: 13¾".

British Museum, London.

depicting scenes of war and hunting. The figures were carved in great detail, and many representations of animals like horses and lions are to be found. The Assyrians commemorated the activities of their kings, such as royal hunting expeditions, in relief sculptures. One of the most touching and sensitive works of ancient art records such an event. It is ironic that it should come from a culture considered to be insensitive and merciless. The Dying Lioness (Fig. 10–9) is a limestone relief that depicts the carnage resulting from a king's sport. A naturalistically portrayed lioness, bleeding profusely from arrow wounds, emits a pathetic, helpless roar as she drags her hindquarters, paralyzed in the assault. The musculature is clearly defined, and the details are extremely realistic. This is quite different from the way in which kings and other human figures were depicted. In these there is an adherence to convention; the forms are rigid and highly stylized.

Persia

At about the time that the Assyrians were beginning to develop a unique artistic style, another culture was gaining strength just east of Mesopotamia in what is now Iran. It consisted of nomadic warring tribes. By the ninth century B.C. the mighty Assyrians had become embroiled in battle with them. By the sixth century B.C. the Persian Empire, under King Cyrus, had grown very strong. It eventually conquered great nations such as Egypt and succumbed to defeat only at the hands of the Greeks at the moment when victory seemed to be within its grasp.

The art of Persia consists of sprawling palaces of grand dimensions and sculpture that is almost totally abstract in its simplicity of design. Favorite subjects included animal forms, such as birds and **ibexes,** translated into decorative column **capitals** or elegant vessels of precious metals. A capital from the Royal Audience Hall of the palace of King Ataxerxes II (Fig. 10–10) illustrates the Persian combination of decorative motifs and stylization. The upper part of the capital consists of beautifully carved back-to-back bulls sharing hindquarters. They rest on intricately carved **volutes** that resemble fronds of vegetation. This stylization leads to the perception of the animals as abstract patterns rather than naturalistic forms, and is characteristic of Persian art in general.

In 525 B.C. Persia conquered the kingdom of Egypt. But as in Mesopotamia, civilization in Egypt had begun some 3,000 years earlier. In the next section we will trace its art from the early post-Neolithic period to the reign of the boy-king Tut in the fourteenth century B.C.

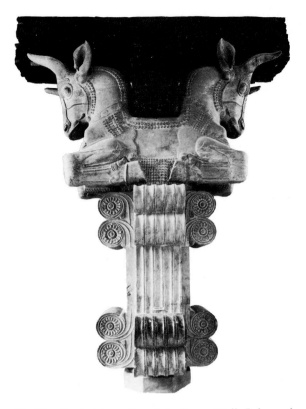

10–10 Capital from Royal Audience Hall, Palace of King Artaxerxes II, Persepolis (Persian, c. 360 B.C.)

EGYPTIAN ART

The lush land that lay between the Tigris and Euphrates rivers, providing sustenance for the Mesopotamian civilizations, is called the **Fertile Crescent.** Its counterpart in Egypt, called the **Fertile Ribbon,** hugs the banks of the great Nile River which flows north from Africa and empties into the Mediterranean Sea (see Map 1, p. 239). Like the rivers of the Fertile Crescent, the Nile was an indispensable part of Egyptian life. Without it, Egyptian life would not have existed. For this reason, it also had spiritual significance; the Nile was perceived as a god.

Like Sumerian art, Egyptian art was religious. There are three aspects of Egyptian art and life that stand as unique: their link to *religion,* their link to *death,* and their ongoing use of strict *conventionalism* in the arts that affords a sense of permanence.

The art and culture of Egypt are divided into three periods. The Old Kingdom dates

from 2680 to 2258 B.C., the Middle Kingdom from 2000 to 1786 B.C., and the New Kingdom from 1570 to 1342 B.C. Art styles proceed from the Old to the New Kingdom with very few variations. The exception to this trend took place between 1372 and 1350 B.C., during the Amarna Revolution under the leadership of the pharaoh Akhenaton. We will begin our exploration of Egyptian art with the Old Kingdom.

Old Kingdom

Egyptian religion was bound closely to the afterlife. Happiness in the afterlife was believed to be ensured through the continuation of certain aspects of earthly life. Thus tombs were decorated with everyday objects and scenes depicting common earthly activities. Sculptures of the deceased were placed in the tombs, along with likenesses of the people who surrounded them in life.

In the years prior to the dawn of the Old Kingdom, art consisted of funerary offerings of one type or another including small sculpted figures, carvings of ivory, pottery, and slate palettes used for cosmetics. Toward the end of this period, called the Predynastic period, large limestone sculptures for which Egypt became famous began to be created.

SCULPTURE

Old Kingdom art brought forth a manner of representation that would last thousands of years. It is characterized by a conceptual approach to the rendering of the human figure that we encountered in Mesopotamian relief sculpture. In Egyptian art, the head, pelvis, and legs are presented in profile while the upper torso and eye were shown in a frontal view. The figures tend to be flat, with no sense of three-dimensionality, and they are placed in space with no use of perspective. Thus, no attempt was made to give the illusion of forms moving within three-dimensional space. Relief sculpture was carved very low with a great deal of **incised** detail. Sculpture in the round closely adhered to the block form. Color

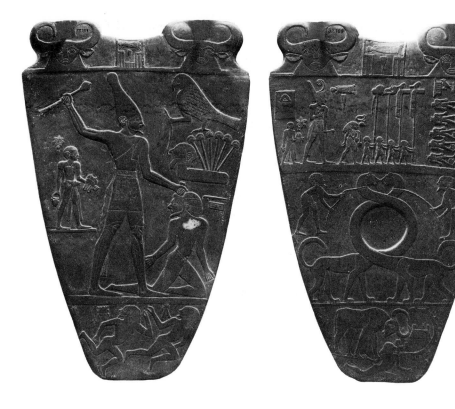

10–11 Narmer Palette, front (*right*) and back (*left*) views (Egyptian, Old Kingdom, c. 3200 B.C.). Slate, Height: 25".
Egyptian Museum, Cairo.

was applied at times but was not used widely because of the relative impermanence of the material. These characteristics were duplicated, with few exceptions, by artists during all of the periods of Egyptian art. There are instances in which a certain naturalism was sought, but the artist rarely strayed from the inherited stylistic conventions. Art historian Erwin Panofsky has stated that this Egyptian method of working clearly reflects their artistic intention, "directed not toward the variable, but toward the constant, not toward the symbolization of the vital present, but toward the realization of a timeless eternity."

One of the most important sculptures from the Old Kingdom period, the Narmer Palette (Fig. 10–11), illustrates these conventions. The Narmer Palette is an example of a type of **cosmetic palette** found in the Predynastic period, but it symbolizes much more. It commemorates the unification of Upper Egypt and Lower Egypt, an event that Egyptians saw as marking the beginning of their civilization.

The back of the palette depicts King Narmer in the crown of Upper Egypt (a bowling pin shape) clubbing the head of his enemy. He stands on a horizontal band representing the ground. Beneath his feet, on the lowest part of the palette, lie two dead enemy warriors. To the king's right is a hawk perched on stylized papyrus plants that seem to grow out of the "back" of a strange object with a man's head. The hawk, a symbol for the Egyptian sky god, stands on this symbol of Lower Egypt. Thus, the gods appear to be sanctioning Narmer's takeover of Lower Egypt. The topmost part of the palette is sculpted with two bull-shaped heads with human features, representing the goddess Hathor, who traditionally symbolized love and joy.

The king is depicted in the typical conventional manner. His head, hips, and legs are sculpted in low relief and rendered in profile. The musculature is defined in incised lines that appear as stylized patterns. His eye and upper torso are shown in full frontal view. He is shown as larger than the people surrounding him, a symbol of his elevated position. The artist has disregarded naturalism and has instead created a kind of timeless rendition of his subject.

The front of the palette is divided into horizontal segments, or **registers,** into

which have been placed many figures. The depressed section of the palette held eye paint, and it is emphasized by the entwined necks of lionlike figures being tamed by two men carved in low relief. The top register depicts King Narmer once again, in the process of reviewing the captured and deceased enemy. He is now shown wearing the crown of Lower Egypt and holding the instruments that symbolize his power. To his right are stacks of decapitated bodies. This is not the first time that we have seen a sculpted monument to a royal conquest, complete with gory details. We witnessed it in the Akkadian victory Stele of Naram Sin (Fig. 10–7). In both works the kings are shown in commanding positions, larger than the surrounding figures, but in the Narmer Palette the king is also depicted as a god. This concept of the ruler of Egypt, along with the strict conventions of his representation, would last some 3,000 years.

Tomb sculpture included large-scale figures in the round carved in very hard materials to ensure permanence. These figures consisted of conventionally represented stylized bodies with portrait heads rendered in an **idealistic** manner. The touch of realism in the faces reflects the function of the sculptures. They were created as images in which the spirit of the deceased could reside if **mummification** failed to provide a sanctuary. The figures are called **Ka figures;** the Ka was the soul thought to inhabit the body after death.

The statue of Khafre (Fig. 10–12), an Old Kingdom pharaoh, is typical of Ka figures. Carved in diorite, a gray-green rock, it shows the pharaoh seated on a throne ornamented with lotus blossoms and papyrus. He sits rigidly, and his frontal gaze is reminiscent of the staring eyes of the Mesopotamian votive figures. He is shown with the conventional attributes of the pharaoh: a finely pleated kilt, a linen headdress gracing the shoulders, and a long thin beard, a part of which has broken off. The sun god **Horus,** represented again as a hawk, sits behind his head. The artist confined his figure to the block of stone from which it was carved instead of allowing it to stand freely in space. The legs and torso are molded to

the throne, and the arms and fists remain close to the body. There is a solidity to the figure that echoes its conception as the permanent and enduring resting place for the Ka.

The representation of the body is stylized according to a specific **canon** of proportions relating different anatomical parts to one another. The forms rely on predetermined rules and not on optical fact. Yet a touch of naturalism is present in the facial features, which are rendered with some degree of

10–12 Statue of Khafre, from Giza (Egyptian, Old Kingdom, c. 2500 B.C.). Dorite. Height: 66".
Egyptian Museum, Cairo.

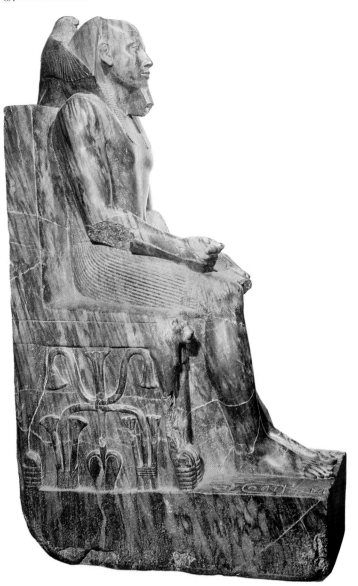

truth to reality. This naturalism is intermittent in Egyptian art, but more prevalent in the art of the Middle Kingdom and the Amarna period.

ARCHITECTURE

The most spectacular remains of Old Kingdom Egypt, and the most famous, are the Great Pyramids at Giza (Fig. 10–13). Constructed as tombs, they provided a resting place for the pharaoh, underscored his status as a deity, and lived after him as a monument to his accomplishments. They stand today as haunting images of a civilization long gone, isolated as coarse jewels in an arid wasteland.

The Pyramids are massive. The largest has a base that is about 775 feet on a side and is 450 feet high. It is constructed of limestone blocks that weigh about 2½ tons each—2,300,000 of them! The massive stones were dragged by slaves up ramps. Thousands of slaves from captive civilizations engaged in this great labor for many generations. Among them, according to the Old Testament, were the Hebrews, who were eventually led out of bondage by Moses. Interestingly, there is no Egyptian record of the bondage or exodus of the He-

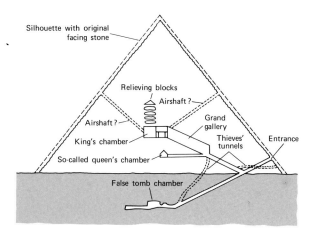

10–14 Interior of the Pyramid of Khufu

brews. After the stones were placed in position, the exterior slopes of the Pyramids were surfaced with white limestone.

The interiors of the Pyramids consist of a network of chambers, galleries, and airshafts (Fig 10–14). One of the problems with the Pyramids was that grave robbers found them as impressive as did the pharaohs, and wasted no time in plundering the tombs. During the Middle Kingdom, the Egyptians designed more inconspicuous and less easily penetrated dwelling places for their spirits.

10–13 Great Pyramids at Giza (Egyptian, Old Kingdom, c. 2570–2500 B.C.)

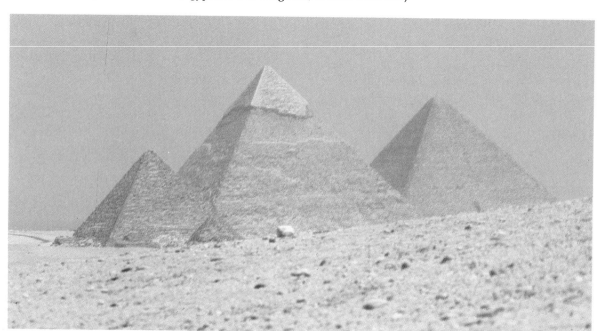

Middle Kingdom

The Middle Kingdom witnessed a change in the political hierarchy of Egypt, as the pharaohs began to be threatened by powerful landowners. During the early years of the Middle Kingdom, the development of art was stunted by internal strife. Egypt was finally brought back on track, reorganized, and reunited under King Mentuhotep, and art began to flourish once again.

Middle Kingdom art carried the Old Kingdom style forward, although there was some experimentation outside of the mainstream of strict conventionalism. We find this experimentation in extremely sensitive portrait sculptures and freely drawn fresco paintings.

A striking aspect of Middle Kingdom architecture were the rock-cut tombs, which may have been built in an attempt to prevent robberies. They were carved out of the **living rock,** and their entranceways were marked by columned **porticoes** of post and lintel construction (see Chapter 7). These porticoes led to a columned entrance hall, followed by a chamber along the same axis. The walls of the hall and tomb chamber were richly decorated with relief sculpture and painting, much of which had a sense of liveliness not found in Old Kingdom art.

New Kingdom

The Middle Kingdom also collapsed, and Egypt fell under the rule of an Asiatic tribe called the Hyskos. They introduced to Egypt Bronze Age weapons, as well as the horse. Eventually the Hyskos were overthrown by the Egyptians, and the New Kingdom was launched. It proved to be one of the most vital periods in Egyptian history, marked by expansionism, increased wealth, and economic and political stability.

The art of the New Kingdom combined characteristics of the Old and Middle Kingdom periods. The monumental forms of the earliest centuries were coupled with the freedom of expression of the Middle Kingdom years. As was the case throughout Egyptian art, a certain vitality appeared in the two-dimensional works. Sculpture in the round retained its concentration on solidity and permanence with few stylistic changes.

Egyptian society embraced a death cult, and some of its most significant monuments continued to be linked with death or worship of the dead. During the New Kingdom period, a new architectural form was created—the **mortuary temple.** Mortuary temples were carved out of the living rock, as were the rock-cut tombs of the Middle Kingdom, but their function was quite different. They did not house the mummified remains of the pharaohs but rather served as their place for worship during life, and a place at which they could be worshipped after death.

One of the most impressive mortuary temples of the New Kingdom is that of a female pharaoh, Queen Hatshepsut (Fig. 10–15). The temple backs into imposing cliffs and is divided into three terraces, which are approached by long ramps that rise from the floor of the valley to the top of pillared **colonnades.** Although the terraces are now as barren as the surrounding country, during Hatshepsut's time they were covered with exotic vegetation. The interior of the temple was just as lavishly decorated, with some 200 large sculptures as well as painted relief carvings.

As the civilization of Egypt became more advanced and powerful, there was a tendency to build and sculpt on a monumental scale. Statues and temples reached gigantic proportions. The delicacy and refinement of earlier Egyptian art fell by the wayside in favor of works that reflected the inflated Egyptian ego. Throughout the New Kingdom period, conventionalism was, for the most part, maintained. During the reign of Akhenaton, however, Egypt was offered a brief respite from stylistic rigidity.

10–15 Mortuary temple of Queen Hatshepsut, Thebes (Egyptian, New Kingdom, c. 1480 B.C.)

The Amarna Revolution: The Reign of Akhenaton and Nefertiti

During the fourteenth century B.C. a king by the name of Amenhotep IV rose to power. His reign marked a revolution in both religion and the arts. Amenhotep IV, named for the god Amen, changed his name to Akhenaton in honor of the sun god Aton, and he declared that Aton was the only god. In his monotheistic fury, Akhenaton spent his life tearing down monuments to the old gods and erecting new ones to Aton.

The art of Akhenaton's reign, or that of the *Amarna period* (so named because the pharaoh moved the capital of Egypt to Tel el-Amarna), was as revolutionary as his approach to religion. The wedge-shaped stylizations that stood as a rigid canon for the representations of the human body were replaced by curving lines and full-bodied forms. The statue of Akhenaton (Fig. 10–16) could not differ more from its precedents in the Old and Middle Kingdoms. The fluid contours of the body contrast strongly with those in earlier sculptures of pharaohs, as do the elongated jaw, thick lips, and thick-lidded eyes. These characteristics suggest that the artist was attempting to create a naturalistic likeness of the pharaoh, "warts and all," as the saying goes.

Aside from its being at odds stylistically with other Egyptian sculptures, the very concept of the work is different. Throughout

the previous centuries, adherence to a stylistic formality had been maintained, especially in the sculptures of revered pharaohs. If naturalism was present at all, it was reserved for lesser works depicting lesser figures. During the Amarna period it was used in monumental statues depicting members of the royal family as well.

One of the most beautiful and famous works of art from this period is the bust of Akhenaton's wife, Queen Nefertiti (Fig. 10–17). The classic profile reiterates the linear patterns found in the pharaoh's sculpture. An almost top-heavy crowned head extends gracefully on a long and sensuous neck. The naturalism of the work is enhanced by the paint that is applied to the limestone.

The naturalism of the works of the Amarna period was short-lived, since subse-

10–17 Bust of Queen Nefertiti (Egyptian, New Kingdom, c. 1344 B.C.). Limestone. Height: c. 20″.

State Museums, West Berlin.

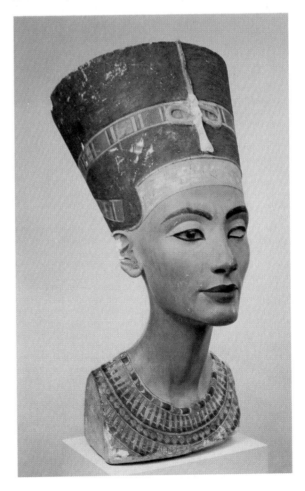

10–16 Pillar statue of Akhenaton from Temple of Amen-Re, Karnak (Egyptian, New Kingdom, c. 1356 B.C.). Sandstone, painted.

Egyptian Museum, Cairo.

quent pharaohs returned to the more rigid styles of the earlier dynasties. Just as Akhenaton destroyed the images and shrines of gods favored by earlier pharaohs, so did his successors destroy his temples to Aton. With Akhenaton's death came the death of monotheism—for the time being. Some have suggested that Akhenaton's loyalty to a single god may have set a monotheistic example for other religions.

Akhenaton's immediate successor was Tutankhamen—the famed King Tut. Called the boy-king, Tut died at about the age of eighteen. His tomb was not discovered until 1922, when British archaeologists unearthed a treasure trove of gold artworks, many inlaid with semiprecious stones. One of these works is an inlaid gold throne **embossed** with the figures of the young pharaoh and his wife (Fig. 10–18). Seated on a throne,

Tutankhamen is being attended by his wife under the rays of the god Amen. In this work, we observe some residual stylistic effects of the Amarna period. Tut's body consists of curvilinear forms not unlike those of the statue of Akhenaton. There is also an emotional naturalism in the tender contact between the boy and his queen.

After Akhenaton's death, Egypt returned to normal. That is, the worship of Amen was resumed and art reverted to the rigid stylization of the earlier stages. The divergence that had taken place with Akhenaton and been carried forward briefly by his successor soon disappeared. Instead, the permanence that was so valued by this people endured for another 1,000 years virtually unchanged despite the kingdom's gradual decline.

10–18 Tutankhamen's Throne (detail—back) (Egyptian, New Kingdom, c. 1340 B.C.). Wood covered with gold leaf, with inlays of silver, colored glass and carnelian. Width of back: 21″.

Egyptian Museum, Cairo.

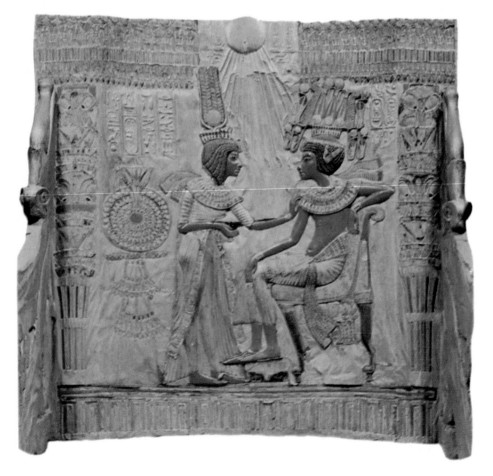

The Tigris and Euphrates valleys and the Nile River banks provided the climate and conditions for the survival of Mesopotamia and Egypt. Other ancient civilizations also flourished because of their geography. Those of the Aegean—Crete in particular—developed and thrived because of their island location. As maritime powers, they maintained contact with distant cultures with whom they traded—including those of Egypt and Asia Minor.

Up until about A.D. 1870, some Aegean civilizations were thought not to have ex-isted. Although they had been sung by the Greek master of the epic, Homer, their strange names were attributed to an overactive imagination. But during the last decades of the nineteenth century, a German archaeologist, Heinrich Schliemann, followed the very words of Homer and unearthed some of the ancient sites, including Mycenae, on the mainland of Greece (Map 2). Following in Schliemann's footsteps, Sir Arthur Evans excavated on the island of Crete and uncovered remains of the Minoan civilization cited by Homer. These cultures and that of the Cyclades Islands in the Aegean comprise the Bronze Age civilizations of **pre-Hellenic** Greece.

Map 2

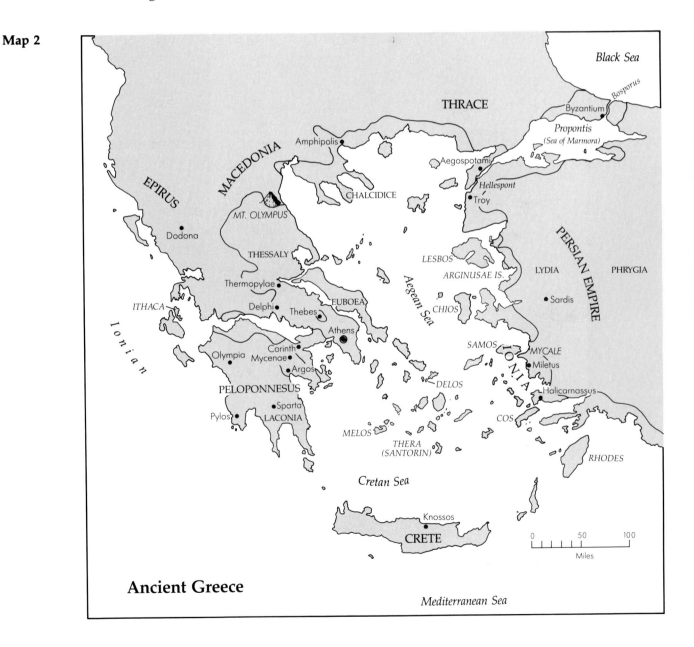

Ancient Greece

The Cyclades

The Cyclades Islands are part of an archipelago in the Aegean Sea off the southeast coast of mainland Greece. They are six in number and include Melos, the site where the famed Venus de Milo (Fig. 11–17) was found; and Paros, one of the chief quarry locations for marble used in ancient Greece. The Cycladic culture flourished on these six islands during the Early Bronze Age, from roughly 2500 to 2000 B.C.

The art that survives has been culled mostly from tombs and includes pottery and small marble figurines. Most of these figures represent fertility goddesses and appear as pared-down geometric versions of the Venus of Willendorf (Fig. 10–2). The fertility

10–19 Cycladic idol, from Amorgos (front and back views) (c. 2500–1100 B.C.). Marble. Height: 31".

Ashmolean Museum, Oxford, England.

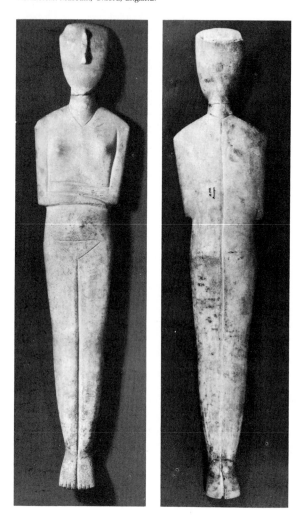

figure in Figure 10–19 is typical of these little sculptures. Note the flattened oval head, the square torso with the bare suggestion of breasts, the arms folded rigidly across the abdomen, and the incised outlines suggesting the pubic region. Some male figures have also been found, most represented as musicians playing highly abstracted instruments. All of these figures are believed to have had a religious function, or at least to have been linked with certain rituals surrounding death.

The Cycladic culture seems to have ended at the same time that the great civilization of Crete was developing. The latter was one of the most remarkable cultures to thrive in the ancient world.

Crete

The civilization that developed on the island of Crete is called the Minoan civilization, named after the legendary king of Crete, Minos. The myths surrounding Minoan life are many, but the most famous is that of the minotaur of King Minos, a cruel beast that was half man and half bull and that often devoured Greek boys and girls. The youths were supposedly placed within a complex **labyrinth** that the minotaur roamed and were forced to try to escape a certain death.

Although Homeric reports such as these were deemed to be myth, the actuality of the Minoan civilization was not. Sir Arthur Evans's excavations revealed Crete to be a bustling culture with exciting artistic and architectural remains. Evans divided the history of Minoan civilization into three parts: the Early Minoan period, known as the pre-Palace period, from which survive some small sculptures and pottery; the Middle Minoan period, or period of the Old Palaces, which began around 2000 B.C. and ended three centuries later with what was probably a devastating earthquake; and the Late Minoan period, during which these palaces were reconstructed, which began during the sixteenth century B.C. and ended probably in about 1400 B.C. It was at that time that the stronghold of Western civiliza-

tion shifted from the Aegean to the Greek mainland. We shall focus on the Middle and Late Minoan periods.

THE MIDDLE MINOAN PERIOD

During the Middle Minoan period, the great palaces, including the most famous one at Knossos, were constructed. A form of writing based on **pictographs,** called Linear A, was developed. Refined articles of ivory, metal, and pottery were also produced.

Some of the finest ceramics of the ancient world prior to the Greek civilization were created on Crete. They were largely due to the development of the potter's wheel, which enabled artists to execute wares that were more uniform in shape and that had thinner, more delicate walls. They were gaily decorated with abstract motifs inspired by the local vegetation and marine life.

Many of the vessels have been found in a cave at Kamáres and thus have been called Kamáres ware. A Kamáres pitcher (Fig. 10–20) is an example of this type of pottery. The pitcher is a full-bodied vessel of elegant contours and impeccable symmetry, due, in part, to the **throwing** process. Characteristic of Kamáres ware of this period is the painted decoration of light patterns on a dark black ground, dotted with bolder tones of red and yellow. The patterns portray no particular plant life, although the swirling forms, tight spirals, and broadly brushed "leaves" or "stems" have a definite organic quality. More important than the individual patterns, however, is the way the painter allows the voluminous forms to embrace and echo the swelling portions of the pitcher. The most dynamic shapes are distributed at the widest part, or shoulder, of the vessel. This freedom of expression reflected the Minoan attitude toward life, which was much more passionate and free-spirited than that of Egypt.

Unlike those of Mesopotamia and Egypt, Minoan architectural projects did not consist of tombs, mortuary temples, or shrines. Instead, the Minoans constructed lavish palaces for their kings and the royal entourage. Not much is known of the old palaces, ex-

10–20 Beaked Kamáres jug from Phaistos (Middle Minoan, c. 1800 B.C.). Height: 10⅝".
Archaeological Museum, Heraklion, Crete.

cept for those that were subsequently built on their ruins. We will examine the architecture of the principal palace at Knossos, erected first during the Middle Minoan period, in our discussion of Late Minoan art.

THE LATE MINOAN PERIOD

Toward the end of the Middle Minoan period, the palace at Knossos was reduced to rubble either by an earthquake or by invaders. About a century after its destruction, however, it was rebuilt on a grander scale. Also during the Late Minoan period, a type of writing called Linear B was developed. This system, finally deciphered in

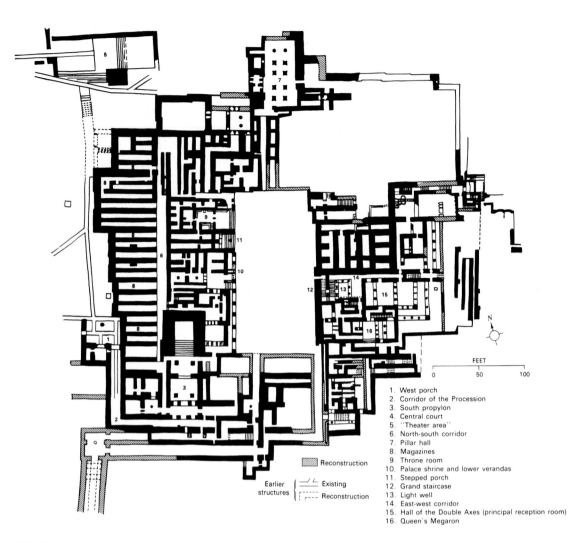

Reconstruction

Earlier structures { Existing / Reconstruction

1. West porch
2. Corridor of the Procession
3. South propylon
4. Central court
5. "Theater area"
6. North-south corridor
7. Pillar hall
8. Magazines
9. Throne room
10. Palace shrine and lower verandas
11. Stepped porch
12. Grand staircase
13. Light well
14. East-west corridor
15. Hall of the Double Axes (principal reception room)
16. Queen's Megaron

10–21 Plan of palace at Knossos (Late Minoan, c. 1500 B.C.)

1953, turned out to be an early form of Greek. The script, found on clay tablets, perhaps indicates the presence of a Greek-speaking people—the Mycenaeans—on Crete during this period.

The most spectacular of the restored palaces on Crete is that at Knossos. The plan (Fig. 10–21) was so large and sprawling that one can easily understand how the myth of the minotaur arose. The adjective "labyrinthine" certainly describes it. The plan indicates a large variety of rooms set off major corridors, and arranged about a large central court. The rooms included the king's and queen's bedrooms, a throne room, reception rooms, servants' quarters, and many other spaces including rows of **magazines,** or stor-

age areas, where large vessels of grain and wine were embedded in the earth for safekeeping. The palace was three stories high and the upper floors were reached by well-lit stairways. Beneath the palace were the makings of an impressive water supply system of terra-cotta pipes that would have provided running water for bathrooms.

Some of the most interesting decorative aspects of the palace at Knossos—seen in the queen's bedroom (Fig. 10–22)—are its unique columns and its vibrant fresco paintings. The columns, carved of stone, are narrower at the base than at the top. This proportion is the reverse of that of the standard columns found in Mesopotamia, Egypt, and later, in Greece. The columns are crowned

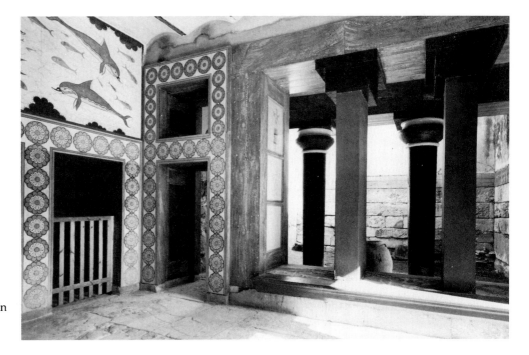

10–22 Queen's bedroom in palace at Knossos (Late Minoan, c. 1500 B.C.)

by cushion-shaped capitals that loom large over the curious stem of the column shaft, often painted bright red or blue.

The rooms were also adorned with painted panels of plant and animal life. Stylized **rosettes** accent doorways, while delicately painted dolphins swim across the surface of the wall, giving one the impression of looking into a vast aquarium. This fascination with marine life that we also see in Minoan pottery of the late period is no doubt due to the fact that, as an island, Crete was surrounded by water and was an impressive maritime power.

The palace at Knossos, and all the other palaces on Crete, were again destroyed sometime in the fifteenth century. At this point the Mycenaeans of the Greek mainland may have moved in and occupied the island. However, their stay was short-lived. Knossos, and the Minoan civilization, had been finally destroyed by the year 1200 B.C.

Mycenae

Although the origins of the Mycenaean people are in doubt, we know that they came to the Greek mainland as early as 2000 B.C. They were a Greek-speaking people who were sophisticated in the forging of weapons. They were also versatile potters and architects. The Minoans clearly influenced their art and culture, even though by about 1600 B.C. Mycenae was by far the more powerful of the two civilizations. As was noted earlier, Mycenaeans occupied Crete after the palaces were destroyed. The peak of Mycenaean supremacy lasted about two centuries, from 1400 to 1200 B.C. At the end of that period, invaders from the north—the fierce and undaunted Dorians—gained control of mainland Greece. They intermingled with the Mycenaeans to form the beginnings of the peoples of ancient Greece.

Lacking the natural defense of a sur-

10–23 Lion Gate at Mycenae (c. 1300 B.C.). Height of sculpture above lintel, 9'6½".

10–24 The Treasury of Atreus (Mycenean, c. 1300–1250 B.C.)

rounding sea that was to Crete's advantage, the Mycenaeans were constantly facing threats from land invaders. They met these threats with strong fortifications, such as the citadels in the major cities of Mycenae and Tiryns. Much of the architecture and art of the Mycenaean civilization reflects the preoccupation with arms.

ARCHITECTURE

As concerned as the Mycenaeans were with matters of protection, they had not lost their aesthetic sense. Citadels were ornamented with frescoes and sculpture, some of which served as architectural decoration. One of the most famous carved pieces from this civilization is the Lion Gate at Mycenae (Fig. 10–23). This gate served as one of the entranceways to the citadel. The actual gateway consists of two massive vertical pillars on which rests a heavy lintel—another example of post and lintel construction. Additional large stones were piled horizontally above the lintel and **beveled** to form an open triangular area; they thus decreased the load to be born by the lintel. Within this triangular space was placed a thick slab sculpted with lions flanking a column that can be recognized as Minoan in style. The heads of the beasts, now gone, were carved of separate pieces of stone and fit into place. Although the animal figures are not intact, their prominent and realistic musculature, carved in high relief, is an awesome sight, one that was sure to give an intruder pause.

Another contribution of the Mycenaean architect was the **tholos,** or beehive tomb. During the early phases of the Mycenaean civilization, members of the royal family were buried in so-called **shaft graves.** These were no more than pits in the ground, lined with stones. The only evidence of their existence was a **stele,** a type of headstone, set above the entrance to the grave. As time went on, however, the tombs became more ambitious.

The Treasury of Atreus (Fig. 10–24), a tholos tomb so named by Schliemann because he believed it to have been the tomb of the mythological ancient Greek king Atreus, is typical of such constructions. The

Treasury consists of two parts: the dromos, or narrow passageway leading to the tomb proper; and the tholos, or beehive-shaped tomb chamber. The latter's circular walls consist of hundreds of stones laid atop one another in concentric rings of diminishing size. The Treasury rose to a height of some 40 feet and enclosed a vast amount of space, an architectural feat not to be duplicated until the domed ceilings of ancient Rome were constructed.

GOLD WORK

Homer's favorite epithet for Mycenae was "rich in gold." To be sure, the Mycenaeans apparently had an insatiable desire to have gold and to work with it. This was verified by the shaft grave excavations that were carried out by Schliemann. The tholos tombs were quickly plundered after their construction, suffering the hazards of being ostentatious, much as was the case with the Pyramids. But a wealth of treasures was still found by Schliemann in the shaft graves. One such find is a gold death mask (Fig. 10–25). Masks such as these were created from thin, hammered sheets of gold laid over the faces of the deceased. Some elements of the face were stylized, such as the ears, eyebrows, and coffee-beanlike eyes, while other features were more naturalistically rendered. Much other craft art was found, including weapons such as inlaid daggers, and spectacular gold vessels.

But even the cyclopian walls of the Mycenaean citadels could not ward off enemies for long. After roughly 1200 B.C., the Mycenaean civilization collapsed at the hands of better-equipped warriors—the Dorians. The period following the Dorian invasions of the Greek mainland witnessed no significant developments in art and architecture. But the peoples of this area formed the seeds of one of the world's most influential and magnificent civilizations—that of ancient Greece.

10–25 Funeral mask from the royal tombs at Mycenae (c. 1500 B.C.). Beaten gold. Height: 12".

National Archaeological Museum, Athens.

11

Classical Art: Greece and Rome

> . . . *the glory that was Greece*
> *And the grandeur that was Rome.*
> —Edgar Allan Poe

No other culture has had as far-reaching or lasting an influence on art and civilization as that of ancient Greece. It has been said that "nothing moves in the world which is not Greek in origin." To this day, Greece's influence can be felt in science, mathematics, law, politics, and art. Unlike some other cultures which flourished, died, and left barely an imprint on the pages of history, that of Greece has asserted itself time and again over the 3,000 years since its birth. During the fifteenth century, there was a revival of Greek art and culture called the **Renaissance,** and, on the eve of the French Revolution of 1789, artists of the **Neoclassical** period again turned to the style and subjects of ancient Greece. Our forefathers looked to Greek architectural styles for the buildings of our nation's capital, and nearly every small town in America has a bank, post office, or library constructed in the Greek Revival style.

Despite its cultural and artistic achievements, ancient Greece was conquered and absorbed by Rome—one of history's strongest and largest empires. Although Greece's political power waned, its influence as a culture did not. It was assimilated by the admiring Romans. The spirit of **Hellenism** lived on in the glorious days of the Roman Empire.

In contrast to the Greeks' intellectual and creative achievements, the Romans' cultural contributions lay in the areas of building, city planning, government, and law. Although sometimes thought of as uncultured and crude, the Romans civilized much of the ancient world following military campaigns that are still studied in military academies.

Despite its awesome might, the Roman Empire also fell. It was replaced by a force whose ideals differed greatly and whose kingdom was not of this world—Christianity. In this chapter we shall examine the artistic legacy of Greece and Rome. This legacy—called **Classical** art—has influenced almost all of Western art, from Early Christian mosaics to contemporary Manhattan skyscrapers.

GREECE

The most important concerns of the ancient Greeks were mankind, reason, and nature, and these concerns formulated their attitude toward life. The Greeks considered human beings to be the center of the universe— the "measure of all things." This concept is called **humanism.** The value put on the individual led to the development of democracy as a system of government among independent city-states throughout Greece. It was also the responsibility of the individual to reach his or her full potential. Much emphasis was placed on the notion of a "sound body"; physical fitness was of utmost importance. The Greeks also recognized the power of the intellect. Their love of reason and admiration for intellectual pursuits led to the development of **rationalism,** a philosophy in which knowledge is assumed to come from reason alone, without input from

the senses. Perfection for the Greeks was the achievement of a sound mind in a sound body (*mens sana in corpore sano*). This is not to say that the Greeks were wholly without emotion—on the contrary, they were vital and passionate—but the Greeks sought a balance between elements: mind and body, emotion and intellect.

The Greeks had a profound love and respect for nature and viewed human beings as a reflection of its perfect order. In art, this concern manifested itself in a **naturalism,** or truth to reality, based on a keen observation of nature. But the Greeks were also lovers of beauty. Thus, although they based their representation of the human body on observation, they could not resist perfecting it. The representation of forms according to an accepted notion of beauty or perfection is called **idealism,** and in the realm of art idealism ruled the Greek mind.

Ancient Greece has given us such names as Aeschylus, Aristophanes, and Sophocles in the world of drama; Homer and Hesiod in the art of poetry; Aristotle, Socrates, and Plato in the field of philosophy; and Archimedes and Euclid in the realms of science and mathematics. It has also given us gods such as Zeus and Apollo and heros such as Achilles and Odysseus. Even more astonishing is the fact that Greece gave us these figures and achieved its accomplishments during a very short period of its history. Although Greek culture spans almost 1,000 years, her "Golden Age," or period of greatest achievement, lasted no more than eighty years.

As with many civilizations, the development of Greece occurred over a cycle of birth, maturation, perfection, and decline. These points in the cycle correspond to the four periods of Greek art that we will examine in this chapter: Geometric, Archaic, Classical, and Hellenistic.

GEOMETRIC PERIOD

The **Geometric period** spanned approximately two centuries, from about 900 to 700 B.C. During this time, a series of invasions

11-1 Dipylon Amphora (Greek, 7th century B.C.) Ceramic. Height: 61".

National Museum, Athens.

egg-shaped body, and two handles; it is generally used to store liquids and grains. Except for a few areas, the entire body of the Dipylon Amphora is decorated with horizontal bands of geometric motifs, some of which may have been inspired by the patterns of woven baskets. The painting is meticulous and the forms are rigidly rendered. The subject of the vase is a funeral procession, which is depicted in the wider band between the handles of the vessel. Highly abstracted human figures with wedge-shaped torsos and profile legs march along with the rigidity of the geometric patterns. A group of four figures in the center hold up a bier on which rests the horizontal figure of the deceased. Around the neck of the vessel are two thin bands with processions of stylized animals. The animals, as well as the human figures, serve as simple decorative elements.

These geometric elements can also be seen in small bronze sculptures of the period, but the stylistic development is most evident in the art of vase painting.

ARCHAIC PERIOD

The **Archaic period** spanned roughly the years from 660 to 480 B.C., but the change from the Geometric style to the Archaic style in art was gradual. As Greece expanded its trade with Eastern countries, it was influenced by their art. Flowing forms and fantastic animals inspired by Mesopotamia appeared on Greek pottery. There was a growing emphasis on the human figure which supplanted geometric motifs.

Vase Painting

During the Archaic period, eastern patterns and forms gradually disappeared. During the Geometric period the human figure was subordinated to decorative motifs, but in the Archaic period it became the preferred subject. In the François Vase (Fig. 11–2), for example, geometric patterns are restricted to a few areas. The entire body of the vessel, a **volute krater,** is divided into

took place, resulting in a decline of the arts. Art will flourish during times of peace, but during a period of war there is little time and money available for it. This period is called Geometric because during this time geometric patterns predominated in art. As in Egyptian art, the representation of the human figure was conceptual rather than optical. When the human figure was present, it was usually reduced to a combination of geometric forms such as circles and triangles. This style changed in later years as Greek artists began to rely more heavily on the observation of nature.

The Dipylon Amphora (Fig. 11–1) is a fine example of the Geometric style. The vase takes its name from the site at which it was found—the Dipylon Cemetery in Athens. An **amphora** is a vessel with a long neck,

11–2 KLEITIAS
François Vase. Attic volute
krater (Greek, c. 570 B.C.)
Ceramic. Height: 26".
Archaelogical Museum, Florence.

six wide bands featuring the exploits of
Greek heroes like **Achilles.** Even though
the drawing is meticulous and somewhat
stilted, the figures of men and animals have
been given substance and an attempt at
naturalistic gestures has been made. Unlike
the figures of the Dipylon Amphora, those
of the François Vase are not static. In fact,
the movement of the battling humans and
the prancing horses is quite lively. This ener-
getic mood is enhanced by the spring forms
of the volute handles.

The François Vase is one of the finest
examples we have of Archaic vase painting.
No doubt, those who made it were also
proud of their work, since the vessel is
signed by both the potter and the painter.
The vase is an example of the **black-figure
painting technique.** Vases of this kind con-
sist of black figures on a reddish back-
ground. This color combination was
achieved through a three-stage firing pro-
cess in the kiln. The decoration was applied
to the clay pot using a brush and a *slip*, a
liquid of sifted clay. The first stage of the

firing process was called the *oxidizing phase*
because oxygen was allowed into the kiln.
Firing under these conditions turned both
the pot and the slip decoration red. In the
second phase of firing, called the *reducing
phase*, oxygen was eliminated from the kiln,
and the vase and the slip both turned black.
In the third and final phase, called a *reoxidiz-
ing phase*, oxygen was again introduced into
the kiln. The coarser material of the pot
turned red, while the fine clay of the slip
remained black. The result was a vase with
black figures silhouetted against a red
ground. The finer details of the figures were
incised with sharp instruments that scraped
away portions of the black to expose the
red clay underneath. In addition, the vases
were painted with touches of red and purple
pigment to highlight the forms. Although
this technique was fairly versatile, Greek
artists did not care for the heavy quality
of the black forms. Around 530 B.C., a rever-
sal of the black-figure process was devel-
oped, enabling painters to create lighter,
more realistic red forms on a black ground.

Architecture

Some of the greatest accomplishments of the Greeks can be witnessed in their architecture. Although their personal dwellings were simple, the dwellings for their gods were fantastic monuments. During the Archaic period, an architectural format was developed that provided the basis for temple architecture throughout the history of ancient Greece. It consisted essentially of a central room (derived in shape from the Mycenaean **megaron**) surrounded by a single or double row of columns. This central room, called the **cella,** usually housed the cult statue of the god or goddess to whom the temple was dedicated. The overall shape of the temple was rectangular and it had a pitched roof.

There were three styles, or orders, in Greek architecture: the **Doric, Ionic,** and **Corinthian.** The Doric order, which originated on the Greek mainland, was the earliest, simplest, and most commonly used. The more ornate Ionic order was introduced by architects from Asia Minor and was gen-

erally reserved for smaller temples. The Corinthian order was by far the most intricate of the three and was used later in less significant buildings, but it was the favorite order of Roman architects, who adopted it in the second century B.C. Figure 11–3 compares the Doric and Ionic orders and illustrates the basic parts of the temple façade. The major weight-bearing elements of the temple are the columns. These cylindrical vertical forms are composed of drums stacked on top of one another and fitted with dowels. They help support the roof structure from either a platform (the **stylobate**) or a base. The main body, or shaft, of the column is crowned by a **capital** that marks a transition from the shaft to a horizontal member (the **entablature**) that directly bears the weight of the roof. In the Doric order, the capital is simple and cushionlike. In the Ionic order it consists of a scroll that ends in volutes similar to those seen on the François Vase (Fig. 11–2). The columns directly support the entablature, which is divided into three parts: the **architrave, frieze,** and **cornice.** The architrave of the Doric order

11–3 Doric and Ionic orders

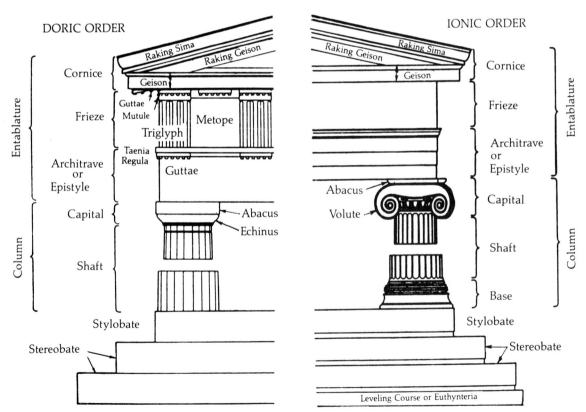

is a solid undecorated horizontal band, while that of the Ionic order is subdivided into three narrower horizontal bands. The frieze, which sits directly above the architrave, contains some sculptural decoration. The Doric frieze is divided vertically into compartments called **triglyphs** and **metopes.** The triglyphs were sculpted panels consisting of clusters of three vertical elements. These alternate with panels that were filled with sculpted figures. The Ionic frieze, by contrast, was sculpted with a continuous band of figures. The absence of compartments freed sculptors from having to work within a square format. Consequently the decoration flows more freely. The topmost element of the entablature is called a cornice. In both orders, it consists of a projecting horizontal band. The entablature is crowned by a **pediment,** a triangular member formed by the slope of the roof lines at the short ends of the temple. This space was also ornamented with figures sculpted to fit within the triangular shape.

Although the Doric order originated in the Archaic period, it attained perfection in the buildings of the Classical period.

Sculpture

In the Archaic period, sculpture emerged as a principal art form. In addition to sculptural decoration for buildings, free-standing life-size and larger-than-life-size statues were executed. Such monumental sculpture was probably inspired by Egyptian figures that Greek travelers would have seen during the early Archaic period.

ARCHITECTURAL SCULPTURE

In Greek temples, the nonstructural members of the building were often ornamented with sculpture. These included the frieze and pediment. Because early Archaic sculptors were forced to work within relatively tight spaces, the figures from this period are often cramped and cumbersome. However, toward the end of the Archaic period artists compensated for the irregularity of the spaces by arranging figures in poses that corresponded to the peculiarities of the architectural element. For example, the *Fallen Warrior* (Fig. 11–4) from the Temple of Aphaia at Aegina was sculpted for one of the sharp angles of its triangular pediment. The warrior's feet would have been wedged into the left corner of the pediment, and his body would have fanned out toward the shield, corresponding to the dimensions of the angle. As in vase painting of the period, the figure is based somewhat on the observation of nature. However, at this early date, stylizations remain as artists were following certain conventions for the representation of the human body. These conventions are most obvious in the sculpt-

11–4 *Fallen Warrior* from Temple of Aphaia at Aegina, Greece. Marble. Length: 6'.

Staatliche Antikensammlungen und Glyptothek, Munich.

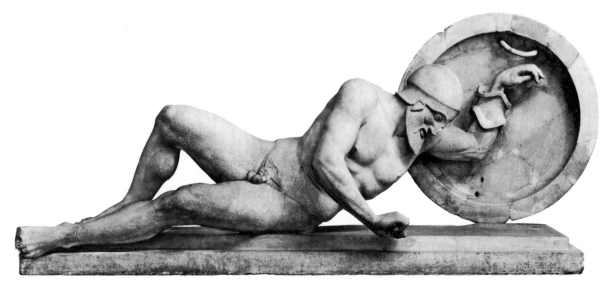

ing of the warrior's head. He has thick-lidded eyes, overdefined lips that purse in an artificial "smile," and an unnaturally pointed beard. Some of the lines of musculature are also stylized, indicating an obsession with anatomical patterns instead of adherence to optical fact. Yet for its conventional representation, the work reveals a marvelous attention to detail. It is, after all, a pitiful sight. The warrior, wounded in battle, crashes down upon the field with his shield in hand. He struggles to lift himself with his right arm, but to no avail. The hopelessness of the situation is echoed in the helplessness of the left arm, which remains trapped in the grasp of the cumbersome shield. It hangs there useless, the band of the shield restricting its flow of blood. It is an emotionally wrenching scene, and yet the emotion comes from the viewer and not from the warrior. The expression on his face is not consonant with his plight. It remains masklike, bound to the restraining conventions of the Archaic style.

FREE-STANDING SCULPTURE

The *Fallen Warrior* from Aegina was created during the last years of the Archaic period, but the history of Archaic Greek sculpture began more than a century earlier. About 600 B.C. large free-standing sculpture began to appear. Some of the earliest of these are the so-called **kouros** figures, which are statues of young men, thought to have been dedicated to a god. Figure 11–5 is typical of these figures. The shape of the body adheres essentially to the block of marble from which it was carved. The arms lie close to the body, the fists are clenched tightly, and one leg advances only slightly. The musculature is full and thick, and parts of the anatomy are emphasized by harsh, patterned lines. The kneecaps, groin muscles, rib cage, and pectoral muscles are all flexed unrealistically. The head has also been treated according to the artistic conventions of the day. The hair is stylized and intricate in pattern. The eyes are thick–lidded and stare directly forward. The youth has very high cheekbones and clearly defined lips

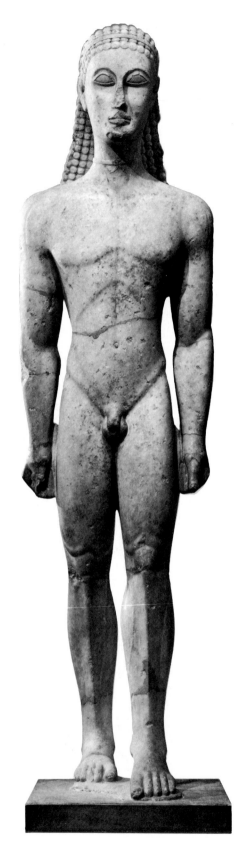

11–5 Kouros figure (Greek, Archaic, c. 600 B.C.) Marble. Height: 6'1½".

The Metropolitan Museum of Art, N.Y.

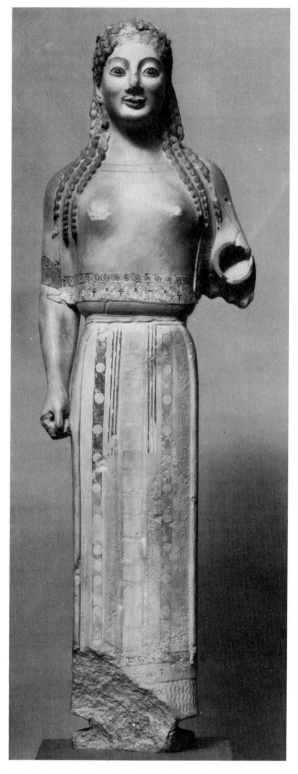

that appear to curl upward in a smile. This facial expression is seen in most sculpture of the Archaic period. It is believed to have been a convention rather than an actual smile that the sculptor was trying to render. Thus it is called the "archaic smile."

The function of these figures is unclear, although they may have been executed to commemorate the subject's accomplishments. In its stately repose and grand presence, the figure might impress us as a god, rather than a mortal. In looking at this kouros figure, one is reminded of the oft-repeated statement, "The Greeks made their gods into men and their men into gods."

The female counterpart to the kouros is the **kore** figure. Unlike the kouros, the kore is clothed and often embellished with intricate carved detail. The *Peplos Kore* (Fig. 11–6), so named because the garment the model wears is a **peplos**, or heavy woolen wrap, is one of the most enchanting images in Greek art, partly because touches of paint remain on the sculpture, giving it a lifelike gaze and sensitive expression. We tend to

11–6 *Peplos Kore* (Greek, Archaic, c. 530 B.C.) Marble. Height: 48".

Acropolis Museum, Athens.

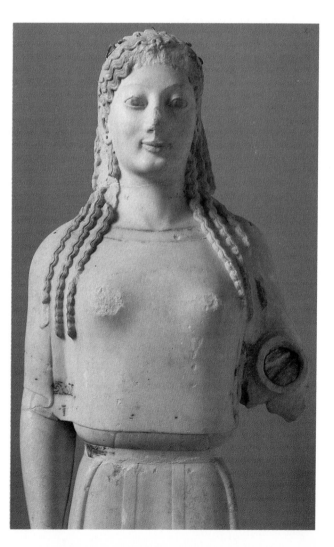

think of Greek architecture and sculpture as pristine and glistening in their pure white surfaces. Yet, most sculpture was painted, some in gaudy colors. Architectural sculpture combined red, blue, yellow, green, black, and sometimes gold pigments. None of this painted decoration remains on temple sculpture. However, statues and wooden panels were painted with **encaustic,** a more durable and permanent medium.

Much of the beauty of the *Peplos Kore* lies in its simplicity. The woman's body is composed of graceful columnar lines echoed in the delicate play of the long braids that grace her shoulders. As is the case in the kouros figures, she remains close to the shape of the marble block. Her right arm, in fact, is attached to her side at the fist. The left arm, now missing, extended outward and probably held a symbolic offering. Although the function of the kore figures is also unknown, some have interpreted them as votive sculptures because many have been found among the ruins of temples.

These architectural and free-standing sculptures were all made of marble. Although expensive, marble was readily available. Some of the finest in the world came from areas immediately around Athens.

The Archaic period was an era of great productivity for the Greeks, but it ended with the invasion of the Persians. After a series of battles, the Persians went for the heart of the Athenian people. In 480 B.C. they sacked the **Acropolis,** the sacred hill above the city that was the site of the Athenians' temples. It was a devastating blow, but one from which the proud and enduring Greeks would recover.

EARLY CLASSICAL ART

The change from Archaic to Classical art coincided with the Greek victory over the Persians in a naval battle at Salamis in 480 B.C. The Greek mood was elevated after this feat, and a new sense of unity among the city-states prevailed, propelling the country into what would be called its "Golden Age." Athens, the site of the Acropolis, became the center for all important postwar activity and was especially significant for the development of the arts. The art of the early phase of the Classical period, which lasted some thirty years, is marked by a power and austerity that reflected the Greek character responsible for the defeat of the Persians. Although it indicates great strides from the Archaic style, some of the rigidity of the earlier period remains. The Early Classical style is therefore sometimes referred to as the Severe style.

Sculpture

The most significant development in Early Classical art was the introduction of implied movement in figure sculpture. This went hand in hand with the artist's keener observation of nature. One of the most widely copied works of this period, which encompasses these new elements, is the *Discobolos* (Fig. 11–7), or Discus Thrower, by Myron. Like most Greek monumental sculpture, it survives only in a Roman copy. The life-size statue depicts an event from the Olympic games—the discus throw. The figure, shown as a young man in his prime, is caught by the artist at the moment when the arm stops its swing backward and prepares to sling forward to release the discus. The athlete's muscles are tensed as he reaches for the strength to release the object. His torso intersects the arc shape of his extended arms, resembling an arrow pulled taut on a bow. It is an image of pent-up energy that the artist will not allow to escape. As in most of Greek Classical art, there is a balance between motion and stability, between emotion and restraint.

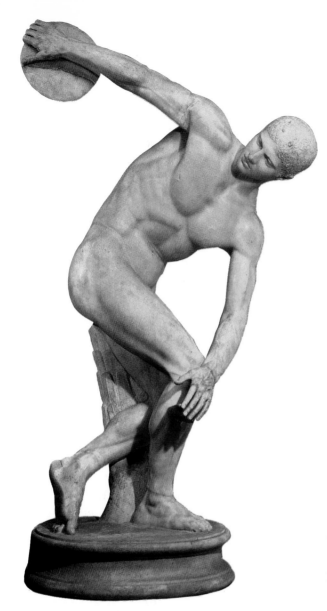

11–7 MYRON *Discobolus*
(*Discus Thrower*) (c. 450 B.C.)
Roman marble copy after bronze original.
Life-size.
Museo Nazionale Romano, Rome.

CLASSICAL ART

Greek sculpture and architecture reached a height of perfection during the Classical period. Greece embarked upon a period of peace—albeit short-lived—and turned its attention to rebuilding its monuments and advancing art, drama, and music. The dominating force behind these accomplishments in Athens was the dynamic statesman Pericles. His reputation was recounted centuries after his death by the Greek historian Plutarch:

> . . . the works of Pericles are . . . admired—though built in a short time they have lasted for a long time. For, in its beauty, each work was, even at that time, ancient, and yet, in its perfection, each looks even at the present time as if it were fresh and newly built. Thus there is a certain bloom of newness in each work and an appearance of being untouched by the wear of time. It is as if some ever-flowering life and unaging spirit had been infused into the creation of these works.

Architecture

After the Persians destroyed the Acropolis, the Athenians refused to rebuild their shrines with the fallen stones that the enemy had touched. What followed, then, was a massive building campaign under the direction of Pericles. Work began first on the

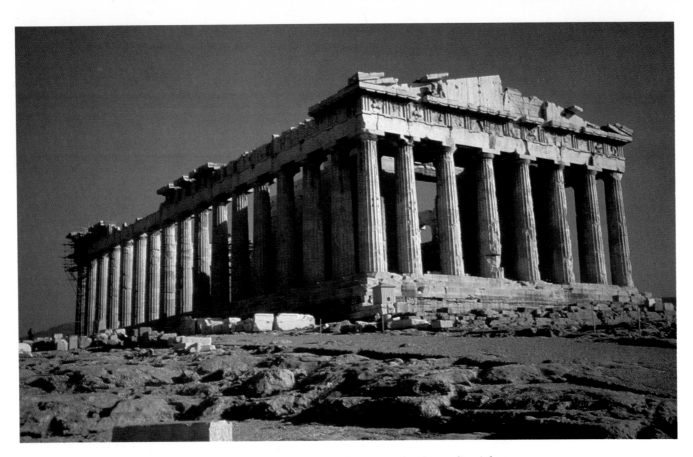

11–8 ICTINOS and CALLICRATES The Parthenon on the Acropolis, Athens
(448–432 B.C.)

temple that was sacred to goddess **Athena,** protector of Athens and its people. This temple, the Parthenon (Fig. 11–8), became one of the most influential buildings in the history of architecture.

Constructed by the architects Ictinos and Callicrates, the Parthenon stands as the most accomplished representative of the Doric order. A single row of Doric columns, now gracefully proportioned, surrounds a two-roomed cella that housed a treasury and a 40-foot-high statue of Athena made of ivory and gold. At first glance, the architecture appears austere, with its rigid progression of vertical elements crowned by the strong horizontal of its entablature. Yet few of the building's lines are strictly vertical or horizontal. For example, the stylobate, or top step of the platform from which the columns rise, is not straight, but curves downward toward the ends. This convex shape is echoed in the entablature. The columns are not exactly vertical, but rather tilt inward. They are not evenly spaced; the intervals between the corner columns are

narrower. The shafts of the columns themselves also differ from one another. The corner columns have a wider diameter, for example. In addition, the shaft of each column swells in diameter as it rises from the base, narrowing once again before reaching the capital. This swelling is called **entasis.**

The reasons for these variations are unknown, although there have been several hypotheses. Errors in construction can be discounted because these variations can be found in other temples. Some art historians have suggested that the change from straight to curved lines is functional. A convex stylobate, for example, might make drainage easier. Others have suggested that the variations are meant to compensate for perceptual distortions on the part of the viewer that would make straight lines look curved from a distance. Regardless of the actual motive, we can assume that the designers of the Parthenon were after an integrated and organic look to their building. The wide base and relatively narrower roof give the appearance of a structure that is

anchored firmly to the ground, yet growing dramatically from it. While it has a grandeur based on a kind of austerity, it also has a lively plasticity. It appears as if the Greeks conceived their architecture as large, free-standing sculpture.

The subsequent history of the Parthenon is both interesting and alarming. In the sixth century A.D. it was converted into a Christian church, and afterward it was used as an Islamic mosque. The Parthenon survived more or less intact until the seventeenth century, when the Turks used it as an ammunition dump in their war against the Venetians. Venetian rockets hit the bull's eye, and the center portion of the temple was blown out in the explosion. The cella still lies in ruins, although fortunately the exterior columns and entablatures were not beyond repair.

Sculpture

ARCHITECTURAL SCULPTURE

The sculptor Phidias was commissioned by Pericles to oversee the entire sculptural program of the Parthenon. Although he was involved in creating the cult statue and thus had no time to carve the architectural sculpture, his assistants followed his style closely.

The Phidian style is characterized by a lightness of touch, attention to realistic detail, contrast of textures, and fluidity and spontaneity of movement.

As was the case with other Doric temples, the sculpted surfaces of the Parthenon were confined to the friezes and the pediments. The subjects of the frieze panels consisted of battles between the Lapiths and the Centaurs, the Greeks and the Amazons, and the Gods and the Giants. In addition, the Parthenon had a continuous Ionic frieze atop the cella wall. This was carved with scenes from the **Panathenaic procession,** an event that took place every four years when the peplos of the statue of Athena was changed. The pediments depicted the Birth of Athena and the Contest between Athena and Poseidon for the city of Athens.

The *Three Goddesses* (Fig. 11–9), a figural group from the corner of the east pediment, is typical of the Phidian style. The bodies of the goddesses are weighty and substantial. Their positions are naturalistic and their gestures fluid, despite the fact that limbs and heads are broken off. The draperies hang over the bodies in a realistic fashion, and there is a marvelous contrast of textures between the heavier garments that wrap around the legs and the more diaphanous fabric covering the upper torsos. The thin-

11–9 *The Three Goddesses*, from east pediment of the Parthenon (c. 438–431 B.C.). Marble. Height of center figure: 4'7".

British Museum, London.

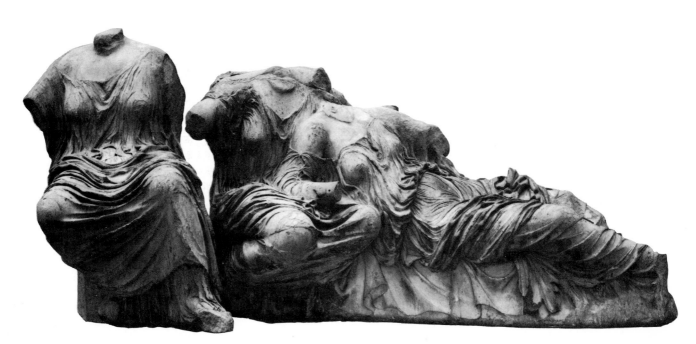

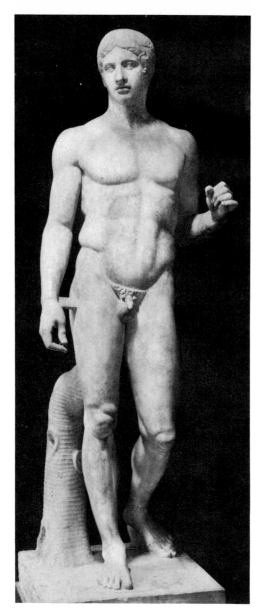

11–10 POLYKLEITOS *Doryphoros*
(*Spearbearer*) (c. 450–440 B.C.) Roman copy
after Greek original.
Marble. Height: 6'6".

National Museum, Naples.

ner drapery clings to the body as if it were wet, revealing the shapely figures of the goddesses. The intricate play of the linear folds renders a tactile quality not seen in art before this time. The lines both gently envelop the individual figures and integrate them in a dynamically flowing composition. Phidias has indeed come a long way from the Archaic artist for whom the contours of the pediment were all but an insurmountable problem.

Some of the Parthenon sculptures were taken down by Lord Elgin (Thomas Bruce) between 1801 and 1803 while he was British ambassador to Constantinople. He sold them to his government, and they are now on view in the British Museum.

FREE-STANDING SCULPTURE

Some of the greatest free-standing sculpture of the Classical period was created by a rival of Phidias named Polykleitos. His favorite medium was bronze and his preferred subject athletes. As with most Greek sculpture, we know his work only from marble Roman copies of the bronze originals.

Polykleitos's work differed markedly from that of Phidias. Whereas the Parthenon sculptor emphasized the reality of appearances and aimed to delight the senses through textural contrasts, Polykleitos's statues were based upon reason and intellect. Rather than mimicking nature, he tried to perfect nature by developing a **canon** of

proportions from which he would derive his "ideal" figures.

Polykleitos's most famous sculpture is the *Doryphoros* (Fig. 11–10), or Spear Bearer. The artist has "idealized" the athletic figure—that is, made it more perfect and beautiful—by imposing on it a set of laws relating part to part (for example, the entire body is equal in height to eight heads). Although some of Phidias's spontaneity is lost, the result is an almost godlike image of grandeur and strength. One of the most significant elements of Polykleitos's style is the principle of **weight shift.** The athlete rests his weight on the right leg, which is planted firmly on the ground. It forms a strong vertical that is accented by the vertical of the relaxed arm. These are counterbalanced by a relaxed left leg bent at the knee, and a tensed left arm bent at the elbow. Tension and relaxation of limbs are balanced across the body *diagonally*; the relaxed arm opposes the relaxed leg, and the tensed arm is opposite the tensed, weight-bearing leg. The weight-shift principle lends naturalism to the figure. Rather than facing forward in a rigid pose, such as that of the kouros figures, the *Doryphoros* stands comfortably at rest. Yet typical of the Polykleitan working method, this appearance of naturalism was derived from a careful balancing of opposing anatomical parts.

Vase Painting

The principle of weight shift and the naturalistic use of implied movement can be seen in Classical vase painting as well. The Argonaut Krater (Fig. 11–11), a red-figure vase decorated by the **Niobid Painter,** incorporates these elements while devoting significantly more space on the body of the vessel to the human figure. In the Dipylon Amphora, the human figure was confined to a single band, whereas the François Vase devoted all of its horizontal bands to the figure (see Figs. 11–1 and 11–2). On later

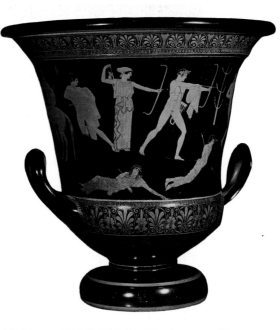

11–11 "NIOBID PAINTER" Argonaut Krater
Attic red-figure krater (Greek, c. 460 B.C.) Ceramic.
Height: 24¼".
Louvre Museum, Paris.

vases, the bands are eliminated and the broad field of the vessel is given over to the human figure in a variety of positions. Yet up until the Classical period, all heads on the vase were arranged on one level. The Niobid Painter, by contrast, attempted to create a three-dimensional space by crudely outlining a foreground, middle-ground, and background. This was a noble attempt at naturalism, based on optical perception; but it failed because the artist neglected to reduce the size of the figures he placed in the background. The ability to arrange figures in space convincingly will come later with the development of perspective.

Vase painting was not the only two-dimensional art form in ancient Greece. There was also **mural painting,** none of which has survived. It is believed, however, that the Romans copied Greek mural painting, as they did sculpture, and it is thus possible to learn what Greek painting looked like by examining surviving Roman wall painting (see Fig. 11–21).

The Ill-Bought Urn

In its day it graced a Grecian banquet table and held perhaps seven gallons of wine. So proud were its makers, the painter Euphronios and the potter Euxitheos, that each signed his name boldly on the front. Even now, 2,500 years later, the Calyx Krater is not merely the best Greek vase in existence. It is perhaps the costliest, having been bought in 1972 by New York's Metropolitan Museum of Art for $1 million. It is also by far the most controversial.

The *New York Times* charged that the vase was booty dug up by grave robbers at an Etruscan site north of Rome in 1971 and illegally sold to an expatriate American. He, in turn, so the story went, smuggled the vase out of Italy and sold it to the Met. In 1970 UNESCO adopted a draft prohibiting illicit traffic in art objects. The Calyx Krater would come under that provision, and both the United States and Italy have signed the pact.

Thomas Hoving, then director of the Metropolitan, dismissed the whole affair as "a lot of hot air" rising from the fierce jealousies that accompanied the million-dollar vase deal. He showed *Time* Magazine sworn statements attesting to the vase's origin and ownership, and he pointed out that so far no real evidence to the contrary had been offered.

The Calyx Krater was declared when it came into the United States, so it is here legally, whatever its provenance in Europe. That makes it far less likely that the vase will ever be pried loose from the Met. Hoving may have been right when he said, "We've got a great pot and we're going to keep it."

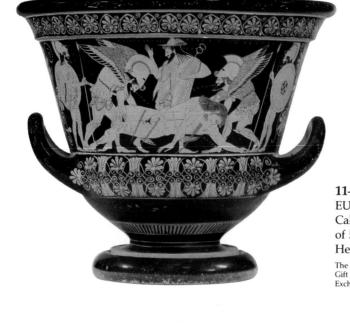

11–12 EUPHRONIOS and EUXITHEOS
Calyx Krater (1st quarter of 5th century B.C.). Ceramic. Height: 18"; diameter: 21¹¹⁄₁₆".

The Metropolitan Museum of Art, Bequest of Joseph H. Durkee, Gift of Darius Ogden Mills, and Gift of C. Ruxton Love, by Exchange, 1972.

Sculpture

The Late Classical period brought a more humanistic and naturalistic style, with emphasis on the expression of emotion. In addition, the stocky muscularity of the Polykleitan ideal was replaced by a more languid sensuality and gracefulness. One of the major proponents of this new style was Praxiteles. His works show a lively spirit that was lacking in some of the more austere sculptures of the Classical period.

The *Hermes and Dionysos* of Praxiteles (Fig. 11–13), interestingly, is the only undisputed original work we have of the Greek masters of the Classical era. Unlike most of the other sculptors, who seem to have favored bronze, Praxiteles excelled in carving. His ability to translate harsh marble surfaces into subtly modeled flesh was unsurpassed. We need only compare his figural group with the *Doryphoros* to witness the changes that had taken place since the Classical period. The *Hermes* is delicately carved and realistic in its muscular emphasis, suggesting a keen observation of nature rather than sculpting according to a rigid canon. The messenger-god holds the infant Dionysos, the god of wine, in his left arm, which is propped up by a tree trunk covered with a drape. His right arm is broken above the elbow but reaches out in front of him. It has been suggested that Hermes once held a bunch of grapes toward which the infant was reaching.

Praxiteles's ability to depict variations in texture is fascinating. Note, for example, the difference between the solid muscularity of Hermes and the soft, chubby body of the infant Dionysos, the rough treatment of Hermes's hair contrasted with the ivory smoothness of his skin, and the deeply carved and billowing drapery against the solidity of the body. This realism is enhanced by the use of a double weight-shift

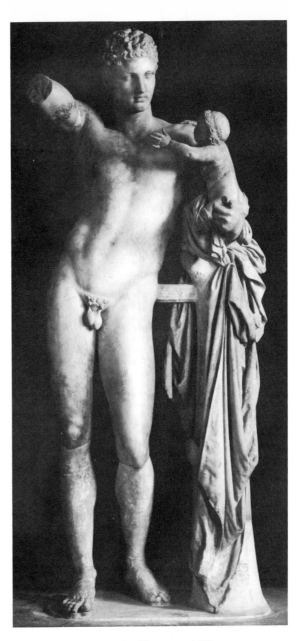

11–13 PRAXITELES *Hermes and Dionysos* (c. 330–320 B.C.). Marble. Height: 7'1".
Museum, Olympia.

principle. Hermes shifts his weight from the right leg to the left arm, resting it on the tree. The resultant stance is known as an **S-curve,** because the contours of the body form an S-shape around an imaginary vertical axis.

Perhaps most remarkable is the emotional content of the sculpture. The aloof quality of Classical statuary is replaced with a touching scene between the two gods. Hermes's facial expression as he teases the child is one of pride and amusement. Dionysos, on the other hand, exhibits typical infant behavior—he is all hands and reaching impatiently for something to eat. There still remains a certain balance to the movement and to the emotion, but it is definitely on the wane. In the Hellenistic period, that time-honored balance will no longer be sought, and the emotionalism present in Praxiteles's sculpture will reach new peaks.

The most important and innovative sculptor to follow Praxiteles was Lysippos. He introduced a new canon of proportions that resulted in more slender and graceful figures, departing from the stockiness of Polykleitos and assuming the fluidity of Praxiteles. Most important, however, was his new concept of the motion of figure in space. All of the sculptures that we have seen so far have had a two-dimensional perspective. That is, the whole of the work can be viewed from a single point before the sculpture. This is not the case in works such as the *Apoxyomenos* (Fig. 11–14) by Lysippos. The figure's arms envelop the surrounding space. The athlete is scraping oil from his body, after which he will bathe. This stance forces the viewer to walk around the sculpture to appreciate its details. Rather than adhering to a single plane, as even the S-curve figure of *Hermes* does, the *Apoxyomenos* seems to spiral around a vertical axis.

Lysippos's reputation was almost unsurpassed. In fact, so highly thought of was his work that Alexander the Great, the Macedonian king who spread Greek culture throughout the Near East, chose him as his court sculptor. It is said that Lysippos was the only sculptor permitted to execute portraits of Alexander. Years after the *Apoxyomenos* was created, it was still seen as a magnificent work of art. Pliny, a Roman writer on the arts, recounted an amusing story about the sculpture:

Lysippos made more statues than any other artist, being, as we said, very prolific in the

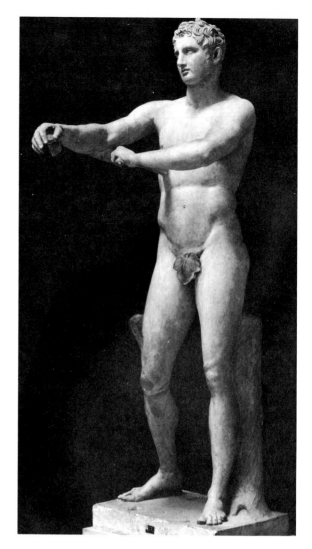

11–14 LYSIPPOS *Apoxyomenos* (c. 330 B.C.) Roman marble copy after a bronze original. Height: 6′6¾″. Vatican Museums, Rome.

art; among them was a youth scraping himself with a strigil, which Marcus Agrippa dedicated in front of his baths and which the Emperor Tiberius was astonishingly fond of. [Tiberius] was, in fact, unable to restrain himself in this case . . . and had it moved to his own bedroom, substituting another statue in its place. When, however, the indignation of the Roman people was so great that it demanded, by an uproar . . . that the Apoxyomenos be replaced, the Emperor, although he had fallen in love with it, put it back.[*]

[*] J. J. Pollitt, *The Art of Greece 1400–31 B.C.: Sources and Documents* (Englewood Cliffs, N.J.: Prentice-Hall, 1965), p. 144.

Greece entered the Hellenistic period under the reign of Alexander the Great. His father had conquered the democratic city-states, and Alexander had been raised amid the art and culture of Greece. When he ascended the throne, he conquered Persia, Egypt, and the entire Near East, bringing with him his beloved Greek culture, or **Hellenism.** With the vastness of Alexander's empire, the significance of Athens as an artistic and cultural center waned.

Hellenistic art is characterized by excessive, almost theatrical emotion and the use of illusionistic effects to heighten realism. In three-dimensional art, the space surrounding the figures is treated as an extension of the viewer's space, at times narrowing the fine line between art and reality.

Sculpture

The Dying Gaul (Fig. 11–15) illustrates the Hellenistic artist's preoccupation with high drama and unleashed passion. Unlike the *Fallen Warrior* (Fig. 11–4), in which the viewer has to extract the emotion by piecing together scattered realistic details, *The Dying Gaul* presents all of the elements that communicate the pathos of the work. Bleeding from a large wound in his side, the fallen barbarian attempts to sustain his weight on a weakened right arm. His head, with expressionistically rendered disheveled hair, hangs down, appearing to lean on his shoulder. He has lost his battle and is now about to lose his life. Strength seems to drain out of his body and into the ground, even as we watch. Our perspective is that of a theatergoer; the Gaul seems to be sitting on a stage. Although the artist intended to evoke pity and emotion from the viewer, the melodramatic pose of the figure and his position on a stagelike platform detach the viewer from the event. We tend to see the scene as well-acted drama rather than cruel reality.

This theatricality can also be seen in one of the most elaborate figural groups in Greek art. The *Laocoön* group (Fig. 11–16) depicts the gruesome death of the Trojan priest Laocoön and his two sons, who were strangled by sea serpents. The slithery creatures were ordered to attack, some say by Poseidon, to punish Laocoön for having warned his people of the Trojan Horse.

Laocoön is portrayed as a burly man, whose knotty musculature and swirling hair and beard bespeak his unbearable plight. He writhes in anguish, vainly attempting to detach the serpents from his neck and limbs. His sons also twist and turn, trying to escape the deadly coils.

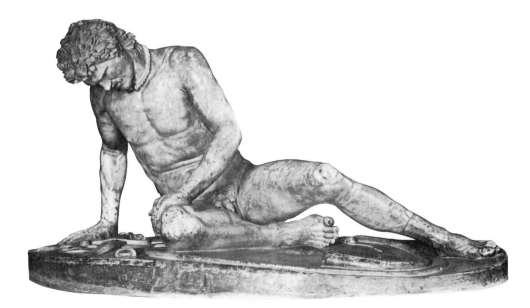

11–15 *The Dying Gaul* (Hellenistic, 240–200 B.C.) Roman marble copy after a bronze original. Life-size.

Capitoline Museum, Rome.

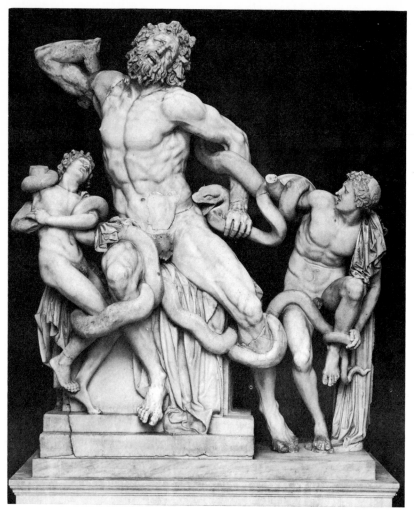

11–16 AGESANDER, ATHENODOROS and POLYDOROS OF RHODES *Laocoön Group* (Hellenistic, 1st century B.C.). Marble. Height: 8′.

Vatican Museums, Rome.

The snakes bind the figures not only physically, but compositionally as well. They pull together the priest and his sons, who otherwise thrust away from the center of the pyramidal composition. It is the artist's way of controlling the potentially runaway action. But it is not a balance of movement and restraint or of tension and relaxation that is sought. Rather, the alternating thrusts and constraints heighten the tension and illustrate the mortals' futile attempts to battle the gods.

In the midst of all the theatricality and high-pitched emotion, there was another trend in Hellenistic art that reflected the simplicity and idealism of the Classical period. One of the most splendid examples of this style, and indeed one of the most famous sculptures in the history of art, is the *Aphrodite of Melos* (Fig. 11–17), often called the *Venus de Milo*. The S-curve and the subtly modeled flesh of the sensuously draped body are reminiscent of the work of Praxiteles. The harsh realism and passionate emotion of the Hellenistic artist could not be farther in spirit from this serene and highly idealized form.

In 146 B.C., the Romans sacked Corinth, a Greek city on the Pelopponesus, after which Greek power waned. Both the territory and the culture of Greece were assimilated by the powerful and growing Roman state. In the next section, we shall examine the art of the Etruscans, a civilization on the Italian peninsula that predated that of the Romans.

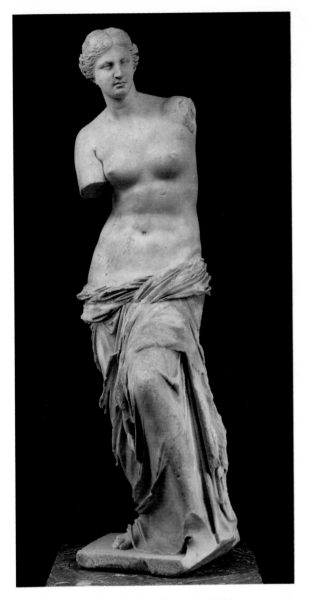

11–17 *Aphrodite of Melos* (*Venus de Milo*) (Hellenistic, 2nd century B.C.) Marble. Larger than life-size.

Louvre Museum, Paris.

THE ETRUSCANS

The center of power of the Roman state was the peninsula of Italy, but the Romans did not gain supremacy over this area until the fourth century B.C., when they began to conquer the **Etruscans.** The Italian peninsula was inhabited by many peoples, but the Etruscan civilization was the most significant one before that of ancient Rome. The Etruscans had a long and interesting history, dating back to around 700 B.C., the period of transition from the Geometric to the Archaic period in Greece. They were not **indigenous** peoples, but rather are believed to have come from Asia Minor. This link may explain some similarities between Etruscan art and culture and that of Eastern countries.

Etruria and Greece had some things in common. The Italian civilization, for example, was a great sea power. Etruria was also divided into independent city-states. They even borrowed motifs and styles from the art of Greece. There is one more similarity between the two civilizations: Etruria also fell prey to the Romans. They were no match for Roman organization, especially since neighboring city-states never came to each other's aid in a time of crisis. By 88 B.C., the Romans had vanquished the last of the Etruscans.

Architecture

The only "architecture" that survives from the Etruscan civilization is tombs, the interiors of which were constructed to resemble those of domestic dwellings. The walls were covered with hundreds of everyday items carved in low relief, including such things as kitchen utensils and weapons. The Etruscans apparently wanted to duplicate their earthly environments for "use" in the afterlife.

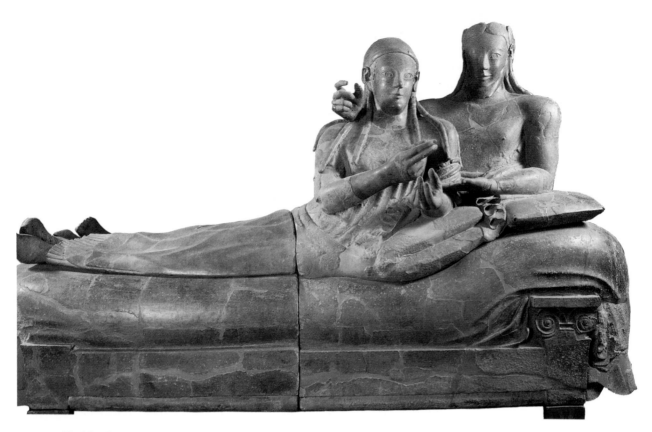

11–18 Sarcophagus, from Cerveteri (Etruscan, c. 520 B.C.). Terra cotta.
Length: 6'7".

Museo Nazionale di Villa Giulia, Rome.

Sculpture

Much sculpture of bronze and clay has sur-
vived from these Etruscan tombs, and we
have learned a great deal about the Etruscan
people from these finds. For example, even
though no architecture survives, we know
what the exterior of domestic dwellings
looked like from the clay models of homes
that served as **cinerary urns.** We have also
been able to gain insight into the personali-
ties of the Etruscan people through their
figural sculpture, particularly that which
topped the lids of their **sarcophagi.**

The Sarcophagus from Cerveteri (Fig. 11–
18) is a translation into terra-cotta of the
banquet scenes of which the Etruscans were
so fond. A man and wife are represented
reclining on a lounge and appear to be en-
joying some banquet entertainment. Their
gestures are sprightly and naturalistic, even

though their facial features and hair are rig-
idly stylized. These stylizations, especially
the thick-lidded eyes, resemble Greek sculp-
ture of the Archaic period and were most
likely influenced by it. However, the seren-
ity and severity of Archaic Greek art are
absent. The Etruscans appear to be as re-
laxed, happy, and fun-loving in death as
they were in life.

ROME

In about 500 B.C. the Roman Republic was
established, and it would last some four cen-
turies. The Roman arm of strength reached
into northern Italy, conquering the Etrus-
cans, who were probably responsible for
having civilized Rome in the first place.
Eventually it stretched in all directions, gain-

ing supremacy over Greece, Western Europe, North Africa, and parts of the Near East. No longer was this the republican city of Rome flexing its muscles—this was the Roman Empire.

Roman art combined native talent, needs, and styles with other artistic sources, particularly those of Greece. The art that followed the absorption of Greece into the Roman Empire is thus often called Greco-Roman. It was fashionable for Romans to own—or at the very least, have copies of—Greek works of art. This tendency gave the Romans a reputation as mere imitators of Greek art, and inferior imitators at that. However, Roman art has been reexamined recently for its own merits, and they are many. A marvelous, unabashed **eclecticism** pervaded much of Roman art, resulting in vigorous and sometimes unpredictable combinations of motifs. The Romans were also fond of a harsh, almost trompe l'oeil, realism in their portrait sculpture, which we have not seen prior to their time. They were also master builders who created some of the grandest monuments in the history of architecture.

THE REPUBLICAN PERIOD

The ancient city of Rome was built on seven hills to the east of the Tiber River, and served as the central Italian base from which the Romans would come to control most of the known world in the West. Their illustrious beginnings are traced to the **Republican period,** which followed upon the heels of their final victories over the Etruscans and lasted until the death of Julius Caesar in 44 B.C. The Roman system of government during this time was based on two parties, although the distribution of power was not equitable. The **patricians** ruled the country and could be likened to an aristocratic class. They came from important Roman families and later were characterized as nobility. The majority of the Roman population, however, belonged to the **plebeian** class. Members of

this class were common folk and had less say in running the government. They were, however, permitted to elect their patrician representatives. It was during the Republican period that the famed Roman senate became the governing body of Rome. The rulings of the senate were responsible for the numerous Roman conquests that would expand its borders into a seemingly boundless empire.

By virtue of its construction, however, the Republic was doomed to crumble. It was never a true democracy. The patricians became richer and more powerful as a result of the plundering of vanquished nations. The lower classes, on the other hand, demanded more and more privileges and resented the wealth and influence of the aristocracy.

After a series of successful military campaigns and the quelling of internal strife in the Republic, Julius Caesar emerged as dictator of the Roman Empire. Under Caesar important territories were accumulated, and Roman culture reached a peak of refinement. The language of Greece, its literature, and religion were adopted along with its artistic styles.

On March 15 (the ides of March) in 44 B.C., Julius Caesar was assassinated by members of the Senate. With his death came the absolute end of the Roman Republic and the beginnings of the Roman Empire under his successor, Augustus.

Sculpture

Although much Roman art is derived in style from that of Greece, its portrait sculpture originated in a tradition that was wholly Italian. It is in this sculpture that we witness Rome's unique contribution to the arts—that of **realism.**

It was customary for Romans to make wax death masks of their loved ones and to keep them around the house, as we do photographs. At times, the wax masks were translated into a more permanent medium

11–19 *Head of a Roman* (Republican period, 1st century B.C.). Marble. Height: 14⅜".

The Metropolitan Museum of Art, N.Y., Rogers Fund, 1912.

such as bronze or terra cotta. The process of making a death mask produced intricately detailed images that recorded every ripple and crevice of the face. As these sculptures were made from the actual faces and heads of the subjects, their realism is unsurpassed. The *Head of a Roman* (Fig. 11–19) records the facial features of an old man, from his bald head and protruding ears to his furrowed brow and almost cavernous cheeks. No attempt has been made by the artist to idealize the figure. Nor does one get the sense, on the other hand, that the artist emphasized the hideousness of the character. Rather, it serves more as an unimpassioned and uninvolved record of the existence of one man.

Architecture

Rome's greatest contribution lay in the area of architecture, although the most significant buildings, monuments, and civic structures were constructed during the **Empire period.** Architecture of the Republican period can be stylistically linked to both Greek and Etruscan precedents, as can be seen in the Temple of Fortuna Virilis (Fig. 11–20). From the Greeks the Romans adopted the Ionic order and post and lintel construction. From the Etruscans, they adopted the

11–20 Temple of Fortuna Virilis, Rome (Rome, Republican period, late 2nd century B.C.)

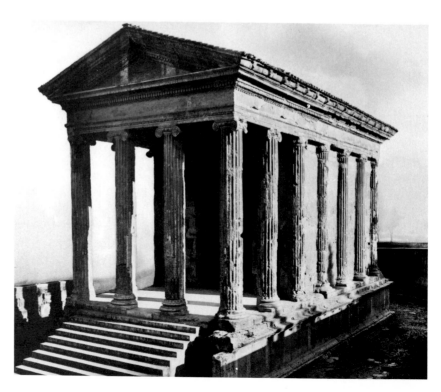

podium on which the temple stands, as well as the general plan of a wide cella extending to the side columns and a free portico in front. But there are Roman innovations as well. The column shafts, for example, are **monolithic** instead of being composed of drums stacked one atop the other. The columns along the sides of the temple are not free standing but rather are engaged. Also the Ionic frieze has no relief sculpture. The most marked difference between the temples of Greece and of Rome is the feeling that the Romans did not treat their buildings as sculpture. Instead, they designed them straightforwardly, with an eye toward function rather than aesthetics.

Painting

The walls of Roman domestic dwellings were profusely decorated with frescoes and mosaics, some of which have survived the ravages of time. These murals are significant in themselves, but they also provide a missing stylistic link in the artistic remains of Greece. That country, you will recall, was prolific in mural painting, but none of it has survived.

Roman wall painting passed through several phases, beginning in about 200 B.C. and ending with the destruction of Pompeii by the eruption of Mount Vesuvius in A.D. 79. The phases have been divided into four overlapping styles.

Ulysses in the Land of the Lestrygonians (Fig. 11–21) is an example of the **Architectural style.** Works in this style give the illusion of an opening of space away from the plane of the wall, as if the viewer were looking through a window. In a loosely sketched and liberally painted landscape, the artist recounts a scene from the Odyssey, in which Ulysses's men were devoured by a race of giant cannibals. The figures rush through

11–21 *Ulysses in the Land of the Lestrygonians,* from a Roman patrician house (50–40 B.C.) Fresco. Height 60".

Vatican Library, Rome.

the landscape in a variety of poses and gestures, their forms defined by contrasts of light and shade. They are portrayed convincingly in three-dimensional space through the use of **herringbone perspective,** a system whereby **orthogonals** vanish to a specific point along a vertical line that divides the canvas. It is believed that Greek wall painting was similar to the Roman Architectural Style.

With the death of Julius Caesar, a dictator, Rome entered its **Empire period** under the rule of Octavian Caesar—later called Augustus. This period marks the beginning of the Roman Empire, Roman rule by emperor, and the Pax Romana, a 200-year period of peace.

THE EARLY EMPIRE

With the birth of the empire there emerged a desire to glorify the power of Rome by erecting splendid buildings and civic monuments. It was believed that art should be created in the service of the state. Although Roman expansionism left a wake of death and destruction, it was responsible for the construction of cities and the provision of basic human services in the conquered areas.

To their subject peoples, the Roman conquerors gave the benefits of urban planning, including apartment buildings, roads, and bridges. They also provided police and fire protection, water systems, sanitation, and food. They even built recreation facilities for the inhabitants, including gymnasiums, public baths, and theaters. Thus, even in defeat, many peoples reaped benefits because of the Roman desire to glorify the empire through visible contributions.

Architecture

Although the Romans adopted structural systems and certain motifs from Greek architecture, they introduced several innovations in building design. The most significant of these was the arch, and, after the second century, the use of concrete to replace cut stone. The combination of these two elements resulted in domed and vaulted structures (see Chapter 7) which were not part of the Greek repertory.

One of the most outstanding of the Romans' civic projects is the **aqueduct,** which carried water over long distances. The Pont du Gard (Fig. 11–22) in southern France carried water over 30 miles and furnished each recipient with some 100 gallons per day. Constructed of three levels of arches, the largest of which spans about 82 feet, the aqueduct is some 900 feet long and 160 feet high. It had to slope down gradually over the long distance in order for gravity to carry the flow of water from the source.

Although the aqueduct's reason for existence is purely functional, the Roman architect did not neglect design. The Pont du

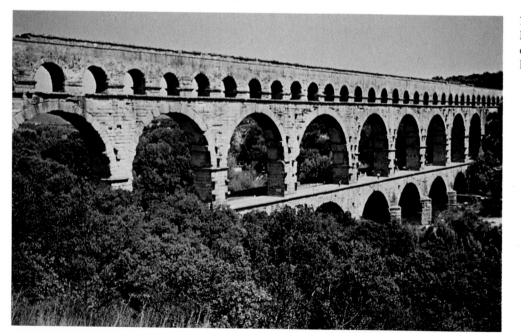

11–22 Pont du Gard, Nîmes, France (Early Empire, c. 14 A.D.). Length: 900'. Height: 160'.

Gard has long been admired for both its simplicity and its grandeur. The two lower tiers of wide arches, for example, anchor the weighty structure to the earth, while the quickened pace of the smaller arches complements the rush of water along the top level. Not only is there a concern in such civic projects for function and form, but in works such as the Pont du Gard, the form *follows* the function.

THE COLOSSEUM

One of the most impressive and famous remains of ancient Rome is the Colosseum (Fig. 11–23). Dedicated in A.D. 80, the structure consists of two back-to-back **amphitheaters** forming an oval arena, around which are tiers of marble seats. This vast "stadium" was the site of entertainment for as many as 50,000 spectators, who were

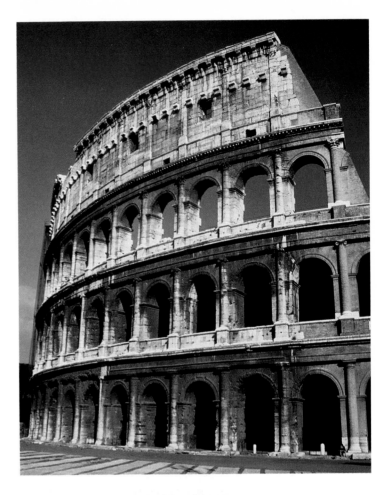

11–23 Colosseum, Rome (Roman, Early Empire, 80 A.D.) Concrete (originally faced with marble). Height: 160'; diameter: 620' and 513'.

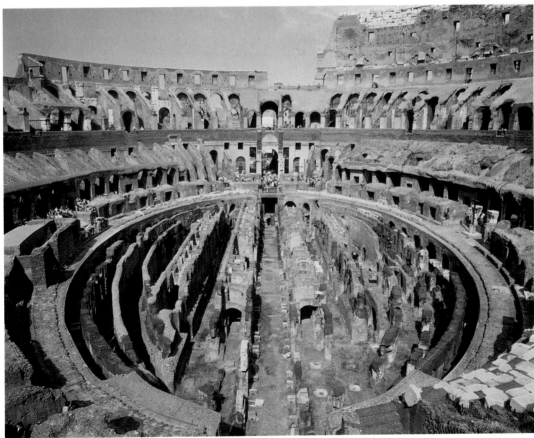

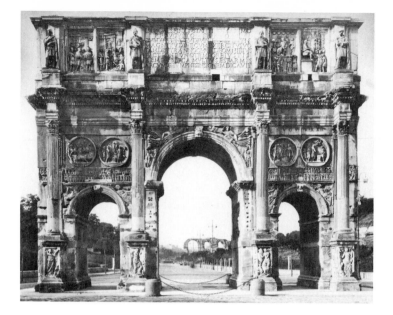

11–24 Arch of Titus, Rome
(Roman, Early Empire, 81 A.D.)

shielded from the blazing Italian sun by canopies stretched over the top of the structure. The events ranged from grueling battles between gladiators to sadistic contests between men and beasts. On opening day, the arena was flooded for a mock sea battle that included some 3,000 "sailors." The Colosseum stood for Rome at its worst, but it also represented Rome at its best.

Even in its present condition, having suffered years of pillaging and several earthquakes, the Colosseum is a spectacular sight. The structure is composed of three tiers of arches separated by engaged columns. (This combination of arch and column can also be seen in another type of Roman architectural monument—the triumphal arch [Fig. 11–24]). The Colosseum's lowest level, whose arches provided easy access and exit for the spectators, is punctuated by Doric columns. This order is the weightiest in appearance of the three and thus visually anchors the structure to the ground. The second level utilizes the Ionic order, and the third level the Corinthian. This combination produces a sense of lightness as one proceeds from the bottom to the top tier. Thick entablatures rest atop the rings of columns, firmly delineating the stories. The topmost level is almost all solid masonry, except for a few regularly spaced rectangular openings. It is ornamented with Corinthian pilasters and is crowned by a heavy cornice.

The exterior was composed of masonry blocks held in place by metal dowels. These dowels were removed over the years when metal became scarce, and thus gravity is all that remains to keep the structure intact.

THE PANTHEON

The Roman engineering genius can be seen most clearly in the Pantheon (Fig. 11–25), a brick and concrete structure originally erected to house sculptures of the Roman gods. Although the building no longer contains these statues, its function remains religious. Since the year A.D. 609, it has been a Christian church.

The Pantheon's design combines the simple geometric elements of a circle and a rectangle. The entrance consists of a rectangular portico, complete with Corinthian columns and pediment. The main body of the building, to which the portico is attached, is circular. It is 144 feet in diameter and is crowned by a dome equal in height to the diameter. Supporting the massive dome are 20-foot-thick walls pierced with deep niches, which in turn are vaulted in order to accept the downward thrust of the dome and distribute its weight to the solid wall. These deep niches alternate with shallow niches, in which sculptures were placed (Fig. 11–26).

The dome itself consists of a rather thin concrete shell that thickens toward the base. The interior of the dome is **coffered,** or carved with recessed squares that physically and visually lighten the structure. The ceiling was once painted blue, with a **gilded** bronze rosette in the center of each square. The sole source of light in the Pantheon is the **oculus,** a circular opening in the top of the dome, 30 feet in diameter and open to the sky.

The interior was lavishly decorated with marble slabs and granite columns that glistened in the spotlight of the sun as it filtered through the opening, moving its focus at different times of the day.

It has been said that Roman architecture differs from other ancient architecture in

11–25 The Pantheon, Rome (Roman, Early Empire, 117–125 A.D.)

11–26 GIOVANNI PAOLO PANNINI
Interior of the Pantheon (c. 1740)
Oil on canvas. 50½ x 39".

National Gallery of Art, Washington, D.C. Samuel H. Kress Collection.

that it emphasizes space rather than solids. Instead of constructing buildings from a variety of forms, the Romans conceptualized a certain space and then proceeded to enframe it. Their methods of harnessing this space were unique in the ancient world and served as a vital precedent for future architecture.

11–27 *Augustus of Primaporta* (Roman, c. 20 B.C.) Marble. Height: 6'8".

Vatican Museums, Rome.

Sculpture

During the empire period, Roman sculpture took on a different flavor. The pure realism of the Republican period portrait busts was joined to Greek idealism. The result, evident in *Augustus of Primaporta* (Fig. 11–27), was often a curious juxtaposition of individualized heads with idealized, anatomically perfect bodies in classical poses. The head of Augustus is somewhat idealized and serene, but his unique facial features are recognizable as those that appeared on empire coins. Augustus adopts an authoritative pose not unlike that of Polykleitos's *Doryphoros* (Fig. 11–10). Attired in military parade armor, he proclaims a diplomatic victory to the masses. His officer's cloak is draped about his hips and his ceremonial armor is embellished with reliefs that portray both historic events and allegorical figures.

As the first emperor, Augustus was determined to construct monuments reflecting the glory, power, and influence of Rome on the western world. One of the most famous of these monuments is the *Ara Pacis* (Fig. 11–28), or Altar of Peace, created to celebrate the empire-wide peace that Augustus was able to achieve. The *Ara Pacis* is composed of four walls surrounding a sacrificial altar. These walls are adorned with relief sculptures of figures and delicately carved floral decoration. Panels such as *The Imperial Procession* (Fig. 11–29) exhibit, once again, a blend of Greek and Roman devices. The right-to-left procession of individuals, unified by the flowing lines of their drapery, clearly refers to the frieze sculptures of the Parthenon. Yet the sculpture differs from its Greek prototype in several respects: The individuals are rendered in portrait likenesses, the relief commemorates a specific event with specific persons present, and these figures are set within a shallow, though very convincing, three-dimensional space. By working in high and low relief, the artist creates the sense of a crowd; fully three rows of people are compressed into this space. They actively turn, gesture, and seem to converse. Despite a noble grandeur which gives the panel an idealis-

11–28 *Ara Pacis* (c. 13–9 B.C.) Marble. Width of altar c. 35'.

Museum of the Ara Pacis, Rome.

11–29 *Imperial Procession,* from the *Ara Pacis* frieze. Marble relief.

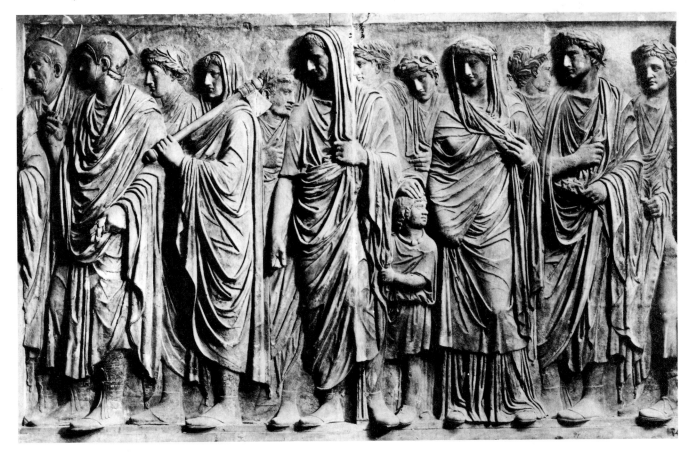

tic cast, the participants in the procession look and act like real people.

As time went on, the Roman desire to accurately record a person's features gave way to a more introspective portrayal of the personality of the sitter. Although portrait busts remained a favorite format for Roman sculptors, their repertory also included relief sculpture, full-length statuary, and a new design—the **equestrian** portrait.

The bronze sculpture of Marcus Aurelius (Fig. 11–30) depicts the emperor on a sprightly horse, as if caught in the action of gesturing to his troops or recognizing the applause of his people. The sculpture combines the Roman love of realism with the later concern for psychologically penetrating portraits. The commanding presence of the horse is rendered through pronounced musculature, a confident and lively stride, and a vivacious head with snarling mouth, flared nostrils, and protruding veins. In contrast to this image of

brute strength is a rather serene image of imperial authority. Marcus Aurelius, clothed in flowing robes, sits erectly on his horse and gestures rather passively. His facial expression is calm and reserved, reflecting his adherence to **Stoic** philosophy. Stoicism advocated an indifference to emotion and things of this world, maintaining that virtue was the most important goal in life.

The equestrian portrait of Marcus Aurelius survives because of a case of mistaken identity. During the Middle Ages, objects of all kinds were melted down because of a severe shortage of metals, and ancient sculptures that portrayed pagan idols were not spared. This statue of Marcus Aurelius was saved because it was mistakenly believed to be a portrait of Constantine, the first Roman emperor to recognize Christianity. The death of Marcus Aurelius brings us to the last years of the empire period, which were riddled with internal strife. The days of the great Roman Empire were numbered.

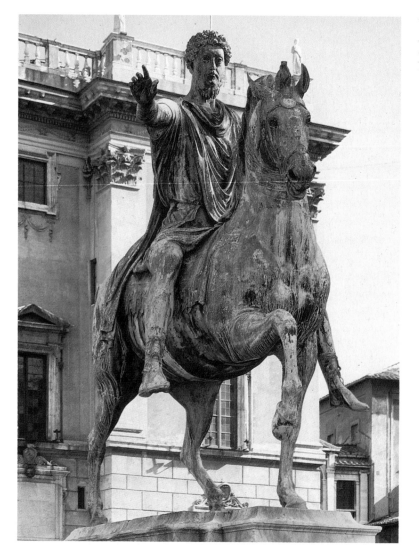

11–30 *Marcus Aurelius on Horseback*, Capitoline Hill, Rome. (Roman, Early Empire, c. 165 A.D.) Bronze. Over life-size.

Architecture

During its late years, the Roman Empire was torn from within. A series of emperors seized the reigns of power only to meet violent deaths, some at the hands of their own soldiers. By the end of the third century, the situation was so unwieldy that the empire was divided into Eastern and Western sections, with separate rulers for each. When Constantine ascended the throne, he returned to the one-ruler system, but the damage had already been done—the empire had become divided against itself. Constantine then dealt the Empire its final blow by dividing its territory among his sons and moving the capital to Constantinople (present-day Istanbul). Thus imperial power was shifted to the Eastern empire, leaving Rome and the Western empire vulnerable. These were decisions from which the empire would never recover.

Although the empire was crumbling around him, Constantine continued to erect monuments to glorify it. Before moving to the East, he completed a basilica in his name (Fig. 11–31) that bespoke the grandeur that had been Rome. In ancient Rome, basilicas were large public meeting halls that were usually built around or near the **forums.** Constantine's basilica was a huge structure, measuring some 300 by 215 feet. It was divided into three rectangular sections, or aisles, the center one reaching a height of 114 feet. The central aisle, called a **nave,** was covered by a **groin vault,** a ceiling structure very popular in buildings of such a vast scale. Little remains of the basilica today, but it survived long enough to set a precedent for Christian church architecture. It would serve as the basic plan for basilicas and cathedrals for centuries to come.

11–31 Basilica of Constantine, Rome (Roman, Late Empire, c. 310–320 A.D.) 300 x 215'.

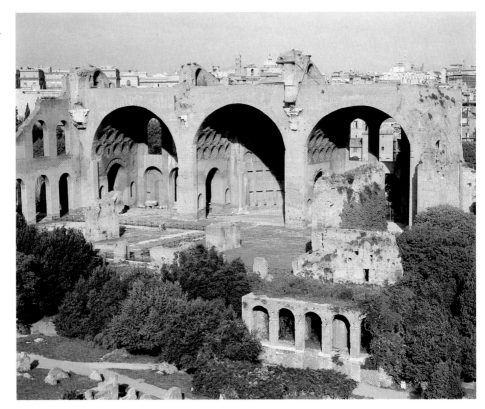

Sculpture

Some 300 years before Constantine's reign, a new force began to gnaw at the frayed edges of the Roman Empire—Christianity. It is said that a man called Jesus was put to death for his beliefs, as well as his disregard for Roman authority, and after him, his followers were persecuted by the Romans for the same reasons. The slaying stopped when Constantine proclaimed tolerance of Christianity. This series of events influenced artistic styles, as can be seen in the Head of Constantine (Fig. 11–32). The literalness and materialism of Roman art and life gave way to a new spirituality and otherworldliness in art. The Head of Constantine was part of a mammoth sculpture of the emperor, consisting of a wooden torso covered with bronze and a head and limbs sculpted from marble. The head is 8½ feet high and weighs over 8 tons. The realism and idealism that we have witnessed in Roman sculpture is replaced by an almost archaic rendition of the emperor, complete with an austere expression and thick-lidded, wide-staring eyes. The artist now elaborates the pensive, passive rigidity of form that we sensed in the portrait of Marcus Aurelius. Constantine's face seems both resigned to the fall of his empire and reflective of the Christian emphasis on a kingdom that is not of this world.

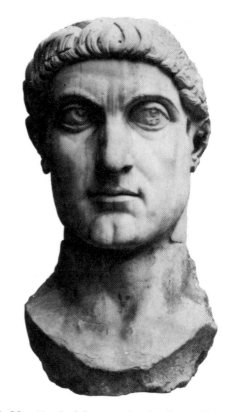

11–32 Head of Constantine the Great (Roman, Late Empire, early 4th century A.D.)
Capitoline Museum, Rome.

12

Christian Art: From Catacombs to Cathedrals

It has been said that the glorious Roman Empire fell to its knees before one mortal man. Of this man we have little factual information, although his life is said to be documented by his followers in the New Testament of the Bible. The month, date, and year of his birth are unknown, although they are stated to be December 25, A.D. 1. He was a Jew named Jesus, whose followers considered him to be the fulfillment of the biblical messianic prophecy. To the Romans, this was blasphemy, and for this and other crimes, Jesus was put to death when he was in his thirties. After his death, he became known as *Jesus Christ* (*Christ* is synonymous with Messiah).

We cannot attribute the fall of the Roman Empire solely to Jesus or to his followers, the Christians. The empire had been having its own problems, both internal and external. It would also be hard to believe that the organizational abilities and influence of the mighty Roman Empire

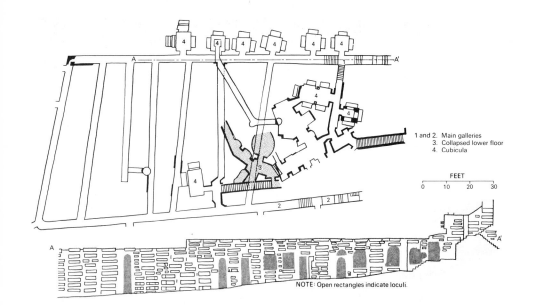

1 and 2. Main galleries
3. Collapsed lower floor
4. Cubicula

FEET
0 10 20 30

NOTE: Open rectangles indicate loculi.

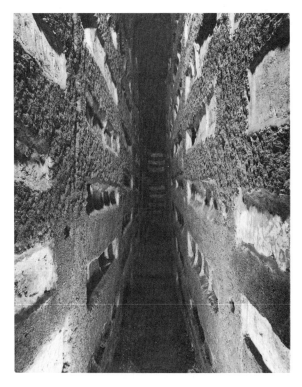

12–1 *Top*: Plan of the catacomb of Callixtus, Rome (2nd century A.D.). *Above*: View of gallery and burial chambers.

could have succumbed to a handful of religious believers. Still the power of spirituality over materialism—and, in this case, of Christianity over worship of the oppressive Caesars—should not be underestimated.

This chapter examines the way in which Christians attempted—through the arts—to glorify Jesus in a period that spans ten centuries or more.

EARLY CHRISTIAN ART

Christianity flowered among the ruins of the Roman Empire, even if it did not cause the empire to collapse. Over many centuries Christianity, too, had its internal and external problems, but unlike the Roman Empire, it has survived. In fact, the concept of survival is central to the understanding of Christianity and its art during the first centuries after the death of Jesus.

To be a Christian before Emperor Constantine's proclamation of religious tolerance, one had to endure persecution. Under the emperors Nero, Trajan, and Domitian, Christians were slain for their beliefs. The Romans saw the Christians as mad cult members and barbaric subversives who refused to acknowledge the emperor as a god.

In the third century A.D., two things happened: First, Emperor Constantine declared in the Edict of Milan that Christianity would be tolerated. Later, he proclaimed Christianity to be the religion of the Roman Empire. Early Christian art, then, can be divided into two phases: The Period of Persecution, before Constantine's proclamation, and then the Period of Recognition.

The Period of Persecution

During the Period of Persecution, Christians worshipped in secret, using private homes

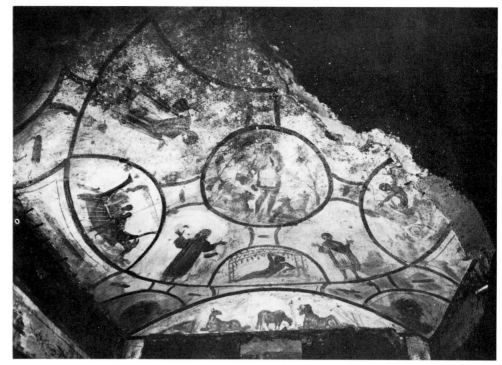

12–2 *The Good Shepherd* in the Catacomb of Sts. Pietro and Marcellino, Rome (Early Christian, early 4th century A.D.). Fresco

Pontifica Commissione di Architettura Sacra, Vatican City.

as well as chapels in **catacombs.** The catacombs were secret burial places for Christians beneath city streets. A huge network of galleries and burial chambers which accommodated almost six million bodies existed beneath the city of Rome (Fig. 12–1). The galleries were carved out of porous stone, and the walls housed niches into which the bodies were placed. Sometimes small chapels were carved out of the gallery walls, and here early Christians worshipped and prayed for the dead. These chapels were very simple, although sometimes they were decorated with frescoes, as in the painted ceiling of the catacomb of Saints Pietro and Marcellino (Fig. 12–2).

The semicircular vault of the chapel was decorated with a cross inscribed in a circle, the symbols for the Christian faith and eternity. The arms of the cross radiate from a central circle in which Jesus is shown as the Good Shepherd, and terminate in **lunettes** depicting scenes from the story of Jonah. Between the lunettes stand figures with arms outstretched in an attitude of prayer. These figures are called **orans,** from the Latin *orare,* meaning "to pray." The style of this fresco is reminiscent of the Classical vase and wall painting of Greece and Rome. The poses are realistic, the proportions are

Classical, and the drapery falls over the body naturally. The early Christians shared the art and culture of Rome, if not its religion. Therefore, there were bound to be similarities in style.

Not all catacomb frescoes were as finished as the one of Saints Pietro and Marcellino. The lighting was poor in the catacombs, and the artists probably wanted to get the work done quickly to avoid having to breathe in the stench of decaying flesh any longer than necessary. It was also unusual to populate such "illicit" frescoes with human figures. Not only was the Christians' place of worship secret, the representation of their Savior, Jesus, was often just as mysterious. Perhaps for safety's sake, they adopted symbols that were already present in Roman art for their own purposes. For example, the fish was used to symbolize Jesus, and grapes to represent the promise of salvation through the blood Jesus had shed. This use of symbols, perhaps at first a survival tactic (Romans might not suspect their meaning), would be of central importance to Christian art over the centuries. The study and interpretation of symbols is called **iconology,** and a work of art's symbolic meaning is called its **iconography.** Both words derive from the Greek *eikōn,* meaning "image."

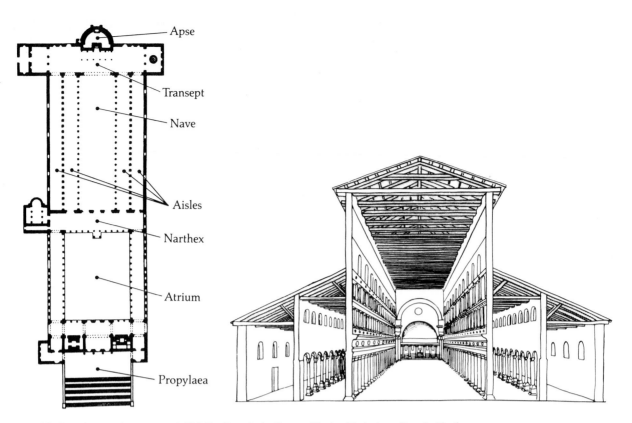

12–3 Plan and section of Old St. Peter's in Rome (Early Christian, first half of 4th century A.D.)

The Period of Recognition

After Constantine adopted Christianity as the faith of the Roman Empire, life for the Christians improved considerably. No longer were they forced to keep their worship secret. Consequently, they poured their energies into constructing houses of worship. It is not surprising that the Christians turned to what they already knew for building models—the basilicas of Rome.

One of the first and most important buildings to be erected during the Early Christian period was the first St. Peter's Cathedral in Rome. The architects of the church, called Old St. Peter's, drew on basilican plans and derived a plan for a Christian cathedral that functioned for centuries to come. The plan of Old St. Peter's (Fig. 12–3) consisted of seven parts. Unlike the Roman basilica, it was entered from one of the short sides, through a kind of gateway called the **propylaeum.** Passing through this gateway, the worshipper entered a large courtyard, or **atrium,** which was open to the sky. Although these two elements were present

in the plan of Old St. Peter's, and appeared occasionally in subsequent churches, they were not carried forward into later buildings with any regularity. Such was not the case with the remainder of the plan. The worshipper gained access to the heart of the basilica through the **narthex,** a portal or series of portals leading to the interior. The long central aisle of the church was called the **nave,** and it was usually flanked by side aisles. As a worshipper walked away from the narthex and up the nave, he or she encountered the **altar** sitting in the **apse.** The apse was generally found at the easternmost end of the structure and was preceded by the **transept,** a kind of crossing arm that intersected the nave and side aisles and was parallel to the narthex. The transept often extended its "arms" beyond the boundaries of the side aisles, resembling a cross in structure. Because of its heritage, this plan is often called a **Latin Cross plan;** it is also referred to as a **longitudinal plan.**

The longitudinal plan was most prominent in Western Europe. Small circular buildings with **central plans** were popular

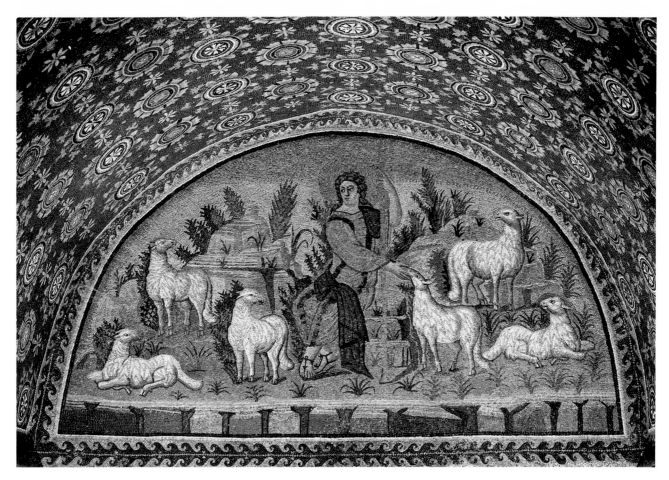

12–4 *Christ as The Good Shepherd* (Early Byzantine, c. 425–26). Mosaic. Mausoleum of Galla Placidia, Ravenna.

in the East but were used only in ancillary buildings in the West.

Old St. Peter's was decorated lavishly with inlaid marble and **mosaics,** none of which survive. The art of mosaic was adopted from the Romans and comprised most of the ornamentation of Early Christian churches. Many of the mosaics were Classical in style. The mosaic of *Christ as the Good Shepherd* (Fig. 12–4) from the Mausoleum of Galla Placidia, for example, is reminiscent of Pompeian wall paintings. The figure of Jesus is seated in a well-defined landscape, amidst a flock of sheep. The figures have substance and are rendered three-dimensional through the use of light and shade. The poses are complex, and the gestures and drapery are naturalistic.

Artists of the Period of Recognition also **illuminated** manuscripts and created some sculpture and small carvings. Their style, like that of the mosaics, can best be described as Late Roman.

BYZANTINE ART

The term **Byzantine** comes from the town of ancient Byzantium, the site of Constantine's capital, Constantinople. The art called "Byzantine" was produced after the Early Christian era in Byzantium, but also in Ravenna, Venice, Sicily, Greece, Russia, and other Eastern countries. We may describe the difference between Early Christian and Byzantine art as a transfer from an earthbound realism to a more spiritual, otherworldly style. Byzantine figures appear to be weightless; they stand in an indeterminate space. Byzantine art also uses more symbolism and is far more decorative in detail.

San Vitale, Ravenna

The city of Ravenna, on the Adriatic coast of Italy, was initially settled by the ruler

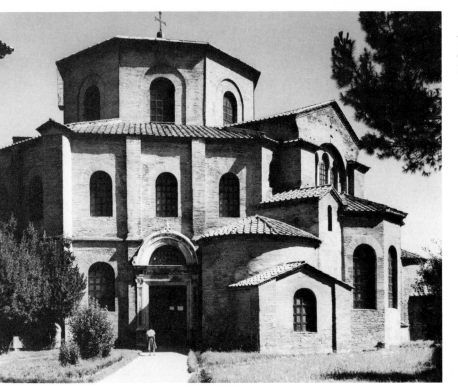

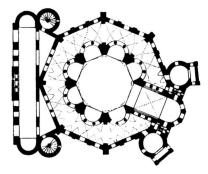

12–5 Church of San Vitale, Ravenna (Byzantine, 526–547) Exterior and plan.

of the Western Roman Empire who was trying to escape barbarians by moving his capital from Rome. As it turned out, the move was timely; eight years later, Rome was sacked. The early history of Ravenna was riddled with strife, its leadership changing hands often. It was not until the age of the emperor Justinian that Ravenna attained some stability and that the arts began to flourish.

During Justinian's reign, the church of San Vitale (Fig. 12–5), one of the most elaborately decorated buildings in the Byzantine style, was erected. The church has a central plan. Its perimeter is an octagon. Although the narthex is placed slightly askew, the rest of the plan is highly symmetrical. A dome, also octagonal, rises above the church, supported by eight massive piers. Between the piers are semicircular niches that extend into a surrounding aisle, or **ambulatory,** like petals of a flower. The "stem" of this flower is a sanctuary that intersects the ambulatory. At the end of this sanctuary is the apse, which in the Byzantine church is often **polygonal.** Unlike the rigid axial alignment of the Latin Cross structures that follow the basilican plan, San Vitale has an organic quality. Soft, curving forms press

into the spaces of the church and are countered by geometric shapes that seem to complement their decorativeness rather than restrain it. The space flows freely, and yet the disparate forms are unified.

This vital, organic quality can also be seen in the interior decoration of the church. Columns are crowned by highly decorative capitals carved with complex, interlacing designs. Decorative mosaic borders, organic in inspiration, form repetitive abstract patterns (Fig. 12–6).

This abstracted, patternlike treatment of forms can also be seen in the representation of human figures in San Vitale's mosaics. *Justinian and Attendants* (Fig. 12–7), an apse mosaic, represents the Byzantine style at its peak of perfection in this medium. The mosaic commemorates Justinian's victory over the Goths and proclaims him as ruler of Ravenna and the Western half of the empire. His title is symbolically sanctioned by the presence of military and religious figures in his entourage. The figures form a strong horizontal band that marches friezelike across the viewer's space. Although they are placed in groups, some slightly in front of others, the heads form a single line. The heavily draped bodies seem to have no sub-

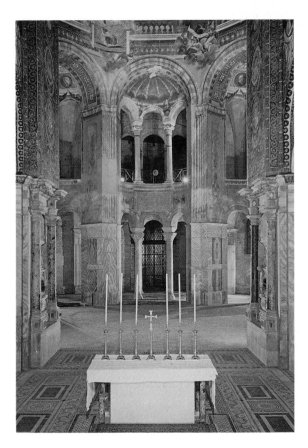

12–6 Interior of San Vitale, Ravenna

stance. The costumes seem to hang on invisible frames. Thickly lidded eyes stare outward, and gestures are unnatural. Space is suggested by a goldish background and a green, grassy band below the figures' feet, but the placement of the images within this space is uncertain. Notice how the feet hover above the earth. They have nothing to do with the support of these weightless bodies. These characteristics contrast strongly with the Classicism of Early Christian art and with mosaics such as the *Christ as the Good Shepherd* (Fig. 12–4).

Hagia Sophia, Constantinople

Even though Ravenna was the capital of the Western Empire, its emperor's most important public building was erected in Constantinople. Constantine moved the capital of the Roman Empire to the ancient city of Byzantium and renamed it after himself. After his death, the empire was divided into Eastern and Western halves, and the Eastern faction remained in Constantinople. It

12–7 *Justinian and Attendants* (Byzantine, c. 547). Mosaic. Church of San Vitale, Ravenna

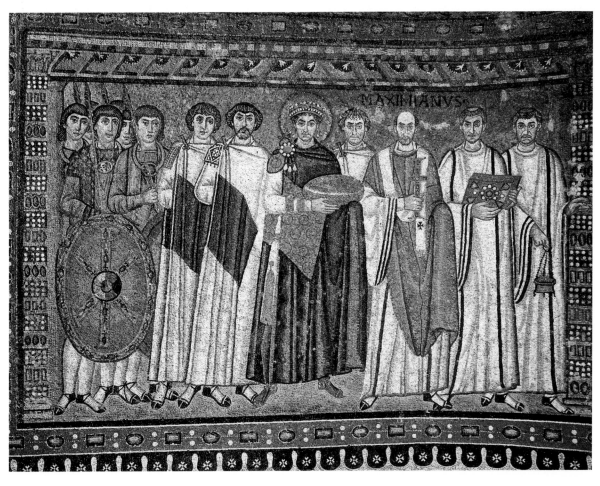

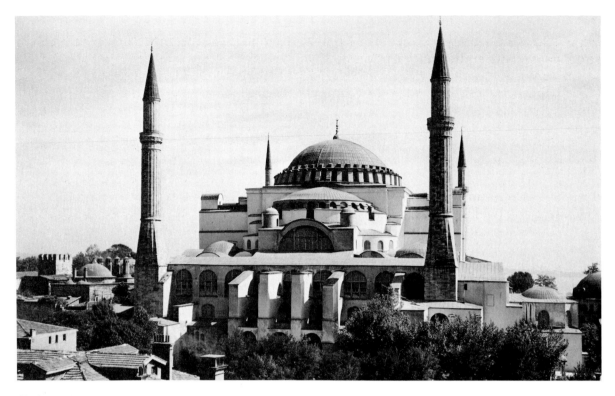

12–8 Church of Hagia Sophia, Istanbul
(Byzantine, 532–537)

12–9 Interior of Church of Hagia Sophia

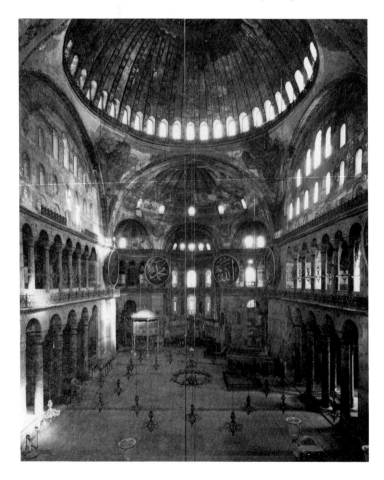

is in this Turkish city—present-day Istanbul—that Justinian built his Church of the Holy Wisdom, or Hagia Sophia (Fig. 12–8). It is a fantastic structure that has served at one time or other in its history as an **Eastern Orthodox** church, an Islamic mosque, and a museum. The most striking aspects of Hagia Sophia are its overall dimensions and the size of its dome. Its floor plan is approximately 240 by 270 feet (Constantine's basilica in Rome was 300 by 215). The dome is about 108 feet across and rises almost 180 feet above the church floor (the dome of the Pantheon, by contrast, rose to a mere 144 feet). Thus its grandiose proportions put Hagia Sophia in the same league with the great architectural monuments of Roman times. To create their dome, the architects Anthemius of Tralles and Isidorus of Miletus used **pendentive** construction (see Chapter 7). Although massive, the dome appears to be light and graceful due to the placement of a ring of arched windows at its base. The light filtering through these windows sometimes gives the impression that the dome is actually hovering on a ring of light, further emphasizing the building's spaciousness (Fig. 12–9).

Like most Byzantine churches, the exterior of Hagia Sophia is very plain. The tower-

ing **minarets** that grace the corners of the structure are later additions. This plainness contrasts strongly with the interior wall surfaces, which are decorated lavishly with marble inlays and mosaics.

Later Byzantine Art

Byzantine architecture continued to flourish until about the twelfth century, varying between the central and longitudinal plans described above. One interesting variation was the **Greek Cross plan** used in such buildings as St. Mark's Cathedral in Venice (Fig. 12–10). In this plan, the "arms" of the cross are equal in length and the focus of the interior is usually a dome that rises above the intersection of these elements. The long nave of the Latin Cross plan is eliminated.

EARLY MEDIEVAL ART

The 1,000 years between about A.D. 400 and 1400 have been called the Middle Ages or the **Dark Ages.** It was believed by some historians that, in effect, this millennium was a "holding pattern" between the era of Classical Rome and the rebirth of its art and culture in the Renaissance of the fifteenth century. Some viewed these 1,000 years as a time when the light of Classicism was temporarily extinguished. The negative attitude toward the people and art of the Middle Ages has recently shifted as awareness of their contributions to economics, religion, scholarship, architecture, and the fine arts has increased. Many works of art from the Early Middle Ages exhibit characteristics similar to those that appear in the small carvings and metalwork of the barbarian tribes who migrated across Eurasia for centuries. An illuminated page from the

12–10 St. Mark's, Venice, begun 1063.
Aerial and frontal views (*below*) and plan (*left*).

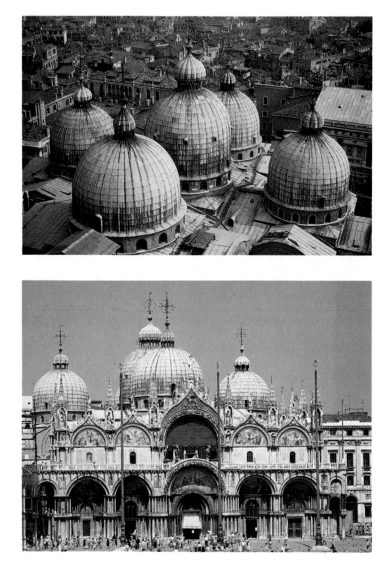

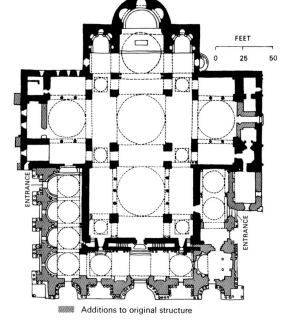

Additions to original structure

12–11 Page from the *Lindisfarne Gospels* (Early Medieval, c. 700 A.D.). Illuminated manuscript. 13½ x 9¾".
British Library, London.

Book of Lindisfarne (Fig. 12–11) depicts a cross inscribed with incessantly meandering scrolls of many colors. Surrounding the cross are repetitive linear patterns that can be decoded as fantastic snakes consuming themselves. This patterning represents the barbarian obsession with fantastic human-animal forms. The motifs also became central to Western European decoration during the Early Middle Ages.

Carolingian Art

The most important name linked to medieval art during the period immediately following the migrations is that of Charlemagne (Charles the Great). This powerful ruler tried to unify the warring factions of Europe under the aegis of Christianity, and, modeling his campaign on those of Roman emperors, he succeeded in doing so. In the

year 800, Charlemagne was crowned Holy Roman emperor by the pope, thus establishing a bond among the countries of Western Europe that lasted over a millennium.

The period of Charlemagne's supremacy is called the **Carolingian** period. He established his court at Aachen, a western German city on the border of present-day Belgium, and imported the most significant intellectuals and artists of Europe and the Eastern countries.

THE PALATINE CHAPEL OF CHARLEMAGNE

Charlemagne constructed his **Palatine** (palace) Chapel with two architectural styles in mind (Fig. 12–12). He sought to emulate Roman architecture but was probably also influenced by the central plan church of San Vitale, erected under the Emperor Justinian. Like San Vitale, the Palatine Chapel is a central plan with an ambulatory and an octagonal dome. However, this is where the similarity ends. The perimeter of Charlemagne's chapel is polygonal, with almost sixteen facets instead of San Vitale's eight. There is also greater axial symmetry in the Palatine Chapel due to the logical placement of the narthex.

The interior displays differences from that of San Vitale as well. The semicircular niches that alternated with columns and pressed into the space of the Ravenna ambulatory have been eliminated at Aachen. There is more definition between the central domed area and the surrounding ambulatory. This clear articulation of parts is a hallmark of Roman design and stands in contrast to the fluid, organic character of some Byzantine architecture. The walls of the Palatine Chapel are divided into three distinct levels, and each level is divided by Roman-inspired archways or series of arches. Classicizing structural elements, decorative motifs, and a general blockiness of form point to the development of **Romanesque** architecture during the eleventh century. However, even though Charlemagne chose a Classical central plan, the longitudinal plan would be preferred by the later Christian architects.

12–12 Palatine Chapel of Charlemagne, Aachen (Carolingian, 792–805 A.D.). Interior and plan.

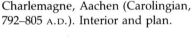

12–13 St. Matthew at work, in Charlemagne's
Coronation Gospels
(Carolingian, c. 795–810 A.D.). Illuminated
manuscript.

Kunsthistorisches Museum, Vienna.

12–14 St. Matthew in *The Gospel Book of Archbishop
Ebbo of Reims*
(Carolingian, 816–841 A.D.). Illuminated manscript.

Bibliothèque Municipale, Epernay, France.

Charlemagne's "pet" project was the decipherment of the true biblical text. Over the years, illiterate scribes with illegible handwriting had gotten the text of the Bible to the point where it was barely decipherable. It was Charlemagne's love of knowledge and pursuit of truth—despite his own illiteracy—that helped keep scholarship alive during the Early Middle Ages.

The style of Charlemagne's own gospel book, called the Coronation Gospels (Fig. 12–13), reflects his love of Classical art. Matthew, an evangelist who was thought to have written the first gospel, is represented as an educated Roman writer diligently at work. Only the halo surrounding his head reveals his sacred identity. He does not appear as an otherworldly weightless figure awaiting a bolt of divine inspiration. His attitude is calm, pensive, deliberate. His body has substance, it is seated firmly, and the drapery of his toga falls naturally over his limbs. The artist uses painterly strokes and contrast of light and shade to define his forms much in the way that the wall painters of ancient Rome had done (see Fig. 11–21).

Although Classicism was the preferred style of the Holy Roman emperor, it was not the only style pursued during the Carolingian period. The Gospel Book of Archbishop Ebbo of Reims (Fig. 12–14) was created only five to ten years after the Coronation Gospels and yet, in terms of style, it could not be further removed. The Classical balance of emotion and restraint evident in Charlemagne's gospel book has succumbed to a display of passion and energy in Ebbo's evangelist. Both figures sit within a landscape, at work before their writing tables. Charlemagne's Matthew, however, appears to rely on his own intellect to set forth the gospels, whereas Ebbo's evangelist, scroll in hand, rushes to jot down every word being set forth by an angel of God, hovering in the upper right corner. He seems to be feverishly trying to keep up! His brow is furrowed, and his hands and feet cramp under the strain of his task.

The mood in the paintings also differs

Anonymous Artists of the Middle Ages

How is it possible that some of the greatest monuments of the human race were created by artists and architects who remain nameless? Schoolchildren are aware that Leonardo da Vinci painted the *Mona Lisa* and that Michelangelo painted the Sistine Chapel ceiling. Everyone has heard of Rembrandt, and it is common knowledge that Van Gogh cut off his ear. People from the four corners of the Earth travel to Paris to see the cathedral of Notre-Dame perched serenely beside the Seine, yet its creator is unknown. The spires of the great cathedrals at Chartres and Amiens punctuate the skies of France, yet their authors, too, are unknown. Why?

The art of the Middle Ages was essentially religious and it was executed for the purpose of worship. There were no colorful patrons who raised the reputations of a select few artists by doling out important commissions. There were no inflated egos, no shining stars. Carvers, painters, manuscript illuminators, and architects worked, for the most part, anonymously. They created their monuments for the greater glory of God—not to glorify themselves. Showing pride in their work by signing it would have been considered sinful; it would have shown a lack of humility. The works were created by all to be enjoyed by all. The individual artists believed they would reap their rewards where it mattered: in the kingdom of God.

drastically. The calm Classical landscape and soft folds of Matthew's drapery create a dignified, intellectual atmosphere in the Coronation Gospels. By contrast, the restless drapery, disheveled hair, facial contortions, and heaving landscape in the Archbishop Ebbo Gospels create an air of dramatic, frantic energy. Interestingly, it is this emotionally charged style that will be most influential in Romanesque art. The naturalism of the Coronation Gospels will not appear again with any regularity until the birth of Early Renaissance art in the fourteenth century.

Ottonian Art

Following Charlemagne's death, internal and external strife threatened the existence of the Holy Roman Empire. It was torn apart on several occasions, only to be consolidated time and again under various rulers. The most significant of these were three German emperors, each named Otto, who succeeded one another in what is now called the Ottonian period. In many respects their reigns symbolized an extension of Carolingian ideals, as is evident in the architecture and sculpture of the period.

The most important architectural achievement of the Ottonian period was the construction of the abbey church of St. Michael in Hildesheim, Germany (Fig. 12–15). St. Michael's offers us our first glimpse of the modified Roman basilica plan that will serve as a basis for Romanesque architecture.

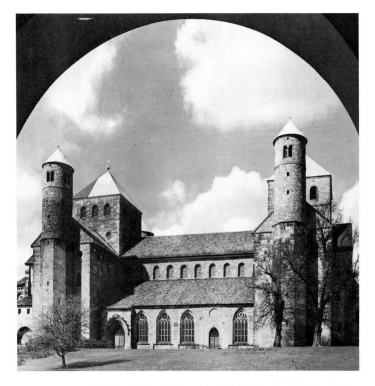

12–15 Abbey Church of St. Michael at Hildesheim, Germany (Ottonian, c. 110–1031) (restored). Exterior (*above*), interior (*below right*), and plan.

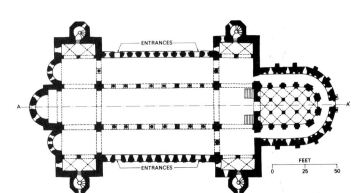

The abbey church does not retain the propylaeum or atrium of Old St. Peter's, and it uses the lateral entrances of Roman basilicas, but all the other elements of a typical Christian cathedral are present: the narthex, nave, two side aisles, a transept, and a much enlarged apse with an ambulatory. Most significant for the future of Romanesque and Gothic architecture, however, is the use of the **crossing square** to define the spaces within the rest of the church. The crossing square is formed by the intersection of the nave and the transept. In the plan of St. Michael's, for example, the nave consists of three modules that are equal in dimensions to the crossing square and marked off by square pillars. This design is an early example of what is called **square schematism,** in which the crossing square determines the dimensions of the entire structure.

St. Michael's also uses an **alternate support system** in the walls of its nave. In such a system, alternating structural elements (in this case pillars and columns) bear the weight of the walls and ultimately the load of the ceiling. The alternating elements in St. Michael's read as pillar-column-column-pillar; its alternate support system is then classified as a-b-b-a in terms of repetition of the supporting elements. An alternate support system of one kind or another will be a constant in Romanesque architecture.

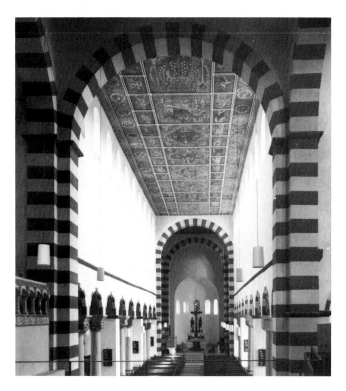

As with Old St. Peter's, the exterior of St. Michael's reflects the character of its interior. Nave, side aisles, and other elements of the plan are clearly articulated in the blocky forms of the exterior. The exterior wall surfaces remain unadorned, as were those of the Early Christian and Byzantine churches. However, St. Michael's was the site of the recovery of the art of sculpture, which had not thrived since the fall of Rome.

SCULPTURE

Adam and Eve Reproached by the Lord (Fig. 12–16), a panel from the bronze doors of St. Michael's, represents the first sculpture cast in one piece during the Middle Ages. It closely resembles the manuscript illumination of the period and in mood and style is similar to the Matthew page of the Archbishop Ebbo gospels. It, too, is an emotionally charged work, in which God points his finger accusingly at the pathetic figures of Adam and Eve. They, in turn, try to deflect the blame; Adam points to Eve and Eve gestures toward Satan, who is in the guise of a fantastic dragonlike animal crouched on the ground. These are not Classical figures who bear themselves proudly under stress. Rather, they are pitiful, wasted images that cower and frantically try to escape punishment. In this work, as well as in that of the Romanesque period, God is shown as a merciless judge, and human beings as quivering creatures who must beware of God's wrath.

ROMANESQUE ART

The Romanesque style appeared in the closing decades of the eleventh century among rampant changes in all aspects of European life. Dynasties, such as those of the Carolingian and Ottonian periods, no longer existed. Individual monarchies ruled areas of Europe, rivaling one another for land and power. After the barbarians stopped invading and started settling, feudalism began to structure Europe, with monarchies at the head.

Feudalism was not the only force in medieval life of the Romanesque period. Monasticism also gained in importance. The monasteries were still the only places for decent

12–16 *Adam and Eve Reproached by the Lord* (Ottonian, 1015). Panel of bronze doors. 23 x 43″. Abbey Church of St. Michael, Hildesheim.

education and had the added attraction of providing guarantees for eternal salvation. Salvation from the fires of hell in the afterlife was a great preoccupation of the Middle Ages and served as the common denominator among classes. Nobility, clergy, and peasantry all directed their spiritual efforts toward this goal.

Two phenomena reflect the medieval obsession with salvation in the afterlife: the Crusades and the great pilgrimages. The Crusades were holy wars waged in an effort to recover the Holy Land from the Moslems, who had taken it over in the seventh century. The pilgrimages were lengthy journeys to visit and worship at sacred shrines or the tombs of saints. Participating in the Crusades and making pilgrimages were seen as weights that would help tip the scale in one's favor on Judgment Day.

The pilgrims' need of a grand place to worship at journey's end gave impetus to church construction during the Romanesque period.

Architecture

In the Romanesque cathedral, there is a clear articulation of parts, with the exterior forms reflecting the interior spaces. The interiors consist of five major areas, with variations on this basic plan evident in different regions of Europe. We can add two Romanesque criteria to this basic format: spaciousness and fireproofing. The large crowds drawn by the pilgrimage fever required larger structures with interior spaces that would not restrict the flow of movement. After barbarian attacks left churches in flames, it was also deemed necessary to fireproof the buildings by eliminating wooden roofs and covering the structures with cut stone.

St. Sernin

The church of St. Sernin (Fig. 12–17) in Toulouse, France, fitted all the requirements of a Romanesque cathedral. An aerial view

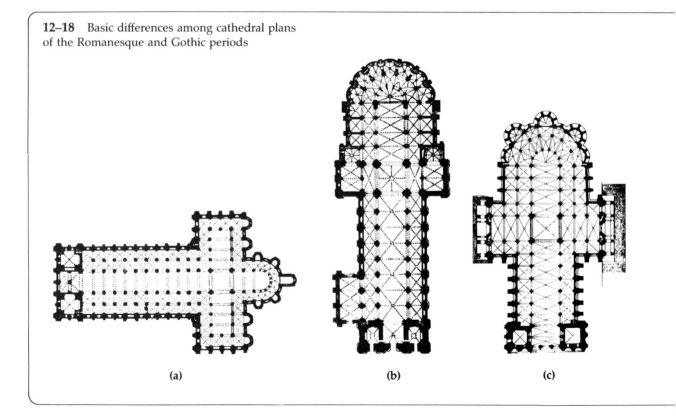

12–18 Basic differences among cathedral plans of the Romanesque and Gothic periods

(a) (b) (c)

of the exterior shows the blocky forms that outline a nave, side aisles, narthex to the west, a prominent transept crowned by a multilevel spire above the crossing square, and an apse at the eastern end from whose ambulatory extend five **radiating chapels.** If you follow the outer aisle up from the narthex in the plan of St. Sernin (Fig. 12–18a), you notice that it continues around the outer borders of the transept arm and runs into the ambulatory around the apse. Along the eastern face of the transept, and around the ambulatory, there is a series of chapels that radiate, or extend, from the aisle. These spaces provided extra room for the crowds of pilgrims and offered free movement around the church, preventing interference with worship in the nave or the celebration of Mass in the apse. Square schematism has been employed in this plan; each rectangular bay measures one-half of the crossing square, and the dimensions of each square in the side aisles measures one-fourth of the main module.

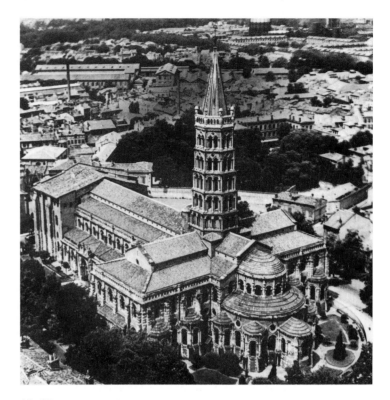

12–17 Church of St. Sernin, Toulouse, France. (Romanesque, c. 1080–1120)

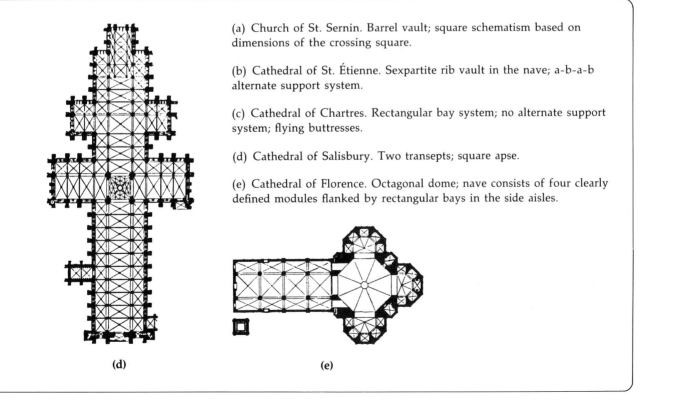

(a) Church of St. Sernin. Barrel vault; square schematism based on dimensions of the crossing square.

(b) Cathedral of St. Étienne. Sexpartite rib vault in the nave; a-b-a-b alternate support system.

(c) Cathedral of Chartres. Rectangular bay system; no alternate support system; flying buttresses.

(d) Cathedral of Salisbury. Two transepts; square apse.

(e) Cathedral of Florence. Octagonal dome; nave consists of four clearly defined modules flanked by rectangular bays in the side aisles.

(d)

(e)

Have Chisel, Will Travel

Imagine a group of workers showing up at a work site some Monday morning, tools in one hand, lunchbag in the other, waiting to get the day's assignment. The foreman says, "You four go to the north side, you four to the south, you to the east, and the rest of you to the west. And remember who your companions are; you're going to be working with them on the next job."

You might not find this unusual; after all, it happens with construction workers every day. But you might find it hard to believe that this scenario took place very often during the construction of some of the most magnificent cathedrals of the Middle Ages. You might also be surprised to learn that bands of artisans during the Romanesque period traveled together from one area of a church to another and from one structure to another, carving some of the most beautiful and intricate column capitals to be found. Art historian Marilyn Low Schmitt has found evidence that groups of carvers divided their labor according to areas within a project, and that carvers moved from one site to another, organizing their labor the same way at each site.[*]

By examining dozens of carved column capitals, Schmitt concluded that there are certain "carving habits," or combinations of motifs, that indicate a "common repertory shared by all the carvers." Apparently different carvers were assigned to different parts of the building and organized their sculpting according to the various parts of each project. Similar unique groups of carved capitals can also be found in different cathedrals, suggesting that the same groups of carvers traveled from site to site.

There seems to have been no time for flashes of inspiration or the spontaneity of creation that we associate with art. And yet these tightly run groups were commissioned to decorate some of the most splendid monuments to the Christian faith.

[*] Marilyn Low Schmitt, "Traveling Carvers in the Romanesque: The Case History of St.-Benoît-sur-Loire, Selles-sur-Cher, Méobecq," *The Art Bulletin*, 63, No. 1 (1981), 6–31.

In St. Sernin, the shift was made from a flat wood ceiling characteristic of the Roman basilica to a stone vault that met the requirement for fireproofing. The ceiling structure, called a **barrel vault,** resembles a semicircular barrel punctuated by arches that spring from engaged columns in the nave to define each bay. The massive weight of the vault is supported partially by the nave walls and partially by the side aisles that accept a share of the downward thrust. This is somewhat alleviated by the **tribune gallery,** which, in effect, reduces the dropoff from the barrel vault to the lower side aisles. The tribune gallery also provided extra space for the masses of worshippers.

Because the barrel vault rests directly atop the tribune gallery, and because **fenestration** would weaken the structure of the vault, there is little light in the interior of the cathedral. Lack of light was considered a major problem, and solving it would be the primary concern of future Romanesque architects. The history of Romanesque architecture can be written as the history of vaulting techniques, and the need for light provided the incentive for their development.

The builders of the cathedral of St. Étienne in Normandy contributed significantly to the future of Romanesque and Gothic architecture in their design of its ceiling vault (Fig. 12–18b). Instead of using a barrel vault that tunnels its way from narthex to apse, they divided the nave of St. Étienne into four distinct modules that reflect the shape of the crossing square. Each of these modules in turn is divided into six parts by **ribs** that spring from engaged columns and **compound piers** in the nave walls. Some of these ribs connect the midpoints of opposing sides of the squares; they are called **transverse ribs.** Other ribs intersect the space of the module diagonally, as seen in the plan; these are called **diagonal ribs.** An **alternate a-b-a-b support system** is used, with every other engaged column sending up a supporting rib that crosses the vault as a transverse arch. These engaged columns are distinguished from other nonsupporting members by their attachment to pilasters. The vault of St. Étienne is one of the first true rib vaults in that the combination of diagonal and transverse ribs functions as a skeleton that bears some of the weight of the ceiling. In later buildings the role of ribs as support elements will be increased, and reliance on the massiveness of nave walls will be somewhat decreased.

Even though the nave walls of St. Étienne are still quite thick when compared with those of later Romanesque churches, the interior has a sense of lightness that does not exist in St. Sernin. The development of the rib vault made it possible to pierce the walls directly above the tribune gallery with windows. This series of windows that appears cut into the slightly domed modules of the ceiling is called a **clerestory.** The clerestory will become a standard element of the Gothic cathedral plan.

The façade of St. Étienne (Fig. 12–19) also served as a model for Gothic architecture. It is divided vertically into three sections by thick **buttresses,** reflecting the nave and side aisles of the interior, and horizontally into three bands, pierced by portals on the entrance floor and arched windows on the upper levels. Two bell towers complete the

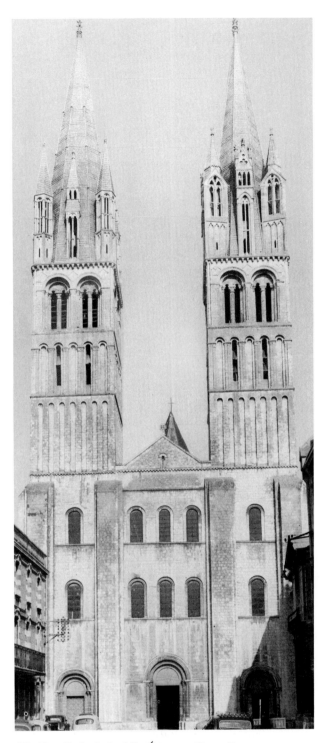

12–19 Cathedral of St. Étienne, Caen, France (Romanesque, 1067–87)

façade, each of which is also divided into three parts (the spires were later additions). This two-tower, tripartite façade will appear again and again in Gothic structures, although the walls will be pierced by more carving and fenestration, lending a lighter look. Yet the symmetry and predictability of the St. Étienne design will be maintained.

Sculpture

Although we occasionally find free-standing sculpture from the Romanesque and Gothic periods, it was far more common for sculpture to be restricted to architectural decoration around the portals. The decorated surfaces (Fig. 12–20) include the **tympanum,** a semicircular space above the doors to a cathedral; **archivolts,** concentric moldings reiterating the shape of the tympanum; the **lintel,** a horizontal, friezelike band on which the tympanum rests; the **trumeau,** a column or pillar in the center of the cathedral doors; and **jambs,** technically the side posts of a doorway, but in this context the wall surfaces that abut the doorway to either side.

Some of the most important and elaborate sculptural decoration is found in cathedral tympanums, such as that of the cathedral of Autun (Fig. 12–21) in Burgundy. The tympanum was an important site for relief carvings because people who entered the church could not help but see it. In sculpting the tympanum of the cathedral of Autun, the opportunity was seized to warn the people that their earthly behavior would be judged

harshly. The scene depicted is that of the Last Judgment. The tympanum rests on a lintel carved with small figures representing the dead. The archangel Michael stands in the center, dividing the horizontal band of figures into two groups. The naked dead on the left gaze upward, hopeful of achieving eternal reward in heaven, while those to the right look downward in despair. Above the lintel, Jesus is depicted as an even-handed judge, overseeing the process of selection. To his left, tall, thin figures representing the apostles observe the scene, while some angels lift bodies into heaven. To Jesus' right, by contrast, is a gruesome event. The dead are snatched up from their graves, and their souls are being weighed on a scale by an angel on the left and a devil-serpent on the right. The devil cheats by adding a little weight, and some of his companions stand ready to grab the souls and fling them into hell.

As in the bronze doors of St. Michael's, humankind is shown as a pitiful, defenseless race, no match for the wiles of Satan. The figures crouch in terror of their surroundings, in strong contrast to the serenity of their impartial judge.

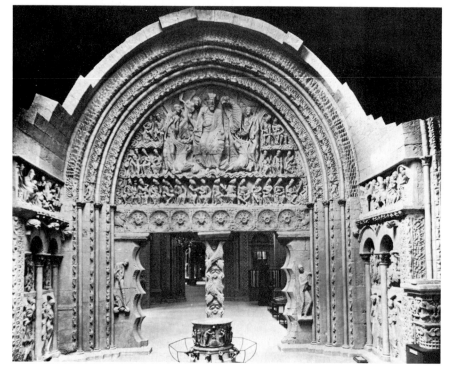

12–20 South portals of the Abbey Church of St. Pierre in Moissac, France (Romanesque, c. 1100)

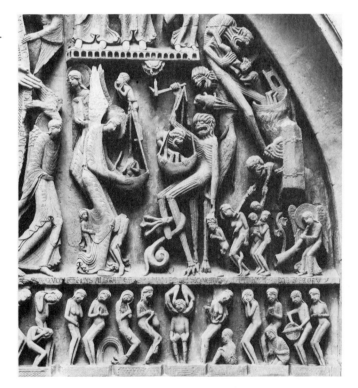

12–21 *Above*: West tympanum of Cathedral of Autun in Burgundy (Romanesque, c. 1130). *Right*: *Last Judgment* (detail).

The Romanesque sculptor sought stylistic inspiration in Roman works, the small carvings of the pre-Romanesque era, and especially manuscript illumination. In the early phase of Romanesque art, naturalism was no concern. The artist turned to art rather than to nature for models, and thus his forms are at least twice, and perhaps one hundred times, removed from the original source. It is no wonder, then, that they appear as dolls or marionettes. The figure of

Jesus is squashed within a large oval, and his limbs bend in sharp angles in order to fit. Although his drapery seems to correspond to the body beneath, the folds are reduced to stylized patterns of concentric arcs that play across a relatively flat surface. Realism is not the goal. The sculptor is merely trying to convey his frightful message with the details and emotionalism that will have the most dramatic impact on the observing worshipper or penitent sinner.

Manuscript Illumination

The relationship between Romanesque sculpture and manuscript illumination can be seen in a page from The Life and Miracles of St. Audomarus (Fig. 12–22). As with the figure of Jesus in the Autun tympanum, the long and gangling limbs of the three frenzied figures are joined to the torso at odd angles. Although the drapery responds somewhat to the unnatural body movement, it is reduced to patterned folds that are also unrealistic. As with other Romanesque artists, the emotion of the scene is of primary importance, and reality fades in its wake.

Toward the end of the Romanesque period, artists paid more attention to their surroundings, and there was a significant increase in naturalism. The drapery falls softly rather than in sharp angles, and the body begins to acquire more substance. The gestures are less frantic and a balance between emotion and restraint begins to reappear. These elements reached their peak of perfection during the Gothic period and pointed to a full-scale revival of Classicism during the Renaissance of the fifteenth century.

12–22 Page from *The Life and Miracles of St. Audomarus* (Romanesque, 11th century). Illuminated manuscript.

Bibliothèque Municipale, St. Omer, France.

GOTHIC ART

Art and architecture of the twelfth and thirteenth centuries is called Gothic. The term "Gothic" originated among historians who believed that the Goths were responsible for the style of this period. Because critics believed that the Gothic style only further buried the light of Classicism, and because the Goths were "barbarians," "Gothic" was used in a disparaging sense. For many years, the most positive criticism of Gothic art was that it was a step forward from the Romanesque. Today such views have been abandoned. "Gothic" is no longer a term of derision, and the Romanesque and Gothic styles are seen as distinct and as responsive to the unique tempers of their times.

Architecture

In the history of art it is rare indeed to be able to trace the development of a particular style to a single work, or the beginning of a movement to a specific date. However, it is generally agreed that the Gothic style of architecture began in 1140 with the construction of the choir of the church of St. Denis near Paris. The vaults of the choir consisted of weight-bearing ribs that formed the skeleton of the ceiling structure. The spaces between the ribs were then filled in with cut stone. At St. Denis the pointed arch is used in the structural skeleton, rather than the rounded arches of the Romanesque style. This vault construction also permitted the use of larger areas of stained glass, dissolving the massiveness of the Romanesque wall.

Although Laon Cathedral is considered an Early Gothic building, its plan resembles those of Romanesque churches. For example, the ceiling is a sexpartite rib vault supported by groups of columns in an alternate a-b-a-b rhythm (Fig. 12–23). Yet there were important innovations at Laon. The interior displays a change in wall elevation from three to four levels. A series of arches, or **triforium,** was added above the tribune gallery to pierce further the solid surfaces of the nave walls. The obsession with reducing the appearance of heaviness in the walls can also be seen on the exterior (Fig. 12–24). If we compare the façade of St. Étienne with that of Laon, we see a change from a massive, fortresslike appearance to one that seems plastic and organic. The façade of Laon Cathedral is divided into three levels, although there is less distinction between them. The portals seem to jut forward from the plane of the façade, providing a tunnel-like entrance. The stone is pierced by arched windows, arcades, and a large **rose window** in the center, and the twin bell towers seem to be constructed of voids rather than solids.

As the Gothic period progressed, all efforts were directed toward the dissolution of stone surfaces. The walls were pierced by greater expanses of glass, nave elevations became higher, and carved details became lacier. There was a mystical quality to these buildings in their seeming exemption from the laws of gravity.

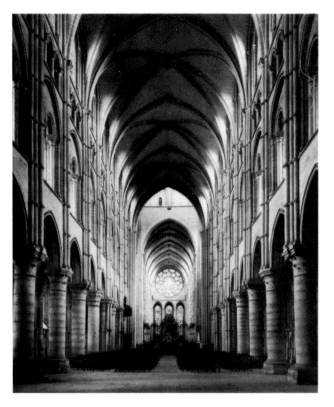

12–23 Interior of Laon Cathedral, France (Early Gothic, c. 1190)

12–24 Exterior of Laon Cathedral

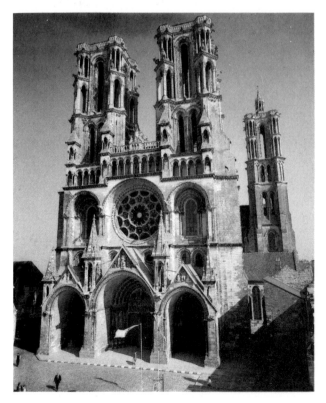

One of the most famous buildings in the history of architecture is the cathedral of Notre-Dame de Paris (Fig. 12–25). Perched on the banks of the Seine, it has enchanted visitors ever since its construction. Notre-Dame is a curious mixture of old and new elements. It retains a sexpartite rib vault and was originally planned to have an Early Gothic four-level wall elevation. It was begun in 1163 and was not completed until almost a century later, undergoing extensive modifications between 1225 and 1250. Some of these changes reflected the development of the High Gothic style, including the elimination of the triforium and the use of **flying buttresses** to support the nave walls. The exterior of the building also communicates this combination of early and late styles. While the façade is far more massive than that of Laon Cathedral, the north and south elevations look light and airy due to their fenestration and the lacy buttressing.

Chartres Cathedral is generally considered to be the first High Gothic church. Unlike Notre-Dame, Chartres was planned to have a three-level wall elevation and flying buttresses. The three-part wall structure allowed for larger windows in the clerestory, admitting more light into the interior. The use of large windows in the clerestory was in turn made possible by the development of the flying buttress.

In the High Gothic period there is a change from square schematism to a **rectangular bay system** (Fig. 12–18c). In the latter, each rectangular bay has its own cross rib vault, and only one side aisle square flanks each rectangular bay. Thus the need for an alternate support system is also eliminated. The interior of a High Gothic cathedral presents several dramatic vistas. There is a continuous sweep of space from the narthex to the apse along a nave that is uninterrupted by alternating supports. There is also

12–25 Cathedral of Notre-Dame, Paris (Gothic, begun 1163, completed 1250)

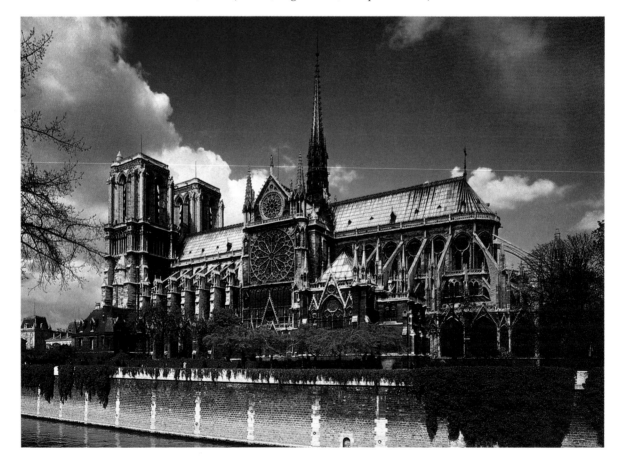

a strong vertical thrust from floor to vaults that is enhanced by the elimination of the triforium and the increased heights of the arches in the nave arcade and clerestory windows. The solid wall surfaces are further dissolved by quantities of stained glass that flood the interior with a mysterious, soft light. The architects directed all of their efforts to creating a spiritual escape to another world. They did so by defying the properties of matter, by creating the illusion of weightlessness in stone, and by capitalizing on the mesmerizing aspects of colored streams of light.

Gothic Architecture Outside of France

The cathedral architecture that we have examined thus far was constructed in France, where the Gothic style flourished. Variations on the French Gothic style can also be perceived elsewhere in northern Europe, although in some English and German structures the general "blockiness" of Ro-

manesque architecture was maintained. The plan of Salisbury Cathedral (Fig. 12–18d) in England illustrates some differences between English and French architecture of the Gothic period, as seen in the double transept and the unique square apse. The profile of Salisbury Cathedral also differs from that of a French church in that the bell towers on the western end are level with the rest of the façade, and a tall tower rises above the crossing square. Still, the remaining characteristics of the cathedral, including the rectangular bay system, bear close relationship to the French Gothic style.

In Italy, on the other hand, there was no strict adherence to the French style, as is seen in the cathedral of Florence (Fig. 12–26). The most striking features of its exterior are the sharp, geometric patterns of green and white marble incrustation and the horizontality, or earthbound quality. These contrast with the vertical lines of the French Gothic cathedral that seem to reach

12–26 Cathedral of Florence (Gothic, begun 1368)

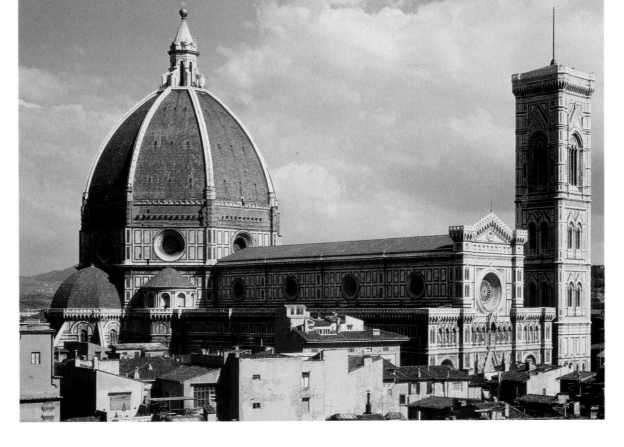

for heaven. The French were obsessed with the visual disintegration of massive stone walls. The Italians, on the other hand, preserved the **mural quality** of the structure. In the cathedral of Florence, there are no flying buttresses. The wall elevation has been reduced to two levels, with a minimum of fenestration.

The cathedral of Florence is also different in plan (Fig. 12–18e) from French cathedrals. A huge octagonal dome overrides the structure. The nave, which seems like an afterthought, consists of four large and clearly defined modules, flanked by rectangular bays in the side aisles. Finally, there is only one bell tower in the Italian cathedral, and it is detached from the façade.

Why would this Italian Gothic cathedral differ so markedly from those of the French? Given its strong roots in Classical Rome, it may be that Italy never succumbed wholeheartedly to Gothicism. It is perhaps for this reason that Italy will be the birthplace of the revival of Classicism during the Renaissance. We shall discuss the cathedral of Florence further in Chapter 13, because the designer of its dome was one of the principal architects of the Renaissance.

Sculpture

Sculpture during the Gothic period exhibits a great change in mood from that of the Romanesque. The iconography is one of redemption rather than damnation. The horrible scenes of Judgment Day that threatened the worshipper upon entering the cathedral were replaced by scenes from the life of Jesus or **apocalyptic** visions. The Virgin Mary also assumed a primary role. Carved tympanums, whole sculptural programs, even cathedrals themselves (for example, Notre-Dame, which means "Our Lady") were dedicated to her.

Gothic sculpture is still pretty much confined to decoration of cathedral portals. Every square inch of the tympanums, lintels, and archivolts of most Gothic cathedrals is carved with a dazzling array of figures and ornamental motifs. However,

some of the most advanced full-scale sculpture is to be found adorning the jambs. Early Gothic jamb figures, such as those found around the portals of Chartres Cathedral (Fig. 12–27; Chartres was rebuilt after a fire in the High Gothic style, but the portal sculpture remained intact), are rigid in their poses, confined by the columns to which they are attached. The drapery falls in predictable folds, at times stylized into patterns reminiscent of manuscript illumination. Yet there is a certain weightiness to the bodies and the elimination of the "hinged" treatment of the limbs that heralds changes from the sculpture of the Romanesque period. During the High Gothic period, these simple elements led to a naturalism that we have not witnessed since Classical times.

The jamb figures of Reims Cathedral (Fig. 12–28) exhibit an interesting combination of styles. The individual figures were no doubt carved by different artists. The detail of the central portal of the façade illustrates two groups of figures. To the left is an **Annunciation** scene with the angel Gabriel and the Virgin Mary, and to the right is a **Visitation** scene depicting the Virgin Mary and Saint Elizabeth. All the figures are detached from columns and instead occupy the spaces between them. Although they have been carved for these specific niches and they are perched on small pedestals, they have a freedom of movement not found in the figures of the Chartres jambs.

The Virgin Mary of the Annunciation group is the least advanced in technique of the four figures. Her stance is the most rigid, and her gestures and facial expression are the most stylized. Yet her body has substance, and anatomical details are revealed beneath a drapery that responds realistically to the movement of the limbs.

The figure of Gabriel contrasts strongly in style with that of the Virgin Mary. He seems relatively tall and lanky. His head is small and delicate, and his facial features are refined. His body has a subtle sway that is accented by the flowing lines of his drapery. Stateliness and sweetness characterize this courtly style; it will be carried forward into the Early Renaissance period in the **International Gothic** style.

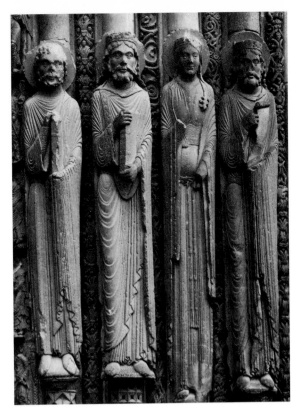

12–27 Jamb figures, west portals, Chartres Cathedral (Gothic, c. 1140–50)

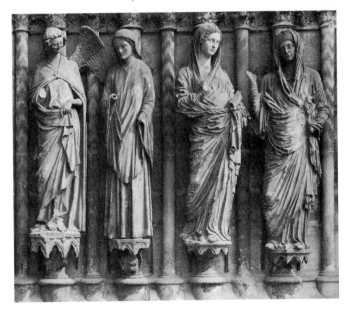

12–28 Jamb figures, west portals, Reims Cathedral (Gothic, begun 1210)

Yet Classicism will be the major style of the Renaissance, and in the Visitation group of the Reims portals we have a fascinating introduction to it. The weighty figures of Mary and Elizabeth are placed in a **contrapposto** stance. The folds of drapery articulate the movement of the bodies beneath with a realism that we have not seen since Classical times. Even the facial features and hair styles are reminiscent of Greek and Roman sculpture. Although we have linked the re-appearance of naturalism to the Gothic artist's increased awareness of nature, we must speculate that the sculptor of the Visitation group was looking directly to Classical statues for inspiration. The similarities are too strong to be coincidental. With his small and isolated attempt to revive Classicism, this unknown artist stands as a transitional figure between the spiritualism of the medieval world and the rationalism of the Renaissance.

13

The Renaissance

While Columbus was coasting along the shores of the New World in 1492, a 17-year-old Michelangelo Buonarroti was perfecting his craft of chiseling human features from blocks of marble. In 1564, the year that Shakespeare was born, Michelangelo died.

These are but two of the marker dates of the **Renaissance.** "Renaissance" is a French word meaning "rebirth," and the Renaissance in Europe was a period of significant historical, social, and economic events. The old feudal system that had organized Europe during the Middle Ages fell to a system of government based on independent city-states with powerful kings and princes at their helms. The economic face of Europe changed, aided by an expansion of trade and commerce with Eastern countries. The cultural base of Europe shifted from Gothic France to Italy. A plague wiped out the populations of entire cities in Europe and Asia. Speculation on the world beyond, which had so preoccupied

the medieval mind, was abandoned in favor of scientific observation of the world at hand. Although Copernicus proclaimed that the sun and not the earth was at the center of the solar system, humanity, and not heaven, became the center of all things.

The Renaissance spans roughly the fourteenth through the sixteenth centuries and is seen by some as the beginning of modern history. During this period we witness a revival of Classical themes in art and literature, a return to the realistic depiction of nature through keen observation, and the revitalization of the Greek philosophy of Humanism, in which human dignity, ideas, and capabilities are of central importance.

Although we can speak of a Renaissance period in England, France, and Spain, the two most significant areas of Europe for the arts were Italy in the South, and Flanders (present-day Belgium and the Netherlands) in the North. Given her Classical roots, Italy never quite succumbed to Gothicism, and readily introduced elements of Greek and Roman art into her works. But Flanders was steeped in the medieval tradition of Northern Europe and continued to concern herself with the spiritualism of the Gothic era, enriching it with a supreme realism. The difference in attitudes was summed up during the later Renaissance years by one of Italy's great artists, Michelangelo Buonarroti, not entirely without prejudice:

> Flemish painting will, generally speaking, please the devout better than any painting in Italy, which will never cause him to shed a tear, whereas that of Flanders will cause him to shed many; . . . In Flanders they paint with a view to external exactness or such things as may cheer you and of which you cannot speak ill, as for example saints and prophets. They paint stuffs and masonry, the green grass of the fields, the shadows of trees, and rivers and bridges.[*]

Thus the subject matter of Northern artists remained more consistently religious, although their manner of representation was

that of an exact, **trompe l'oeil** rendition of things of this world. They used the "trick-the-eye" technique to portray mystical religious phenomena in a realistic manner. The exactness of representation of which Michelangelo spoke originated in manuscript **illumination,** where complicated imagery was reduced to a minute scale. Since this imagery illustrated the writings, it was often laden with symbolic meaning. Symbolism was carried forth into **panel paintings,** where **iconography** was fused with a keen observation of nature.

FIFTEENTH-CENTURY NORTHERN PAINTING

Flemish Painting: From Page to Panel

As we saw in Chapter 12, a certain degree of naturalism appeared in the work of the Northern book illustrator during the Gothic period. The manuscript illuminator *illuminated* literary passages with visual imagery. As the art of manuscript illumination progressed, these thumbnail sketches were enlarged to fill greater portions of the manuscript page, eventually covering it entirely. As the text pages became less able to contain this imagery, the Northern Renaissance artist shifted to painting in tempera on wood panels.

THE LIMBOURG BROTHERS

One of the most dazzling texts available to illustrate this transfer from minute to more substantial imagery is *Les Très Riches Heures du Duc de Berry,* a Book of Hours illustrated by the Limbourg brothers (b. after 1385, d. by 1416) during the opening decades of the fifteenth century. Books of Hours were used by nobility as prayer books and included psalms and litanies to a variety of saints. As did most Books of Hours, *Les Très Riches Heures* contained calendar pages that illustrated domestic tasks and social events of the twelve months of the year. In *May* (Fig. 13–1), one of the calendar pages, we witness a parade of aristocratic

[*]Robert Goldwater and Marco Treves, eds., *Artists on Art* (New York: Pantheon Books, 1972), p. 68.

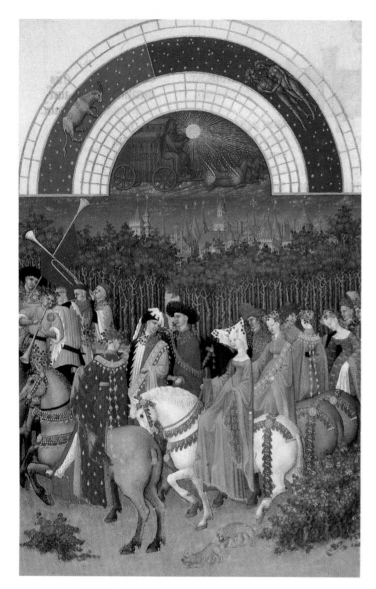

13–1 LIMBOURG BROTHERS
"May" from *Les Très Riches Heures du Duc de Berry* (1416)
Illumination. 8⅞ x 5⅜".
Musée Condé, Chantilly, France.

gentlemen and ladies who have come in their bejeweled costumes of pastel hues to celebrate the first day of May. Complete with glittering regalia and festive song, the entourage romps through a woodland clearing on carousel-like horses. In the background looms a spectacular castle complex, the chateau of Riom. The calendar pages of *Les Très Riches Heures* are rendered in the **International style,** a manner of painting common throughout Europe during the late fourteenth and early fifteenth centuries. This style is characterized by ornate costumes embellished with gold leaf and by

subject matter literally fit for a king, including courtly scenes and splendid processions. The refinement of technique and attention to detail in these calendar pages recall earlier manuscript illumination. These qualities, and a keen observation of the human response to the environment—or in this case the merrymaking—bring to mind Michelangelo's assessment of Northern painting as obsessed with representation of the real world through the painstaking rendition of its everyday objects and occurrences.

Although these calendar pages illustrated a holy book, the themes were secular. Renaissance artists tried to reconcile religious subjects with scenes and objects from everyday life, and Northern artists accomplished this by using symbolism. Artists would populate ordinary interiors with objects that might bear some spiritual significance. Many, if not most, of the commonplace items might be invested with a special religious meaning. You might ask how you, the casual observer, are supposed to decipher the cryptic meaning lurking behind an ordinary kettle. Chances are that you would be unable to do so without a specialized background. Yet you can enjoy the warm feeling of being invited into someone's home when you look at a Northern Renaissance interior, and be all the more enriched by the knowledge that there really is something more there than meets the eye.

ROBERT CAMPIN, THE MASTER OF FLÉMALLE

Attention to detail and the use of commonplace settings were carried forward in the soberly realistic religious figures painted by Robert Campin, the Master of Flémalle (c. 1378–1444). His *Merode Altarpiece* (Fig. 13–2) is a triptych whose three panels, from left to right, contain the kneeling donors of the altarpiece, an **Annunciation** scene with the Virgin Mary and the angel Gabriel, and Joseph, the foster father of Jesus, at work in his carpentry shop. The architectural setting is a typical contemporary Flemish dwelling. The donors kneel by the doorstep in a garden thick with grass and wildflowers. Although the door is ajar, it is not clear whether they are witnessing the

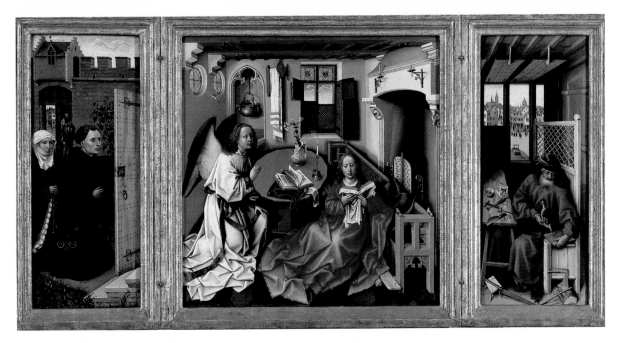

13–2 ROBERT CAMPIN *Merode Altarpiece: The Annunciation with Donors and St. Joseph* (c. 1425–28). Oil on wood. Center: 24¼ x 24⅞"; wings: 25⅜ x 10⅞" each.

The Metropolitan Museum of Art, The Cloisters, N.Y. Purchase.

event inside, or whether Campin has used the open door as a compositional device to lead the spectator's eye into the central panel of the triptych. In any event, we are visually and psychologically coaxed into viewing this most atypical Annunciation. Mary is depicted as a prim and proper middle-class Flemish woman surrounded by the trappings of a typical Flemish household, all rendered in exacting detail (Fig. 13–3). Just as the garden outdoors symbolizes the holiness and purity of the Virgin Mary, the items within also possess symbolic meaning. For example, the bronze kettle hanging in the Gothic niche on the back wall symbolizes the Virgin's body—it will be the immaculate container of the redeemer of the Christian world. More obvious symbols of her purity include the spotless room and the vase of lilies on the table. Rays of light stream toward the Virgin's ear, through which she was believed to have conceived the infant Jesus. A small child bearing a cross hovers in this "divine light." The wooden table situated between Mary and Gabriel and the room divider between Mary and Joseph guarantee that the light accomplished the deed. Typically Joseph is shown

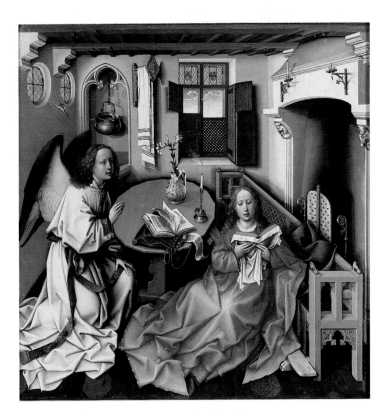

13–3 ROBERT CAMPIN *Merode Altarpiece,* center panel.

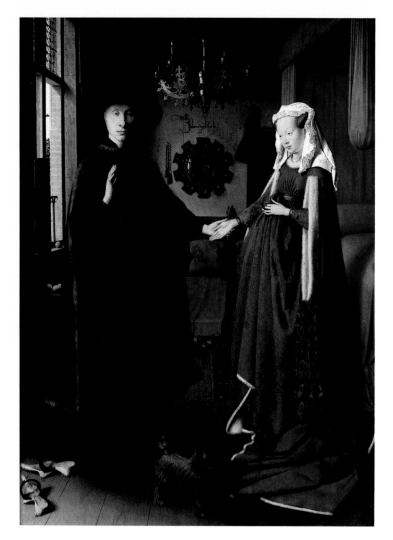

13–4 JAN VAN EYCK
Giovanni Arnolfini and His Bride (1434)
Oil on wood. 33 x 22½".

The National Gallery, London.

saintly and common folk; the facial types of the heavenly beings are as individual as the portraits of the donors. Although fifteenth-century viewers would have been aware of the symbolism and the sacredness of the event, they would have also been permitted to become "a part" of the scene, so to speak, and to react to it as if the people in the painting were their peers and just happened to find themselves in extraordinary circumstances.

JAN VAN EYCK

We might say that Campin "humanized" his Mary and Joseph in the *Merode Altarpiece.* As religious subjects became more secular in nature, and the figures themselves became rendered as "human," an interest in ordinary, secular subject matter sprang up. During the fifteenth century in Northern Europe we have the development of what is known as **genre painting,** painting that depicts ordinary people engaged in run-of-the-mill activities. These paintings make little or no reference to religion; they exist almost as art for art's sake. Yet they are no less devoid of symbolism.

Giovanni Arnolfini and His Bride (Fig. 13–4) was executed by one of the most prominent and significant Flemish painters of the fifteenth century, Jan van Eyck (c. 1395–1441). This unique double portrait was commissioned by an Italian businessman working in Bruges to serve as a kind of marriage contract, or record of the couple's taking of marriage vows in the presence of two witnesses. The significance of such a document—in this case a visual one—is emphasized by the art historian, Erwin Panofsky: According to Catholic dogma, the sacrament of matrimony is "immediately accomplished by the mutual consent of the persons to be married when this consent is expressed by words and actions" in the presence of two or three witnesses. Records of the marriage were necessary to avoid lawsuits in which "the validity of the marriage could be neither proved nor disproved for want of reliable witnesses."[*]

as a man too old to have been the biological father of Jesus, although Campin's depiction does not quite follow this tradition. He is gray, but by no means ancient. Jesus' earthly father is busy preparing mousetraps—one on the table and one on the windowsill—commonplace objects that symbolize the belief that Christ was the bait with which Satan would be trapped. The symbolism in the altarpiece presents a fascinating web for the observer to untangle and interpret. Yet it does not overpower the hardcore realism of the ordinary people and objects. With the exceptions of the slight inconsistency of size and the tilting of planes toward the viewer, Campin offers us a continuous realism that sweeps the three panels. There is no distinction between

[*] Erwin Panofsky, "Jan van Eyck's 'Arnolfini' Portrait," *Burlington Magazine*, LXIV (1934), 117–27.

Once again we see the Northern artist's striking realism and fidelity to detail offering us exact records of the facial features of the wedding couple. The figures of the two witnesses are reflected in the convex mirror behind the Arnolfinis. Believe it or not, they are Jan van Eyck and his wife, a fact corroborated by the inscription above the mirror: "Jan van Eyck was here." As in most Flemish paintings, the items scattered about are invested with symbolism relevant to the occasion. The furry dog in the foreground symbolizes fidelity, and the oranges on the windowsill may symbolize victory over death. Giovanni himself has kicked off his shoes out of respect for the holiness of the ground on which this sacrament takes place. Finally, the finial on the bedpost is an image of St. Margaret, the patroness of childbirth, and around her wooden waist is slung a small whisk broom, a symbol of domesticity. It would seem that Giovanni had his bride's career all mapped out. With Jan van Eyck,

Flemish painting reached the height of symbolic realism in both religious and secular subject matter. No one ever quite followed in his footsteps.

German Art

Northern Renaissance painting is not confined to the region of Flanders and, indeed, some of the most emotionally striking work of this period was created by German artists. Their work contains less symbolism and less detail than that of Flemish artists, but their message is often more powerful.

MATTHIAS GRÜNEWALD

These characteristics of German Renaissance art can clearly be seen in the *Isenheim Altarpiece* (Fig. 13–5) by Matthias Grünewald, (c. 1480–1528), painted more than three-quarters of a century after Jan van Eyck's Arnolfini portrait. The central panel of the German altarpiece is occupied by a

13–5 MATTHIAS GRÜNEWALD *The Crucifixion,* center panel of the *Isenheim Altarpiece* (exterior) (completed 1515). Oil on panel. 8'10" x 10'1".
Musée d'Unterlinden, Colmar.

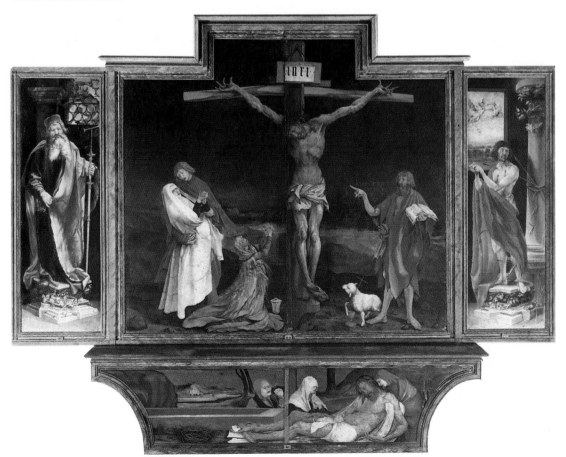

It's a Lemon . . . It's a Fig . . . It's Adam's Apple!

Just what on Earth (or in Eden) can that tiny, bulbous, shriveled thing cupped in Eve's right hand be? Over the years, art historians have asked, answered, and ignored the question of the identity of the forbidden fruit in Jan van Eyck's *Ghent Altarpiece* (Fig. 13–6).

In 1432, Jan van Eyck completed work on the *Ghent Altarpiece*, a sprawling polyptych that contains a total of twelve panels, some of which are painted on both sides. When the altarpiece is closed, two of the images visible are those of our first parents. Although we are not offered many props, we know that they are shown after the Fall because they are covering themselves in shame. Adam clutches the fig leaf, while Eve grasps the symbol of Satan's deed—the apple. Right? Wrong. A close-up of the fruit (Fig. 13–7) proves that this is no ordinary apple; and for those of us who would like to tie it into the fig-tree theory, figs are green and have a very smooth skin. Some art historians hypothesized the elusive fruit to be a pomegranate or a lemon, but neither one seems to fill the bill. So what is it?

Casting aside these dull possibilities, art historian James Snyder rolled up his sleeves and looked through, among other things, sixteenth-century herbals.* It

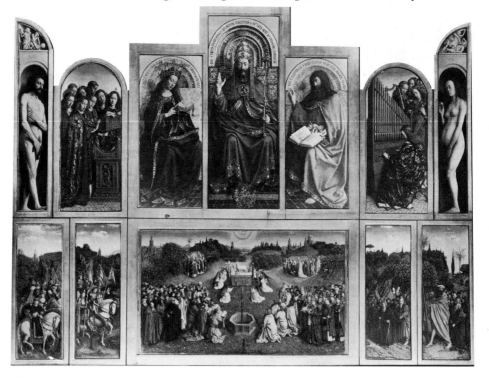

13–6 JAN VAN EYCK *Ghent Altarpiece* (completed 1432). Oil on panel. 11'3" x 14'5". St. Bavo, Ghent.

*James Snyder, "Jan Van Eyck and Adam's Apple," *The Art Bulletin*, 58, No. 4 (1976), 511–16.

was there that he discovered an unquestionable lookalike for Jan van Eyck's fruit, called, appropriately, an Adam's Apple (Fig. 13–8). A species of orange, the Adam's Apple had a thick, roughly textured pale yellow skin and tasted pretty much like a lemon. Since this curious citrus is so foreign and did not swell the fruit carts in the streets of Flanders, you might wonder how van Eyck managed to get his hands on one. Snyder speculates that he came across the fruit during his travels through Spain and Portugal, where the Adam's Apple grew, and just couldn't resist including it in the altarpiece. After all, an apple by any other name could not have been as appropriate.

By the way, did you know that the projection of the larynx in a man's throat, popularly called the Adam's apple, was so named because it was believed that Adam choked on the fruit Eve offered him.

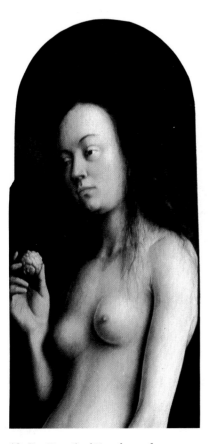

13–7 Detail of Eve from the *Ghent Altarpiece* (right panel).

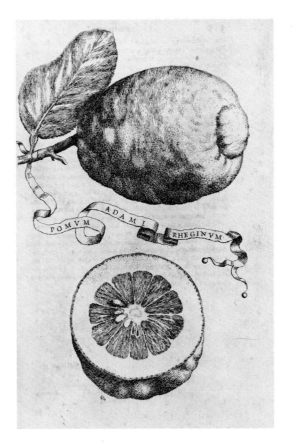

13–8 "Adam's Apple" from an herbal published in Rome in 1646 by Giovanni Battista Ferrari.

Rare Book and Special Collections Division, Library of Congress, Washington, D.C.

tormented representation of the Crucifixion, one of the most dramatic in the history of art. The dead Christ is flanked by his mother, Mary, the apostle John, and Mary Magdalene to the left, and John the Baptist and a sacrificial lamb to the right. These figures exhibit a bodily tension in their arched backs, clenched hands, and rigidly pointing fingers, creating a melodramatic, anxious tone. The crucified Christ is shown with a deadly pallor. His skin appears cancerous, and his chest is sunken with his last breath. His gnarled hands reach painfully upward, stretching for salvation from the blackened sky. We do not find such impassioned portrayals outside Germany during the Renaissance.

ALBRECHT DÜRER

We appropriately close our discussion of Northern Renaissance art with the Italianate master, Albrecht Dürer (1471–1528). His passion for the Classical in art stimulated extensive travel in Italy, where he copied the works of the Italian masters, who were also enthralled with the Classical style. The development of the printing press made it possible for him to disseminate the works of the Italian masters throughout Northern Europe.

Dürer's *Adam and Eve* (Fig. 13–9) conveys his admiration for the Classical style. In contrast to figures rendered by other German and Flemish artists, Dürer emphasized the idealized beauty of the human body. His Adam and Eve are not everyday figures of the sort Campin depicted in his Virgin Mary. Instead, the images arise from Greek and Roman prototypes. Adam's young muscular body could have been drawn from a live model or from Classical statuary. Eve represents a standard of beauty different from that of other Northern artists. The familiar slight build and refined facial features have given way to a more substantial and well-rounded woman. She is reminiscent of a

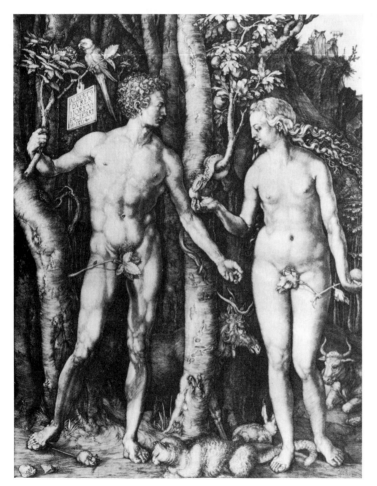

13–9 ALBRECHT DÜRER
Adam and Eve (1504)
Engraving, 4th state. 9⅞ x 7⅝".
The Metropolitan Museum of Art, N.Y. Fletcher Fund, 1919.

fifth-century B.C. Venus in her features and her pose. The symbols associated with the event—the Tree of Knowledge and the Serpent (Satan)—play a secondary role. Dürer has chosen to emphasize the profound beauty of the human body. Instead of focusing on the consequences of the event as an admonition against sin, we delight in the couple's beauty for its own sake. Indeed, this notion is central to the art of Renaissance Italy.

THE RENAISSANCE IN ITALY

The Early Renaissance

Not only was there a marked difference between Northern and Italian Renaissance art, but there were notable differences in the art of various sections of Italy itself. Florence and Rome witnessed a resurgence of Classicism as Roman ruins were excavated in ancient sites, hillsides, and people's backyards. In Siena, on the other hand, the International style lingered, and in Venice a Byzantine influence remained strong. There may be several reasons for this diversity, but the most obvious is that of geography. For example, while the Roman artist's stylistic roads led to that ancient city, the trade routes in the northeast brought an Eastern influence to works of art and architecture.

The Italian Renaissance took root and flourished most successfully in Florence. The development of this city's painting, sculpture, and architecture parallels that of the Renaissance in all of Italy. Throughout the Renaissance, as Florence went, so went the country.

Cimabue and Giotto

Some of the earliest changes from a medieval to a Classical style can be perceived in the painting of Florence during the late thirteenth and early fourteenth centuries, the prime exponents being Cimabue and Giotto. So significant were these artists that Dante Alighieri, the fourteenth-century poet, mentioned both of them in his *Purgatory* of *The Divine Comedy*:

> O gifted men, vainglorious for first place,
> how short a time the laurel crown stays green
> unless the age that follows lacks all grace!
> Once Cimabue thought to hold the field
> in painting, and now Giotto has the cry
> so that the other's fame, grown dim, must yield.*

Who were these artists? Apparently they were rivals, although Cimabue (*c.* 1240–*c.* 1302) was older than Giotto (*c.* 1276–*c.* 1337) and probably had a formative influence on the latter who would ultimately steal the limelight. The similarities and differences between the works of these two artists can be seen in two tempera paintings on wood panels depicting the Madonna and Child enthroned.

*Dante Alighieri, *The Purgatorio*, trans. John Ciardi. Copyright © 1957, 1959, 1960, by John Ciardi. Reprinted by agreement with New American Library, New York, N.Y.

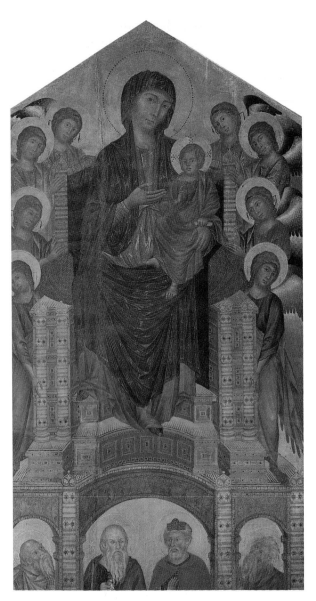

13–10 CIMABUE
Madonna Enthroned (c. 1280–90).
Tempera on wood panel. 12'7½" x 7'4".
Uffizi Gallery, Florence.

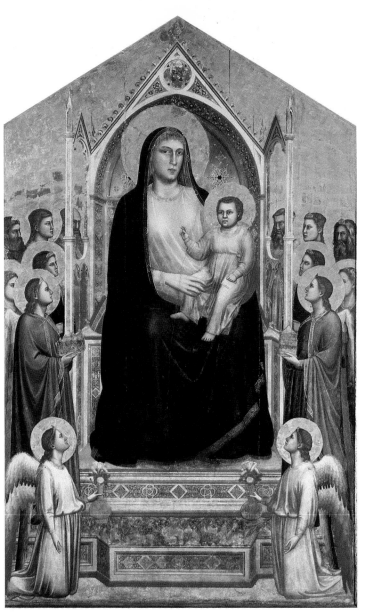

13–11 GIOTTO
Madonna Enthroned (c. 1310)
Tempera on wood panel. 10'8" x 6'8".
Uffizi Gallery, Florence.

A curious combination of Late Gothic and Early Renaissance styles betrays Cimabue's composition (Fig. 13–10) as a transitional work. The massive throne of the Madonna is Roman in inspiration, with column and arch forms embellished with **intarsia.** The Madonna has a corporeal presence that sets her apart from "floating" medieval figures, but the effect is compromised by the unsureness with which she is placed on the throne. She does not sit solidly; her limbs are not firmly "planted." Rather, the legs resemble the "hinged" appendages of Romanesque figures. This characteristic placement of the knees causes the drapery to fall in predictable folds—concentric arcs reminiscent of a more stylized technique. The angels supporting the throne rise parallel to it, their glances forming an abstract zig-zag pattern. The resultant lyrical arabesque, the flickering color patterns of the wings, and the lineup of unobstructed heads recall the Byzantine tradition, particularly the Ravenna mosaics (see Figs. 12–4 and 12–6).

Giotto's rendition of the same theme (Fig. 13–11) offers some dramatic differences. The overall impression of the *Madonna Enthroned* is one of stability and corporeality instead of instability and weightlessness. Giotto's Madonna sits firmly on her throne, the outlines of her body and drapery forming a solid triangular shape. Although the throne is lighter in appearance than Cimabue's Roman throne—and is, in fact, Gothic, with pointed arches—it too seems more firmly planted on the earth. Giotto's genius is also evident in his conception of the forms in three-dimensional space. They not only have height and width, as do those of Cimabue, but they also have depth and mass. This is particularly noticeable in the treatment of the angels. Their location in space is from front to rear, rather than atop one another as in Cimabue's composition. The halos of the foreground angels obscure the faces of the background attendants, since they have mass and occupy space.

Despite these discrepancies between the two works, they do have elements in common. Both artists retain the Gothic, otherworldly gold-leaf background. Both advance their craft through the early use of chiaroscuro. Yet Giotto's composition impresses us as more naturalistic: Giotto appears to have observed *nature*, or reality, more carefully, and he is better able to communicate the impression of that reality on a two-dimensional surface. This naturalism will become the hallmark of the Renaissance style in Italy.

The Renaissance Begins, and So Does the Competition

With Cimabue and Giotto we witness strides toward an art that was very different from that of the Middle Ages. But artists, like all of us, must walk before they can run, and those very "strides" that express such a stylistic advance from the "cut-out dolls" of the Ravenna mosaics and the "hinged marionettes" of the Romanesque era will look primitive in another half century. Because the art of Cimabue and Giotto contains vestiges of Gothicism, their style is often termed proto-Renaissance. But at the dawn of the fifteenth century in Florence, the Early Renaissance began—with a competition.

Imagine workshops and artists abuzz with news of one of the hottest projects in memory up for grabs. Think of one of the most prestigious architectural sites in Florence. Savor the possibility of being known as *the* artist who had cast, in gleaming bronze, the massive doors of the Baptistery of Florence. This landmark competition was held in 1401. There were countless entries but only two panels have come down to us. The artists had been given a scene from the Old Testament to translate into bronze—the sacrifice of Isaac by his father Abraham. There were specifications, naturally, but the most obvious is the **quatrefoil** format. Within this space, a certain cast of characters was mandated, including Abraham, Isaac, an angel, and two "extras" who appear to have little or nothing to do with the scene. The event takes place out of doors, where Abraham has lured his son to the sacrificial altar on the pretense of performing a ritual animal sacrifice. When they arrive on the scene, Abraham, in an attempt to prove his love and loyalty to God, turns the blade to Isaac's throat. At this moment, an angel flies in to prevent Abraham from completing the deed.

FILIPPO BRUNELLESCHI AND LORENZO GHIBERTI

The two extant panels were executed by Filippo Brunelleschi (c. 1377–1446), and Lorenzo Ghiberti (1378–1455). The obligatory

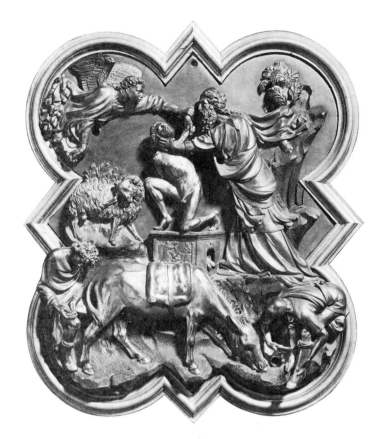

13–12 FILIPPO BRUNELLESCHI
Sacrifice of Isaac
(1401–02) Gilt bronze. 21 x 17½".
Bargello, Florence.

13–13 LORENZO GHIBERTI
Sacrifice of Isaac
(1401–02). Gilt bronze, 21 x 17½".
Bargello, Florence.

characters, bushes, animals, and altar are present in both, but the placement of these elements, the artistic style, and the emotional energy within each work differ considerably. Brunelleschi's panel (Fig. 13–12) is divided into sections by strong vertical and horizontal elements, each section filled with objects and figures. In contrast to the rigidity of the format, a ferocious energy bordering on violence pervades the composition. Isaac's neck and body are distorted by his father's grasping fist, and Abraham himself lunges viciously toward his son's throat with a knife. With similar passion, an angel flies in from the left to grasp Abraham's arm. But this intense drama and seemingly boundless energy are weakened by the introduction of ancillary figures who are given more prominence than the scene requires. The donkey, for example, detracts from Isaac's plight by being placed broadside and practically dead center. Also, one is struck by the staccato movement throughout. Although this choppiness complements the anxiety in the work, it compromises the successful flow of space and tires the eye.

In Lorenzo Ghiberti's panel (Fig. 13–13), the space is divided along a diagonal rock formation that separates the main characters from the lesser ones. Space flows along this diagonal, exposing the figural group of Abraham and Isaac and embracing the shepherd boys and their donkey. The boys and donkey are appropriately subordinated to the main characters but not sidestepped stylistically. Abraham's lower body parallels the rock formation and then lunges expressively away from it in a dynamic counterthrust. Isaac, in turn, pulls firmly away from his father's forward motion. The forms move rhythmically together in a continuous flow of space. Although Ghiberti's emotion is not quite as intense as Brunelleschi's, and his portrayal of the sacrifice is not quite as graphic, the impact of Ghiberti's narrative is as strong.

It is interesting to note the inclusion of Classicizing elements in both panels. Brunelleschi, in one of his peasants, adapted the Classical sculpture of a boy removing a thorn from his foot, and Ghiberti rendered

his Isaac in the manner of the fifth-century sculptor. Isaac's torso, in fact, may be the first nude in this style since Classical times.

Oh, yes—Ghiberti won the competition and Brunelleschi went home with his chisel. The latter never devoted himself to sculpture again, but went on to become the first great Renaissance architect. Ghiberti himself was not particularly modest about his triumph:

> To me was conceded the palm of victory by all the experts and by all . . . who had competed with me. To me the honor was conceded universally and with no exception. To all it seemed that I had at that time surpassed the others without exception, as was recognized by a great council and an investigation of learned men . . . highly skilled from the painters and sculptors of gold, silver, and marble.*

DONATELLO

If Brunelleschi and Ghiberti were among the last sculptors to harbor vestiges of the International style, Donatello (c. 1386–1466), the Florentine master, was surely among the first to create sculptures that combined Classicism with realism. In his *David* (Fig. 13–14), the first life-size nude statue since Classical times, Donatello struck a balance between the two styles by presenting a very real image of an Italian peasant boy in the guise of a Classical nude figure. David, destined to be the second king of Israel, slew the Philistine giant Goliath with a stone and a sling. Even though Donatello was inspired by Classical statuary, notice that he did not choose a Greek youth in his prime as a prototype for his David. Instead, he chose a barely developed adolescent boy, his hair still unclipped and his arms flaccid for lack of manly musculature. After decapitating Goliath, whose head lies at David's feet, his sword rests at his side—almost too heavy for him to handle. Can such a youth have accomplished such a forbidding task? Herein lies the power of Donatello's statement. We are amazed, from the appearance of this young

13–14 DONATELLO
David (1408). Bronze. Height: 5'2".
Bargello, Florence.

boy, that he could have done such a deed, much as David himself seems incredulous as he glances down toward his body. What David lacks in stature he has made up for in intellect, faith, and courage. His fate was in his own hands—one of the ideals of the Renaissance man.

MASACCIO

The Early Renaissance painters shared most of the stylistic concerns of the sculptors. However, included in their attempts at realism was the added difficulty of projecting a naturalistic sense of three-dimensional space on a two-dimensional surface. In addition to copying from nature and Clas-

*E. G. Holt, ed., *Literary Sources of Art History* (Princeton, N.J.: Princeton University Press, 1947), pp. 87–88.

13–15 MASACCIO
Holy Trinity (c. 1425). Fresco.
Santa Maria Novella, Florence.

sical models, these painters developed rules of perspective to depict images in the round on flat walls, panels, and canvases. One of the pioneers in developing systematic laws of one-point **linear perspective** was Brunelleschi, of Baptistery Doors near-fame.

Masaccio's *Holy Trinity* (Fig. 13–15) uses these laws of perspective. In this chapel fresco, Masaccio (1401–1428) creates the illusion of an extension of the architectural space of the church by painting a **barrel-vaulted** "chapel" housing a variety of holy and common figures. God the Father supports the cross that bears his crucified son

while the Virgin Mary and the apostle John attend. Outside the columns and pilasters of the realistic, Roman-inspired chapel kneel the donors, who are invited to observe the scene. Aside from the trompe l'oeil rendition of the architecture, the realism in the fresco is enhanced by the donors, who are given importance equal to that of the "principal" characters, similar to Campin's treatment of the donors in the *Merode Altarpiece* (Fig. 13–2). The architecture appears to extend our physical space, and the donors appear as extensions of ourselves.

Masaccio's *Madonna Enthroned* (Fig. 13–16) is the centerpiece of a multipaneled work

13–16 MASACCIO
Enthroned Madonna and Child, center panel of a polyptych from Sta. Maria del Carmini, Pisa (1426) Panel painting, 53¼ x 23¾".
National Gallery, London.

that has long since been sundered. The placement of the Madonna and child is similar to that in earlier works by Cimabue (Fig. 13–10) and Giotto (Fig. 13–11), and the elaborate throne offers a similar note of traditional formality. But there are notable differences in the relative secularism and realism of Masaccio's version. First, there are fewer adoring angelic attendants, and those that kneel before the Virgin Mary serenade her on the lute. The Madonna and child are also very different. The child is more child-like, both in bodily proportions and in behavior. In the Masaccio work he is active—leaning forward and eating grapes—not bestowing a blessing. The face of the Masaccio Madonna is human and shows complex emotions. Perhaps she recognizes the symbolism of the eating of the grapes as prophetic of the Passion and the Eucharist—of her son's ultimate sad fate in this world. Massacio's Madonna is presented not only in her role as queen of heaven; she is foremost a mother, gently holding her child.

FILIPPO BRUNELLESCHI

The revival of Classicism was even more marked in the architecture of the Renaissance. Some twenty years after Brunelleschi's unsuccessful bid for the Baptistery Doors project in Florence, he was commissioned to cover the crossing square of the cathedral of Florence with a dome. Interestingly, Ghiberti worked with him at the outset but soon bowed out, and Brunelleschi was left to complete the work alone. It was quite an engineering feat, involving a double-shell dome constructed around twenty-four ribs (Fig. 13–17). Eight of these ribs rise upward to a crowning lantern on the exterior of the dome. You might wonder why Brunelleschi, whose architectural models were essentially Classical, would have constructed a somewhat pointed dome reminiscent of the Middle Ages. The fact is that the architect might have preferred a more rounded or hemispherical structure, but the engineering problem required an ogival, or pointed, section, which is inherently more

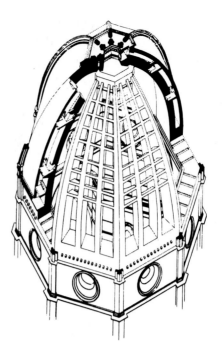

13–17 FILIPPO BRUNELLESCHI
Construction of the Cathedral Dome, Florence (1420–36)

stable. The dome was a compromise between a somewhat Classical style and traditional Gothic building principles.

Although the cathedral dome is Brunelleschi's greatest engineering achievement, his Ospedale degli Innocenti (Hospital for Foundlings) in Florence (Fig. 13–18) is more characteristic of his architectural style. The hospital stands as another example of Brunelleschi's commitment to a highly rational expression of Classical elements. The sweeping horizontal façade is marked by a procession of round arches and slender Corinthian columns framed by substantial pilasters which visually support the simple flat entablature. The rhythm is repeated on the second floor, where a series of windows topped by pediments serve as counterpoints to the archways beneath. Although Brunelleschi was influenced by Romanesque architecture, the utter logic of the foundling hospital links it more clearly to Classical architecture than to the more recent Medieval period. Brunelleschi's clear restatement of Classical elements would influence architecture for decades to come.

13–18 FILIPPO BRUNELLESCHI Hospital for Foundlings, Florence (1421–24)

13–19 ANDREA DEL VERROCCHIO
David (c. 1470). Bronze. Height: 49⅝".
Bargello, Florence.

Renaissance Art at Midcentury and Beyond

ANDREA DEL VERROCCHIO

As we progress into the middle of the fifteenth century, the most important and innovative sculptor is Andrea del Verrocchio (1435–1488). An extremely versatile artist who was trained as a goldsmith, Verrocchio ran an active shop that attracted many young artists, including Leonardo da Vinci. We see in Verrocchio's bronze *David* (Fig. 13–19), commissioned by the Medici family, a strong contrast to Donatello's handling of the same subject. The Medici also owned the Donatello *David*, and Verrocchio probably wanted to outshine his predecessor. Although both artists chose to represent David as an adolescent, Verrocchio's hero appears somewhat older and exudes pride and self-confidence rather than a dreamy gaze of disbelief. Whereas Donatello reconciled realistic elements with an almost idealized, Classically inspired torso, Verrocchio's goal was supreme realism in minute details, including orientalizing motifs on the boy's doublet that would have made him look like a Middle Easterner. The sculptures differ considerably also in terms of technique. Donatello's *David* is essentially a closed-form sculpture with objects and limbs centered around an **S-curve** stance; Verroc-

chio's sculpture is more open, as is evidenced by the bared sword and elbow jutting away from the central core. Donatello's graceful pose has been replaced, in the Verrocchio, by a jaunty **contrapposto** that enhances David's image of self-confidence.

PIERO DELLA FRANCESCA
PIERO DELLA FRANCESCA

The artists of the Renaissance, along with the philosophers and scientists, tended to share the sense of the universe as an orderly place that was governed by natural law and capable of being expressed in mathematical and geometric terms. Piero della Francesca (c. 1420–1492) was trained in mathematics and geometry and is credited with writing the first theoretical treatise on the construction of systematic perspective in art. Piero's art, like his scientific thought, was based on an intensely rational construction of forms and space.

His *Resurrection* fresco (Fig. 13–20) for the town hall of Borgo San Sepolcro reveals the artist's obsessions with order and geometry.

Christ ascends vertical and triumphant, like a monumental column, above the "entablature" of his tomb, which serves visually as the pedestal of a statue. Christ and the other figures are constructed from the cones, cylinders, spheres, and rectangular solids that define the theoretical world of the artist. There is a tendency here toward the simplification of forms—not only of people, but also of natural features such as trees and hills. All the figures in the painting are contained within a triangle—what would become a major compositional device in Renaissance painting—with Christ at the apex. The sleeping figures and the marble sarcophagus provide a strong and stable base for the upper two-thirds of the composition. Regimented trees rise in procession behind Christ, as they never do when nature asserts its random jests; Piero's trees are swept back by the rigid cultivation of scientific perspective. They crown, as ordered, just above the crests of rounded hills. The artist of the Renaissance was not only in awe of nature, but also commanded it fully.

13–20 PIERO DELLA FRANCESCA
Resurrection (c. Late 1450s).
Fresco. Town Hall, San Sepolcro.

In *The Dead Christ* (Fig. 13–21) by Andrea Mantegna (1431–1506), naturalism is taken to the limit through a daring use of perspective and **foreshortening.** The use of foreshortening is based upon the perceptual phenomenon that objects and figures diminish in size as they recede into space. The startling realism in Mantegna's painting is a result of the poignant rendition of the savior of humanity as a pitiful cadaver whose filthy soles reveal nail holes long drained of blood. The harshness of the cold stone slab on which Jesus lies, the icy folds of drapery that cover his legs, the sunken chest, and funereal chiaroscuro evoke an intensity of emotion perhaps not seen since the Crucifixion of Grünewald's *Isenheim Altarpiece* (Fig. 13–5).

During the latter years of the fifteenth century, we come upon an artistic personality whose style is somewhat in opposition to the prevailing trends. Since the time of Giotto, painters had relied on chiaroscuro, or the contrast of light and shade to create a sense of roundness and mass in their figures and objects, in an effort to render a realistic impression of three-dimensional forms in space. Sandro Botticelli (c. 1444–1510), however, constructed his compositions with line instead of tonal contrasts. His art relied primarily on drawing. Yet when it came to subject matter, his heart lay with his Renaissance peers, for above all else, he loved to paint mythological themes. Along with other artists and men of letters, his mania for these subjects was

13–21 ANDREA MANTEGNA *The Dead Christ* (c. 1466) Oil on canvas. 26¾ x 37⅞".
Brera Gallery, Milan.

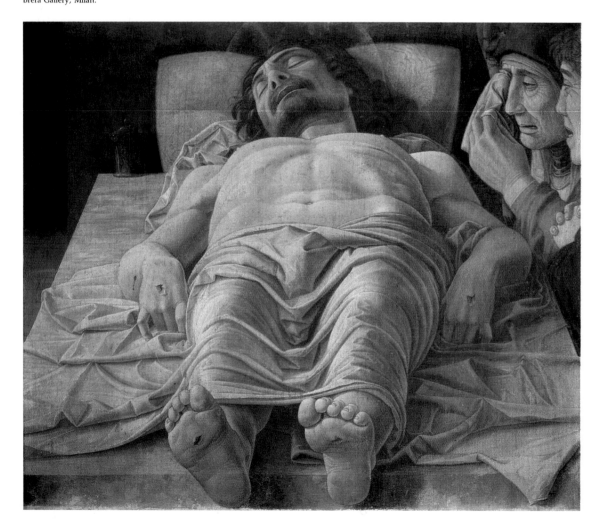

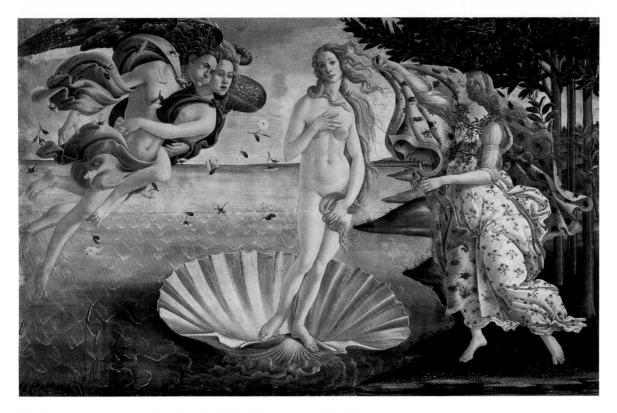

13–22 SANDRO BOTTICELLI *The Birth of Venus* (c. 1482) Oil on canvas. 5'8⅞" x 9'1⅞".

Uffizi Gallery, Florence.

fed and perhaps cultivated by the Medici prince Lorenzo the Magnificent, who surrounded himself with Neoplatonists, or those who followed the philosophy of Plato.

One of Botticelli's most famous paintings is *The Birth of Venus* (Fig. 13–22), or, as some art historians would have it, "Venus on the Half-shell." The model for this Venus was Simonetta Vespucci, a cousin of Amerigo Vespucci, the navigator and explorer after whom America was named. The composition presents Venus, born of the foam of the sea, floating to the shores of her sacred island on a large scallop shell, aided in its drifting by the sweet breaths of entwined zephyrs. The nymph Pomona awaits her with an ornate mantle and is herself dressed in a billowing, flowered gown. Botticelli's interest in Classicism is evident also in his choice of models for the Venus. She is a direct adaptation of an antique sculpture of this goddess in the collection of the Medici family. Notice how the graceful movement in the composition is evoked through a combination of different lines. A firm horizon line and regimented verticals in the trees contrast with the subtle curves and vigorous arabesques that caress the mythological figures. The line moves from image to image and then doubles back to lead your eye once again. Shading is confined to areas within the harsh, linear sculptural contours of the figures. Botticelli's genius lay in his ability to utilize the differing qualities of line to his advantage; with this formal element he created the most delicate of compositions.

LEON BATTISTA ALBERTI

Some of the purest examples of Renaissance Classicism lie in the buildings designed by Leon Battista Alberti (1404–1472). Alberti was among the first to study treatises written by Roman architects, the most famous of whom was Vitruvius, and he combined his Classical knowledge with innovative ideas in his grand opus, *Ten Books on Architecture*. One of his most visually satisfying buildings in the great Classical tradition is the Palazzo Rucellai (Fig. 13–23) in Florence. The building is divided by prominent horizontal string courses into three stories, crowned by a heavy cornice. Within each story are apertures enframed by pilasters

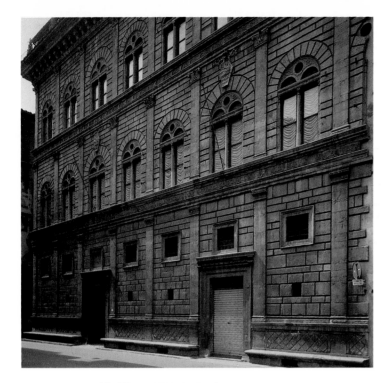

13–23 LEON BATTISTA ALBERTI
Palazzo Rucellai, Florence (1446–51)

of different orders. The first-floor pilasters are of the Tuscan order, which resembles the Doric order in its simplicity; the second story uses a composite capital of volutes and acanthus leaves, seen in the Ionic and Corinthian orders respectively; and the top-floor pilasters are crowned by capitals of the Corinthian order. As we saw in the Colosseum (see Fig. 11–23), this combination of orders gives an impression of increasing lightness as we rise from the lower to the upper stories. This effect is enhanced in Alberti's building by a variation in the masonry. Although the texture remains the same, the upper stories are faced with lighter-appearing smaller blocks in greater numbers. The palazzo's design, with its clear articulation of parts, overall balance of forms, and rhythmic placement of elements in horizontals across the façade, shows a clear understanding of Classical design adapted successfully to the contemporary nobleman's needs.

The High Renaissance

Demanding patrons, the high cost of materials, and a lack of money have a way of fostering crabbiness among artists as well as butchers, bakers, and candlestick makers. It can be difficult to concentrate on our endeavors when others are mistreating us.

Sometime in 1542, Pope Julius II and Michelangelo Buonarroti were in conflict, with the artist bearing the brunt of the pontiff's behavior. As if backing out of his tomb commission and refusing to pay for materials were not enough, the Pope laid the last straw by having Michelangelo thrown out of the Vatican by one of his attendants on one occasion when the artist sought to redress his grievances. Was that any way to treat a genius? The artist thought not, as he complained in a letter to one of Julius's underlings:

> . . . a man paints with his brains and not with his hands, and if he cannot have his brains clear he will come to grief. Therefore I shall be able to do nothing well until justice has been done me. . . . As soon as the Pope [carries] out his obligations towards me I [will] return, otherwise he need never expect to see me again.
>
> All the disagreements that arose between Pope Julius and myself were due to the jealousy of Bramante and of Raffaelo da Urbino; it was because of them that he did not proceed with the tomb, . . . and they brought this about in order that I might thereby be ruined. Yet Raffaello was quite right to be jealous of me, for all he knew of art he learned from me.[*]

Although this is only one side of the story, and Michelangelo might also have been somewhat jealous of Raffaelo (Raphael), this passage affords us a glimpse of the personality of an artist of the High Renaissance. He was independent yet indispensable—arrogant, aggressive, and competitive.

From the second half of the fifteenth century onward, a refinement of the stylistic principles and techniques associated with the Renaissance can be observed. Most of this significant, progressive work was being done in Florence, where the Medici family played an important role in supporting the

[*]Robert Goldwater and Marco Treves, eds., *Artists on Art* (New York: Pantheon Books, 1972), p. 63.

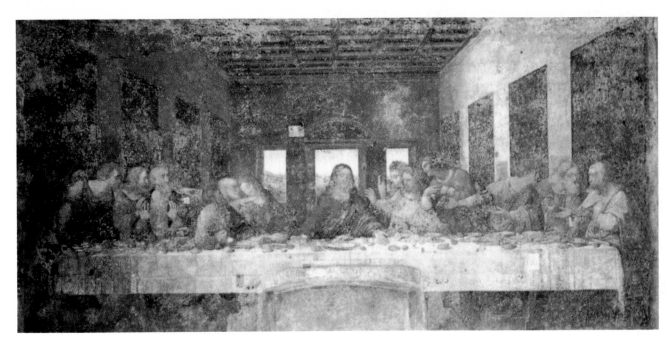

13–24 LEONARDO DA VINCI *The Last Supper* (1495–98). Fresco. 13'10" x 29'7½".

Santa Maria delle Grazie, Milan.

arts. At the close of the decade, however, Rome was the place to be, as the popes began to assume the grand role of patron. The three artists who were in most demand—the great masters of the High Renaissance in Italy—were Leonardo da Vinci, a painter, scientist, inventor, and musician; Raphael, the Classical painter thought to have rivaled the works of the ancients; and Michelangelo, the painter, sculptor, architect, poet, and enfant terrible. Donato Bramante is deemed to have made the most significant architectural contributions of this period. These are the stars of the Renaissance, the artistic descendants of the Giottos, Donatellos, and Albertis, who, because of their earlier place in the historical sequence of artistic development, are sometimes portrayed as but steppingstones to the greatness of the sixteenth-century artists, rather than as masters in their own right.

LEONARDO DA VINCI

If the Italians of the High Renaissance could have nominated a counterpart to the Classical Greek's "four-square man," it most assuredly would have been Leonardo da Vinci (1452–1519). His capabilities in engineering, the natural sciences, music, and the arts seemed unlimited, as he excelled in everything from solving drainage problems (a project he undertook in France just before his death), to designing prototypes for airplanes and submarines, to creating some of the most memorable Renaissance paintings.

The Last Supper (Fig. 13–24), a fresco painting executed for the dining hall of a Milan monastery, stands as one of Leonardo's greatest works. The condition of the work is poor, because of Leonardo's experimental fresco technique—although the steaming of pasta for centuries on the other side of the wall may also have played a role. Nonetheless, we can still observe the Renaissance ideals of Classicism, humanism, and technical perfection, now coming to full fruition. The composition is organized through the use of one-point linear perspective. Solid volumes are constructed from a masterful contrast of light and shadow. A hairline balance is struck between emotion and restraint.

The viewer is first attracted to the central triangular form of Jesus sitting among his apostles by **orthogonals** that converge at his head. His figure is silhouetted against a triple window that symbolizes the Holy Trinity and pierces the otherwise dark back wall.

Leonardo da Vinci

ON IMITATION: I tell painters never to imitate other painters' manners because, by so doing, they will be called grandsons, and not sons of nature, as far as art is concerned. For, as natural things are so plentiful, one must rather have recourse to nature herself than to the masters who learned from nature.

ON THE NEED TO KNOW ANATOMY: It is a necessary thing for the painter, in order to be able to fashion the limbs correctly in the positions and actions which they can represent in the nude, to know the anatomy of the sinews, bones, muscles, and tendons in order to know, in the various different movements and impulses, which sinew or muscle is the cause of each movement, and to make only these prominent and thickened, and not the others all over the limb, as do many who, in order to appear great draftsmen, make their nudes wooden and without grace, so that it seems rather as if you were looking at a sack of nuts than a human form or at a bundle of radishes rather than the muscles of nudes.

ON REPRESENTATIONAL ART: That painting is the most praiseworthy which is most like the thing represented.

ON ARTISTIC "MODESTY" (*from a letter of application for a job*): . . . I can execute sculpture in marble, bronze, or clay, and also painting, in which my work will stand comparison with that of anyone else, whoever he may be.

One's attention is held at this center point by the Christ-figure's isolation that results from the leaning away of the apostles. Leonardo has chosen to depict the moment when Jesus says, "One of you will betray me." The apostles reflexively fall back at this shocking statement, gesturing expressively, denying personal responsibility, and asking, "Who can this be?" The guilty one, of course, is Judas, who is shown clutching a bag of silver pieces at Jesus' left, with his elbow on the table. The two groups of apostles, who sweep dramatically away from Jesus along a horizontal line, are subdivided into four smaller groups of three that tend to moderate the rush of the eye out from the center. The viewer's eye is wafted outward and then coaxed back inward through the "parenthetic" poses of the apostles at either end. Leonardo's use of strict rules of perspective, and his graceful balance of motion and restraint, underscore

the artistic philosophy and style of the Renaissance.

Although Leonardo does not allow excessive emotion in his *Last Supper*, the reactions of the apostles seem genuinely human. There is probably no better example of Humanism in sixteenth-century Renaissance art, however, than the subject of Virgin and Child. One of the most significant paintings to capture this spirit is the *Madonna of the Rocks* (Fig. 13–25) by Leonardo. Notice all that has changed in the representation of this figural group during the course of the preceding century. Mary is no longer portrayed as the queen of heaven, enthroned and surrounded by angels in a nondescript golden environment, but rather as a mother in the midst of the world—in this case a grotto embellished with luscious vegetation and beautiful rock formations. She has been given a human portrayal. Compositionally, she forms the apex of a rather broad, stable

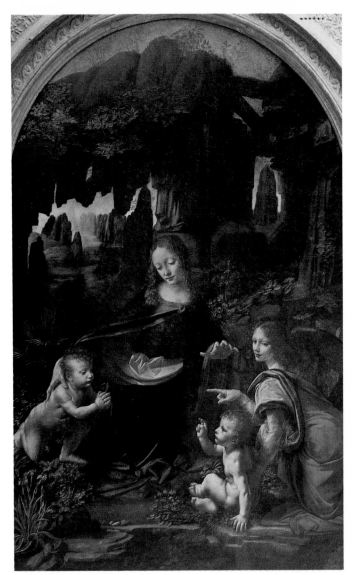

13–25 LEONARDO DA VINCI
Madonna of the Rocks (c. 1483). Oil on panel,
transferred to canvas. 78½ x 48".
Louvre Museum, Paris

triangle, extending her arms toward the in-
fants Jesus and John the Baptist. Her right
arm embraces John, but she is unable to
reach the child Jesus because of the interfer-
ing hand of an angel who sits near him.
Mary's inability to complete her embrace
may symbolize her ultimate inability to pro-
tect him from his fate. Yet the tender human
aspect of the scene stands independent of
its iconography.

Raphael Sanzio

A younger artist who assimilated the les-
sons offered by Leonardo, especially on the
Humanistic portrayal of the Madonna, was
Raphael Sanzio (1483–1520). As a matter of
fact, Michelangelo was not far off base in

his accusation that Raphael copied from
him, for the younger artist freely adopted
whatever suited his purposes. Raphael truly
shone in his ability to combine the tech-
niques of other masters with an almost in-
stinctive feel for Classical art. He rendered
countless canvases depicting the Madonna
and Child along the lines of Leonardo's *Ma-
donna of the Rocks*. Raphael was also sought
after as a muralist. Some of his most impres-
sive Classical compositions, in fact, were
executed for the papal apartments in the
Vatican. The commission, of course, came
from Pope Julius and, to add fuel to Michel-
angelo's fire, was executed at the same time
Michelangelo was at work on the Sistine
Chapel ceiling. For the Stanza della Segna-
tura, the room in which the highest papal

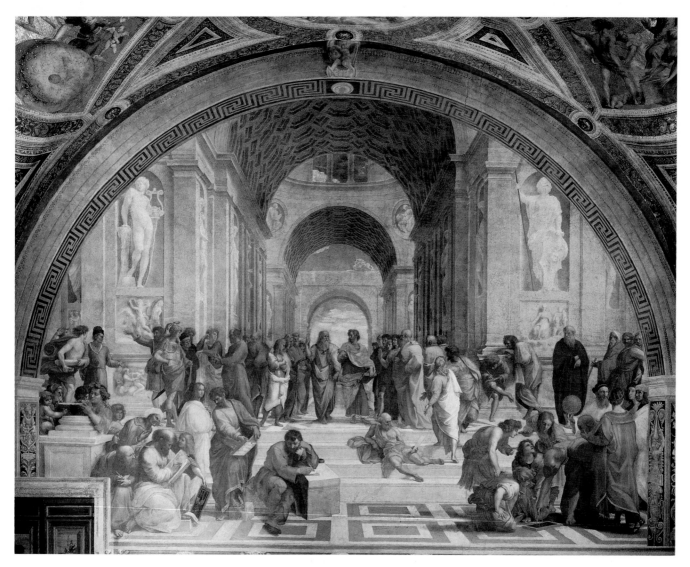

13–26 RAPHAEL *The School of Athens* (1510–11). Fresco. 26 x 18'.
Stanza della Segnatura, Vatican, Rome

tribunal was held, Raphael painted *The School of Athens* (Fig. 13–26), one of four frescoes designed within a semicircular frame. In a textbook exercise of one-point linear perspective, Raphael crowded a veritable "who's who" of Classical Greece convening beneath a series of barrel-vaulted archways. The figures symbolize philosophy, one of the four subjects deemed most valuable for a pope's education. (The others were law, theology, and poetry.) The members of the gathering are divided into two camps representing opposing philosophies and are led, on the right, by Aristotle and on the left, by his mentor, Plato. Corresponding to these leaders are the Platonists, whose concerns are the more lofty realm of Ideas (notice Plato pointing upward), and the Aristotelians, who are more in touch with matters of the Earth such as natural science. Some of the figures have been identified: Diogenes, the Cynic philosopher, sprawls out on the steps, and Herakleitos, a founder of Greek metaphysics, sits pensively just left of center. Of more interest is the fact that Raphael included a portrait of himself, staring out toward the viewer, in the far right foreground. He is shown in a group surrounding the geometrician Euclid. Raphael clearly saw himself as important enough to be commemorated in a Vatican mural as an ally of the Aristotelian camp.

As in *The Last Supper* by Leonardo, our attention is drawn to the two main figures by orthogonals leading directly to where they are silhouetted against the sky breaking through the archways. The diagonals that lead toward a single horizon point are balanced by strong horizontals and verticals in the architecture and figural groupings, lending a feeling of Classical stability and predictability. Stylistically, as well as iconographically, Raphael has managed to balance opposites in a perfectly graceful and logical composition.

Michelangelo Buonarroti

Of the three great Renaissance masters, Michelangelo (1475–1564) is probably most familiar to us. During the 1964 World's Fair in New York City, hundreds of thousands of culture seekers and religious pilgrims were trucked along a conveyor belt for a brief glimpse of his *Pietà* at the Vatican Pavilion. Many of us have seen the film *The Agony and the Ecstasy*, in which Charlton Heston—who, by the way, bears a striking resemblance to the artist—lies flat on his back on a scaffold 70 feet off the ground painting a ceiling for the Pope. It took Charlton Heston under an hour and a half; Michelangelo, who was paid less, required four years. Such is the gulf between art and . . . art?

In any event, that famed ceiling is the vault of the chapel of Pope Sixtus IV, known as the Sistine Chapel. The decorative fresco cycle was commissioned by none other than Pope Julius II, but the iconographic scheme was Michelangelo's. The artist had agreed to the project in order to pacify the temperamental Julius in the hope that the pontiff would eventually allow him to complete work on his mammoth tomb. For whatever reason, we are indeed fortunate to have this painted work from the sculptor's hand. After much anguish and early attempts to populate the vault with a variety of religious figures, Michelangelo settled on a division of the ceiling into geometrical "frames" (Figs. 13–27 and 13–28) housing biblical prophets, mythological soothsayers, and Old Testament scenes from Genesis to Noah's flood.

The most famous of these scenes is *The Creation of Adam* (Fig. 13–29). As Leonardo had done in *The Last Supper*, Michelangelo chose to communicate the event's most dramatic moment. Adam lies on the Earth listless for lack of a soul, while God the Father rushes toward him amidst a host of angels, who enwrap him in a billowing cloak. The contrasting figures lean toward the left, separated by an illuminated diagonal that provides a backdrop for the Creation. Amidst an atmosphere of sheer electricity, the hand of God reaches out to spark spiritual life into Adam—but does not touch him! In some of the most dramatic negative space in the history of art, Michelangelo has left it to the spectator to complete the act. In terms of style, Michelangelo integrated chiaroscuro with Botticelli's extensive use of line. His figures are harshly drawn and

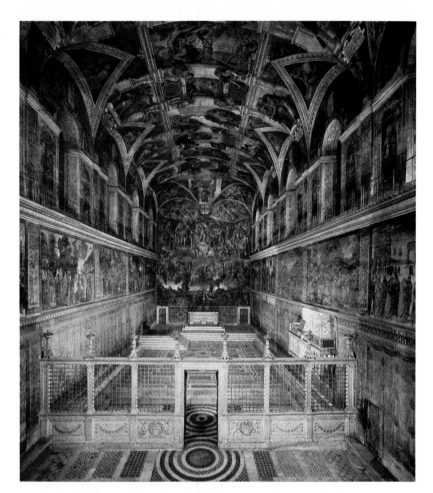

13–27 (*left*) MICHELANGELO
The Sistine Chapel in the Vatican, Rome
(1508–12)

13–28 (*below*) MICHELANGELO
Ceiling in the Sistine Chapel. 5,800 sq. ft.

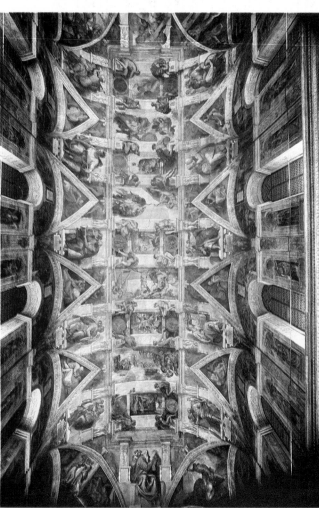

muscular with almost marblelike flesh. In translating his sculptural techniques to a two-dimensional surface, the artist has conceived his figures in the round and has used the tightest, most expeditious line and modeling possible to render them in paint.

It is clear that Michelangelo saw himself more as a sculptor than as a painter, and the "sculptural" drawing and modeling in *The Creation of Adam* attest to this. When Michelangelo painted the Sistine Chapel ceiling, he was all of 33 years old, but he began his career some twenty years earlier as an apprentice to the painter Domenico Ghirlandaio (1449–1494). His reputation as a sculptor, however, was established when at the age of 27 he carved the 13½-foot-high *David* (Fig. 13–30) from a single piece of almost unworkable marble. Unlike the Davids of Donatello and Verrocchio, Michelangelo's hero is not shown after conquering his foe. Rather, David is portrayed as a most beautiful animal preparing to kill—not by savagery and brute force, but by intellect and skill. Upon close inspection, the tensed

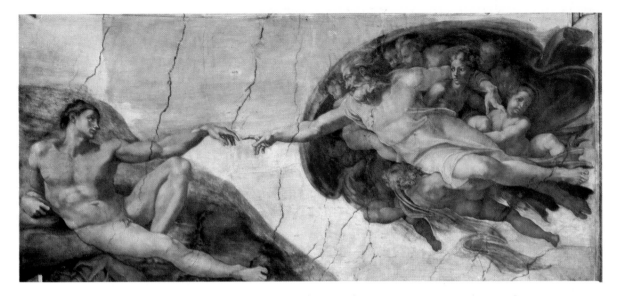

13–29 MICHELANGELO *The Creation of Adam*
(detail from ceiling of the Sistine Chapel)

muscles and the furrowed brow negate the
first impression that this is a figure at rest.
David's sling is cast over his shoulder and
the stone is grasped in the right hand, the
veins prominent in anticipation of the fight.
Michelangelo's *David* is part of the Classical
tradition of the "ideal youth" who has just
reached manhood and is capable of great
physical and intellectual feats. Like Donatel-
lo's *David*, Michelangelo's sculpture is
closed in form. All of the elements move
tightly around a central axis. Michelangelo
has been said to have sculpted by first con-
ceptualizing the mass of the work and then
carefully extracting all of the marble that
was not part of the image. Indeed, in the
David, it appears that he worked from front
to back instead of from all four sides of the
marble block, allowing the figure, as it were,
to "step out of" the stone. The identification
of the figure with the marble block provides
a dynamic tension in Michelangelo's work,
as the forms try at once to free themselves
from and succumb to the binding dimen-
sions.

Michelangelo led a long life that spanned
ninety chronological years and the entire

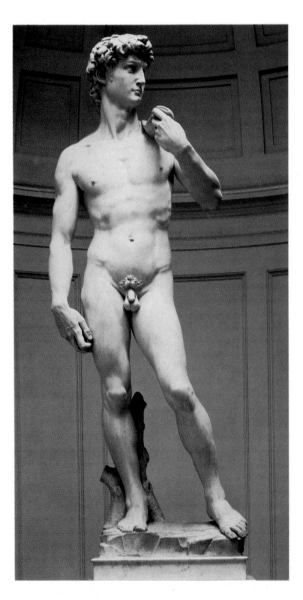

13–30 MICHELANGELO
David (1501–04)
Marble. Height: 13½'.
Academy, Florence

On the Mutilation of Michelangelo's *Pietàs*

The art world recoiled in shock in 1972 when a crazed Italian man viciously hacked off the Virgin's nose in Michelangelo's famed Vatican *Pietà*. Centuries earlier, around 1555, another crazed Italian man, it is believed, hacked off Christ's leg in Michelangelo's Florence *Pietà*. The contemporary villain was apprehended and identified as Láslo Toth. The Renaissance culprit was never so much as scolded. It was Michelangelo himself.

Why would the artist mutilate his own work, especially one that obsessed him during his last years, one designed for his own tomb? There has been much speculation. The art historian Leo Steinberg believed that Michelangelo was disturbed by the possible sexual connotations associated with the leg of Jesus being slung over that of his mother. The scholar Tolnay believed that the sculpture was not disfigured at all, but rather that the leg "was originally made from a separate piece of marble." Psychiatrist Robert S. Liebert suggests that Michelangelo had committed a technical error in executing the leg and, out of disappointment, removed it, with the intention of carving another. He further posits that the notion of not carving a single sculpture from a single block of marble disturbed Michelangelo and thus, in frustration, he tried to destroy the work.[*]

Yet one piece of the puzzle has never quite been integrated into any of these explanations. Michelangelo himself, when asked why he had mutilated the work, answered that it was because his servant had nagged him to finish it. Liebert follows up this clue and links it with Michelangelo's despair over his servant's ultimate death and a fear of his own imminent death, offering a psychoanalytic interpretation of the deed. Michelangelo was very close to his servant of twenty-six years, and if, in fact, the latter had "nagged" him into completing the work before he died, then perhaps, Liebert argues, Michelangelo was afraid of creating a kind of self-fulfilling prophecy. Were Michelangelo to complete the work, the servant might actually die. The fear of his own death might also have caused him to destroy the work for the very same reason.

[*]Robert S. Liebert, "Michelangelo's Mutilation of the Florence 'Pietà': A Psychoanalytic Inquiry," *The Art Bulletin*, 59 (March 1977), 47–53.

High Renaissance, leading into the Baroque period. His last great undertaking was work on St. Peter's in Rome, a building that sums up the ideas of the Renaissance while heralding the age of the Baroque. Many architects had worked on the basilica, but it was left to a reluctant Michelangelo to revise the extant plan and complete the dome. The commission for the renovation was given initially to Donato Bramante (1444–1514) by Pope Julius II, but the architect died before his plans could be realized. Bramante's plan for St. Peter's was that of a central cross with arms of equal length ending in apses (Fig. 13–33). The crossing square, or point where the arms intersect, was to be covered by an extremely large dome, while smaller domes covering chapels would echo along the diagonal axes of the square plan. Michelangelo used Bramante's basic plan but simplified it by inscribing the Greek Cross within a square, reducing the number of chapels to four, and relegating them to the corners of the square (Fig. 13–34). He also

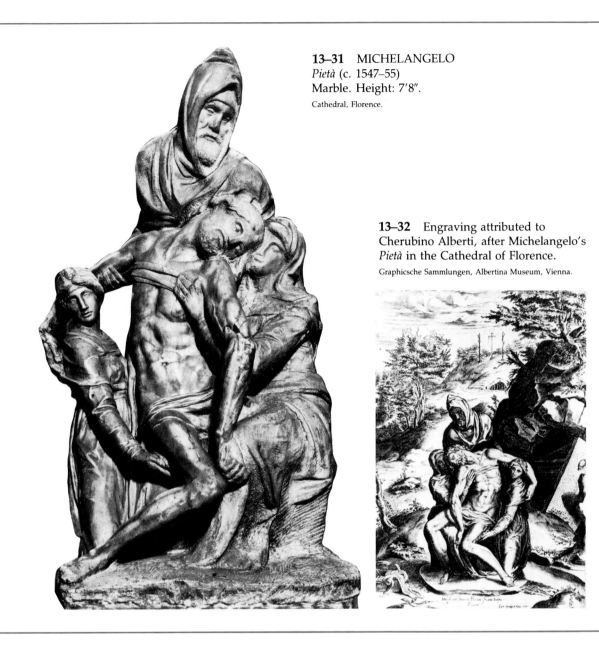

13–31 MICHELANGELO
Pietà (c. 1547–55)
Marble. Height: 7'8".

Cathedral, Florence.

13–32 Engraving attributed to
Cherubino Alberti, after Michelangelo's
Pietà in the Cathedral of Florence.

Graphicsche Sammlungen, Albertina Museum, Vienna.

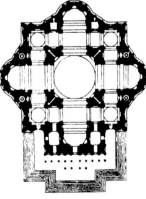

13–33 *(left)*
DONATO BRAMANTE
Original plan for St. Peter's,
Vatican, Rome (1506)

13–34 *(right)*
MICHELANGELO
Plan of St. Peter's, Vatican,
Rome (1546–64)

had plans for a majestic dome, wholly Classic in its hemispherical shape and rhythmic application of details. Michelangelo's other contribution was to have been the western portico, which, in plan, resembles the Pantheon's in relation to the main mass of the building (see Fig. 11–25). Michelangelo's plan bears no resemblance to the St. Peter's of today, which is longitudinal in plan (see Fig. 14–8). The dome was completed after Michelangelo's death by another architect, who had to resort to the ogival section of Brunelleschi's dome, and the western portico was ultimately constructed with another plan. The southern elevation of the building, however, indicates Michelangelo's intentions. Balance, unity, strength through simplicity, respect for Classicism, and an almost sculptural treatment of the architecture characterize his contribution to the development of St. Peter's. It would be taken over by master architects and sculptors of the Baroque era who would capitalize on this concept of treating architecture as sculpture on a vast scale—indeed, making it a central precept of their style. It is fitting that this painter-sculptor-architect, this "crazed" genius, paved the way for the successful fusion of these arts in the seventeenth century.

14

The Age of Baroque

The Baroque period spans roughly the years from 1600 to 1750. Like the Renaissance, which preceded it, the Baroque period was an age of genius in many fields of endeavor. Sir Isaac Newton derived laws of motion and of gravity that have only recently been modified by the discoveries of Einstein. The achievements of Galileo and Kepler in astronomy brought the vast expanses of outer space into sharper focus. The Pilgrims also showed an interest in motion when, in 1620, they put to sea and landed in what is now Massachusetts. Our forefathers had a certain concern for space as well—they wanted as much as possible between themselves and their English oppressors.

The Baroque period in Europe included a number of post-Renaissance styles that do not have all that much in common. On the one hand, there was a continuation of the Classicism and naturalism of the Renaissance. On the other, a far more colorful, **ornate,** painterly, and dynamic

style was born. If one name had to be applied to describe these different directions, it is just as well that that name is **Baroque**—for the word is believed to derive from the Portuguese *barroco*, meaning "irregularly shaped pearl." The Baroque period was indeed irregular in its stylistic tendencies, and it also gave birth to some of the most treasured gems of Western art.

Motion and *space* were major concerns of the Baroque artists, as they were of the scientists of the period. The concept of *time*, a dramatic use of *light*, and a passionate *theatricality* complete the list of the five most important characteristics of Baroque art, as we shall see throughout this chapter.

Although this chapter is entitled "The Age of Baroque," the material covered will include **proto-Baroque** works that immediately precede the movement, as well as works that follow on its coattails. Before the dawn of the seventeenth century, and following the masters Leonardo, Raphael, and Michelangelo, are found the proto-Baroque artists of the Venetian school and the **Mannerists.** Following 1750 we find the **Rococo** painters and sculptors. Both proto-Baroque and Rococo movements are similar to the Baroque period in spirit as well as style.

PROTO-BAROQUE

The Venetians

The Venetian artists lived and worked in the Italian city of Venice. They were the first Italian artists to perfect the medium of oil painting that we first witnessed with van Eyck in Flanders. Perhaps influenced by the mosaics in St. Mark's Cathedral, perhaps intrigued by the dazzling colors of imports from eastern countries into this maritime province, the Venetian artists sought the same clarity of hue and lushness of surface in their oil-on-canvas works.

Titian

Although he died in 1576, almost a quarter century before the birth of the Baroque era, the Venetian master Tiziano Vecellio

(b. 1477)—called Titian—had more in common with the artists who would follow him than with his Renaissance contemporaries in Florence and Rome. Titian's pictorial method differed from those of Leonardo, Raphael, and Michelangelo in that he was foremost a painter and colorist rather than a draftsman or sculptural artist. He constructed his compositions by means of colors and strokes of paint and layers of varnish, rather than by line and **chiaroscuro.** As noted in Chapter 4, a shift from painting on wood panels to painting on canvas occurred at this time, and with it a change from tempera to oil paint as the preferred medium. With its versatility and lushness, oil painting served Titian well, with its vibrant, intense hues and its more subtle, semitransparent glazes.

Titian's *Venus of Urbino* (Fig. 14–1) is one of the most beautiful examples of the **glazing** technique. The composition was painted for the duke of Urbino, from which its title derives. Titian adopted the figure of the reclining Venus from his teacher Giorgione, and it has served as a model for many compositions since that time. In the foreground, a nude **Venus pudica** rests on voluptuous pillows and sumptuous sheets spread over a red brocade couch. Her golden hair, complemented by the delicate flowers she grasps loosely in her right hand, falls gently over her shoulder. A partial drape hangs in the middle ground, providing a backdrop for her upper torso and revealing a view of her boudoir. The background of the composition includes two women looking into a trunk—presumably handservants—and a more distant view of a sunset through a columned veranda. Rich, soft tapestries contrast with the harsh Classicism of the stone columns and inlaid marble floor. Titian appears to have been interested in the interaction of colors and the contrast of textures. The creamy white sheet complements the radiant golden tones of the body of Venus, built up through countless applications of glazes over flesh-toned pigment. Her sumptuous roundness is created by extremely subtle gradations of tones in these glazes, rather than the harshly sculptural chiaroscuro that Leonardo or Raphael might have

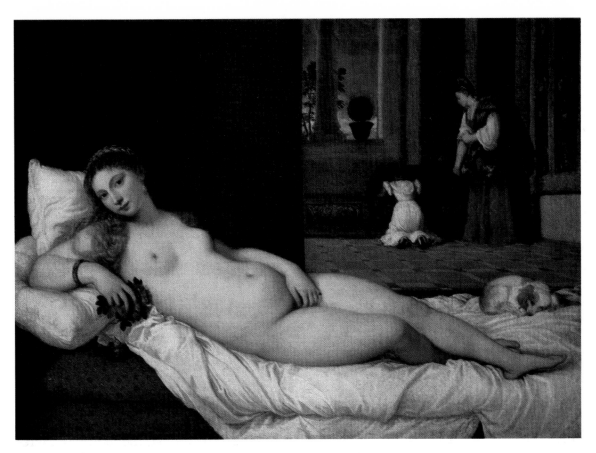

14-1 TITIAN *Venus of Urbino* (1538). Oil on canvas. 47 x 65".
Uffizi Gallery, Florence.

used. The forms evolve from applications of color instead of line or shadow. Titian's virtuoso brushwork allows him to define different textures: the firm yet silken flesh, the delicate folds of drapery, the servant's heavy cloth dress, the dog's soft fur. These colors and textures excite the senses as no Renaissance painting had.

Yet, even more significant is Titian's use of color as a compositional device. How does he use it? We have already noted the drape, whose dark color forces our attention on the most important part of the composition—Venus's face and upper torso. It also blocks out the left background, encouraging viewers to narrow their focus on the vista in the right background. The forceful diagonal formed by the looming body of Venus is balanced by three elements opposite her: the little dog at her feet and the two handmaidens in the distance. They do not detract from her since they are engaged in activities that do not concern her or the spectator. The diagonal of her body is also balanced

by an intersecting diagonal that can be visualized by integrating the red areas in the lower left and upper right corners. Titian thus subtly balances the composition in his placement of objects and color areas.

Titian lived to a ripe old age; in fact, he is supposed to have lied about his birthdate—to appear older than he actually was. In his later years, Titian's brushwork became looser and rougher of texture as he strayed from the glasslike surfaces of the glazing technique. He devoted more time to religious painting, and, as was the case with the aging Michelangelo, his painting became more somber and introspective. But the sensuousness and brilliance of his earlier canvases provided a legacy for younger Venetian painters as well as artists of the modernist period.

TINTORETTO

Perhaps none of the artists we will examine in this section anticipated the Baroque style so strongly as Jacopo Robusti, called

Tintoretto, or "little dyer," after the profession of his father. Supposedly a pupil of Titian, Tintoretto (1518–1594) emulated the master's love of color, although he combined it with a more linear approach to constructing forms. This interest in draftsmanship was culled from Michelangelo, but the younger artist's compositional devices went far beyond those of the Florentine and Venetian masters. His dynamic structure and passionate application of pigment provide a sweeping, almost frantic, energy within compositions of huge dimensions.

Art historian Frederick Hartt notes that his painting technique was indeed unique.[*] Tintoretto arranged doll-like figures on small stages and hung his flying figures by wires in order to copy them in correct perspective for the final canvas. This he first executed on sheets of paper, which he then translated onto the much larger canvases using a grid (similar to the technique of **fresco** painting described in Chapter 4).

Tintoretto primed the entire canvas with dark colors, and then he quickly painted in the lighter sections. Thus many of his paintings appear very dark, except for bright patches of radiant light. The artist painted extremely quickly, using broad areas of loosely swathed paint. John Ruskin, a nineteenth-century art critic, is said to have suggested that Tintoretto painted with a broom.[†] Although this is unlikely, Tintoretto had certainly come a long way from the sculptural, at times marble-like, figures of the High Renaissance and the painstaking finish of Titian's glazed *Venus of Urbino*. It is this loose brushwork and dramatic use of white spotlighting on a dark ground that encourage us to label him proto-Baroque.

There are additional characteristics of his style, however, evident in *The Last Supper* (Fig. 14–2), that further seal his relationship to the later period. A comparison of this composition with Leonardo's *Last Supper* (Fig. 13–24) will illustrate the dramatic changes that had taken place in both art and the concept of art over almost a century. The interests in motion, space, and time, the dramatic use of light, and the theatrical presentation of subject matter—outlined

[*]Frederick Hartt, *History of Italian Renaissance Art*, 2nd ed. (Englewood Cliffs, N.J.: Prentice-Hall, and New York: Harry N. Abrams, 1979), p. 615.

[†] Ibid.

14–2 TINTORETTO *The Last Supper* (1592–94). Oil on canvas. 12' x 18'8".
S. Giorgio Maggiore, Venice.

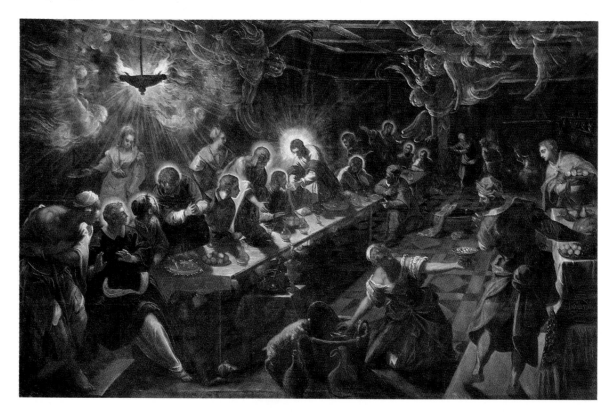

above as traits of Baroque art—are all present in Tintoretto's *Last Supper*. We are first impressed by the movement. Everything and everyone is set into motion: People lean, rise up out of their seats, stretch, and walk. Angels fly and animals dig for food. The space, sliced by a sharp, rushing diagonal that goes from lower left toward upper right, seems barely able to contain all of this commotion; but this "cluttered" effect enhances the energy of the event. Leonardo's obsession with symmetry, and his balance between emotion and restraint, yield a composition that appears static in comparison to the asymmetry and overpowering emotion in Tintoretto's canvas. Leonardo's apostles seem posed for the occasion when contrasted with Tintoretto's spontaneously gesturing figures. The element of time is evident in that a particular moment is captured. We feel that if we were to look away for a fraction of a second, the figures would have changed position by the time we looked back! The timelessness of Leonardo's figural poses has given way to a seemingly temporary placement of characters. The moment that Tintoretto has chosen to depict also differs from Leonardo's. The Renaissance master chose the point at which Jesus announced that one of his apostles would betray him. Tintoretto, on the other hand, chose the moment when Jesus shared bread, which symbolized his body as the wine stood for his blood. This moment is commemorated to this day during the celebration of Mass in the Roman Catholic faith. Leonardo chose a moment signifying death, Tintoretto a moment signifying life, depicted within an atmosphere that is teeming with life.

Tintoretto has often been labeled a Mannerist artist. **Mannerism** was a movement prior to the Baroque period that differed in many aspects of style from the Renaissance art from which it grew. Artists subscribing to this style stand as a splinter group, relating to little of the past and having little bearing on the future. It will be obvious from the discussion of Mannerism that follows that Tintoretto's linkage to this group is erroneous. His only relationship to them is chronological. Tintoretto's work stands as a complement to the Renaissance and as a legacy to the Baroque.

Mannerism

During the Renaissance, the rule of the day was to observe and emulate nature. Toward the end of the Renaissance and before the beginning of the seventeenth century, this rule was suspended for a while, during a period of art that historians have named Mannerism. Mannerist artists abandoned copying directly from nature and copied art instead. Works thus became "secondhand" views of nature. Line, volumes, and color no longer duplicated what the eye saw but were derived instead from what other artists had already seen. Several characteristics separate Mannerist art from the Renaissance and the Baroque: distortion and elongation of figures; flattened, almost two-dimensional space; lack of a defined focal point; and the use of discordant pastel hues.

JACOPO PONTORMO

A representative of early Mannerism, Jacopo Pontormo (1494–1557) used most of its stylistic principles. In *Entombment* (Fig. 14–3), we witness a strong shift in direction from High Renaissance art, even though the painting was executed during Michelangelo's lifetime. The weighty sculptural figures of Michelangelo, Leonardo, and Raphael have given way to less substantial, almost weightless, forms that balance on thin toes and ankles. The limbs are long and slender in proportion to the torsos, and the heads are dwarfed by billowing robes. There is a certain innocent beauty in the arched eyebrows of the haunted faces, and in the nervous glances that dart this way and that past the boundaries of the canvas. The figures are pressed against the picture plane, moving within a very limited space. Their weight seems to be thrust outward toward the edges of the composition and away from the almost void center. The figures' robes are composed of odd hues, departing drastically in their soft pastel tones from the vibrant primary colors of the Renaissance masters. The weightlessness, distortion,

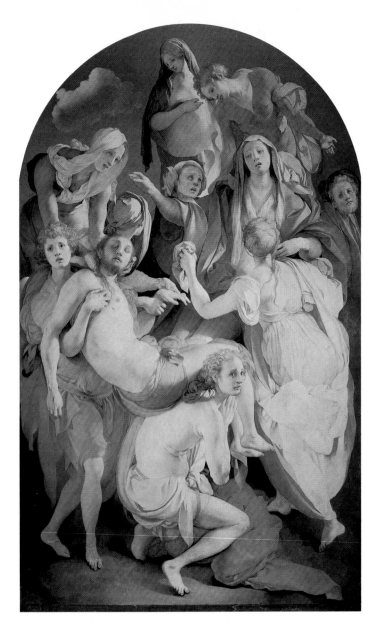

14–3 JACOPO PONTORMO *Entombment*
(1525–28)
Oil on panel. 10'3" x 6'4".
Capponi Chapel, Sta. Felicita, Florence.

and ambiguity of space create an almost otherworldly feeling in the composition, a world in which objects and people do not come under an earthly gravitational force. The artist accepts this "strangeness" and makes no apologies for it to the viewer. The ambiguities are taken in stride. For example, note that the character in a turban behind the head of the dead Jesus does not appear to have a body—there is really no room for it in the composition. And even though a squatting figure in the center foreground appears to be balancing Christ's torso on his shoulders after having taken him down

from the cross a moment before, there is no cross in sight! Pontormo seems to have been most interested in elegantly rendering the high-pitched emotion of the scene. Iconographic details and logical figural stances are irrelevant.

EL GRECO

The Late Renaissance outside of Italy brought us many different styles, and Spain is no exception. During the chronological period we have labeled Mannerism, Spanish art polarized into two stylistic groups of religious painting: the mystical and the realistic. One painter was able to pull these opposing trends together in a unique pictorial method. El Greco (1541–1614), born Domeniko Theotokopoulos in Crete, integrated many styles in his work, including those influenced by Byzantine art and Italian Mannerism. As a young man he traveled to Italy, where he encountered the works of the Florentine and Roman masters, and he was for a time affiliated with Titian's workshop. The colors that El Greco incorporated in his paintings suggest a Venetian influence, and the distortion of his figures and use of an ambiguous space speak for his interest in Mannerism.

These pictorial elements can clearly be seen in one of El Greco's most famous works, *The Burial of Count Orgaz* (Fig. 14–4). In this single work, El Greco combines mysticism and realism. The canvas is divided into two halves by a horizontal line of white-collared heads, separating "heaven" and "earth." The figures in the lower half of the composition are somewhat elongated, but well within the bounds of realism. The heavenly figures, by contrast, are extremely attenuated and seem to move under the influence of a sweeping, dynamic atmosphere. It has been suggested that the distorted figures in El Greco's paintings might have been the result of astigmatism in the artist's eyes, but there is no convincing proof of this. For example, at times El Greco's figures appear no more distorted than those of other Mannerists. Heaven and earth are disconnected psychologically but joined convincingly in terms of composition. At the center of the rigid, horizontal

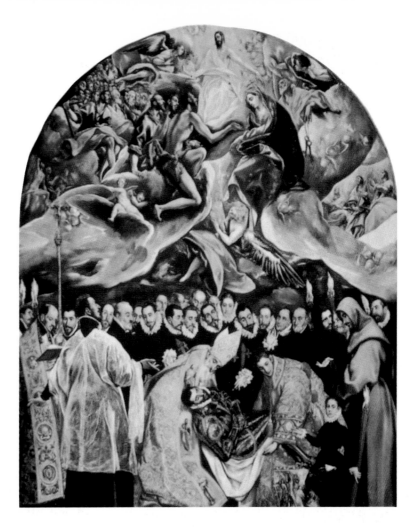

14–4 EL GRECO
The Burial of Count Orgaz (1586)
Oil on canvas. 16′ x 11′10″.
Santo Tomé, Toledo, Spain.

row of heads that separates the two worlds, a man's upward glance encourages the viewer to follow a path into the upper realm. This compositional device is complemented by a sweeping drape that rises into the upper half of the canvas from above his head, continuing to lead the eye between the two groups of figures, left and right, up toward the image of the resurrected Christ. El Greco's color scheme also complements the worldly and otherwordly habitats. The colors used in the costumes of the earthly figures are realistic and vibrantly Venetian, but the colors of the upper half of the composition resemble the discordant hues of the Italian Mannerist canvases. The high-pitched emotion in the work of Pontormo is also present here, exaggerated by the tumultuous atmosphere. This emphasis on emotionalism links El Greco to the onset of the Baroque era. His work contains a dramatic, theatrical flair, and this, of course, is one of the hallmarks of the seventeenth century.

GIOVANNI DA BOLOGNA

The bodily distortion characteristic of Mannerist painting appeared in sculpture as well, although not all artists subscribed to it fully. This stylistic characteristic was not very important for the future of sculpture, but that was not the case with other innovations in sculpture of the latter sixteenth century. One of the most important artists of this time was the Flemish Giovanni da Bologna (1529–1608) (Jean de Boulogne), who preferred to imbue his name with an Italian flavor. Giovanni da Bologna was a transitional figure. His work encompassed the accomplishments of Michelangelo and anticipated the Baroque through several compositional innovations, as illustrated in *The Rape of the Sabine Women* (Fig. 14–5).

Giovanni did not utilize the weightlessness and distortion characteristic of his contemporaries in the two-dimensional arts. Rather, the solidity and muscularity of his forms hearken back to the High Renais-

14–5 GIOVANNI DA BOLOGNA
The Rape of the Sabine Women (completed 1583). Marble. Height: 13'6".
Loggia dei Lanzi, Florence.

14–6 ANDREA PALLADIO
Villa Rotunda, Vicenza (c. 1567–70)

sance. His originality lies in his compositional format. During the Renaissance, a **contrapposto** stance often formed what was perceived as an S-curve that followed a strong vertical axis. In most cases, the figures appeared to lie in a single plane. Thus one could comprehend the work by observing from a single point. Such is not the case in *The Rape of the Sabine Women*. Giovanni moved significantly from a two-dimensional S-curve to a three-dimensional spiral. His figures revolve around a central axis, such that their positions appear to change as the spectator moves around the work. This movement is encouraged by a series of deliberately placed diagonals in arms and legs that force the viewer to move around to take in the entire work. Limbs also begin to extend into space, suggesting quite a different concept from Michelangelo's respect for the block of marble. This minimal extension will be adopted by Baroque artists, who will also use the spiral and force their forms even farther into the surrounding space.

ANDREA PALLADIO

You might wonder how one could apply the principles of Mannerism to architecture. Certainly we cannot speak of discordant hues, distorted limbs, and heightened passion when we look at buildings. Furthermore, much Mannerist architecture expresses a clarity of form that opposes the ambiguity of space in paintings of this period. How, then, can we call an architect like Andrea Palladio a Mannerist?

As we have seen, artists are often related to a particular movement on the basis of their birth and death dates and not their adherence to a style. This is partially true of Palladio (1518–1580), although we can make a case for Mannerist tendencies in his architecture if we look beyond the visible. The Villa Rotunda (Fig. 14–6) consists of a central square whose sides are graced by columned and pedimented porticoes. Access to the villa is gained by stairways approaching these porticoes, reminiscent of Roman buildings. Atop the central square is a drum and dome that resembles the Pantheon (Fig. 11–25) in its relation to the porti-

coes as seen from any side of the square. Classical details include Ionic volutes on the columns, **dentil molding** within the pediments, and even sculpted figures at the corners of the pediments! Where is the Mannerism in such a Classical structure?

If we look to the dictionary definition of Mannerism instead of the art historical definition, perhaps there is a relationship between Palladio and Mannerism. The dictionary defines the adjective ''mannered'' as stylized, and ''mannerism'' as the excessive use of some distinctive, often affected, manner or style in art. Palladio's Villa Rotunda is a vegetable soup of Greek and Roman Classicism. The building is stylized in that it uses elements of these styles without regard for the purity of either one. As Mannerist painters went to art for models, rather than to the source of art, so too Palladio relied heavily on style or detail rather than on the sources for these elements in nature. Thus, even though architecture bears little resemblance to the painting and sculpture of the day in terms of details, the spirit of Mannerism is strongly felt.

PIETER BRUEGEL THE ELDER

During the second half of the sixteenth century in the Netherlands, changes in the subject matter of painting were taking place that would affect the themes of artists working in Northern Europe during the Baroque period. Scenes of everyday life involving ordinary people were becoming more popular. One of the masters of this **genre painting** was Pieter Bruegel the Elder (c. 1520–1569), whose compositions focused on human beings in relation to nature and the life and times of plain Netherlandish folk. *Hunters in the Snow* (Fig. 14–7) is a good example of Bruegel's ''slice of life'' canvases. It also shows an interest in landscape painting that was common among Northern European artists. Perched high above the action, the viewer observes people in the midst of their daily tasks. Hunters return from the woods accompanied by a pack of dogs. All trudge through the heavy blanket of snow while women stoke a fire to their left and skaters glide over frozen ponds below. Below and in the distance lies a peaceful landscape of snow-covered roofs, steeples, and craggy

14–7 PIETER BRUEGEL THE ELDER *Hunters in the Snow* (1565)
Oil and tempera on panel. 46 x 63¾".
Kunstistorisches Museum, Vienna.

mountain tops. Regimented trees march down the hillside, while birds sit frozen in the leafless branches or fly boldly to free their icy wings. There is no hidden message here, no religious fervor, no battle between mythological giants. Human activities are presented as sincere and viable subject matter. There are few examples of such painting before this time, but genre painting will play a principal role in the works of Netherlandish artists during the Baroque period.

The proto-Baroque artists from the second half of the sixteenth century through the beginning of the seventeenth century all broke away from the Renaissance tradition in one way or another. Some were opposed to the stylistic characteristics of the Renaissance and turned them around in an original but ultimately uninfluential style called Mannerism. Others, such as Titian and Tintoretto, emphasized the painting *process*, constructing their compositions by means of stroke and color rather than line and shadow. Still others combined an implied movement and sense of time in their compositions, foreshadowing some of the concerns of the artist in the Baroque period. The proto-Baroque period is a potpourri of sorts, consisting of artists of intense originality who provide a fascinating transition between the grand Renaissance and the dynamic Baroque.

THE BAROQUE PERIOD IN ITALY

The Baroque era was born in Rome, some say in reaction to the spread of Protestantism resulting from the **Reformation**. Even though many areas of Europe were affected by the new post-Renaissance spirit, it was more alive and well and influential in Italy than elsewhere—partly because of the strengthening of the papacy in religion, politics, and patronage of the arts. During the Renaissance, the principal patron of the arts

was the infamous Pope Julius II. However, during the Baroque era, a series of powerful popes—Paul V, Urban VIII, Innocent X, and Alexander VII—assumed this role. The Baroque period has been called the Age of Expansion, following the Renaissance Age of Discovery, and this expansion is felt keenly in the arts.

ST. PETER'S

The expansion and renovation of St. Peter's Cathedral in Rome (Fig. 14–8) is an excellent project with which to begin our discussion of the Baroque in Italy, for three reasons: The building expresses the ideals of the Renaissance, stands as a hallmark of the Baroque style, and brings together work by the finest artists of both periods—Michelangelo and Bernini.

The major change in the structure of St. Peter's was from the central **Greek Cross** plans of Bramante and Michelangelo to a longitudinal **Latin Cross** plan. Thus, three bays were added to the nave between the domed crossing and the façade. The architect Carlo Maderno was responsible for this task as well as the design for the new façade, but the job of completing the project fell into the hands of the most significant sculptor of the day, Gianlorenzo Bernini.

GIANLORENZO BERNINI

Gianlorenzo Bernini (1598–1680) made an extensive contribution to St. Peter's as we see it today, both to the exterior and the interior. In his design for the **piazza** of St. Peter's, visible in the aerial view (Fig. 14–9), Bernini had constructed two expansive arcades extending from the façade of the church and culminating in semicircular "arms" enclosing an oval space. This space, the piazza, was divided into trapezoidal "pie sections" in the center of which rises an Egyptian obelisk. The Classical arcades, true in details to the arts that inspired them, stretch outward into the surrounding city, as if to welcome worshippers and cradle

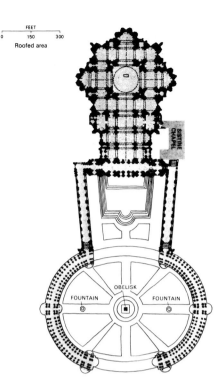

14-8 Plan of St. Peter's Cathedral, Rome (1605-13)

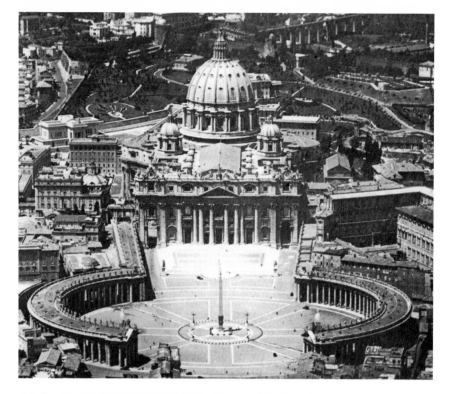

14-9 GIANLORENZO BERNINI Piazza of St. Peter's

them in spiritual comfort. The curving arms, or arcades, are composed of two double rows of columns with a path between, ending in Classical pedimented "temple fronts." In the interior of the cathedral, beneath Michelangelo's great dome, Bernini designed a bronze canopy to cover the main altar. In the apse, Bernini combined architecture, sculpture, and stained glass in a brilliantly golden display for the Cathedra Petri, or Throne of St. Peter. Through his many other sculptural contributions to St. Peter's, commissioned by various popes, Bernini's reputation as a master is solidified.

Bernini's *David* (Fig. 14–10) testifies to the artist's genius and also illustrates the dazzling characteristics of Baroque sculpture. This David is remarkably different from those of Donatello, Verrocchio, and Michelangelo. Three of the five characteristics of Baroque art are present in Bernini's sculpture: motion (in this case, implied), a different way of looking at space, and the introduction of the concept of time. The Davids by Donatello and Verrocchio were figures at rest after having slain their Goliaths. Michelangelo, by contrast, presented David

14-10 GIANLORENZO BERNINI
David (1623). Marble. Height: 6'7".
Borghese Gallery, Rome.

Gianlorenzo Bernini

ON ACHIEVING A "NATURAL STANCE" IN SCULPTURE: [One] of the most important points for a student to bear in mind concerning the posture of a figure is that it should have a natural stance. Seldom does a man, unless he is very old, rest his weight on more than one leg. The artist must be careful to reproduce this posture accurately and make the shoulder on the side of the leg bearing the weight of the body lower than the other. If one of the arms is raised, it should always be the one on the side opposite the leg bearing the body. If this maxim is disregarded, the figure will lack grace, and violence will be done to nature.

before the encounter, with the tension and emotion evident in every vein and muscle, bound to the block of marble that had surrounded the figure. Bernini does not offer David before or after the fight, but instead *in the process* of the fight. He has introduced an element of time in his work. As in *The Last Supper* by Tintoretto, we sense that David would have used his weapon if we were to look away and then back. We, the viewers, are forced to complete the action that David has begun for us, and in this encouragement of spectator participation, Bernini has carried Giovanni da Bologna's *Rape of the Sabine Women* a step farther.

A new concept of space comes into play with David's positioning. No longer does the figure remain still in a Classical contrapposto stance but rather extends *into* the surrounding space away from a vertical axis. This movement outward from a central core forces the viewer to take into account both solids and voids—that is, both the form and the spaces between and surrounding the forms—in order to appreciate the complete composition. As in *The Rape of the Sabine Women*, we must move around the work in order to understand it fully, and as we move, the views of the work change radically.

We may compare the difference between Michelangelo's *David* and Bernini's *David* to the difference between Classical and Hellenistic Greek sculpture. In Chapter 11, we saw that the movement out of Classical art

into Hellenistic art was marked by an extension of the figure into the surrounding space, a sense of implied movement, and a large degree of theatricality. The time-honored balance between emotion and restraint coveted by the Classical Greek artist as well as the Renaissance master had given way in the Hellenistic and Baroque periods to unleashed passion.

Uncontrollable passion and theatrical drama might best describe Bernini's *The Ecstasy of St. Theresa* (Fig. 14–11), a sculptural group executed for the chapel of the Cornaro family in the church of Santa Maria della Vittoria in Rome. The sculpture commemorates a mystical event involving St. Theresa, a Carmelite nun who believed that a pain in her side was caused by an angel of God stabbing her repeatedly with a fire-tipped arrow. Her response combined pain and pleasure, as conveyed by the sculpture's submissive swoon and impassioned facial expression. Bernini summoned all of his sculptural powers to execute these figures, and combined the arts of architecture, sculpture, and painting to achieve his desired theatrical effect. Notice the way in which Bernini described vastly different textures with his sculptural tools: the roughly textured clouds, the heavy folds of St. Theresa's woolen garment, the diaphanous "wet-look" drapery of the angel. "Divine" rays of glimmering bronze shower down on the figures, as if emanating from the painted ceiling of the chapel, and are illuminated

14–11 GIANLORENZO BERNINI
The Ecstasy of St. Theresa (1645–52)
Marble. Height of group: c. 11'6".

Cornaro Chapel, Sta. Maria della Vittoria, Rome.

14–12 GIANLORENZO BERNINI
The Cornaro family in a theatre box (1645–52)
Marble. Figures life-size.

Cornaro Chapel, Santa Maria della Vittoria, Rome.

by a hidden window. Bernini enhanced this self-conscious theatrical effect by including marble sculptures in the likenesses of members of the Cornaro family in theater boxes to the left and right (Fig. 14–12). They observe, gesture, and discuss the scene animatedly as would theatergoers. The fine line between the rational and the spiritual that so interested the Baroque artist was presented by Bernini in a tactile yet illusionary masterpiece of sculpture.

CARAVAGGIO

This theatrical drama and passion found its way into Baroque painting as well, and can be seen most clearly in the work of Michelangelo de Merisi, called Caravaggio (1573–1610). Unlike Bernini's somewhat idealized facial and figural types, the models for Caravaggio came literally from the streets. Whereas Bernini was comfortable in the company of popes and princes, Caravaggio was more comfortable with the dregs

of humanity. In fact, he was one of them and had a police record for violent assaults. Caravaggio chose lower-class models for quite a shocking painting, *The Conversion of St. Paul* (Fig. 14–13). Paul—originally Saul—was chosen as an apostle while riding his horse. Blinded by a bright light, he was thrown from the animal only to hear a voice ask why he was persecuting Christians. Saul was ultimately persuaded to convert, stop the killing, and change his name. Very much in the Baroque spirit, Caravaggio has chosen the exact moment when Saul was thrown from his horse. He lies flat on his back, his arms flailing in space as he struggles with the shock of the episode as well as his resultant blindness. He looks as if he is about to be trampled by his horse, but the animal is held and calmed by the strong hands of an unknown man. The piercing light of God flashes upon an otherwise dark scene, picking out certain forms while casting others into the night. This exaggerated chiaroscuro is attributed to Caravaggio and

14–13 CARAVAGGIO
The Conversion of St. Paul (1600–01)
Oil on canvas. 90 x 69".
Santa Maria del Popolo, Rome.

A CLOSER LOOK

Caravaggio's Police Blotter: The Art of Violence

One of Caravaggio's major works is *The Conversion of St. Paul*, which captures the apostle at a moment when he renounces violence, recognizing the error of his ways. It is rather ironic that the artist's own life showed a pattern of increasing violence, such that he acquired a lengthy police record in Rome. Between 1600 and 1606 he was arrested for: attacking a man with a sword, disrespect toward a police officer, carrying weapons without a permit, breaking windows, assaulting a waiter, and wounding a man following an argument about a prostitute. He fled Rome in 1606, after killing a man during an argument about a tennis match. Exile from Rome did not quite lead to reform, however: A few years later he was forced to flee Messina after attacking a teacher who accused him of molesting schoolchildren.

has been called **tenebrism,** or "dark manner." Tenebrism, which usually involved one very small source of light and evoked a harsh realism or naturalism in the figures, profoundly influenced Baroque artists elsewhere in Europe, including France and Spain.

ARTEMISIA GENTILESCHI

Among the foremost of Caravaggio's contemporaries was Artemisia Gentileschi (1593–c. 1652), the daughter of a successful artist who recognized her talent and sent her to study with Agostino Tassi, a well-known fresco painter. Tassi seduced and raped Artemisia, and, when he refused to marry her, Artemisia's father sued him. During the trial, Artemisia was subjected to the "lie detector" of thumbscrews on the witness stand, and at one point she shouted to Tassi, "Is this the wedding ring you promised me?" The case was ultimately dismissed.

Artemisia developed a dramatic and passionate Baroque style and, after her marriage to a Florentine, brought this expressive style to her adopted city. One of the most successful—and violent—paintings of her Florentine period is based on the Old Testament story of the heroine *Judith Decapitating Holofernes* (Fig. 14–14) at night after stealing into the camp of the tyrant. Artemisia painted many pictures of Judith, and it is tempting to see in them a working out of the hostility the artist surely experienced toward her own assailant. In this painting the artist pulls no punches. There is no way for the viewer to escape the graphic violence. The forms of the figures are all placed in the foreground and dramatically lit. The head, the sword, and Judith's powerful hands meet at the center of the dynamic composition. There the arms of the three participants also interact dramatically, thrusting in different directions. Judith's arms are not the arms of a delicate damsel, but of a sturdy warrior, lending further credibility to the action in the work. All of this takes place upon the firm "pedestal" of Holofernes's bed, which ought to provide for rest, not murder.

14–14 ARTEMISIA GENTILESCHI
Judith Decapitating Holofernes (c. 1620). Oil on canvas.
Uffizi Gallery, Florence

BAROQUE CEILING DECORATION

We cannot leave Baroque painting without discussing the advances that had been made in the art of ceiling decoration. The Baroque interest in combining the arts of painting, sculpture, and architecture found its home in the naves and domes of churches and cathedrals, as artists used the three media to create an unsurpassed illusionistic effect. Unlike Renaissance ceiling painting, as exemplified by Michelangelo's decoration for the Sistine Chapel, the space was not divided into "frames" that were then filled with individual scenes. Rather, the Baroque artist created the illusion of a ceiling vault open to the heavens with figures flying freely in and out of the church (Fig. 14–15). Columns and other architectural supports appeared to rise into the sky through *painted* extensions of their vertical lines.

14–15 PIETRO DA CORTONA *The Triumph of the Barberini* (1633–39)
Ceiling fresco.

Grand Salon, Barberini Palace, Rome.

Saints and angels, dynamically painted, also flew between columns or hovered above archways. These artists, and their patrons, spared no illusionistic device to create a total, mystical atmosphere.

FRANCESCO BORROMINI

Although it is hard to imagine an architect incorporating the Baroque elements of motion, space, and light in buildings, this was accomplished by the great seventeenth-century architect Francesco Borromini (1599–1667). His San Carlo alle Quattro Fontane (Fig. 14–16) shows that the change from Renaissance to Baroque architecture was one from the static to the organic. Borromini's façade undulates in implied movement complemented by the concave entablatures of the bell towers on the roof. Light plays across the plane of the façade, bouncing off the engaged columns while leaving the recessed areas in darkness. The stone seems to breathe because of the **plasticity** of the design and the innovative use of light and shadow. The interior is equally alive, consisting of a large oval space surrounded by rippling concave and convex walls. For the first time since we examined the Parthenon (Fig. 11–8) do we appreciate a building first as sculpture and only second as architecture.

14–16 FRANCESCO BORROMINI
San Carlo alle Quattro Fontane, Rome (1665–67)

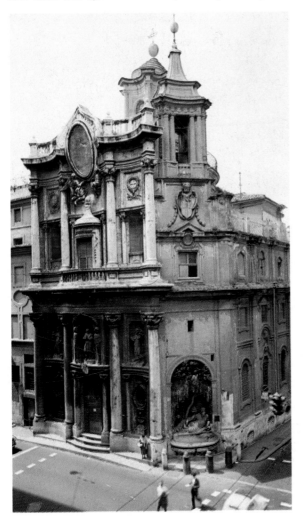

THE BAROQUE PERIOD OUTSIDE OF ITALY

Baroque characteristics were found in the art of other areas of Europe also. Artists of Spain and Flanders adopted the Venetian love of color, and with their application of paint in loosely brushed swaths, they created an energetic motion in their compositions. Northern artists had always been interested in realism, and during the Baroque period they carried this emphasis to an extreme and used innovative pictorial methods to that end. Paintings of everyday life and activities became the favorite subjects of Dutch artists, who followed in Bruegel's footsteps and perfected the art of genre painting. The Baroque movement also extended into France and England, but there it often manifested itself in a strict adherence to Classicism. The irregularity of styles suggested by the term "baroque" is again apparent.

Spain

Spain was one of the wealthiest countries in Europe during the Baroque era—partly because of the influx of riches from the New World—and the Spanish court was lavish in its support of the arts. Painters and sculptors were imported from different parts of Europe for royal commissions, and native talent was cultivated and treasured.

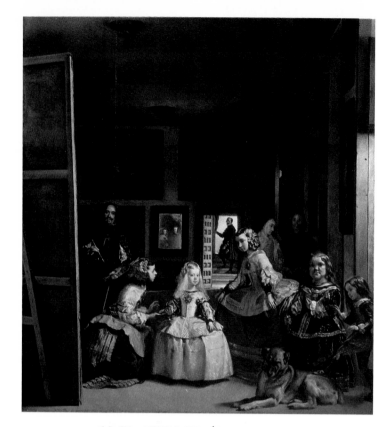

14–17 DIEGO VELÁSQUEZ
Las Meninas (*The Maids of Honor*) (1656).
Oil on canvas. 10'5" x 9'¾".
Prado Museum, Madrid.

14–18 DIEGO VELÁSQUEZ
Las Meninas (detail)

DIEGO VELÁSQUEZ

Diego Velásquez (1599–1660) was born in Spain and rose to the position of court painter and confidant of King Philip IV. Although Velásquez relied on Baroque techniques in his use of Venetian colors, highly contrasting lights and darks, and a deep, illusionistic space, he had contempt for the idealized images that accompanied these elements in the Italian art of the period. Like Caravaggio, Velásquez preferred to use common folk as models to assert a harsh realism in his canvases. Velásquez brought many a mythological subject down to earth by portraying ordinary facial types and naturalistic attitudes in his principal characters. Nor did he restrict this preference to paintings of the masses. Velásquez adopted the same genre format in works involving the royal family, such as the famous *Las Meninas* (Fig. 14–17). The huge canvas is crowded with figures engaged in different tasks. *Las meninas*, "the maids in waiting," are attending the little princess Margarita,

who seems dressed for a portrait-painting session. She is being entertained by the favorite members of her entourage, including two dwarfs and an oversized dog. We suspect that they are keeping her company while the artist, Velásquez, paints before his oversized canvas.

Is Velásquez, in fact, supposed to be painting exactly what we see before us? Some have interpreted the work in this way. Others have noted that Velásquez would not be standing behind the princess and her attendants if he were painting them. Moreover, on the back wall of his studio, we see the mirror images of the king and queen standing next to one another with a red drape falling behind. Since we do not actually see them in the flesh, we may assume that they are standing in the viewer's position, before the canvas and the artist. Is the princess being given a few finishing touches before joining her parents in a family portrait? We cannot know for sure. The reality of the scene has been left a mystery by Velásquez, just as has the identity of

the gentleman observing the scene from an open door in the rear of the room. It is interesting to note the prominence of the artist in this painting of royalty. It makes us aware of his importance to the court and to the king in particular. Recall the portrait of Raphael in *The School of Athens* (Fig. 13–26). Raphael's persona is almost furtive by comparison.

Velásquez pursued realism in technique as well as in subject matter. Building upon the Venetian method of painting, Velásquez constructed his forms from a myriad of strokes that captured the light exactly as it played over different surface textures. Upon close examination of his paintings (Fig. 14–18), we find small and separate strokes that hover on the surface of the canvas, divorced from the very forms they are meant to describe. Yet from a few feet away, together they evoke an overall *impression* of silk or fur or flowers. This dissolution of forms into small, roughly textured brushstrokes that recreate the play of light over surfaces would be the foundation of a movement called **Impressionism** some two centuries later. In his pursuit of realism, Velásquez truly was an artist before his time.

Flanders

After the dust of Martin Luther's Reformation had settled, the region of Flanders was divided. The northern sections, now called the Dutch Republic (present-day Holland), accepted Protestantism, while the southern sections, still called Flanders (present-day Belgium), remained Catholic. This separation more or less dictated the subjects that artists rendered in their works. Dutch artists painted scenes of daily life, carrying forward the tradition of Bruegel, while Flemish artists continued painting the religious and mythological scenes already familiar to us from Italy and Spain.

Peter Paul Rubens

Even the great power and prestige held by Velásquez were exceeded by the Flemish artist Peter Paul Rubens (1577–1640). One of the most sought-after artists of his time,

Rubens was an ambassador, diplomat, and court painter to dukes and kings. He ran a bustling workshop with numerous assistants to help him complete commissions. Rubens's style combined the sculptural qualities of Michelangelo's figures with the painterliness and coloration of the Venetians. He also emulated the dramatic chiaroscuro and theatrical presentation of subject matter we found in the Italian Baroque masters. Much as had Dürer, Rubens admired and adopted from his southern colleagues. Although Rubens painted portraits, religious subjects, mythological themes, as well as scenes of adventure, his canvases were always imbued with the dynamic energy and unleashed passion we link to the Baroque era.

In *The Rape of the Daughters of Leucippus* Fig. 14–19), Rubens recounted a tale from Greek mythology in which two mortal women were seized by the twin sons of Zeus, Castor and Pollux. The action in the

14–19 PETER PAUL RUBENS
The Rape of the Daughters of Leucippus (1617).
Oil on canvas. 7'3" x 6'10".
Alte Pinakothek, Munich.

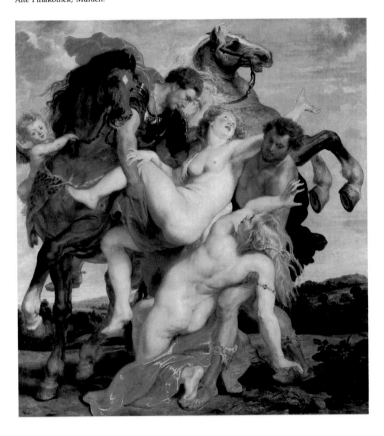

Rubens, Inc.

A rose by any other name may smell as sweet, but would a Rubens painted by any other artist still be a Rubens?

Peter Paul Rubens may have been a masterful Flemish artist, respected diplomat, and dashing man-about-the-courts, but he was also a shrewd and efficient business-man whose activities pressed far beyond painting. In addition to his many important commissions, according to art historian Julius Held, Rubens ran an active workshop and trained engravers to reproduce his paintings. He executed sketches for tombs and altars and architectural decoration. He made illustrations for the title pages of books and even planned his own text on ancient cameos. The artist also found time to write on architectural drawings and on the imitation of ancient sculptures. It is no small wonder, then, that Rubens had to employ assistants to work on his paintings in order to meet the demands of his patrons.

Certain questions arise concerning employing artists for this reason. For example, was Rubens justified in calling his own the many compositions produced by assistants in his workshops—just because he had added a few finishing touches? Which is more important, the concept of a painting or its execution? Are there works in museums painted by Rubens's assistants but credited to the master himself? Does the actual identity of the artist matter? If these works are so close to the master's style that they confuse even the connoisseurs, should they be accepted as his?

Some of these questions are more easily answered than others. Rubens ran a tightly controlled workshop. His assistants were trained to follow the master's style in every aspect—from compositional structure to simple brush gesture. Before a commissioned work left the shop, Rubens apparently went over the canvas, adding touches here and there to make the work his own. Furthermore, Rubens felt strongly that the conception of a picture was more important than its execution. So even though the process was carried out by assistants, the concept was that of the master.

It may be of interest to ask whether Rubens's use of assistants was similar to that of the contemporary artist whose heavy steel sculptures are crafted by factory workers according to the artist's blueprints. In both instances, the concept is the artist's but the execution is, at least in part, the assistant's. Does it matter who applied the brushstroke or who poured the molten metal? When should the artist share the credit with assistants? What do you think?

composition is described by the intersection of strong diagonals and verticals that stabilize the otherwise unstable composition. Capitalizing on the Baroque "stop-action" technique, which depicts a single moment in an event, Rubens placed his struggling, massive forms within a diamond-shaped structure that rests in the foreground on a single point—the toes of a single man and woman. Visually, we grasp that all this energy cannot be supported on a single point, so we infer continuous movement. The action has been pushed up to the picture plane, where the viewer is confronted with the intense emotion and brute strength of the scene. Along with these Baroque devices, Rubens used color and texture much in the way the Venetians used it. The virile sun-tanned arms of the abductors contrast strongly with the delicately colored flesh

of the women. The soft blonde braids that flow outward under the influence of all of this commotion correspond to the soft, flowing manes of the overpowering horses.

Holland

The grandiose compositional schemes and themes of action executed by Rubens could not have been further removed from the concerns and sensibilities of most seventeenth-century Dutch artists. Whereas mysticism and religious naturalism flourished in Italy, Flanders, and Spain amidst the rejection of Protestantism and the invigorated revival of Catholicism, artists of the Low Countries turned to secular art, abiding by the Protestant mandate that man not create "false idols." Not only did artists turn to scenes of everyday life, but the collectors of art were themselves everyday folk. In the Dutch quest for the establishment of a middle class, aristocratic patronage was lost and artists were forced to "peddle" their wares in the free market. Landscapes, still lifes, and genre paintings were the favored canvases, and realism was the word of the day. Although the subject matter of Dutch artists differed radically from that of their colleagues elsewhere in Europe, the spirit of the Baroque, with many, if not most, of its artistic characteristics, was present in their work.

REMBRANDT VAN RIJN

The golden-toned, subtly lit canvases of Rembrandt van Rijn (1606–1669) possess a certain degree of timelessness. Rembrandt concentrates on the personality of the sitter or the psychology of a particular situation rather than on surface characteristics. This introspection is evident in all of Rembrandt's works, whether religious or secular in subject, landscapes or portraits, drawings, paintings, or prints.

Rembrandt painted a great number of self-portraits that offer us an insight into his life and personality. In a self-portrait at the age of 46 (Fig. 14–20), Rembrandt paints an image of himself as a self-confident, well-respected, and sought-after artist

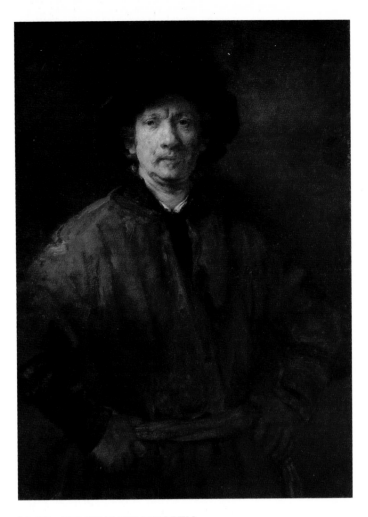

14–20 REMBRANDT VAN RIJN
Self-Portrait (1652)
Oil on canvas. 45 x 32".
Kunsthistorisches Museum, Vienna.

who stares almost impatiently out toward the viewer. It is as if he had been caught in the midst of working and will allow us only a moment. It is a powerful image, with piercing eyes, thoughtful brow, and determined jaw that betray a productive man who is more than satisfied with his position in life. All of this may seem obvious, but notice how few clues he gives us to reach these conclusions about his personality. He stands in an undefined space with no props that reveal his identity. The figure itself is cast into darkness; we can hardly discern his torso and hands resting in the sash around his waist. The penetrating light in the canvas is reserved for just a portion of the artist's face. Rembrandt gives us a minute fragment with which he beckons us to complete the whole. It is at once a mysteri-

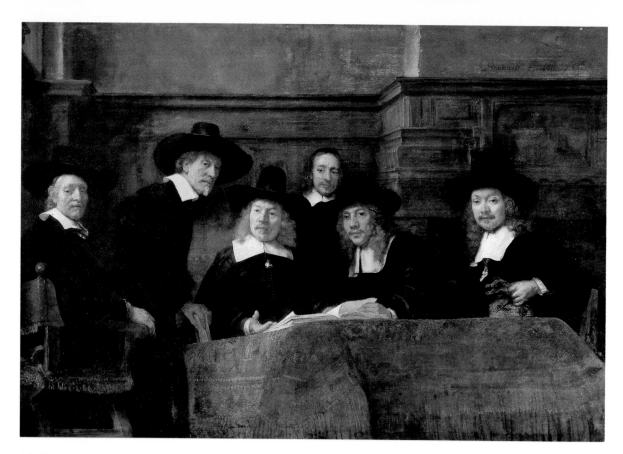

14–21 REMBRANDT VAN RIJN *Syndics of the Drapers' Guild* (1661–62)
Oil on canvas. 72⅞ x 107⅞".

Rijksmuseum, Amsterdam.

14–22 REMBRANDT VAN RIJN
Resurrection of Christ. Oil on canvas. 91.9 x 67 cm.

Alte Pinakothek, Munich

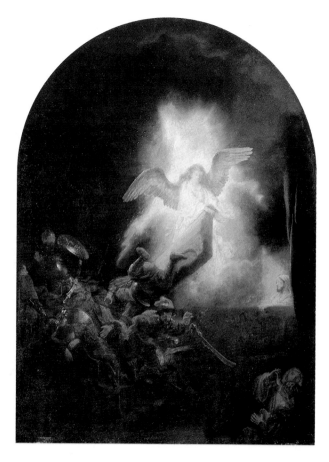

ous and revealing portrayal that relies on a mysterious and revealing light.

Rembrandt also painted large group portraits. In his *Syndics of the Drapers' Guild* (Fig. 14–21), which you may recognize from the cover of Dutch Masters Cigar boxes, we, the viewers, become part of a scene involving Dutch businessmen. Bathed in the warm light of a fading sun that enters the room through a hidden window to the left, the men appear to be reacting to the entrance of another person. Some rise in acknowledgment. Others seem to smile. Still others gesture to a ledger as if to explain that they are gathering to "go over the books." Even though the group operates as a whole, the portraits are highly individualized and themselves complete. As in his self-portrait, Rembrandt concentrates his light on the heads of the sitters, from which we, the viewers, gain insight into their personalities. The haziness that surrounds Rembrandt's figures is born from his brushstroke and his use of light. Rembrandt's strokes

are heavily loaded with pigment and applied in thick **impasto.** As we saw in the painterly technique of Velásquez, Rembrandt's images are more easily discerned from afar than from up close. As a matter of fact, Rembrandt is reputed to have warned viewers to keep their "nose" out of his painting because the smell of paint was bad for them. We can take this to mean that the technical devices Rembrandt used to create certain illusions of realism are all too evident from the perspective of a few inches. Above all, Rembrandt was capable of manipulating light. His is a light that alternately constructs and destructs, that alternately bathes and hides from view. It is a light that can be focused as unpredictably, and that shifts as subtly, as the light we find in nature.

Rembrandt's *The Resurrection of Christ* (Fig. 14–22) is vastly different from the rendering of the same subject by the Renaissance artist Piero della Francesca (Fig. 13–20). Piero's vision is the model of restraint. Christ is risen, calm, and stately; the soldiers sleep; and the genetic imperatives of nature follow the precise mathematical precepts of the artist. Rembrandt's Christ is rising amidst the tumult and fury of the Baroque universe. Here too there is a figure triangle—but what a difference in the figures. An angel at the apex, born of an unwordly light, pulls back the lid of the sepulchre, unleashing forces that blast away the soldiers in attendance. Piero's figures seemed to pose for the rendering, whereas Rembrandt chose to capture a fleeting, dynamic moment.

Although Rembrandt was sought after as an artist for a good many years and was granted many important commissions, he fell victim to the whims of the free market. The grand master of the Dutch Baroque died at the age of 63, out of fashion and penniless.

JAN VERMEER

If there is a single artist who typifies the Dutch interest in painting scenes of daily life, the commonplace narratives of middle-class men and women, it is Jan Vermeer (1632–1675). Although he did not paint many pictures and never strayed from his native Delft, his precisely sketched and pleasantly colored compositions made him well respected and influential in later centuries.

Young Woman with a Water Jug (Fig. 14–23) exemplifies Vermeer's subject matter and technique. In a tastefully underfurnished corner of a room in a typical middle-class household, a woman stands next to a rug-covered table, grasping a water jug with one hand and, with the other, opening a stained glass window. A blue cloth has been thrown over a brass and leather chair, a curious metal box sits on the table, and a map adorns the wall. At once we are presented with opulence and simplicity. The elements in the composition are perfectly placed. One senses that their position could not be moved even a fraction of an inch without disturbing the composition. Pure colors and crisp lines grace the space in the painting rather than interrupting it. Every item in the painting is of a simple, almost

14–23 JAN VERMEER
Young Woman with a Water Jug (c. 1665)
Oil on canvas. 18 x 16".

The Metropolitan Museum of Art, N.Y. Gift of Henry G. Marquand, 1889. Marquand Collection.

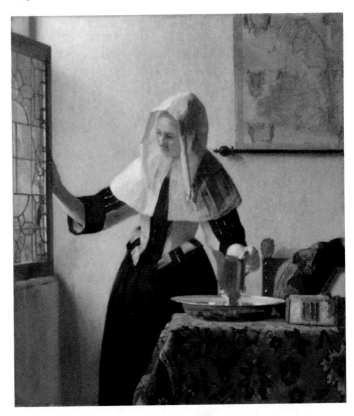

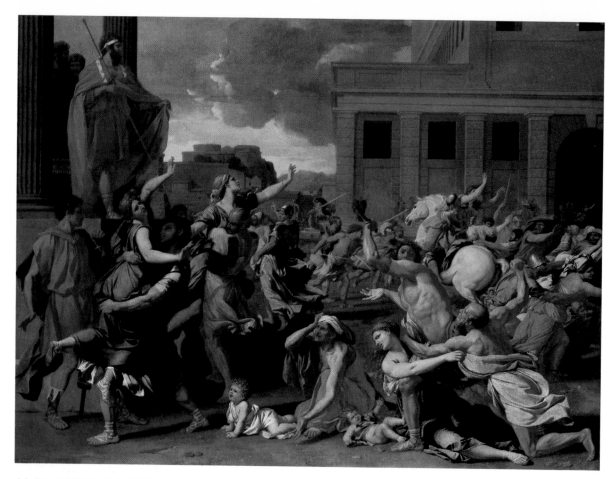

14–24 NICOLAS POUSSIN *The Rape of the Sabine Women* (c. 1636–37)
Oil on canvas. 60⅞ x 82⅝".

timeless, form and corresponds to the time-less serenity of the porcelainlike image of the woman. Her simple dress and starched collar and bonnet epitomize grace and serenity. We might not see this as a Baroque composition if it were not for three things: a single source of light bathing the elements in the composition, the genre subject, and a bit of mystery surrounding the moment captured by Vermeer. What is the woman doing? She has opened the window and taken a jug into her hand at the same time, but we will never know for what purpose. Some have said that she may intend to water flowers at a window box. Perhaps she was in the midst of doing something else and paused to investigate a noise in the street. Vermeer gives us a curious combination of the momentary and the eternal in this almost photographic glimpse of everyday Dutch life.

France

During the Baroque period, France, under the reign of the "sun king," Louis XIV, began to replace Rome as the center of the art world. The king preferrred Classicism. Thus did the country, and painters, sculptors, and architects alike created works in this vein. Louis XIV guaranteed adherence to Classicism by forming academies of art that perpetuated this style. These academies were art schools of sorts, run by the state, whose faculties were populated by leading proponents of the Classical style.

When we examine European art during the Baroque period, we thus perceive a strong stylistic polarity. On the one hand, we have the exuberant painterliness and high drama of Rubens and Bernini, and, on the other, a reserved Classicism that hearkens back to Raphael.

The principal exponent of the Classical style in French painting was Nicolas Poussin (1594–1665). Although he was born in France, Poussin spent much of his life in Rome, where he studied the works of the Italian masters, particularly Raphael and Titian. Although his *Rape of the Sabine Women* (Fig. 14–24) was painted four years before he was summoned back to France by the king, it illustrates the Baroque Classicism that Poussin would bring to his native country. The flashy dynamism of Bernini and Rubens gives way to a more static, almost staged, motion in the work of Poussin. Harshly sculptural, Raphaelesque figures thrust in various directions, forming a complex series of intersecting diagonals and verticals. The initial impression is one of chaos, of unrestrained movement and human anguish. But as was the case with the Classical Greek sculptors and Italian Renaissance artists, emotion is always balanced carefully with restraint. For example, the pitiful scene of the old woman in the foreground, flanked by crying children, forms part of the base of a compositional triangle that stabilizes the work and counters excessive emotion. If one draws a vertical line from the top of her head upward to the top border of the canvas, one encounters the apex of this triangle, formed by the swords of two Roman abductors. The sides of the triangle, then, are formed by the diagonally thrusting torso of the muscular Roman in the right foreground, and the arms of the Sabine women on the left, reaching hopelessly into the sky.

This compositional triangle, along with the Roman temple in the right background that prevents a radically receding space, are Renaissance techniques for structuring a balanced composition. Poussin used these, along with a stagelike, theatrical presentation of his subjects, to reconcile the divergent styles of the harsh Classical and the vibrant Baroque.

Polar opposites in style occur in other movements throughout the history of art. It will be important to remember this aspect of the Baroque, because in later centuries we will encounter the polarity again, among artists who divide themselves into the camps **Poussiniste** and **Rubeniste**.

VERSAILLES

The king's taste for the Classical extended to architecture, as seen in the Palace at Versailles (Fig. 14–25). Originally the site of the king's hunting lodge, the palace and surrounding area just outside of Paris were converted by a host of artists, architects, and landscape designers into one of the grandest monuments to the French Baroque. In their tribute to Classicism, the architects Louis Le Vau (1612–1670) and Jules Hardouin-Mansart (1646–1708) divided the horizontal sweep of the façades into three stories. The structure was then divided vertically into three major sections, and these were in turn subdivided into three additional sections. The windows march along the façade in a rhythmic beat accompanied by rigid pilasters that are wedged between the strong horizontal bands that delineate the floors.

14–25 LOUIS LE VAU and JULES HARDOUIN-MANSART Garden Front, Palace of Versailles (1669–85)

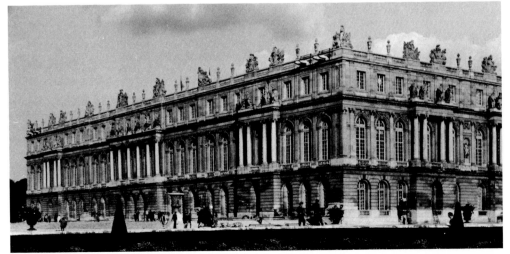

A **balustrade** tops the palace, further emphasizing the horizontal sweep while restraining any upward movement suggested by the building's vertical members. The divisions into Classically balanced threes and the almost obsessive emphasis on the horizontal echo the buildings of Renaissance architects. The French had come a long way from the towering spires of their glorious Gothic cathedrals!

THE ROCOCO

We have roughly dated the Baroque period from 1600 to 1750. However, art historians have recognized a more distinct style within the Baroque that began shortly after the dawn of the eighteenth century. This **Rococo** style strayed further from Classical principles than did the Baroque. It is more ornate and characterized by sweetness, gaity, and light. The courtly pomp and reserved Classicism of Louis XIV were replaced with a more delicate and sprightly representation of the leisure activities of the upper class.

The early Rococo style appears as a refinement of the painterly Baroque in which Classical subjects are often rendered in wispy brushstrokes that rely heavily on the Venetian or Rubensian palette of luscious golds and reds. The later Rococo period, following midcentury, is more frivolous in its choice of subjects (that of love among the very rich), palette (that of the softest pastel hues), and brushwork (the most delicate and painterly strokes).

JEAN-HONORÉ FRAGONARD

Jean-Honoré Fragonard (1732–1806) is one of the finest representatives of the Rococo style, and his painting *Happy Accidents of the Swing* (Fig. 14–26) is a prime example of the aims and accomplishments of the Rococo artist. In the midst of a lush green park, whose opulent foliage was no doubt inspired by the Baroque, we are offered a glimpse of the "love games" of the leisure class. A young, though not-so-innocent, maiden, with petticoats billowing beneath her sumptuous pink dress, is being swung by an unsuspecting bishop high over the head of her reclining gentleman friend, who seems delighted with the view. The subjects' diminutive forms and rosy cheeks make them doll-like, an image reinforced by the idyllic setting. This is eighteenth-century life at its best—pampered by subtle hues, embraced by lush textures, and bathed by the softest of lights. Unfortunately, this was all a mask for life at its worst. As the ruling class continued to ignore the needs of the common people, the latter were preparing to rebel.

14–26 JEAN-HONORÉ FRAGONARD
Happy Accidents of the Swing (1767)
Oil on canvas. 31⅞ x 25⅜".

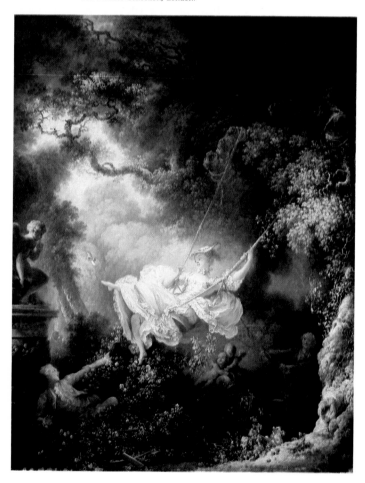

Whereas Rembrandt epitomizes the artists who achieves recognition after death, Elisabeth Vigée-Lebrun (1755–1842) was a complete success during her lifetime. The daughter of a portrait painter, she received instruction and encouragement from her father and his colleagues from an early age. As a youngster she also studied paintings in the Louvre and was particularly drawn to the works of Rubens. By the time she reached her early twenties, she commanded high prices for her portraits and was made an official portrait painter for Marie Antoinette, the Austrian wife of Louis XVI. Neither Marie Antoinette nor her husband survived the French Revolution, but Vigée-Lebrun's fame spread throughout Europe, and by the end of her career she had created some 800 paintings.

Marie Antoinette and Her Children (Fig. 14–27) was painted nearly a decade after Vigée-Lebrun had begun to paint the royal family. In this work she was commissioned to counter the anti-monarchist sentiments spreading throughout the land by portraying the queen as, first and foremost, a loving mother. True, the queen is set within the imposing Salon de la Paix at Versailles, with the famous Hall of Mirrors to the left and the royal crown atop the cabinet on the right. True, the queen's enormous hat and voluminous skirts create a richness and monumentality to which the common person could not reasonably aspire. But the triangular composition and the child on the lap are reminiscent of Renaissance images of the Madonna and child (see Chapter 13), at once creating a sympathetic portrait of a mother and her children and, subliminally, asserting their divine right. Even amid the opulence at Versailles, Marie Antoinette displays her children as her real jewels. The young dauphin to the right, set apart as the future king, points to an empty cradle that might have originally contained the queen's fourth child, an infant who died

14–27 ELISABETH VIGÉE-LEBRUN
Marie Antoinette and Her Children (1781)
Oil on canvas. 8'8" x 6'10".
Palace of Versailles

two months before the painting was scheduled for exhibition.

The French populace, of course, was not persuaded by this portrait or by other public relations efforts to paint the royal family as accessible and sympathetic. The artist, in fact, did not exhibit her painting as scheduled for fear that the public might destroy it. Two years after the painting was completed, the convulsions of the French Revolution shook Europe and the world. The royal family were imprisoned and then executed. More than the royal family had passed into history, and more than democracy was about to be born. Modern art was also to be ushered into this brave new world.

15

Modern Art

Historians of modern art have repeatedly posed the question, "When did modern art begin?" Some link the beginnings of modern painting to the French Revolution in 1789. Others have chosen 1863, the year of a landmark exhibition of "modern" painting in Paris.

Another issue of interest has been, "Just what is modern about modern art?" The artists of the mid-fifteenth century looked upon their art as modern. They chose new subjects, materials, and techniques that signaled a radical change from a medieval past. Their development of one-point linear perspective altered the face of painting completely. From our perspective, modern art begins with the changes in the representation of space introduced by artists of the late-eighteenth century. Unlike the Renaissance masters, who sought to open up endless vistas within the canvas, the artists of the latter 1700s brought all of the imagery to the picture plane. The flatness or two-dimensionality of the canvas surface

was asserted by use of **planar recession** rather than **linear recession.** Not all artists of the eighteenth and nineteenth centuries abided by this novel treatment of space, but with this innovation the die was cast for the future of painting.

In short, what was *modern* about the modern art of the eighteenth century in France was its concept of space. In a very real sense, the history of modern art is the history of two differing perceptions and renderings of that space.

As we shall see in this chapter, the first period of modern art to use planar recession was *Neoclassicism*. We shall also examine its contemporaneous, though often contrary movement, *Romanticism*. We shall discuss the survival of Academic painting in the nineteenth century and address the use of art for political purposes. At mid-nineteenth century we shall witness the rise of a group of **bohemian** artists whose painting of optical impressions stood as the scandal of the age and the legacy to the future. Although we shall focus our attention on Paris and its surroundings—the center of the art world during these dynamic years—we shall glance at contemporaneous trends in Germany and in the United States.

The emphasis in this chapter will be on painting, the medium in which modernism made its greatest strides.

NEOCLASSICISM

Modern art declared its opposition to the whimsy of the late Rococo style with **Neoclassicism.** The Neoclassical style is characterized by harsh sculptural lines, a subdued palette, and, for the most part, planar instead of linear recession into space. The subject matter of Neoclassicism was inspired by the French Revolution and designed to heighten moral standards. The new morality sought to replace the corruption and decadence of Louis XVI's France. The Roman Empire was often chosen as the model to emulate. For this reason, the artists of the Napoleonic era imitated the form and content of Classical works of art. This interest

in antiquity was fueled by contemporaneous archeological finds at sites such as Pompeii as well as by numerous excavations in Greece.

JACQUES-LOUIS DAVID

The sterling proponent of the Neoclassical style and official painter of the French Revolution was Jacques-Louis David (1748–1825). David literally gave postrevolutionary France a new look. He designed everything from clothing to coiffures. David also set the course for modern art with a sudden and decisive break from the ornateness and frivolity of the Rococo.

In *The Oath of the Horatii* (Fig. 15–1), David portrayed a dramatic event from Roman history in order to heighten French patriotism and courage. Three brothers prepare to fight an enemy of Rome, swearing an oath to the Empire on swords upheld by their father. To the right, their mother and other relatives collapse in despair. They weep for the men's safety but are also distraught because one of the enemy men is engaged to be married to a sister of the Horatii. Family is pitted against family in a conflict that no one can win. Such a subject could descend into pathos, but David controlled any tendency toward sentimentality by reviving the Classical balance of emotion and restraint. The emotionality of the theme is countered by David's cool rendition of forms. The elements of the composition further work to harness emotionalism. Harsh sculptural lines define the figures and setting. The palette is reduced to muted blues and grays, with an occasional splash of deep red. Emotional response is barely evident in the idealized Classical faces of the figures.

A number of Classical devices in David's compositional format also function to balance emotion and restraint. The figural groups form a rough triangle. Their apex—the clasped swords of the Horatii—is the most important point of the composition. In the same way that Leonardo used three windows in his *Last Supper*, David silhouetted his dramatic moment against the central opening of three arches in the background. David further imitated Renaissance canvases by presenting cues for a linear per-

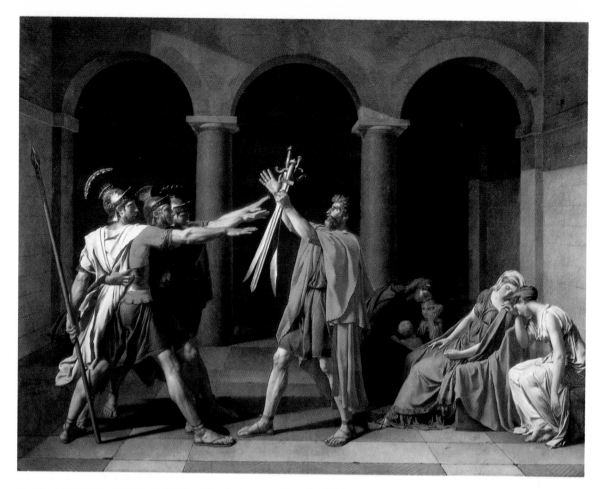

15–1 JACQUES-LOUIS DAVID *The Oath of the Horatii* (1784)
Oil on canvas. 14' x 11'.
Louvre Museum, Paris.

spective in the patterning of the floor. But unlike sixteenth-century artists, David led his orthogonals into a flattened space instead of a vanishing point on a horizon line. The closing off of this background space forces the viewer's eye to the front of the picture plane, where it encounters the action of the composition and the canvas surface itself. No longer does the artist desire to trick observers into believing they are looking through a window frame into the distance. Now the reality of the two-dimensionality of the canvas is asserted.

David was one of the leaders of the French Revolution, and his political life underwent curious turns. Although he painted *The Oath of the Horatii* for Louis XVI, he supported the faction that deposed him. Later he was to find himself painting a work commemorating the coronation of Napoleon. Having struggled against the French monarchy and

then living to see it restored, David chose to spend his last years in exile in Brussels.

Jean-Auguste-Dominique Ingres

David abstracted space by using planar rather than linear recession. His most prodigious student, Jean-Auguste-Dominique Ingres (1780–1867), created sensuous, though pristinely Classical compositions in which line functions as an abstract element. Above all else, Ingres was a magnificent draftsman.

Ingres's work is a combination of harsh linearity and sculptural smoothness on the one hand, and delicacy and sensuality on the other. His *Grande Odalisque* (Fig. 15–2) portrays a Turkish harem mistress in the tradition of the great reclining Venuses of the Venetian Renaissance. Yet how different it is, for example, from Titian's *Venus of Ur-*

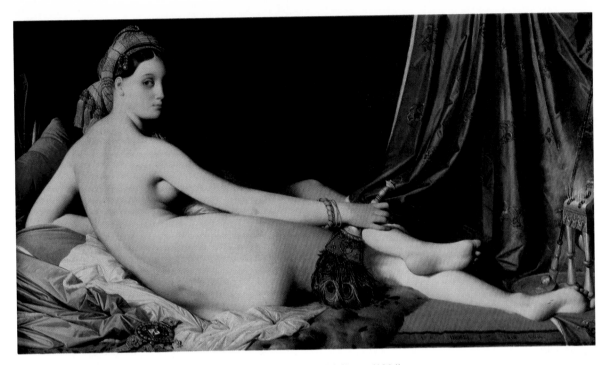

15–2 JEAN-AUGUSTE-DOMINIQUE INGRES *Grande Odalisque* (1814).
Oil on canvas. 35¼ x 63¾".
Louvre Museum, Paris.

bino (Fig. 14–1)! The elongation of her spine, her attenuated limbs, and odd fullness of form recall the distortions and abstractions of Mannerist art. In the *Grande Odalisque,* Ingres also delights in the differing qualities of line. The articulation of heavy drapery contrasts markedly with the staccato treatment of the bed linens and the languid, sensual lines of the mistress's body. Like David's, Ingres's forms are smooth and sculptural, and his palette is muted. Ingres also flattens space in his composition by placing his imagery in the foreground, as in a relief.

Ingres's exotic nudes were a popular type of imagery in the late eighteenth century, but such subjects were often rendered quite differently by other artists. There was a polarity of style during this period that was similar to that existing during the Baroque era. On the one hand were artists such as David and Ingres, who represented the linear style. On the other hand were artists whose works were painterly. The foremost proponents of the painterly style were Géricault and Delacroix. The linear artists, called **Poussinistes,** followed in the footsteps of Classicism with their subdued palette and emphasis on draftsmanship and sculptural

forms. The painterly artists, termed the **Rubenistes,** adopted the vibrant palette and aggressive brushstroke of the Baroque artist. The two factions argued vehemently about the merits of their own style and the shortcomings of the other. No artists were more deeply entrenched in this feud than the leaders of both camps, Ingres and Delacroix. Such was the state of art at the turn of the nineteenth century.

ROMANTICISM

Both Neoclassicism and **Romanticism** reflected the revolutionary spirit of the times. But whereas Neoclassicism emphasized restraint of emotion, purity of form, and subjects that inspired morality, Romantic art sought extremes of emotion enhanced by virtuoso brushwork and a brilliant palette. As a movement, Romanticism is not as easily defined as Neoclassicism. Artists classified as Romantic differed in style. Some were mirror images of the Baroque, and others were more abstracted. Still others dedicated themselves wholeheartedly to representing the passion of the French Revolution.

The most famous Rubeniste—and Ingres's archirival—was Eugène Delacroix (1798–1863). Whereas Ingres believed that a painting was nothing without drawing, Delacroix advocated the spontaneity of painting directly on canvas without the tyranny of meticulous preparatory sketches. Ingres believed that color ought to be subordinated to line, but Delacroix maintained that compositions should be constructed of color. Their continual verbal jousting was satirized in a contemporaneous caricature (Fig. 15–3), and their bitter words have been brought down to us in various letters.

One of Delacroix's most dynamic statements of the Romantic style occurs in one of his many compositions devoted to the more exciting themes from literary history. *The Death of Sardanapalus* (Fig. 15–4), inspired

15–3 Caricature of Delacroix and Ingres jousting in front of the Institut de France (after a 19th-century print).
Delacroix: "Line is color!"
Ingres: "Color is Utopia. Long live line!"

15–4 EUGÈNE DELACROIX *The Death of Sardanapalus* (1826). Oil on canvas. 12'11½" x 16'3".
Louvre Museum, Paris.

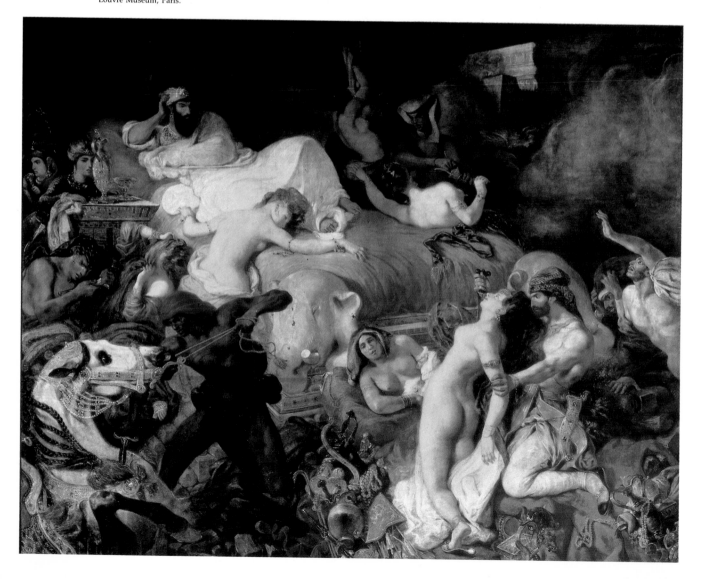

by a tragedy by Byron, depicts the murder-suicide of an Assyrian king who, rather than surrender to his attackers, set fire to himself and his entourage. All of the monarch's earthly possessions, including concubines, servants, and Arabian stallions, are heaped upon his lavish gold and velvet bed, now turned funeral pyre. The chaos and terror of the event is rendered by Delacroix with all the vigor and passion of a Baroque composition. The explicit contrast between the voluptuous women and the brute strength of the king's executioners brings to mind *The Rape of the Daughters of Leucippus* by Rubens (Fig. 14–19). Arms reach helplessly in all directions and backs arch in hopeless defiance or pitiful submission before the passive Sardanapalus. Delacroix's unleashed energy and assaulting palette were strongly criticized by contemporaries who felt that there was no excuse for such a blatant depiction of violence. But his use of bold colors and freely applied pigment, along with the observations on art and nature that he recorded in his journal, were an important influence on the young artists of the nineteenth century who were destined to transform artistic tradition.

FRANCISCO GOYA

Ironically, the man considered the greatest painter of the Neoclassical and Romantic periods belonged to neither artistic group. He never visited France, the center of the art world at the time, and was virtually unknown to painters of the late eighteenth and early nineteenth centuries. Yet his paintings and prints foreshadowed the art of the nineteenth-century **Impressionists.**

Francisco Goya (1746–1828) was born in Spain and, except for an academic excursion to Rome, spent his entire life there. He enjoyed a great reputation in his native country and was awarded many important commissions, including religious frescoes and portraits of Spanish royalty. But Goya is best known for his works with political overtones, ranging from social satire to savage condemnation of the disasters of war. One of his most famous depictions of war is *The Third of May, 1808* (Fig. 15–5). The painting commemorates the massacre of the peasant-citizens of Madrid after the city fell to the French. Reflecting the procedures of Velásquez and Rembrandt—two Baroque masters whom Goya acknowledged as influential in the development of his style—Goya focuses

15–5 FRANCISCO GOYA
The Third of May, 1808
(1814–15). Oil on canvas.
8′9″ x 13′4″.
Prado, Madrid.

the viewer's attention on a single moment in the violent episode. A Spaniard thrusts his arms upward in surrender to the bayonets of the faceless enemy. The brusqueness of the application of pigment corresponds to the harshness of the subject. The dutiful and regimented procedure of the executioners, dressed in long coats, contrasts visually and psychologically with the expressions of horror, fear, and helplessness on the faces of the ragtag peasants. The emotion is heightened by the use of acerbic tones and by a strong chiaroscuro that illuminates the pitiful victims while relegating all other details to darkness.

15–6 ADOLPHE WILLIAM BOUGUEREAU
Nymphs and Satyr (1873)
Oil on canvas. 102⅜ x 70⅞".
Sterling and Francine Clark Art Institute, Williamstown, Mass.

Goya devoted much of his life to the graphic representation of man's inhumanity to man. Toward the end of his life he was afflicted with deafness and plagued with bitterness and depression over the atrocities he had witnessed. These feelings were manifested in macabre paintings and lithographs which presaged the style of the great painters of the nineteenth century.

The Academy

Ingres's paintings spoke of a calm, though exotic Classicism. Delacroix retrieved the dynamism of the Baroque. Goya swathed his canvases with the spirit of revolution. Ironically, the style of painting that had the least impact on the development of modern art was the most popular type of painting in its day. This was **Academic art,** so called because its style and subject matter were derived from conventions established by the Académie Royale de Peinture et de Sculpture in Paris.

Established in 1648, the Academy had maintained a firm grip on artistic production for over two centuries. Many artists steeped in this tradition were followers rather than innovators, and the quality of their production left something to be desired. Some, however, like David and Ingres, worked within the confines of a style acceptable to the Academy but rose above the generally rampant mediocrity.

ADOLPHE WILLIAM BOUGUEREAU

One of the more popular and accomplished Academic painters was Adolphe William Bouguereau (1825–1905). Included among his oeuvre are religious and historical paintings in a grand Classical manner, although he is most famous for his meticulously painted nudes and mythological subjects. *Nymphs and Satyr* (Fig. 15–6) is nearly photographic in its refined technique and attention to detail. Four sprightly and sensuous wood nymphs corral a satyr and pull him into the water against his will. Their innocent playfulness would have appealed to the Frenchman on the street, although the saccharine character of the subject mat-

ter and the extreme lighthandedness with which the work was painted served only as a model against which the new wave of painters rebeled.

REALISM

The "modern" painters of the nineteenth century objected to Academic art on two levels: The subject matter did not represent life as it really was, and the manner in which the subjects were rendered did not reflect reality as it was observed by the naked eye.

The modern artists chose to depict subjects that were evident in everyday life. The way in which they rendered these subjects also differed from that of Academic painters. They attempted to render on canvas objects as they saw them—**optically**—rather than as they knew them to be—**conceptually.** In addition, they respected the reality of the medium they worked with. Instead of using pigment merely as a tool to provide an illusion of three-dimensional reality, they emphasized the two-dimensionality of the canvas and asserted the painting process itself. The physical properties of the pigments were highlighted. Artists who took these ideas to heart were known as the **Realists.** They include Honoré Daumier and two painters whose work stands on the threshold of the Impressionist movement: Gustave Courbet, and Edouard Manet.

HONORÉ DAUMIER

Of all of the modern artists of the mid-nineteenth century, Honoré Daumier (1880–1879) was perhaps the most concerned with bringing to light the very real subject of the plight of the masses. Daumier worked as a caricaturist for Parisian journals, and he used his cartoons to convey his disgust with the monarchy and contemporary bourgeois society. His public ridicule of King Louis Phillipe landed him in prison for six months.

Daumier is known primarily for his lithographs, which number some 4,000, although he was also an important painter. He brought to his works on canvas the technique and style of a caricaturist. Together, they make for a powerful rendition of his realistic subjects. One of Daumier's most famous compositions is *The Third Class Carriage* (Fig. 15–7), an illustration of a crowded third-class compartment of a French train.

15–7 HONORÉ DAUMIER
The Third-Class Carriage
(c. 1862). Oil on canvas.
25¾ x 35½".

The Metropolitan Museum of Art, N.Y.
Bequest of Mrs. H. O. Havemeyer,
1929. The H.O. Havemeyer Collection.

His caricaturist style is evident in the flowing dark outlines and exaggerated features and gestures, but it also underscores the artist's concern for the working class by advertising their ill fortune. The peasants are crowded into the car, their clothing poor and rumpled, their faces wide and expressionless. They contrast markedly with bourgeois commuters, whose felt top hats tower above their kerchiefed heads. It is a candid-camera depiction of these people. Wrapped up in their own thoughts and disappointments, they live their quite ordinary lives from day to day, without significance and without notice.

GUSTAVE COURBET

The term "realist," when it applies to art, is synonymous with Gustave Courbet (1819–1877). Considered to be the father of the Realist movement, Courbet used the term "realism" to describe his own work and even issued a manifesto on the subject. As was the case with many artists who broke the mold of the Academic style, Courbet's painting was shunned and decried by contemporary critics. But Courbet proceeded undaunted. After his paintings were rejected by the jurors of the 1855 **salon,** he set up his own pavilion and exhibited some forty of his own paintings. Such antics, as well as his commitment to realistic subjects and vigorous application of pigment, served as a strong model for the younger painters at midcentury who were also to rebel against the established Academic tradition in art.

Paintings such as *The Stone-Breakers* (Fig. 15–8) were the objects of public derision. Courbet was moved to paint the work after seeing an old man and a young boy breaking stones on a roadside. So common a subject was naturally criticized by contemporary critics who favored mythological or idealistic subjects. But Courbet, who was quoted as saying that he couldn't paint an angel because he had never seen one, continued in this vein despite the art world's rejection. It was not only the artist's subject matter, however, that the critics found offensive. They also spurned his painting technique. Although his choice of colors was fairly traditional—muted tones of brown and ochre—their quick application with a palette knife resulted in a coarsely textured surface that could not have been farther removed from the glossy finish of an Academic painting. Curiously, although Courbet believed that this type of painting was more realistic than that of the salons, in fact the reverse is closer to the truth. The Academic painter strove for what we would today consider

15–8 GUSTAVE COURBET
The Stone-Breakers (1849).
Oil on canvas. 63 x 102".

Formerly Staatliche Kunstsammlungen, Dresden (painting destroyed in World War II).

to be an almost photographically exact representation of the figure, while Courbet attempted quickly to jot down his impressions of the scene in an often spontaneous flurry of strokes. (For this reason, Courbet can be said to have foreshadowed the Impressionist movement, which we shall discuss in the next section.) Despite Courbet's advocacy of hard-core realism, the observer of *The Stone-Breakers* is presented ultimately with the artist's subjective view of the world.

Courbet's painting may have laid the groundwork for Impressionism, but he himself was not to be a part of the new wave. His old age brought conservatism, and with it disapproval of the younger generation's painting techniques. One of the targets of Courbet's derision was Edouard Manet (1832–1883). According to some art historians, Manet is the artist most responsible for changing the course of the history of painting.

Edouard Manet

What was modern about Manet's painting was his technique. Instead of beginning with a dark underpainting and building up to bright highlights—a method used since the Renaissance—Manet began with a white surface and worked to build up dark tones. This approach lent a greater luminosity to the work, one that duplicated sunlight as closely as possible. Manet also did not model his figures with a traditional **chiaroscuro.** Instead, he applied his pigments flatly and broadly. With these techniques he attempted to capture an impression of a fleeting moment, to duplicate on canvas what the eye would perceive within that collapsed time frame.

All too predictably, these innovations met with disapproval from critics and the public alike. Manet's subjects were found to be equally abrasive. One of his most shocking paintings, *Le Déjeuner sur l'Herbe* or *Luncheon on the Grass* (Fig. 15–9), stands as a pivotal work in the rise of the Impressionist movement. Manet's luncheon takes place in a lush woodland setting. Its guests are ordinary members of the French middle class.

It is culled from a tradition of Venetian Renaissance **pastoral** scenes common to the masters Giorgione and Titian. The composition is rather traditional. The figural group forms a stable pyramidal structure that is set firmly in the middle ground of the canvas. In fact, the group itself is derived from an engraving by Marcantonio Raimondi after a painting by Raphael called *The Judgment of Paris* (Fig. 15–10).

What was so alarming to the Parisian spectator, and remains so to this day, is that there is no explanation for the behavior of the picnickers. Why are the men clothed and the women undraped to varying degrees? Why are the men chatting between themselves, seemingly unaware of the women? The public was quite used to the painting of nudes, as we have seen, but they were not prepared to witness one of their fold—an ordinary citizen—displayed so shamefully on such a grand scale. The painting was further intolerable because the seated woman meets the viewer's stare, as if the viewer had intruded on their gathering in a voyeuristic fashion.

Viewers expecting another pastoral scene replete with nymphs and satyrs got, instead, portraits of Manet's model (Victorine Meurend), his brother, and a sculptor friend. In lieu of a highly polished Academic painting, they found a broadly brushed application of flat, barely modeled hues that sat squarely on the canvas with no regard for illusionism. With this shocking subject and unconventional technique, modernism was on its way.

Manet submitted the work to the 1863 Salon, and it was categorically rejected. He and other artists whose works were rejected that year rebelled so vehemently that Napoleon allowed them to exhibit their work in what was known as the *Salon des Réfusés,* or Salon of the Rejected Painters. It was one of the most important gatherings of **avant-garde** painters in the century.

Although Manet was trying to deliver a message to the art world with his *Déjeuner,* it was not his wish to be ostracized. He was just as interested as the next painter in earning recognition and acceptance. Commissions went to artists whose style

15–9 EDOUARD MANET *Le Déjeuner sur l'Herbe* (1863). Oil on canvas. 7' x 8'10".
Musée d'Orsay, Galerie du Jeu de Paume.

15–10 MARCANTONIO RAIMONDI Engraving after Raphael's *The Judgment of Paris* (detail) (c. 1520)
The Metropolitan Museum of Art, N.Y. Rogers Fund, 1919.

was sanctioned by the academics, and painting salon pictures was, after all, a livelihood. Fortunately, Manet had the private means by which he could continue painting in the manner he desired.

Manet further attacked traditional themes in art with his masterpiece *Olympia* (Fig. 15–11). This painting also recalls works by the Venetian masters, specifically Titian's *Venus of Urbino* (see Fig. 14–1). But Manet replaced the reclining Venus of the Renaissance work with a well-known courtesan of the Parisian demimonde. Presented a bouquet of flowers from an admirer, Manet's prostitute stares shamelessly out at the viewer from her rumpled bed. This impudence is matched only by the harsh, unflattering light cast on the flatly painted figure.

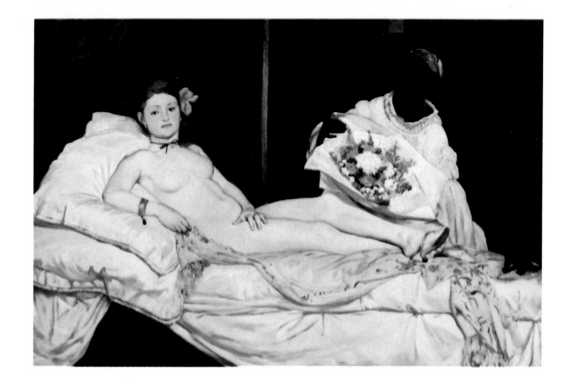

15–11 EDOUARD MANET
Olympia (1863)
Oil on canvas.
51⅜ x 74¾″.

Manet was perhaps the most important influence on the French Impressionist painters, a group of artists was advocated the direct painting of optical impressions. His *Déjeuner* began a decade of exploration of these new ideas that culminated in the first Impressionist exhibition of 1874. Although considered by his followers to be one of the Impressionists, Manet declined to exhibit with that avant-garde group. A quarter of a century later, only seventeen years after his death, Manet's works were shown at the prestigious Louvre.

IMPRESSIONISM

Manet served as the inspiration to a group of younger artists who banded together against the French art establishment. Suffering from lack of recognition and vicious criticism, many of them lived in abject poverty for lack of commissions. Yet they stand today as some of the most significant and certainly among the most popular artists in the history of art. They were called the Impressionists. The very name of their movement was coined by a hostile critic and intended to malign their work. The word "impressionism" suggests a lack of realism,

and realistic representation was the standard of the day.

The Impressionist artists had common philosophies about painting, although their styles differed widely. They all reacted against the constraints of the Academic style and subject matter. They advocated painting out-of-doors and chose to render subjects found in nature. They studied the dramatic effects of atmosphere and light on people and objects and, through a varied palette, attempted to duplicate these effects on canvas.

Through intensive investigation, they arrived at awareness of certain visual phenomena. When bathed in sunlight, objects are optically reduced to facets of pure color. The actual color—or **local color**—of these objects is altered by different lighting effects. Solids tend to dissolve into color fields. Shadows are not black or gray but a combination of colors.

Technical discoveries accompanied these revelations. The Impressionists duplicated the glimmering effect of light bouncing off the surface of an object by applying their pigments in short, choppy strokes. They used **complementary colors** such as red and green next to one another to reproduce the optical vibrations perceived when one is

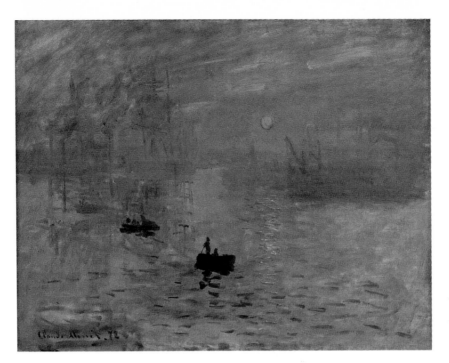

15–12 CLAUDE MONET
Impression: Sunrise (1872)
Oil on canvas. 19½ x 25½'.
Musée Marmottan, Paris.

15–13 CLAUDE MONET *Rouen Cathedral* (1894)
Oil on canvas. 39¼ x 25⅞".
The Metropolitan Museum of Art, N.Y. Theodore M. Davis Collection, 1915.

looking at an object in full sunlight. Toward this end they also juxtaposed **primary colors** such as red and yellow to produce, in the eye of the spectator, the **secondary color** orange. We shall discuss the work of the Impressionists Claude Monet, Pierre Auguste Renoir, Berthe Morisot, and Edgar Degas.

CLAUDE MONET

The most fervent follower of Impressionist techniques was the painter Claude Monet (1840–1926). It was his canvas entitled *Impression—Sunrise* (Fig. 15–12) that inspired the epithet "impressionist" when it was exhibited at the first Impressionist exhibition in 1874. Fishing vessels sail from the port of Le Havre toward the morning sun, which rises in a foggy sky to cast its copper beams on the choppy, pale blue water. The warm blanket of the atmosphere envelops the figures, their significance having paled in the wake of nature's beauty.

The dissolution of surfaces and the separation of light into its spectral components remain central to Monet's art. They are dramatically evident in a series of canvases depicting *Rouen Cathedral* (Fig. 15–13) from a variety of angles, during different seasons and times of day. The harsh stone façade

On Impressionism

CLAUDE MONET: No one is an artist unless he carries his picture in his head before painting it, and is sure of his method and composition. Techniques vary, art stays the same: it is a transposition of nature at once forceful and sensitive. But the new movements, in the full tide of reaction against what they call "the inconstancy of the impressionist image," deny all that in order to construct their doctrine and preach the solidity of unified volume.

Pictures aren't made out of doctrine. Since the appearance of Impressionism, the official salons, which used to be brown, have become blue, green, and red. . . . But peppermint or chocolate, they are still confections.

PIERRE AUGUSTE RENOIR: [About 1883] I had wrung Impressionism dry, and I finally came to the conclusion that I knew neither how to paint nor how to draw. In a word, Impressionism was a blind alley, as far as I was concerned. . . .

I finally realized that it was too complicated an affair, a kind of painting that made you constantly compromise with yourself. Out-of-doors there is a greater variety of light than in the studio, where, to all intents and purposes, it is constant; but, for just that reason, light plays too great a part outdoors; you have no time to work out the composition; you can't see what you are doing. I remember a white wall which reflected on my canvas one day while I was painting; I keyed down the color to no purpose—everything I put on was too light; but when I took it back to the studio, the picture looked black. . . . If the painter works directly from nature, he ultimately looks for nothing but momentary effects; he does not try to compose, and soon he gets monotonous.

It is not enough for a painter to be a clever craftsman; he must love to "caress" his canvas too.

PAUL GAUGUIN: The Impressionists study color exclusively, but without freedom, always shackled by the need of probability. For them the ideal landscape, created from many different entities, does not exist. They look and perceive harmoniously, but without aim. Their edifice rests upon no solid base and ignores the nature of the sensation perceived by means of color. They heed only the eye and neglect the mysterious centers of thought, so falling into merely scientific reasoning. When they speak of their art, what is it? A purely superficial thing, full of affectations and only material. In it thought does not exist.

PAUL CÉZANNE: What follows [Impressionism] does not count.

of the cathedral dissolves in a bath of sunlight, its finer details obscured by the bevy of brushstrokes crowding the surface. Dark shadows have been transformed into patches of bright blue and splashes of yellow and red. With these delicate touches, Monet has recorded for us the feeling of a single moment in time. He offers us his impressions as eyewitness to a set of circumstances that will never be duplicated.

PIERRE AUGUSTE RENOIR

Most Impressionists counted among their subject matter landscape scenes or members of the middle class enjoying leisure-time activities. Of all the Impressionists, however, Auguste Renoir (1841–1919) was perhaps the most significant figure painter. Like his peers, Renoir was interested primarily in the effect of light as it played across the surface of objects. He illustrated his preoccupation in one of the most wonderful paintings of the Impressionist period, *Le Moulin de la Galette* (Fig. 15–14). With characteristic feathery strokes, Renoir communicated all of the charm and gaity of an afternoon dance. Men and women caress and converse in frocks that are dappled with sunlight filtering through the trees. All of the spirit of the event is as fresh as if it were yesterday. From the billowing skirts and ruffled dresses to the rakish derbies, top hats, and skimmers, Renoir painted all the details that imprint such a scene on the mind forever.

BERTHE MORISOT

Like a number of other Impressionists, Berthe Morisot (1841–1895) exhibited at the salon early in her career, but she surrendered the safe path as an expression of her allegiance to the new. Morisot was a granddaughter of the eighteenth-century painter Jean-Honoré Fragonard (see Chapter 14)

15–14 PIERRE AUGUSTE RENOIR *Le Moulin de la Galette* (1876)
Oil on canvas. 51½ x 69".
Louvre Museum, Paris.

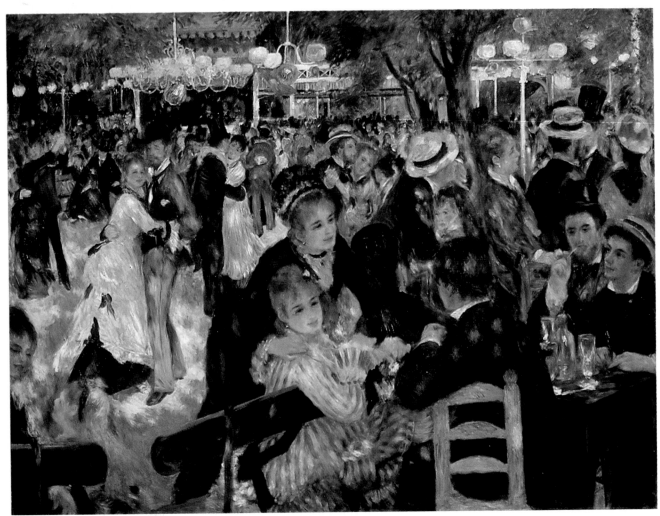

and the sister-in-law of Edouard Manet. Manet painted her quite often; in fact, Morisot is the seated figure in his *The Balcony*.

In Morisot's *Young Girl by the Window* (Fig. 15–15), surfaces dissolve into an array of loose brushstrokes, applied, it would seem, at a frantic pace. The vigor of these strokes contrasts markedly with the tranquility of the woman's face. The head is strongly modeled, and a number of structural lines, such as the back of the chair, the contour of her right arm, the blue parasol astride her lap, and the vertical edge of drapery to the right, anchor the figure in space. Yet in this as in most of Morisot's works, we are most impressed by her ingenious ability to suggest complete forms through a few well-placed strokes of pigment.

EDGAR DEGAS

We can see the vastness of the aegis of Impressionism when we look at the work of Edgar Degas (1834–1917), whose approach to painting differed considerably from that of his peers. Degas, like Morisot, had exhibited at the salon for many years before joining the movement. He was a superb draftsman who studied under Ingres. While in Italy, he copied the Renaissance masters. He was also intrigued by Japanese prints and the new art of photography.

The Impressionists, beginning with Manet, were strongly influenced by Japanese woodcuts, which were becoming readily available in Europe, and oriental motifs appeared widely in their canvases. They also adopted certain techniques of spatial organization found in Japanese prints, including the use of line to direct the viewer's eye to different sections of the work and to divide areas of the essentially flattened space (see Chapter 18). They found that the patterning and flat forms of oriental woodcuts complemented similar concerns in their own painting. Throughout the Impressionist period and even more so in the Postimpressionist period, the influence of Japanese artists remained strong.

Degas was also strongly influenced by the developing art of photography, and the camera's exclusive visual field served as a

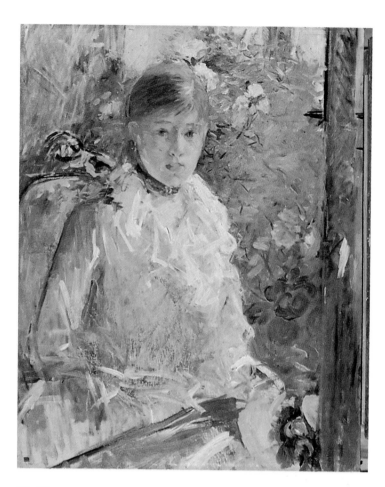

15–15 BERTHE MORISOT
Young Girl by the Window (1878). Oil on canvas. 29¹⁵⁄₁₆ x 24".
Musée Fabre, Montpellier. Marie de Montpellier.

model for the way in which he framed his own paintings. *Ballet Rehearsal* (*Adagio*) (Fig. 15–16) contains elements of both photographs and Japanese prints. Degas draws us into the composition with an unusual and vast off-center space that curves around from the viewer's space to the background of the canvas. The diagonals of the floorboards carry our eyes briskly from outside the canvas to the points at which the groups of dancers congregate. The imagery is placed at eye level so that we feel we are part of the scene. This feeling is enhanced by the fact that our "seats" at the rehearsal are less than adequate; a spiral staircase to the left blocks our view of the ballerinas. In characteristic camera fashion, the borders of the canvas slice off the forms and figures in a seemingly arbitrary manner.

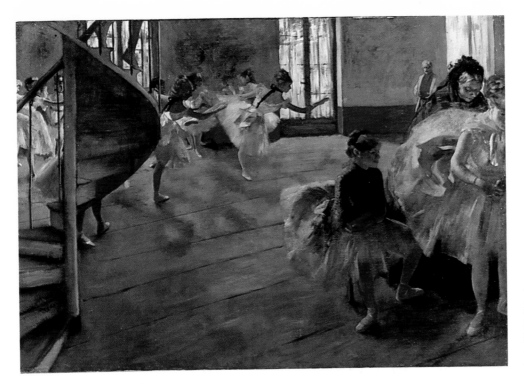

15–16 EDGAR DEGAS
Ballet Rehearsal (*Adagio*)
(1877). Oil on canvas.
26 x 39⅜".

Although it appears as if Degas has failed to frame his subject correctly or has accidentally cut off the more important parts of the scene, he carefully planned the placement of his imagery. These techniques are what render his assymmetrical compositions so dynamic and, in the spirit of Impressionism, so immediate.

POSTIMPRESSIONISM

The Impressionists were united in their rejection of many of the styles and subjects of the art that preceded them. These included Academic painting, the emotionalism of Romanticism, and even the depressing subject matter of some of the Realist artists. During the latter years of the nineteenth century, a group of artists that came to be called **Postimpressionists** were also united in their rebellion against that which came before them—in this case, Impressionism. The Postimpressionists were drawn together by their rebellion against what they considered an excessive concern for fleeting impressions and a disregard for traditional compositional elements.

Although they were united in their rejection of Impressionism, their individual styles differed considerably. Postimpressionists fell into two groups that in some ways parallel the stylistic polarities of the Baroque period as well as the Neoclassical-Romantic period. On the one hand, the work of Georges Seurat and Paul Cézanne had at its core a more systematic approach to compositional structure, brushwork, and color. On the other hand, the lavishly brushed canvases of Vincent van Gogh and Paul Gauguin coordinated line and color with symbolism and emotion.

GEORGES SEURAT

At first glance, the paintings by Georges Seurat (1859–1891), such as *A Sunday Afternoon on the Island of La Grande Jatte* (Fig. 15–17) and *The Models* (Fig. 2–22) have the feeling of Impressionism "tidied up." The small brush strokes are there, as are the juxtapositions of complementary colors. The subject matter is entirely acceptable within the framework of Impressionism. However, the spontaneity of direct painting found in Impressionism is relinquished in favor of a

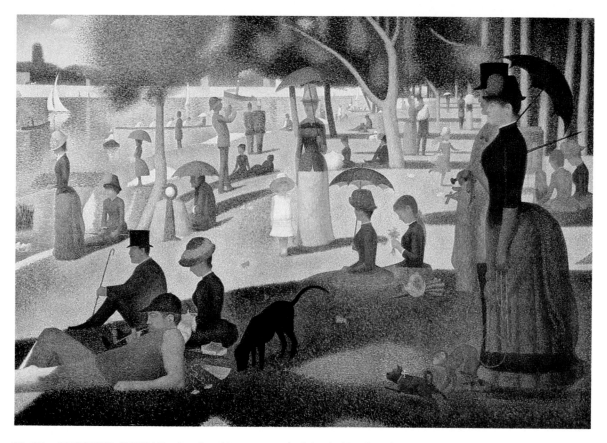

15–17 GEORGES SEURAT *Sunday Afternoon on the Island of La Grande Jatte* (1884–86). Oil on canvas. 81 x 120⅜″.

Courtesy of The Art Institute of Chicago.

more tightly controlled, "scientific" approach to painting.

Seurat's technique has also been called **Pointillism,** after his application of pigment in small dabs, or points, of pure color. Upon close inspection, the painting appears to be a collection of dots of vibrant hues—complementary colors abutting one another, primary colors placed side by side (Fig. 15–18). These hues intensify or blend to form yet another color in the eye of the viewer who beholds the canvas from a distance.

Seurat's meticulous color application was derived from the color theories and studies of color contrasts by the scientists Hermann von Helmholtz and Michel-Eugène Chevreul. He used these theories to restore a more intellectual approach to painting that countered nearly two decades of works that focused wholly on optical effects.

15–18 GEORGES SEURAT
*Sunday Afternoon
on the Island of La Grande Jatte* (detail)

From the time of Manet, there was a movement away from a realistic representation of subjects toward one that was abstracted. Early methods of abstraction assumed different forms. Manet used a flatly painted form, Monet a disintegrating light, and Seurat a tightly painted and highly patterned composition. Paul Cézanne (1839–1906), a Postimpressionist who shared with Seurat an intellectual approach to painting, is credited with having led the revolution of abstraction in modern art from those first steps.

Cézanne's method for accomplishing this radical departure from tradition did not disregard the Old Masters. Although he allied himself originally with the Impressionists and accepted their palette and subject matter, he drew from Old Masters in the Louvre and desired somehow to reconcile their lessons with the thrust of modernism, saying, "I want to make of Impressionism something solid and lasting like the art in the museums." Cézanne's innovations include a structural use of color and brushstroke that appeals to the intellect, and a solidity of composition enhanced by a fluid application of pigment that delights the senses.

Cézanne's most significant stride toward modernism, however, was a drastic collapsing of space. This treatment of space is seen in works such as *Still Life with Basket of Apples* (Fig. 15–19), in which he cancels pictorial depth by forcing all of the imagery to the picture plane. The tabletop is tilted toward us, and we simultaneously view the basket, plate, and wine bottle from front and top angles. Cézanne did not paint the still-life arrangement from one vantage point. He moved around his subject, painting not only the objects but the relationship among them. He focused not only on solids, but on the void spaces between two objects as well. If you run your finger along the tabletop in the background of the painting, you will see that it is not possible to trace a continuous line. This discontinuity follows from Cézanne's movement around his subject. In spite of this spatial inconsistency, the overall feeling of the composition is one of completeness.

Cézanne's painting technique is also innovative. The lusciously round fruits are constructed of small patches of pigment crowded within dark outlines. They look as if they would roll off the table were it not for the supportive facets of the rumpled tablecloths.

Cézanne can be seen as advancing the flatness of planar recession begun by David over a century earlier. Cézanne asserted the

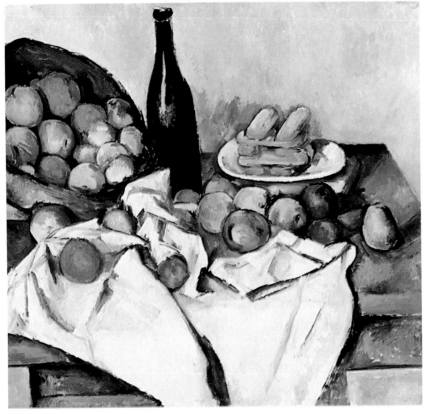

15–19 PAUL CÉZANNE
Still Life with Basket of Apples (c. 1895). Oil on canvas. 65 x 80 cm.

The Art Institute of Chicago. Helen Birch Bartlett Memorial Collection.

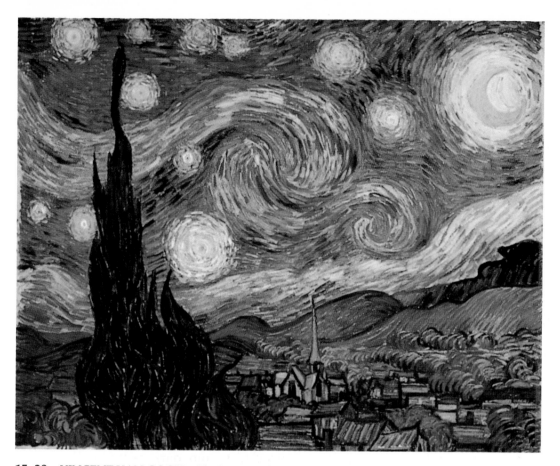

15–20 VINCENT VAN GOGH *The Starry Night* (1889). Oil on canvas. 29 x 36¼".

Collection, The Museum of Modern Art, N.Y. Acquired through the Lillie P. Bliss Bequest.

flatness of the two-dimensional canvas by eliminating the distinction between foreground and background, and at times merging the two imperceptibly. This was perhaps his most significant contribution to future modern movements.

VINCENT VAN GOGH

One of the most tragic and best-known figures in the history of art is the Dutch Postimpressionist Vincent van Gogh (1853–1890). We associate him with bizarre and painful acts, such as the mutilation of his ear and his suicide. With these events, as well as his tortured, eccentric painting, he typifies the impression of the mad, artistic talent. Van Gogh also epitomizes the cliché of the artist who achieves recognition only after death: just one of his paintings was sold during his lifetime.

"Vincent," as he signed his paintings, decided to become an artist only ten years

before his death. His most beloved canvases were created during his last 29 months. He began his career painting in the dark manner of the Dutch Baroque, only to adopt the Impressionist palette and brushstroke after he settled in Paris with his brother. Feeling that he was a constant burden on his brother, he left Paris for Arles, where he began to paint his most significant Postimpressionist works. Both his life and his compositions from this period were tortured, as Vincent suffered from bouts of epilepsy and mental illness. He was eventually hospitalized in an asylum at Saint-Rémy, where he painted the famous *Starry Night* (Fig. 15–20).

In *Starry Night* an ordinary painted record of a sleepy valley town is transformed into a cosmic display of swirling fireballs that assault the night sky and command the hills and cypresses to undulate to their sweeping rhythms. Vincent's palette is laden with vi-

Why Did van Gogh Cut Off His Ear?

Two days before Christmas in the year 1888, the 35-year-old Vincent van Gogh cut off the lower half of his left ear. He took the ear to a brothel, asked for a prostitute by the name of Rachel, and handed it to her. "Keep this object carefully," he said.

How do we account for this extraordinary event? Over the years, many explanations have been advanced. As noted by William McKinley Runyan in the June 1981 issue of the *Journal of Personality and Social Psychology*, many of them are psychoanalytic in nature. That is, they argue that van Gogh fell prey to unconscious primitive impulses.

As you consider the following suggestions, keep in mind that van Gogh's bizarre act occurred many years ago, and that we have no way today to determine which, if any, of them is accurate. Perhaps one of them cuts to the core of van Gogh's urgent needs; perhaps several of them contain a kernel of truth. But it could also be that all of them fly far from the mark. In any event, here are the explanations compiled by Runyan:

1. Van Gogh was frustrated by his brother's engagement and his failure to establish a close relationship with Gauguin. The aggressive impulses stemming from the frustrations were turned inward and expressed in self-mutilation.

2. Van Gogh was punishing himself for experiencing homosexual impulses toward Gauguin.

3. Van Gogh identified with his father, toward whom he felt resentment and hatred, and the cutting off of his own ear was a symbolic punishment of his father.

4. Van Gogh was influenced by the practice of awarding the bull's ear to the matador after a bullfight. In effect, he was presenting such an "award" to the lady of his choice.

5. Van Gogh was influenced by newspaper accounts of Jack the Ripper, who mutilated prostitutes. Van Gogh was imitating the "ripper," but his self-hatred led him to mutilate himself rather than others.

6. Van Gogh was seeking his brother's attention.

7. Van Gogh was seeking to earn the sympathy of substitute parents. (The mother figure would have been a model he had recently painted rocking a cradle.)

brant yellows, blues, and greens. His brushstroke is at once restrained and dynamic. His characteristic long, thin strokes define the forms but also create the emotionalism in the work. He presents his subject not as we see it but as he would like us to experience it. His is a feverish application of paint, an ecstatic kind of drawing, reflecting at the same time his joys, hopes, anxieties, and despair. Vincent wrote in a letter to his brother, Theo, "I paint as a means to make life bearable. . . . Really we can speak only through our paintings."

PAUL GAUGUIN

Paul Gauguin (1848–1903) shared with van Gogh the desire to express his emotions on canvas. But whereas the Dutchman's brushstroke was the primary means to that

8. Van Gogh was expressing his sympathy for prostitutes, with whom he identified as social outcasts.

9. Van Gogh was symbolically emasculating himself so that his mother would not perceive him as an unlikeable "rough" boy. (Unconsciously, the prostitute was a substitute for his mother.)

10. Van Gogh was troubled by auditory hallucinations (hearing things that were not there) as a result of his mental state. He cut off his ear to put an end to disturbing sounds.

11. In his troubled mental state, Van Gogh may have been acting out a biblical scene he had been trying to paint. According to the New Testament, Simon Peter cut off the ear of the servant Malchus to protect Christ.

12. Van Gogh was acting out the crucifixion of Jesus, with himself as victim.

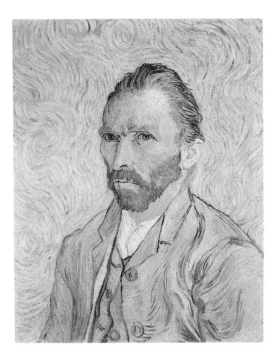

15–21 VINCENT VAN GOGH
Self-Portrait (1889–90). Oil on
canvas. 25½ x 21¼".
Louvre Museum, Paris.

end, Gauguin relied on broad areas of intense color to transpose his innermost feelings to canvas.

Gauguin, a stockbroker by profession, began his artistic career as a weekend painter. It was not until the age of 35 that he devoted himself full time to his art, leaving his wife and five children to do so. Gauguin identified early with the Impressionists, adopting their techniques and participating in their exhibitions. But Gauguin was a restless soul. Soon he decided to leave France for Panama and Martinique, primitive places where he hoped to purge the civilization from his art and life. The years until his death were spent between France and the South Seas, where he finally died of syphilis five years after he attempted to take his own life and failed.

Gauguin developed a theory of art called **Synthetism,** in which he advocated the use

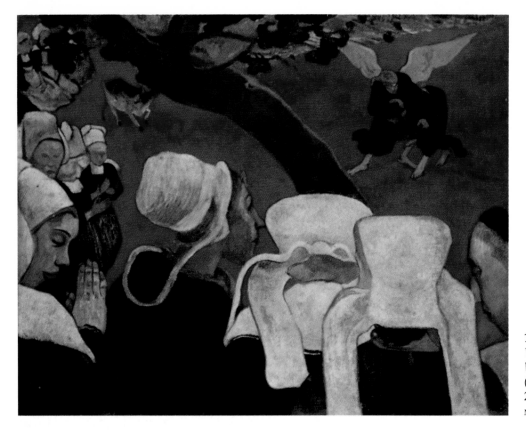

15–22 PAUL GAUGUIN
Vision after the Sermon (Jacob Wrestling with the Angel) (1888). Oil on canvas.
28¾ x 36½".

National Galleries of Scotland, Edinburgh.

of broad areas of unnaturalistic color and primitive or symbolic subject matter. His *Vision After the Sermon (Jacob Wrestling with the Angel)* (Fig. 15–22), one of the first canvases to illustrate his theory, combines reality with symbolism. After hearing a sermon on the subject, a group of Breton women believed they had a vision of Jacob, ancestor of the Hebrews, wrestling with an angel. In a daring composition that cancels pictorial depth by thrusting all elements to the front of the canvas, Gauguin presented all details of the event, actual and symbolic. An animal in the upper left portion of the canvas walks near a tree that interrupts a bright vermillion field with a slashing diagonal. The Bible tells us that it was on the banks of the Jabbok River in Jordan that Jacob had wrestled with an angel. Caught, then, in a moment of religious fervor, the Breton women may have imagined the animal's four legs to have been those of the wrestling couple and the tree trunk might have been visually analogous to the river.

Gauguin's contribution to the development of modern art lay largely in his use of color. Writing on the subject, he said: "How does that tree look to you? Green? All right, then use green, the greenest on your palette. And that shadow, a little bluish? Don't be afraid. Paint it as blue as you can." He intensified the colors he observed in nature to the point where they became unnatural. He exaggerated his lines and patterns until they became abstract. These were the lessons he learned from the primitive surroundings of which he was so fond. They were his legacy to art.

HENRI DE TOULOUSE-LAUTREC

Henri de Toulouse-Lautrec (1864–1901), along with van Gogh, is one of the best-known nineteenth-century European artists—both for his art and for the troubled aspects of his personal life. Born into a noble French family, Toulouse-Lautrec broke his legs during adolescence and they failed to develop correctly. This deformity resulted in alienation from his family. He turned to painting and took refuge in the demimonde of Paris, at one point taking up residence

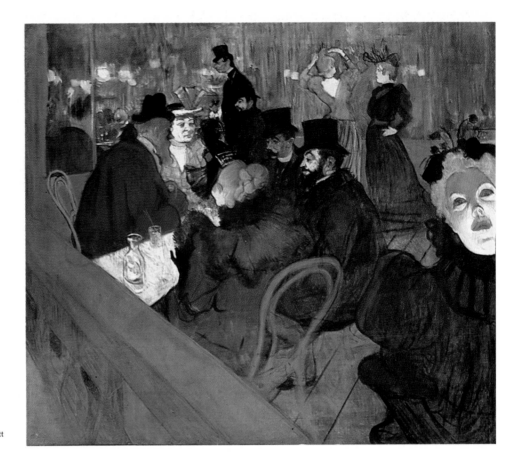

15–23 HENRI DE TOULOUSE-LAUTREC
At the Moulin Rouge (1892)
Oil on canvas. 123 x 141 cm.

The Art Institute of Chicago. Helen Birch Bartlett Memorial Collection.

in a brothel. In this world of social outcasts, Toulouse-Lautrec, the dwarflike scion of a noble family, apparently felt at home.

He used his talents to portray life as it was in this cavalcade of cabarets, theaters, cafes, and bordellos—sort of seamy, but also vibrant and entertaining, and populated by real people. He made numerous posters to advertise cabaret acts (see Chapter 9) and numerous paintings of his world of night and artificial light. In *At the Moulin Rouge* (Fig. 15–23), we find something of the Japanese-inspired oblique perspective we found earlier in his poster work. The extension of the picture to include the balustrade on the bottom and the heavily powdered entertainer on the right is reminiscent of those "poorly cropped snapshots" of Degas, who had influenced Toulouse-Lautrec. The fabric of the entertainer's dress is constructed of fluid Impressionistic brushstrokes, as are the contents of the bottles, the lamps in the background, and the amorphous overall backdrop—lost suddenly in the unlit recesses of the Moulin Rouge. But the strong

outlining, as in the entertainer's face, marks the work of a Postimpressionist. The artist's palette is limited and muted, except for a few accents, as found in the hair of the woman in the center of the composition and the bright mouth of the entertainer. The entertainer's face is harshly sculpted by artificial light from beneath, rendering the shadows a grotesque but not ugly green. The green and red mouth clash, of course, as green and red are complementary colors, giving further intensity to the entertainer's masklike visage. But despite her powdered harshness, the entertainer remains human—certainly as human as her audience. Toulouse-Lautrec was accepting of all his creatures, just as he hoped that they would be accepting of him. The artist is portrayed within this work as well, his bearded profile facing left, toward the upper part of the composition, just left of center—a part of things, but not at the heart of things, certainly out of the glare of the spotlight. There, so to speak, the artist remained for many of his brief thirty-seven years.

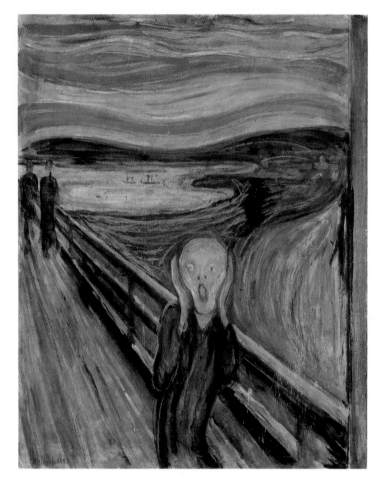

15–24 EDVARD MUNCH
The Scream (1893).
Casein on paper. 35½ x 28⅔".
National Gallery, Oslo.

EXPRESSIONISM

We have seen that a polarity existed in Post-impressionism that was like the polarity of the Neoclassical-Romantic period. On the one hand were artists who sought a more scientific or intellectual approach to painting. On the other were artists whose works were more emotional, expressive, and laden with symbolism. The latter trend was exemplified by van Gogh and particularly Gauguin. These artists used color and line to express inner feelings. In their vibrant palettes and bravura brushwork, van Gogh and Gauguin foreshadowed **Expressionism.**

The expressionistic painting of Gauguin was adopted by the Norwegian, Edvard Munch (1863–1944), who studied the Frenchman's works in Paris. Munch's early work was Impressionistic, but during the 1890s he abandoned his light palette and lively subject matter in favor of a more somber style that reflected a growing preoccupation with anguish, fear, and death.

The Scream (Fig. 15–24) is one of Munch's best-known works. This paperwork portrays the pain and isolation that became his turn-of-the-century themes. A skeletal figure walks across a bridge toward the viewer, cupping his ears while screaming. Two figures in the background walk in the opposite direction, unaware of or uninterested in the sounds of desperation piercing the atmosphere. Munch transformed the placid landscape into one that echoes in waves the high-pitched tones that emanate from the sunken head. We are reminded of the swirling forms of van Gogh's *Starry Night*, but the intensity and horror pervading Munch's paperwork speaks of Munch's view of humanity as being consumed by an increasingly industrialized and dehumanized society.

Munch's unique style would be adopted in the early twentieth century by younger German artists who shared his view of the world and also participated in the revival of the woodcut medium. They used innovative carving to complement their expressive subjects. This younger generation of artists had various styles, but collectively they have been called the Expressionists. We shall examine their work in Chapter 16.

AMERICAN EXPATRIATES

Until the twentieth century, art in the United States remained fairly provincial. Striving artists of the eighteenth and nineteenth centuries would go abroad for extended pilgrimages to study the Old Masters

and mingle with the avant-garde. In some cases, they emigrated to Europe permanently. These artists, among them Mary Cassatt and James Abbott McNeill Whistler, are called the American Expatriates.

MARY CASSATT

Mary Cassatt (1844–1926) was born in Pittsburgh but spent most of her life in France, where she was part of the inner circle of the Impressionists. Her early career was influenced by the artists Manet and Degas, photography, and Japanese prints. Cassatt was a figure painter whose subjects centered on family life, particularly images of motherhood and childhood.

A painting such as *The Boating Party* (Fig. 15–25), with its broad areas of color, bold lines and collapsed space, suggests Cassatt's

debt to Japanese prints. Color, line, and the treatment of space, along with the simplified and abstracted shapes such as those of the boat and sail, construct a solid composition that differs from the atmospheric and transitory images of other Impressionists.

JAMES ABBOTT MCNEILL WHISTLER

In the same year that Monet painted his *Impression—Sunrise* and launched the movement of Impressionism, the American artist James Abbott McNeill Whistler (1834–1903) painted one of the best-known compositions in the history of art. Who among us has not seen "Whistler's Mother," whether on posters, billboards, or television commercials? *Arrangement in Black and Gray: The Artist's Mother* (Fig. 15–26) exhibits a combination of candid realism and abstraction that

15–25 MARY CASSATT *The Boating Party* (1893–94). Oil on canvas. 35½ x 46⅛".
National Gallery of Art, Washington, D.C. Chester Dale Collection.

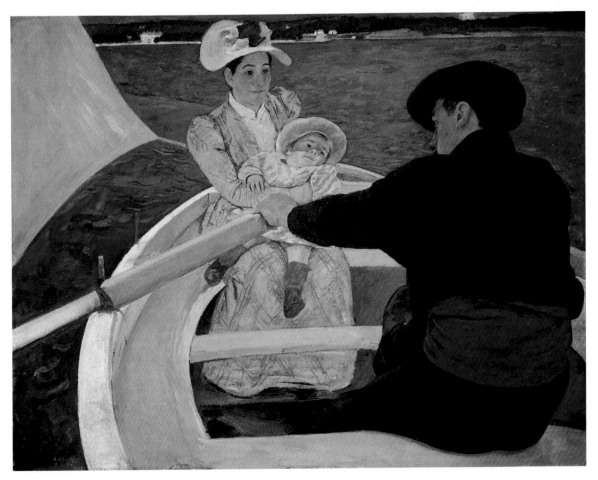

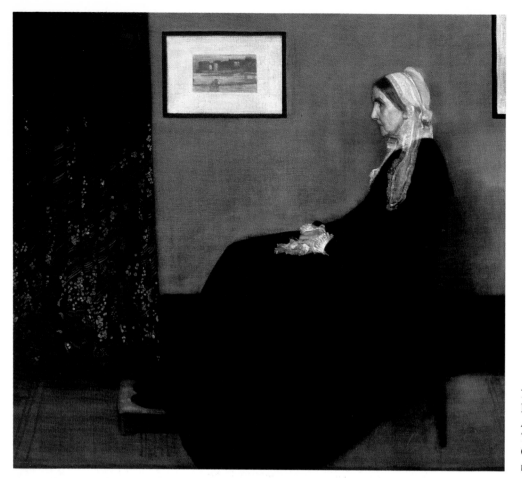

15–26 JAMES ABBOTT McNEILL WHISTLER *Arrangement in Black and Gray: The Artist's Mother* (1871). Oil on canvas. 57 x 64½".
Louvre Museum, Paris.

indicates two strong influences on Whistler's art: Courbet and Japanese prints. Whistler's mother is silhouetted against a quiet backdrop in the right portion of the composition. The strong contours of her black dress are balanced by an oriental drape and simple rectangular picture on the left. The subject is rendered in a harsh realism reminiscent of Northern Renaissance portrait painting. However, the composition is seen first as a logical and pleasing arrangement of shapes in tones of black, gray, and white that work together in pure harmony.

AMERICANS IN AMERICA

While Whistler and Cassatt were working in Europe, several American artists of note remained at home working in the Realist tradition. This realism can be detected in figure painting and landscape painting, both of which were tinted with romanticism.

THOMAS EAKINS

The most important American portrait painter of the nineteenth century was Thomas Eakins (1844–1916). Although his early artistic training took place in the United States, his study in Paris with painters who depicted historical events provided the major influence on his work. The penetrating realism of a work such as *The Gross Clinic* (Fig. 15–27) stems from Eakins's endeavors to become fully acquainted with human anatomy by working from live models and dissecting corpses. Eakins's dedication to these practices met with disapproval from his colleagues and ultimately forced his resignation from a teaching post at the Pennsylvania Academy of Art.

The Gross Clinic—no pun intended—depicts the surgeon Dr. Samuel Gross operating on a young boy at the Jefferson Medical College in Philadelphia. Eakins thrusts the brutal imagery to the foreground of the painting, spotlighting the surgical proce-

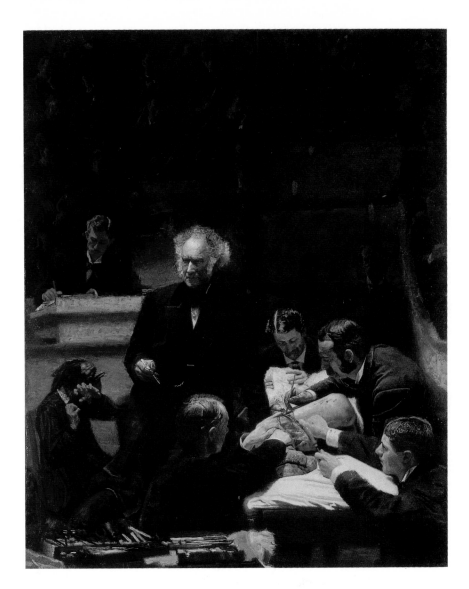

15–27 THOMAS EAKINS
The Gross Clinic (1875).
Oil on canvas. 96 x 78".

Jefferson Medical College of Thomas Jefferson University,
Philadelphia.

dure and Dr. Gross's bloody scalpel while casting the observing medical students in the background into darkness. The painting was deemed so shockingly realistic that it was rejected by the jury for an exhibition. Part of the impact of the work lies in the contrast between the matter-of-fact discourse of the surgeon and the torment of the boy's mother. She sits in the lower left corner of the painting, shielding her eyes with whitened knuckles. In brush technique Eakins is close to the fluidity of Courbet, although his compositional arrangement and dramatic lighting are surely indebted to Rembrandt.

Eakins devoted his career to increasingly realistic portraits. Their haunting veracity often disappointed sitters who would have preferred more flattering renditions. The artist's passion for realism led him to use photography extensively, as a point of departure for his paintings as well as an art form in itself. Eakins's style and ideas influenced American artists of the early twentieth century who also worked in a Realist vein.

THOMAS COLE

During the nineteenth century, American artists turned, for the first time, from the tradition of portraiture to landscape painting. Inspired by French landscape painting of the Baroque period, these artists fused this style with a pride in the beauty of their native United States and a romantic vision

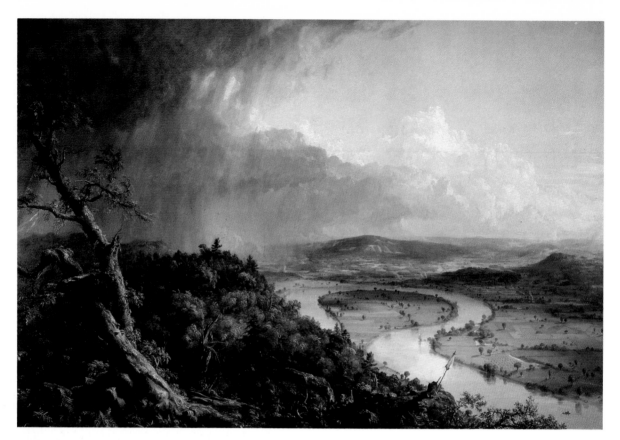

15–28 THOMAS COLE *The Oxbow (Connecticut River near Northampton)* (1836). Oil on canvas. 51½ x 76".

The Metropolitan Museum of Art, N.Y. Gift of Mrs. Russell Sage, 1908.

that was embodied in the writings of James Fenimore Cooper.

One such artist was Thomas Cole (1801–1848). Although Cole was born in England, he emigrated to the United States at the age of 17. Cole was always fond of landscape painting and settled in New York, where there was a ready audience for this genre. Cole became the leader of the **Hudson River School**—a group of artists whose favorite subjects included the scenery of the Hudson River Valley and the Catskill Mountains in New York State.

The Oxbow (Fig. 15–28) is typical of such paintings. It records a natural oxbow formation in the Connecticut River Valley. Cole combines a vast, sun-drenched space with meticulously detailed foliage and farmland. There is a contrast in moods between the lazy movement of the river, which meanders diagonally into the distance, and the more vigorous diagonal of the gnarled tree trunk in the left foreground. Half of the

canvas space is devoted to the sky, whose storm clouds roll back to reveal rays of intense light. These atmospheric effects, coupled with our "crow's-nest" vantage point, magnify the awesome grandeur of nature and force us to contemplate the relative insignificance of humans.

ART NOUVEAU

In looking at examples of French, Norwegian, and American art of the nineteenth century, we witnessed a collection of disparate styles that reflected the artists' unique situations or personalities. Given the broad range of circumstances that give rise to a work of art, it would seem unlikely that a cross-cultural style could ever evolve. However, at the turn of the century, or **fin de siècle,** there arose a style called **Art Nouveau** whose influence extended from Europe to the United States. Its idiosyncratic

characteristics could be found in painting and sculpture as well as architecture, furniture, jewelry, fashion, and glassware (see Tiffany glassware, Fig. 9–13).

Art Nouveau is marked by a lyrical linearity, the use of symbolism, and rich ornamentation. There is an overriding sense of the organic in all of the arts in this style, with many of the forms reminiscent of exotic plant life. Antonio Gaudi's (1852–1926) apartment house in Barcelona, Spain, (Fig. 15–29) shows an obsessive avoidance of straight lines and flat surfaces. The material looks as if it had grown in place, or hardened in malleable wooden forms, as would cement, but in actuality it is cut stone. The rhythmic roof is wavelike, and the chimneys seem dispensed like shaving cream or soft ice cream. Nor are any two rooms on a floor alike. This multistory organic hive is clearly the antithesis of the steel-cage construction (see Chapter 7) that was coming into its own at the same time.

Art Nouveau originated in England. It was part of an arts and crafts movement that arose in rebellion against the pretentiousness of nineteenth-century art. Although it continued into the early years of the twentieth century, the style disappeared with the onset of World War I. At that time art began to reflect the needs and fears of humanity faced with self-destruction.

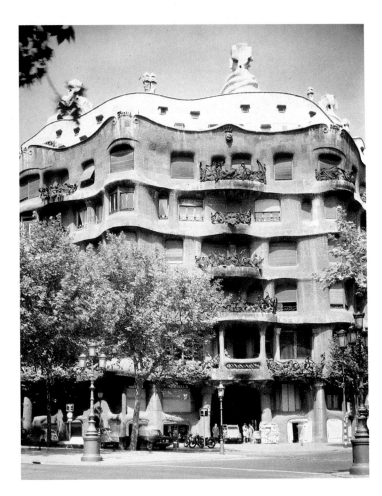

15–29 ANTONIO GAUDI
Casa Mila Apartment House, Barcelona (1905–07)

THE BIRTH OF MODERN SCULPTURE

Some of the most notable characteristics of modern painting include a newfound realism of subject and technique, a more fluid, or impressionistic, handling of the medium, and a new treatment of space. Nineteenth-century sculpture, for the most part, continued stylistic traditions that artists saw as complementing the inherent permanence of the medium with which they worked. It would seem that working on a large scale with materials such as marble or bronze was not well suited to the spontaneous technique that captured fleeting impressions.

One nineteenth-century artist, however, changed the course of the history of sculpture by applying to his work the very principles on which modern painting was based, including Realism, Symbolism, and Impressionism—Auguste Rodin.

AUGUSTE RODIN

Auguste Rodin (1840–1917) devoted his life almost solely to the representation of the human figure. These figures were imbued with a realism so startlingly intense that he was accused of casting the sculptures from live models. (It is interesting to note that this technique is used in the twentieth century without such negative criticism.)

Rodin's *The Burghers of Calais* (Fig. 1–18) represents all of the innovations of modernism thrust into three dimensions. The work commemorates a historical event in which six prominent citizens of Calais offered their lives to the conquering English so that their

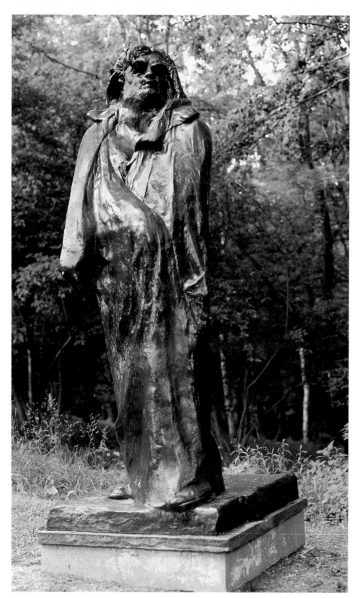

15–30 AUGUSTE RODIN
Monument to Balzac (1893)
Bronze. Height: 9'10".

Hirshhorn Museum and Sculpture Garden,
Smithsonian Institution.

fellow townspeople might be spared. They present themselves in coarse robes with nooses around their necks. Their psychological states range from quiet defiance to frantic desperation. The reality of the scene is achieved in part by the odd placement of the figures. They are not a symmetrical or cohesive group. Rather, they are a scattered collection of individuals, who were meant to be seen at street level. Captured as they are, at a particular moment in time, Rodin ensured that spectators would partake of the tragic emotion of the scene for centuries to come.

Rodin preferred modeling soft materials to carving because they enabled him to achieve highly textured surfaces that captured the play of light, much as in an Impressionist painting. As his career progressed, Rodin's sculptures took on an abstract quality. Distinct features were abandoned in favor of solids and voids that, together with light, constructed the image of a human being. *Balzac* (Fig. 15–30) is such a work. Like a monolith, the larger-than-life bronze sculpture impresses us with its bulk. The elemental head erupts from an abstracted cloak that would be at home in any age.

Like many great works, *Balzac* was outrageous in its own day, and it was rejected by the committee that had commissioned it. It was audacious and quite new, its abstracted features setting the stage for yet newer and more audacious artforms that would rise with the dawn of the twentieth century.

16

The Twentieth Century: The Early Years

It could be said that the art world has been in a state of perpetual turmoil for the last hundred years. All the important movements that were born during the late nineteenth and early twentieth centuries were met by the hostile, antiseptic gloves of critical disdain. When Courbet's paintings were rejected by the 1855 Salon, he set up his own Pavilion of Realism and pushed the Realist movement on its way. Just eight years later, rejection by the salon jury prompted the origin of the Salon des Réfusés, an exhibition of works including those of Manet. These ornery French artists went on to found the influential Impressionist movement. As noted in Chapter 15, their very name—Impressionism—was coined by a hostile critic who degraded their work as mere "impressions" —sort of quick and easy sketches—of the painter's view of the world, rather than the preferred illusionistic realism of Academic painting.

The opening years of the twentieth century saw no letup to these scandalous entrées into the world of modern art. In 1905 the **Salon d'Automne**—an independent exhibition so named to distinguish it from the Academic salons that were traditionally held in the spring—brought together the works of an exuberant group of French avant-garde artists who assaulted the public with a bold palette and distorted forms. One art critic who peeked in on the show saw a Renaissance-type sculpture surrounded by these blasphemous forms. He was sufficiently unnerved by the juxtaposition to exclaim, *"Donatello au milieu des fauves!"* (Donatello among the wild beasts). With what pleasure, then the artists adopted as their epithet: "The **Fauves.**" After all, it was a symbol of recognition.

THE FAUVES

In some respects, the Fauvist movement was a logical successor to the painting of van Gogh and Gauguin. Like these Postimpressionists, the Fauvists also rejected the subdued palette and delicate brushwork of Impressionism. They chose their color and

brushwork on the basis of their emotive qualities. Despite the aggressiveness of their method, however, their subject matter centered on traditional nudes, still lifes, and landscapes.

What set the Fauves apart from their nineteenth-century predecessors was their use of harsh, nondescriptive color, bold linear patterning, and a distorted form of perspective. They saw color as autonomous, a subject in and of itself, not merely an adjunct to nature. Their vigorous brushwork and emphatic line grew out of their desire for a direct form of expression, unencumbered by theory. Their skewed perspective and distorted forms were also inspired by the discovery of primitive works of art from Africa, Polynesia, and other ancient cultures.

ANDRÉ DERAIN

One of the founders of the Fauvist movement was André Derain (1880–1954). In his *London Bridge* (Fig. 16–1) we find the convergence of elements of nineteenth-century styles and the new vision of Fauvism. The outdoor subject matter is reminiscent of Impressionism (Monet, in fact, painted many renditions of Waterloo Bridge in London), and the distinct zones of unnaturalistic color

16–1 ANDRÉ DERAIN
London Bridge (1906)
Oil on canvas. 26 x 39".

Collection, The Museum of Modern Art, N.Y. Gift of Mr. and Mrs. Charles Zadok.

relate the work to Gauguin. But the forceful contrasts of primary colors and the delineation of forms by blocks of thickly applied pigment speak of something new.

Nineteenth-century artists emphasized natural light and created their shadows from color components. Derain and the Fauvists evoked light in their canvases solely with color contrasts. Fauvists tended to negate shadow altogether. Whereas Gauguin used color areas primarily to express emotion, the Fauvist artists used color to construct forms and space. Although Derain used his bold palette and harsh line to render his emotional response to the scene, his bright blocks of pigment also function as building façades. Derain's oblong patches of color define both stone and water. His thickly laden brushstroke constructs the contour of a boat and the silhouette of a fisherman.

HENRI MATISSE

Along with Derain, Henri Matisse (1869–1954) brought Fauvism to the forefront of critical recognition. Yet Matisse was one of the few major Fauvist artists whose reputation exceeded that of the movement. Matisse started law school at the age of 21, but when an illness interrupted his studies,

he began to paint. Soon thereafter he decided to devote himself totally to art. Matisse's early paintings revealed a strong and traditional compositional structure, which he gleaned from his first mentor, Adolphe William Bouguereau (see pp. 384–385), and from copying Old Masters in the Louvre. His loose brushwork was reminiscent of Impressionism, and his palette was inspired by the color theories of the Postimpressionists. In 1905 he consolidated these influences and painted a number of Fauvist canvases in which, like Derain, he used primary color as a structural element. These canvases were exhibited with those of other Fauvists at the Salon d'Automne of that year.

In his post-Fauvist works, Matisse used color in a variety of other ways—structurally, decoratively, sensually, and expressively. In his *Red Room* (*Harmony in Red*) (Fig. 16–2), all of these qualities of color are present. The gay mood of the canvas is created by a vibrant palette and curvilinear shapes. The lush red of the wallpaper and tablecloth absorb the viewer in their brilliance. The arabesques of the vines create an enticing surface pattern.

A curious contest between flatness and three dimensions in *Red Room* characterizes

16–2 HENRI MATISSE
Red Room (*Harmony in Red*) (1908–09). Oil on canvas. 69¾ x 85⅞".

The Hermitage, Leningrad.

Henri Matisse

ON EXPRESSION: What I am after, above all is expression. . . . I am unable to distinguish between the feeling I have for life and my way of expressing it.

ON THE USE OF LINE: Supposing I want to paint the body of a woman: first of all I endow it with grace and charm, but I know that something more than that is necessary. I try to condense the meaning of this body by drawing its essential lines. The charm will then become less apparent at first glance, but in the long run it will begin to emanate from the new image. [See *Large Reclining Nude*, Fig. 2–42.]

ON COLOR: If upon a white canvas I jot down some sensations of blue, of green, of red—every new brush stroke diminishes the importance of the preceding ones. Suppose I set out to paint an interior: I have before me a cupboard; it gives me a sensation of bright red—and I put down a red which satisfies me; immediately a relation is established between this red and the white of the canvas. If I put a green near the red, if I paint in a yellow floor, there must still be between this green, this yellow, and the white of the canvas a relation that will be satisfactory to me. But these several tones mutually weaken one another. It is necessary, therefore, that the various elements that I use be so balanced that they do not destroy one another. [See *Red Room*, Fig. 16–2.]

much of Matisse's work. He crowds the table and wall with the same patterns. They seem to run together without distinction. This jumbling of patterns propels the background to the picture plane, asserting the flatness of the canvas. The two-dimensionality of the canvas is further underscored by the window in the upper left, which is rendered so flatly that it suggests a painting of a garden scene instead of an actual view of a distant landscape. Yet for all of these attempts to collapse space, Matisse counteracts the effect with a variety of perspective cues: the seat of the ladder-back chair recedes into space, as does the table; and the dishes are somewhat foreshortened, combining frontal and bird's-eye views.

Matisse used line expressively, moving it rhythmically across the canvas to complement the pulsing color. Although the structure of *Red Room* remains assertive, Matisse's foremost concern was to create a pleasing pattern. Matisse insisted that painting ought to be joyous. His choice of palette, his lyrical use of line, and his brightly painted shapes are all means toward that end. He even said of his work that it ought to be devoid of depressing subject matter, that his art ought to be "a mental soother, something like a good armchair in which to rest."[*]

Although the colors and forms of Fauvism burst explosively on the modern art scene, the movement did not last very long. For one thing, the styles of the Fauvist artists were very different from one another, and so the members never formed a cohesive group. After about five years, the "Fauvist qualities" began to disappear from their works as they pursued other styles. Their disappearance was, in part, prompted by a retrospective exhibition of Cézanne's painting held in 1907, which revitalized an interest in this nineteenth-century artist's work. His principles of composition and constructive brush technique were at odds with the Fauvist manifesto.

[*] Robert Goldwater and Marco Treves, eds., *Artists on Art* (New York: Pantheon Books, 1972), p. 413.

While Fauvism was descending from its brief colorful flourish in France, related art movements, termed *expressionistic*, were ascending in Germany.

EXPRESSIONISM

If we define **Expressionism** as the distortion of nature—as opposed to the imitation of nature—in order to achieve a desired emotional effect or representation of inner feelings, then we have already seen many examples of this type of painting. The work of van Gogh and Gauguin would be clearly expressionistic, as would the paintings of the Fauves. Even Matisse's *Red Room* distorts nature or reality in favor of a more intimate portrayal of the artist's subject, colored, as it were, by his own emotions. In Chapter 15 we saw that Edvard Munch was an expressionistic artist who used his painting and prints as vehicles to express his anxieties and obsessions.

Two other movements of the early twentieth century have been termed Expressionist: *Die Brücke* and *Der Blaue Reiter*. Although very different from one another in the forms they took, these movements were both reactions against Impressionism and Realism.

They also both sought to communicate the inner feelings of the artist.

Die Brücke (The Bridge)

Die Brücke, or The Bridge, was founded in Dresden, Germany, at the same time that Fauvism was afoot in France. The artists who began the movement chose the name *Die Brücke* because, in theory, they saw their movement as bridging a number of disparate styles. Die Brücke, like Fauvism, was short-lived because of the lack of cohesion among its proponents. Still, Die Brücke artists showed some common interests in subject matter that ranged from boldly colored landscapes and cityscapes to horrific and violent portraits. Their emotional upheaval may, in part, have reflected the mayhem of World War I.

EMIL NOLDE

The supreme colorist of the Expressionist movement was Emil Nolde (1867–1956), who joined Die Brücke a year after it was founded. Canvases of his such as *Dance Around the Golden Calf* (Fig. 16–3) are marked by a frenzied brush technique in which clashing colors are applied in lush strokes.

16–3 EMIL NOLDE
Dance Around the Golden Calf (1910). Oil on canvas. 34⅜ x 41".

Staatsgalerie Moderner Kunstmuseum, Munich.

The technique complements the nature of the subject—a biblical theme recounting the worshipping of an idol by the Israelites even as their liberator, Moses, was receiving the Ten Commandments on Mount Sinai. In Nolde's characteristic fashion, both ecstasy and anguish are brought to the same uncontrolled, high pitch.

Nolde was also well known for his graphics. He used the idiosyncratic, splintered characteristics of the woodcut—a medium that had not been in vogue for centuries—to create ravaged, masklike portraits of pain and suffering.

Der Blaue Reiter (The Blue Rider)

Emotionally charged subject matter, often radically distorted, was the essence of Die Brücke art. **Der Blaue Reiter** (The Blue Rider) artists—who took their group name from a painting of that title by Wassily Kandinsky, a major proponent—depended less heavily on content to communicate feelings and evoke an emotional response from the viewer. Their work focused more on the contrasts and combinations of abstract forms and pure colors. In fact, the work of Der Blaue Reiter artists, at times, is completely without subject and can be described as nonobjective, or abstract. Whereas Die Brücke artists always used nature as a point of departure, Der Blaue Reiter art sought to free itself from the shackles of observable reality.

Wassily Kandinsky

One of the founders of Der Blaue Reiter was Wassily Kandinsky (1866–1944), a Russian artist who left a career in law to become an influential abstract painter and art theorist. During numerous visits to Paris early in his career, Kandinsky was immersed in the works of Gauguin and the Fauves and was himself inspired to adopt the Fauvist idiom. The French experience opened his eyes to color's powerful capacity to communicate the artist's innermost psychological and spiritual concerns. In his seminal essay, "Concerning the Spiritual in Art," he examined this capability and discussed the psychological effects of color on the viewer. Kandinsky further analyzed the relationship between art and music in this study.

Early experiments with these theories can be seen in works such as *Sketch I for "Composition VII"* (Fig. 16–4), in which bold colors, lines, and shapes tear dramatically across the canvas in no preconceived fashion. The

16–4 WASSILY KANDINSKY
Sketch I for Composition VII
(1913). Oil on canvas.
30¾ x 39⅜".
Museum of Fine Arts, Bern, Switzerland.
Collection of Felix Klee.

pictorial elements flow freely and independently throughout the painting, reflecting, Kandinsky believed, the free flow of unconscious thought. *Sketch I for "Composition VII"* and other works of this series not only underscore the importance of Kandinsky's early Fauvist contacts in their vibrant palette, broad brushstrokes, and dynamic movement; they also stand as harbingers of a new art unencumbered by referential subject matter.

For Kandinsky, color, line, and shape are subjects in themselves. They are often rendered with a spontaneity born of the psychological process of free association. At this time free association was also being explored by the founder of psychoanalysis, Sigmund Freud, as a method of mapping the geography of the unconscious mind. Some years later, in the world of art, psychoanalysis would provide the basis for **surrealistic** subject matter and technique.

As World War I drew to a close, different factions of German Expressionism could be observed. The fretful emotionalism of The Bridge artists contrasted with the uplifting spirit of The Blue Rider group. Some artists, calling themselves The New Objectivity, reacted to the horrors and senselessness of wartime suffering with an art that bitterly satirized the bureaucracy and the military with ghastly visions of shrieking madmen and decayed flesh. Others rejected the Expressionist groups, painting as independents who attempted to reconcile Expressionist innovations with more traditional figurative styles.

CUBISM

The history of art is colored by the tensions of stylistic polarities within given eras, particularly the polarity of an intellectual versus an emotional approach to painting. Fauvism and German Expressionism found their roots in Romanticism and the emotional expressionistic work of Gauguin and van Gogh. The second major art movement of the twentieth century, **Cubism,** can trace its heritage to Neoclassicism and the analytical and intellectual work of Cézanne.

Cubism is an offspring of Cézanne's geometrization of nature and his abandonment of scientific perspective, his rendering of multiple views, and his emphasis on the two-dimensional canvas surface. Picasso, the driving force behind the birth of Cubism, and perhaps the most significant artist of the twentieth century, combined the pictorial methods of Cézanne with formal elements from primitive African, Oceanic, and Iberian sculpture.

PABLO PICASSO

Pablo Ruiz y Picasso (1881–1973) was born in Spain, the son of an art teacher. As an adolescent, he enrolled in the Barcelona Academy of Art, where he quickly mastered the illusionistic techniques of the realistic Academic style. By the age of 19, Picasso was off to Paris, where he remained for over forty years—introducing, influencing, or reflecting the many styles of modern French art.

Picasso's first major artistic phase has been called his Blue Period. Spanning the years 1901 to 1904, this work is characterized by an overall blue tonality, a distortion of the human body through elongation reminiscent of El Greco and Toulouse-Lautrec, and melancholy subjects consisting of poor and downtrodden individuals engaged in menial tasks or isolated in their loneliness. *The Old Guitarist* (Fig. 16–5) is but one of these haunting images. A contorted white-haired man sits hunched over a guitar, consumed by the tones that emanate from what appears to be his only possession. The eyes are sunken in the skeletal head, and the bones and tendons of his hungry frame are painfully evident. We are struck by the ordinariness of poverty, from the unfurnished room and barren window view to the uneventfulness of his activity and the insignificance of his plight. The monochromatic blue palette creates an unrelenting somber mood. Tones of blue contrast eerily with the ghostlike features of the guitarist.

Picasso's Blue Period was followed by works that were lighter both in palette and in spirit. Subjects from this so-called Rose Period were drawn primarily from circus life and rendered in tones of pink. During this second period, which dates from 1905 to 1908, Picasso was inspired by two very different art styles. He, like many artists, viewed and was strongly influenced by the Cézanne retrospective exhibition held at the Salon d'Automne in 1907. At about that time, Picasso also became aware of the formal properties of primitive art from Africa, Oceania, and Iberia, which he saw regularly at the Musée de l'Homme. These two art-forms, which at first glance might appear dissimilar, had in common a fragmentation, distortion, and abstraction of form that were adopted by Picasso in works such as *Les Demoiselles d'Avignon* (Fig. 16–6).

This startling, innovative work, still primarily pink in tone, depicts five women from Barcelona's red-light district. They line up for selection by a possible suitor who stands, as it were, in the position of the spectator. Three of the women have primitive masks as faces. The facial features of the other two have been radically simplified by combining frontal and profile views. The

16–5 PABLO PICASSO
The Old Guitarist (1903)
Oil on canvas. 47¾ x 32½".

Courtesy of The Art Institute of Chicago.

16–6 PABLO PICASSO
Les Demoiselles d'Avignon (1907)
Oil on canvas. 8' x 7'8".

Collection, The Museum of Modern Art, N.Y.
Acquired through the Lillie P. Bliss Bequest.

thick-lidded eyes stare stagefront, calling to mind some of the Mesopotamian votive sculptures we saw in Chapter 10.

The bodies of the women are fractured into geometric forms and set before a background of similarly splintered drapery. In treating the background and the foreground imagery in the same manner, Picasso collapses the space between the planes and asserts the two-dimensionality of the canvas surface in the manner of Cézanne. In some radical passages, such as the right leg of the leftmost figure, the limb takes on the qualities of drapery, masking the distinction between figure and ground. The extreme faceting of form, the use of multiple views, and the collapsing of space in *Les Demoiselles* together provided the springboard for **Analytic Cubism,** co-founded with the French painter Georges Braque in about 1910.

Analytic Cubism

The term "Cubism," like so many others, was coined by a hostile critic. In this case the critic was responding to the predominance of geometrical forms in the works of Picasso and Braque. Cubism is a limited term in that it does not adequately describe the appearance of Cubist paintings and it minimizes the intensity with which Cubist artists analyzed their subject matter. It ignores their most significant contribution— a new treatment of pictorial space that hinged upon the rendering of objects from multiple and radically different views.

The Cubist treatment of space differed significantly from that in use since the Renaissance. Instead of presenting an object from a single view, assumed to have been the complete view, the Cubists, like Cézanne, realized that our visual comprehension of objects consists of many views that we perceive almost at once. They tried to render this visual "information gathering" in their compositions. In their dissection and reconstruction of imagery, they reassessed the notion that painting should reproduce the appearance of reality. Now the very reality of appearances was being questioned. To Cubists, the most basic reality involved

consolidating optical vignettes instead of reproducing fixed images with photographic accuracy.

GEORGES BRAQUE

During the analytic phase of Cubism, which spanned the years from 1909 to 1912, the works of Picasso and Braque were very similar. The early work of Georges Braque (1882–1963) graduated from Impressionism to Fauvism to more structural compositions based on Cézanne. He met Picasso in 1907, and from then until about 1914 the artists worked together toward the same artistic goals.

The theory of Analytic Cubism reached the peak of its expression in 1911 in works such as Braque's *The Portuguese* (Fig. 16–7).

16–7 GEORGES BRAQUE
The Portuguese (1911). Oil on canvas. 45½ x 31½".
Oeffentliche Kunstsammlung, Kunstmuseum, Basel.

Picasso's *Guernica* Goes Home

They called it "Operation Big Picture." Working under tight security, officials at New York's Museum of Modern Art secretly rolled a 26-by-11-foot canvas into a fireproof casing and whisked it off to the hold of a jumbo jet bound for Madrid. There, 44 years after Picasso painted it, the Spaniards got back *Guernica*, a furious indictment of fascism that evokes a German air raid during the Spanish Civil War on the Basque town of Guernica in 1937. "This is a moment of great joy, of immense emotion," said Picasso's comrade-at-oils Joan Miró.

It took Spain five years to convince the New York museum that the Spanish Republic had commissioned the work in 1937. It also had to reassert Picasso's view that he had sent the painting to the United States on loan and that he expected its return to the Prado Museum once democracy returned to Spain. Franco's death in 1975, free elections in 1977, and Spain's new democratic constitution met Picasso's conditions for *Guernica*'s return.

The painting hangs in a seventeenth-century annex of the Prado and went on display October 25, 1981, the centenary of Picasso's birth. The Basques would still like to see it moved to Guernica, but it has probably found its home.

—From NEWSWEEK, September 21, 1981.
© 1981 Newsweek, Inc. All rights reserved. Reprinted by permission.

Numerous planes intersect and congregate at the center of the canvas to form a barely perceptible triangular human figure, which is alternately constructed from and dissolved into the background. There are only a few concrete signs of its substance: dropped eyelids, a moustache, the circular opening of a stringed instrument. The multifaceted abstracted form appears to shift position before our eyes, simulating the time lapse that would occur in the visual assimilation of multiple views. The structural lines—sometimes called the *Cubist grid*—that define and fragment the figure are thick and dark. They contrast with the delicately modeled short, choppy brush strokes of the remainder of the composition. The monochromatic palette, chosen so as not to interfere with the exploration of form, consists of browns, tans, and ochres.

Although the paintings of Picasso and Braque were almost identical at this time, Braque first began to insert words and numbers and to use **trompe l'oeil** effects in portions of his Analytic Cubist compositions.

These realistic elements contrasted sharply with the abstraction of the major figures and reintroduced the nagging question, "What is reality and what is illusion in painting?"

Synthetic Cubism

Picasso and Braque did not stop with the inclusion of precisely printed words and numbers in their works. They began to add characters cut from newspapers and magazines, other pieces of paper, and found objects such as labels from wine bottles, calling cards, theater tickets—even swatches of wallpaper and bits of rope. These items were pasted directly onto the canvas in a technique Picasso and Braque called *papier collé*—what we know as **collage.** The use of collage marked the beginning of the synthetic phase of Cubism.

Some **Synthetic Cubist** compositions, such as Picasso's *The Bottle of Suze* (Fig. 16–8), are constructed entirely of found ele-

ments. In this work, newspaper clippings and opaque pieces of paper function as the shifting planes that hover around the aperitif label and define the bottle and glass. These planes are held together by a sparse linear structure much in the manner of Analytic Cubist works. In contrast to Analytic Cubism, however, the emphasis is on the form of the object and on constructing instead of disintegrating that form. Color reentered the compositions, and much emphasis was placed on texture, design, and movement.

After World War I, Picasso and Braque no longer worked together, and their styles, although often reflective of the Cubist experience they shared, came to differ markedly. Braque, who was severely wounded during the war, went on to create more delicate and lyrical still-life compositions, abandoning the austerity of the early phase of Cubism. While many of Picasso's later works carried forward the Synthetic Cubist idiom, his artistic genius and versatility became evident after 1920 when he began to move in radically different directions. These new works were rendered in Classical, Expressionist, and Surrealist styles.

When civil war gripped Spain, Picasso protested its brutality and inhumanity through highly emotional works such as *Guernica* (Fig. 16–9). This mammoth mural,

16–8 PABLO PICASSO
The Bottle of Suze (1912–13). Pasted paper with charcoal. 25¾ x 19¾".
Washington University Gallery of Art, St. Louis.

16–9 PABLO PICASSO *Guernica* (1937). Oil on canvas. 11'6" x 25'8".
Prado Museum, Madrid.

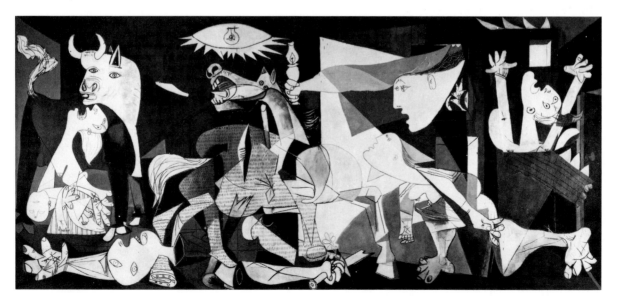

painted for the Spanish Pavilion of the Paris International Exposition of 1937, broadcast to the world the carnage of the German bombing of civilians in the Basque town of Guernica. The painting captures the event in gruesome details such as the frenzied cry of one woman trapped in rubble and fire and the pale fright of another woman who tries in vain to flee the conflagration. A terrorized horse rears over a dismembered body while an anguished mother embraces her dead child and wails futilely. Innocent lives are shattered into Cubist planes that rush and intersect at myriad angles, distorting and fracturing the imagery. Confining himself to a palette of harsh blacks, grays, and whites, Picasso expressed, in his words, the "brutality and darkness" of the age.

Derivations of Cubism

As Cubism entered its Synthetic phase, numerous highly personalized visions of the style appeared in the works of other artists. Some were bastardizations composed without understanding of the principles of Cubism, while others reflected the more sophisticated refinements of Cubist theory. Still others, like the French painter Fernand Léger (1881–1955), who knew Picasso and Braque, illustrated the adaptability of the Cubist aesthetic to imagery of contemporary life.

FERNAND LÉGER

The "paste and patch" quality of Léger's *The City* (Fig. 16–10) attests to its affinity

16–10 FERNAND LÉGER *The City* (1919). Oil on canvas. 90¾ x 117¼".
Philadelphia Museum of Art: The A. E. Gallatin Collection.

to Synthetic Cubism. As in collage, large flat fields of pure color overlap and partially obscure one another. Unlike the work of Picasso and Braque, however, Léger's paintings seem busy and impersonal. The subjects of the original Cubists' paintings were intimate—portraits of loves and acquaintances, nostalgic collections of bits of memorabilia. Léger, by contrast, enthralled with the trappings of modernism, drew attention to the beauty of the flawless movements of well-designed machines and the robot-like precision of the humans who operate them. Léger offered homage to the sights and sounds and quickened pace of the twentieth-century city. Without apology, he brought contemporary facts of life into the world of fine art.

Cubist Sculpture

Cubism was born as a two-dimensional artform. Cubist artists attempted to render on canvas the manifold aspects of their subjects as if they were walking around three-dimensional forms and recording every angle. The attempt was successful, in part, because they recorded these views with transparent planes that allowed viewers to perceive the many sides of the figure.

Because Cubist artists were trying to communicate all the visual information available about a particular form, they were handicapped, so to speak, by the two-dimensional surface. In some ways the medium of sculpture was more natural to Cubism, because a viewer could actually walk around a figure to assimilate its many facets. The transparent planes that provided a sense of intrigue in Analytical Cubist paintings were often translated as flat solids, often with innovative results.

JACQUES LIPCHITZ

One of the innovations in Cubist sculpture was the use of void space as solid form. Another was the three-dimensional interpenetration of Cubist planes, as seen in *Man with a Guitar* (Fig. 16–11) by Polish-born sculptor Jacques Lipchitz (1891–1964). *Man*

16–11 JACQUES LIPCHITZ
Man with a Guitar (1915). Limestone. 38¼″ high.
Collection, The Museum of Modern Art, N.Y. Mrs. Simon Guggenheim Fund (by exchange).

with a Guitar is dominated by vertical, ascending linear planes, lending the figure a rhythmic, architectural quality. Although there is a good degree of abstract simplification in the figure, the overall impression of the chunky forms prompts recognition of the humanity of the subject. The charm of the figure, as with many other sculptures, can only be suggested by the two dimensions to which we are limited in a book.

Several years after the advent of Cubism, a new movement sprang up in Italy under the leadership of the poet Filippo Marinetti (1876–1944). **Futurism** was introduced angrily by Marinetti in a 1909 manifesto that called for an art of "violence, energy, and boldness" free from the "tyranny of . . . harmony and good taste."[*] In theory, Futurist painting and sculpture were to "glorify the life of today, unceasingly and violently transformed by victorious science." In practice, these artists owed much to Cubism.

Umberto Boccioni

An oft-repeated word in Futurist credo is **dynamism,** defined as the theory that force or energy is the basic principle of all phenomena. Umberto Boccioni (1882–1916), a leading Futurist painter and sculptor, said:

> Everything moves, everything runs, everything turns swiftly. The figure in front of us never is still, but ceaselessly appears and disappears. Owing to the persistence of images on the retina, objects in motion are multiplied, distorted, following one another like waves through space. Thus a galloping horse has not four legs; it has twenty.[†]

The principle of dynamism is illustrated in Boccioni's drawing *Male Figure in Motion Towards the Left* (Fig. 3–3), in which irregular, agitated lines communicate the energy of movement. The Futurist obsession with illustrating images in perpetual motion also found a perfect outlet in sculpture. In works such as *Unique Forms of Continuity in Space* (Fig. 16–12), Boccioni, whose forte was sculpture, sought to convey the elusive surging energy that blurs an image in motion, leaving but an echo of its passage. Although it retains an overall figural silhouette, the sculpture is devoid of any

16–12 UMBERTO BOCCIONI
Unique Forms of Continuity in Space (1913)
Bronze (cast 1931). 43⅞ x 34⅞".
Collection, The Museum of Modern Art, N.Y. Acquired through the Lillie P. Bliss Bequest.

representational details. The flamelike curving surfaces of the striding figure do not exist to define its movement; instead, they are a consequence of it.

Cubist and Futurist works of art, regardless of how abstract they might appear, always contain vestiges of representation, whether they be unobtrusive details like an eyelid or moustache, or an object's recognizable contours. Yet with Cubism, the seeds of abstraction were planted. It was just a matter of time until they would find fruition in artists who, like Kandinsky, would seek pure form unencumbered by referential subject matter.

EARLY TWENTIETH-CENTURY ABSTRACTION IN THE UNITED STATES

The Fauvist and German Expressionist artists had an impact in the United States as well as in Europe. It was the American pho-

[*] F. T. Marinetti, "The Foundation and Manifesto of Futurism," in Herschel B. Chipp, ed., *Thieves of Modern Art* (Berkeley, Ca.: University of California Press, 1968), pp. 284–88.
[†] Robert Goldwater and Marco Treves, eds., *Artists on Art* (New York: Pantheon Books, 1972), p. 35.

16–13 GEORGIA O'KEEFFE
Light Iris (1924). Oil on canvas.
40 x 30".

Virginia Museum of Fine Arts. Gift of Mr. and Mrs.
Bruce Gottwald.

tographer Alfred Stieglitz who propounded and supported the development of abstract art in the United States by exhibiting this work and calling attention to its originality. Among the artists supported by Stieglitz were Georgia O'Keeffe and John Marin.

GEORGIA O'KEEFFE

Throughout her long career, Georgia O'Keeffe (1887–1986) painted many subjects, from flowers to city buildings to the skulls of animals baked white by the sun of the desert Southwest. In each case she captured the abstract essence of her subjects by simplifying their forms. In 1924, the year O'Keeffe married Stieglitz, she began to paint enlarged flower pictures such as *Light Iris* (Fig. 16–13); (I present these facts as coincidence, not cause and effect). In these paintings, she magnified and abstracted the details of her botanical subjects, so that often

a large canvas was filled with but a fragment of the intersection of petals. These flowers have a yearning, reaching organic quality, and her botany seems to function as a metaphor for zoology. That is, her plants are animistic; they seem to grow because of will, not merely because of the blind interactions of the unfolding of the genetic code with water, sun, and minerals. And although O'Keeffe denied any attempt to portray sexual imagery in these flowers, the edges of the petals, in their folds and convolutions, are frequently reminiscent of parts of the female body. The sense of will and reaching renders these petals active rather than passive in their implied sexuality, and so they seem symbolically to express a feminist polemic. This characteristic might be one of the reasons that O'Keeffe was "invited" to Judy Chicago's *Dinner Party*, as was noted on page 206.

JOHN MARIN

John Marin (1870–1953), like Georgia O'Keeffe, showed a fierce individualism in his work. Many of his paintings, however, such as *Deer Isle—Marine Fantasy* (Fig. 16–14), show the influences of the fractured planes of Cubism and the distortions and vibrant colors of Expressionism. Because of his tendency to apply swaths of paint to his supports, especially in his later oil paintings, some critics have seen Marin as a forerunner of the post-World War II Abstract Expressionist movement. Certainly Marin was fascinated by the properties of his media in their own right, as well as in their ability to render abstractions of the external world. Marin told one biographer that he tried "to give paint a chance to show itself entirely as paint." This love affair with paint also characterizes the Abstract Expressionists of the New York School, as we shall see in the next chapter.

16–14 JOHN MARIN
Deer Island—Marine Fantasy (1917). Watercolor.
Honolulu Academy of Arts, Honolulu.

EARLY TWENTIETH-CENTURY ABSTRACTION IN EUROPE

The second decade of the twentieth century witnessed the rise of many dynamic schools of art in Europe. Two of these—Constructivism and De Stijl—were dedicated to pure abstraction, or **nonobjective art.** Nonobjective art differs from the abstraction of Cubism or Futurism in its total lack of representational elements. It does not use nature or visual reality as a point of departure; it has no subject other than that of the forms, colors, and lines that compose it. In nonobjective art, the earlier experiments in abstracting images by Cézanne and then by the Cubists reached their logical conclusion.

Kandinsky is recognized as the first painter of pure abstraction, although several artists were creating nonobjective works at about the same time. The two major centers for abstract art were Russia and Holland.

KASIMIR MALEVICH

Shortly after Kandinsky painted his first nonobjective work in 1910, a small group of Russian artists whom he inspired began to follow suit with geometric abstractions related to Cubism and Futurism. A few years later, one of these artists, Kasimir Malevich (1878–1935), emerged as a radical innovator. He purged his canvases of subject matter and, in his words, "sought refuge in the square form."

In 1913 Malevich launched the movement he called **Suprematism** with a composition that consisted of a black square penciled on a white ground. He defined Suprematism as "the supremacy of pure feeling in creative art," independent of the imitation of visual reality. As with Kandinsky, Malevich's simplified forms began to take on a spiritual quality. After initial works composed of simple squares, Malevich expanded his vocabulary to include the circle and square cross. This led to more complex works which analyzed relationships between numerous geometric forms and their influence on the surrounding space. By 1918, however, he returned to a more severe style of painting with works such as *White*

16-15 KASIMIR MALEVICH
Suprematist Composition: White on White (1918?)
Oil on canvas. 31¼ x 31¼".
Collection, The Museum of Modern Art, N.Y.

16-16 NAUM GABO
Column (c. 1923)
Perspex, wood, metal, glass. 41½ x 29 x 29".
Solomon R. Guggenheim Museum, N.Y.

on White (Fig. 16-15). Free of contrasts of colors and various shapes, the viewer is now able to contemplate the simple geometric relationship of a square within a square.

It is interesting to note that Kandinsky and Malevich—both Russians—initiated the two major trends in twentieth-century art: expressionistic abstraction and geometric abstraction. They exemplify a stylistic polarity that exists to the present day.

Constructivism

Whereas nonobjective painting was the logical outgrowth of Analytical Cubism, Cubist collage gave rise to Constructivist sculpture. Born in Russia, **Constructivism** challenged the traditional sculptural techniques of carving and casting that emphasized mass rather than space.

NAUM GABO

Naum Gabo (1890–1977), a constructivist sculptor, challenged the ascendance of mass over space by creating works in which inter-

secting planes of metal, glass, plastic, or wood defined space. The nonobjective *Column* (Fig. 16-16) exudes a high-tech feeling. It is somewhat reminiscent of magnetic fields, of things plugged in, of the old vacuum tube. But the subject of the work consists in the constructed forms themselves. The column itself is suggested by intersecting planes that interact with the surrounding space; it does not envelop space, and—true to the Constructivist aesthetic—it denies mass and weight. The beauty of *Column* is found in the purity of its elements and in the contrasts between horizontal and vertical elements and translucent and opaque elements.

PIET MONDRIAN

Influenced by Vincent van Gogh, fellow Dutch painter Piet Mondrian (1872–1944) began his career as a painter of impressionistic landscapes. In 1910 he went to Paris and

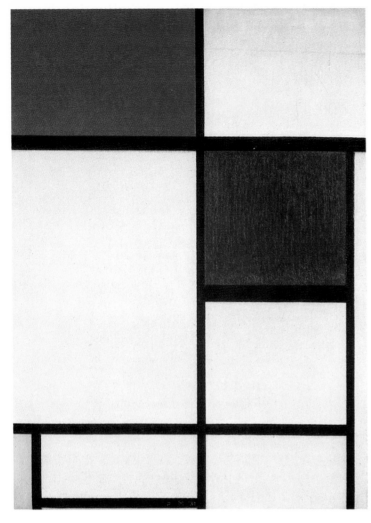

16–17 PIET MONDRIAN
Composition with Red, Blue, and Yellow (1930)
Oil on canvas. 28½ x 21¼".
Courtesy Sidney Janis Gallery, N.Y.

16–18 GERRIT RIETVELDT
Schroeder House, Utrecht (1924)

was immediately drawn to the geometricism of Cubism. During the war years, when he was back in Holland, his studies of Cubist theory led him to reduce his forms to lines and planes and his palette to the primary colors and black and white. These limitations, Mondrian believed, permitted a more universally comprehensible art.

Mondrian developed his own theories of painting that are readily apparent in works such as *Composition with Red, Blue, and Yellow* (Fig. 16–17):

> All painting is composed of line and color. Line and color are the essence of painting. Hence they must be freed from their bondage to the imitation of nature and allowed to exist for themselves.
>
> Painting occupies a plane surface. The plane surface is integral with the physical and psychological being of the painting. Hence the plane surface must be respected, must be allowed to declare itself, must not be falsified by imitations of volume. Painting must be as flat as the surface it is painted on.[*]

If Mondrian's views had been a theory of architecture, perhaps they would have found expression in works such as Gerrit Rietveldt's *Schroeder House* (Fig. 16–18) of the same era. Here there is an almost literal translation of geometry to architecture. Broad expanses of white concrete intersect to define the strictly rectilinear dwelling, or appear to float in superimposed planes. As in a Mondrian painting, these planes are accented by black verticals and horizontals in supporting posts or window mullions. The surfaces are unadorned, like the color fields of a Mondrian.

Mondrian's obsessive respect for the two-dimensionality of the canvas surface is the culmination of the integration of figure and ground begun with the planar recession of Jacques-Louis David (see Chapter 15). No longer was it necessary to tilt tabletops or render figure and ground with the same brushstrokes and palette to accomplish this task. Canvas and painting, figure and ground were one.

[*] Robert Goldwater and Marco Treves, eds., *Artists on Art* (New York: Pantheon Books, 1972), p. 426.

The universality sought by Mondrian through extreme simplification can also be seen in the sculpture of Constantin Brancusi (1876–1957). Yet unlike Mondrian's, Brancusi's works, however abstract they appear, are rooted in the figure.

Brancusi was born in Rumania thirteen years after the Salon des Réfusés. After an apprenticeship as a cabinetmaker and studies at the Bucharest Academy of Fine Arts, he traveled to Paris to enroll in the famous École des Beaux-Arts. In 1907 Brancusi exhibited at the Salon d'Automne, leaving favorable impressions of his work. One of those who saw potential in Brancusi was Auguste Rodin, who asked him to become his assistant. The younger artist rejected the proposal with his now famous comment, "Nothing grows under the shade of great trees."

Brancusi's work, heavily indebted to Rodin at this point, did indeed grow in a radically different direction. As early as 1909 he reduced the human head—a favorite theme he would draw upon for years—to an egg-shaped form with sparse indications of facial features. In this, and in other abstractions such as *Bird in Space* (Fig. 16–19), he reached for the essence of the subject by offering the simplest contour that, along with a descriptive title, would fire recognition in the spectator. *Bird in Space* evolved from more representational versions into a refined symbol of the cleanness and solitude of flight.

FANTASY AND DADA

Throughout the history of art, most critics and patrons have seen the accurate representation of visual reality as a noble goal. Those artists who have departed from this goal, who have chosen to depict their personal worlds of dreams or supernatural fantasies, have not had it easy. Before the twentieth century, only isolated examples of what we call **Fantastic art** could be found. The early 1900s, however, saw many artists exploring fanciful imagery and working in styles as varied as their imaginations.

16–19 CONSTANTIN BRANCUSI
Bird in Space (c. 1928). Bronze (unique cast). 54″ high.
Collection, The Museum of Modern Art, N.Y. Given anonymously.

How do we describe Fantastic art? The word *fantastic* derives from the Greek *phantastikos*, meaning the ability to represent something to the mind, or to create a mental image. Fantasy is further defined as unreal, odd, seemingly impossible, and strange in appearance. Fantastic art, then, is the representation of incredible images from the artist's mind. At times the images are joyful reminiscences, at times horrific nightmares. They may be capricious or grotesque.

PAUL KLEE

One of the most whimsical yet subtly sardonic of the Fantastic artists is Paul Klee (1879–1940). Although influenced early in his career by nineteenth-century artists such as Goya, who touched upon fantasy, Klee received much of his stylistic inspiration from Cézanne. In 1911 he joined Der Blaue Reiter, where his theories about intuitive approaches to painting, growing abstraction, and love of color were well received.

A certain innocence pervades Klee's idiosyncratic style. After abandoning representational elements in his art, Klee turned to

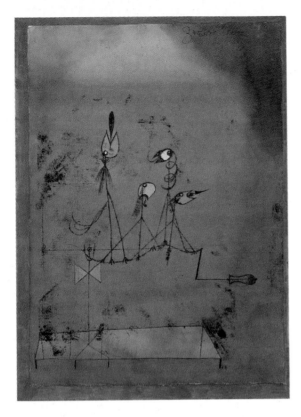

16–20 PAUL KLEE
Twittering Machine (1922)
Watercolor, pen and ink. 16¼ x 12".

Collection, The Museum of Modern Art, N.Y. Purchase.

primitive and children's art, seeking a universality of expression in their extreme simplicity. Many of his works combine a charming naïveté with wry commentary. *Twittering Machine* (Fig. 16–20), for example, offers a humorous contraption composed of four fantastic birds balanced precariously on a wire attached to a crank. The viewer who is motivated to piece together the possible function of this apparatus might assume that turning the crank would result in the twittering suggested by the title.

In this seemingly innocuous painting, Klee perhaps satirizes contemporary technology, in which machines may sometimes seem to do little more than express the whims and ego of the inventor. But why a machine that twitters? Some have suggested a darker interpretation in which the mechanical birds are traps to lure real birds to a makeshift coffin beneath. Such gruesome doings might in turn symbolize the entrapment of humans by their own exis-

tence. In any event, it is evident that Klee's simple, cartoon-like subjects may carry a mysterious and rich iconography.

GIORGIO DE CHIRICO

Equally mysterious are the odd juxtapositions of familiar objects found in the works of Giorgio de Chirico (1888–1978). Unlike Klee's figures, Chirico's are rendered in a realistic manner. Chirico attempted to make the irrational believable. His subjects are often derived from dreams, in which ordinary objects are found in extraordinary situations. The realistic technique tends to heighten the believability of these events and imparts a certain eeriness characteristic of dreams or nightmares. Part of the intrigue of Chirico's subjects lies in their ambiguity and in the uncertainty of the outcome. Often we do not know why we dream what we dream. We do not know how the strange juxtapositions occur, nor how the story will evolve. We may now and then "save" ourselves from danger by awakening.

The intrigues of the dream world are captured by Chirico in works such as *The Mystery and Melancholy of the Street* (Fig. 16–21). Some of his favorite images—the icy arcade, the deserted piazza, the empty boxcar—provide the backdrop for an encounter between two figures at opposite ends of a diagonal strip of sunlight. A young girl, seemingly unaware of the tall dark shadow beyond her, skips at play with stick and hoop. What is she doing there? Why is she alone? Who is the source of the shadow? Is it male or female? What is the spearlike form by the figure? We quickly perceive doom. We wonder what will happen to the girl and imagine the worst. For example, we are not likely to assume that the girl is rushing to her father standing by a flagpole. Viewers must stew in their active imaginations, pondering the simple clues to a mystery that Chirico will not unlock.

Dada

In 1916, during World War I, an international movement arose that declared itself against art. Responding to the absurdity of

16–21 GIORGIO DE CHIRICO
*The Mystery and Melancholy
of the Street* (1914). Oil on canvas.
34¼ x 28⅛.
Private collection, USA.

war and the insanity of a world that gave rise to it, the Dadaists declared that art—a reflection of this sorry state of affairs—was stupid and must be destroyed. Yet in order to communicate their outrage, the Dadaists created works of art! This inherent contradiction spelled the eventual demise of their movement. Despite centers in Paris, Berlin, Cologne, Zurich, and New York City, **Dada** ended with a whimper in 1922.

The name "Dada" was supposedly chosen at random from a dictionary. It is an apt epithet. The nonsense term describes nonsense art—art that is meaningless, absurd, unpredictable. While it is questionable whether this catchy label was in truth derived at random, the element of chance was indeed important to the Dada artform. Dada poetry, for example, consisted of nonsense verses of random word combinations. Some

works of art, such as the Dada collages, were constructed of materials found by chance and mounted randomly. Yet however meaningless or unpredictable the poets and artists intended their products to be, in reality they were not. In an era dominated by the doctrine of psychoanalysis, the choice of even nonsensical words spoke something at least of the poet. Works of art supposedly constructed in random fashion also frequently betrayed the mark of some design.

MARCEL DUCHAMP

In an effort to advertise their nihilistic views, the Dadaists assaulted the public with irreverence. Not only did they attempt to negate art, but they also advocated antisocial and amoral behavior. Marcel Duchamp offered for exhibition a urinal, turned on

16–22 MARCEL DUCHAMP
Mona Lisa (L.H.O.O.Q.)
(1919). Rectified readymade;
pencil on a reproduction.
7¾ x 4⅞".

Private collection.

its back and entitled *Fountain* (see Fig. 1–28). Later he summed up the Dada sensibility in works such as *Mona Lisa* (Fig. 16–22), in which he impudently defiled a color print of Leonardo da Vinci's masterpiece with a moustache and goatee.

Duchamp's early work showed a number of contemporary influences, including Cubism, the development of motion picture photography, and the dynamism of Futurism. Consider the well-known *Nude Descending a Staircase #2* (Fig. 16–23). At the time it was exhibited, a critic described the painting as "an explosion in a shingle factory." Certainly the intersecting, splintered planes can leave such an impression. But these planes do not burst forth uncontrolled from a central core. Instead, they are arranged in an orderly, coherent fashion that describes the multifaceted form of a human figure in motion down a flight of stairs. It could be said that *Nude* creates the illusion of movement through a progressive series of still images, in a sense paralleling the effects of **stroboscopic motion** (see p. 190) in a painting. In his simulation of the fourth dimension of time through a series of overlapping images, the early Duchamp added a new element to the experiments of Cubism.

Fortified by growing interest in psychoanalysis, Dada, with some modification, would provide the basis for a movement called Surrealism that began in the early 1920s. Like Max Ernst's Dada composition, *Two Children Are Threatened by a Nightingale* (Fig. 16–24), some Surrealist works offer irrational subjects and the chance juxtaposition of everyday objects. These often menacing paintings also incorporate the realistic technique and the suggestion of dream imagery found in Fantastic art.

16–23 MARCEL DUCHAMP
Nude Descending a Staircase #2 (1912)
Oil on canvas. 58 x 35".

Philadelphia Museum of Art. Louise and Walter Arensberg Collection.

16–24 MAX ERNST
Two Children Are Threatened by a Nightingale (1924)
Oil on wood with wood construction.
27½ x 22½ x 4½".

Collection, The Museum of Modern Art, N.Y. Purchase.

SURREALISM

Surrealism began as a literary movement after World War I. Its adherents based their writings on the nonrational, and thus they were naturally drawn to the Dadaists. Both literary groups engaged in **automatic writing,** in which the mind was to be purged of purposeful thought and a series of free associations were then to be expressed with the pen. Words were not meant to denote their literal meanings, but rather to symbolize the often seething contents of the unconscious mind. Eventually the Surrealist writers broke from the Dadaists, believing that the earlier movement was becoming too academic. Under the leadership of the poet André Breton, they defined their movement as follows in a 1924 manifesto:

> *Surrealism,* noun, masc., pure psychic automatism by which it is intended to express either verbally or in writing, the true function of thought. Thought dictated in the absence of all control exerted by reason, and outside all aesthetic or moral preoccupations.
>
> *Encycl. Philos.* Surrealism is based on the belief in the superior reality of certain forms of association heretofore neglected, in the omnipo-

tence of the dream, and in the disinterested play of thought. It leads to the permanent destruction of all other psychic mechanisms and to its substitution for them in the solution of the principal problems of life.

From the beginning, Surrealism expounded two very different methods of working. **Illusionistic Surrealism,** exemplified by artists such as Salvador Dalí and Yves Tanguy, rendered the irrational content, absurd juxtapositions, and metamorphoses of the dream state in a highly illusionistic manner. The other, called **Automatist Surrealism,** was a direct outgrowth of automatic writing and was used to divulge mysteries of the unconscious through abstraction. The automatist phase is typified by Joan Miró and André Masson.

SALVADOR DALÍ

One of the few "household names" in the history of art belongs to a leading Surrealist figure, the Spaniard Salvador Dalí (1904–1986). His reputation for leading an unusual—one could say surrealistic—life would seem to precede his art, for many not familiar with his canvases had seen

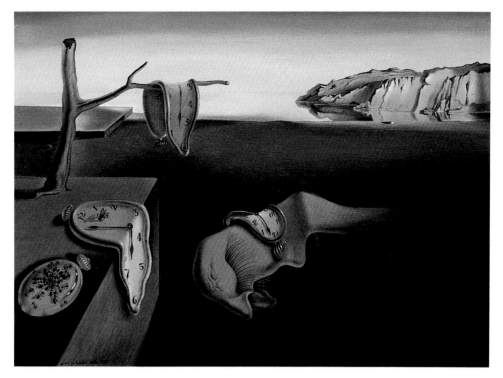

16–25 SALVADOR DALÍ
The Persistance of Memory (1931)
Oil on canvas. 9½ x 13".

Collection, The Museum of Modern Art, N.Y.
Given anonymously.

Dalí's outrageous moustache and knew of his absurd shenanigans. Once as a guest on the Ed Sullivan television show, he threw open cans of paint at a huge canvas.

Dalí began his painting career, however, in a somewhat more conservative manner, adopting, in turn, Impressionist, Pointillist, and Futurist styles. Following these forays into contemporary styles, he sought academic training at the Academy of Fine Arts in Madrid. This experience steeped him in a tradition of illusionistic realism that he never abandoned.

In what is perhaps Dalí's most famous canvas, *The Persistence of Memory* (Fig. 16–25), the drama of the oneiric imagery is enhanced by his **trompe l'oeil** technique. Here, in a barren landscape of incongruous forms, time, as all else, has expired. A watch is left crawling with insects like scavengers over carrion; three other watches hang limp and useless over a rectangular block, a dead tree, and a lifeless, amorphous creature that bears a curious resemblance to Dalí. The artist conveys the world of the dream, juxtaposing unrelated objects in an extraordinary situation. But a haunting sense of reality threatens the line between perception and imagination. Dalí's is, in the true definition of the term, a surreality—or reality above and beyond reality.

JOAN MIRÓ

Not all of the Surrealists were interested in rendering their enigmatic personal dreams. Some found this highly introspective subject matter meaningless to the observer and sought a more universal form of expression. The Automatist Surrealists believed that the unconscious held such universal imagery, and through spontaneous, or automatic, drawing, they attempted to reach it. Artists of this group, such as Joan Miró (1893–1983), sought to eliminate all thought from their minds and then trace their brushes across the surface of the canvas. The organic shapes derived from intersecting skeins of line were believed to be unadulterated by conscious thought and thus drawn from the unconscious. Once the basic designs had been outlined, a conscious period of work could follow in which the artist intentionally applied his or her craft to render them in their final form. But because no conscious control was to be exerted

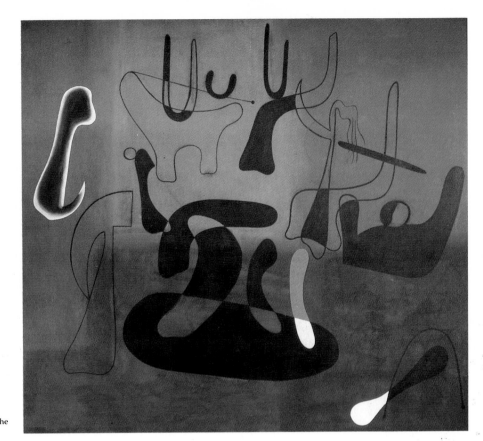

16–26 JOAN MIRÓ
Painting (1933)
Oil on canvas. 68½ x 77¼".

Collection, The Museum of Modern Art, N.Y. Gift of the
Advisory Committee (by exchange).

to determine the early course of the designs, the Automatist method was seen as spontaneous, as employing chance and accident. Needless to say, the works are abstract, although some shapes are amoebic.

Miró was born near Barcelona and spent his early years in local schools of art learning how to paint like the French. He practiced a number of styles ranging from Romanticism to Realism to Impressionism, but Cézanne and van Gogh seem to have influenced him most. In 1919 Miró moved to Paris, where he was receptive to a number of art styles. The work of Matisse and Picasso along with the primitive innocence of Rousseau found their way into his canvases. Coupled with a rich native iconography and an inclination toward fantasy, these different elements would shape Miró's unique style.

Miró's need for spontaneity in communicating his subjects was compatible with Automatist Surrealism, although the whimsical nature of most of his subjects often appears at odds with that of other members of the

movement. In *Painting* (Fig. 16–26), meandering lines join or intersect to form the contours of clusters of organic figures. Some of these shapes are left void to display a nondescript background of subtly colored squares. Others are filled in with sharply contrasting black, white, and bright red pigment. In this work, Miró applied Breton's principles of psychic automatism in an aesthetically pleasing, decorative manner.

By 1930 Surrealism had developed into an international movement, despite the divorce of many of the first members from the group. New adherents exhibiting radically different styles kept the movement alive. As the decade of the 1930s evolved, however, Adolph Hitler rose to power and war once again threatened Europe. Hitler's ascent drove refugee artists of the highest reputation to the shores of the United States. Among them were the leading figures of Abstraction and Surrealism, two divergent styles that would join to form the basis of an avant-garde American painting. The center of the art world had moved to New York.

17

Contemporary Art

Ah! stirring times we live in—stirring times.
—Thomas Hardy, *Far from the Madding Crowd*, 1874

If Thomas Hardy were writing today instead of a century ago, he might say that we too live in stirring times. If he were writing about art, he would doubtless insist upon it. Never before in history have artists experimented so freely with medium, content, and style. Never before in history have the mass media brought the images wrought by artists so rapidly into our homes. Never before has the general public been so conscious of, and affected by, art.

In this chapter we will talk about the painting and sculpture that have appeared since the end of World War II—the art of recent times and of today. After the war, the center of the art world shifted to New York after its long tenure in Paris. There were a number of reasons. The wave of immigrant artists who escaped the Nazis had settled largely in New York. Among them were Marcel Duchamp, Fernand Léger, Josef Albers, Hans Hofmann, and others. The Federal Art Project of the WPA

had also nourished the New York community of artists during the Great Depression. This group included Arshile Gorky, Willem de Kooning, Jack Tworkov, James Brooks. Philip Guston, and Stuart Davis, among many others. Together these were known as the first-generation New York School. Even the Mexican muralists Diego Rivera and José Clemente Orozco sojourned and taught in the city.

Just before the Great Depression began, Orozco had already argued that the artists of the New World should no longer look to Europe for their inspiration and their models. In January of 1929 he wrote: "If new races have appeared upon the lands of the New World, such races have the unavoidable duty to produce a New Art in a new spiritual and physical medium. Any other road is plain cowardice." Despite his devotion to the arts and culture of the Mexican Native Americans, Orozco added: "Already the architecture of Manhattan is a new value, something that has nothing to do with Egyptian pyramids, with the Paris Opéra, with the Geralda of Seville, or with Saint Sofia, any more than it has to do with the Maya palaces of Chichén-Itzá or with the pueblos of Arizona."[*]

There is no question that the postwar generation produced an art never before seen on the face of the planet. It is a lively art that stirs both adoration and controversy. It is also a fertile art, giving birth to exploration down many branching avenues.

PAINTING

In this section we will look at a number of the vital movements that have given shape to contemporary painting. We will begin with painters of the first-generation New York School and their powerful new movement of Abstract Expressionism. Then we will consider the work of a younger, second generation of New York School painters, including color-field and hard-edge painters. Finally, we will discuss a number of the other movements in painting that have defined the postwar years, including figurative painting, Pop art, Photorealism, and Op art.

THE NEW YORK SCHOOL: THE FIRST GENERATION

At midcentury the influences of earlier nonobjective painting, the colorful distortions of Expressionism, Cubist design, the supposedly automatist processes of Surrealism, and a host of other factors—even an interest in **Zen Buddhism**—converged in New York. From this artistic melting pot, Abstract Expressionism flowered. At first, like other innovative movements in art, it was not universally welcomed by critics. Writing in *The New Yorker* in 1945, Robert M. Coates commented:

> [A] new school of painting is developing in this country. It is small as yet, no bigger than a baby's fist, but it is noticeable if you get around to the galleries much. It partakes a little of Surrealism and still more of Expressionism, and although its main current is still muddy and its direction obscure, one can make out bits of Hans Arp and Joan Miró floating in it, together with large chunks of Picasso and occasional fragments of [black African] sculptors. It is more emotional than logical in expression, and you may not like it (I don't either, entirely), but it can't escape attention.[†]

Abstract Expressionism is characterized by spontaneous execution, large gestural brushstrokes, abstract imagery, and fields of intense color. Many canvases are quite large, lending monumentality to the imagery. The abstract shapes frequently have a **calligraphic** quality found in the painting of the Far East (see Chapter 18). However, the scope of the brushstrokes of the New York group was vast and muscular compared with the gentle, circumscribed brush strokes of Chinese and Japanese artists.

[*] Robert Goldwater and Marco Treves, eds., *Artists on Art* (New York: Pantheon Books, 1972), p. 479.

[†] Robert M. Coates, "The Art Galleries," *The New Yorker*, May 26, 1945, p. 68.

Turning the Corner Toward an Abstract Expressionism

Before we discuss the work of the major Abstract Expressionists, let us explore the vibrant canvases of two artists whose work, near midcentury, showed the influence of earlier trends and, in turn, presaged Abstract Expressionism: Arshile Gorky and Hans Hofmann.

ARSHILE GORKY

> The vital task was a wedding of abstraction and surrealism. Out of these opposites something new could emerge, and Gorky's work is part of the evidence that this is true.[*]

Born in Armenia, Arshile Gorky (1905–1948) emigrated to the United States in 1920 and became part of a circle that included Willem de Kooning and Stuart Davis. Some of Gorky's early still lifes show the influence of the great nineteenth-century painter Paul

Cézanne. Later abstract works resolve the shapes of the objects of still lifes into sharp-edged planes that recall the works—and the fascination with primitive forms—of Pablo Picasso and Georges Braque. Abstractions of the late 1940s show the influence of Expressionists such as Wassily Kandinsky and Surrealists such as Joan Miró.

Gorky's *The Liver Is the Cock's Comb* (Fig. 17–1) is 6 feet high and more than 8 feet long. Free, spontaneous lines pick out unstable, organic shapes from a lush molten background of predominantly warm colors: analogous reds, oranges, and yellows. The shapes are reminiscent of the surrealistic forms of Joan Miró in *The Birth of the World* (see Fig. 2–46).

Many of Gorky's paintings, like those of the Surrealists, are like erotic panoramas. Here and there we can pick out abstracted forms that seem to hark back to dreams of childhood or to the ancestral figures of primitive artists. Transitional works such as this form a logical bridge between early twentieth-century abstraction, **Automatist Surrealism,** and the gestural painting of Jackson Pollock and Willem de Kooning, as we shall see below.

[*] Adolph Gottlieb, in Introduction to catalog of an exhibition, "Selected Paintings by the Late Arshile Gorky," Kootz Gallery, New York, March 28–April 24, 1950.

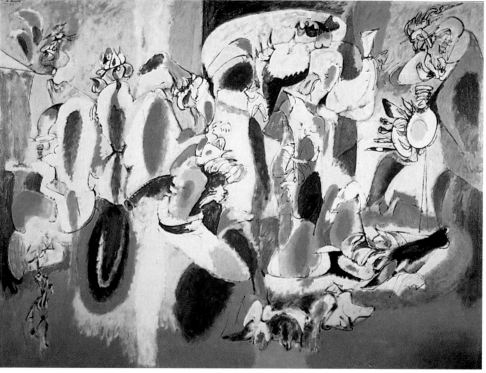

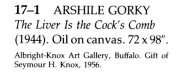

17–1 ARSHILE GORKY
The Liver Is the Cock's Comb
(1944). Oil on canvas. 72 x 98".

Albright-Knox Art Gallery, Buffalo. Gift of Seymour H. Knox, 1956.

17–2 HANS HOFMANN
The Golden Wall (1961)
Oil on canvas. 60 x 72½".
Courtesy of The Art Institute of Chicago.

HANS HOFMANN

Born in Bavaria, Hans Hofmann (1880–1966) studied in Paris early in this century. He witnessed at close hand the Fauvists' use of high-keyed colors and the Cubists' resolution of shapes into abstract planes. He emigrated to the United States from Germany in 1932 and established schools of fine art in New York City and in Provincetown, Massachusetts.

Hofmann's early works were figural and expressionistic, showing the influence of Henri Matisse, but from the war years on, his paintings showed a variety of abstract approaches, from lyrically free curving lines to the depiction of geometrical masses. Hofmann is considered a transitional figure between the Cubists and the Abstract Expressionists. In his abstract paintings, he shows some allegiance to Fauvist coloring and Cubist design, but Hofmann also used color architecturally, to define structure.

In *The Golden Wall* (Fig. 17–2), intense fields of complementary and primary colors are pitted against each other in Fauvist fashion, but they compose abstract rectangular forms. The gestural brushstrokes in the color fields of paintings such as these would soon spread through the art world. Hofmann, the analyst and instructor of painting, knew very well that the cool blues and greens in *The Golden Wall* would normally recede and the warm reds and oranges would emerge; but sharp edges and interposition press the blue and green areas forward, creating tension between planes and flattening the canvas. Hofmann saw this tension as symbolic of the push and pull of nature; but the "tension" is purely technical, for the mood of *The Golden Wall*, as of most of his other works, is joyous and elevating.

Later Hofmann would claim that paintings such as these were derived from nature, even though no representational imagery can be found. In their expressionistic use of color and their abstract subject matter, Hofmann's paintings form a clear base for the flowering of **Abstract Expressionism.**

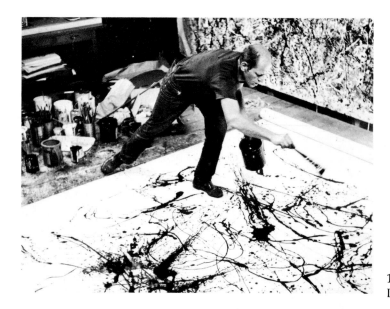

17–3 Jackson Pollock at work in his Long Island studio, 1950.

17–4 JACKSON POLLOCK *One (Number 31, 1950)* (1950). Oil and enamel paint on canvas. 8'10" x 17'5⅝".

Collection, The Museum of Modern Art, N.Y. Sidney and Harriet Janie Collection Fund (by exchange).

17–5 JACKSON POLLOCK *One (Number 31, 1950)* Detail.

Focus on Gesture

For some Abstract Expressionists, such as Jackson Pollock and Willem de Kooning, the gestural application of paint seems to be the most important aspect of their work. For others, whom we shall discuss in the section following this, the structure of the color field seems to predominate.

JACKSON POLLOCK

Pollock's talent is volcanic. It has fire. It is unpredictable. It is undisciplined. It spills itself out in a mineral prodigality not yet crystallized. It is lavish, explosive, untidy. . . . What we need is more young men who paint from inner compulsion without an ear to what the critic or spectator may feel—painters who will risk spoiling a canvas to say something in their own way. Pollock is one.[*]

Jackson Pollock (1912–1956) is probably the best-known of the Abstract Expressionists. Photographs or motion pictures of the artist energetically dripping and splashing paint across his huge canvases (Fig. 17–3) are familiar to many Americans. Pollock would walk across the surface of the canvas as if controlled by primitive impulses and unconscious ideas. Accident became a prime compositional element in his painting. Art critic Harold Rosenberg coined the term **action painting** in 1951 to describe the outcome of such a process—a painting whose surface implied a strong sense of activity, as created by the signs of brushing, dripping, or splattering of paint (see Fig. 17–5, which is a detail of Pollock's *One*, shown in Fig. 17–4).

Born in Cody, Wyoming, Pollock came to New York to study with Thomas Hart Benton at the Art Students League. The 1943 quote from Clement Greenberg shows the impact that Pollock made at an early exhibition of his work. His paintings of this era (see Fig. 1–35) frequently depicted actual or implied figures that were reminiscent of the abstractions of Picasso and, at times, of Expressionists and Surrealists.

Aside from their own value as works of art, Pollock's drip paintings of the late 1940s and early 1950s made a number of innovations that would be mirrored and developed in the work of other Abstract Expressionists. Foremost among these was the use of an overall gestural pattern barely contained by the limits of the canvas. In *One* (Figs. 17–4 and 17–5), the surface is an unsectioned, unified field. Overlapping skeins of paint create dynamic webs that project from the picture plane, creating an illusion of infinite depth. In Pollock's best work, these webs seem to be composed of energy that pushes and pulls the monumental tracery of the surface like the architectural shapes of a Hofmann painting.

Pollock was in psychoanalysis at the time he executed his great drip paintings. He believed strongly in the role of the unconscious mind, of accident and spontaneity, in the creation of art. He was influenced not only by the intellectual impact of the Automatist Surrealists, but also by what must have been his own impression of walking hand in hand with his own unconscious forces through the realms of artistic expression. Before his untimely death in 1956, Pollock had returned to figural paintings that were heavy in impasto and predominantly black. One wonders what might have emerged if the artist had lived a fuller span of years.

WILLEM DE KOONING

Born in 1904 in Rotterdam, Holland, Willem de Kooning emigrated in 1926 to the United States, where he joined the circle of Gorky and other forerunners of Abstract Expressionism. Until 1940 de Kooning painted figures and portraits. His first abstractions of the 1940s, like Gorky's, remind one of Picasso's paintings. As the 1940s progressed, de Kooning's compositions began to combine biomorphic, organic shapes with harsh, jagged lines. By midcentury, his art had developed into a force in Abstract Expressionism.

De Kooning is best known for his series

[*]Clement Greenberg, quoted in Introduction to catalog of an exhibition, "Jackson Pollock," Art of This Century Gallery, New York, Nov. 9–27, 1943.

On Pollock and the Role of the Unconscious in Painting

CLEMENT GREENBERG: The reliance upon the unconscious and the accidental serves to lift inhibitions which prevent the artist from surrendering, as he needs to, to his medium.

—Clement Greenberg, "Surrealist Painting," *The Nation*, Vol. CLIX, No. 7 (August 12, 1944), p. 193.

JACKSON POLLOCK: When I am in painting, I'm not aware of what I'm doing. It is only after a sort of "get acquainted" period that I see what I have been about. I have no fears about making changes, destroying the image, etc., because the painting has a life of its own. I try to let it come through. It is only when I lose contact with the painting that the result is a mess. Otherwise there is pure harmony, an easy give and take, and the painting comes out well.

—Jackson Pollock, "My Painting," *Possibilities I*, No. 1 (Winter 1947–48), p. 79.

JACK TWORKOV: [At the time Pollock was executing his drip paintings, there was] a belief that you could reach some kind of psychological truth that way, just the way you do in psychoanalysis. [But] I don't think you can set a trap for the unconscious and say, "This is what is going to get at it." The fact is that by setting such a trap, you become too conscious of the unconscious and therefore you really miss it. In the end you have to ignore that problem, and then the unconscious will express itself any way it wants to.

—Author interview with Jack Tworkov, Provincetown, Massachusetts, 1981.

of paintings of women that began in 1950. In contrast to the appealing figurative works of an earlier day, many of his abstracted women are frankly overpowering and repellent. Faces are frequently resolved into skull-like primitive masks reminiscent of ancient fertility figures; they assault the viewer from a loosely brushed backdrop of tumultuous color. Perhaps they portray what was a major psychoanalytic dilemma during the 1950s: how women could be at once seductive, alluring, and castrating. In our own liberated times, this notion of woman or of eroticism as frightening seems sexist or out of joint. In any event, in some of his other paintings, abstracted women communicate an impression of being unnerved, even vulnerable.

The subjects of *Two Women* (Fig. 17–6) are among the more erotic of the series. Richly curved pastel breasts swell from a sea of spontaneous brushstrokes that here and there violently obscure the imagery. The result is a free-floating eroticism. A primal urge has been cast loose in space, pushing and pulling against the picture plane. But de Kooning is one of the few Abstract Expressionists who never completely surrendered figurative painting.

De Kooning's work frequently seems obsessed with the violence and agitation of the "age of anxiety." The abstract backgrounds seem to mirror the rootlessness many of us experience as modern modes of travel and business call us to foreign towns and cities.

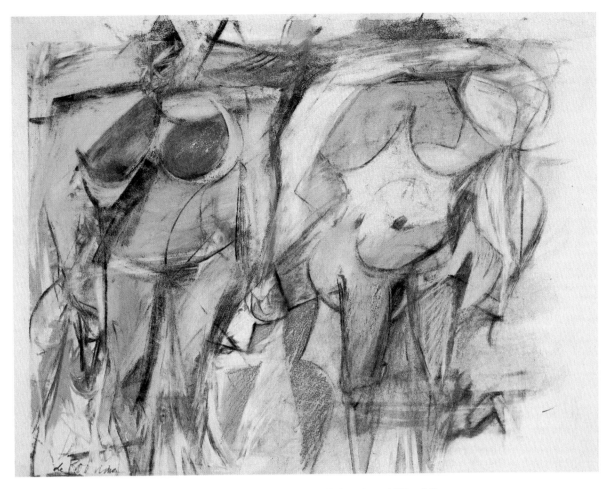

17–6 WILLEM DE KOONING *Two Women* (1953). Pastel drawing. 18⅞ x 24".

Focus on the Color Field

For a number of Abstract Expressionists, the creation of pulsating fields of color was more important than the gestural quality of the brushstroke. Color fields are frequently so large in Abstract Expressionist canvases that they seem to envelop viewers, giving them the impression of resonating with the push and pull of the picture plane. The creation of the color field is a very direct communication of the artist's experience—one that viewers may sense if they relax their inhibitions.

Numbered among the color field painters are Adolph Gottlieb, Mark Rothko, and Barnett Newman.

ADOLPH GOTTLIEB

Born in New York City, Adolph Gottlieb (1903–1974) studied with John Sloan at the Art Students League. During the 1940s and early 1950s, he painted a series of "Pictographs" in which the canvases were sectioned into rectangular compartments filled with schematized or abstract forms such as primitive ancestral images, sinuous shapes of reptiles and birds, pure geometric forms, anatomic parts, and complex shapes suggestive of cosmic symbols or microscopic life forms. He denied that the Pictographs had any rational meaning, but much of the enjoyment in viewing them stems from trying to decipher the content.

Some of Gottlieb's most successful paint-

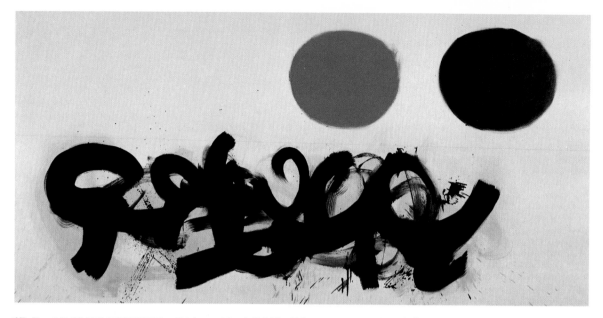

17–7 ADOLPH GOTTLIEB *Dialogue No. 1* (1960). Oil on canvas. 66 x 132".
Albright-Knox Art Gallery, Buffalo. Gift of Seymour H. Knox.

ings belong to the "Bursts" series that began in 1957. In the Bursts, there is an implied horizontal division of the canvas. A field of color floats and pulsates like a burning orb in the upper part of the picture plane, while a gestural formless shape bursts beneath it into the loosely brushed overall background. Visually, the Bursts are studies in contrast between pure closed forms and amorphous open forms. On a symbolic level, they seem to reflect the opposites in human nature.

Dialogue No. 1 (Fig. 17–7), painted in 1960, is a variation on the Bursts theme. A crude black pictograph explodes below an implied horizon line, while two pristine orbs float above. The pictograph is strongly calligraphic, as if the baser history of our species is being broadly recorded in swaths of paint. By comparison the orbs seem immaculate in conception. These pulsating fields of color imply a pure but obscure symbol that is close at hand yet unreachable.

Mark Rothko

Mark Rothko (1903–1970) painted lone figures in urban settings in the 1930s and biomorphic surrealistic canvases through the early 1940s. Later in that decade he began to paint the large floating, hazy-edged color fields for which he is renowned. Dur-

ing the 1950s, the color fields consistently assumed the form of rectangles floating above one another in an atmosphere defined by subtle variations in tone and gesture. They alternately loom in front of and recede from the picture plane, as in *Earth and Green* (Fig. 2–14). The large scale of these canvases envelops and washes the viewer in color.

Early in his career, Rothko had favored pale colors. During the 1960s, however, his palette grew somber. Reds that earlier had been intense, warm, and sensuous were now awash in deep blacks and browns and took on the worn appearance of old cloth. Oranges and yellows were replaced by grays and black. Light that earlier had been reflected was now trapped in his canvases. Despite public acclaim, Rothko suffered from depression during his last years. In 1968 he suffered heart disease, and in 1969 his second marriage was in ruins. He committed suicide the following winter. His paintings of the later years may be an expression of the turmoil and the fading spark within.

Barnett Newman

Barnett Newman (1905–1970) might have been the most daring of the Abstract Expressionists. Like many other Abstract Expressionists, he had rejected realism and painted

biomorphic, surrealistic abstractions early in his career. Finding Surrealism melodramatic, he turned to color-field painting, which he carried to a near extreme—to fields of flat color that filled the canvas, with the exception of one or more vertical stripes of contrasting hue, as in *Vir Heroicus Sublimis* (Fig. 17–8). These wall-sized experiments in **Minimalism** inundate the viewer in color. The vertical stripes seem to allow the viewer a glimpse of a purer world beyond the picture plane.

Newman's mature paintings are stern and simplified. The lack of a gestural surface heightens the pure impact of the color. Many critics have been hostile to his work. Nor have other Abstract Expressionists been quick to rally behind him, perhaps because he no longer employed the aesthetic of the gestural brushstroke. It became his goal to create a new aesthetic, one that cast aside the almost universal objective of beauty in order to reveal what, to him, was a primitive expression of pure ideas.

Abstract Expressionism may be the major movement in painting of the postwar eras, but contemporary painting has been a rich and varied undertaking, with tentative strokes and brilliant bursts of fulfillment in many directions.

THE NEW YORK SCHOOL: THE SECOND GENERATION

Abstract Expressionism was a painterly movement, meaning that contours and colors were loosely defined, edges were frequently blurred, and long brushstrokes trailed off into ripples, streaks, and specks of paint. During the mid-1950s, a number of younger abstract artists, referred to as the "second generation" New York School, began to deemphasize this painterly approach by focusing increasingly on clarity of line and clearness of edges. The structure of their compositions became more open, the centers often virtually clear of color and shape. Their brushstrokes became less gestural. Beyond these few common features, their styles were quite different, and they modified and extended in a number of ways the forces that had led to Abstract Expressionism. Let us first consider the work of a transitional second-generation painter, Sam Francis, and then turn to the work of a number of artists who brought new vitality to the tradition of pure geometric abstraction that was earlier found in the works of artists such as Kasimir Malevich and Piet Mondrian. Some of these artists, such as Morris Louis, Helen Frankenthaler, and Kenneth

17–8 BARNETT NEWMAN *Vir Heroicus Sublimis* (1950–51). Oil on canvas. 7'11⅜" x 17'9¼".

Collection, The Museum of Modern Art, N.Y. Gift of Mr. and Mrs. Ben Heller.

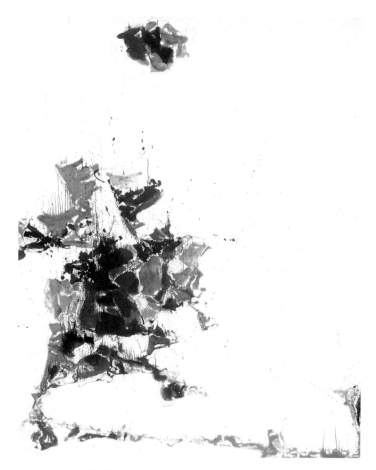

17–9 SAM FRANCIS
The Whiteness of the Whale (1957)
Oil on canvas. 104½ x 85½".

Albright-Knox Art Gallery, Buffalo. Gift of Seymour H. Knox, 1959.

Color-Field Painting

MORRIS LOUIS

Morris Louis (1912–1962) is best known for his billowing "veil" paintings (see Fig. 4–10), in which rich bands of color flow over one another and allow a subtle light to shine through from layer to layer. His (non-painterly) method of applying thin paint to unstretched canvas allowed the edges of his diaphanous color fields to be formed by the process of drying instead of by the gestures of the brush. The result is an immeasurably soft, gauzelike texture that seems to imply layers of meaning. Louis's soft-edged color shapes stand in marked contrast to the hard-edge paintings of Kenneth Noland.

HELEN FRANKENTHALER

Helen Frankenthaler (b. 1928), like Morris Louis and the first-generation Abstract Expressionists before her, is fascinated by the color field. She asserts the flatness of the canvas in works such as *Magic Carpet* (Fig. 2–9) by pouring fields of thinned vibrant color onto it. The resulting central image is open, billowing, and abstract, free of gestural brushing. Frankenthaler's equally lyrical recent paintings frequently show limited areas of color stain against large backdrops of unpainted canvas. By trickling paint onto her canvases, Frankenthaler eliminates the gestural brushstroke of the Abstract Expressionist color-field painter, but she does magnify the roles of accident and spontaneity.

KENNETH NOLAND

Like Morris Louis and Helen Frankenthaler, Kenneth Noland (b. 1924) is a color-field painter. But unlike the others, his fields frequently have hard, formal edges—the clarity of line that is characteristic of many second-generation painters. Noland for many years has been what critic Lawrence Alloway refers to as a **systemic** painter: Many of his works have been created ac-

Noland, are noted for their creation of color fields in **color-field painting.** Others, such as Ellsworth Kelly, have focused on the creation of clear geometric shapes through **hard-edge painting.** Many abstract painters, Kelly among them, have also used the **shaped canvas,** which extends the painting into three-dimensional space.

SAM FRANCIS

Sam Francis (b. 1923) was strongly associated with Abstract Expressionism during the 1950s, and his more recent works show the gestural brushstrokes and dripping and spattering that are hallmarks of a number of painters in the Abstract Expressionist movement. But in works such as *Shining Back* (Fig. 17–9) we find the open structure and emerging clarity of line and shape that typify works of the second generation and lead toward color-field painting.

17–10 KENNETH NOLAND *Graded Exposure* (1967). Acrylic on canvas. 7'4¾" x 19'1".

André Emmerich Gallery, N.Y.

17–11 ELLSWORTH KELLY
Red/Blue (1964). Oil on canvas. 72 x 58".
Private collection. Courtesy Blum Helman Gallery, N.Y.

cording to a group of rules or principles of organization. Noland has systematically explored the relationships between colors and simple shapes such as stripes, circles, and chevrons.

Noland's *Graded Exposure* (Fig. 17–10) shows stripes of various widths and intense color whose relationships produce a variety of effects. Now and then analogous hues face one another harmoniously across the stripes. Here and there primary or complementary hues confront one another. More recent paintings show stippled color fields and irregularly shaped canvases, as the artist seeks to expand his creative vocabulary.

Hard-Edge Painting

ELLSWORTH KELLY

Ellsworth Kelly (b. 1923) is best known for monumental canvases in which he has applied paint flatly to create images with clear contours. During the 1950s and 1960s Kelly painted many ovoid color fields against rectangular planes. The flatness of the color field contrasted with the gestural color fields of the Abstract Expressionists and, as in *Red/Blue* (Fig. 17–11), prevented the perception of clear figure–ground relationships.

17–12 JEAN DUBUFFET
Sang et Feu (1950). Oil on canvas. 45¾ x 35".
Courtesy Secretariat of Jean Dubuffet, Paris.

FIGURATIVE PAINTING

Since World War II a number of painters have continued in the vein of **figurative** painting. These artists have portrayed human and animal figures either realistically, expressionistically, or abstractedly. De Kooning's *Women* series remains figurative, although De Kooning is classified as an Abstract Expressionist because of his overall gestural brushing. Notable figurative painters of the postwar era include the Frenchman Jean Dubuffet and the Irish-born Francis Bacon.

JEAN DUBUFFET

Jean Dubuffet (1901–1985) was fascinated by the artistic productions of psychologically disordered people and, like Paul Klee, by the art of children. Children and disturbed individuals can show little regard for realistic depiction of space and form. Fantasy, to them, vies with reality for ascendance, and frequently it predominates.

As in *Sang et Feu* (Fig. 17–12), Dubuffet's monstrous figures emerge powerfully from a thick ground of pigment, sand, and other elements. The title means "blood and fire," suggestive of the primitive elements that Dubuffet portrays. But "blood" also refers to ancestry in French as it does in English, reflecting further the magical prehistoric themes and symbols that occupied the artist.

Sang et Feu is numbered among Dubuffet's *art brut* works. These figures are raw and brutal. In them the artist's palette is frequently limited to blacks, deep shades of yellow, and browns. But rather than being drawn into the abyss of melancholy tones, as was Rothko, Dubuffet began in the 1960s to compose pictures from what appear to be pieces from children's puzzles. Some "pieces" are figurative, others are fillers. Some are brushed in gestural white strokes, others have red, blue, or black stripes. The overall background is a web of thick meandering lines that sometimes reverse figure and ground. He also assembled three-dimensional "puzzle pieces" into figurative sculptures. His work of the 1970s also includes paintings in which children's stick-type figures swim against scribbled backgrounds of bright, cheerful hues.

FRANCIS BACON

Many of the figurative canvases of Francis Bacon (b. 1910) rework themes by masters such as Giotto, Rembrandt, and van Gogh. But Bacon's personalized interpretation of history is expressionistically distorted by what must be a very raw response to the quality of contemporary life.

Head Surrounded by Sides of Beef (Fig. 17–13) is one of a series of paintings from the 1950s in which Bacon reconstructed Velásquez's portrait of Pope Innocent X. The tormented, open-mouthed figure is partially obscured, as if seen through a curtain or veil. The brilliantly composed slabs of beef, which stand like totems richly threaded with silver and gold, replace ornamental metalwork posts that rise from the back corners of the papal throne in the Velásquez portrait. As in the Rubin Vase (Fig. 2–4) profiles can be seen in the sides of beef, and a goblet of noble proportions is constructed from the negative space between them. The bloody whisperings shared by the profiles are anybody's guess. Whereas the background of Velásquez's subject was a textured space of indefinite depth, Bacon's seated figure and the sides of beef are set by single-point perspective within an abstract black box.

In recent years Bacon has continued to paint dysphoric figures. Frequently they recline in Classical poses and take on the shape of butchered beefy slabs themselves. Bacon does not explain the meanings of his works, but we cannot deny their emotional impact and the grandness of their composition.

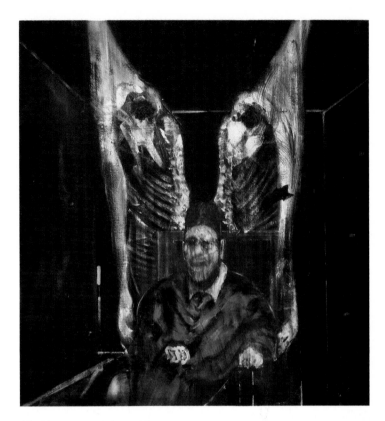

17–13 FRANCIS BACON
Head Surrounded by Sides of Beef (1954)
Oil on canvas. 50⅞ x 48".
Courtesy of The Art Institute of Chicago.

POP ART

If one were asked to choose the contemporary school of art that was most enticing, surprising, controversial, and also exasperating, one would have to choose **Pop art.** The term "Pop" was coined by English critic Lawrence Alloway in 1954 to refer to the universal images of "popular culture," such as movie posters, billboards, magazine and newspaper photographs, and advertisements. Pop art, by its selection of subject matter that is commonplace and familiar—subjects that are already too much with us—also challenges commonplace conceptions about the meaning of art.

Whereas many artists have strived to portray the beautiful, Pop art intentionally portrays the mundane. Whereas many artists depict the noble, stirring, or monstrous, Pop art depicts the boring. Whereas other forms of art often elevate their subjects, Pop art is often matter-of-fact. In fact, one tenet of Pop art is that the work should be so objective that it does not show the "personal signature" of the artist. This maxim contrasts starkly, for example, with the highly personalized gestural brushing found in Abstract Expressionism.

RICHARD HAMILTON

Despite the widespread view that Pop art is a purely American development, it originated during the 1950s in England. British artist Richard Hamilton (b. 1922), one of its creators, had been influenced by Marcel Duchamp's idea that the function of art is to destroy the normal meanings and functions of art.

Hamilton's tiny collage *Just What Is It That Makes Today's Homes So Different, So Appealing?* (Fig. 1–22) is one of the early and most revealing Pop art works. It is a collection of objects and emblems that form our envi-

17–14 ROBERT RAUSCHENBERG
Bed (1955). Combine painting, 75¼ x 31½ x 6½".
Courtesy Leo Castelli Gallery, N.Y.

ronment. It is easy to read satire and irony into Hamilton's work, but his placement of these objects within the parameters of "art" encourages us to truly *see* them instead of just coexisting with them. The artist's selection or portrayal of these images imbues them with a larger meaning. It is up to us to divine what we will.

ROBERT RAUSCHENBERG

American Pop artist Robert Rauschenberg (b. 1925) studied in Paris and then with Josef Albers and others at Black Mountain College in North Carolina. Before developing his own Pop art style, Rauschenberg experimented with loosely and broadly brushed Abstract Expressionist canvases. Rauschenberg is best known for introducing a construction referred to as the **combine painting,** in which stuffed animals, bottles, articles of clothing and furniture, and scraps of photographs are attached to the canvas.

Rauschenberg's *The Bed* (Fig. 17–14) is a paint-splashed quilt and pillow. An equally famous 1959 work, *Monogram*, combines a stuffed goat—a rubber tire around its middle—with a base that consists of scraps of photos and prints and loose, gestural painting. In more recent years Rauschenberg's interests have expanded to include set and costume design. His frequent use of gestural brushing seems designed to integrate the disparate elements of his constructions. Perhaps it also expresses the human impulse to integrate the bits and pieces of experience.

JASPER JOHNS

Jasper Johns (b. 1930) was a classmate of Rauschenberg at Black Mountain College. His works frequently portray familiar objects such as numbers, maps, and color charts. As in the case of *Flags* (Fig. 2–18), we also often find a thick gestural brushing that integrates the compositional elements into a unified field. The overall brushing suggests that Johns has been no more willing than Rauschenberg to break completely with Abstract Expressionism.

Recall the "tenet" of Pop art that imagery is to be presented objectively, that the personal signature of the artist is to be elimi-

nated. That principle must be modified if we are to include as Pop the works of Rauschenberg, Johns, and others, for many of them immediately betray their devotion to expressionistic brushwork.

ROY LICHTENSTEIN

For how many centuries have artists portrayed heroic moments, noble heroes and heroines, and idealized figures? Roy Lichtenstein (b. 1923) has parodied these artistic functions by magnifying the images that have wrenched the emotions of generations of American comic-strip readers. *Forget It! Forget Me!* (Fig. 1–31) is authentic comic-strip imagery, right down to the greatly enlarged **Ben Day dots.** The new scale of the imagery, and its consequent newfound gravity, confront viewers with their attachment to such visual presentations. Do we not feel slight embarrassment before them? It is as if they were made somehow pornographic. Are we not tempted to assert, "My neighbor may look at such things, but not me"?

ANDY WARHOL

Andy Warhol (1930–1987) once earned a living designing packages and Christmas cards. Today he epitomizes the Pop artist in the public mind. Just as Campbell's soups represent bland, boring nourishment, Andy Warhol's soup cans (Fig. 5–16), Brillo boxes (Fig. 9–27), and Coca-Cola bottles (Fig. 17–15) elicit comments that contemporary art has become bland and boring and that there is nothing much to be said about it. Warhol also evoked contempt here and there for his underground movies, which have portrayed sleep (see p. 193) and explicit eroticism (*Blue Movie*) with equal disinterest. Even his shooting (from which he recovered) by a disenchanted actress seemed to evoke yawns and a "What-can-you-expect?" reaction from the public.

Warhol painted and printed much more than industrial products. During the 1960s he reproduced multiple photographs of disasters from newspapers. He executed a series of portraits of public figures such as Marilyn Monroe (Fig. 1–7) and Jackie Kennedy in the 1960s, and he turned to portraits

17–15 ANDY WARHOL
Green Coca-Cola Bottles (1962). Oil on canvas.
82¼ x 57".
Collection of Whitney Museum of American Art, N.Y.

of political leaders such as Mao Tse-Tung in the 1970s. Although his silk screens have at least in their technique met the Pop art objective of obscuring the personal signature of the artist, his compositions and his expressionistic brushing of areas of his paintings achieved a rather individual stamp.

It could be argued that other Pop artists owe some of their popularity to the inventiveness of Andy Warhol. Without Warhol, Pop art might have remained a quiet movement, one that might have escaped the notice of the art historians of the next century.

17–16 LARRY RIVERS
Amel-Camel (1962). Oil on canvas. 39½ x 39½".
Williams College Museum of Art, Williamstown, Mass. Gift of Mrs. Lawrence H. Bloedel.

LARRY RIVERS

Larry Rivers (b. 1923) has painted in a number of styles but is best known for his many mixed-media canvases based on commercial images. In *Amel-Camel* (Fig. 17–16), Rivers alternately constructs, dissolves, and erases the camel of the familiar cigarette package. Other canvases have referred to well-known works of art as part of their popular imagery. For example, Rivers has reworked Dutch Masters cigar boxes whose lids are illustrated with a version of Rembrandt's *The Syndics of the Drapers' Guild* (see Fig. 14–21). He paints out bits and pieces of the familiar imagery with gestural brush strokes, so that ironically the viewer struggles to perceive the images that have been so familiar.

Rivers's rhythmic, repetitious images seem to emerge and then fall back within the implied depths of his canvases; similarly, it could be argued that these all-too-familiar images emerge and then fall back within the depths of the consciousness of the public who are repeatedly exposed to them.

ROBERT INDIANA

Robert Indiana (b. 1928) was born Robert Clark in the state of Indiana. He is undoubtedly best known for his portrayal of brief verbal concepts, such as the number 5 (see Fig. 2–45) and his series of sculptures of the word *LOVE*. His numbers and letters are hard-edged and painted in dissonant colors, and his use of stencils erases any personal signature. The frequent presentation of bitter commands such as EAT and DIE on diagonal squares suggests that they are to be read as road signs. It is ironic that the public associates him with the *LOVE* sculptures, because most of his works seem to be angry satires of the messages that Indiana finds underlying American signs and symbols.

What, then, do we make of Pop Art? Is it a cynical gesture to place expensive but meaningless objects in a gullible marketplace? Is it the sincere expression of deeply felt experience?

Pop artists show diversified approaches, themes, and modes of technical execution. Despite the ideal of technical anonymity, we have seen that some Pop artists are very much concerned with their personal signatures. Others use sources of imagery that are unexpected, even if familiar. Many of the works are brilliant and beautiful in their execution, even if their subject matter is mundane. Since Pop artists show so much diversity, it may not be meaningful to try to speak of the "motives" or objectives of their movement.

It is also worthwhile to remember that artists usually go about their work from day to day, inspired by the social scene, their own talents, and, of course, to some degree, the work of others. Some artists have theorized about art and given direction to schools or movements of art, but most artists invest their energies more completely in the creation of art, leaving the critics and the art historians to group them and label movements. Few artists are oblivious to the labels the critics assign them, but they are not obligated to live up to the labels. In fact, artists frequently object to such pigeonholing by critics and historians.

Photorealism, or the rendering of subjects with sharp, photographic precision, is firmly rooted in the long realistic tradition of art. But as a movement that first gained major recognition during the early 1970s, it also owes some of its impetus to the Pop artist's objective portrayal of familiar images. Photorealism is also in part a reaction to the expressionistic and abstract movements of the twentieth century. That is, Photorealism permits artists to do something very new to the public eye even while they are doing something very old.

PHILIP PEARLSTEIN

The slightly exaggerated tonal variations in the figurative paintings of Philip Pearlstein (b. 1924) highlight the surface qualities of the human form. His works portray lounging models in the studio, with contrasting values that reveal their often-sagging flesh and their psychological alienation from the moment. In mood they are very much as if caught by the candid camera.

Female Model on Adirondacks Rocker, Male Model on Floor (Fig. 17–17) is in many ways a typical work. It is organized in an interesting pattern, along a diagonal line that is constructed from the interaction of the male and female bodies provided by the oblique perspective. The face of one of the models is cut off. There is a study of contrasting textures—human flesh, some sagging and some firm, versus the wood of the bentwood rocker and the parquet floor, and the fabric of the rug. The obfuscation of much of the male figures causes the lower limbs of the models to become visually entangled, creating a subtle sensuality and at the same time suggesting that it really might not matter which limb belongs to which model—a rather dehumanizing notion. Although Pearlstein has denied that his paintings are comments on the human condition, there is something about the artist's realistic approach that seems to deprive models of their uniqueness and importance.

17–17 PHILIP PEARLSTEIN
Female Model on Adirondacks Rocker, Male Model on Floor (1980). Oil on canvas. 72 x 72".

Collection of Whitney Museum of American Art. Purchase, with funds from the Painting and Sculpture Committee, and the Friends of the Whitney Museum of American Art, by exchange.

CHUCK CLOSE

If Pearlstein's figures are matter-of-fact, those of Chuck Close (b. 1940) are sometimes ugly. Close captures exact detail and perspective by a contemporary advance over the **camera obscura.** For paintings such as his *Self-Portrait* (see Fig. 1–5), he first uses an opaque projector to project close-up photographs of his subjects onto canvas. He then paints over the projected images in a lateral manner, deliberately avoiding any gestural quality in his brush strokes. When we stand near his paintings, his subjects' realistic blemishes as well as their positive features are magnified to the point where they become almost abstract tonal variations.

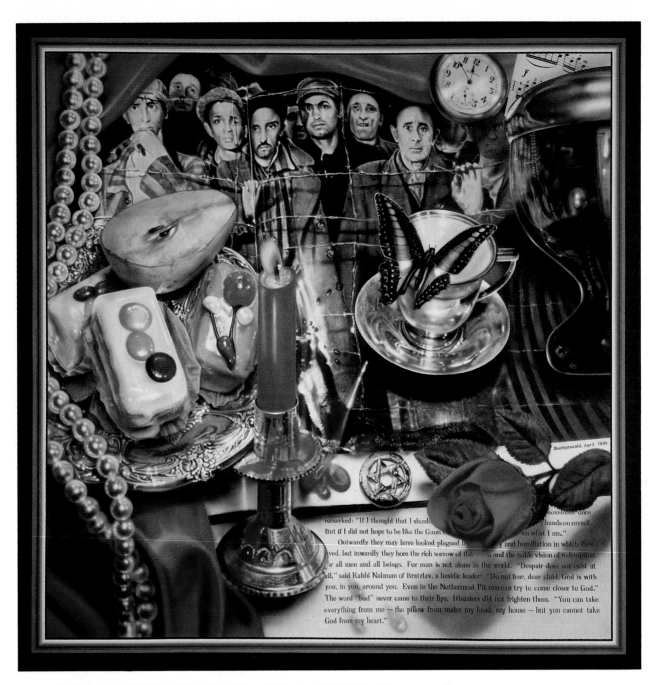

17–18 AUDREY FLACK *World War II* (*Vanitas*) (1976–77). Oil over acrylic on canvas. 96 x 96".

Photo courtesy Louis K. Meisel Gallery, N.Y. Incorporating a portion of Margaret Bourke-White's photograph "Buchenwald, 1945" copyright Time Inc.

AUDREY FLACK

Audrey Flack (b. 1931) was born in New York and studied at the High School of Music and Art, at Cooper Union, and at Yale University's Graduate School. During the 1950s she showed figure paintings that were largely ignored, in part because of the popularity of Abstract Expressionism, but she persisted in realism. Like Chuck Close and a number of other Photorealists, she fre-

quently projects color slides and other photographic reproductions onto her canvases in order to create paintings. Her focus has largely shifted away from the figure to still-life arrangements.

One of Flack's best-known works from the 1970s is *World War II* (Fig. 17–18). This painting combines Margaret Bourke-White's photo *The Living Dead of Buchenwald* (see Fig. 8–10) with still-life objects including

fruit, candy, a teacup, a chalice, a candle, a string of pearls, a rose, and a Star of David. The painting functions as a memorial to those who perished in the Holocaust and as a tribute to the survivors. Note that the table cannot be perceived; each object is brought close to the viewer in a flattened picture frame. Flack is fascinated by the ways in which objects reflect light, and in this painting and others she uses an airbrush to create a surface that imitates the textures of these objects. She layers the primary colors—red, yellow, and blue—in transparent glazes to produce the hues she desires without lines and without brushstrokes. The resulting hues are harsh and highly saturated, and the sense of realism is stunning.

Richard Estes

In many of his paintings, such as *Ansonia* (Fig. 17–19), Richard Estes (b. 1936) has shown fascination with the portrayal of single-point perspective and of images reflected in plate-glass windows. In this sense he shared the recognition of other realists from earlier eras that glass immediately multiplies imagery and provides new perspectives.

Estes's paintings usually do not include people. They reveal instead the architectural details of the urban settings of our contemporary lives. In a reversal of the natural order, plant life in *Ansonia* is largely contained in artificial pots and is dependent on people for survival.

OP ART (OPTICAL PAINTING)

In **Op art,** also called **optical painting,** the artist manipulates light or color fields, or repeats patterns of line, in order to produce visual illusions. The effects can sometimes be disorienting. Bridget Riley's *Current* (see Fig. 2–3) achieves the illusion of wavelike motion through a pattern of nearly identical lines. Hungarian-born Victor Vasarely may be the best-known Op artist. In many paintings of recent decades, Vasarely has experimented with the illusion of three dimensions in two-dimensional space through the use of linear perspective and atmospheric effects.

17–19 RICHARD ESTES
Ansonia (1977)
Oil on canvas. 48 x 60".

Collection of Whitney Museum of American Art, N.Y. Gift of Frances and Sydney Lewis.

On the Happening of Happenings

A kind of Action Painting with living materials. —Suzi Gablik

In 1959, American artist Red Grooms (b. 1937) role-acted a pyromaniac running from the clutches of a Keystone cop through the loft of an old boxing gym. At the finale, Grooms leapt into the arms of a stunned audience, who had suddenly become participants. At Cornell University in 1964, students licked jelly from the hood of an old car (Fig. 17–20). What did these events have in common? Both were Happenings.

Toward the end of the 1950s and throughout the 1960s, the performance-artform called the Happening briefly saw the light of day. The Happening was a form of improvisation, a spontaneous performance by a group of people. It expressed the Dadaist theme of art as anti-art. Since Happenings might occur in supermarkets or while driving on a highway, they were also filled with familiar objects and were therefore, perhaps, a form of Pop art.

The major force behind Happenings was New York artist Allan Kaprow (b. 1927). Kaprow defined the Happening as "an assemblage of events" in a constructed or ready-made environment. The Happening was planned but unrehearsed. There was no audience, only participants. The gap between "art" and "viewer," or actor and audience, had been eliminated. And Happenings happened but once; they were not repeated.

Perhaps, then, Happenings could also be viewed as sort of kinetic self-destructing sculptures with real people and environments both as subjects and participants. Although "planned" and, for that reason, "created" by the artist, there was the element of spontaneity, of accident, of chance. In the one-time nature of the Happening lay its self-destruction. As it unfolded, it ceased to exist. Self-destruction was consistent with the Dadaist execution of art that was anti-art, as with Tinguely's *Homage to New York* (see Fig. 17–34).

17–20 ALLAN KAPROW *Happening: Household.* A Happening commissioned by Cornell University, May, 1964

SCULPTURE

Contemporary sculpture, like contemporary painting, has taken many forms. First we shall look at the sculpture of Henry Moore, which spans the earlier part of the twentieth century and the postwar years. Then we shall survey the figurative and abstract sculpture of the postwar years.

SCULPTURE AT MIDCENTURY

At midcentury, there were two major directions in sculpture: figurative and abstract. In a moment we shall follow these two paths over the years. First let us have a look at British artist Henry Moore, whose work encompasses both the figurative and the abstract and who, more than any other individual, epitomizes sculpture in the twentieth century.

HENRY MOORE

Henry Moore (1898–1986) had a long and prolific career that spanned the seven decades since the 1920s, but we introduce him at this point because, despite his productivity, his influence was not generally felt until after World War II.

In the late 1920s, Moore was intrigued by the massiveness of stone. In an early effort to be true to his material, he executed blocky reclining figures reminiscent of the Native American art of Mexico. In the 1930s, Moore turned to bronze and wood and was also influenced by Picasso. His figures became abstracted and more fluid. Voids opened up, and air and space began to flow through his works.

At midcentury, Moore's works received the attention they deserve. He continued to produce figurative works, but he also executed a series of abstract bronzes in the tradition of his early reclining figures, such as the one at Lincoln Center for the Performing Arts in New York City (Fig. 17–21). No longer as concerned about limiting the scope of his expression because of material, he could now let his bronzes assume the massiveness of his earlier stonework. However, his continued exploration of abstract biomorphic shapes, and his separation and opening of forms created a lyricism that was lacking in his earlier sculptures.

17–21 HENRY MOORE
Lincoln Center Reclining Figure (1963–65). Bronze. Height: 16'; width: 30'.

Lincoln Center for the Performing Arts, Inc., N.Y.

Let us now turn our attention to the figurative and abstract works of other contemporary sculptors.

CONTEMPORARY FIGURATIVE SCULPTURE

Figurative art continues to intrigue postwar sculptors as it intrigues postwar painters. Some figurative works have the utter realism of Fumio Yoshimura's (b. 1926) *Dog Snapper* (Fig. 6–10). Others are highly abstracted, such as the recent reclining figures of Henry Moore or the horses and riders of Marino Marini.

MARINO MARINI

Italian sculptor Marino Marini (1901–1980) is best known for his series of horses and riders, which he began sculpting in the 1930s. His early figures were rounded and their moods were composed. But as the years wore on, and war came and went, both his horses and riders began to thrust their limbs to the four winds in anguish, as in the bronze *Horse and Rider* of 1952–

1953 (Fig. 17–22). These expressionistically distorted figures seem to be crying out in agony—a symbol of human suffering as clear as Picasso's fragmented figures in *Guernica*.

As the 1960s and then the 1970s came along, Marini's horses and riders became progressively abstract, as did the sculptures of Henry Moore. Biomorphic shapes in bronze and stone finally expressed their torment as did the figurative organisms before them.

GEORGE SEGAL

George Segal (b. 1924) was a student of Hans Hofmann and painted until 1958. During the 1960s he achieved renown as a Pop art sculptor. As in *The Bus Riders* (Fig. 6–4), he casts his figures in plaster from live models and then surrounds them with familiar objects of the day—Coke machines, Formica and chrome tables, chairs, shower stalls, bathtubs, porcelain sinks and copper pipes, mirrors, window shades, neon signs, telephone booths, television sets. In Segal's able hands, these Pop items clearly proclaim the horrors of the age.

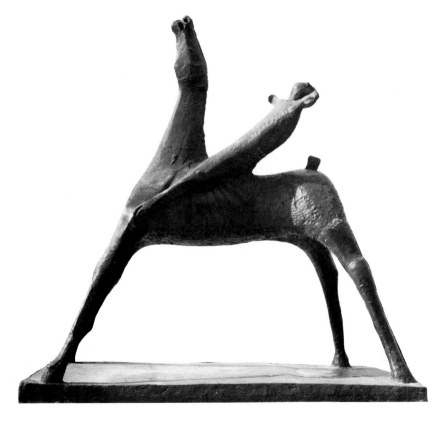

17–22 MARINO MARINI
Horse and Rider (1952–53)
Bronze. 82 x 81 x 46½".

Hirshhorn Museum and Sculpture Garden, Smithsonian Institution, Washington, D.C.

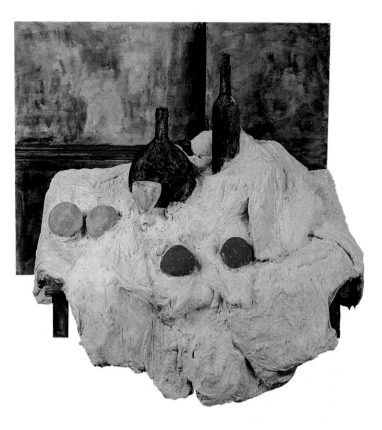

17–23 GEORGE SEGAL
Cezanne Still Life #5 (1982)
Painted plaster, wood, and metal.
37 x 36 x 29".

In the 1970s Segal courageously extended his thematic repertoire to sculpt the magnificent *Abraham's Sacrifice of Isaac* (Fig. 1–9). Segal has also made sensuous reliefs of women and more recently still lifes, as in *Cézanne Still Life #5* (Fig. 17–23). The plaster of the drapery is modeled extensively by the sculptor's fingers in these reliefs, giving large areas an almost gestural quality. In many of his works since 1978, Segal has used primary colors, eliminating the ghostlike quality of his earlier works.

CLAES OLDENBURG

Claes Oldenburg (b. 1929) has been one of the wittier Pop artists. In 1961 he opened his own store on Second Street in New York City and sold painted-plaster sandwiches, pieces of cake, and ice cream sundaes for but a few hundred dollars. How many observers of art wish that they had had the foresight to buy an Oldenburg during those days.

Oldenburg has also fashioned objects such as toilets (Fig. 6–14), typewriters, and engines from soft materials such as vinyl.

Why such **soft sculptures?** The artist himself noted sardonically that soft sculptures fly in the face of the tradition of permanent sculptures carved from stone or forged from metal: "I am for an art that is political-erotical-mystical, that does something other than sit on its ass in a museum." Naturally many of these sculptures have found their way into museum collections, and there they sit.

Oldenburg may be best known for his "monuments," such as the *Clothespin* in Philadelphia (see Fig. 2–44). Pop art frequently stimulates the viewer to examine the familiar object by increasing its scale, or simply by recording it at all. The familiar-object-as-monument motif carries this precept to its logical extreme.

EDWARD KIENHOLZ

California sculptor Edward Kienholz (b. 1927), like George Segal, frequently integrates his figures into assemblages that contain familiar objects. Frequently they contain appalling visions of brutality, some of

which grew out of his brief experience as a psychiatric aide. The gruesome reality of the quality of life of the subject in *The Wait* (Fig. 17–24) is expressed in her fabric-covered skeletal makeup. Her mental life is suggested by the photograph of her earlier self that occupies her head, and by the mementos and the trappings of earlier generations that walk through his world, as out of place as are the pasty apparitions of a Segal assemblage.

Venezuelan artist Marisol Escobar (b. 1930), known to the world as Marisol, creates figurative assemblages from plaster, wood, fabric, paint, found objects, photographs, and other sources. As in *Women and Dog* (Fig. 17–25), Marisol frequently repeats images of her own face and body in her work. She has also used these techniques to render satirical portraits of world leaders.

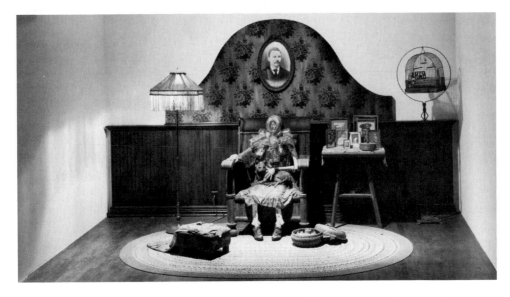

17–24 EDWARD KIENHOLZ *The Wait* (1964–65). Tableau: epoxy, glass, wood and found objects. 80 x 148 78".

Collection of Whitney Museum of American Art, N.Y. Gift of the Howard and Jean Lipman Foundation, Inc.

17–25 MARISOL
Women and Dog (1964)
Fur, leather, plaster, synthetic polymer, wood. 72 x 82 x 16".

Collection of Whitney Museum of American Art, N.Y.

17–26 DUANE HANSON
Tourists (1970). Polyester resin/
fiberglas. Life-size.
O.K. Harris Works of Art, N.Y.

DUANE HANSON

Duane Hanson (b. 1925) was reared on a dairy farm in Minnesota. His *Tourists* (Fig. 17–26) is characteristic of the work of a number of contemporary sculptors in that it uses synthetic substances such as liquid polyester resin to closely approximate the visual and tactile qualities of flesh. Such literal surfaces allow the artist no expression of personal signature. In the presence of a Hanson figure, or a John De Andrea nude, viewers watch for rising and falling of the chest. They do not wish to stare too hard or to say something careless on the off-chance that the sculpture is real. There is an electricity in gallery storerooms where these sculptures coexist in waiting. One tries to decipher which ones will get up and walk away.

Duane Hanson's liberal use of off-the-rack apparel, and objects such as "stylish" sunglasses, photographic paraphernalia, and shopping bags lend these figures a caustic, satirical edge. But not all of Hanson's sculptures have been lighthearted. Like Andy Warhol, Hanson has portrayed disasters, such as death scenes from the conflict in Vietnam. In recent works he has focused more on the psychological content of his figures, as expressed by tense postures and grimaces.

CONTEMPORARY ABSTRACT SCULPTURE

Abstract sculpture remains vital in the post-war years, ever varied in form and substance. Contemporary abstract sculptures range from the wrappings of Christo and the earthworks of Smithson to the machined surfaces of David Smith's cubes and the anti-art machines of Jean Tinguely.

17–27 DAVID SMITH Cubi Series. Stainless steel. (left): *Cubi XVIII* (1964). Height 9′8″. Museum of Fine Arts, Boston. (center): *Cubi XVII* (1963). Height 9′. Dallas Museum of Fine Arts. (right): *Cubi XIX* (1964). Height 9′5″. The Tate Gallery, London.

David Smith papers. Archives of American Art. Smithsonian Institution.

DAVID SMITH

American artist David Smith (1906–1965) moved away from figurative sculpture in the 1940s. His works of the 1950s were compositions of linear steel that crossed back and forth as they swept through space. In his great Cubi Series (Fig. 17–27) of the early 1960s, Smith assembled cubes and cylinders of stainless steel in architectural masses.

Many sculptors of massive works create the designs but then farm out their execution to assistants or to foundries. Smith, however, took pride in constructing his own metal sculptures. Even though Smith's shapes in the Cubi Series are geometrically pure, some note that his loving burnishing of their highly reflective surfaces grants them the overall gestural quality found in Abstract Expressionist paintings.

LOUISE NEVELSON

Louise Nevelson (b. 1900), as noted in Chapter 6, assembled abstract wooden walls throughout much of the 1960s. During the latter part of the 1960s she began to experiment with materials such as lucite and metal, and during the 1970s she sculpted many large outdoor works from aluminum and steel, two of which are found on the campuses of Princeton University and Massachusetts Institute of Technology. The free-form group at MIT, *Transparent Horizon*, which she executed at the age of 75, shows a lyrical quality not found in the earlier wooden walls. In spirit it is jaunty, uplifting, and forward-looking, very much unlike the nostalgic mood created by Figure 6–15.

Like those of Henry Moore, the familiar works of American sculptor Alexander Calder (1898–1976) span most of the twentieth century. In the 1920s Calder carved figures from wood or constructed them from wire, but his works became abstract in the 1930s. He began constructing the mobiles for which he is best known in the 1940s. Many of these metal pieces, such as *Zarabanda* (Fig. 6–20), contain delicately lyrical biomorphic shapes. Many of Calder's mobiles hang, but others, called **standing mobiles,** are supported by a base and can be placed outdoors.

After the war, Calder's mobiles began to assume monumental scale. During the 1960s, Calder also turned to the creation of **stabiles**—his term for a number of soaring winglike sculptures fashioned from sheets of steel. Nonkinetic, these stabiles are generally balanced by numerous points that meet the ground. His largest stabile, called *Man,* was constructed for EXPO '67 in Montreal. Its pylons soar and arch 94 feet into the air. The metal skin looks stretched and seems to express our yearning to extend ourselves.

JOHN CHAMBERLAIN

Whereas Pop artists have compelled us to see anew the familiar objects of the age by rendering them with matter-of-fact precision, a number of sculptors have forced us to reexamine the materials on which our civilization is based by combining debris and other objects into assemblages known as **junk sculptures.** One such sculptor is John Chamberlain (b. 1927), whose *Essex* (Fig. 17–28) is composed of automobile parts and other scraps and pieces of metal. The title of the work refers to a make of car that

17–28 JOHN CHAMBERLAIN
Essex (1960). Automobile body parts and other metal, relief.
9' x 6'8" x 43".

Collection, The Museum of Modern Art, N.Y. Gift of Mr. and Mrs. Robert C. Scull and Purchase.

vanished earlier in the century, like so many of the twentieth-century objects that become obsolete almost as soon as they are conceived and constructed. The shape of the work is also reminiscent of the process by which many junked automobiles are compressed into rectangular solids, for ease of recycling or "burial." On the other hand, *Essex* has an aesthetic life of its own, one that thrives on the juxtaposing of "swaths" of sheet metal in vibrant colors. It is as if the deceased automobile were being reincarnated as an Abstract Expressionist painting.

TONY SMITH

Tony Smith (b. 1912) has fashioned massive angular black forms from steel and other materials. They are frequently shown in painted plywood before being rendered in steel. His *Die* (the singular of *dice*) executed in 1962 is a monumental black steel cube, 6 feet on a side. *Die* shocks because of its explicitly simple expression of form.

Other pieces are more involved, jutting and arching into the air and then turning back on themselves.

Moses (Fig. 17–29), constructed from black painted steel, stands 15 feet high on the Princeton University campus. Out in the open, with its metal points, it is something of a dangerous object. Its massiveness is somewhat compromised by the flow of space throughout. The parallel edges lend the work a certain rhythm, but it does not seem quite balanced: the parallel stacks give the piece a jutting, top-heavy appearance. The imbalance makes the sculpture seem poised, ready for action.

The parallel stacks are probably a reworking of the horns that adorn earlier representations of Moses, including that of Michelangelo (see Fig. 1–6). According to the Bible, when Moses descended from Mt. Sinai with the Commandments, he had an "aura" about him. The word *aura* had been mistranslated in earlier centuries as "horns." Note also that if Smith's *Moses* seems poised for action, this implied movement may re-

17–29 TONY SMITH
Moses (model executed 1967–68; fabricated and installed 1969). Painted mild steel. Number 1 of edition of 2. Height: 15'1"; length: 11'6".

The John B. Putnam, Jr., Memorial Collection, Princeton University.

17–30 DON JUDD *Untitled* (1968). Stainless steel. 8 boxes, each 48 x 48 x 48".
Photo courtesy of Leo Castelli Gallery, N.Y.

flect the dynamism of the Michelangelo statue.

How else does Smith's abstract sculpture earn its title? How does the work impart a sense of leadership or of law, if indeed it does? Perhaps there is also something of the feeling of what we know of Moses in the work's severe formality, in its somber monumentality.

DON JUDD

The repeated precise geometric forms of Donald Judd (b. 1928) are usually fashioned from metal, although now and then he uses translucent Plexiglass. Judd's *Untitled* (Fig. 17–30), like Tony Smith's *Die*, is a formal piece that pays homage to the cube. In many of Judd's sculptures that employ rectangular solids, the spaces between the masses are as precisely uniform as the masses themselves.

Judd's sculptures, like Smith's *Die*, are an example of **Minimal art**, which relies on Mies van der Rohe's axiom of architecture that "less is more." Through precise repetition, the compositional element of unity vies with the rectangular solids for the role of subject matter. In many instances, Judd has painted his masses with bright colors, in a sense denying the material from which they were formed and highlighting their functions as pure forms in space.

ISAMU NOGUCHI

Japanese-American Isamu Noguchi (b. 1904), at one time an apprentice to Constantin Brancusi (see p. 427), has experimented over the years with forms as diverse as tradi-

17–31 ISAMU NOGUCHI
Cube, Marine Midland Building, N.Y. (1968)
Steel subframe and aluminum panels.
Height: 28'; sides: 16'.

tional ceramic Japanese figures and Minimalist abstract forms. *Big Boy* (Fig. 9–1) is a variation on the first theme.

Noguchi's monumental *Cube* (Fig. 17–31) thrusts 28 feet into the air before a bank building in New York City. It really cannot be seen as standing alone. Its high-tech steel and aluminum construction is a counterpoint to the glass and metal façade of the skyscraper. Its precarious balance seems, like the building, to express the contemporary capacity to build structures of almost any form. Its simple form is no simpler than that of the rectangular solid of the building, and its painted red surface increases its weight, allowing it to balance the mass of the building.

LUCAS SAMARAS

Lucas Samaras (b. 1936) is known for his surrealistic sculptures, such as *Box No. 3* (Fig. 6–18), and for his recent "phototransformations." In the latter, also called "autopolaroids," Samaras takes Polaroid photographs of himself and scratches, draws, or paints on the film's emulsion as it is developing.

His *Mirrored Room* (Fig. 17–32) is an altogether different experience. In the photograph of the room, the form of a chair is reflected to infinity in six directions, and in every conceivable permutation and combination of these directions. This sculpture is meant to be walked through. It is a playful, meditative, and narcissistic environment in which viewers become part of the work. By subtle repositioning, viewers catch glimpses of themselves from different angles, underscoring their positive features as well as their faults. Any activity undertaken with companions becomes instantly replicated an infinite number of times.

CHRYSSA

As noted in Chapter 6, Chryssa (b. 1933) uses incandescent and fluorescent lights to create her light sculptures. Favorite themes are inspired by the commercial signs of midtown Manhattan (see Fig. 6–23). In a number of recent works, her sculptures turn "on" and "off" at preprogrammed intervals.

GEORGE RICKEY

The highly polished surfaces of the kinetic sculptures of George Rickey (b. 1907) are somewhat similar to those in David Smith's Cubi Series. But as is seen in Figure 6–21, Rickey's repeated pronged shapes are at one with their open environments. They have a sense of immateriality, of melting away into space and motion, in contrast to the geometric solidity of David Smith's work.

17–32 LUCAS SAMARAS *Mirrored Room* (1966). Mirrors on wood frame. 8 x 8 x 10'.

Albright-Knox Art Gallery, Buffalo. Gift of Seymour H. Knox, 1966.

17–33 JUDY PFAFF
Dragons (Jan.-Apr. 1981)
Installation. View: Whitney
Biennial, The Whitney
Museum of American Art,
N.Y.

JUDY PFAFF

Another contemporary sculpture form is the **installation,** in which materials from planks of wood to pieces of string and metal are assembled to fit within specific room-sized exhibition spaces. Installations are not necessarily intended to be permanent. In *Dragons* (Fig. 17–33), by Judy Pfaff (b. 1946), the viewer roams around within the elements of the piece, an experience that can be pleasurable and overwhelming among the vibrant colors and assorted textures. Many of the elements of Pfaff's installations hang down around the viewer, creating an atmosphere reminiscent of foliage, sometimes of an underwater landscape.

The only stable thing is movement.

—Jean Tinguely

Swiss-born kinetic sculptor Jean Tinguely (b. 1925) is an able satirist of the machine age who shares the Dadaist view of art as anti-art. He is best known for his *Homage to New York* (Fig. 17–34), a motorized, mixed-media construction which self-destructed (intentionally) in the garden of the Museum of Modern Art. But an unexpected fire within the machine necessitated the intervention of the New York Fire Department, which provided a spontaneous touch without charge. Tinguely's machines, more than those on which his work comments, frequently fail to perform precisely as intended.

As a further reflection of his philosophy of art, in the 1950s Tinguely introduced kinetic sculptures that served as "painting machines." One of them produced thousands of "Abstract Expressionist" paintings—on whose quality we need not comment. It does seem appropriate to bring the section on abstract sculpture to an end with the work of Tinguely. What could we add?

CONCEPTUAL ART

This book began with the question, What is art? That is, what is meant by the concept of art? In bringing our discussion of contemporary art around to **Conceptual art,** we more or less come full circle. For in Conceptual art the work exists in the mind of the artist as it is conceived—just as we could say that the concept of art has no specific requirements for execution or expression but is known or understood by those who think about art.

In any event, if the public has sometimes reacted negatively to contemporary movements such as Pop art or Minimalist art, this response has been magnified in the case

17–34 JEAN TINGUELY
Fragment from *Homage to New York* (1960)
Painted metal. 6'8¼" x 29⅝" x 7'3⅞".
Collection, The Museum of Modern Art, N.Y. Gift of the artist.

of Conceptual art. In Conceptual art the transitory act of creation is said to have taken place in the artist's mind. A painting or a sculpture is but a poor, dumb record of the actual creative event. Imagery in Conceptual art is deemphasized, frequently in favor of suggestive verbiage, as in Joseph Kosuth's *Art as Idea as Idea* (Fig. 1–13).

Conceptual art is perhaps the ultimate separation of the artistic concept from its execution. Traditionally, artists have been noted not only as creative visionaries, but also as masters of their media. Michelangelo not only conceived *David,* but also personally "released" him from his captive stone. Van Gogh not only conceived his *Sunflowers,* but also personally brought them into being by means of his masterful brushstrokes. Consider also the creative process in Abstract Expressionism: To Pollock, "being in"

If Possible, Steal Any One of These Drawings

Japanese-American artist Shusaku Arakawa (b. 1936) has incorporated physics formulas, citations from famous books, abstract geometric forms, and an assortment of objects and other elements into his contemporary paintings. A number of them are purely conceptual. A painting in 1969 bore nothing but the stenciled image:

I HAVE DECIDED TO
LEAVE THIS CANVAS
COMPLETELY BLANK

Another painting done in the same year bore a straight line, a vague geometric shape, identifying data (title, artist's name, and date), and the stenciled legend: IF POSSIBLE STEAL ANY ONE OF THESE DRAWINGS INCLUDING THIS SENTENCE.

At New York's Dwan Gallery the painting, priced at $2,000, was summarily stolen. The thieves left a note stating that they were complying with Arakawa's instructions.

In an interview with Lawrence Alloway, Arakawa reported, "My first reaction was very surprised. Then I felt angry at the situation. Then minutes later I was strangely excited. I talked to the secretary at the gallery explaining the painting. It was as if I was explaining it to myself. Then I felt very good about it."[*]

The next month the painting was returned to a museum, and from there to the artist. Arakawa claimed that the thieves had misinterpreted his meaning.

He had stenciled a legend to the effect that the linear drawings on the painting, including the stenciled sentence, should be stolen—but not the painting itself. The thieves' concept had not coincided with the artist's. So go the vagaries of human thought.

[*] Howard Smagula, *Currents* (Englewood Cliffs, N.J.: Prentice-Hall, Inc., 1983), p. 66.

the act of executing a painting somehow caused its form and content to leap into being. By contrast, the contemporary sculptors Tony Smith and Alexander Calder have allowed technicians to actualize their sketches in metal—and Rubens at times assigned the detailed renderings of his paintings to well-schooled assistants. And so, works of art have not always been fully executed by the artists who conceived them.

In the Tony Smith *Moses*, where lies the art? Is the "art" in the artist's mind or on the green Princeton campus in the center of New Jersey, across Nassau Street from P. J.'s Pancake House? The Conceptual artist seems to be making the point that the essence of a work of art is conceived and dwells within the mind of the artist. The rest is communication.

But what grand communication it is!

18

Beyond Europe and the United States: A World of Art

As members of Western civilization, we share an extensive and varied heritage. Western art originated in ancient Egypt and Greece and then developed in Europe and the United States as we have outlined. Its richness cannot be encompassed in a single course, nor in a lifetime.

As citizens of the world, we share a yet more extensive and varied heritage. Just as there is a Western culture and a Western tradition in art, there are many other cultures and many other traditions in art. Artistic expression is found in the ancient wooden sculpture and crafts of Africa, and among black Africans and Afro-Americans today. Art, like the catamarans of the islanders of Oceania, has spanned the realms of the Pacific. Great Mexican stone sculptures, South American metropolises, Native American cliff palaces, crafts, and earthworks all preceded the European explorers and settlers by many centuries.

On Native Art: "Primitive" or Sophisticated?

The native art of the Africans, Pacific Islanders, and Native Americans has been frequently referred to as *primitive art*. In a literal sense, the term "primitive art" means merely that it is art produced by primitive tribes and societies. But as sculptor Henry Moore has noted, the term suggests that primitive art is crude art and reflects the maker's ignorance and incompetence. The sophistication of primitive art belies any inference of crudeness. Because the term is misunderstood, however, it may be better to refer to such art as "native art."

When we study native art, we may find it differs from Western art in subject matter and style; however, we also find that it expresses genuine feeling and uses the elements of art to create exciting compositions. Western artists such as Amedeo Modigliani, Pablo Picasso, and Henry Moore have gone to school on them. In fact, we find more and more that the Western use of the word "primitive" reflects Western ignorance of the ways and values of other societies, rather than crudeness in those societies themselves.

On the Art of the East

The Islamic art of the Near, Middle, and Far East, Indian art, and the Oriental art of China and Japan are somewhat more familiar to Westerners than is the native art. The great mosques of the world of Islam and the cathedrals of Christian Europe share the same Judaic tradition. Persian-style rugs are popular, and the Western eye need not be especially schooled to appreciate them. Some of the great works of the Indian subcontinent are also familiar. The art of the Orient has influenced Western art since the explorations and beginnings of trade in the early part of this millennium. The refined ceramics of the Chinese were known to European potters. The perspective and the delicacy of the drawings and paintings of the Japanese have influenced modern artists such as the Impressionists and Postimpressionists.

In this chapter we will discuss the world of art beyond Europe and the United States to broaden our answer to the question raised in Chapter 1: What is art? We will begin with Africa and end our journey with the art of the Orient.

AFRICAN ART

Although we can devote only limited space to African art, it is not a narrow field. African art is as varied as are the cultures that have populated the continent. The earliest African art, like the earliest art of Europe and North America, is found in figurative and nonobjective rock paintings and engravings that date back to the New Stone Age. The lost-wax casting technique, explained in Chapter 6, had been developed in tropical Africa by the ninth century A.D.—apparently fully independent of its invention elsewhere.

In the kingdom of Benin, which occupied what is now Nigeria, during the fifteenth through the eighteenth centuries fine sculptures were wrought from iron, carved from wood and ivory, modeled in **terra cotta,** and cast in bronze. The bronze *Altar of the Hand* (Fig. 18–1) achieves monumentality within a height of 18 inches. In the *Altar,* numerous human figures and animals worship the divine king. The staffs of office and the shield and weapons of the attendants all reinforce a stylized pyramid shape familiar in Classical Western art. In contrast to the relative realism of the attendant figures, the head of the king is expressionistically magnified. The distortion may suggest the intelligence and power attributed to his office.

Africans have also highly refined the art of the **masquerade,** a show in which actors dance in costumes and masks that represent social positions (ranging from king and hunter to prostitute), animals, symbolic figures, and specific members of the tribe. The

18–1 Altar of the Hand, Benin, Nigeria. Bronze. Height: 17½".

British Museum, London.

Kagle mask (see Fig. 6–8) of the Dan people of present-day Sierra Leone represents a judge or an officer of the law.

The Itumba mask (Fig. 18–2) from the area of Brazzaville in present-day Zaire was carved from wood toward the end of the eighteenth century. The features and curves of the face are resolved into abstract geometric shapes. Pablo Picasso and Georges Braque found this abstraction interesting and adopted it in their early twentieth-century works. Note, for example, the similarity between this mask and the fragmented faces of the figures in Picasso's *Les Demoiselles d'Avignon* (Fig. 16–6). African art also influenced the work of Italian-born Amedeo Modigliani, who spent most of his artistic career in France. There is a striking resemblance between the stylized Itumba mask and Mo-

18–2 Mask, Itumba region, Brazzaville, Zaire. Wood. Height: 13".

Musée Barbier-Miller, Geneva.

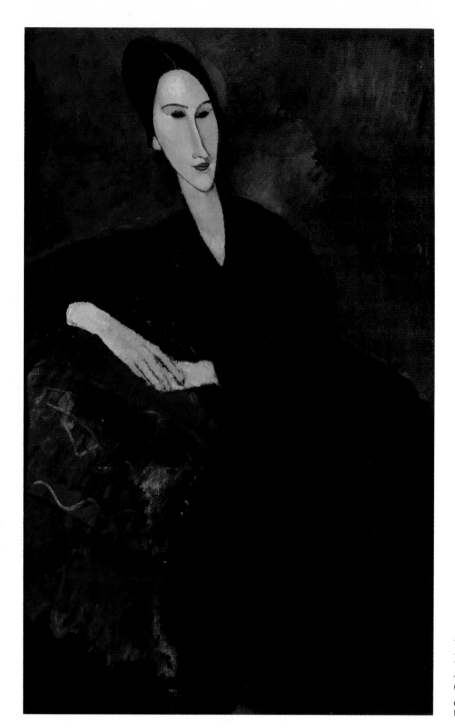

18–3 AMEDEO MODIGLIANI
Anna Zborowska (1917)
Oil on canvas. 51¼ x 32".

Collection, The Museum of Modern Art,
N.Y. Lillie P. Bliss.

digliani's *Anna Zborowska* (Fig. 18–3). In this and many other works, Modigliani rendered heads with pointed chins, small mouths, elongated noses and cheeks, and a delicate sweep of eyebrow into the lines of nose, cheek, and jaw.

The Yoruba of modern-day northern Nigeria have created fine sculptures, garments, and beaded works. The great modern sculptor Areogun carved the expressionistic door shown in Figure 18–4 for the palace at Ikerre. The overall form of its com-

partments is reminiscent of a Louise Nevelson wooden assemblage (see Fig. 6–15). But, unlike Nevelson's abstract works, the door is a specific record of a visit by an early Britisher. In this design of high wooden reliefs, the divine king and his visitor meet, in the second row of panels from the top. Compositionally, they balance one another. Both are dignified—the king by his throne, the Englishman by his bearers. There is a pervasive textured backdrop of lines suggestive of the structure of Yoruba buildings.

The rhythm of these lines and the repetition of figures lend the work an understated unity.

The blunt-nosed wooden animal in Figure 18–5 is a nineteenth- or early twentieth-century **fetish figure** from Brazzaville. Early fetish figures held state-of-the-art shafts, but since the introduction of the nail from Europe, they have bristled with Western objects. In Western societies, Christians light votive candles to request favors from saints or God, or to thank them for help. In a number of African societies, medicine men have hammered nails into fetish figures to ask for help from the gods, to ward off evil, and to vanquish enemies. Christianity was the state religion in this region during most of the sixteenth and seventeenth centuries, incidentally, and for this reason, it has been suggested that the nails may symbolize those used in the Crucifixion.

The abstracted faces of the ancestor figures of the Dogon tribe of Mali (Fig. 18–6) again remind one of the faces in *Les Demoiselles d'Avignon* (see Fig. 16–6). The overall textured patterns of the bodies are like those the Dogon people used to decorate themselves. These highly stylized, rigid, and distorted figures represent a sort of Creation scene. They are meant to be the Adam and Eve of all of us, not just of a Dogon family or of the Dogon tribe.

British sculptor Henry Moore wrote that African sculpture of this sort is "upward and vertical like the tree it was made from, but in its heavy bent legs . . . is rooted in the earth."[*] The immobile erectness of the Dogon figures communicates a sense of immortality. Rhythm is provided by the repetition of vertical lines that seem architectural, like posts or columns. The horizontal of the protective arm, like a lintel, formally closes the sculpture at the top. The choppy rectangular spaces that flow through the statue have the appearance of **monoliths.** The mass implied by this wooden piece of only 30 inches in height—the evocation of strength—is masterful.

[*] Henry Moore, "Primitive Art," *Listener*, Vol. 35, No. 641 (April 24, 1941).

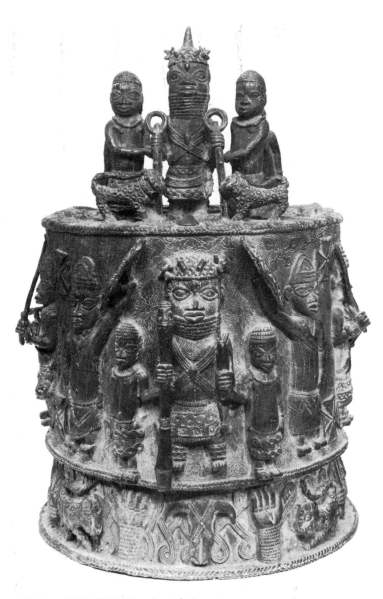

18–4 AREOGUN (Yoruba tribe) Door for Palace at Ikerre, Nigeria

18–5 Fetish figure, Brazzaville, Zaire (late 19th–early 20th century). Wood with iron nails and blades. Length: 35".

Musée de l'Homme, Paris.

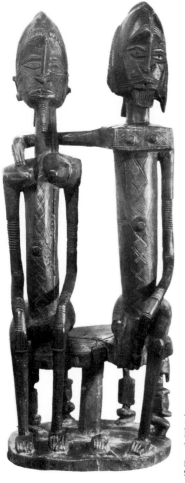

18–6 Dogon Couple, Dogon tribe, Mali. Wood. Height: 30".

Photo © Barnes Foundation, Merion Station, Pa.

18–7 Animal stool, Bamun tribe, Cameroon (19th or 20th century). Wood, glass beads, cowrie shells, burlap, cotton cloth. Height: 19⅛".

The Metropolitan Museum of Art, N.Y. The Michael C. Rockefeller Memorial Collection, Bequest of Nelson A. Rockefeller, 1979.

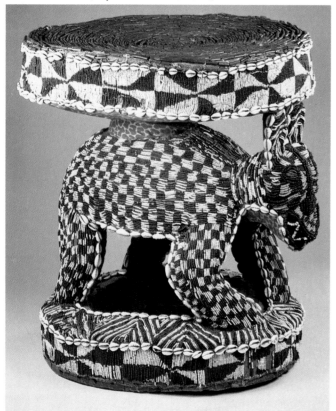

The animal stool from the Cameroon (Fig. 18–7) is a mixed-media piece of furniture made from woven fiber, cowrie shells, glass beads, and wood. The Bangwa of the Cameroon believed that the soul of a departed person would reside in such stools. Other household crafted objects were also frequently ornamented with shells, feathers, beads, colorful stones, or paint.

Before leaving the continent of Africa, let us note a contemporary sculpture of the Yoruba tribe (Fig. 18–8). Atop a traditional Yoruba mask sits a man and bicycle, expressionistically reduced to the idealized, rounded look of a child's toy. The mask is worn by a Gelede society actor to entertain the gods and powerful women in the tribe. One need not understand the ins and outs Yoruba tradition to perceive that this mask is a clever comment on the effects of contemporary civilization on the Yoruba.

Afro-American Art

Michelangelo is my grandfather. —Ed Wilson

The art produced by Americans of African descent is as rich and varied as the art of Africa itself. Like some black writers, a number of black American artists have focused on themes of racial injustice and social protest, or have dedicated themselves to portraying the black experience in America. Other black artists, like other black writers, have worked without reference to ethnicity.

The paintings of Horace Pippin become even more outstanding when one considers that Pippin never had an art lesson and that he started painting at age 42. "Pictures just come to my mind," Pippin once explained, "and I tell my heart to go ahead." Note the sculptural quality afforded by contrasting values in *The Buffalo Hunt* (Fig. 18–9). Pippin's use of vivid colors was not influenced by primitive art, but rather by his interest in the work of Henri Matisse (see pp. 411–412).

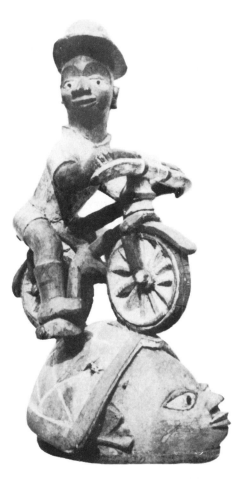

18–8 (*left*) SAMUEL LAROYE Bicycle mask of the Gelede Secret Society, Yoruba tribe (1958)

18–9 (*below*) HORACE PIPPIN *The Buffalo Hunt* (1933). Oil on canvas. 21½ x 31".
Collection of the Whitney Museum of American Art, N.Y.

The Art in Ordinary African Objects

"Suppose you had a slightly mad and creative gas station attendant," Susan Vogel said. "Now suppose he had a huge pile of spare tires, and he said, 'I could make those into something,' and he threw them into a big pile. Is it a work of art? If the same pile of tires is shown in front of the Whitney Museum, does it then become art?"

In a show at the Center for African Art in Manhattan, Ms. Vogel, the director of the center, created an entire exhibition that posed for African art the same philosophical query that she applied to spare tires: if you take an object that had a practical use in Africa and put it in an art museum, does that make it a work of art?

The show, entitled "Art/Artifact," consisted of 160 African objects, all of them designed with great style and often "beautiful" in appearance to Western eyes, yet nearly all of which, in their African context, were considered as objects of purely practical use.

In the catalogue essay to the show, Ms. Vogel argued that whether an object is considered as art or as an artifact is a distinction created largely by the manner in which it is displayed.

The exhibition, in a startling display of curatorial prestidigitation, brought home this point by creating no fewer than four different types of museum displays—each of which presents the same sorts of objects—but making them look strikingly different each time.

In one of the settings, a group of African objects was displayed as it would be at a contemporary art museum: each item in a Plexiglass case, illuminated with a spotlight, as if it were a gem. In another room, a group of similar objects was presented in a slightly musty, 19th-century "curiosity room," whose antique glass cases display each object like a souvenir from an exotic, alien land.

Another room closely resembled a gallery of contemporary art, in which a dozen slender wood sculptures, originally memorial effigies of the Mijikenda people in Kenya, were artfully arranged like a forest of Giacomettis. Finally, a diorama,

18–10 CHARLES WHITE
Preacher (1952). Ink on cardboard. 21⅜ x 29⅜".

Collection of the Whitney Museum of American Art, N.Y.

similar to those in natural history museums, depicted three Mijikendans, represented by lifelike mannequins, engaged in the ritual painting and dressing of the same sort of memorial effigy sculptures.

"I'm showing how we manipulate the public," Ms. Vogel said. "I'm showing how we can make people see things in different ways, and make the same things look different. I think it's fine to look at these things as pure form, but I think we have to realize that it's only one way of looking at them. Otherwise, it's very limiting, and we cut ourselves off from African societies and the way they thought."

The show presented itself—not the objects themselves—as the center of attention. The catalogue essays, with contributions by a museum curator, a philosopher, an anthropologist and others, explored the multiple roads of inquiry that the exhibition suggested.

"Is a thing a work of art if it is displayed as such, or is being a work of art, as they say, a deeper ontological question?" said Arthur Danto, a professor of philosophy at Columbia College who wrote one of the catalogue essays, in an interview. Mr. Danto added that Ms. Vogel's exhibition also raised questions similar to those posed by the famous " 'Primitivism' in 20th-Century Art" exhibition at the Museum of Modern Art in 1984. That show included many works by contemporary Western artists that resembled sculptures from African and other tribal societies.

"The philosophical problem is of things of very different orders that look alike," he said. "The thing to resist is saying that since they look alike, they really must be the same."

In the show at the Center for African Art, the planar construction of a wooden Dogon ritual figure [see, for example, Fig. 18–6] looks like a Cubist painting. The stocky, intricately carved figure on a wooden box from Nigeria is powerfully reminiscent of medieval sculpture. And a needle case of the Loza tribe, from Zambia, which consists of a dozen iron needles stuck into soft wood wrapped in leather, bears an uncanny resemblance to "fetish box" sculptures of several modern artists, especially Lucas Samaras [see Fig. 6–18].

Charles White is one of many black American artists who were sponsored by the Works Projects Administration in the 1930s. His *Preacher* (Fig. 18–10) is daring in its perspective—an exciting study of the projection of personality through hands. This ink-on-cardboard drawing exquisitely implies light and shade and masterfully portrays the textures of flesh and fabric. In its way, *Preacher* is as compelling as the Mexican social protest painting *Echo of a Scream* (Fig. 1–24), although the mood is not dysphoric.

Faith Ringgold was born in Harlem and educated in the public schools of New York City. In the 1960s she painted murals and other works inspired by the political turmoil of the civil rights movement. In the 1970s her art took a feminist turn because of her exclusion from an all-male exhibition at New York's School of Visual Arts. Her mother, a fashion designer, was always sewing, as the artist recalled it, and at this time Ring-

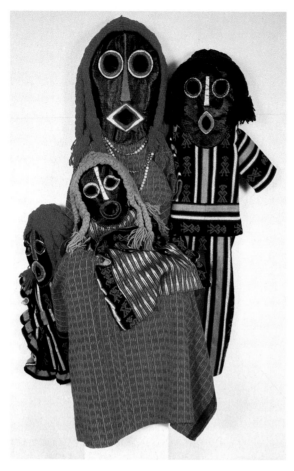

18–11 FAITH RINGGOLD
Mama Jones, Andrew, Barbara, and Faith (1973). Mixed media. Life size. From The Family of Women series.
Photo by Faith Ringgold. Reproduced by permission of the artist.

18–12 MELVIN EDWARDS
Homage to the Poet Leon Gontran Damas (1978) Scrap iron.

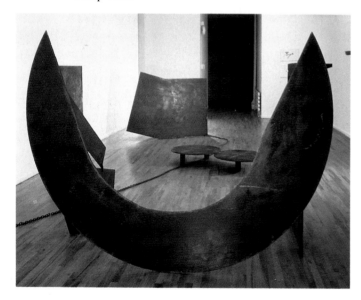

gold turned to sewing and related techniques—needlepoint, beading, braided ribbon, and sewn fabric—to produce soft sculptures such as those in *Mama Jones, Andrew, Barbara, and Faith* (Fig. 18–11), which is from her series *The Family of Women*. The clothing of these figures is inspired by African garments and the faces are reminiscent of African masks. Ringgold's works express her sensitivities as an American, a black, and a woman.

A 1980 exhibition at New York's rehabilitated school-building museum, P.S. 1, contained contemporary abstractions such as Melvin Edwards's *Homage to the Poet Leon Gontran Damas* (Fig. 18–12) and Alvin Loving's *Shades of '73: Composition for 1980* (Fig. 18–13). Edwards's junk sculptures, made from forged and welded scrap iron, subtly hark back to the tribal art of **bricolage,** in which scraps of metal—cartridge cases, tin, nails, and the like—were integrated into wooden carvings. *Homage* is an open, sweeping, and embracing work of geometric purity, monolothic and religious in quality.

Loving's *Shades of '73* is a wall hanging made from sewn and dyed canvas. One feels that the work would be at home on two continents, despite the fact that it makes no specific allusion to African art. Yet the richly colored fibrous textures suggest the very physical vitality of much of African art.

As has been noted, there is no one type of black artist and no one type of black art. Afro-American artists have been raised in Western culture and, as they mature, may be encouraged to search for their African artistic roots. Black sculptor Ed Wilson frequently tells students, "Malcolm X is my brother, but Michelangelo is my grandfather."

OCEANIC ART

The peoples and art of Oceania are also varied. They span millions of square miles of ocean, ranging from the continent of Australia and large islands of New Guinea and New Zealand to small islands such as the Gilberts, Tahiti, and Easter Island. They are

divided into the cultures of Polynesia, Melanesia, and Micronesia. We shall discuss works from Polynesia and Melanesia.

Polynesia

The Polynesian artists are known for their figural sculptures, such as the huge stone images of Easter Island (Fig. 18–14). More than 600 of these heads and half-length figures survive, some of them 60 feet tall. Polynesian art is also known for its massiveness and compactness. Carved between the fifth and seventeenth centuries A.D., their jutting, monolithic forms have the abstracted quality of African masks and ancestor figures. Figure after figure has the same angular sweep of nose and chin, the severe pursed lips, and the overbearing brow.

18–13 ALVIN LOVING
Shades of '73: Composition for 1980
Wall hanging of sewn, dyed canvas.
Time Magazine.

18–14 Giant stone figures on Easter Island (Polynesian) (c. 15th century A.D.). Height: c. 30'.

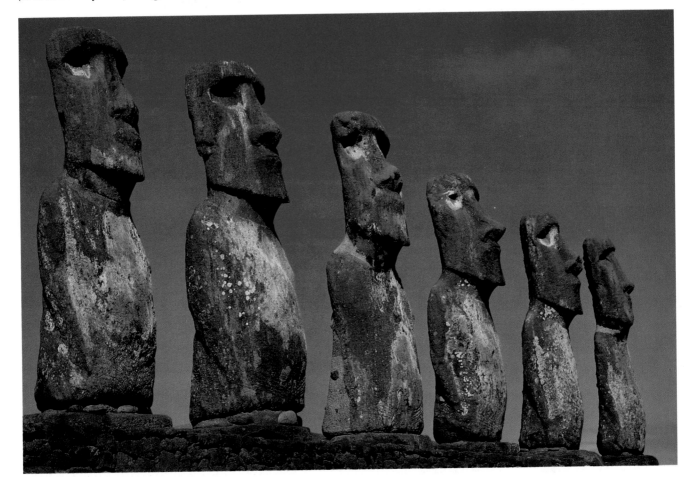

Henry Moore on "Primitive" Art

The term *primitive art* is generally used to include the products of a great variety of races and periods in history, many different social and religious systems. [I shall use it] to cover most of those cultures which are outside European and the great Oriental civilizations, . . . though I do not much like the application of the word "primitive" to art, since . . . it suggests to many people an idea of crudeness and incompetence, ignorant gropings rather than finished achievements. Primitive art means far more than that; it makes a straightforward statement, its primary concern is with the elemental, and its simplicity comes from direct and strong feelings.

The most striking quality common to all primitive art is its intense vitality. It is something made by people with a direct and immediate response to life. Sculpture and painting for them was not an activity of calculation and academism, but a channel for expressing powerful beliefs, hopes, and fears. It is art before it got smothered in trimmings and surface decorations, before inspiration had flagged into technical tricks and intellectual conceits. But apart from its own enduring value, a knowledge of it conditions a fuller and truer appreciation of the later developments of the so-called great periods, and shows art to be a universal continuous activity with no separation between past and present.

One of the first principles of art so clearly seen in primitive work is truth to material; the artist shows an . . . understanding of his material, its right use and possibilities. Wood has a stringy fibrous consistency and [the African sculptor could carve it] into thin forms without breaking [it]. Much [African] carving . . . has pathos, a static patience and resignation to unknown mysterious powers; it is religious and, in movement, upward and vertical like the tree it was made from, but in its heavy bent legs is rooted in the earth.

[Mexican sculpture's] "stoniness," by which I mean its truth to material, its tremendous power without loss of sensitiveness, its astonishing variety and fertility of form-invention, and its approach to a full three-dimensional concept of form, make it unsurpassed in my opinion by any other period of stone sculpture. . . .

Primitive art is a mine of information for the historian and the anthropologist, but to understand and appreciate it, it is more important to look at it than to learn the history of primitive peoples, their religions and social customs. . . . All that is really needed is response to the carvings themselves, which have a constant life of their own, independent of whenever and however they came to be made, and they remain as full of sculptural meaning today to those open and sensitive enough to perceive it as on the day they were finished.

Archaeologists have determined that these figures symbolize the power that chieftains were thought to derive from the gods and to retain in death through their own deification. Political power in Polynesia was believed to be a reflection of spiritual power. The images of the gods were thought to be combined with those of their descendants in the carvings and other art works like those on Easter Island.

The Polynesian Maori of New Zealand are known for their wooden relief carvings. The plentiful nature of tough durable pine woods allowed them to sculpt works with

the curvilinear intricacy and vitality of the nearly 6-foot-long canoe prow shown in Figure 18–15. The figure at the front of the prow is intended to have an earthy phallic thrust.

The winding snake pattern on the mythic figure and scrollwork of the eighteenth-century canoe prow is like that found on the Maori's tattooed bodies. Body painting and tattooing are governed by tradition and are believed to link the individual to the spirits of ancestors. Ancestor figures are intended to appear menacing to outsiders, but they are perceived as benevolent within the group. Other Maori carvings are found on assembly houses, storehouses, and stockades.

Melanesia

Melanesian art is generally more colorful than that of Polynesia. The cloth masks of New Britain are woven with a certain flair, and the mixed-media ancestral poles of New Guinea (Fig. 18–16) are painted in vivid hues. The intricate poles are carved from single pieces of wood and adorned with palm leaves and paint. Space flows around and through the ancestral poles as it could not pass through the figures at Easter Island. The expressionistically elongated and attenuated bodies again represent ancestors. The openwork banners are phallic symbols, intended to give courage to community men in ceremonies before combat with other tribes.

Practical, ceremonial, and decorative uses of art swept across the Pacific into the New World. Many historians and archaeologists believe, in fact, that the Americas were first populated many thousands of years ago by migrations across the Pacific.

18-15 Canoe prow, Maori tribe (pre-1935). Wood. 70⅞ x 29½".

Musée d'Histoire Naturelle, Ethnographie et Préhistoire, Rouen.

18–16 Ancestor poles, New Guinea (Melanesian, Asmat tribe). Wood, paint, and fiber. Height of tallest pole: 17'11".

The Metropolitan Museum of Art, N.Y. The Michael C. Rockefeller Collection. Gift of Nelson A. Rockefeller and Mrs. Mary C. Rockefeller, 1965.

The art of the Americas was rich and varied before the arrival of European culture. We shall briefly explore the native arts of North America and Peru.

Native Arts of Mexico

Some of the earliest, and certainly the most massive, art of the Americas was produced by the Olmecs in southern Mexico long before the Golden Age of Greece. In addition to huge heads such as that in Figure 18–17, the Olmecs produced small stone carvings, including reliefs.

More than a dozen great heads up to 12 feet in height have been found at Olmec ceremonial centers. The hard basalt and jadeite from which they were carved had to be carted nearly 100 miles. The difficulty of working this material with primitive tools may to some degree account for the works'

18–18 Effigy vessel, girl on swing, from Remojadas region, Veracruz, Mexico (300–900 A.D.). Ceramic. 9¾".

The Metropolitan Museum of Art, N.Y. The Michael C. Rockefeller Memorial Collection. Bequest of Nelson A. Rockefeller, 1979.

18–17 Colossal head, Villahermosa, Mexico (Olmec culture) (c. 500 B.C.–200 A.D.). Basalt. Height: 8'.

close adherence to the original monoliths. The heads share the same tight-fitting helmets, broad noses, full lips, and wide cheeks. Whether these colossal heads represent gods or earthly rulers is unknown, but there can be no doubting the power they project.

Henry Moore stated that Mexican sculpture is known for its massiveness. But contrast the Olmec heads with the sprightliness of the kinetic sculpture of the swinging girl (Fig. 18–18). This small piece is actually a whistle. The swinging girl was created many hundreds of years after the Olmec heads and was found in the same region of southern Mexico. We can find a continuity of tradition in the oversized head, but note the delicacy of the curved body. The entire length of the body, like that of Noguchi's *Big Boy* (see Fig. 9–1), is nothing but a spread-eagled, draped abstraction.

The Mayans, whose civilization reached its height in the Yucatán region of Mexico and the highlands of Guatemala from about 300 to 600 A.D., built many huge limestone structures with **corbelled** vaults. Mayan

temples were highly ornamented with figural relief carvings that represent rulers and gods, and with commemorative and allegorical murals. The temple discovered at Bonampak in 1947 is decorated with murals of vivid hues such as that in Figure 18–19, in which prisoners are being presented for sacrifice.

The placement of the reasonably realistic figures along the receding steps symbolizes the social hierarchy. At the bottom are the common people. On the upper platform are noblemen and priests in richly embellished headdresses, as well as their personal attendants, and symbols of the heavens. The prisoners sit and kneel on various levels, visually without a home, whereas the Mayans are rigidly erect in their ascendance. There

is no perspective; the figures on the upper registers are not smaller, even though they are farther away. The eye is drawn upward to the center of the composition by the pyramidal shape formed by the scattered prisoners. The figures face toward the center of the composition, providing symmetry, and the rhythm of the steps provides unity. The subject of human sacrifice is repugnant to us, and well it should be. The composition of the mural, however, shows a classical refinement.

While the Mayans were reaching the height of their power in lower Mexico, the population of the agricultural civilization of Teotihuacán may have reached 100,000. The temples of Teotihuacán, harmoniously grouped in the fertile valley to the North

18–19 Mural from Mayan temple at Bonampak, Mexico (c. 6th century A.D.). Watercolor copy by Antonio Tejeda.

Carnegie Institution, Washington, D.C.

18–20 Temple of Quetzalcóatl, Teotihuacan, Mexico (300–700 A.D.)

of modern-day Mexico City, include the massive 250-feet-high Pyramid of the Sun and the smaller Temple of Quetzalcóatl (Fig. 18–20). The god Quetzalcóatl was believed to be a feathered serpent. The high-relief head of Quetzalcóatl projects repeatedly from the terraced sculptural panels of the temple, alternating with the square-brimmed geometric abstractions of Tlaloc, the rain god. **Bas reliefs** of abstracted serpent scales and feathers follow sinuous paths on the panels in between.

The warlike Aztecs were a small group of poor nomads until they established their capital, Tenochtitlán, in about 1325 A.D. on the site of modern Mexico City. Once established in Tenochtitlán, the Aztecs made

great advances in art and architecture, as well as in mathematics and engineering. But they also cruelly subjugated peoples from surrounding tribes. Prisoners of war were used for human sacrifice in order to compensate the sun god, who was believed to have sacrificed himself in the creation of the human race. It is not surprising that in the early part of the sixteenth century the invading Spaniards found many neighbors of the Aztecs more than eager to help them in their conquest of Mexico. The Aztecs also helped seal their own fate by at first treating the Spanish with great hospitality, because they believed that the Spanish were descended from Quetzalcóatl. The Spanish were thus able to creep into the hearts of the Aztecs

within the Trojan Horse of mistaken identity. The Spanish, needless to say, did not rush to disabuse their hosts of this notion.

Coatlcue was the Aztec goddess of earth and death. In the compact, monumental stone effigy shown in Figure 18–21, Coatlcue takes the form of a composite beast that never was. Her head consists of facing snakes. Her hands are also snakes, her fingers fangs. Hands, hearts, and skull compose her necklace. Coiled human figures hang from her midsection. Her gargantuan toes repeat the abstracted serpent fangs above. If one does not take into account the fearsome symbolic content of the statue, Coatlcue is a fascinating basalt assemblage of organic forms. But it is difficult to ignore the work's meanings.

Native Arts of Peru

The native arts of Peru include pyramid-shaped structures that form supports for temples, as in Mexico; stone carvings, mostly in the form of ornamental reliefs on ceremonial architecture; ceramic wares; and astounding feats of engineering.

The ceramic portrait jar shown in Figure 18–22 was created in about the fifth or sixth century A.D. by the Mochica culture along the Pacific coast of northern Peru. These realistic jars were modeled without benefit of a potter's wheel and probably accompanied the departed person into the grave. This particular jar is thought to be a portrait of a high-placed person, perhaps a warrior or a religious figure. It has a typical flat bottom and stirrup-shaped spout. Similar jars show their subjects grinning, sneering, or showing other expressions which must have impressed the artist as characteristic of their dominant traits. Still other jars show entire human or animal figures, some of them caught in erotic poses.

In Chapter 7 we noted the grand ruins of Machu Picchu (Fig. 7–3), the fortress that straddled the Peruvian Andes. This structure, built by the Incas in about 1500 A.D., shows an engineering genius that has been compared to the feats of the Romans. The tight fit of the dry masonry walls seems to

18–21 Statue of Coatlcue (Aztec, Toltec culture) (15th century). Height: 99″.
Museo Anthropologica, Mexico City.

18–22 Ceramic portrait jar from Peru (Mochica culture) (c. 500 A.D.)

reflect the tightness of the totalitarian fist with which the Incan nobility regulated the lives of their own masses and of subjugated peoples from Equador to Chile. The conquering Spaniards were amazed by the great Incan "Royal Road of the Mountains"; 30 feet wide and walled for its entire 3,750 miles, it had no parallel in Europe.

Native Arts of the United States and Canada

Some native art objects in the United States and Canada date back nearly 12,000 years. Much of it is practical craft, and much of it is ceremonial.

Eskimo sculpture shows simplicity of form and elegant refinement in the precision of both its realistic and nonobjective designs. Ivory is a favorite material of the Eskimos, and they have carved many fine, small figures and masks from it. The Eskimo pipe shown in Figure 18–23 is incised with black and red circular designs that highlight the simple semicylindrical shape of the piece. These nonobjective geometric forms advance rhythmically along the tube and find a compositional counterpoint in the conical bowl.

Prehistoric sculptors in what is now the United States carved many practical and ceremonial objects from stone. One of their larger ceremonial sculptures is a prehistoric earthwork called the Serpent Mound, which meanders some 1,400 feet in the Ohio countryside. Pyramidal temple platforms reminiscent of those of Mexico and South America have also been unearthed. The magnificent Cliff Palace of Colorado's Mesa Verde National Park (Fig. 7–1) was constructed around 1100 A.D.

The Navajos of the Southwest are noted for their fine fiber artistry. They also still make sand paintings that portray highly stylized mythic figures and gods and that are believed to have the power to heal while priests chant ritualistic prayers. The patient sits in the center of the painting. Unfortunately, even the best of sand paintings must be short-lived.

The tribes of the Northwest Coast have produced masks used by shamans in healing rituals; totem poles not unlike the ancestor poles of Oceania; bowls; clothing; and canoes and houses that are highly embellished with carving and other ornamentation. The Chilkat blanket discussed in Chapter 9 (see Fig. 9–16) was worn during ceremonies and shows highly abstracted animal designs. The wood and muslin of the 4-foot-high Kwakiutl headdress from British Columbia (Fig. 18–24) is vividly painted. When the string hanging from the inner mask is pulled, the two profiles to the sides are drawn together, forming another mask. The symbols represent the sun and a number of spirits. As a composition, the wooden mask is balanced by the circular flow of fabric above, and the representational and symbolic forms have bilateral symmetry. The embellishment of the masks reflects traditional body painting.

Native Americans in eastern North America produced ceremonial masks and feathered and beaded handicrafts. The highly nomadic tribes of the Great Plains poured their artistic energies into embellishing portable items, such as garments and teepees.

The final work in this section on native art of the Americas, like the final work in the African section, is a response to the interaction of European and native cultures. The muslin teepee lining of the Crow tribe of the Plains (Fig. 18–25) is a multi-hued and fairly realistic portrayal of nineteenth-century warfare with the U.S. cavalry. In this symbolic collection of events, Crow

18–23 Eskimo pipe from Gambell, St. Lawrence Island, Alaska.

Peabody Museum, Harvard University.

18–24 Kwakiutl headdress from Vancouver Island, British Columbia, Canada (c. 1895–1900). 52 x 46".

Museum of the American Indian, N.Y.

18–25 *Custer's Last Stand* (Sioux, Crow tribe) (late 19th century). Teepee lining. Painted muslin. 35 x 85".

National Museum of Natural History, Smithsonian Institution, Washington, D.C.

warriors advance rhythmically from the right. Many chieftains sport splendid feather headdresses. The cavalry is largely unhorsed and apparently unable to stop the implied momentum of the charge, which is very much like the sequence of frames in a motion picture.

Now that we have glanced at the native arts of Africa, Oceania, and the Americas, let us look once more across the Atlantic to the East. We will work our way across southern Europe and Asia so that we may sample the artistic contributions of the Islamic, Indian, Chinese, and Japanese cultures.

ISLAMIC ART

The era of Islam (also known as Moslem) was founded in Arabia by Mohammed in 622 A.D. Within a century, the Moslem faith had been spread by conquering armies westward across North Africa to the Atlantic

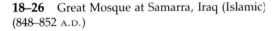

18–26 Great Mosque at Samarra, Iraq (Islamic) (848–852 A.D.)

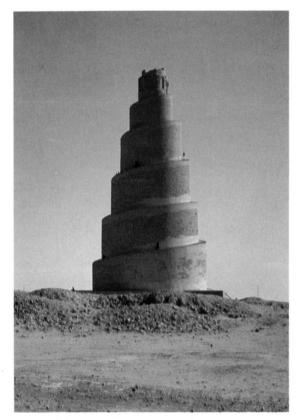

Ocean. It also spread to the east. So it is that many of the great monuments of Islamic art and architecture are found as far west as Spain and as far east as Agra in India. Mohammedans look upon the Old and New Testaments as well as the Koran as holy scriptures, and they number Abraham, Moses, and Jesus among their prophets.

The Great Mosque at Samarra, Iraq (Fig. 18–26) was constructed between 848 and 852 A.D. Once the largest mosque in the world of Islam, it now lies in ruins. Its most striking feature is the spiral **minaret,** from which a crier known as a **muezzin** called followers to prayer at certain hours. Mosques avoid symbols, and early mosques in particular do not show ornamentation. Nor, in Islam, is there the clerical hierarchy found in many Christian religions. The leader of gatherings for worship, called the **imam,** stands on a pulpit in the Mosque, near the wall that faces Mecca, the spiritual center of Islam.

The mosque at Samarra was a simple building, 800 feet long and 520 feet wide, covered in part by a wooden roof, with a great open courtyard. The roof was supported by the **hypostyle** system of multiple rows of columns that could be expanded in any direction as the population of the congregation grew. By bowing toward Mecca in the same yard, worshippers were granted equal psychological access to Allah, the Islamic name of God.

The interior of the mosque at Córdoba, Spain (Fig. 18–27), shows the system of arches that spanned the distances between columns in the hypostyle system. A system of vaults, supported by heavier piers, overspreads the arches. There is not the grand open space of the cathedral, but air and light flow through as in a forest of high-crowned, sturdy trees. The mosque at Córdoba was built somewhat later than the Great Mosque, and the arches become richly decorated in the area of the **mihrab,** a niche in the wall facing Mecca that provides a focus of worship. At Córdoba, a richly ornamented dome was also constructed before the mihrab.

The Taj Mahal at Agra (Fig. 18–28) is a mausoleum built by the Shah Jahan in the

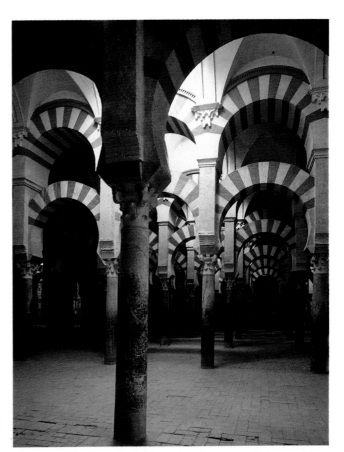

18–27 (*right*) Interior of mosque at Cordoba, Spain (Islamic) (786–987 A.D.)

18–28 (*below*) Taj Mahal, Agra, India (Islamic) (1630–48)

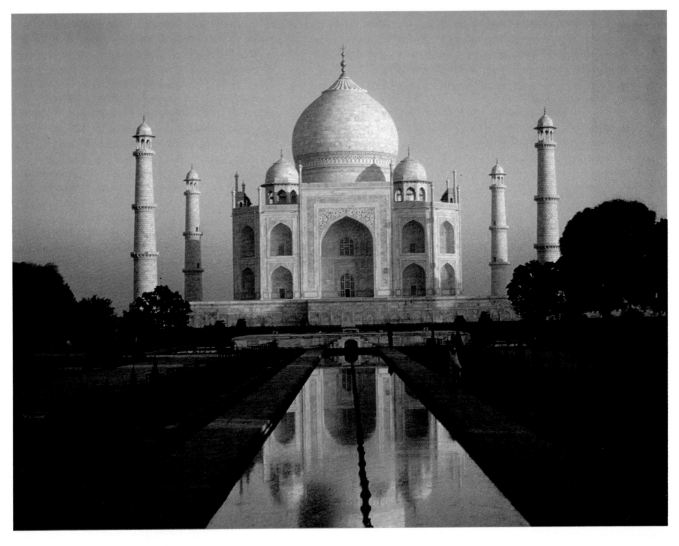

seventeenth century in memory of his wife. In sharp contrast to the plainness of early Islamic architecture, tree-lined pools here reflect a study in refined elegance. The three-quarters sphere of the dome is a stunning feat of engineering. Open archways, with their ever-changing play of light and shade, slender minarets, and spires unify the composition and give the marble structure a look of weightlessness. Creamy marble seems to melt in the perfect order.

Islamic culture has also produced a wealth of fine craft objects. Persian carpets like that shown in Figure 9–15, which was woven during the century in which the Taj Mahal was built, have set a high standard for the worldwide textile industry since the tenth century. Richly ornamented ceramics, enameled glass, highly embellished metalworks, and fine manuscript illumination also characterize the visual arts of the Moslem world.

INDIAN ART

Indian art, like that of the Americas, shows a history of thousands of years, and it too has been influenced by different cultures. Stone sculptures and **seals** that date to the second or third millennium B.C. have been discovered. In low relief, the seals portray sensuous, rounded native animals and humanoid figures that presage the chief Hindu god, **Shiva.**

India once encompassed present-day Pakistan, Bangladesh, and the buffer states between modern India and China. Many religious traditions have conflicted and sometimes peacefully coexisted in India, among them the Vedic religion, Hinduism, Buddhism, and Islam. Today Islam is the dominant religion of Pakistan, and Hinduism predominates in India. Indian art, like Islamic art, is found in many parts of Asia where Indian cultural influence once reigned, as in Indochina.

Buddhism flowered from earlier Indian traditions in the sixth century B.C., largely as a result of the example set by a prince named Siddhartha. In his later years Siddhartha renounced his birthright and earthly luxuries to become a **buddha,** or enlightened being. Through meditation and self-denial, he is believed to have reached a comprehension of the universe that Buddhists call **nirvana.** The Great Buddhist **stupa** at Sanchi, whose architecture was discussed in Chapter 7, was completed in the first century A.D. The stupa houses religious relics and also symbolizes the harmony of the universe, stimulating meditation by the visitor.

For many hundreds of years there were no images of the Buddha, but sculptures and other representations began to appear in the second century A.D. Some sculpted Buddhas show a Western influence that can be traced to the conquest of northwestern India by Alexander the Great in 327 B.C. Others (as in Fig. 18–29) have a sensuous,

18–29 Buddha, Bengal, India (Pala period, 9th century A.D.). Black chlorite. Height: 37".
Cleveland Museum of Art, Dudley P. Allen Fund.

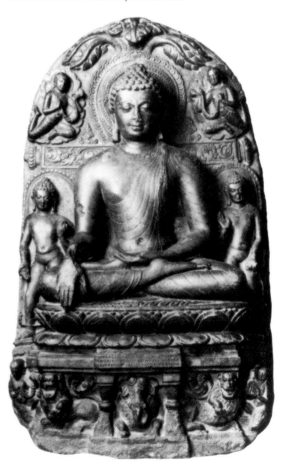

rounded look that recalls the ancient seals and is decidedly Indian. The slender chlorite Buddha in Figure 18–29 shows delicate fingers and gauzelike, revealing drapery. The face exhibits a pleasant cast that is as inscrutable as the expression of La Gioconda in Leonardo's *Mona Lisa* (see Fig. 1–1).

In the sixth and seventh centuries A.D., Hinduism rose to prominence in India, perhaps because it permitted more paths for reaching nirvana, including the simple carrying out of one's daily duties. Another reason for the popularity of Hinduism may be its frank appreciation of eroticism. Western religions impose a distinction between the body or flesh, on the one hand, and the soul or mind, on the other. As a consequence, sex is often seen as unrelated or anatagonistic to religious purity. Hinduism considers sexual expression one legitimate path to virtue; explicit sexual acts in high reliefs adorn temple walls and amaze Western visitors.

There are many Hindu gods, including Shiva, the Lord of Lords and god of creation and destruction, which, in Hindu philosophy, are one. Figure 18–30 shows Shiva as Nataraja, the Lord of the Dance. With one foot on the Demon of Ignorance, this eleventh-century bronze figure dances within a symbolically splendid fiery aura. The limbs are sensuous, even erotic. The small figure to the right side of his head is Ganga, the river goddess. This periodic dance destroys the universe, which is then reborn. So, in Hindu belief, is the human spirit reborn after death, its new form reflecting the sum of the virtues of its previous existences.

Hindu temples are considered to be the dwelling places of the gods, not houses of worship. The proportions of the famous Kandarya Mahadeva Temple at Khajuraho (Fig. 18–31) symbolize cosmic rhythms. The gradual unfolding of spaces within is highlighted by the sculptural procession of exterior forms. The organic, natural shapes of the multiple roofs are in most sections separated from the horizontal **registers** of the base by sweeping cornices. The main tower is an abstracted mountain peak, reached visually by ascending what appear to be architectural and natural hurdles. All this

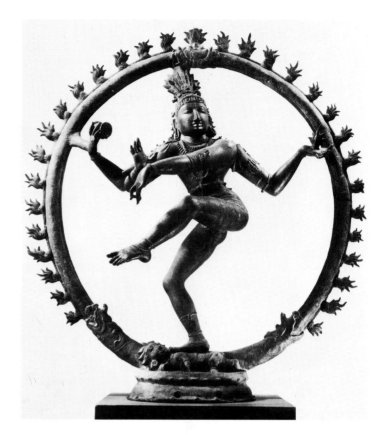

18–30 Shiva as Nataraja, Lord of the Dance (South Indian) (Chola period, 11th century, A.D.). Copper. Height: 43⅞"; width: 40".
The Cleveland Museum of Art. Purchase from the J. H. Wade Fund.

can be seen as representing human paths to oneness with the universe. The registers of the base are populated by high reliefs of gods, allegorical scenes, and idealized men and women in erotic positions.

Other Hindu temples are even more intricate. Vast pyramidal bases contains forests of towers and spires, corniced at the edges as they ascend from level to fanciful level. They are thick with low and high reliefs. In the Buddhist temples of Indochina, the giant face of Buddha looms from the walls of imposing towers and gazes in many directions. Indian art, including Indian painting—of which little, sad to say, survives—teaches us again how different the content of the visual arts can be. Still, techniques such as that of stone carving and bronze casting, as well as elements of composition, seem to possess a universal validity.

18–31 Kandariya Mahadeva Temple, Khajuraho, India (10th–11th centuries)

CHINESE ART

China houses more than a billion people in a country not quite as large as the United States. Nearly 4,000 years ago, inhabitants of China were producing primitive crafts. Beautiful bronze vessels embellished with stylized animal imagery were cast during the second millennium B.C. During the feudal period of the Late Chou Dynasty, which was contemporaneous with the Golden Age of Greece, royal metalworks were inlaid with gold, silver, and polished mirrors. Elegant carvings of fine jade were buried with their noble owners.

Confucianism ascended as the major Chinese way of life during the second century B.C. It is based on the moral principles of Confucius, which argue that social behavior must be derived from sympathy for one's fellows. Paintings and reliefs of this period show the **conceptual space** of Egyptian painting and create the illusion of depth by means of overlapping. Missionaries from

India successfully introduced Buddhism to China during the second century A.D., and many Chinese artists imitated Indian models for a few centuries afterward. But by the sixth century, Chinese art was again Chinese. Landscape paintings transported viewers to unfamiliar, magical realms. It was believed by many that artist and work of art were united by a great moving spirit. Centuries after the introduction of Buddhism, Confucianism again emerged. The present-day Peoples Republic of China is officially atheistic, but many Chinese still follow the precepts of Confucius.

Fan K'uan's *Travelers Among Mountains and Stream* (Fig. 18–32) was painted on a silk scroll during the early part of the eleventh century. Years of political turmoil had reinforced the artistic escape into imaginary landscapes. It is executed in the so-called Monumental Style. Rocks in the foreground create a visual barrier that prevents the viewer from being drawn suddenly into the painting. Rounded forms rise in orderly,

18–32 FAN K'UAN
*Travelers Among Mountains
and Streams* (c. 1000 A.D.).
Hanging scroll, ink and
colors on silk. Height: 81¾".

Collection of the National Palace Museum,
Taiwan.

18–33 MU CH'I
Six Persimmons (Southern Sung Dynasty, c. 1270).
Ink on paper. Width: 14¼".
Daitoku-ji, Kyoto, Japan.

ity, with the suggestion that their relationships to one another were more important to the artist than their relationship to external objects. The second and fifth persimmons along the line overlap the fruit at the extremes, one barely and the other noticeably. The third and fourth persimmons may or may not touch, creating a tension between the two, whereas there is a decided distance between the second and third. The lower persimmon stands alone. What subtle variations on a compositional theme! Note, too, how stems and leaves are created with swift, calligraphic strokes of the brush. *Six Persimmons* is executed in the Spontaneous Style, which is characterized by a paucity of rapid brushstrokes that resemble **calligraphy,** and a monochromatic palette.

The blue and white porcelain vase from the Ming Dynasty (Fig. 18–34) speaks eloquently of the refinement of Chinese ceramics. The crafting of vases such as these was

18–34 Vase, Ming Dynasty (1368–1644). Porcelain.
Musée Guimet.

rhythmic fashion from foreground through background. Sharp brushstrokes clearly delineate conifers, deciduous trees, and small temples on the cliff in the middle ground. The waterfall down the high cliffs to the right is balanced by the cleft to the left. A high contrast in values picks out the waterfall from the cliffs. Human figures are dwarfed by distant mountains. In contrast to the perspective typical of Western landscapes, there is no single vanishing point or set of vanishing points. The perspective shifts, offering the viewer a freer journey back across the many paths and bridges.

Six Persimmons (Fig. 18–33) was painted in blue-black ink by Mu Ch'i some two centuries later. It is considered a masterful study of the way in which brushstrokes and different values imply mass and textures. Note how the flatter base of the central persimmon lends it the greatest mass. The placement of the persimmons is extraordinarily delicate and precise. They stand alone in space and are thus given an abstract qual-

18–35 LI K'AN *Bamboo* (detail of 1st section) (1308 A.D.). Handscroll. Ink on paper. 14⅝ x 92⅝".

Nelson-Atkins Museum of Art, Kansas City, Mo.

a hereditary art, passed on from father to son over many generations. Labor was also frequently divided so that one craftsman made the vase and others glazed and decorated it. The vase in Figure 18–34 has a blue underglaze decoration, that is, a decoration molded or incised beneath rather than on top of the glaze. Transparent glazing increases the brilliance of the piece. In many instances the incising or molding was so subtle that it amounted to "secret" decoration.

Li K'an's courageous fourteenth-century ink painting, *Bamboo* (Fig. 18–35), possesses an almost unbearable beauty. The entire composition consists of minor variations in line and tone. On one level it is a realistic representation of bamboo leaves, with texture gradient providing a powerful illusion of depth. On another level, it is a nonobjective symphony of calligraphic brushstrokes. The mass of white paper showing in the background is a symbolic statement of purity, not a realistic rendering of natural elements such as haze.

In much of Chinese art there is a non-Western type of reverence for nature in which people are seen as integral parts of the order of nature, neither its rulers nor its victims. In moments of enlightenment, we understand how we create and are of this order, very much in the way Li K'an must have felt that his spirit had both created and been derived from these leaves of bamboo and the natural order that they represent.

How can we hope to have spoken meaningfully about the depth and beauty of Chinese philosophies and Chinese arts in but a few sentences? Our words are mean strokes, indeed, but perhaps they point in the right direction.

JAPANESE ART

Japan is an island country off the east coast of Asia, holding more than 120 million people in an area not quite as large as California. The islands were originally formed from porous volcanic rock and thus they are devoid of hard stone suitable for sculpture and building. Therefore Japan's sculpture tradition has focused on clay modeling and bronze casting, and its structures have been built from wood.

Ceramic figures and vessels date to the fourth millennium B.C. Over the past 2,000 years, Japanese art has been intermittently influenced by the arts of nearby China and Korea. In the fifth and sixth centuries A.D., the Japanese produced **haniwa,** hollow ceramic figures with tubular limbs modeled from slabs of clay. Haniwa were placed around burial plots, but their function is unknown.

By the beginning of the seventh century, Buddhism had been exported from China and established as the state religion in Japan. Many sculptors produced wooden and

18–36 Kumano Mandala (Japan, Kamakura period, c. 1300 A.D.). Hanging scroll. Color on silk. 53¾ x 24⅜".

The Cleveland Museum of Art. John L. Severance Fund.

bronze effigies of the Buddha, and Buddhist temples reflected the Chinese style. Shinto, the native religion of Japan, teaches love of nature and the existence of many beneficent gods, who are never symbolized in art or any other visual form.

For nearly 2,000 years, wooden Shinto shrines, such as those shown in Figure 18–36, have been razed every twenty years and replaced by duplicates. The landscapes, portraits, and narrative scrolls produced by the Japanese during the Kamakura Period, which spanned the late twelfth through the early fourteenth centuries A.D., are highly original and Japanese in character. Some of them express the contemplative life of Buddhism, others express the active life of the warrior, and still others express the aesthetic life made possible by love of nature.

The *Kumano Mandala* (Fig. 18–36), a scroll executed at the beginning of the fourteenth century, represents three **Shinto** shrines. These are actually several miles apart in mountainous terrain, but the artist collapsed the space between them to permit the viewer an easier visual pilgrimage. The scroll pays homage to the unique Japanese landscape in its vivid color and rich detail. The several small figures of the seated Buddha portrayed within testify to the Japanese reconciliation of disparate spiritual influences. The repetition of forms within the shrines, and the procession of the shrines themselves, afford the composition a wonderful rhythm and unity. A **mandala** is a religious symbol of the design of the universe. It seems as though the universe of the shrines of the *Kumano Mandala* must carry on forever, as, indeed, it did in the minds of the Japanese.

The well-known *Portrait of Yoritomo* (Fig. 18–37), a great general, is also of the Kamakura Period. The head and the official costume are outlined in strong, bold lines. The flatness of the general's robes reflects the stiffness of the fabric, but also underscores the abstract, geometric purity with which it seems carved out against the background. The form of the figure—a dark pyramidal mass occupying the center of the composition—reminds one of a noble falcon or eagle

18–37 Attributed to FUJIWARA TAKANOBU
Portrait of Yoritomo (12th century A.D.).
Hanging scroll. Color on silk. Height: 54¾".
Jingo-ji, Kyoto, Japan.

18–38 HASEGAWA TOHAKU
Pine Wood (1539–1610). Detail from a pair of six-fold screens. Ink on paper. Height: 61".
Tokyo National Museum, Japan.

at rest. Vast power is implied by the wing shapes and the embellished hilt of the sword. Other compositions of the period portray frail elders with great realism and equally intense emotion.

Some two centuries later, Hasegawa Tohaku painted his masterful *Pine Wood* (Fig. 18–38) on a pair of screens. It is reminiscent of Li K'an's study of bamboo in that the plant life stands alone. No rocks or figures occupy the foreground. No mountains press the skies in the background. Like *Bamboo*, it is also monochromatic. The illusion of depth—and, indeed, the illusion of dreamy mists—is evoked by subtle gradations in tone and texture. Overlapping and relative size also play their roles in the provision of perspective. Without foreground and background, there is no point of reference from which we can infer the scale of the trees. Their monumentality is implied by the power of the artist's brushstrokes. The groupings of trees to the left have a soft sculptural quality and the overall form of delicate ceramic wares. The groupings of trees within each screen balance one an-

18–39 TORII KIYONAGA *Bathhouse Scene.* Print. 30 x 20½".

Courtesy, Museum of Fine Arts, Boston. Bigelow Collection.

other, and the overall composition is suggestive of the infinite directional strivings of nature to find form and express itself.

Torii Kiyonaga's *Bathhouse Scene* (Fig. 18–39) is a modern print that influenced European artists during the second half of the nineteenth century. French Impressionist Edgar Degas, in fact, hung the print in his bedroom. Other noted modern Japanese printmakers include Ando Hiroshige (see Fig. 5–2) and Katsushika Hokusai (see Fig. 3–12). In Figure 18–39, strong outlines depict unposed women in a communal bathhouse. There is none of the subtle variation in tone or texture that we find in *Pine Wood.* The charm of the picture in large part derives from the mundane but varied activities and positions of the women. The robes and hair to some degree document the styles of the day. The choice of subject—average people engaged in daily routines—is also a decidedly modern departure from earlier Japanese tradition.

The Japanese tradition, like the Western tradition, has various periods and styles. In Japanese art, as in Western art, we find a developing technology, the effect of native materials, indigenous and foreign influences, a mix of religious traditions, and disagreement as to what art is intended to portray. Despite its vast differences from Western art, Japanese art shows similar meanings and functions. Japanese artists also use the same elements of art, in their own fashion, to shape brilliant compositions.

Art is a visual language that seems to transcend national boundaries, tongues, and customs. It seems that we can begin to understand Japanese art, Chinese art, and other types of non-Western art by using the same language that applies to our own art. In understanding the art of peoples from sundry cultures, we begin to fathom the aesthetic and expressive potential that we hear within ourselves.

Glossary

a-b-a-b alternate support system A support system in which every other nave wall support sends up a supporting rib that crosses the vault as a transverse arch.

abrade To scrape or rub off.

abstract A simplified or sometimes distorted rendering of an object that has the essential form or nature of that object (*abstracted*); a work of art whose forms make no reference to visible reality (*nonobjective*).

abstract art Art whose forms make no reference to visible reality; nonobjective art.

abstracted art Art that departs significantly from the appearance of objects, but whose subject is derived from visible reality; art that emphasizes what the artist perceives as the essential forms of objects, deemphasizing superficial characteristics.

Abstract Expressionism A style of painting and sculpture of the 1950s and 1960s, in which artists expressionistically distorted abstract images with loose, gestural brushwork. See *expressionistic*.

abstraction The essential form of an object; a process in which the artist focuses on and exaggerates the forms of objects for aesthetic and expressive purposes.

Academic Art A neo-classical, nonexperimental style promoted by the Royal French Academy during the eighteenth and nineteenth centuries.

Achilles The famed mythical Greek warrior and hero of the Trojan War.

achromatic Without color.

acquisitioning Buying (a work of art).

Acropolis The fortified upper part of a Greek city; literally, "city on a hill."

acrylic paint A paint in which pigments are combined with a synthetic plastic medium that is durable, soluble in water, and quick-drying.

Action painting A contemporary method of painting characterized by implied movement in the brushstroke and the splattering and dripping of paint on the canvas.

actual mass The mass of an object, as determined by its weight. Contrast with *implied mass.*

actual texture The texture of an object or picture, as determined by the sense of touch. Contrast with *implied texture.*

additive process A process in which a sculpture is created by adding or assembling materials, as in modeling and constructing. Contrast with *subtractive process.*

afterimage The lingering impression made by a stimulus that has been removed. Afterimages of colors are their complements.

allegory A narrative in which people and events have consistent symbolic meanings; extended metaphor.

altar A raised platform or stand used for sacred ceremonial or ritual purposes in a place of worship.

alternate support system An architectural system in which alternating structural elements bear the weight of the walls and the load of the ceiling.

ambulatory A continuation of the side aisles of a Latin cross plan into a passageway which extends back behind the choir and apse and allows traffic to flow to the chapels which often are placed in this area; from the Latin *ambulare*, to walk.

amorphous Without clear shape or form.

amphitheatre A round or oval open-air theatre with an arena surrounded by rising tiers of seats.

amphora A two-handled vessel with a long neck and an egg-shaped body.

analogous hues Hues that lie next to one another on the color wheel, and share qualities of hue due to mixture of adjacent hues; harmonious hues.

Analytic Cubism The early phase of Cubism (1909–1912), during which objects were dissected or analyzed in a visual "information-gathering" process and then reconstructed on the canvas.

Annunciation The angel Gabriel's announcement to Mary that she was going to give birth to Jesus.

aperture Opening.

Apocalypse The ultimate triumph of good over evil foretold in Judeo-Christian writings.

applied arts Arts whose primary aims are utilitarian.

apse A semicircular or polygonal projection of a building with a semi-circular dome, especially on the east end of a church.

aquarelle A watercolor technique in which transparent films of paint are applied to a white, absorbent surface.

aquatint An etching technique in which a metal plate is covered with acid-resistant resin and heated, causing the resin to melt. Areas of the plate are then exposed by a needle, and the plate receives an acid bath before being printed.

aqueduct A bridgelike structure that carries a canal or pipe of water across a river or valley. (From Latin roots meaning "to carry water.")

arabesque Descriptive of an intricate and elaborate design of geometric forms, intertwined flowers, and foliage.

arch A curved or pointed structure consisting of wedge-shaped blocks that span an open space and support the weight of material above by transmitting the load outward and downward over two vertical supports, or piers.

Archaic period A period of Greek art dating roughly 660–480 B.C. The term "archaic" refers to "old," or the art created prior to the Classical period.

Architectural style A style of Roman wall painting in which a wall was painted to give the illusion of opening onto a scene.

architecture The art and science of designing aesthetic buildings, bridges, and other structures to help us meet personal and communal needs.

architrave In architecture, the lower part of an entablature, which may consist of one or more horizontal bands.

archivolts In architecture, concentric moldings that repeat the shape of an arch.

arcology Solari's term for designs that combine architecture and ecological planning.

armature In the sculpture method of modeling, a framework for supporting plastic material.

Art Nouveau (French for "new art"). A highly ornamental style of the 1890s, characterized by floral patterns, rich colors, whiplash curves, and vertical attenuation.

assemblage A work of art that consists of the assembling of essentially three-dimensional objects to create an image. Artists often manipulate these pre-existing objects in various ways and incorporate them with other media such as painting or printmaking.

asymetry Lack of similarity between the left and right sides of a composition; placement of equivalent rather than identical visual forms to either side of an axis. Assymetrical balance creates the pictorial equivalent of symmetry without the literal replication of the same image on either side of the axis.

Athena Greek goddess of wisdom, skills, and war.

atmospheric perspective The creation of the illusion of depth through techniques such as texture gradient, brightness gradient, color saturation, and the use of warm and cool colors; an indistinct or hazy effect produced by distance and its illusion in visual art. Its name derives from the acknowledgement that the intervening atmosphere causes the effect.

Atreus An ancient king in Greek mythology.

atrium A hall or entrance court.

automatic writing The written expression of free associations.

Automatist Surrealism An outgrowth of automatic writing in which the artist attempts to derive the outlines of images from the unconscious through free association.

avant-garde The leaders in new, unconventional movements; the vanguard. (A French term meaning "advance guard.")

balance The distribution of the weights, masses, or other elements of a work of art such that they achieve harmony.

balloon framing In architecture, the construction of the wooden skeleton of a building from prefabricated studs and nails.

balustrade A railing held up by small posts, or balusters, as on a staircase.

Baroque style A seventeenth-century style of art in Europe characterized by ornamentation, curved lines, irregularity of form, dramatic lighting and color, and exaggerated gestures.

barrel vault A roofed-over space or tunnel that is constructed by placing arches behind one another.

basalt A dark, tough volcanic rock.

bas-relief Relief sculptures that project only slightly from their backgrounds. Contrast with *high relief.* (*Bas* means "low" in French.)

batik The making of designs in cloth by waxing the fabric to prevent a dye from coloring certain areas; a cloth or design made in this way.

bay The area of space spanned by a single unit of vaulting that may be marked off by piers or columns.

Ben Day process Dots or stippling used to add tone or shadow to a line drawing.

berm A shoulder or ledge of earth.

bevel To cut at an angle.

bilateral symmetry Similarity between the left and right sides of a composition.

binder A material that binds substances together.

biomorphic Having the form of a living organism.

bisque firing In ceramics, a preliminary firing that hardens the body of a ware.

bitumen Asphalt.

black-figure painting technique A three-stage firing process which gave vases black figures on a reddish ground. In the first phase of firing (*oxidizing phase*), oxygen in the kiln turns the vase and slip red. In the second phase of firing (*reducing phase*), oxygen is eliminated from the kiln and the vase and slip turn black. In the third phase of firing (*reoxidizing phase*), oxygen is reintroduced into the kiln, turning the vase red once more.

bohemian Literally, of Bohemia, a section of Czechoslovakia. However, the term signifies a nonconformist, unconventional style of life because gypsies had passed through Bohemia in transit to Western Europe.

brass A yellowish alloy of copper and zinc.

brick A hard substance made from clay, fired in a kiln or baked in the sun, and used in construction.

brightness gradient The rendering of nearby objects as having greater intensity than distant objects.

Buddha An enlightened man.

buon fresco True fresco, as executed on damp lime plaster. Contrast with *fresco secco.*

burin A pointed cutting tool used by engravers.

burnish To make shiny by rubbing or polishing.

buttress To support or prop up construction with a projecting structure, usually built of brick or stone; a massive masonry structure on the exterior wall of a building whose function is to press inward and upward to hold in place the stone blocks of arches. Flying buttresses connect the exterior buttresses with the vaults of the nave arcade.

Byzantine style A style associated with eastern Europe that arose after the year 300 A.D. when the emperor Constantine moved the capital of his empire from Rome to Byzantium (he renamed the capital Constantinople; present-day Istanbul). The style was concurrent with the Early Christian style in western Europe.

calligraphy Beautiful handwriting; penmanship.

camera obscura An early camera consisting of a large, dark chamber with a lens opening through which an image is projected onto the opposite surface in its natural colors.

candid Unposed, informal.

canon A set of rules.

capital The area at the top of the shaft of a column which provides a solid base for the horizontal elements above. Capitals are decorative transitions between the cylinder of the column and the rectilinear architrave above.

caricature A picture of a person or event that exaggerates predominant features or mannerisms for satirical effect.

Carolingian Relating to Charlemagne or his period.

cartoon A preparatory drawing made for a fresco, usually on paper and drawn to scale with the finished work; a drawing that caricatures or satirizes an event or person of topical interest.

carving The process of cutting away material.

casting The process of creating a form by pouring a liquid material into a mold, allowing it to harden, and then removing the mold.

cast iron A hard alloy of iron that contains silicon and carbon and is made by casting.

catacomb A vault or gallery in an underground burial place.

celadon In ceramics, a pale, grayish-green glaze.

cella The inner room of a Greek temple, used to house the statue of the god or goddess to whom the temple is dedicated. The cella is small and located behind solid masonry walls; it was accessible only to the temple priests.

centering In architecture, a wooden scaffold used in the construction of an arch.

ceramics The art of creating objects made of baked clay, such as pottery and earthenware.

chalk A form of soft limestone that is easily pulverized and can be used as a drawing implement.

charcoal A form of carbon produced by partially burning wood or other organic matter; can be used as a drawing implement.

Charlemagne Emperor of the Holy Roman Empire 800–814 A.D.

chiaroscuro From the Latin roots meaning "clear" and "dark," an artistic technique in which subtle gradations of tone or a gradual shift from light to shadow create the illusion of rounded, three-dimensional forms in space; also called modelling.

china A whitish or grayish porcelain that rings when struck.

chinoiserie An eighteenth-century ornate European style based on Chinese motifs.

chisel A sharp-edged tool used for cutting or shaping materials such as wood and stone.

cinematography The photographic art of creating motion pictures.

cinerary urn A vessel for keeping the ashes of people who have been cremated.

circular plan A circle-shaped, centralized plan in which the main central space is dominant and all other spaces are subordinate in function and serve merely to feed into the central space.

clapboard In architecture, siding composed of thin, narrow boards placed in horizontal, overlapping layers.

Classical period The period of Greek art spanning roughly 480–400 B.C.; also known as the Hellenic period, after "Hellas," the Greek name for Greece.

clerestory In a Latin cross plan, the area above the triforium in the elevation of the nave which contains windows to provide direct lighting for the nave.

close-up In cinematography or video, a "shot" made from very close range, providing intimate detail.

coffer A decorative sunken panel.

coiling A pottery technique in which lengths of clay are wound in a spiral fashion.

collage The assembling of essentially two-dimensional objects to create an image; works of art in which materials such as paper, cloth, and wood are pasted to a two-dimensional surface such as a wooden panel or a canvas. (From the French *coller*, meaning "to paste.")

colonnade A series of columns placed side by side to support a roof or a series of arches.

color negative film Color film from which negatives are made.

color reversal film Color film from which color prints (positives) are made directly (without using negatives).

combine painting A contemporary style of painting which attaches other media—frequently, found objects—to the canvas.

complementary colors Those specific pairs of colors (red and green, yellow and violet, and blue and orange) which most enhance one another by virtue of their simultaneous contrast. Each pair contains one primary color plus the secondary color made by mixing the other two primaries. Since the complements do not share characteristics of hue, and are as unlike as possible, the eye does not need to alter them, and rather readily distinguishes them.

composition The act of organizing or composing the plastic elements of art. The organization of the plastic elements in a work of art.

compound pier In the Gothic style, a complex-shaped vertical support, often to which are attached a number of colonnettes, or thin half-columns.

compressive strength The degree to which a material can withstand being squeezed or pressed together.

computer graphics The use of the computer to create images.

concave Curved like the inside of a ball.

conceptual Portrayed as a subject is known or thought to be, not as it appears. (Not to be confused with the contemporary style called *Conceptual art*.)

Conceptual art An anticommercial art movement begun in the 1960s in which works of art are conceived and "executed" in the mind of the artist. The commercial aspect of the "work" is frequently a written description of what exists in the artist's mind.

concrete A building material made from sand and gravel bonded with cement.

Confucianism An ethical system based on the teachings of Confucius, emphasizing devotion to family and friends, ancestor worship, and the seeking of justice and peace.

conservator A person who protects or repairs damaged works of art.

constructed sculpture A type of sculpture in which forms are built from materials such as wood, paper and string, and sheet metal and wire.

Constructivism A sculptural outgrowth of the Cubist collage in which artists attempted to use a minimum of mass to create volumes in space.

contact print Photographic print that is made by placing the negative in contact with a second sheet of photo-sensitive paper and exposing both of them to light.

conté crayon A wax crayon with a hard texture.

content All that which is contained within a work of art—the plastic elements, the subject matter, and its underlying meaning or themes.

convex Curved like the outside of a ball.

cool colors Blues, greens, and violets; colors that appear to recede spatially behind advancing, or warm colors and are therefore used to differentiate foreground and background.

corbel A supportive, bracket-shaped piece of metal, stone, or wood.

corbelling In architecture, a technique in which stones are placed above piers in such a way that each new course of masonry projects out slightly more than the one below until the courses on both sides of the arch opening meet at the top (like a staircase in reverse).

Corinthian order The most ornate of the Greek architectural styles, adopted by the Romans and characterized by slender, fluted columns and capitals consisting of acanthus leaf designs.

cornice In architecture, a horizontal molding that projects along the top of a wall or a building. The uppermost part of an entablature.

cosmetic palette A palette for mixing cosmetics, such as eye makeup, with water.

craft A special skill. A skilled trade.

crayon A small stick of colored wax, chalk, or charcoal.

crosshatching Shading a drawing through the use of two sets of parallel lines that cross each other.

crossing square The area which defines the right-angle intersection of the vaults of the nave and the transept of a church.

cross-section A diagram of the interior space of a building as seen with the façade removed (section) or side remove (lateral section).

cubiculum In architecture, a chapel in a burial chamber. Plural: cubicula.

Cubism A twentieth-century art style developed by Picasso and Braque, which emphasized a new treatment of pictorial space. Cubism was characterized by multiple views of the same object, the geometric cubelike essentials of form, and the two-dimensionality of the canvas.

Cubist Of or similar to Cubism; an artist who uses this style.

cuneiform Wedge-shaped; descriptive of the characters used in ancient Akkadian, Assyrian, Babylonian, and Persian alphabets.

curator The person in charge of a collection of works or of a museum.

Dada A post-World War I style of art that attempted to use art to destroy art, thereby underscoring the paradoxes and absurdities of modern life.

daguerreotype Named after Louis Daguerre, a photograph made from a silver-coated copper plate.

Dark Ages The Middle Ages in Europe (approximately the fifth through tenth centuries A.D.). Some scholars consider this period as characterized by intellectual and cultural stagnation.

deaccession Selling (a work of art).

dentil molding In architecture, a molding with a series of small rectangular blocks that project like teeth, as from under a cornice.

Der Blaue Reiter (The Blue Rider) A twentieth-century German Expressionist art movement that focused on the contrasts between and combinations of abstract forms and pure colors.

design The art of making designs or patterns.

diagonal rib In architecture, a rib that connects the opposite corners of a groin vault.

Die Brücke (The Bridge) A short-lived twentieth-century German Expressionist art movement characterized by boldly colored landscapes and cityscapes and violent portraits.

diptych A painting consisting of two panels, hinged together.

direct-metal sculpture Metal sculpture that is assembled by techniques such as welding and riveting, instead of being cast.

dissolve In cinematography and video, a fading technique in which the current scene grows dimmer as the subsequent scene grows brighter.

dome In architecture, a hemispherical structure that is round when viewed from beneath.

Doric order The earliest and simplest of the Greek architectural styles, consisting of relatively short, squat columns, sometimes unfluted, and a very simple capital shaped like a square. The frieze of the Doric order is usually divided into triglyphs and metopes.

drawing The act of running an implement which leaves a mark over a surface; a work of art created in this manner.

dry masonry Brick or stone construction that does not use mortar.

dry media Drawing materials that do not involve the application of water or other liquids. Contrast with *fluid media*.

drypoint A variation of engraving in which the surface of the matrix is cut with a sharp needle in such a way that rough edges are made. Rough edges make soft rather than crisp lines in the prints.

dynamism The futurist view that force or energy is the basic principle underlying all events.

earthenware Reddish-tan, porous pottery fired at a relatively low temperature (below 2000 degrees F).

earth-sheltered Descriptive of buildings that are protected from inclement weather and insulated against extremes of heat and cold by earth.

earthwork A work of art in which large amounts of earth or land are shaped into a sculpture.

Eastern Orthodox The Christian church dominant in Eastern Europe, Western Asia, and North Africa.

eclecticism An approach characterized by selecting from various styles and doctrines.

editing Rearranging a film or television record to provide a more coherent or desirable narrative or presentation of images.

egg tempera A medium in which ground pigments are bound with egg yolk.

emboss To decorate with designs that are raised above the surface.

embroidery The art of ornamenting fabric with needlework.

Empire period The Roman period from about 27 B.C. to 395 A.D., when the empire was divided.

Empire style An early nineteenth-century style characterized by massiveness and dignity, reflective of the Napoleonic era.

emulsion A suspension of a salt of silver in gelatin or collodion that is used to coat film and photographic plates.

enamel To apply a hard, glossy coating to the surface. A coating of this type.

encaustic A method of painting in which the colors in a wax medium are burned into a surface with hot irons.

engraving Cutting; in printmaking, an intaglio process in which plates of copper, zinc, or steel are cut with a burin and the ink image is pressed onto paper.

entablature In architecture, a horizontal structure supported by columns which, in turn, supports any element, such as a pediment, placed above. The entablature consists, reading from top to bottom, of a cornice, a frieze, and an architrave.

entasis In architecture, a swelling in a column.

equestrian In sculpture, represented on horseback.

etching An intaglio process in which the matrix is first covered with an acid-resistant ground. The ground is then removed from certain areas with a needle, and the matrix is dipped in acid, which eats away at the areas exposed by the needle. These areas become grooves which can be inked and printed.

Etruscans Natives of ancient Etruria, who dwelled along the northwestern shores of modern Italy.

Expressionism A modern school of art in which an emotional impact is achieved through agitated brushwork, intense colors, and the use of violent, hallucinatory imagery.

expressionistic Descriptive of art that emphasizes the distortion of form and color in order to achieve an emotional impact.

extrude To force metal through a die or through very small holes in order to give it shape.

façade A French word meaning the front or face of a building.

fading In cinematography and video, the gradual dimming or brightening of a scene, used as a transition between scenes.

fantastic art The representation of fanciful images, sometimes joyful and whimsical, sometimes horrific and grotesque.

Fauvism An early twentieth-century style of art characterized by the juxtaposition of areas of bright color, distorted linear perspective, and drawing that is unrelated to color.

fenestration The arrangement of windows and doors in a structure.

ferroconcrete Same as reinforced concrete.

Fertile Crescent The arable land lying between the Tigris and Euphrates Rivers in ancient Mesopotamia.

Fertile Ribbon The arable land lying along the Nile River in Egypt.

fetish figure An object believed to have magical powers.

fiber A slender, threadlike structure that can be woven.

fiberglass Finespun glass filaments that can be woven into textiles.

figurative Representing the likeness of a human figure.

film A thin sheet of cellulose material that is coated with a photosensitive substance.

fin de siècle A phrase generally referring to the waning of the nineteenth century; literally, the French phrase for "end-of-century."

fine arts Arts whose primary aims are aesthetic and expressive.

finial A decorative part or piece at the top of a lampshade support, spire, gable, or piece of furniture.

flashback In cinematography or video, interruption of the story line by portrayal of an earlier event.

flashforward In cinematography or video, interruption of the story line by portrayal of a future event.

flint glass A hard, bright glass that contains lead oxide.

fluid media Drawing materials that involve the application of water or other liquids. Contrast with *dry media*.

fluting The vertical grooves on the shafts of columns or pilasters.

flying buttress A structure which connects a buttress on the exterior of the building with the interior vault it supports.

foreshortening Diminishing the size of the parts of an object represented as farthest from the viewer. Specifically, diminishing the size of parts of an object rendered as receding away from the viewer at angles oblique to the picture plane, so that they appear proportionately shorter than parts of the object which are parallel to the picture plane.

forge To form or shape (usually heated) metal with blows from a hammer, press, or other machine.

free association In psychoanalytic theory, the process of allowing one's consciousness to flow naturally from thought to thought, without interference from intention or censorship. The free expression of thoughts as they occur.

free-blown Referring to glass that is blown into a bubble by means of a hollow tube.

free-standing sculpture Sculpture which is carved or cast in the round, unconnected to any architectural member, which can be experienced from the 360 possible points of view achieved by walking around it in a circle. Free-standing sculpture can also be designed for a niche, which would necessarily limit one's point of view.

fresco From the Italian word "fresh," a type of painting in which pigments are applied to a fresh, wet plaster surface or wall and thereby become part of the surface.

fresco secco Dry fresco, painting executed on dry plaster. Contrast with *buon fresco*.

frieze In architecture, a horizontal band between the architrave and the cornice that is often decorated with sculpture.

F-stop A setting on a camera that determines the size of the aperture.

Futurism An early twentieth-century style of art which portrayed modern machines and the dynamic character of modern life and science.

gadrooning Oval-shaped beading used to decorate silverware.

gallery A long, narrow corridor or room; A place for exhibiting or selling works of art.

gates In the lost-wax technique, these are wax rods connected to the mold. As the molten bronze flows into the mold, the gates allow air to escape.

gauffrage An inkless intaglio process.

genre painting Simple human representations; realistic figure painting which focuses on themes from everyday life.

geometric Shapes that are regular, easy to measure and easy to describe (as distinguished from organic or biomorphic shapes, which are irregular, difficult to measure, and difficult to describe).

Geometric period A Greek art style that roughly spanned the years 900–700 B.C. During this period, works of art emphasized the geometric patterns suggested by forms.

gesso Plaster of Paris that is applied to a wooden or canvas support and used as a surface for painting, or as the material for sculpture. (Italian for "gypsum.")

Gestalt A German word meaning "shape" or "form." The name of a school of psychology that emphasizes the tendency to perceive whole forms rather than the elements that compose or suggest the form.

gestural Brushwork which is loose and spontaneous, indicative of the bodily gesture which produced it.

gilding The art or process of applying gold leaf or thin sheets of a goldlike substance to a surface.

glazing In painting, the coating of a painted surface with a semitransparent color to provide a glassy or glossy finish; In ceramics, the application of a liquid suspension of powdered materials to the surface of a ware. After drying, the ware is fired at a temperature that causes the ingredients to melt together to form a hard, glossy coating.

Golden Section Developed in ancient Greece, a specific mathematical formula for determining the relationships of parts to the whole, based on the replication of a module or its multiples.

Gothic International style A refined style of painting in late fourteenth- and early fifteenth-century Europe that was characterized by splendid processions and courtly scenes, ornate embellishment, and attention to detail.

Gothic style A style of Western European art and architecture developed between the twelfth and sixteenth centuries. In architecture, characterized by ribbed vaults, pointed arches, flying buttresses, and high, steep roofs.

gouache A type of watercolor paint that is made opaque by mixing pigments with a particular gum binder.

graphic design Design for advertising and industry according to the specific needs of the client.

graphite A soft, black form of carbon. (From a Greek word meaning "to write.")

graver A cutting tool used by engravers and sculptors. A tool used in stone carving.

Greek cross plan A cross-shaped plan (particularly of a church) in which the arms (nave and transept) are equal in length.

griffin A mythical creature with the body and back legs of a lion and the head, wings, and talons of an eagle.

groin vault A vault that is constructed by placing barrel vaults at right angles so that a square space is covered.

ground The surface on which a two-dimensional work of art is created; a coat of liquid material applied to a support that serves as a base for drawing or painting.

gum A sticky substance found in many plants.

gum arabic A gum obtained from the African acacia plant.

haniwa A hollow ceramic figure placed at an ancient Japanese burial plot.

hard-edge painting A contemporary art style in which geometric forms are rendered with precision but there is no distinction between foreground and background.

hatcher An engraving instrument that leaves a metal matrix printed.

haute couture A French phrase meaning "high fashion."

heliography From the Greek, "Helios," meaning the sun, a photographic process in which bitumen is placed on a pewter plate to create a photosensitive surface which is then exposed to the sun.

Hellenism The culture, thought, and ethical system of ancient Greece.

high relief Relief sculptures that project from their backgrounds by at least half their natural depth. Contrast with *bas-relief*.

holography A lensless photography method in which laser light produces three-dimensional images by splitting into two beams and recording both the original subject and its reflection in a mirror.

horizon In linear perspective, the imaginary line (frequently, where the earth seems to meet the sky) along which converging lines meet. Vanishing points are placed on the horizon.

Horus The ancient Egyptian sun god.

Hudson River school A group of nineteenth-century artists whose favorite subjects included the scenery of the Hudson River Valley and the Catskill Mountains of New York State.

hue Color; the distinctive characteristics of a color that permit us to label it (as red or blue, for example) and to assign it a place in the visible spectrum.

Humanism A system of belief in which mankind is viewed as the standard by which all things are measured.

hypostyle In architecture, a structure whose roof is supported by rows of piers or columns.

iconoclast A person opposed to the use of religious symbols or icons.

iconography In a work of art, the conventional meanings attached to the images used by the artist; As an artistic approach, representing or illustrating by using the visual conventions and symbols of a culture.

iconology The study of visual symbols in art, which frequently have literary or religious origins.

idealism In art, the representation of forms according to a concept of perfection.

idealistic Based on the artist's conception of how the subject ought to appear.

illumination Illustration and decoration of a manuscript with pictures or designs.

illusionistic surrealism A method of surrealism which renders the irrational content, absurd juxtapositions, and changing forms of dreams in a highly illusionistic manner that blurs the distinctions between the real and the imaginary.

imam The leader in prayer at a Moslem mosque.

impasto Application of media such as oils and acrylics so that an actual texture is built up on a surface.

implied mass The apparent mass of a depicted object, as determined, for example, by the use of forms or of fields of color. Contrast with *actual mass*.

implied motion The use of plastic elements, composition, or content to create the impression of movement.

implied texture The illusion of textured surfaces created in a work, unrelated to the actual or tactile texture on its surface.

implied time The use of plastic elements, composition, or content to create the impression of the passage of time.

Impressionism A late nineteenth-century style of art characterized by the attempt to capture fleeting effects of light by applying paint in short strokes of pure color.

incise To cut into with a sharp tool.

incrustation style A style of Roman wall painting in which a wall was divided into solid-colored panels by painted pilasters and columns.

indigenous Native.

industrial design The planning and artistic enhancement of industrial products.

intaglio A printing process in which metal plates are incised, covered with ink, wiped, and pressed against paper. The print receives the image of the areas that are below the surface of the matrix.

intarsia A style of decorative mosaic inlay.

interior design The aesthetic organization and furnishing of interior spaces to serve human needs.

International style A post-World War I school of art and architecture that used modern materials and methods and expressed the view that form must follow function.

intricate style A style of Roman wall painting which created the illusion of open areas and framed them with elaborate architectural motifs.

investiture The fire-resistant mold used in metal casting.

Ionic order A moderately ornate Greek architectural style introduced from Asia Minor and characterized by spiral scrolls (*volutes*) on capitals, and a continuous frieze.

jamb In architecture, the side post of a doorway, window frame, fireplace, etc.

jasper A kind of porcelain developed by Josiah Wedgwood. Jasper (also called Jasperware) is characterized by a dull green or blue surface and raised white designs.

junk sculpture A contemporary style of sculpture that assembles industrial debris and other discarded objects.

Ka figure An image of a body in which the ancient Egyptians believed that the soul would dwell after death.

keystone The stone block placed directly in the center of a semi-circular arch.

keystone The wedge-shaped stone placed in the top center of an arch.

kiln An oven used for drying and firing ceramics.

kinetic sculpture Sculpture that moves.

kiva A circular, subterranean structure built by Native Americans for community and ceremonial functions.

kore The Greek word for "maiden"; this refers to the female figure represented in the sculpture of the geometric and Archaic styles.

kouros The Greek word for "youth"; this refers to the male figure represented in the sculpture of the geometric and Archaic styles.

krater A vessel with a wide mouth and hemispherical body used by the ancient Greeks for mixing water and wine.

labyrinth A structure containing an intricate network of passages, as a maze.

laminate To make by building up in layers.

language A means of communicating ideas and feelings that uses symbols and/or plastic elements that are organized according to certain rules or customs.

lapis lazuli An opaque blue, semiprecious stone.

Latin cross plan A cross-shaped church plan in which the nave is longer than the transept.

lavender oil An aromatic oil derived from plants of the mint family.

legitimate theater Professionally produced stage plays.

lens A transparent substance with at least one curved surface that causes the convergence or dispersal of light rays that are passing through. In the eye and camera, lenses are used to focus images onto photosensitive surfaces.

lift-ground etching An etching technique in which a sugar solution is brushed onto a resin-coated plate, creating the illusion of a brush and ink drawing.

light Electromagnetic energy that composes the part of the spectrum that excites the eyes and produces visual sensations.

line The mark left by a moving point.

linear Determined or characterized by the use of line.

linear perspective A system of organizing space in a work wherein lines which in reality are parallel and horizontal are represented as diagonals converging at a point. It is based upon foreshortening; the space between the lines grows smaller until it finally disappears. Linear perspective is made possible by the fact that objects appear to grow smaller as they recede from the eye.

lintel In architecture, a horizontal member supported by posts.

lithography A surface printing process in which an image is drawn onto a matrix with a greasy wax crayon. The matrix is dampened, but the waxed areas repel water. The matrix is then inked, but the ink adheres only to the waxed areas. When the matrix is pressed against paper, the paper receives the image of the crayon.

living rock Natural rock formations, as on a mountainside.

local color The hue of an object as created by the colors reflected by its surface under normal lighting conditions (contrast with *optical color*); colors which are natural for the objects they describe, rather than symbolic.

logo A distinctive company trademark or signature. (Short for "logotype.")

longitudinal plan A church plan in which the nave is longer than the transept and in which parts are symmetrical against an axis.

longshot In cinematography and video, a "shot" made from a great distance, providing an overview.

loom A machine for the weaving of thread into yarn or cloth.

lost-wax technique A bronze casting process in which an initial mold is made from a model (usually clay) and filled with molten wax. A second, fire-resistant mold is made from the wax, and molten bronze is cast in it.

Lucite An acrylic plastic that is cast or molded into transparent or translucent sheets and other shapes; frequently used in contemporary sculpture.

lunette A crescent-shaped space. (A French word meaning "little moon.")

magazine In architecture, a large supply chamber.

mandala In the Hindu and Buddhist traditions, a circular design symbolizing the wholeness or unity of life.

mandorla An almond-shaped halo which sometimes surrounds the entire body of a divine figure.

Mannerism A post-Renaissance sixteenth-century style of art characterized by artificial poses and gestures, harsh color, and distorted, elongated figures.

manuscript illumination The decoration of books and letters with designs and colors.

masquerade A staged event in which performers wear masks signifying persons who play various social and communal roles.

mass In painting, a large area of one form or color. Also see *implied mass* and *actual mass*.

matrix In printmaking, the working surface of the block, slab, or screen.

In sculpture, a mold or hollow shape used to give form to a material that is inserted in a plastic or molten state.

mausoleum A large, imposing tomb.

medium Latin for "means," refers to the materials and techniques used to create an image; in two-dimensional art, the medium is normally a liquid vehicle, or means of applying pigment to the ground.

megalith A huge stone, especially as used in prehistoric construction.

megaron A rectangular room with a two-columned porch.

Mesolithic Referring to the Middle Stone Age.

metope In architecture, the panels containing relief sculpture which appear between the triglyphs of the Doric frieze.

mezzotint A nonlinear engraving process in which the matrix is pitted with a hatcher.

mihrab A niche in the wall of a mosque that faces toward Mecca.

minaret A high, slender tower of a mosque from which the faithful are called to prayer.

Minimal art A contemporary art style that adheres to the Minimalist philosophy.

Minimalism A twentieth-century style of nonobjective art in which a minimal number of visual elements are arranged in a simple fashion.

mixed media The use of two or more traditional or non-traditional media to create a single visual image.

mobile A type of kinetic (moving) sculpture which moves in response to currents of air.

modeling In two-dimensional works of art, the creation of the illusion of depth through the use of light and shade (*chiaroscuro*); in sculpture, the process of shaping a pliable material such as clay or wax into a three-dimensional form.

Modernism A contemporary style of architecture which deemphasizes ornamentation and uses recently developed materials of great strength.

moiré pattern A wavy pattern that appears to vibrate because of the juxtaposition of similar lines whose changes are subtle and progressive.

mold A hollow shape or matrix used to give form to a material that is inserted in a plastic or molten state.

monochromatic Literally, "one-colored," it describes images which are executed in a single color or with so little contrast of colors as to appear essentially uniform in hue; opposite of *polychromed*.

monolith A single large block of stone; in sculpture, monolith refers to a work which strongly retains the original shape of the block of stone.

monotype A technique in which paint is brushed onto a matrix which is then pressed against a piece of paper, yielding a single print.

montage In cinematography or video, the use of flashing, whirling, or abruptly alternating images to convey connected ideas, suggest the passage of time, or provide an emotional effect.

mortar Plaster or cement that binds bricks or stones together in construction.

mortuary temple An Egyptian temple of the New Kingdom in which the pharaoh worshipped during his or her lifetime and at which the pharaoh was worshipped after death.

mosaic A medium in which the ground is wet plaster on an architectural element (such as a wall), and the vehicle consists of small bits of colored tile, stone, or glass (*tesserae*) which are assembled to create an image.

mosque A Moslem temple or place of worship.

motif A repeated visual theme.

muezzin A crier who calls the faithful to prayer at the proper hours, as from a minaret.

mummification The process of preserving a dead body by embalming.

mural painting Any painting either literally painted on a wall or intended to completely cover a wall.

mural quality From the Latin *muralis*, meaning "of a wall," it refers to solidity.

narrative editing In cinematography or video, selection from multiple images of the same subject to advance a story.

narthex A church vestibule leading to the nave, constructed for use by the

catechumens (individuals preparing for Baptism into Christianity). This space ceased to be built once Christianity had spread throughout Europe.

nave The central aisle of a church constructed for use by the congregation.

negative In photography, an exposed and developed film or plate on which light and shade are the reverse of what they are in the actual scene and in the print, or *positive*.

Neoclassical style An eighteenth-century style that revived the classical character of Greek and Roman art and is characterized by simplicity and straight lines.

Neolithic Referring to the New Stone Age.

neutrals "Colors" (black, white, gray) that do not contribute to the hue of other colors they are mixed with.

newel post The post that supports the rail at the top or bottom of a flight of stairs.

nib The point of a pen. The split and sharpened end of a quill pen.

Nihilism In art, the view that existing styles and institutions must be destroyed.

Niobid painter Anonymous vase painter of the Classical Period in Greece.

nirvana In Buddhist belief, a state of perfect blessedness in which the individual soul is absorbed into the supreme spirit.

nocturne A painting of a night scene; a musical composition with a dreamy, romantic character.

nonobjective art Art that does not portray objects. Art that does not have real models or subject matter.

nonporous Not containing pores that allow the passage of fluids.

ocher A dark yellow color derived from an earthy clay.

oculus Latin for eye; in architecture it refers to any round window, particularly one placed in the apex of a dome.

oil paint Paint in which pigments are combined with an oil medium.

oneiric Of dreams.

one-point perspective A type of linear perspective in which one vanishing point is placed on the horizon.

Op painting A style of art (Op or Optical art) begun in the 1960s which creates the illusion of vibrations through afterimages, disorienting perspective, and the juxtaposition of contrasting colors.

optical color The perception of the color of an object, which may vary markedly according to atmospheric conditions. Contrast with *local color*.

oran A praying figure.

organic Composed of interrelated parts that are usually soft, curvilinear, and irregular, as of living things found in nature.

Orientalizing phase A transitional period in Greek art (circa 700–600 B.C.) during which emphasis was shifting from geometry to the human figure.

ornate Heavily ornamented or adorned.

ornate style A style of Roman wall painting in which areas that gave the illusion of opening onto a scene were confined in frames on a solid-colored background.

orthogonal A line placed at right angles to another line.

Ottonian Of the period defined by the consecutive reigns of the German kings named Otto, begun in 936 A.D.

oxidizing phase See *black-figure painting technique*.

paint A mixture of a pigment with a vehicle or medium.

painting The applying of a pigment to a surface; A work of art created in this manner.

palette A surface on which pigments are placed and prepared and from which the artist works; the artist's choice of colors as seen in a work of art.

pan To move a motion picture or television camera from side to side to provide a comprehensive or continuous view of the subject.

Panathenaic procession The celebration, taking place every four years, during which the statue of Athena Parthenos was presented with a new robe.

panel painting A painting whose ground is a wooden panel. The vehicle is usually tempera, but may also be oil.

papyrus A writing surface made from the papyrus plant.

parallel editing In cinematography or video, shifting back and forth from one event or story line to another.

pastel A drawing implement that is produced by grinding up coloring matter, mixing it with gum, and forming it into a crayon.

pastoral Relating to idyllic rural life, especially of shepherds and dairy maids.

patina A fine crust or film that forms on bronze or copper because of oxidation and which usually provides a desirable green or greenish-blue tint to the metal.

Pax Romana A century and a half of peace that was enforced by the power of the Roman Empire. (A Latin phrase meaning "Peace of Rome.")

pediment Any triangular architectural shape surrounded by cornices, especially one which surmounts the entablature of the Greek temple portico façade. The Romans frequently placed pediments without support over windows and doorways.

pencil A rod-shaped drawing instrument with a center stick that is usually made of graphite.

pendentive A spherical triangle which fills the wall space between the four arches of a groin vault in order to provide a circular base on which a dome may rest.

peplos In Greek Classical art, a heavy woolen wrap.

photography The creation of images by the exposure of a photosensitive surface to light.

Photorealism An art movement that began in the late 1960s in which subjects are rendered with hard, photographic precision.

photosensitive Descriptive of a surface that is sensitive to light and therefore capable of being changed by light and recording images.

piazza An open public square or plaza.

picture plane The flat, two-dimensional surface on which an image is created. In much Western art, the picture plane is viewed as a window opening onto a deep space behind it.

pier In architecture, a support member which is vertical like a column,

but whose profile is rectilinear rather than cylindrical. Piers generally support arches.

pigment Coloring matter that is usually mixed with water, oil, or other substances in order to form paint.

pilaster A purely decorative element that recalls the shape of a structural pier. Pilasters are attached to the wall plane and project very little from it; they are, in effect, piers in relief. They have all the visual elements of piers (base, shaft, capital, and often entablature above).

pile weave A type of weave in which knots are tied, then cut, forming an even surface.

plain weave A type of weave in which the woof thread passes above one warp fiber and beneath the next.

planar recession A type of perspective in which the illusion of depth is created through parallel planes that appear to recede from the picture plane.

planography Any method of printing from a flat surface, such as *lithography*.

plastic elements Those elements of a work of art—line, form, color, texture, and so on—that artists manipulate in order to express themselves and achieve desired effects.

plasticity A quality of a material that gives it the capacity of being molded or shaped.

plebeian In ancient Rome, a common person.

plywood Sheets of wood that resist warping because they are built up from layers that are glued together.

pointed arch An arch which comes to a point at the top rather than being rounded.

Pointillism Also called Divisionism, a systematic method of applying minute dots of unmixed pigment to the canvas to be mixed solely by the eye when the painting is viewed.

polygon A many-sided geometric figure.

polyptych A painting constructed of a number of panels, hinged together.

Pop art An art style which originated in the 1960s and uses commercial and popular images and themes as its subject matter.

porcelain A hard, white, translucent, nonporous clay body. The bisque is fired at a relatively low temperature and the glaze at a high temperature.

portico Greek for porch; usually refers to the entrance façade of a Greek temple. The Greek temple portico façade also has been used extensively as a decorative entrance for other types of buildings. It consists of a colonnade, an entablature, and a pediment.

post and beam A type of construction in which vertical (posts) and horizontal timbers (beams) are pieced together with wooden pegs.

post and lintel A type of construction in which vertical posts are used to support horizontal crosspieces (lintels); also called *trabeated structure.*

Postimpressionists A group of late nineteenth century artists who relied upon the gains made by the Impressionists in terms of use of color and spontaneous brushwork, but who began to use these elements as expressive devices. The Postimpressionists also rejected the essentially decorative aspects of Impressionist subject matter.

Postmodernist A contemporary style of architecture which draws from classical and historical sources to provide ornamentation.

pottery Pots, bowls, dishes, and similar wares made of clay and hardened by heat. A shop at which such objects are made.

Poussiniste Descriptive of neoclassical artists who took Nicolas Poussin as their model. Contrast with *Rubeniste.*

Pre-Columbian Referring to art objects created in the Western hemisphere prior to the arrival of Columbus in 1492.

prefabricate To build beforehand at the factory rather than to make at the building site.

Pre-hellenic Of ancient Greek culture prior to the eighth century B.C.

primary colors The hues (red, blue, yellow) that are not obtained by the mixing of other hues. Other colors are derived from primary colors.

print A picture or design made from pressing or hitting a surface with a plate, block, etc., as in an etching, woodcut, or lithograph. In photog-

raphy, a photograph, especially one made from a negative.

prism A transparent, triangular body that disperses white light into the colors of the visible sprectrum.

proportion The relationship of parts to the whole in terms of size.

propylaeum A gateway building leading to an open court before a Greek or Roman temple; specifically, such a building on the Acropolis.

proto-Baroque Descriptive of works of art that immediately preceded the Baroque movement and which show characteristics of High Renaissance art and Baroque art.

psychic automatism A process of generating imagery in which artists attempt to allow themselves to receive ideas from the unconscious mind and to express them in an unrestrained manner.

pure abstraction Same as *nonobjective art.*

pylon A massive, towering structure that can be used to support a building or to flank an entrance; the entrance façade to the precincts of an Egyptian temple.

quarry tile Reddish-brown tile, similar to terra cotta.

quill A pen made from a large, stiff feather.

radiating chapel An apse-shaped chapel located beyond the ambulatory of a Latin cross plan. There are usually several of these, which appear to radiate outward from the ambulatory.

rasp A rough file that has raised points instead of lines.

ready-made Found objects that are exhibited as art, frequently after being placed in a new context and given a new title.

realistic A method of representing subject matter emphasizing accurate, truthful portrayal of that which is observed by the artist.

rectangular bay system A church plan in which rectangular bays serve as the basis for the overall design. Contrast with *square schematism.*

reducing phase See *black-figure painting technique.*

Reformation A social and religious movement of the sixteenth century in which various and often uncon-

nected groups attempted to reform the Roman Catholic Church both from within and via the establishment of rival religions—the various Protestant sects.

register A horizontal segment of a work of art or structure.

reinforced concrete Concrete that is strengthened by steel rods or mesh. Also called *ferroconcrete*.

relief printing Any of several printing techniques in which the printing matrix is carved with knives so that the areas not meant to be printed (to leave an image) are below the surface of the matrix.

relief sculpture Sculpture that is carved as ornament for architecture or furniture, as opposed to free-standing sculpture.

Renaissance Literally, rebirth. A period spanning the fourteenth and fifteenth centuries, the Renaissance was a rejection of medieval art and philosophy which first turned for inspiration to classical antiquity and then developed artistic forms and philosophical attitudes which paved the way for the modern world.

reoxidizing phase See *black-figure painting technique*.

repoussé Formed in relief, like a pattern on a metal sheet that is formed by hammering from beneath.

representational Descriptive of art that presents natural objects in recognizable form.

Republican period The Roman period lasting from the victories over the Etruscans to the death of Julius Caesar.

resolution In video, the sharpness of a picture as determined by the number of lines composing the picture.

rhythm The orderly repetition or progression of elements.

rib In architecture, a structural member which reinforces the stress points of groin vaults; seen in Gothic buildings.

Rococo style An eighteenth-century phase of the Baroque era that is characterized by lighter colors, greater wit, playfulness, occasional eroticism, and yet more ornate decoration.

Romanesque style A style of European architecture of the eleventh and twelfth centuries characterized by thick, massive walls, the Latin cross plan, the use of a barrel vault in the nave, round arches, and a twin-towered façade.

Romanticism A movement in the nineteenth century which rebelled against academic neoclassicism in the sense that it turned to sources of inspiration for subject matter and artistic style other than those promoted in the academies.

rosette A painted or sculpted circular ornament with petals and leaves radiating from the center.

rose window A large, circular window in a Gothic church. Rose windows are assembled in segments resembling petals of a flower and are usually adorned with stained glass and plantlike ornamental work.

rotunda A round hall or room, especially a domed hall or room.

Rubeniste Descriptive of romantic artists who took Peter Paul Rubens as their model. Contrast with *Poussiniste*.

salon During the eighteenth and nineteenth centuries, an annual exhibition of the French Academy held in the spring.

Salon d'Automne An independent exhibition of experimental works held in 1905—so named to distinguish it from the Academic salons which were usually held in the spring.

sampler A cloth embroidered with various designs and stitches, showing the artisan's skill.

sarcophagus A coffin or tomb, especially one made of limestone.

satin weave A type of weave in which the woof passes above and below several warp threads.

saturation The degree of purity of hue, as measured by its intensity or brightness.

scale The relative size of an object as compared to other objects, the setting, or people.

sculpture The art of carving, casting, modeling, or assembling materials into three-dimensional figures or forms; a work of art made in one of these manners.

S-curve Developed in the Classical style as a means of balancing the human form, and consisting of the distribution of tensions so that tension and repose are passed from one side of the figure to the other and back again, resulting in an S-shape; contrapposto.

seal A distinctive design.

secondary colors Colors that are derived from mixing pigments of primary colors in equal amounts. They are orange (red and yellow), violet (red and blue), and green (blue and yellow).

serigraphy A printing process in which stencils are applied to a screen of silk or similar material stretched on a frame. Paint or ink is forced through the open areas of the stencil onto paper underneath.

service systems In architecture, mechanical systems that provide structures with transportation, heat, the elimination of waste products, and so on.

shade The degree of darkness of a color, as determined by the extent of its mixture with black.

shaft grave A vertical hole in the ground where one or more bodies are buried.

shaped canvas A canvas that may be an irregular polygon, as opposed to the traditional rectangle, and that may project considerably from the wall on which it is hung.

Shinto A major religion of Japan, which emphasizes nature and ancestor worship.

Shiva The Hindu god of destruction and reproduction.

shutter In photography, a device for opening and closing the aperture or a lens in a camera so that the film or plate is exposed to light.

siding In architecture, a covering for an exterior wall.

silicon A hard, glassy mineral compound of silicon and oxygen.

silverpoint A drawing medium in which a silver-tipped instrument inscribes lines on a support that has been coated with a ground or pigment.

slow motion A cinematographic process in which action is made to appear fluid but slower than normal by exposing a greater-than-normal number of frames per second but then projecting the film at normal speed.

soft-ground etching An etching technique in which a ground of softened

wax yields effects similar to those of pencil or crayon drawings.

soft sculpture Sculpture made from soft materials like fabrics and vinyl rather than traditional hard materials like stone, wood, and metal.

sound track An area on the side of a strip of motion picture film which carries a record of the sound accompanying the visual information.

square schematism A church plan in which the crossing square serves as the basis for determining the overall dimensions of the building. Contrast with *rectangular bay system*.

squeegee A T-shaped tool with a rubber blade used to remove liquid from a surface.

stabile A type of winglike, nonmoving sculpture that strongly implies movement through soaring lines.

staccato Composed of abrupt, distinct elements.

stainless steel Steel made virtually immune to corrosion by being alloyed with chromium or other metals.

stamp To impress or imprint with a mark or design.

standing mobile A mobile that is supported on a base rather than hung.

steel A hard, tough metal composed of iron, carbon, and other metals, such as nickel or chromium.

steel cable A strong cable composed of multiple steel wires.

steel cage A method of building that capitalizes on the great strength of steel by piecing together slender steel beams to form the skeletons of structures.

stele An engraved stone slab or pillar that serves as a marker.

step pyramid An ancient Egyptian tomb consisting of squares of diminishing size stacked upon one another.

stereoscopy The photographic process of creating the illusion of a three-dimensional image by simultaneously viewing two photographs of a scene that are taken from slightly different angles.

Stoicism The philosophy that the universe is governed by natural laws and that mankind should follow virtue, as determined by reason, and remain indifferent to passion and emotion.

stoneware In ceramics, a slightly porous or nonporous ware fired at a high temperature.

stroboscopic motion The creation of the illusion of movement by the presentation of a rapid progression of stationary images—such as the frames of a motion picture.

style A characteristic manner or mode of artistic expression or design.

stylobate A continuous base or platform that supports a row of columns.

stylus A pointed, needle-like tool.

subject matter The objects or ideas depicted in a work of art.

subtractive process A process in which a sculpture is created by the removal of unwanted material, as in carving. Contrast with *additive process*.

sunspace In architecture, an area within a solar building that allows light to penetrate and builds up heat, which is usually conducted to cooler areas of the structure.

support A surface on which a two-dimensional work of art is made.

Suprematism Malevich's approach to nonobjective art, characterized by "the supremacy of pure feeling."

Surrealism A twentieth-century art style whose imagery is believed to stem from unconscious, irrational sources and therefore takes on fantastic forms. Although the imagery is fantastic, it is often presented in an extraordinarily realistic or illusionistic manner.

surrealistic Of or similar to Surrealism.

Synthetic Cubism The second phase of Cubism, which emphasized the form of the object, and constructing rather than disintegrating that form.

Synthetism Gauguin's theory of art, which advocated the use of broad areas of unnaturalistic color and primitive or symbolic subject matter.

systemic painting Any form of painting that follows a specific system of rules or principles of organization.

telephoto Descriptive of a lens that produces large images of distant objects.

tenebrism A style of painting that uses very little modeling. The artist goes rapidly from highlighting to deep

shadow without using a subtle gradation of tones.

tensile strength The degree to which a material can withstand being stretched.

terra cotta A hard, reddish brown earthenware that is used in sculpture and pottery and usually left unglazed.

tertiary colors Colors derived from mixing pigments of primary and adjoining (on the color wheel) secondary colors.

texture The surface character of materials as experienced primarily by the sense of touch.

texture gradient The rendering of nearby objects as having rougher, more detailed surfaces than distant objects.

tholos In architecture, a beehive tomb.

throwing In ceramics, the process of shaping that takes place on the potter's wheel.

tie-dying The making of designs by sewing or tying folds in cloth to prevent a dye from reaching certain areas.

tier A row or rank.

tint The degree of lightness of a color, as determined by the extent of its mixture with white.

transept The "arms" of a Latin cross plan, used by pilgrims and other visitors to allow access to the area behind the crossing square.

transverse rib In architecture, a rib that connects the midpoints of a groin vault.

tribune gallery In architecture, the space between the nave arcade and the clerestory used for traffic above the side aisles on the second stage of the elevation.

triglyph Panels incised with vertical grooves (usually three, hence triglyph) which serve to divide the scenes in the Doric frieze.

trombe wall In solar architecture, a thick masonry wall that collects heat during the day and releases it through the night.

trompe l'oeil A French phrase meaning "fool the eye." It refers to a painting or other art form that creates such a realistic image that the viewer at first glance wonders whether the image is real or a representation.

trumeau In Romanesque and Gothic architecture, a dividing element in the center of a portal below the tympanum which serves as an area for sculpture.

truss A rigid, triangular frame used for supporting roofs, bridges, and other structures.

tryglyph In architecture, a sculpted panel in a Doric frieze.

tryptych A set of three panels with pictures or other embelishment, often hinged so that the side panels may be folded over the center panel.

tufa A kind of porous stone.

twill weave A type of weave with broken diagonal patterns.

two-point perspective A type of linear perspective in which two vanishing points are placed along the horizon.

tympanum The semicircular space above the doors to a cathedral.

typography The arts of designing, arranging, and setting types for printing.

umber A kind of earth that has a yellowish or reddish brown color.

unity The oneness or wholeness of a work of art.

Upper Paleolithic The late years of the Old (paleolithic) Stone Age.

value The lightness or darkness of a color.

vanishing points In linear perspective, points on the horizon where parallel lines appear to converge.

vantage point The actual or apparent spot from which a viewer observes an object or picture.

vault Any series of arches other than an arcade used to create space. Barrel vaults are created by the placement of arches one behind the other; groin vaults are created by the intersection of barrel vaults at right angles to one another.

vehicle A liquid such as water or oil with which pigments are mixed for painting.

veneer In architecture, a thin layer of fine-quality material used to enhance the appearance of the façade of a structure.

Venus Roman goddess of beauty; also refers to prehistoric fertility sculptures such as the Venus of Willendorf.

Venus pudica A Venus with her hand held over her genitalia for modesty.

video A catch-all term for several arts that use the video screen, including, but not limited to, commercial and public television, video art, and computer graphics.

video art Use of the video screen in works of art. Video art refers to images on these screens and the use of video screens in assemblages.

videotape Magnetic tape that records images that can be instantly replayed and cannot be discriminated from originals ("live pictures") when played on the video screen.

vinescroll A design in which circular forms are embedded in vines that double back upon themselves.

vinyl A leathery material made from one of various synthetic resins and plastics.

visual arts Arts that appeal primarily to the visual sense, such as drawing, painting, sculpture, architecture, many crafts, photography, cinematography, and video art; also called space arts, to distinguish them from the time arts (music, live theatre, etc., whose forms progress primarily through time).

vitrify To become hard, glassy, nonporous.

volute A spiral scroll forming a feature of Ionic and Corinthian capitals.

volute krater A wide-mouthed vessel (*krater*) with scroll-shaped handles.

votive Refers to the quality of being worshipful and is usually employed to describe figures associated with the worship of a diety.

voussoir A wedge-shaped stone block used in the construction of an arch.

wainscoting A wood paneling or lining along the walls of a room, particularly along the lower parts of walls.

ware Pottery or porcelain; a good to be sold by a merchant.

warm colors Reds, oranges, and yellows; colors that appear to advance spatially before cool colors (greens, blues, violets).

warp In weaving, the threads that run lengthwise in a loom and which are crossed by the weft or woof.

wash A thin, watery film of paint—especially watercolor—applied with even, sweeping movements of the brush.

watercolor A paint with a water medium. Watercolors are usually made by mixing pigments with a gum binder and thinning the mixture with water.

weaving The making of fabrics by the interlacing of threads or fibers, often on a loom.

webbing In architecture, a netlike structure that comprises that part of a ribbed vault that lies between the ribs.

weft In weaving, the yarns that are carried back and forth across the warp. Also called *woof*.

weight shift The situating of the figure so that the legs and hips are turned in one direction and the chest and arms in another. This shifting of weight causes a diagonal balancing of tension and relaxation.

wide-angle Descriptive of a lens that covers a wider angle of view than an ordinary lens.

woodcut A type of relief printing in which the grain of the wooden matrix is carved with a knife.

wood engraving A type of relief printing in which a hard, laminated, non directional wood surface is used as the matrix.

woof See *weft*.

wordworks Contemporary works of art whose imagery consists of words.

Zen Buddhism An anti-rational Buddhist worldview that enlightenment is to be sought through introspection and intuition.

zoogyroscope An early motion picture projector.

zoom To use a zoom lens, which can be rapidly adjusted to provide distance shots or close-ups while keeping the image in focus.

Index

PHOTO CREDITS and COPYRIGHTS

LOIS FICHNER-RATHUS received an M.A. from the Williams College Graduate Program in the History of Art, which was offered in collaboration with the Sterling and Francine Clark Art Institute. She received her Ph.D. in the history, theory, and criticism of art from the Massachusetts Institute of Technology. Her areas of specialization include the theory of art, ancient and classical art, and contemporary art and architecture. She has authored grants, contributed to books, written exhibition catalogs, and published numerous articles in professional journals including ARTS Magazine and the *Print Collector's Newsletter*. She has taught at the State University of New York at Albany, Union College, M.I.T., and the University of Texas, and currently teaches at Trenton State College. She resides in Summit, New Jersey with her husband and two daughters.